The Grove Dictionary of Art

From Rembrandt to Vermeer

The Grove Dictionary of Art

Other titles in this series:

From Renaissance to Impressionism
Styles and Movements in Western Art, 1400–1900

From Expressionism to Post-Modernism
Styles and Movements in 20th-century Western Art

From David to Ingres
Early 19th-century French Artists

From Monet to Cézanne
Late 19th-century French Artists

Praise for *The Dictionary of Art*

'It is hard to resist superlatives about the new *Dictionary of Art*... If this isn't the most important art-publishing event of the 20th century, coming right at its end, one would like to know what its plausible competitors are. In fact there aren't any....'
Robert Hughes, *Time Magazine*

'The *Dictionary of Art* succeeds in performing that most difficult of balancing acts, satisfying specialists while at the same time remaining accessible to the general reader.'
Richard Cork, *The Times*

'As a reference work, there is nothing to compare with *The Dictionary of Art*. People who work in the arts - lecturers, curators, dealers, researchers and journalists - will find it impossible to do their jobs without the magnificent resource now available to them.'
Richard Dorment, *The Daily Telegraph*

'These are whole books within books... An extraordinary work of reference.'
E. V. Thaw, *The Wall Street Journal*

'It's not at all hyperbolic to say the dictionary is the rarest kind of undertaking, one that makes you glad it happened during your life.'
Alan G. Artner, *Chicago Tribune*

The Grove Dictionary of Art

From Rembrandt to Vermeer

17th-century Dutch Artists

Edited by Jane Turner

GROVEart

From Rembrandt to Vermeer

Copyright © 2000 by Jane Turner

St. Martin's Press, Scholarly and Reference Division
175 Fifth Avenue, New York, NY 10010

First published in the United States of America in 2000

Printed in the United Kingdom

ISBN: 0-312-22972-0

Library of Congress Cataloging-in-Publication Data

The Grove dictionary of Art. From Rembrandt to Vermeer : 17th-century Dutch artists /
edited by Jane Turner
 p.cm – (The GroveArt series)
 Includes bibliographical references and index.
 ISBN 0-312-22972-0 (cloth)
 1. Art, Dutch. 2. Art, Modern – 17th–18th centuries – Netherlands.
 I. Title: From Rembrandt to Vermeer.
 II. Turner, Jane Shoaf. III. Series

N6946.G76 2000
759.9492´09´032–dc21 99-087772

Contents

Preface

In these days of information glut, *The Dictionary of Art* has been a godsend, instantly relegating all its predecessors to oblivion. Within its stately thirty-four volumes (one for the index), the territory covered seems boundless. Just to choose the most amusingly subtitled of the series, *Leather to Macho* (vol. 19), we can learn in the first article not only about the way animal skins are preserved, but about the use of leather through the ages, from medieval ecclesiastical garments to Charles Eames's furniture. And if we then move to the last entry, which turns out to be a certain Victorio Macho, we discover that in the early 20th century, he graced Spanish cities with public sculpture, including a monument to the novelist Benito Pérez Galdós (1918) that many of us have passed by in Madrid's Parque del Retiro. And should we wish to learn more about Macho, there is the latest biblio graphical news, bringing us up to date with a monograph of 1987.

Skimming the same volume, we may stumble upon everything from the art of the Lega people in Zaïre and the use of artificial Lighting in architecture to somewhat more predictable dictionary entries such as Lichtenstein, roy; London: westminster abbey; Lithography; or Los angeles: museums. If browsing through one volume of *The Dictionary of Art* can open so many vistas, the effect of the whole reference work is like casting one's net into the waters and bringing back an unmanageable infinity of fish. Wouldn't it be more useful at times to single out in one place some of the myriad species swimming through the pages of *The Dictionary*? And then there is the question of cost and dimensions. In its original, complete form, the inevitably stiff price and the sheer size of all thirty-four volumes meant that it has fallen mostly to reference libraries to provide us with this awesome and indispensable tool of knowledge.

Wisely, it has now been decided to make this overwhelming databank more specialized, more portable, and more financially accessible. To do this, the myriad sands have been sifted in order to compile more modest and more immediately useful single volumes that will be restricted, say, to Dutch painting of the 17th century or to a survey of major styles and movements in Western art from the Renaissance to the end of the 19th century. So, as much as we may enjoy the countless delights of leafing through the thirty-four volumes in some library, we can now walk off with only one volume that suits our immediate purpose, an unparalleled handbook for a wide range of readers, especially for students and scholars who, rather than wandering through the astronomical abundance of art's A to Z, want to have between only two covers the latest words about a particular artist or 'ism'.

The great art historian Erwin Panofsky once said 'There is no substitute for information'. This new format of *The Dictionary of Art* will help many generations meet his sensible demands.

Robert Rosenblum
Henry Ittleson jr, Professor of Modern European Art
Institute of Fine Arts
New York University

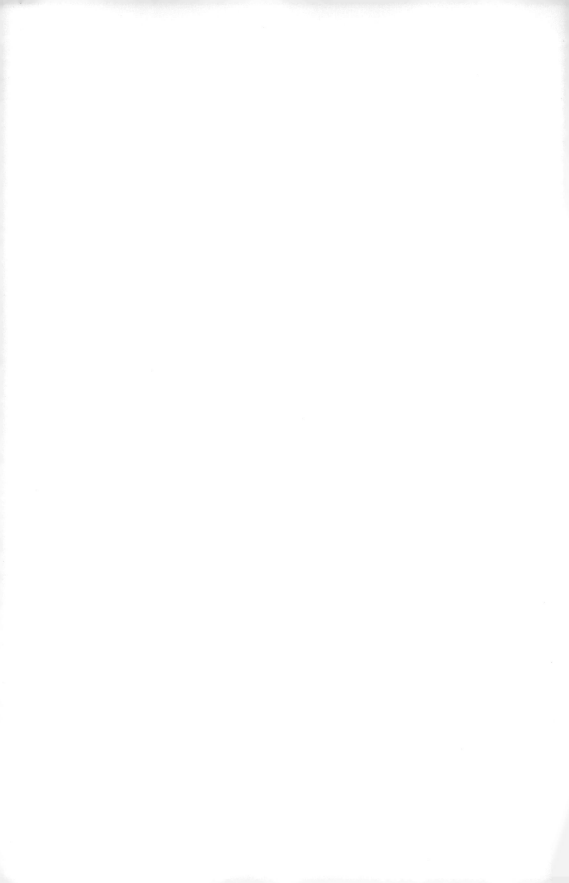

List of Contributors

Allen, Eva J.

Andrews, Keith

Baer, Ronni

Beck, H.-U.

Berge-Gerbaud, Maria Van

Bogendorf Rupprath, C. Von

Bos, Luuk

Broos, B. P. J.

Brown, Christopher

Brusati, C.

Bruyn, J.

Chong, Alan

Cordingly, David

Döring, Thomas

Davies, Alice I.

Dijk-Koekoek, H. G.

Domela Nieuwenhuis, Eric

Donahue Kuretsky, Susan

Duparc, Frederik J.

Ekkart, Rudolf E. O.

Franits, Wayne

Gordon, George

Grisebach, Lucius

Groot, Agnes

Haberland, Irene

Harwood, L. B. L.

Hensbroek-Van Der Poel, D. B.

Hofrichter, Frima Fox

Honig, Elizabeth Alice

Huys Janssen, Paul

Jansen, G.

Jensen Adams, Ann

Kamp, Netty Van De

Keyes, George S.

Kilian, Jennifer

Lawrence, Cynthia

Leistra, J. E. P.

Levine, David A.

Liedtke, Walter

Limouze, Dorothy

Loughman, John

Lowenthal, Anne W.

Luijten, Ger

Mcneil Kettering, Alison

Meij-Tolsma, Marijke Van Der

Mens, Pierre F. M.

Meyere, J. A. L. De

Miller, Debra

Moltke, J. W. Von

Mühlberger, Richard C.

Noldus, J. W.

Otten, M. J. C.

Rem, Paul II.

Reznicek, E. K. J.

Robinson, William W.

Roy, Alain

Royalton-Kisch, Martin

Russell, Margarita

Sayre, Eleanor A.

Schapelhouman, Marijn

Schatborn, Peter

Schnackenburg, B.

Schuckman, Christiaan

Schulz, Wolfgang

Scott, Mary Ann

Segal, Sam

Slatkes, Leonard J.

Sluijter, Eric J.

Sluijter-Seijffert, Nicolette C.

Spicer, Joaneath A.

Stampfle, Felice

Steland, Anne Charlotte

Sullivan, Scott A.

Sutton, Peter C.

Trezzani, Ludovica

Tümpel, Astrid

Vermet, Bernard

Vries, Lyckle De

Walsh, Amy L.

Wansink, C. J. A.

Weller, Dennis P.

Wieseman, Marjorie E.

Worm, Ingeborg

Zadelhoff, Trudy Van

General Abbreviations

The abbreviations employed throughout this book do not vary, except for capitalization, regardless of the context in which they are used, including the bibliographical citations and for locations of works of art. For the reader's convenience, separate full lists of abbreviations for locations, periodical titles and standard reference books and series are included as Appendices.

AD	Anno Domini	*d*	died	inc.	incomplete		
addn	addition	ded.	dedication,	incl.	includes,		
a.m.	ante meridiem		dedicated to		including,		
	[before noon]	dep.	deposited at		inclusive		
Anon.	Anonymous(ly)	destr.	destroyed	Incorp.	Incorporation		
app.	appendix	diam.	diameter	inscr.	inscribed,		
Assoc.	Association	diss.	dissertation		Inscription		
attrib.	attribution,	Doc.	Document(s)	intro.	introduced by,		
	attributed to				introduction		
		ed.	editor, edited (by)	inv.	inventory		
B.	Bartsch [catalogue	edn	edition	irreg.	irregular(ly)		
	of Old Master	eds	editors				
	prints]	e.g.	*exempli gratia* [for	jr	junior		
b	born		example]				
bapt	baptized	esp.	especially	kg	kilogram(s)		
BC	Before Christ	est.	established	km	kilometre(s)		
bk, bks	book(s)	etc	*et cetera* [and so on]				
BL	British Library	exh.	exhibition	l.	length		
BM	British Museum			lb, lbs	pound(s) weight		
bur	buried	f, ff	following page,	Ltd	Limited		
			following pages				
c.	circa [about]	facs.	facsimile	m	metre(s)		
can	canonized	fasc.	fascicle	m.	married		
cat.	catalogue	*fd*	feastday (of a saint)	M.	Monsieur		
cf.	confer [compare]	fig.	figure (illustration)	MA	Master of Arts		
Chap., Chaps		figs	figures	MFA	Master of Fine Arts		
	Chapter(s)	*fl*	*floruit* [he/she	mg	milligram(s)		
Co.	Company;		flourished]	Mgr	Monsignor		
	County	fol., fols	folio(s)	misc.	miscellaneous		
Cod.	Codex, Codices	ft	foot, feet	Mlle	Mademoiselle		
Col., Cols	Colour;			mm	millimetre(s)		
	Collection(s);	g	gram(s)	Mme	Madame		
	Column(s)	gen.	general	Movt	Movement		
Coll.	College	Govt	Government	MS., MSS	manuscript(s)		
collab.	in collaboration	Gt	Great	Mt	Mount		
	with, collaborated,	Gtr	Greater				
	collaborative			N.	North(ern);		
Comp.	Comparative;	h.	height		National		
	compiled by,	Hon.	Honorary,	n.	note		
	compiler		Honourable	n.d.	no date		
cont.	continued			NE	Northeast(ern)		
Contrib.	Contributions,	ibid.	*ibidem* [in the	nn.	notes		
	Contributor(s)		same place]	no., nos	number(s)		
Corp.	Corporation,	i.e.	*id est* [that is]	n.p.	no place (of		
	Corpus	illus.	illustrated,		publication)		
Corr.	Correspondence		illustration	nr	near		
Cttee	Committee	in., ins	inch(es)	n. s.	new series		
		inc.	Incorporated	NW	Northwest(ern)		

Occas.	Occasional	**red.**	reduction,		Santissimi
op.	opus		reduced for	**St**	Saint, Sankt,
opp.	opposite; opera	**reg**	*regit* [ruled]		Sint, Szent
	[pl. of opus]	**remod.**	remodelled	**Ste**	Sainte
oz.	ounce(s)	**repr.**	reprint(ed);	**suppl., suppls**	supplement(s),
			reproduced,		supplementary
p	pence		reproduction	**SW**	Southwest(ern)
p., pp.	page(s)	**rest.**	restored,		
p.a.	per annum		restoration	**trans.**	translation,
Pap.	Paper(s)	**rev.**	revision, revised		translated by;
para.	paragraph		(by/for)		transactions
pl.	plate; plural	**Rev.**	Reverend;	**transcr.**	transcribed
pls	plates		Review		by/for
p.m.	post meridiem				
	[after noon]	**S**	San, Santa,	**unpubd**	unpublished
Port.	Portfolio		Santo, Sant',		
Posth.	Posthumous(ly)		São [Saint]	**v**	*verso*
prev.	previous(ly)	**S.**	South(ern)	**var.**	various
priv.	private	**SE**	Southeast(ern)	**viz.**	*videlicet*
pseud.	pseudonym	**sect.**	section		[namely]
pt	part	**ser.**	series	**vol., vols**	volume(s)
pubd	published	**sing.**	singular	**vs.**	versus
pubn(s)	publication(s)	**sq.**	square		
		SS	Saints, Santi,	**W.**	West(ern)
R	reprint		Santissima,	**w.**	width
r	*recto*		Santissimo,		

Note on the Use of the Book

This note is intended as a short guide to the basic editorial conventions adopted in this book.

Abbreviations in general use in the book are listed on p. x; those used in bibliographies and for locations of works of art or exhibition venues are listed in the Appendices.

Author's signatures appear at the end of the articles. Where an article was compiled by the editors or in the few cases where an author has wished to remain anonymous, this is indicated by a square box (□) instead of a signature.

Bibliographies are arranged chronologically (within a section, where divided) by order of year of first publication and, within years, alphabetically by authors' names. Abbreviations have been used for some standard reference books; these are cited in full in Appendix C. Abbreviations of periodical titles are in Appendix B. Abbreviated references to alphabetically arranged dictionaries and encyclopedias appear at the beginning of the bibliography (or section).

Biographies in this dictionary start with the subject's name and, where known, the places and dates of birth and death and a statement of nationality and occupation. In the citation of a name in a heading, the use of parentheses indicates parts of the name that are not commonly used, while square brackets enclose variant names or spellings.

Members of the same family with identical names are usually distinguished by the use of parenthesized small roman numerals after their names. Synonymous family members commonly differentiated in art-historical literature by large roman numerals appear as such in this dictionary in two cases: where a family entry does not contain the full sequence (e.g. Karel van Mander I and Karel van Mander III); and where there are two or more identical families whose surnames are distinguished by parenthesized small roman numerals (e.g. Velde, van de (i) and Velde, van de (ii)).

Cross-references are distinguished by the use of small capital letters, with a large capital to indicate the initial letter of the entry to which the reader is directed; for example, 'He commissioned LEONARDO DA VINCI...' means that the entry is alphabetized under 'L'. Given the comprehensiveness of this book, cross-references are used sparingly between articles to guide readers only to further useful discussions.

Aelst, Willem van

(*b* Delft, 1627; *d* ?Amsterdam, after 1687). Dutch painter. He specialized in still-lifes, as did his uncle and teacher Evert van Aelst of Delft (1602–57), whose name survives only in inventories and who died in poverty. Willem's earliest known work, a *Still-life with Fruit* (1642; destr., ex-Suermondt-Ludwig-Mus., Aachen), is likely to have been influenced by his uncle's style. On 9 November 1643 he enrolled in the Delft painters' guild and from 1645 to 1649 was in France, where he painted the *Still-life with Fruit* (1646; Stockholm, E. Perman priv. col.). From 1649 to 1656 he worked in Florence as court painter to Ferdinando II de' Medici, Grand Duke of Tuscany. There he met his fellow countrymen Matthias Withoos and Otto Marseus van Schrieck, the latter also a still-life painter, who probably influenced van Aelst's detailed and smooth style, and with whom van Aelst returned to the Netherlands in 1656—first briefly to Delft before settling in Amsterdam in 1657. Van Aelst's usual signature on paintings, *Guill[er]mo van Aelst*, recalls his stay in Italy, as does the (occasional) use of his bent-name 'Vogelverschrikker' (scarecrow), which appears, for example, on a *Still-life with Poultry* (1658; Amsterdam, Rijksmus.).

Van Aelst became famous for his ornate still-lifes with fine glassware, precious silver goblets, fruit and flowers (see fig 1). They are unparalleled in the rendering of surfaces and characterized by a bright, sometimes rather harsh colour scheme. His *Still-life with Shell* (1659; Berlin, Bodemus.) demonstrates that, although he was influenced by Willem Kalf, he preferred sharply outlined forms and more striking colour contrasts. His connection with Amsterdam is especially evident in the flower still-lifes painted between 1659 and 1663, such as *Still-life with Flowers in a Niche* (1662; Rotterdam, Boymans–van Beuningen) and *Still-life with Flowers and a Watch* (1663; The Hague, Mauritshuis), in which the ear-shaped vases can be recognized as the work of Johannes Lutma, a famous Amsterdam silversmith. As well as a subtle combination of bright colours and the use of striking light effects, the Mauritshuis painting is remarkable for its asymmetrical arrangement of the bouquet, a new idea in flower painting, and one soon taken up by many other painters.

Van Aelst also specialized in still-lifes with game, at least 60 of which survive, painted between 1652 and 1681. A comparison between one of the earliest dated examples (1653; destr. World War II, ex-Kaiser-Friedrich Mus., Berlin, see Sullivan, fig. 100) and his latest known work, *Still-life with Dead Cocks* (1681; sold The Hague, Van Marne & Bignall, 27 Jan 1942, lot 2; see Sullivan, fig. 105), shows that his successful formula was established early and remained virtually unchanged for over 30 years. At the centre of both is a marble tabletop on which birds and hunting accessories are displayed, the vertical element provided by a bird hanging down over the table. Certain items associated with hunting (game bag, bird net, hunting horn, falcon's hoods and quail pipes) are always included, yet the compositions are individually varied, and the skilful style of painting makes each one a pleasure to look at (e.g., 1664, Stockholm, Nmus.; 1668, Karlsruhe,

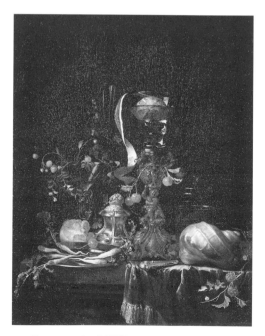

1. Willem van Aelst: *Still-life* (St Petersburg, Hermitage Museum)

Staatl. Ksthalle; 1671, The Hague, Mauritshuis). His pupils included Maria van Oosterwijck in Delft and Rachel Ruysch in Amsterdam.

Bibliography

S. A. Sullivan: *The Dutch Gamepiece* (Totowa and Montclair, NJ, 1984), pp. 52–4, 97

Great Dutch Paintings from America (exh. cat.; The Hague, Mauritshuis; San Francisco, F.A. Museums; 1990–91), pp. 130–33, no. 1

B. P. J. BROOS

Asselijn [Asselein; Asselin; Asselyn], Jan [Janus; Jean]

(*b* Dieppe, after 1610; *d* Amsterdam, 1652). Dutch painter and draughtsman, of French descent. With Jan Both and Jan Baptist Weenix, he was one of the most important artists of the second generation of Dutch Italianates. The Asselin family moved from Dieppe to Amsterdam *c.* 1621 and adopted the Dutch spelling of their surname after 1650. Of Jan's three brothers, Abraham Asselijn (1609–97) became a goldwire-maker. In Amsterdam Jan studied with Jan Martszen the younger (*c.* 1609–after 1647), Esaias van de Velde's nephew and follower, a specialist in depicting battle scenes with cavalry. Asselijn's early works, such as *Battle Scene* (1634; Brunswick, Herzog Anton Ulrich-Mus., see Steland-Stief, 1971, pl. VIII), show this influence.

Shortly after November 1635 Asselijn travelled, probably via France, to Rome, where he became a member of the Schildersbent, the association of northern artists in Rome (a counterproof of his drawing of some of the members, the *Bentvueghels*, is in Berlin, Kupferstichkab.). According to Houbraken, his bent-name was 'Krabbetje' (Little Crab) on account of his crippled left hand. He was in Rome for about seven years, where his principal influences up to *c.* 1641 were the paintings of Pieter van Laer, Jan Both and Andries Both. He drew and painted copies and variants of their compositions, depicting everyday life in Rome, either outdoors or in rocky grottoes. He went on to select his own subject-matter, chiefly landscapes with ruins, herdsmen and animals, broad panoramas, river views with bridges and quays, and picturesque seaports. Coarsely realistic figures, whose prototypes occur in his earlier cavalry scenes, animate these landscapes; whereas initially they are small and wildly gesticulating, later, better modelling gives them a degree of authority. His sensitive evocation of idyllic southern sunlight, as in *Landscape with the Ruins of an Aqueduct* (1646; Rome, Accad. N. S Luca), has much in common with Jan Both's manner. Yet although his works are apparently related stylistically to those of Claude Lorrain and Herman van Swanevelt, he did not adhere to their invented Arcadian imagery, preferring the actual Campagna for his naturalistic presentations of ruins, figures and the countryside.

On Asselijn's journey back to the northern Netherlands, he stayed *c.* 1644–5 in Lyon, where he married Antoinette Huaart [Houwaart], and in 1646 in Paris, where he provided three paintings (Paris, Louvre) for the decoration of the Cabinet d'Amour in the Hôtel Lambert. Shortly after his return to Amsterdam, aged between 35 and 40, his portrait was etched by Rembrandt (*c.* 1648; B. 277). He continued to produce Italianate works, such as *Panoramic Landscape* (*c.* 1649; Vienna, Akad. Bld. Kst.), with characteristically warm colours and careful attention to naturalistic detail. In addition, between 1647 and 1652 he painted Dutch subjects, such as the *Collapse of the St Anthonis Dike, 1651* (Schwerin, Staatl. Mus.), *Repair of the St Anthonis Dike, 1652* (Berlin, Gemäldegal.) and the *Frozen Moat outside City Walls* (Worcester, MA, A. Mus.). In his earlier works Asselijn tended to apply the paint thickly; around 1650 his palette became lighter and clearer and he painted more smoothly, creating broader, occasionally summary effects. This change, perhaps prompted by Weenix, clearly acknowledged the market's taste for a more decorative style. (His paintings on copper, however, have an enamel-like quality.)

Asselijn was also a prolific draughtsman. His sketches, done both from nature and in the studio, include Roman ruins, buildings and landscapes. The 11 surviving preparatory drawings of ruins (e.g. *Aqueduct at Frascati*, New York, Pierpont Morgan Lib.) for the series of 18 engravings by

Gabriel Perelle (Hollstein, nos 15–32) repeat subjects found in a Roman sketchbook (dispersed, e.g. *Temple of the Sibyl at Tivoli*, Darmstadt, Hess. Landesmus.). Eight pages of a second sketchbook are also preserved (London, BM). His architectural drawings display an unassuming naturalism and painstaking observation and representation of space, form, surface and atmosphere. He applied grey washes over pencil or chalk on white paper, sometimes adding white highlights, covering most of the surface of the paper. He also made compositional studies in either black and white chalk on blue paper, grey or brown wash, opaque white or sometimes pen and ink. The earlier studies, based on van Laer and Andries Both, add elements from his cavalry subjects (e.g. *Departure for the Hunt*, Brussels, Mus. Royaux A. & Hist.). Later, he developed his own rapid ideas, with energetic outlines on blue paper (e.g. Amsterdam, Rijksmus.; Hamburg, Ksthalle; Dresden, Kupferstichkab.; Leiden, Rijksuniv., Prentenkab.). In addition, he drew highly detailed preparatory sketches for paintings, both types probably inspired by Claude's drawings on blue and white paper in the *Liber veritatis* (1636; London, BM).

During his lifetime, Asselijn's closest follower was Willem Schellinks, and, according to Houbraken, Frederick de Moucheron was his pupil. Others who were influenced by him include Adam Pijnacker, Nicolaes Berchem, Karel Dujardin and Thomas Wijck, who adopted architectural motifs from the Roman studies, as well as Allaert van Everdingen, who adopted the waterfall subjects.

Bibliography

Hollstein: *Dut. & Flem.*

J. von Sandrart: *Teutsche Academie* (1675–9); ed. A. R. Pelzer (1925), p. 182

A. Houbraken: *De groote schouburgh* (1718–21), ii, p. 327; iii, p. 64

A. von Bartsch: *Le Peintre-graveur* (1803–21) [B.]

J. Kusnetsow: 'Tableau de la jeunesse de Jan Asselijn au Musée de l'Hermitage', *Bull. Mus. Ermitage*, xiv (1958), pp. 34–7

A. C. Steland-Stief: 'Jan Asselijn und Willem Schellinks', *Oud-Holland*, lxxix (1964), pp. 99–110

Nederlandse 17e eeuwse Italiaanisierende landschapschilders (exh. cat., ed. A. Blankert; Utrecht, Cent.

Mus., 1965); rev. and trans. as *Dutch 17th-century Italianate Painters* (Soest, 1978), pp. 129–44

A. C. Steland-Stief: 'Jan Asselijn und Karel Dujardin', *Raggi*, vii (1967), pp. 99–107

E. Knab: 'De genio loci', *Miscellanea J. Q. van Regteren Altena* (Amsterdam, 1969)

A. C. Steland-Stief: Drei Winterlandschaften des Italianisten Jan Asselijn und ihre Auswirkungen', *Kst. Hessen & Mittelrhein*, x (1970), pp. 59–65

—: *Jan Asselijn: Nach 1610 bis 1652* (Amsterdam, 1971)

—: 'Zum zeichnerischen Werk des Jan Asselijn', *Oud-Holland*, xciv (1980), pp. 213–58

—: 'Zu Willem Schellinks' Entwicklung als Zeichner: Frühe Zeichnungen der Frankreichreise um 1646 und die Ausbildung zum Italianisten in der Nachfolge des Jan Asselijn', *Niederdt. Beitr. Kstgesch.*, xxv (1986), pp. 79–108

—: 'Beobachtungen zur frühen Zeichnungen des Jan Both und zum Verhältnis zwischen Jan Both und Jan Asselijn in Rom vor 1641', *Niederdt. Beitr. Kstgesch.*, xxvii (1988), pp. 115–38

—: *Die Zeichnungen des Jan Asselijn* (Fridingen, 1989)

ANNE CHARLOTTE STELAND

Ast, Balthasar van der

(*b* Middelburg, ?1593–4; *d* Delft, *bur* 19 Dec 1657). Dutch painter. He was the brother-in-law of Ambrosius Bosschaert, whose household he entered in 1609, after the death of his father. He remained as Bosschaert's pupil, until he was 21. In 1615 van der Ast moved with the Bosschaert family to Bergen-op-Zoom. However, a year later the Bosschaerts were living in Utrecht, but van der Ast is not recorded there until 1619, when he was entered as a master in the Guild of St Luke. He remained in Utrecht until 1632, then lived in Delft, where he enrolled in the painters' guild on 22 June 1632. On 26 February 1633 he married Margrieta Jans van Bueren in Delft, where he spent the rest of his career; the marriage produced two children.

Van der Ast belonged to what Bol has called the Bosschaert dynasty: like his brother-in-law, he painted predominantly flower and fruit still-lifes, but as a new element he also painted shell still-lifes, which probably reflected the fashion for collecting exotic rarities. His oeuvre of c. 200 paintings is considerably larger than that of his

teacher Bosschaert. However, the chronology of van der Ast's work is more difficult to establish: there are dated works only from 1620–28. Moreover, his compositions are more diverse, with fewer exact repetitions, and were carried out in a wider variety of formats, ranging from small copper paintings of *c.* 500 mm to canvases of 2 m.

Van der Ast's earliest works are clearly influenced by the flower still-lifes of his nephew Ambrosius Bosschaert: usually they show a rich, vertically composed, symmetrical bouquet, the longitudinal axis being emphasized by a large leading flower, such as a tulip or an iris, and the lower arrangement filled with roses, peonies, carnations or asters. The bouquet, in an elegant vase of porcelain or glass before an open or closed background, is composed of flowers from different seasons, based on individual studies from nature (e.g. *Vase with Flowers and Shells*, 1628; Madrid, Mus. Thyssen-Bornemisza). What is also new in his work is the importance attached to realistically depicted animals, lizards, grasshoppers, toads or flies, used as accessories flanking the flowers and probably inspired by the work of Roelandt Savery (e.g. *Bouquet before a Landscape*, 1624; priv. col., see 1984 exh. cat., no. 13). Also novel, and clearly distinguishable from the work of his teacher, are van der Ast's depictions of individual flowers shown in a vase (e.g. *Tulip in a Glass Vase*, ex-art market, Solingen, 1980; see 1984 exh. cat., no. 15) and the 'still-lifes' of single flowers lying on a board or table (e.g. *Tulip and Forget-me-not*, priv. col., see 1984 exh. cat., no. 16). In composition and conception, these paintings anticipate the work of such artists as Jan van Kessel and Adriaen Coorte. Van der Ast's fruit still-lifes are often shown together with such non-European rarities as Chinese porcelain or parrots (e.g. *Flowers and Fruits with a Parrot*, Amersfoort, Mus. Flehite). His shell still-lifes are painted in a monochrome manner, which creates a unified composition and palette, despite the diversity of the objects depicted (e.g. *Still-life with Shells, Fruit and Red Currant Branch*, Dresden, Gemäldegal. Alte Meister). His brother Johannes van der Ast was also a flower painter and probably a pupil of Ambrosius Bosschaert the elder.

Bibliography

L. J. Bol: 'Bartholomaeus Assteijn', *Oud-Holland*, lxviii (1953), pp. 136–48

——: 'Een Middelburgse Breughel-Groep, Teil III', *Oud-Holland*, lxx (1955), pp. 138–54

——: *The Bosschaert Dynasty* (Leigh-on-Sea, 1960), pp. 36–40

P. Mitchell: *European Flower Painters* (London, 1973)

I. Bergström: 'Baskets with Flowers by Ambrosius Bosschaert the Elder and their Repercussions on the Art of Balthasar van der Ast', *Tableau*, vi (1983), pp. 721ff

Masters of Middelburg (exh. cat., Amsterdam, Waterman Gal., 1984), pp. 45–62

M.-L. Hairs: *Les Peintres flamands de fleurs au XVIIe siècle* (Brussels, 1985), pp. 130–31

IRENE HABERLAND

Avercamp

Dutch family of painters and draughtsmen.

(1) Hendrick (Barentsz.) Avercamp [de Stomme van Kampen]

(*bapt* Amsterdam, 27 Jan 1585; *bur* Kampen, 15 May 1634). He was the first artist in the northern Netherlands to paint winter landscapes. Before him only a few Flemish artists, among them Pieter Bruegel I and his sons, and Jacob Grimmer, had made winter scenery the main subject of their work. Avercamp created a new genre of Dutch painting by combining the panoramic scope, bright colours and high vantage point of these Flemish models with an emphasis on anecdotal detail.

1. Life and work

(i) **Paintings.** In 1586 the Avercamp family moved to Kampen, where Hendrick's father had been appointed a pharmacist. Hendrick was deaf-mute from birth, and throughout his life was commonly known by his nickname 'de Stom', or 'de Stomme' (Dut.: 'the mute'). It is generally assumed that he was a pupil of the history and portrait painter Pieter Isaacsz., in whose house in Amsterdam he was presumably living in 1607. This is inferred from a reference to 'the mute [who lives] at Pieter Isacqs's', documented as one of the buyers at a sale on 3 March 1607. During this period of training

in Amsterdam Avercamp must have come across the work of Flemish landscape painters, including Hans Bol, Gillis van Coninxloo and David Vinckboons, who had fled to Amsterdam when Antwerp once again fell to the Spanish in 1585. He may have seen some of their drawings and paintings, but in any case was familiar with engravings made after their work. The high horizon and the use of trees and houses as devices to balance the composition in early works, for example the *Winter Landscape* of before 1610 (Vienna, Ksthist. Mus.; see col. pl. I), clearly reveal their influence. In the *Winter Landscape* of 1609 (ex-Col. Thyssen-Bornemisza, Lugano) the horizon is much lower, and the composition is simpler with fewer details. Although the interval between the two pictures was only a year, the difference between them is considerable, leading some scholars (e.g. Blankert) to assert that Avercamp underwent a very rapid development in this period, while others (e.g. Stechow) have used these two works as evidence of the difficulty of establishing a chronology within Avercamp's oeuvre.

There are only a few reliably dated pictures after 1609, but it seems clear that in the later works the Flemish influence becomes less noticeable; the horizon tends to be lower, the perspective is suggested in a more natural way and the figures are grouped together more coherently. A good late example is the multi-figured *Winter Landscape with a Brewery* (c. 1615; London, N.G.). In this work the horizon is low, and the colours suggest the wintry atmosphere remarkably well. A characteristic of Hendrick Avercamp's paintings is that the figures are the centre of attention; although usually numerous, they are skilfully arranged (see fig. 2). Hendrick was a sharp observer of people, capturing their pose, dress, status and occupation. Once he had determined the details of a particular figure, or group of figures, they entered his repertory and were repeated often in both his paintings and his drawings. Although Hendrick is best known for his winter scenes, he also painted a number of summer landscapes, such as *River Landscape* (Enschede, Mrs van Heek-van Hoorn priv. col.), which has a fortress at the left and various boats on the river, but remarkably few

2. Hendrick Avercamp: *Winter Scene with Skaters near a Castle* (London, National Gallery)

figures. According to Kampen's city records, Hendrick Avercamp was paid in 1622 for painting two horses in the municipal stables, one of the few occasions on which he is mentioned in official documents. He probably lived in retreat because of his disability.

(ii) **Drawings.** Hendrick Avercamp was a prolific draughtsman. Some of his drawings are figure studies for paintings, such as the *Standing Gentleman in a High-crowned Hat*, one of the many examples of Avercamp's work at the Royal Library, Windsor Castle, Berks. Others, for example *Winter Landscape* (Haarlem, Teylers Mus.), are as fully worked out and richly detailed as his paintings and were probably intended for sale. Most of these drawings were executed in Hendrick's preferred technique of pen and watercolour.

In contrast to the paintings, there is a considerable number of extant drawings dating from after 1609. In 1612 Claes Jansz. Visscher I made six engravings after drawings by Hendrick Avercamp showing summer landscapes strongly reminiscent of the Flemish countryside, but with Classical ruins. The drawings for these engravings may have been made before 1612 (Blankert). It seems that Hendrick Avercamp returned to Kampen no later

than 1613, as can be deduced from an inscription on his *Oval River Landscape with Old Buildings* (Paris, Fond. Custodia, Inst. Néer.). Written in an old hand, probably that of the purchaser at the time, it states that the drawing was bought on 28 January 1613 from Hendrick Avercamp in Kampen. The drawing, showing a summer landscape, is very close to the engravings by Visscher and was possibly made in 1612 or earlier. Later drawings include a sheet that has always been thought to represent *The IJ in Winter* but is probably actually a view of Kampen (1620; Amsterdam, Rijksmus.) and *Water Landscape* (1624; Amsterdam, Rijksmus.).

It is generally assumed that Hendrick passed most of his life in Kampen, although he was long thought to have undertaken a journey to the Mediterranean. This assumption was based on a number of drawings, formerly attributed to him, of southern landscapes, resembling his early drawings of Flemish landscapes with Classical ruins. Welcker convincingly reattributed these to Gerrit van der Horst (1581/2–1629), a wine merchant who lived in Kampen from 1609. In 1610 Claes Jansz. Visscher made an engraving after one of these drawings.

2. Critical reception and posthumous reputation

During his life Hendrick Avercamp's paintings were already much sought after and commanded high prices. Before Welcker's archival research, which established when Hendrick was buried, he was believed to have died at a much later date, and such paintings as the *View of Kampen* (1663) were thought to be by him. The weaker quality of this work and a small number of others was credited to Avercamp's increasing age and inability to keep up the high standards of the earlier work. As Hendrick signed his work with the monogram HA, Welcker concluded that the paintings bearing the signature 'Avercamp' or 'B. Avercamp' and/or those dated after 1634 should be attributed to his nephew (2) Barent Avercamp. Paintings by artists such as Arent Arentsz. (nicknamed 'Cabel'; 1585–before Oct 1635), Adam van Breen (*fl* 1611–29) and Anthonie Verstralen (1593/4–1641) all resemble, to a greater or lesser extent, the works

of Hendrick Avercamp. Little is known about these painters, their oeuvre and their relationship with Hendrick Avercamp, and undoubtedly there are still paintings by them, as well as by Barent, among the works presently ascribed to him.

(2) Barent Avercamp

(*b* Kampen, 1612/13; *bur* Kampen, 24 Oct 1679). Nephew of (1) Hendrick Avercamp. Barent Avercamp lived in Kampen for most of his life but spent extended periods in Zwolle (?1615–26) and Zutphen (?1640–50). He probably learnt how to paint from his uncle. He held many public positions, notably one in the Guild of St Luke, Kampen, and worked in various other capacities, including as a lumber merchant. For a long time, though his artistic activities were known from archival documents, his paintings were generally attributed to his uncle. A small group was ascribed to Barent Avercamp in the early 1920s by Welcker, who proposed that paintings dated after 1634 or signed 'Avercamp' or 'B. Avercamp' should be attributed to Barent instead of to Hendrick Avercamp.

Barent was less talented than his uncle. His figures, on occasion borrowed from his uncle's paintings, are sometimes wooden and often rather arbitrarily arranged. The transition from foreground to background is more abrupt and effected by rather obvious devices (e.g. a bank in the foreground). Another characteristic of his work is that some of the figures wear clothes that came into fashion *c.* 1650. His paintings frequently show people playing an outdoor game called 'kolf' wearing big hats, flat collars (usually tasselled) and boots with large flaps, for example *Fun on the Ice near Kampen* (1654; Atlanta, GA, High Mus. A.). One of his best-known paintings is the large *Winter Landscape near Kampen* (1663; Kampen, Stadhuis). There are only two drawings that can be attributed to Barent Avercamp with certainty, *Fishermen Pulling in Nets* (1654; Hamburg, Ksthalle) and *Two Married Couples* (1650; sold London, Sotheby's, 27 June 1974, lot 120).

Bibliography

C. J. Welcker: *Hendrick Avercamp, 1585–1634, bijgenaamd 'de Stomme van Campen' en Barent Avercamp,*

1612–1679: 'Schilders tot Kampen' [Hendrick Avercamp, 1585–1634, nicknamed 'the mute from Kampen' and Barent Avercamp, 1612–1679: 'Painters in Kampen'] (Zwolle, 1933, rev. 1979)

W. Stechow: *Dutch Landscape Painting of the Seventeenth Century* (London, 1966), pp. 5, 82–7

A. Blankert: 'Hendrick Avercamp', *Frozen Silence* (exh. cat., Amsterdam, Waterman Gal., 1982), pp. 15–36

D. B. Hensbroek-van der Poel: 'Barent Avercamp (1612–79)', *Frozen Silence* (exh. cat., Amsterdam, Waterman Gal., 1982), pp. 57–62

D. B. HENSBROEK-VAN DER POEL

Baburen, Dirck (Jaspersz.) van

(*b* Wijk bij Duurstede, nr Utrecht, *c.* 1594–5; *d* Utrecht, 21 Feb 1624). Dutch painter. His father, Jasper van Baburen (*d* ?1599), had been in the service of Geertruijd van Bronckhorst van Battenburg, Baroness (*vrijvrouw*) of Vianen, Viscountess (*burggravin*) of Utrecht, and thus Dirck must have received a better than average education, a fact at least partially confirmed by the innovative and often literary nature of his subject-matter. In 1611 he is recorded as a pupil of the portrait and history painter Paulus Moreelse in Utrecht. It is likely that this was the last year of his apprenticeship. Van Baburen probably left for Italy shortly after 1611, for a document rediscovered in the late 1980s records a signed and dated altarpiece of the *Martyrdom of St Sebastian* (1615; untraced), executed for a church in Parma. His most important pictures made in Italy were painted in collaboration with David de Haen (*d* 1622) for the Pietà Chapel of S Pietro in Montorio, Rome, which was decorated between 1615 and 1620. Van Baburen's paintings for the chapel were mentioned by Giulio Mancini in his manuscript notes, *Considerazioni sulla pittura* (*c.* 1619–20); there Mancini claims the artist was 22 or 23 years old when he carried out the commission. One of his best-known works, the *Entombment* (formerly dated 1617), is still *in situ* on the altar of the chapel. This much-copied composition reveals van Baburen's close study of Caravaggio's famous *Entombment* (Rome, Pin. Vaticana). In 1619 and the spring of 1620 van Baburen and de Haen were recorded as living in the same house in the Roman parish of S Andrea delle Fratte. Caravaggio's close follower and presumed student, Bartolomeo Manfredi, was living in the same parish in 1619. Van Baburen must have known the works of Manfredi—if not the artist himself—for both versions of his *Christ Crowned with Thorns* (*c.* 1621–2; Utrecht, Catharijneconvent, and Kansas City, MO, Nelson–Atkins Mus. A.) are deeply indebted to Manfredi's interpretation of Caravaggio's style and subject-matter. In Rome van Baburen attracted the patronage of Vincenzo Giustiniani, for whom he executed a large *Christ Washing the Feet of the Apostles* (Berlin, Gemäldegal.), and Cardinal Scipione Borghese, for whom he painted an *Arrest of Christ* (Rome, Gal. Borghese).

The date of van Baburen's return to Utrecht from Italy has been the subject of some controversy. That he may still have been in Italy in 1622 is suggested by the existence in various Italian collections of versions of his signed and dated *Christ among the Doctors* (1622; Oslo, N.G.). However, the autograph replica formerly in the Mansi collection, Lucca, entered the Italian collection only in 1675 as part of the dowry brought through marriage with a member of the Amsterdam van Diemen family. It is likely that van Baburen had already returned to Utrecht by 1622, most probably during the summer of 1620, before the resumption of hostilities brought about by the end of the Twelve Years' Truce in 1621. This seems to be confirmed by the inquiry held in August 1622 following David de Haen's death in the Palazzo Giustiniani, Rome: van Baburen was neither present nor mentioned in the proceedings. Moreover, his *Youth Playing a Small Whistle* (1621; Utrecht, Cent. Mus.), with its style and cool colours that appealed to northern taste, and its secular subject-matter, could only have been painted after his return to Utrecht. This half-length, artificially illuminated figure may be the first theatrical musician painted in Utrecht. It played an important role in the development of the theme, which was explored first by such Utrecht artists as Abraham Bloemaert, Gerrit van Honthorst and Hendrick ter Brugghen and later spread throughout the northern Netherlands.

Van Baburen was closely associated with the artists known as the Utrecht Caravaggisti, especially with Hendrick ter Brugghen. It is likely that van Baburen and ter Brugghen shared a common workshop with assistants and students who drew upon the innovations of both artists. Van Baburen quickly became one of the most important early iconographic innovators in Utrecht, if not the Netherlands. In addition to single-figured, theatrical musicians, van Baburen also painted a variety of pictures that established new stylistic and iconographic patterns in genre and history painting, and these ideas were quickly taken up by other members of the Utrecht Caravaggisti. For instance his compact, three-figured *Procuress Scene* (1622; Boston, MA, Mus. F.A.)—perhaps the painting owned by Vermeer's mother-in-law that appears in the background of two pictures by the Delft artist—introduced into the vocabulary of Utrecht art an updated Caravaggesque version of an old northern moralizing theme associated with the parable of the Prodigal Son. Van Baburen also executed the earliest version of what quickly became one of the most popular Dutch pastoral themes, *Granida and Daifilo* (1623; New York, priv. col., see 1986 exh. cat., no. 37), which is based upon an episode from P. C. Hooft's famous play *Granida*. Van Baburen also produced important moralizing genre subjects such as his *Backgammon Players*, of which there are at least three versions (e.g. *c.* 1622; New York, priv. col., see Slatkes, 1965, fig. 24). One of his most important innovations is in the area of religious art, where he depicted, shortly before his death, *St Sebastian Tended by Irene* (Hamburg, Ksthalle). This new compassionate rendering of the saint—the first in the north—caught on immediately in Utrecht, where it was taken up first by Jan van Bijlert in 1624 (Rohrau, Schloss) and then by Hendrick ter Brugghen in an important monumental composition of 1625 (Oberlin, OH, Allen Mem. A. Mus.).

Van Baburen also painted large mythological paintings, such as *Prometheus* (1623; Amsterdam, Rijksmus.), as well as an impressive *Cimon and Pero (Roman Charity)* (York, C.A.G.), based on an episode in Valerius Maximus's *Factorum et dictorum memorabilium* (31 BC). Valerius Maximus

(IX.iv) stressed the role of painting in strengthening moral character, in this case filial piety, and thus it seems likely that van Baburen was drawn to the unusual theme because of these associations. The moralizing content of such genre paintings as the *Backgammon Players* and the *Procuress Scene* helped to prepare the way for later moralizing traditions in Dutch genre art.

Bibliography

P. T. A. Swillens: 'De schilder Theodorus (of Dirck?) van Baburen', *Oud-Holland*, xlviii (1931), pp. 88–96

A. von Schneider: *Caravaggio und die Niederländer* (Marburg, 1933)

B. Nicolson: 'A Postscript to Baburen', *Burl. Mag.*, civ (1962), pp. 539–43

L. J. Slatkes: *Dirck van Baburen* (diss., U. Utrecht, 1962)

——: *Dirck van Baburen (c. 1595–1624): A Dutch Painter in Utrecht and Rome* (Utrecht, 1965)

——: 'David de Haen and Dirck van Baburen in Rome', *Oud-Holland*, lxxv (1966), pp. 173–86

——: 'Additions to Dirck van Baburen', *Album amicorum J. G. van Gelder* (The Hague, 1973), pp. 267–73

B. Nicolson: *The International Caravaggesque Movement* (Oxford, 1979); review by L. J. Slatkes in *Simiolus*, xii (1981–2), pp. 167–83

Holländische Malerei in neuem Licht: Hendrick ter Brugghen und seine Zeitgenossen (exh. cat., ed. A. Blankert, L. J. Slatkes and others; Utrecht, Cent. Mus.; Brunswick, Herzog Anton Ulrich-Mus.; 1986)

LEONARD J. SLATKES

Backer, Jacob (Adriaensz.)

(*b* Harlingen, 1608; *d* Amsterdam, 26 Aug 1651). Dutch painter and draughtsman. In 1611 his father, a Mennonite baker, left Friesland and settled in Amsterdam. Jacob Backer returned to Friesland in 1627 to study under Lambert Jacobsz., a history painter of biblical scenes who was originally from Amsterdam and had settled in Leeuwarden, capital of Friesland, about 1620. Jacobsz. was a lay preacher of the Mennonite congregation in Leeuwarden and was also an art dealer who sold, among other items, works by or after Rembrandt. In Jacobsz.'s studio Backer was a fellow pupil with Govaert Flinck, who was seven years his junior. In 1633 Flinck and Backer went

together to Amsterdam, where Flinck alone entered Rembrandt's studio. The tradition, dating back to Houbraken, of referring to Flinck and Backer together as Rembrandt's pupils is persistent but mistaken; Bauch perpetuated the error in the subtitle of his monograph on Backer.

Soon after his arrival in Amsterdam, Backer received his first important commission, for a group portrait of the *Governesses of the Civic Orphanage of Amsterdam* (Amsterdam, Hist. Mus.). This is one of the most famous Amsterdam group portraits, with its balanced composition and masterly treatment of light. In his history paintings Backer was strongly inspired by Flemish examples rather than by Rembrandt, evident, for example, in the large canvas of *John the Baptist Rebuking Herod and Herodias* (1633; Leeuwarden, Fries Mus.), which demonstrates Backer's great compositional and colouristic abilities and shows him to be an independent painter who by 1633 had little to learn from Rembrandt. Moreover, a simple portrait painted the following year, *Boy in Grey* (1634; The Hague, Mauritshuis), shows that he made only incidental use of the strong chiaroscuro so characteristic of Rembrandt. The strongest influences on Backer remained Friesian ones: in his history paintings he elaborated on the Flemish style of Lambert Jacobsz.; in his portraits the style of Wybrand de Geest predominates.

Except for a short stay in Flushing in 1638, documented by a signed, dated and inscribed *Self-portrait* drawing (Vienna, Albertina), Backer worked in Amsterdam until his death. He never married. His development as a history painter in the 1630s is unclear, as there are no dated works. Stylistically related to his *John the Baptist*, however, are such large historical canvases as *Granida and Deiphilos* (St Petersburg, Hermitage) and *Cymon and Iphigeneia* (Brunswick, Herzog Anton Ulrich-Mus.), which make obvious use of models by Rubens. Combining his skills as a portrait and history painter during the 1630s, Backer painted several *tronies*, character studies from life of heads in exotic disguises. A *Self-portrait as a Shepherd* (The Hague, Mauritshuis) belongs to a series of paintings from the same period (1635–40), in which Backer used himself as a model in allegorical or pastoral representations. The paintings of *Taste* (Berlin, Gemäldegal.) and *Hearing* (Budapest, Mus. F.A.) are examples of such allegories. The free handling in the *Self-portrait as a Shepherd* seems to have been inspired by the work of Frans Hals, but the subject and composition show Backer to have been aware of similar allegorical half-length figures by Italian painters as well as variations on them by the Utrecht Caravaggisti.

In 1642 Backer painted the *Militia Company of Capt. Cornelis de Graeff and Lt Hendrick Lawrensz.* (Amsterdam, Rijksmus.) for the Great Hall at the Kloveniersdoelen, for which Rembrandt supplied 'The Nightwatch' (Amsterdam, Rijksmus.) as a pendant. Backer's is painted in a sober and matter-of-fact style, while Rembrandt's is more imaginative and narrative in form and content. Backer's last group portrait, the *Governors of the Nieuwezijds Huiszittenhuis at Amsterdam* (c. 1650; Amsterdam, Rijksmus.), is similarly characterized by a cool, objective rendering of the subject, with emphasis on the good likenesses of the individual sitters. Besides commissions for portraits of citizens and group portraits of Amsterdam governors, he also worked for the court. For Frederick Henry, Stadholder of the Netherlands, he painted an *Allegory to Freedom* (c. 1645; Berlin, Jagdschloss Grunewald), and the painters of Amsterdam chose him and Jacob van Loo to supply decorations for the Huis ten Bosch, although none was realized. Good examples of Backer's later history paintings are *Granida and Deiphilos* (Harlingen, Hannemahuis), *Amaryllis Crowning Myrtilus* (1646; ex-Schatzker priv. col., Vienna) and the finely composed *Venus and Adonis* (c. 1650; Fulda, Schloss Fasanerie), in which he seems to have favoured a more classicizing style. A preliminary study for the *Venus and Adonis* in black chalk of the figure of *Venus* (Boston, Maida and George Abrams priv. col.; see Sumowski, 1979, no. 54x) has survived, as has a preparatory composition study (Amsterdam, Rijksmus.) for the painting of Nieuwezijds Huiszittenhuis governors; these are both good examples of his attractive and spontaneous draughtsmanship. His figure drawings are mostly

done in black and white chalk on tinted paper. Some are purely costume studies, others female nude studies. The same technique was used by Flinck, whose drawings are often confused with Backer's.

Backer's fame has been eclipsed by that of Rembrandt. Nevertheless, he was praised in his own time and afterwards: in almost all printed 17th-century sources on contemporary painting he is acclaimed for, among other things, his 'beautiful, large nudes' (de Bie) and his 'great modern paintings' (von Sandrart).

Bibliography

C. de Bie: *Het gulden cabinet* (Antwerp, 1661), p. 130
J. von Sandrart: *Teutsche Academie* (Nuremberg, 1675); ed. A. Peltzer (Munich, 1925), pp. 178, 370, 401, 426
A. Houbraken: *De groote schouburgh* (1718–21/R 1976), p. 186
K. Bauch: *Jakob Adriaensz. Backer: Ein Rembrandtschüler aus Friesland* (Berlin, 1926)
W. Sumowski: *Drawings of the Rembrandt School*, i (New York, 1979), nos 1–86; review by B. P. J. Broos in *Oud-Holland*, xcviii (1984), pp. 176–8
Gods, Saints and Heroes: Dutch Painting in the Age of Rembrandt (exh. cat., Washington, DC, N.G.A.; Detroit, MI, A. Inst.; Amsterdam, Rijksmus.; 1980–81), no. 52
W. Sumowski: *Gemälde der Rembrandtschüler*, i (1983), pp. 133–279; review by J. Bruyn in *Oud-Holland*, xcviii (1984), pp. 149–52
The Impact of a Genius: Rembrandt, his Pupils and Followers in the Seventeenth Century (exh. cat., Amsterdam, Waterman Gal.; Groningen, Groninger Mus.; 1983)

B. P. J. BROOS

Baen, Jan de

(*b* Haarlem, 20 Feb 1633; *d* The Hague, *bur* 8 March 1702). Dutch painter. He was one of the most popular Dutch portrait painters in the years 1665–1700, since he brought to his work the kind of elegance and flattery preferred by his patrons. The son of a merchant, he was already orphaned at the age of three. He was then taken into the household of his uncle, the magistrate and painter Heinrich Piemans (*d* 1645), who lived in Emden in East Friesland and who later gave him his first lessons in painting. After the death of his uncle, he was apprenticed in 1646 to Jacob Adriaensz. Backer in Amsterdam; after Backer's death in 1651, de Baen remained in Amsterdam, working independently as an artist. The only known work from his earliest years is an etching of the *Burning of the Amsterdam Town Hall, 1652* (see Hollstein, i, p. 64). A painted portrait of the merchant *Willem van der Voort* (Amsterdam, Hist. Mus.) can probably be dated around the late 1650s. In 1660, de Baen moved to The Hague, where he is reputed to have achieved rapid success as a portrait painter. According to Houbraken, he was called to England by Charles II and worked for the court there. Although there is no clear evidence, the painter was probably active in London for some time in the years 1660–65. In 1665 he married Maria de Kinderen in The Hague; at least eight children were born to them, one of whom, Jacobus de Baen (*b* 1673), became a painter.

A continuous series of works, consisting mostly of life-size half-length portraits, has survived from the 1660s onwards. They are fashionable and somewhat flattering likenesses, showing the influence of Anthony van Dyck, but they are not remarkable for their panache. French influences are also perceptible, for example in his frequent backgrounds of parks or rolling landscapes. In contrast to many of his contemporaries, such as Caspar Netscher, de Baen did not follow the new fashion for smaller paintings, continuing instead to produce life-size portraits of his models. The most characteristic examples from 1665–75 include the various portraits of *Johann Maurits of Nassau-Siegen* (e.g. The Hague, Mauritshuis) and those of *Hieronymous van Beverdinck* and his wife *Johanna Le Gillon* (1670; Amsterdam, Rijksmus.). He was commissioned by the city of Dordrecht to paint the large *Triumph of Cornelis de Witt on his Return from the Voyage to Chatham, 1667* for the Town Hall (destr. 1672; smaller replica in Amsterdam, Rijksmus.). During this period, de Baen also worked for the family of the stadholder and for Frederick William, Elector of Brandenburg, who appointed him court painter in 1676 and tried unsuccessfully to lure him to Berlin. From 1675 he painted a series of group portraits of regents for

patrons in The Hague, Leiden, Amsterdam and Hoorn, for example the *Directors of the Dutch East India Company, Hoorn* (1682; Hoorn Westfries Mus.), indicating that his reputation was not limited to his city of residence. In his individual portraits from 1680 and after, there is an increasing tendency to superficiality and a strong inclination for stereotyped poses that are repeated from portrait to portrait.

Jan de Baen's position in society benefited from his reputation as a portrait painter. From 1666 onward he was a regular member of the painters' confraternity De Pictura in The Hague and a number of times the dean. In 1672 he was captain of The Hague civic guard company and, towards the end of his life, in 1699, regent of the drawing academy of his city. He regularly made use of assistants in his work, including the painters Barend Appelman (1640–86) and Johannes Vollevens (1649–1728). His pupils included his son Jacobus de Baen, Nicolaes van Ravesteyn (1661–1750), Johan Friedrich Bodecker (1658–1727) and Hendrick van Limborch (1681–1759).

Bibliography

Hollstein: *Dut. & Flem.*; Thieme–Becker

A. Houbraken: *De groote schouburgh* (1718–21); ed. P. T. A. Swilleus (Maastricht, 1943–53), ii, pp. 237–54

<div align="right">RUDOLF E. O. EKKART</div>

Bailly, David

(*b* Leiden, 1584; *d* Leiden, Oct 1657). Dutch painter and draughtsman. The son of a Flemish immigrant who was a calligrapher and fencing-master, Bailly was apprenticed to a local surgeon-painter and then to Cornelius van der Voort (1576–1624), a portrait painter in Amsterdam. In the winter of 1608 he started out as a journeyman, spending a year in Hamburg and then travelling through several German cities to Venice and Rome. On the return voyage he visited several courts in Germany, working for local princes, including the Duke of Brunswick-Wolfenbüttel. While no works survive from the immediate period following his return to the Netherlands in 1613, descriptions in old sale catalogues suggest that he may have produced history paintings in the manner of his contemporaries Pieter Lastman and the Pynas brothers.

Bailly executed many portraits, of which a fair number have survived. These include meticulous small-scale drawings done in pen or with a fine brush, dating from 1621 to 1633, as well as some paintings. They represent professors and students at the University of Leiden and such fellow artists as Jan Pynas and Crispijn de Passe the younger. Bailly also depicted himself in a few drawings and a painting. He contributed his own likeness to a group portrait, the *Civic-guard Company of Capt. Harman van Brosterhuyzen* (1626; Leiden, Stedel. Mus. Lakenhal), by Joris van Schooten (1587–1651). In 1648 Bailly was among the founder-members of the Leiden Guild of St Luke, of which he was a dean in the following year.

Bailly's combination of portraiture and Vanitas still-life constitutes his most original contribution to 17th-century art. Besides the usual allusions to the transience of human life such as a skull, a smoking pipe, flowers, precious objects and a burning or extinguished candle, Bailly included pieces of sculpture and portraits of himself and his wife, Agneta van Swanenburgh. In a portrait of Bailly by Thomas de Keyser of *c.* 1627 (Paris, priv. col., see Bruyn, p. 161), the still-life element of the work—executed by Bailly himself—includes a roll of parchment that is found in precisely the same form in a drawing of 1624 and again in a painting dated 1651. From this it may be concluded that, like most of his contemporaries, Bailly worked from model drawings rather than from direct observation.

In *Vanitas Still-life with a Portrait of a Young Painter* (1651; Leiden, Stedel. Mus. Lakenhal) a young man, with the features of Bailly himself when about 20 years old, holds his self-portrait as an older man. This forms part of a display of fragile, corruptible and otherwise 'vain' objects. The intention is to demonstrate the transitoriness not only of earthly life, but also of human achievements including his own art.

Bailly's work served as a model for a number of artists specializing in *vanitas* paintings who also incorporated small portraits and *objets d'art* into their compositions. Among them are Bailly's

nephews Harmen (1612–after 1655) and Pieter van Steenwijck (c. 1615–after 1654), who were his pupils between 1628 and c. 1635. Gerrit Dou also appears to have been influenced by Bailly's style and occasionally his iconography. It is unlikely that, as was formerly supposed, Bailly influenced Jan de Heem and Rembrandt, both of whom included books and other still-life items in their paintings done in Leiden as early as 1625–30.

Bibliography

K. Boström: 'David Baillys Stilleben', *Ksthist. Tidskr.*, xviii (1949), pp. 99–110

J. Bruyn: 'David Bailly, "Fort bon peintre en pourtraicts et en vie coye"', *Oud-Holland*, lxvi (1951), pp. 148–64, 212–27

P. J. M. de Baar: 'Het overlijden van David Bailly' [The death of David Bailly], *Oud-Holland*, lxxxvii (1973), pp. 239–40

N. Popper-Voskuil: 'Self-portraiture and Vanitas Still-life Painting in 17th-century Holland in Reference to David Bailly's Vanitas Oeuvre', *Pantheon*, xxxi (1973), pp. 58–74

J. BRUYN

Bakhuizen [Backhuysen; Bakhuisen; Bakhuyzen], Ludolf

(*b* Emden, East Frisia [now Germany], 28 Dec 1630; *d* Amsterdam, 6–7 Nov, *bur* 12 Nov 1708). Dutch painter, draughtsman, calligrapher and printmaker of German origin. He was the son of Gerhard Backhusz. (Backhusen) of Emden, and he trained as a clerk in his native town. Shortly before 1650 he joined the Bartolotti trading house in Amsterdam, where his fine handwriting attracted attention. He practised calligraphy throughout his life (examples in Amsterdam, Rijksmus.; Dresden, Kupferstichkab.; London, BM). During his early years in Amsterdam he also displayed his skilled use of the pen in drawings, mainly marine scenes, done in black ink on prepared canvas, panel or parchment. He probably derived this technique and subject-matter from Willem van de Velde (ii) the elder's pen drawings of the 1650s. Bakhuizen continued to produce pen drawings until the 1660s, some depicting recognizable ships and existing views, such as his *Ships Leaving*

Amsterdam Harbour (Amsterdam, Kon. Coll. Zeemanschoop), others depicting unidentified locations, as in the *View of a Dutch Waterway* (Amsterdam, Ned. Hist. Scheepvaartsmus.).

According to Houbraken, Bakhuizen learnt to paint in oils from the marine painters Hendrick Dubbels and Allaert van Everdingen. His earliest known paintings, among them *Ships in a Gathering Storm* (1658; Leipzig, Mus. Bild. Kst.), have a silvery-grey tonality and simple composition and resemble the work of his presumed teachers and also that of Simon de Vlieger. A new element, frequently repeated in Bakhuizen's later work, is a brightly lit strip of sea, forming the transition between the dark foreground and the sky. He was a recognized marine painter by 1658, the year in which he painted the background with ships for Bartholomeus van der Helst's *Portrait of a Lady* (Brussels, Mus. A. Anc.). He painted the backgrounds for van der Helst's pendant portraits of *Lieutenant-Admiral Aert van Nes* and his wife *Geertruida den Dubbelde* and also for *Vice-Admiral Johan de Liefde* (all 1668; Amsterdam, Rijksmus.).

Still referred to in 1656 as a calligrapher and in 1657 and 1660 as a draughtsman ('teyckenaer'), Bakhuizen did not declare his profession as painter until his third marriage in 1664 to Alida Greffet. He painted a portrait of *Alida* wearing sumptuous fabrics (Emden, Ostfries. Landesmus. & Städt. Mus.), alluding to the fact that she ran a silk business (of which he was the nominal owner). On her death in 1678 she left him a considerable fortune. Two years later Bakhuizen married again, his fourth wife being Anna de Hooghe, a prosperous merchant's daughter.

Bakhuizen did not join the Amsterdam guild of painters until 1663; thereafter his fame as a marine specialist was rapidly established. In 1665 the burgomaster of Amsterdam commissioned him to paint a *View of Amsterdam and the IJ* (Paris, Louvre), intended as a diplomatic gift for Hugues de Lionne, Louis XIV's Foreign Minister. With the resumption of hostilities between the Netherlands and England in 1672, Willem van de Velde the elder and Willem van de Velde the younger moved to England, and Bakhuizen

became the leading marine painter in the Netherlands. His success brought him commissions from high places: according to Houbraken, Cosimo III de' Medici, Grand Duke of Tuscany (1610–1723), Frederick I of Prussia, Elector of Saxony, and Peter the Great, Tsar of Russia, visited his studio. (Peter the Great was reputed to have taken drawing lessons from him.)

After 1665 Bakhuizen's compositions became more daring, his colours brighter and the atmosphere more dramatic, with ominous cloudy skies. His subject-matter was often inspired by historical or military events, as in the *Return of the 'Hollandia' to the Landsdiep in 1665* (1666–7; Amsterdam, Ned. Hist. Scheepvaartsmus.), the *First Day of the Four Days' Battle* (c. 1670; Copenhagen, Stat. Mus. Kst), *Soldiers Embarking at the Montelbaanstoren* (1685; London, Apsley House) and the *'Brielle' on the Maas near Rotterdam* (1689; Amsterdam, Rijksmus.). Paintings such as the *Arrival of Stadholder King William III in the Orange Polder in 1691* (1692; The Hague, Mauritshuis) and the preliminary sketches for it (Paris, Petit Pal.; London, N. Mar. Mus.) demonstrate that decorative effect was thought more important than historical accuracy. Unlike the van de Veldes, who were more concerned with representing the technical aspects of sailing vessels and naval battles (see fig. 56), Bakhuizen depicted the perpetually changing climate and the magnificent skies of the Netherlands. Much of his work, moreover, glorifies Amsterdam and the mercantile trade that had made it great. With this in mind he made his first etchings in 1701, at the age of 71 as he proudly stated on the title page of *D'Y stroom en zeegezichten* ('Views of the River IJ and the sea'), a series of harbour scenes preceded by a representation of the Maid of Amsterdam in a triumphal chariot.

The portraits Bakhuizen painted of numerous friends are of less value artistically than as a record of his good relations with contemporary scholars and literary figures. His drawings are less well-known, although they were much sought after in his own day due to their fine depiction of atmosphere and meticulous rendering. His steady hand is evident in the precision with which he drew intricate ship's rigging, while he could also sketch fluently with an almost Rembrandtesque virtuosity. The finest examples of his drawings are in the print rooms of Amsterdam (Hist. Mus.; Rijksmus.), Dresden (Kupferstichkab.) and London (BM). None of Bakhuizen's children by any of his marriages was an artist, but one of his grandsons, Ludolf Bakhuizen the younger (1717–82), became a painter and imitated his grandfather's work.

Bibliography

A. Houbraken: *De groote schouburgh*, ii (1718–21), pp. 236–44

C. Hofstede de Groot: *Verzeichnis*, vii (1918), pp. 237, 356

L. J. Bol: *Die holländische Marinenmalerei des 17. Jahrhunderts* (Brunswick, 1973)

Ludolf Bakhuizen, 1631–1708: Schryfmeester, teyckenaer, schilder [Calligrapher, draughtsman, painter] (exh. cat. by B. Broos, R. Vorstman and W. van de Wetering, Amsterdam, Ned. Hist. Scheepvaartsmus., 1985)

H. Nannen: *Ludolf Backhuyzen: Emden 1630–Amsterdam 1708* (Emden, 1985)

B. P. J. BROOS

Bassen, Bartholomeus (Cornelisz.) van

(*b* ?The Hague, *c.* 1590; *d* The Hague, *bur* 28 Nov 1652). Dutch painter and architect. He was the grandson of Bartolt Ernst van Bassen from Arnhem, who was Clerk of the Court of Holland in The Hague. In 1613 van Bassen was admitted to the Guild of St Luke in Delft, having come from outside the city. In 1622 he became a member of the Guild in The Hague where he was also municipal architect from 1638 until his death. He married in 1624; his son Aernoudt married a daughter of Cornelis van Poelenburch.

Van Bassen's earliest dated work is an *Interior of a Church* (1614; untraced; see *Connoisseur*, clxxxi, 1972, p. 58), which, though strongly inspired by the cathedral in Antwerp, was probably copied after a painting by Hendrik van Steenwijk I or Pieter Neeffs I rather than from life. From 1620 his development can be clearly traced. In the *Fantasy Interior of the Nieuwe Kerk, Delft, with the Tomb of William of Orange* (1620; Budapest, Mus. F.A.), van Bassen included both

Antwerp motifs, some borrowed from the print by Jan van Londerseel after a painting by Hendrick Aertsz. (d 1603), and Dutch motifs, such as the furnishings and the accurately rendered tomb. The more natural fall of light and spatial effect are also typically Dutch. This combination of fantasy and reality has been described by Liedtke as 'the realistic imaginary church'.

Until about 1626 van Bassen painted mainly monumental Renaissance-type church interiors, with a view down the centre of the nave, although the inclusion of a pronounced transept or side chapel distinguished his work from the traditional tunnel perspective of the Antwerp painters. After 1626 his interiors became less symmetrical, with the vanishing point less apparent and moved to the side. The space becomes more complex, and the architecture is often either completely or partly Gothic in character. Striking parallels exist with the contemporary work of Dirck van Delen. By the 1630s the dichotomy between the orthogonals towards the vanishing point on the one side and the successively receding spaces towards the other side, as in the *Interior of the St Cunerakerk at Rhenen* (1638; London, N.G.) and in the *Interior of a Church* (1639; Budapest, Mus. F.A.), forms one of the most important points of departure for the radical development of the diagonal or two-point perspective introduced around 1650 by van Bassen's pupil Gerrit Houckgeest. Towards the end of his life van Bassen regularly returned to his previous, more monumental and centralized spatial treatment, though changed in a high Baroque style.

In addition to church interiors van Bassen painted a series of room interiors, mainly in the 1620s. The rooms are decorated with heavy Renaissance-style wood panelling and portals and ceilings coffered in the manner of Serlio. Until 1631 the figures were often painted by Esaias van de Velde, and occasionally by Frans Francken II (e.g. *Interior*, 1624; Berlin, Bodemus.). Van Bassen later employed Anthonie Palamedesz. and Cornelis van Poelenburch as staffage painters. Van Bassen's use of colour was initially varied, if matt and heavy, but later became more monochrome.

The most important sources for his paintings were the works of the Antwerp architectural painters, the prints of Hans Vredeman de Vries and the published editions of Italian architectural books and print series, although the only known case in which a direct source has been identified is a painting (Copenhagen, Stat. Mus. Kst) after a print by Mattäus Greuter (c. 1565–1638) of Carlo Maderno's design for the façade of St Peter's, Rome.

Although van Bassen's architectural paintings are often fantastic and Italianate, as an architect he started work more or less in the traditional idiom of the Dutch Renaissance, as exemplified by the work of Hendrik de Keyser I. He was far less progressive than his contemporaries Jacob van Campen and Pieter Post. From 1629 he built the palace in Rhenen for Frederick V, Elector of the Palatinate, the expelled 'Winter King' of Bohemia. From 1630 onwards he was involved, though probably only as an executant, in the building of the hunting castle at Honselaarsdijk and the Huis Ter Nieuburch, Rijswijk (destr. 1703; see drawing by Jan de Bisschop, Amsterdam, Rijksmus.), for Prince Frederick Henry, both near The Hague.

Between 1634 and 1639 van Bassen worked on the town hall, the Catharinakerk and the Gasthuispoort, all in Arnhem. In The Hague he built the butter weigh-house (1650) and the Nieuwe Kerk (1649–56), the latter together with Pieter Arentsz. Noorwits (d 1669), who is usually considered to be the main architect. Van Bassen's design for the Nieuwe Kerk, later to be amended, is preserved in a painting by him setting it in its actual surroundings (1650; The Hague, Gemeentemus.).

Bibliography

H. Jantzen: *Das niederländische Architekturbild* (Leipzig, 1910/R Brunswick, 1979), pp. 58–65

E. A. J. Vermeulen: *Handboek tot de geschiedenis der Nederlandse bouwkunst* [Handbook of the history of architecture in the Netherlands], iii (The Hague, 1941), pp. 60–61, 107–10

E. H. ter Kuile and others: *Duizend jaar bouwen in Nederland* [A thousand years of building in the Netherlands], ii (Amsterdam, 1957), pp. 122–7

W. A. Liedtke: *Architectural Painting in Delft* (Doorspijk, 1982), pp. 22–33

C. Scheffer: *Bartholomeus van Bassen* (diss., Leiden, Rijksuniv., 1985)

BERNARD VERMET

Beerstraten

Dutch family of artists. Jan Abrahamsz. Beerstraten, the most successful of the family, was the son of Abraham Danielsz. Beerstraten, a cloth-weaver from Emden. In August 1642 he married Magdalena Bronkhorst, by whom he had five children: Abraham (b 1644); Johannes (b 1653); Jacobus (b 1658); Magdalena (b 1660) and David (b 1661). Both Jan and his eldest son, Abraham, specialized in paintings of winter townscapes, sea battles and southern sea ports. Paintings signed *J*, *I*, or *Johannes Beerstraten* are assumed to be by Jan. To date, however, it is unclear who made the paintings signed *A. Beerstraten*, which differ considerably in quality. Besides Abraham, a certain Anthonie Beerstraten is said to have been active as a painter of winter landscapes and sea battles in Amsterdam from 1635–65. His relationship to Jan Beerstraten is not known. The better paintings are attributed to Abraham, on the basis of comparison with the *View of the Old Town Hall in Kampen* (1665; ex-Lansdowne Col., Bowood House, Wilts; see Hofstede de Groot), which is signed *Abraham Beerstraten*. These include the winter view of the *Noorder Kerk in Amsterdam* (Amsterdam, Hist. Mus.), which is signed *A. Beerstraten*, but not dated. Anthonie is thought to have used rather harsh colours. To him is attributed another painting signed *A. Beerstraten*, depicting a *Southern Seaport with the Mariakerk of Utrecht* (1667; Utrecht, Cent. Mus.). The incorporation of northern European buildings—in this case a Romanesque church no longer extant—in southern Mediterranean landscapes was a common theme used by Dutch Italianate painters in the 1660s. The Beerstratens were imitated by the Storck brothers.

Bibliography

C. Hofstede de Groot: 'Kritische opmerkingen omtrent de oud-Hollandsche schilderijen in onze musea' [Critical remarks regarding Dutch Old Masters in our museums], *Oud-Holland* (1904), p. 114

(1) Jan (Abrahamsz.) Beerstraten

(b Amsterdam, 1622; d Amsterdam, 1 June 1666). Painter and draughtsman. His townscapes were mostly winter scenes, as in the first known topo-graphical painting by him: *View of Oude Kerk in the Winter* (1659; Amsterdam, Rijksmus.). Although his work reflects the increased public interest in topography in mid-17th-century Amsterdam, there is also a somewhat romantic atmosphere pervading his winter landscapes. His colours are generally tonal and his style soft by comparison with the clearly defined townscapes by Jan van der Heyden. His subjects were also romanticized, as in the *Ruins of the Old Town Hall of Amsterdam after the Fire of 7 July 1652* (1653; Amsterdam, Rijksmus.). Shortly before his death Jan Beerstraten painted the *Church of Nieuwkoop* (Hamburg, Ksthalle), depicting the church under a dark, cloudy sky, with a funeral procession emerging from behind it.

Beerstraten might have been a pupil of Claes Claesz. Wou (1592–1665), a marine painter in the Flemish tradition, who seems to have influenced his paintings of sea battles. His southern ports and seashores were influenced by the works of such Dutch Italianate painters as Nicolaes Berchem (see fig. 4) and Jan Baptist Weenix. Unlike his townscapes, Beerstraten's ports were totally imaginary, sometimes with a well-known northern European building incorporated on the seashore. It is not known whether he went to Italy, although in his paintings the southern light seems to be accurately conveyed, as in the *Imaginary View of a Port with the Façade of S Maria Maggiore of Rome* (formerly known as the 'Port of Genoa', 1662, Paris, Louvre). For his Italian subjects he may have copied drawings given to him by Johannes Lingelbach, an Italianate painter who had been to Italy. Lingelbach occasionally painted the figures in Beerstraten's compositions. His drawings represent themes similar to those of his paintings.

Bibliography

Dutch 17th-century Italianate Painters (exh. cat. by A. Blankert, Utrecht, Cent. Mus., 1967; rev. Soest, 1978)
L. J. Bol: *Die holländische Marinemalerei im 17. Jahrhundert* (Brunswick, 1973)
The Dutch Cityscape in the 17th Century and its Sources (exh. cat. by L. van Lakerveld, Amsterdam, Hist. Mus.; Toronto, A.G. Ont.; 1977)
C. Schloss: *Travel and Temptation: The Dutch Italianate Harbour Scenes, 1640–1680* (Ann Arbor, 1982)

☐

Bega, Cornelis (Pietersz.)

(*b* Haarlem, 1631/2, *bapt* ?22 Jan 1632; *d* Haarlem, ?27 Aug 1664). Dutch painter, draughtsman and etcher. He was born into prosperous circumstances; his mother, Maria Cornelis, inherited half the estate (gold, silver, paintings, drawings and prints) and all of the red chalk drawings of her father, Cornelis Cornelisz. van Haarlem, a renowned Mannerist artist. Bega's father was Pieter Jansz. Begijn (*d* 1648), a gold- and silversmith. Like other family members, Bega was probably Catholic. Houbraken's claim that Bega studied with Adriaen van Ostade is likely to be correct; this was probably before 24 April 1653, when Bega joined Vincent Laurentsz. van der Vinne in Frankfurt for a journey through Germany, Switzerland and France. Bega had returned to Haarlem by 1 September 1654, at which time he joined the Guild of St Luke; he was already a competent draughtsman, as indicated by his first extant dated work, *Interior with a Nursing Mother* (1652; Frankfurt am Main, Städel. Kstinst.), and by a remarkable double portrait (Amsterdam, Rijksmus.) drawn by him and Leendert van der Cooghen in 1654.

Bega painted, drew, etched and made counterproofs in a wide variety of materials on different types of small-scale supports. He may have been the first Dutch artist to make monotypes, but this remains controversial. Approximately 160 paintings, 80 drawings and six monotypes by Bega have been catalogued (Scott, 1984), as well as around 34 etchings (Bartsch and Hollstein). Bega's principal subjects were genre representations of taverns, domestic interiors and villages. He depicted nursing mothers, prostitutes, drunks, smokers, gamblers and fools such as quack doctors and alchemists. Less common subjects include the ridiculed or pestered woman, as in *Two Figures and Mother with a Spirits Bottle* (*c.* 1662; Gouda, Stedel. Mus. Catharina Gasthuis) and *The Inn* (etching), and witty satires on traditional scenes of middle-class music-makers, such as the *Music Lesson* (1663; Paris, Petit Pal.).

Bega's early paintings, such as the *Weaver's Family* (*c.* 1652; St Petersburg, Hermitage), are freely executed, dark and coarse, recalling the many-figured peasant subjects of van Ostade. Between *c.* 1660 and 1664 he began to paint genre scenes with fewer figures, which are finely articulated, colourful and psychologically expressive, for example *Two Men Singing* (1662; Dublin, N.G.) and *Woman Playing the Lute* (Florence, Uffizi; see fig. 3). His exquisite, late *fijnschilderen* ('fine painting') manner, evident in *The Alchemist* (1663; Malibu, CA, Getty Mus.), compares well with that of Gerrit Dou.

As a draughtsman Bega is noted for his single-figure studies, executed mainly in black and white chalk on blue paper or red chalk on white paper. None of the studies, which were drawn *naer het leven* (from life), seems to relate to a painting or etching. Bega traded drawings or shared models with other artists of the Haarlem school, including van der Cooghen, Gerrit Berckheyde, Dirck Helmbreker and Cornelis Visscher. These artists drew chalk figure studies in a very similar style, characterized by regular and precise parallel shading and well-defined forms; their drawings, especially those of Bega and Berckheyde, have been frequently confused. Unlike the realistic figure studies, Bega's etchings depict interiors

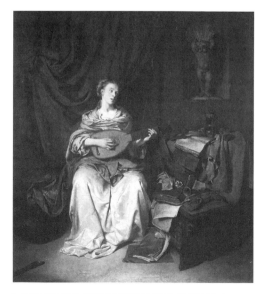

3. Cornelis Bega: *Woman Playing the Lute* (Florence, Galleria degli Uffizi)

with figures or single figures in the manner of van Ostade; the compositions, often with masterful chiaroscuro effects (e.g. the *Old Hostess*, see Bartsch, p. 238, no. 32), reflect most closely the paintings of the 1650s.

Bega presumably remained in Haarlem, where he paid dues to the Guild in 1661. He probably succumbed to plague (Houbraken); fees for his expensive funeral at St Bavo's were paid on 30 August 1664. Among the artists he influenced were Thomas Wijck, Jan Steen, Richard Brakenburg (1650–1702) and Cornelis Dusart. Painters such as R. Oostrzaen (*fl* ?1656) and Jacob Toorenvliet (1635/6–1719) and later European artists imitated Bega's style and borrowed principal characters from his low-life dramas.

Bibliography

Hollstein: *Dut. & Flem.*

A. Houbraken: *De groote schouburgh* (1718–21), i, pp. 349–50

A. von Bartsch: *Le Peintre-graveur* (1803–21), v, pp. 223–43

A. Bredius: *Künstler Inventare: Urkunden zur Geschichte der holländischen Kunst des XVIten, XVIIten und XVIIIten Jahrhunderts*, 7 vols (The Hague, 1920–21)

C. van Hees: 'Nadere gegevens omtrent de Haarlemse vrienden Leendert van der Cooghen en Cornelis Bega' [Later inf. about the Haarlem friends Leendert van der Cooghen and Cornelis Bega], *Oud-Holland*, lxxi (1956), pp. 243–4

Cornelis Bega Etchings (exh. cat. by B. Pearce, Adelaide, A.G. S. Australia, 1977)

P. Begheyn: 'Biografische gegevens betreffende de Haarlemse schilder Cornelis Bega (ca. 1632–1664) en zijn verwanten', [Biog. inf. about the Haarlem painter Cornelis Bega (c. 1632–64) and his relatives], *Oud-Holland*, xciii (1979), pp. 270–78

P. Schatborn: *Dutch Figure Drawings from the Seventeenth Century* (Amsterdam, 1981), pp. 105–7

M. Scott: *Cornelis Bega (1631/32–1664) as Painter and Draughtsman* (diss., College Park, U. MD, 1984)

Masters of Seventeenth-century Dutch Genre Painting (exh. cat. by P Sutton and others, Philadelphia, PA, Mus. A.; W. Berlin, Gemäldegal.; London, RA; 1984), pp. 132–6

M. Scott: *Cornelis Pietersz. Bega* (in preparation)

MARY ANN SCOTT

Berchem [Berghem; Berighem; Berrighem], Nicolaes (Pietersz.)

(*bapt* Haarlem, 1 Oct 1620; *d* Amsterdam, 18 Feb 1683). Dutch painter, draughtsman and etcher, son of PIETER CLAESZ. He was one of the most talented, versatile and well-paid artists of his time. A prolific member of the second generation of Dutch Italianates, Berchem also produced scenes of his native landscape, winter landscapes, night scenes, hunts, battles, imaginary Mediterranean harbours, complex allegories, as well as history paintings. According to Hofstede de Groot, his oeuvre amounts to *c.* 857 paintings, and while this estimate is inflated by numerous misattributions, Berchem was undoubtedly a prolific artist. He also made more than 300 drawings and around 50 etchings, mostly of animal subjects. In addition, he painted the staffage in the works of such artists as Jacob van Ruisdael (e.g. the *Great Oak*, 1652; Birmingham, Mus. & A.G.), Meindert Hobbema, Willem Schellinks, Allaert van Everdingen and Jan Hackaert. Furthermore, Berchem collaborated with Gerrit Dou, Jan Wils (*c.* 1610–66) and Jan Baptist Weenix the elder.

Berchem used several different spellings of his surname, which was sometimes preceded by *C* (for Claes) or *CP* (Claes Pietersz.), although after 1660 he generally used *N*.

1. Life

Berchem's first teacher was his father who, according to the records of the Haarlem Guild of St Luke, instructed his son in drawing in 1634. Houbraken claimed that Berchem studied with Jan van Goyen, Claes Moeyaert, Pieter de Grebber, Jan Wils and Jan Baptist Weenix. Though none of these periods of study is documented, evidence of the works themselves largely corroborates Houbraken's statement. Berchem's early paintings in the native Dutch tonal style support some connection with van Goyen; a drawing by Berchem (the *Calling of St Matthew*, *c.* 1642; New Haven, CT, Yale U. A G.) after a work by Moeyaert (1639; Brunswick, Herzog Anton Ulrich-Museum) lends credence to the suggestion that he studied with Moeyaert in Amsterdam, as does his receptiveness to the pre-Rembrandtists in his early work; and Berchem's

classicizing works of the 1650s can be related to Haarlem classicism, one of whose greatest exponents was de Grebber. However, given that Jan Baptist Weenix and Berchem were so close in age, a student–teacher relationship seems unlikely; there are nonetheless parallels in the work of both artists and they collaborated on at least one occasion, in the *Calling of St Matthew* (c. 1655; The Hague, Mauritshuis), which includes a self-portrait of Berchem.

Berchem joined the Haarlem Guild of St Luke on 6 May 1642 and had three pupils by August of that same year. In 1646 he married Catrijne Claesdr. de Groot in Haarlem; he is also said to have been married a second time, to the daughter of Jan Wils. His son Nicolaes (van) Berchem (c. 1649/50–1672) was also an artist and copied his father's works (e.g. *Crab-catchers by Moonlight*; Göteborg, Kstmus.). Several drawings confirm that Berchem the elder travelled with Jacob van Ruisdael (his 'great friend', as Houbraken noted) through Westphalia c. 1650, and the Castle of Bentheim, a landmark there, figures in works by both artists (e.g. Berchem's *Landscape with Castle Bentheim*, 1656; Dresden, Gemäldegal. Alte Meister).

The question of whether and when Berchem visited Italy remains unclear. It has been assumed that he went twice, perhaps even three times. Houbraken stated that Berchem made a sea voyage as a young man, adding that he had already been painting for some time. Berchem is said to have made the first trip in 1642 together with Jan Baptist Weenix, but although the latter is documented as being in Rome until 1645, there is no mention of Berchem's presence there. The second, more plausible trip would have occurred sometime between 1651 and 1653, and the fact that Berchem and his wife drew up their will in 1649 may have been in anticipation of the artist's prolonged absence. Based on a misreading of a document, it was proposed that the artist made a third trip in 1673, but this has been proved wrong. While not conclusive, the presence of works by Berchem at an early date in the Colonna family collection (inventory of 1714) and a biography, most likely of Berchem, written by Nicola Pio in

1724, with a list of the collections he knew that contained works by Berchem, provide support for the artist's presence in Italy at some point.

From the mid-1650s until his death, Berchem shuttled back and forth between Haarlem and Amsterdam. He is mentioned in Haarlem in 1656 and 1657, in Amsterdam in 1660 (when he served as witness at the betrothal of Jan Wils), again in Haarlem in 1670, after which he moved permanently to Amsterdam. The paintings remaining in his estate were auctioned by his wife on 4 May 1683 for 12,000 guilders (notice in the *Haarlemsche Courant*, 27 April 1683, no. 16), and on 7 December 1683, (notice in the *Haarlemsche Courant*, 30 Nov 1683) his books and all the graphic works he had owned were sold, including drawings and prints by himself and others (over 1300 by Antonio Tempesta).

2. Work

(i) Paintings. The quality and variety of Berchem's painted work is remarkable. Around 1645 he produced landscapes with shepherds and cattle in a brownish tonality inspired by Jan van Goyen and by Pieter van Laer, whose work Berchem knew either directly (van Laer was in Haarlem in 1642) or through prints. However, c. 1650 Berchem's coloration became brighter and he turned to scenes of panoramic vistas (e.g. *Italian Landscape with Figures and Animals*; Windsor Castle, Berks, Royal Col.) that are indebted to Jan Asselijn. From the 1650s he began making landscapes in a purely Italianate style, characterized by more varied and saturated colours, some of which are reminiscent of the work of Jan Both. The figures became more elegant and attenuated and the scenes, often idealizing rural life, are pervaded by a warm southern light (see fig. 4). Berchem's *Landscape with Tall Trees* (1653; Paris, Louvre) combines a number of elements considered typical, including the warm light, fluid handling, distant vistas, shepherds on the move and imposing trees. Sometimes Berchem's landscapes incorporate identifiable sites and architecture, such as the waterfalls at Tivoli or the nearby Temple of the Sibyls, as well as Dutch landmarks, such as the ruins of Brederode Castle or Kronenburg Castle near Loenen.

4. Nicolaes Berchem: *Landscape with Jacob and Rachel* (Paris, Musée du Louvre)

He also painted imaginary Mediterranean harbour scenes, which found their most sophisticated form in the 1660s. A masterpiece in this genre is the *Moor Presenting a Parrot to a Lady* (*c.* 1660; Hartford, CT, Wadsworth Atheneum), in which the elegantly dressed woman, her maid and a Moor with a parrot hold pride of place. Painted in his most liquid yet precise style, the composition exquisitely balances the colourful group of exotically dressed figures and the monochrome group, including the statue of Venus with the two turtle-doves, and the classicizing building in the background. The specific subject of this painting is unclear.

Berchem continued to paint landscapes and histories in the 1670s and 1680s, and his style became broader and looser, marked by stronger contrasts of light and dark and a thinner application of paint (see col. pl. II). His figures were less fluid and graceful and could almost be described as agitated (e.g. *Landscape*, 1680; Vienna, Ksthist. Mus.). Towards the end of his career he painted a considerable number of allegorical scenes and histories (e.g. the *Allegory of Celestial and Profane Love*; Wiesbaden, Mus. Wiesbaden).

(ii) **Drawings and etchings.** Berchem was also a versatile and prolific draughtsman with both figure studies and landscapes to his name. His early figure studies from the 1640s, a number of them of shepherds drawn in black and white chalk on blue paper, are related to a type found in the work of

Pieter van Laer. Berchem incorporated some of these drawings into his paintings, for example the drawing of a *Resting Shepherd* (Amsterdam, Rijksmus.) recurs in the *Resting Shepherds* (164[?4]; New York, Met.). His later figure studies are independent works of art, marked by greater detail and contrast (e.g. *Man Holding a Whip, Seen from behind*; Boston, priv. col., see Schatborn, fig. 14).

Some of the figures recall Classical statues; for example, both the figure studies already mentioned are loosely based on the Farnese *Hercules* (Naples, Mus. Archeol. N.). Other drawings are more properly described as figured scenes, for instance a group representing scenes from the *Story of Venus and Adonis* (Bremen, Ksthalle), which were incorrectly attributed to Laurent de la Hyre. Drawings with religious subject-matter are preserved in Amsterdam (Rijksmus.) and Leiden (Rijksuniv., Prentenkab.), some of which are squared for transfer (Leiden). Berchem generally worked in black chalk, sometimes heightened with white, and red chalk. However, for some detailed landscapes he worked with charcoal impregnated with linseed oil (e.g. *Landscape with Diana and her Nymphs*, c. 1655–60; Amsterdam, Rijksmus.), a technique rarely used in the 17th century.

Berchem produced approximately 50 etchings representing idyllic Italian views with pastoral subjects. The figures in his early etchings were again inspired by Pieter van Laer and, following the trend also noticeable in his paintings, they eventually became more graceful. This is evident in the etching and drypoint of c. 1644–5 called *The Bagpiper* (Hollstein, no. 4), known in the 18th century as 'The Diamond', which is characterized by southern light and strong contrasts between the central group and the landscape. His style is distinguished by fine tonal meshes or masses of stipples. Later etchings abandon the earlier tonal, atmospheric approach for stronger contrasts and rhythmic calligraphic contours. The figures in the *Cows at the Watering-place* (1680; etching and drypoint, Hollstein, no. 1) are larger than previously and the landscape plays a lesser role.

In addition to his own independent etchings, Berchem provided designs for map ornaments, frontispieces and title-pages, many of them for bibles (e.g. the frontispiece to the *Statenbijbel*, Leiden, 1663, published by the widow of Johannes Elzevier). Berchem collaborated with Nicolaes Visscher in 1658 on an impressive map of the world, for which he designed allegorical scenes of the Elements for the corners. He also designed allegorical vignettes for Visscher's maps of America, Asia, France and Malta. Berchem's designs for biblical maps (*La Sainte Bible*, 1669; Paris, Bib. N.) were engraved by Abraham Blooteling and Jan de Visscher.

3. Critical reception and posthumous reputaion

Berchem appears to have had many pupils and followers. Houbraken noted that Pieter de Hooch and Jacob Ochtervelt, both from Rotterdam, trained under Berchem, probably between 1646 and 1655. He also stated that Karel Dujardin, Johannes Glauber, Jan van Hughtenburgh (1647–1733), Dirck Maas and Jan van Huysum studied with the artist, although no proof of this exists. Other students mentioned in contemporary documents include Willem Romeijn, whose early work has been confused with Berchem's, and Simon Du Bois. His closest imitators include Romeijn, Abraham Begeyn, Dirck van den Bergen and Johannes van der Bent (1650–90); Berchem's influence was considerable and lasted long after his death.

Italianates in general and Berchem in particular held an exalted position in the 17th and 18th centuries and in the early 19th, losing ground only in the late 19th century and first half of the 20th. Collectors in the 18th century, especially French ones, preferred a view of Italy by Berchem or Both to a scene of the Dutch countryside by Jacob van Ruisdael, for instance. Thus it is not surprising that works by Berchem and Wouwermans fetched the highest prices at the sales of the collections of the Comtesse de Verrue (1737) and Jean de Julienne (1767). In the 18th century more engravings were made after works by Berchem than any other Dutch artist, and Jean-Baptiste Oudry even said of Berchem that 'one single picture of this brilliant artist can replace a complete course in practical training'.

The taste for Berchem and the Italianates continued undiminished into the 19th century. An early voice denouncing these artists was that of John Constable in 1836; at the end of a lecture, a collector in the audience asked him, 'I suppose I had better sell my Berchems', to which Constable replied, 'No sir, that would only continue the mischief. Burn them!' Initially his criticism went unheeded but, by the end of the century, Italianates had lost favour partly because of the rise of Impressionism and the appreciation of the Dutch national school of landscape expounded by such eminent critics as Wilhelm von Bode, E. W. Moes and Cornelis Hofstede de Groot. This trend was definitively reversed by the first comprehensive exhibition of Italianate art organized by Albert Blankert and held in Utrecht in 1965. Since then other exhibitions have presented the Italianates in a balanced context, and numerous studies and monographs devoted to these artists have been written.

Bibliography

Hollstein: *Dut. & Flem.*

C. de Bie: *Het gulden cabinet* (1661), p. 385

A. Houbraken: *De groote schouburgh* (1718–21), ii, pp. 109–14

J. Smith: *A Catalogue Raisonné of the Works of the Most Eminent Dutch, Flemish and French Painters*, 9 vols (London, 1829–42), v, pp. 1–111; ix, pp. 593–619

C. Hofstede de Groot: *Holländischen Maler* (1907–28), ix, pp. 51–292

I. von Sick: *Nicolaes Berchem: Ein Vorläufer des Rokoko* (Berlin, 1930)

E. Schaar: 'Berchem und Begeijn', *Oud-Holland*, lxvii (1954), pp. 241–5

—: 'Zeichnungen Berchems zu Landkarten', *Oud-Holland*, lxxi (1956), pp. 239–43

—: *Studien zu Nicolaes Berchem* (diss., U. Cologne, 1958)

Nederlandse 17de eeuwse Italianiserende landschap-schilders [Dutch 17th-century Italianate landscape painters] (exh. cat., ed. A. Blankert; Utrecht, Cent. Mus., 1965/R 1978), pp. 147–71

P. Schatborn: 'Figuurstudies van Nicolaes Berchem', *Bull. Rijksmus.*, xxii (1974), pp. 3–16

W. L. van der Watering: 'The Later Allegorical Paintings of Nicolaas Berchem', *Old Master Paintings* (exh. cat., London, Leger Gals, 1981), pp.14–6

C. Schloss: *Travel, Trade, and Temptation: The Dutch Italianate Harbour Scene, 1640–1680* (Ann Arbor, MI, 1982)

Masters of the 17th-century Dutch Landscape Painting (exh. cat. by P. C. Sutton, Amsterdam, Rijksmus.; Boston, MA, Mus. F.A.; Philadelphia, PA, Mus. A.; 1987–8), pp. 262–8

S. K. Bennett: 'Nine Religious Drawings by Nicolaes Berchem: Designs to Ornament Maps in a 1669 Bible', *Hoogsteder-Naumann Mercury*, 13–14 (1992), pp. 60–73

JENNIFER KILIAN

Berckheyde

Dutch family of painters and draughtsmen. (1) Job Berckheyde and his brother (2) Gerrit Berckheyde were renowned for their architectural paintings. Gerrit was the only recorded pupil of his older brother Job. During the 1650s the brothers made an extended trip to Germany along the Rhine, visiting Cologne, Bonn, Mannheim and finally Heidelberg. Whether this occurred before or after 1654, when Job became a master of the Guild of St Luke in Haarlem, is uncertain. According to legend, the brothers worked in Heidelberg for Charles Ludwig (*d* 1680), Elector Palatine; however, their inability to adapt to court life led them to return to Haarlem, where Gerrit became a member of the Guild of St Luke on 27 July 1660. In Haarlem the Berckheyde brothers shared a house and perhaps a studio as well. The idea that Job was the superior artist and habitually contributed the figures to Gerrit's architectural subjects has been discounted, but the degree of their mutual influence and involvement remains unclear. Confusion between them may have resulted from the similarity of their signatures, where Job's *j* resembles Gerrit's *g*. Job also signed his work with an *H* (for Hiob or Job) and with the monogram *HB*.

(1) Job (Adriaensz.) Berckheyde

(*b* Haarlem, 27 Jan 1630; *d* Haarlem, 23 Nov 1693). He was apprenticed on 2 November 1644 to Jacob Willemsz. de Wet, whose influence is apparent in his first dated canvas, *Christ Preaching to the Children* (1661; Schwerin, Staatl. Mus.), one of the few biblical scenes in his oeuvre. On 10 June 1653

he repaid a loan from the Haarlem Guild of St Luke, which he subsequently joined on 10 March 1654. During his stay in Heidelberg, Job painted portraits and hunting scenes at the court of the Elector Palatine, who rewarded him with a gold chain, perhaps the one he wears in his early *Self-portrait* (c. 1655; Haarlem, Frans Halsmus.), his only documented work from the 1650s. Job is better known for his later work, which consists mainly of interior views of St Bavo's church in Haarlem and simple genre scenes recalling those of his Haarlem contemporaries Adriaen van Ostade and Jan Steen.

While Job's meticulous delineation of church interiors indicates his debt to Pieter Saenredam, his introduction of a subtle chiaroscuro and lusher atmospheric effects suggest the influence of Emanuel de Witte. His emphasis on the staffage varies from work to work: in a canvas of 1676 (Detroit, MI, Inst. A.) the subject is simply the south-east side aisle of St Bavo's, while in a similar view of 1674 (Amsterdam, Rijksmus.) the genre component is intrusive. His refined palette reinforces the meditative mood, but this sombreness is relieved by the judicious introduction of patterns of light dappling the walls and floor. After 1668 Job painted several views of the *Stock Exchange* in Amsterdam (Amsterdam, Hist. Mus.; Rotterdam, Boymans–van Beuningen; Frankfurt-am-Main, Städel. Kstinst.), influenced by de Witte. The signature and date of his only townscape, *Oude Gracht in Haarlem* (1666; The Hague, Mauritshuis), depicting a canal now filled in, were added later.

Job combined portraiture and genre in *The Baker* (1681; Worcester, MA, A. Mus.), which is perhaps a self-portrait. The composition is based on his characteristic motif of a figure framed by an arch. The bakery theme appears in two other works from the 1680s: *Baker's Shop* (Oberlin Coll., OH, Allen Mem. A. Mus.) and *Baker's Shop with a Woman Making Lace* (The Hague, Dienst Verspr. Rijkscol.). Also from the same decade are his *Musician at a Window* (Schwerin, Staatl. Mus.) and the *Pigment Seller* (Leipzig, Mus. Bild. Kst.). The only drawing attributed to Job, *Standing Man Leaning on a Cradle* (Lübeck, St-Annen-Mus.), is

related to a genre painting of a *Fish Market* (ex-van Diemen Gal., Berlin; untraced).

In 1666 Job became a member of the Haarlem society of rhetoricians, De Wijngaardranken. He served as its agent between 1673 and 1681, and later as its chairman. In May 1680 he was involved in the appraisal of the van der Meulen collection in Amsterdam. During the 1680s and 1690s he assumed a position of influence within the guild and was named a commissioner in January 1682. Records indicate, however, that he rarely attended meetings.

(2) Gerrit (Adriaensz.) Berckheyde

(*b* Haarlem, 6 June 1638; *d* Haarlem, 10 June 1698). Brother of (1) Job Berckheyde. Gerrit specialized in a particular type of architectural subject, the Townscape. His painted work shows a debt not only to Pieter Saenredam's conception of the building portrait but also to Saenredam's refined draughtsmanship and dispassionate attitude (see fig. 5); these qualities mark Berckheyde as a classicist and akin to Vermeer. Berckheyde favoured views of monuments on large open squares, a choice that distinguishes him from the other great Dutch townscape painter, Jan van der Heyden, who preferred views along canals in which clarity was sacrificed for pictorial effect.

Gerrit's Dutch views are invariably topographically correct, but this is not true of those of Cologne (e.g. *Street in Cologne with the Church of the Holy Apostles*; Schwerin, Staatl. Mus.). Although individual elements are accurately depicted, their juxtaposition is frequently capricious. This suggests that they were not executed from life in the 1650s, as has been claimed, but were painted later in his Haarlem studio, using sketches and drawings made by him in Cologne, and possibly some by other artists as well.

Gerrit's works from the 1660s record the landmarks of his native city, and he repeated these subjects throughout his career. While his portraits of the *Town Hall* (Haarlem, Frans Halsmus.) indicate his early dependence on Saenredam, he introduced several devices of his own: for instance, he retained Saenredam's limited staffage but placed his figures in a way that enhanced the structural

5. Gerrit Berckheyde: *Palace of the Dukes of Burgundy in Brussels* (The Hague, Mauritshuis)

components of the architectural backdrop. He was also more adventurous in his use of light, creating strong contrasts that organize the compositions as well as convey atmosphere and mood. He used this method in his depictions of the *Grote Markt with the Church of St Bavo* (Leipzig, Mus. Bild. Kst.); like his brother Job, Gerrit also painted several interior views of the church (Hamburg, Ksthalle). These suggest a debt to Emanuel de Witte's lush and evocative lighting schemes.

Following the completion of Amsterdam Town Hall in the mid 1660s, Gerrit painted several formal portraits of it (e.g. three different versions, 1672, 1673 and 1693; Amsterdam, Rijksmus.) as well as panoramic views of *The Dam*, the large public square on which it stood (Antwerp, Kon. Acad. S. Kst.). He also painted scenes along the canals in the old city centre, some of which were composed as if from a bridge or boat: these include the *Nieuwezijds Voorburgwal* (Amsterdam, Hist. Mus.), the *Singel* (San Francisco, CA, de Young Mem. Mus.), the *Kloveniersburgwal* and the *Grimburgwal* (Amsterdam, Hist. Mus.). In the 1670s Gerrit began producing views of the palatial houses built along the extension of the *Herengracht* (Amsterdam, Rijksmus.) and the *Binnen Amstel* (Amsterdam, Col. Six).

Several of Gerrit's townscapes from the early 1670s have dramatic foreshortening and oblique angles that suggest the influence of Daniel Vosmaer (*fl* Delft, 1650–1700). Two works from this group, the *Church of St Bavo* in Haarlem and the *Town Hall* in Amsterdam (both Cambridge, Fitzwilliam), were created as pendants, one of

several such pairs in Gerrit's oeuvre. Views of the *Grote Markt* in Haarlem (Florence, Uffizi; see col. pl. III) and *The Dam* (Amsterdam, Hist. Mus.) pointedly juxtapose Gothic, Renaissance and Baroque buildings and thus reveal Berckheyde's sensitivity to period styles. Other Haarlem views include the *Spaarne with the Weigh House* (Douai, Mus. Mun.) and the *City Gates* (Antwerp, Mus. Smidt van Gelder); he also painted the nearby country houses of *Egmont* (Amsterdam, Rijksmus.), *Heemstede* and *Elswout* (Haarlem, Frans Halsmus.).

Berckheyde's scenes of the Hofvijver with the Binnenhof in The Hague (Salzburg, Residenzgal.) date from the 1680s and 1690s, reflecting the contemporary popularity of the House of Orange Nassau. His depictions of the royal residence recall Hendrick Pacx's (1602/3–?*c*. 1658) canvases showing the Princes of Orange parading with their families and retinues around the Hofvijver. Gerrit represented this site from all angles, producing views of the Gevangenpoort (The Hague, Mauritshuis), the Korte Vijverberg (The Hague, Gemeentemus.) and the Mauritshuis. He also painted portraits of the *Ridderzaal* (Madrid, Mus. Thyssen-Bornemisza). While some of these views in The Hague have robust forms painted in saturated colours, others have more attenuated figures and paler tonalities that anticipate the Rococo. Gerrit also produced a small number of Italianate landscapes with ruins, pastoral subjects and hunting scenes (e.g. Strasbourg, Mus. B.-A.).

Several figure studies in red or black chalk have been attributed to Gerrit, some of which are connected with paintings. These include the *Study of a Little Boy with a Basket* (Amsterdam, Rijksmus.) and the *Study of a Woman Seated Beside a Barrel* (Brookline, MA, Gordon priv. col., see 1977 exh. cat., no. 11, as Bega), both of which are preparatory for the *Oriental Market Hall* (ex-Munich, Gebhardt, 1971); two others, including *Seated Man with a Pipe* (Berlin, Kupferstichkab.), are inscribed with his name. Like other draughtsmen of the so-called Haarlem school, Berckheyde drew in a highly consistent chalk style, using regular parallel hatching to shade the figures. Many of his drawings have been confused with those of Cornelis Bega, to whom most have been traditionally ascribed.

From 1666 to 1681 Gerrit was a member of the same Haarlem society of rhetoricians, De Wijngaardranken, as his brother; he also served as an official of the Haarlem Guild of St Luke in 1691–5. Although he had no formal shop or students, his works influenced such later townscape specialists as Timotheus de Graaf (*fl* 1682–1718), Jan ten Compe and Isaac Ouwater. He is known to have worked with Jan van Huchtenburg (1647–1733), but the question of his collaboration with Nicolas Guérard (*d* 1719), Dirk Maas and Johannes Lingelbach remains open. On returning home from a cabaret on 10 January 1698, Gerrit fell into the Brouwersvaart and drowned; he was buried in the nave of St Jan's four days later.

Bibliography

A. Houbraken: *De groote schouburgh* (1718–21), pp. 189–97

H. Jantzen: *Das niederländische Architecturbild* (Leipzig, 1910), pp. 87–8

W. Stechow: 'Job Berckheyde's *Bakery Shop*', *Allen Mem. A. Mus. Bull.*, xv/1 (1957), pp. 5–14

W. Liedtke: *Architectural Painting in Delft: Gerard Houckgeest, Hendrick van Vliet, Emanuel de Witte* (Doornspijk, 1977), pp. 73–4

The Dutch Cityscape and its Sources in the Seventeenth Century (exh. cat., Amsterdam, Hist. Mus.; Toronto, A.G. Ont.; 1977)

Old Master Drawings from the Gordon Collection (exh. cat. by F. W. Robinson, Framingham, MA, Danforth Mus. A., 1977)

J. A. Welu: 'Job Berckheyde's *Baker*', *Worcester A. Mus. Bull.*, n. s., vi/3 (1977), pp. 1–9

A Mirror of Nature: Dutch Paintings from the Collection of Mr & Mrs Edward William Carter (exh. cat. by J. Walsh jr and C. P. Schneider, Los Angeles, Co. Mus. A.; Boston, MA, Mus. F.A.; New York, Met.; 1981–2)

Masters of Seventeenth-century Dutch Genre Painting (exh. cat., ed. P. C. Sutton; Philadelphia, PA, Mus. A.; W. Berlin, Gemäldegal.; London, RA; 1984), pp. 138–9, cat. no. 6

P. Biesboer: 'Schilderijen over de kerk' [Paintings of the church], *De Bavo te Boek* (Haarlem, 1985), pp. 96–104

C. Lawrence: *Gerrit Berckheyde (1638–98): Haarlem Cityscape Painter* (Doornspijk, 1991)

CYNTHIA LAWRENCE

Beyeren, Abraham van

(*b* The Hague, 1620–21; *d* Overschie, 1690). Dutch painter. He painted seascapes as well as fruit, flower, fish, game and banquet still-lifes. He almost always signed these works with his monogram AVB, but he dated only a few. This, together with the fact that he painted diverse subjects simultaneously and his style changed little, makes it difficult to establish a chronology. He became a master in The Hague in 1640 and was related by marriage to the fish painter Pieter de Putter (before 1600–59). Van Beyeren lived in Delft from 1657 to 1661 and was again in The Hague between 1663 and 1669. He was then recorded in Amsterdam, Alkmaar and Gouda before settling in Overschie in 1678.

Van Beyeren's earliest marine paintings appear to date from the early 1640s. They characteristically include high cloud-filled skies, choppy seas and fishing boats under sail (e.g. *Riverview*, Amsterdam, Rijksmus.). The artist employed a soft, painterly brushstroke and grey tonal scheme to create moist atmospheric effects. In these pictures he was strongly influenced by Jan van Goyen, who settled in The Hague in 1631.

Van Beyeren is the undisputed master of Dutch fish painting. He depicted a great variety of sea creatures in a most lifelike manner, their bodies falling gracefully across baskets, piled on top of one another or tied head-to-tail (e.g. *Fish-piece*, Brussels, Mus. A. Anc.). Most of these works depict the fish on a table in a rustic interior with a view of the sea through a background window. However, a group of five still-lifes show fish arranged on a beach with fishermen along the distant shore and a large cloud-filled sky above. These may have been the artist's earliest versions of the subject and thus represent a transitional stage between his marine paintings and later fish pieces. In the fish paintings his palette was limited to the natural brown and grey shades of the sea creatures, but he enlivened this through the pink tones of the sliced fish and the rich contrast of light as it played across their slick surfaces, reproducing the tactile qualities of glistening skin and translucent flesh with fluid strokes. Often he included crustaceans, earthenware pots, copper scales and other fishing paraphernalia.

Van Beyeren's banquet still-lifes date from the 1650s and 1660s. These large pictures generally depict a table laden with a variety of ornate glassware, gilded goblets, nautilus cups, silver dishes, Chinese porcelains, costly fruits and other delicacies (e.g. *Banquet Still-life*, 1655; Worcester, MA, A. Mus.). Many of these objects appear repeatedly in his paintings. Often a pocket watch is included as a *vanitas* symbol warning the viewer of the brevity of life and the transience of earthly pleasures. Van Beyeren's grandiose compositions were influenced by Jan de Heem but are more broadly painted and employ a softer palette. Van Beyeren also executed some smaller, more intimate paintings of fruit and glassware related to those of Jacques de Claeuw (*c.* 1620–79 or after). The pictures often display a warm tonal quality and subtle atmospheric effects (e.g. *Still-life with Roemer and Fruit*, Stockholm, Nmus.). His rare flower-pieces display a similar soft touch and a preference for pink, red and white specimens (e.g. *Vase of Flowers*; The Hague, Mauritshuis).

Bibliography

H. E. van Gelder: *W. C. Heda, A. van Beyeren, W. Kalf*, Palet Series (Amsterdam, 1941), pp. 21–38

I. Bergstrom: *Studier i Holländskt stillebenmäleri under 1600-talet* (Stockholm, 1947); Eng. trans. by C. Hedström and G. Taylor as *Dutch Still-life Painting in the Seventeenth Century* (New York, 1956), pp. 229–46

S. A. Sullivan: 'A Banquet-piece with *Vanitas* Implications', *Bull. Cleveland Mus. A.*, 61 (1974), pp. 271–82

——: 'Abraham van Beyeren's *Visserij-bord* in the Groote Kerk, Maasluis', *Oud-Holland*, ci (1987), pp. 115–25

SCOTT A. SULLIVAN

Bijlert [Bylert], Jan (Hermansz.) van

(*b* Utrecht, ?1597–8; *d* Utrecht, *bur* 12 Nov 1671). Dutch painter. He was the son of the Utrecht glass painter Herman Beerntsz. van Bijlert (*c.* 1566–before 1615). Jan must have trained first with his father but was later apprenticed to the painter Abraham Bloemaert. After his initial training, he visited France and travelled to Italy, as did other artists from Utrecht. Jan stayed mainly in Rome, where he became a member of the Schildersbent;

he returned to Utrecht in 1624. In Rome he and the other Utrecht artists had come under the influence of the work of Caravaggio; after their return home, this group of painters, who became known as the Utrecht Caravaggisti, adapted the style of Caravaggio to their own local idiom. The Caravaggesque style, evident in van Bijlert's early paintings, such as *St Sebastian Tended by Irene* (1624; Rohrau, Schloss) and *The Matchmaker* (1626; Brunswick, Herzog Anton Ulrich-Mus.), is characterized by the use of strong chiaroscuro, the cutting off of the picture plane so that the image is seen close-up and by an attempt to achieve a realistic rather than idealized representation. Van Bijlert continued to paint in this style throughout the 1620s, a particularly productive period.

Probably inspired by Gerard van Honthorst, who had already turned from Caravaggism to classicism, around 1630 van Bijlert adopted a more classicizing style. His paintings became clearer and the colours lighter, sometimes demonstrating a strong affinity to the work of Simon Vouet. Van Bijlert painted elegant subjects such as the *Virgin and Child* and personifications of *Charity* (e.g. Quimper, Mus. B.-A., and Sibiu, Brukenthal Mus.). During the 1630s he also painted compositions with small figures. The most important example of this is the history piece depicting the *Banquet of Alexander and Cleitos* (1625; Berlin, Bodemus.). There is a small number of paintings in which the Italianate style of Cornelis van Poelenburch is evident. However, van Bijlert generally used this small-figure format for genre scenes of brothels or musical gatherings, similar to those being painted in Utrecht by Jacob Duck. From 1632 to 1636 van Bijlert was dean of the Guild of St Luke in Utrecht. At this time his pupils included Ludolf de Jongh, Bertram de Fouchier (1609–73) and Abraham Willaerts; Matthias Wytmans was a later pupil in the 1660s.

Patrons of van Bijlert included burgomasters and nobles in Utrecht, for instance members of the Strick van Linschoten family, whose portraits he painted over the years (examples in the family's former country seat, Huis te Linschoten). Jan van Bijlert painted some 200 pictures, the best collection of which is in the Centraal Museum, Utrecht.

Bibliography

G. J. Hoogewerff: 'Jan van Bijlert, schilder van Utrecht (1598–1671)', *Oud-Holland*, lxxx (1965), pp. 2–33 [incl. list of works]

Nieuw licht op de Gouden Eeuw: Hendrick ter Brugghen en tijdgenoten [New light on the Golden Age: Hendrick ter Brugghen and his contemporaries] (exh. cat., ed. A. Blankert and L. J. Slatkes; Utrecht, Cent. Mus.; Brunswick, Herzog Anton Ulrich-Mus.; 1986–7), pp. 194–207

P. Huys Janssen: *Jan van Bijlert (1597/8–1671), Painter in Utrecht* (Amsterdam and Philadelphia, 1996) [inc. cat. rais.]

PAUL HUYS JANSSEN

Bisschop, Jan de [Episcopius, Joannes]

(*b* Amsterdam, 1628; *d* The Hague, 7 Nov 1671). Dutch draughtsman and etcher. He was a lawyer by profession and a skilled amateur draughtsman. At the Amsterdam Latin school his teacher was the humanist Hadrianus Junius (1511–75), under whose supervision he wrote a poem about the Atheneum Illustre and Collegium Auriacum in Breda, published by Johannes Blaeu in 1647. From 1648 to 1652 he read law at Leiden University. In 1653 he married Anna van Baerle, daughter of the famous professor and theologian Caspar van Baerle (1584–1648), and throughout his life he moved in prominent intellectual circles. One of his closest friends was Constantijn Huygens the younger, who was also an amateur draughtsman, with a very similar drawing style (especially in landscapes), and who was probably a member— with Jacob van der Does (1623–73) and Willem Doudijns (1630–97)—of the small drawing academy that de Bisschop founded in The Hague. Although de Bisschop lived for a while in a house adjoining Claes Moeyaert's in Amsterdam, it was probably Bartholomeus Breenbergh, also living in Amsterdam at the time, rather than Moeyaert who most influenced his style of drawing. De Bisschop made two large etchings after paintings by Breenbergh: *Joseph Selling Corn to the People* (1644; untraced) and the *Martyrdom of St Lawrence* (1647; Frankfurt am Main, Städel. Kstinst.).

Besides landscape drawings, the earliest of which show views of Amsterdam, Bergen op Zoom

and Hoogstraten (e.g. *Beckeneelshuisje (Nieuwe Kerk), Amsterdam*, 1648; Amsterdam, Rijksmus.), de Bisschop made numerous figure studies (e.g. *Jacobus Ewijk Reading*; Amsterdam, Rijksmus.) and drawings after Classical sculptures and famous paintings (mostly by Italian artists). The latter drawings, which Houbraken called 'imitations', were carried out in a particularly fluid technique using brush and luminous wash. De Bisschop also designed a number of title pages for books, mostly by Classical authors, and there are some drawings from 1660 recording the *Departure of King Charles II from Scheveningen* (e.g. Amsterdam, Rijksmus.).

Almost all of de Bisschop's drawings, whether drawn in pen or with the brush, were executed in a warm golden-brown ink, known as 'bisschopsinkt' after the artist. According to Willem Goeree in his *Inleiding tot de algemeene teyken-konst* ('Introduction to the general art of drawing', Amsterdam, 1697, p. 91), de Bisschop mixed Indian ink with a bit of copper red to obtain this 'modest colour of charm and beauty'. As did Breenbergh, de Bisschop drew over a preliminary sketch in black chalk, a technique imitated by Jacob van der Ulft (1627–89) and Jan Goeree (1670–1731), some of whose drawings are virtual copies of those of de Bisschop. Wallerant Vaillant made several mezzotints based on de Bisschop's drawings of paintings; de Bisschop's brush and wash technique in these drawings was strongly determined by the use of chiaroscuro, which made it easy for Vaillant to translate the images into mezzotint. Other artists who made prints of his drawings include Hendrick Bary (*b* 1640), David Philippe and Petrus Philippe.

Although de Bisschop's drawings include a considerable number of Italianate landscapes (e.g. *View of Rome*, ?1650s; New York, Pierpont Morgan Lib.), he may not have been to Italy himself, and his Italian views could have been composed with the help of prints and drawings by others who had, such as Willem Doudijns, Adriaen Bakker (*b* 1635–6), Jacob Matham and Dirck Ferreris (1639–93). He certainly depended on drawings by other artists as well as the illustrations from François Perrier's *Icones* (Paris, 1645) for his two influential series of prints in book form, the

Signorum veterum icones (1668–9), with 100 prints after Classical sculptures, dedicated to Johannes Wtenbogaard and Constantijn Huygens, and the *Paradigmata graphices variorum artificum* (1671), with prints after Old Master drawings and dedicated to Jan Six. Some of the Classical sculptures reproduced in de Bisschop's *Icones* were from the 17th-century collections of Gerrit Uylenburgh and Hendrik Scholten, to which de Bisschop had direct access; most of the Old Master drawings in the *Paradigmata* were based on works by Italians: Annibale Carracci, Domenichino, Francesco Salviati, Cavaliere d'Arpino, Giulio Romano and others. The sequence of the *Icones* adhered strictly to the Classical tradition: first the individual parts of the body were illustrated (this section was left unfinished at de Bisschop's premature death), then complete figures, followed by poses and suggestions for compositions with more than one figure. The prints were intended to provide artists with examples of ideal poses. From the paintings of Adriaen van der Werff and Nicolaes Verkolje, it is clear just how influential these studies were in the development of Dutch classical painting during the late 17th century.

Writings

Bisschop, Jan de

Prints

Signorum veterum icones, 2 vols (The Hague, 1668–9)
Paradigmata graphices variorum artificum (The Hague, 1671, rev. Amsterdam, 2/[1671])

Bibliography

Thieme–Becker: 'Episcopius'
A. Houbraken: *De groote schouburgh* (1718–21), iii, p. 212
J. G. van Gelder: 'Jan de Bisschop, 1628–1671', *Oud-Holland*, lxxxvi (1971), pp. 201–8
—: 'De ongenoemde "inventor"', *Bijdragen tot de geschiedenis van de grafische kunst opgedragen aan Louis Lebeer . . .* (Antwerp, 1975), pp. 115–33
J. G. van Gelder and I. Jost: *Jan de Bisschop and his Icones and Paradigmata* (Doornspijk, 1985)
Episcopius: Jan de Bisschop (1628–1671), advocaat en tekenaar/Lawyer and Draughtsman (exh. cat. by R. E. Jellema and M. Plomp, Amsterdam, Rembrandthuis, 1992)

GER LUIJTEN

Bloemaert

Dutch family of artists. Cornelis Bloemaert I (b Dordrecht, c. 1540; d Utrecht, bur 1 Nov 1593) was an architect, sculptor and teacher, whose pupils included Hendrick de Keyser I. In 1567 he visited 's Hertogenbosch in order to repair the city gates and the pulpit of the St Janskerk, which had been damaged in 1566 during the Iconoclastic Fury. From 1576 he lived in Utrecht, where in 1586 he collaborated on decorations for the ceremonial entry of Robert Dudley, 1st Earl of Leicester and self-styled Governor General of the United Provinces. From 1591 to 1593 Bloemaert was master builder of Amsterdam. His son Abraham Bloemaert (b 1566) was the most gifted member of the family and became one of the most important painters working in Utrecht in the first half of the 17th century. Four of Abraham's sons also worked as artists, all of them receiving their initial training from their father. The eldest son, Hendrick Bloemaert (b Utrecht, 1601–2; d Utrecht, 30 Dec 1672), was a painter and poet. Hendrick travelled to Italy and was in Rome in 1627; he returned to Utrecht c. 1630. His oeuvre includes religious works, mythological and genre scenes and portraits. His best works are those in which he combined the style of the Utrecht Caravaggisti with the decorative manner of his father. As a poet, Hendrick is best known for his rhymed translation of Guarini's Il pastor fido (Venice, 1590). Abraham Bloemaert's second son, Cornelis Bloemaert II (b Utrecht, 1603; d Rome, ?1684), studied with his father, Gerrit van Honthorst and Crispijn de Passe I, but although he was originally trained as a painter, he devoted himself primarily to printmaking (see Hollstein, nos 1–321). In 1630 Cornelis the younger travelled to Paris and then to Rome, where he made prints after paintings and sculptures in major collections. He also made engravings after works by his father (e.g. six Pastorals, Hollstein, nos 212–15). Another of Abraham's sons, Adriaen Bloemaert (b Utrecht, c. 1609; d Utrecht, 8 Jan 1666), was a painter, draughtsman and perhaps also an engraver. He travelled to Italy and worked for a time in Salzburg, where in 1637 he painted eight canvases: the Mysteries of the Rosary (all U. Salzburg, Aula Academica). The landscapes signed A. Blommaert, which are attributed

to him, are now believed to be the work of Abraham Blommaert (fl 1669–83) from Middelburg (see Bok and Roethlisberger). Frederick Bloemaert (b Utrecht, c. 1616; d Utrecht, 11 June 1690) worked exclusively as an engraver; almost all his prints were after his father's compositions. These include the engravings for his father's Konstryk tekenboek ('Artistic drawing book'), which was reprinted many times up to the 19th century.

Writings
Bloemaert

Prints
Oorspronkelyk en vermaard konstryk tekenboek van Abraham Bloemaert, geestryk getekent, en meesterlyk gegraveert by zyn zoon Frederik Bloemaert (Amsterdam, 1711)

Bibliography
Hollstein: Dut. & Flem.; Thieme–Becker; Wurzbach
K. van Mander: Schilder-boeck ([1603]–1604), fol. 297
M. G. Roethlisberger and M. J. Bok: Abraham Bloemaert and his Sons: Paintings and Prints, 2 vols (Doornspijk, 1993)
M. J. Bok and M. Roethlisberger: 'Not Adriaen Bloemaert but Abraham Blommaert (of Middelburg), Landscape Painter', Oud-Holland, cix (1995)

(1) Abraham Bloemaert

(b Gorinchem, 24 Dec 1566; d Utrecht, 13 Jan 1651). Painter, draughtsman, writer and teacher. His long, successful career and many prominent pupils, especially among the Utrecht Caravaggisti, made him one of Utrecht's principal painters in the first half of the 17th century. During his lifetime he enjoyed high esteem for his paintings of religious and mythological subjects and for his numerous drawings. At first he worked in a Mannerist style, then in a Caravaggesque manner, finally adopting a distinctive, decorative synthesis of both approaches.

1. Life and painted work

According to van Mander, as a child Bloemaert moved with his family from Gorinchem to 's Hertogenbosch and from there to Utrecht. He began to draw in Utrecht, under the direction of his father, Cornelis Bloemaert I, copying works by

Frans Floris. He was apprenticed to the painter Gerrit Splinter (fl 1569–89) but remained with him for only two weeks. His second teacher, Joos de Beer (d 1599), was a mediocre painter in van Mander's view, although he possessed an excellent collection of paintings, including works by Dirck Barendsz. and Anthonie Blocklandt. In preparation for an apprenticeship with Blocklandt (then the most important painter in Utrecht), Bloemaert was sent by his father to study with an unnamed bailiff at Hedel Castle, but the bailiff used Bloemaert as a house servant rather than instructing him, and Bloemaert returned home empty-handed after 18 months. Then, c. 1582, he travelled to Paris, where he studied first with Jehan Bassot, later with a 'Maître Herry' and finally with Hieronymous Francken. (In later years Bloemaert complained bitterly of his fragmented training, under no fewer than six masters.) Before leaving Paris, he came in contact with French Mannerist works from the school of Fontainebleau. By 1585 he was back in Utrecht, where he probably worked with his father. In April 1591 he accompanied him to Amsterdam, of which he became a citizen on 13 October. In May 1592, the banns proclaimed in both Utrecht and Amsterdam, he married Judith van Schonenburgh (d 1599), a wealthy spinster 20 years his senior; this marriage remained childless. A year later he returned to Utrecht, where he remained for the rest of his life.

Two circular paintings, *Bacchus* and *Ceres* (both Buscot Park, Oxon, NT) were recognized by Roethlisberger as probably the earliest known works by Bloemaert (see Roethlisberger, 1994). They show a strong influence of the work of Frans Floris and the Fontainebleau school. The earliest known dated paintings, the *Death of the Children of Niobe* (1591; Copenhagen, Stat. Mus. Kst) and *Apollo and Daphne* (1592; ex-Schles. Mus. Bild. Kst., Breslau; ? destr.), were executed in Amsterdam in a style strongly related to the late Mannerist style influenced by Bartholomäus Spranger that was current in Haarlem at that time. In works of this period one part of the scene, often the principal subject, takes place in the background, while the foreground is filled with large, usually nude, figures, who are presented in unnaturally twisted poses. The distinction between foreground and background is emphasized by colour: warm foreground colours, such as brown and red, contrast with the cooler greens and grey-whites of the background. Although the muscular figures betray the considerable influence of Cornelis Cornelisz. van Haarlem's characteristically Mannerist works of the late 1580s, they are distinguished by their lyrical character: strong emotion and violence are alien to Bloemaert, and his modelling of the muscles is softer. Several of Bloemaert's Mannerist works before c. 1600 represent religious and mythological subjects not previously depicted in Dutch art, such as the *Death of the Children of Niobe* and the *Burning of Troy* (Frankfurt am Main, Städel. Kstinst. & Städt. Gal.). The latter is one of several loosely painted nocturnes executed c. 1593; these small panels, which also include two versions of *Judith* (Vienna, Ksthist. Mus.; see fig. 6; and Frankfurt am Main, Städel. Kstinst. & Städt. Gal.), reveal a combination of brilliant lighting effects and bright acidic colours.

After 1595 the transition between the foreground and background in Bloemaert's works became less abrupt. He deployed the figures more evenly within the picture space, as in *Moses Striking Water from the Rock* (1596; New York, Met.). Landscape elements became more important after 1596, as can be seen, for example, in *St John the Baptist Preaching* (Amsterdam, Rijksmus.) and the *Baptism* (Ham House, Surrey, NT); powerful tree formations in particular are prominent in his work of this period. The attitudes of the figures remain unnatural, however, and the musculature is still exaggerated.

After the death of his first wife, Bloemaert married Gerarda de Roij, the daughter of a local brewer, on 12 October 1600; they had many children, four of whom became artists. Around this time his work manifested a development that had occurred earlier in Haarlem, influenced by Hendrick Goltzius's journey to Italy. The exaggerated poses used by Bartholomäus Spranger began to give way to more relaxed, natural figures who move freely, usually within more naturalistic surroundings, giving the paintings of these years, such as the *Baptism* (1602; Ottawa, N.G.), a more

6. Abraham Bloemart: *Judith Shows the Head of Holofernes to the People*, 1593 (Vienna, Kunsthistorisches Museum)

subdued Mannerism. At the same time he painted his first landscapes with picturesque ruined cottages, in which the religious or mythological figures play a subordinate role, such as the *Parable of the Sower* (1605; print by Jacob Matham after Bloemaert, Hollstein, xi, p. 221) and *Tobias and the Angel* (St Petersburg, Hermitage). Country life was to remain a favourite subject, which he depicted with an increasing naturalism; however, as van Mander recommended, he drew such motifs as peasant cottages, dovecotes and trees from life ('*naer het leven*') and then in his studio composed them into imagined scenes ('*uyt den geest*').

Between 1610 and 1615 the Catholic Church awarded several important commissions to Bloemaert, who was a devout Catholic. In 1612 he painted an *Adoration of the Shepherds* (Paris, Louvre; see col. pl. IV) for the convent of the Poor

Clares in 's Hertogenbosch, where his sister Barbara was a nun, and in 1615 *Christ and the Virgin before God the Father* for the new high altar of the St Janskerk in the same town. In 1611 he was one of the founders of the Utrecht Guild of St Luke.

Bloemaert's career reached a peak in the 1620s; influenced by his pupil Gerrit van Honthorst, who had returned from Italy in 1620, and other Utrecht Caravaggisti, he painted several Caravaggesque pieces *c.* 1623, some of which are notable for their use of candlelight effects, as in the *Supper at Emmaus* (Brussels, Mus. A. Anc.) and the *Adoration of the Shepherds* (Brunswick, Herzog Anton Ulrich-Mus.), and others for the half-length figures, such as *The Flute-player* (Utrecht, Cent. Mus.). He also made large altarpieces for clandestine Catholic churches, including an *Adoration of*

the *Shepherds* (1623; The Hague, St Jacobskerk) and an *Adoration of the Magi* (Utrecht, Cent. Mus.). In 1625 Bloemaert was commissioned by Frederick Henry, Stadholder of the Netherlands, to paint two scenes from the *Story of Theagenes and Chariclea* for Honselersdijk: *Theagenes, Chariclea and the Robbers* (1625; Potsdam, Schloss Sanssouci) and *Theagenes Receiving the Prize from Chariclea* (1626; The Hague, Mauritshuis). Still under the influence of the Utrecht Caravaggisti, he also painted several small pastoral landscapes with peasants and shepherds (e.g. Hannover, Niedersächs. Landesmus.), as well as half-length shepherds and shepherdesses (e.g. Karlsruhe, Staatl. Ksthalle; Toledo, OH, Mus. A.). Bloemaert's large figural works of the 1620s, such as the *Adoration of the Magi* and *Theagenes Receiving the Prize from Chariclea*, are characterized by an extremely rich palette, with colours varying from citron yellow and bright blue to penetrating reds, acidic greens and pinks. This multicoloured mixture enhances the decorative character of the paintings. The pastoral landscapes of the same period, with shepherds and peasants, were painted in lighter pastel tints; these found great favour during the 18th century, notably with François Boucher.

Bloemaert's interest in peasant life was expressed in the 1630s mainly in studies of heads of old men and women (e.g. Stockholm, Nmus.; Dresden, Gemäldegal. Alte Meister). These reveal Bloemaert as a keen observer, though they lack the psychological depth of similar studies by Jan Lievens or Rembrandt. Bloemaert's *Rest on the Flight to Egypt* (1632; Amsterdam, Rijksmus.) is set, most unusually, in a peasant hut. In 1635 Frederick Henry commissioned another painting from Bloemaert for Honselersdijk, this time the *Wedding of Amarillis and Mirtillo* (Berlin, Jagdschloss Grunewald), a scene from Guarini's *Il pastor fido* (Venice, 1590).

Bloemaert's last paintings, executed in the 1640s when he was in his eighties, show his technical skill undiminished; their style is still decorative and their subjects increasingly recall his earlier works, as in *Mercury, Argus and Io* (1645; Vaduz, Samml. Liechtenstein) and *Leto and the*

Peasants (1645; Utrecht, Cent. Mus.). In the background of his *Landscape with a Farmhouse* (1650; Berlin, Gemäldegal.) is a Mannerist scene of Tobias and the Angel.

2. Drawings

Bloemaert was also a talented draughtsman. His enormous output, more than 1500 drawings, covers not only figure drawings, peasant cottages, nature studies and preparatory studies for paintings, but also countless detailed drawings that served as models for prints. According to van Mander he had 'a very nice manner of drawing and handling the pen, and he obtained an unusual effect by adding a few succulent touches of colour'. His drawings are characterized by the great variety of both the techniques he applied and especially the styles he used. The latter is not surprising, as he had a long professional life and probably continued drawing until the last year of his life. His early landscape drawings can be considered as belonging to the best ever made in this genre. On the one hand they still show influence of such predecessors as Pieter Bruegel the elder and Hendrick Goltzius, but on the other they stand out because of a very precise observation of nature. Compositions from his Mannerist period were made into prints by, among others, Jan Saenredam, Jan Muller and Jacques de Gheyn II, and later by his sons Cornelis and Frederick, which greatly facilitated the dissemination of his oeuvre. His drawings were extremely popular and were frequently copied. His *Konstryk tekenboek* ('Artistic drawing book'), a pattern book for young artists, was engraved by Frederick Bloemaert and appeared in numerous editions up to the 19th century.

3. Influence and posthumous reputation

As a teacher, Bloemaert played an important role in the formation of a distinctive Utrecht style of painting. Not only were such Utrecht Caravaggisti as Gerrit van Honthorst, Hendrick ter Brugghen and Jan van Bijlert his pupils, but the Dutch Italianates Cornelis van Poelenburch, Jan Both and Jan Weenix also studied with him, as did Jacob Gerritsz. Cuyp. The great Flemish master Peter

Paul Rubens visited him in 1627. Bloemaert's early style had a significant influence on the work of Joachim Wtewael, but his son Hendrick Bloemaert was the only artist who continued to work in his mature manner. Although Abraham Bloemaert enjoyed high esteem in his own day, his reputation has, for a long time, up to 1993, suffered from the lack of an up-to-date catalogue raisonné of his entire oeuvre.

Bibliography

Hollstein: *Dut. & Flem.*; Thieme–Becker

K. van Mander: *Schilder-boeck* ([1603]–1604), fols 297r–298r

G. Delbanco: *Der Maler Abraham Bloemaert* (diss., U. Strasbourg, 1928)

M. A. Lavin: 'An Attribution to Abraham Bloemaert', *Oud-Holland*, lxxx (1965), pp. 123–5 [rosailles]

M. Röthlisberger: 'Abraham Bloemaert', *Gemälde bedeutender niederländischer Meister des 17. Jahrhunderts* (exh. cat., Vienna, Gal. Friederike Pallamar, 1967), pp. 15–26

Abraham Bloemaert, 1564–1651: Prints and Drawings (exh. cat., New York, Met., 1973)

G. Vikan: 'Notes on Princeton Drawings, 10: Abraham Bloemaert', *Rec. A. Mus., Princeton U.*, xxxiii (1974), pp. 2–17

R. S. Slatkin: 'Abraham Bloemaert and François Boucher: Affinity and Relationship', *Master Drgs*, xiv/3 (1976), pp. 247–60

J. Bolten: *Method and Practice: Dutch and Flemish Drawing Books, 1600–1750* (Landau, 1985)

Nieuw licht op de Gouden Eeuw (exh. cat., ed. A. Blankert and L. J. Slatkes; Utrecht, Cent. Mus.; Brunswick, Herzog Anton Ulrich-Mus., 1986–7), pp. 208–17

R. Ruurs: 'The Date of Abraham Bloemaert's Birth', *Hoogsteder-Naumann Mercury*, 9 (1989), pp. 4–5

J. Bolton: 'Abraham Bloemaert (1564–1651) and his *Tekenboek*', *Delineavit & Sculp.*, 9 (March 1993), pp. 1–10

M. G. Roethlisberger and M. J. Bok: *Abraham Bloemaert and his Sons: Paintings and Prints*, 2 vols (Doornspijk, 1993)

Dawn of the Golden Age: Northern Netherlandish Art, 1580–1620 (exh. cat., ed. G. Luijten and others; Amsterdam, Rijksmus., 1993–4), pp. 300–01 and *passim*

M. G. Roethlisberger: 'Early Abraham Bloemaert', *Tableau*, xvii/3 (1994), pp. 44–51

C. J. A. WANSINK

Bol, Ferdinand

(*b* Dordrecht, *bapt* 24 June 1616; *d* Amsterdam, *bur* 24 July 1680). Dutch painter and draughtsman. He was a pupil and prominent follower of Rembrandt in Amsterdam. His reputation and fame are based on his history paintings, which, though successful at the time, lack originality, and on his portraits, a genre for which he showed more talent.

1. Life and career

His father, a surgeon, belonged to the prosperous middle class. Ferdinand received his initial training as a painter in Dordrecht from Jacob Gerritsz. Cuyp. It is possible that he, like Cuyp, worked for a short time in Utrecht, for his earliest signed work, *Vertumnus and Pomona* (c. 1635; London, Cevat priv. col., see Blankert, 1982, pl. 1), exhibits influences of the Utrecht school. Unlike many of his contemporaries, Bol did not travel to Italy, but left for Amsterdam in 1637, at the age of nearly 20, to study in Rembrandt's workshop. The older painter's influence profoundly affected the whole of his subsequent career. It is not known how long he remained with Rembrandt; however, there is no surviving signed and dated work before 1642. This would suggest that he had set up around this time as an independent painter.

Bol received his first major commission in 1649, a group portrait of the *Four Regents of the Amsterdam Lepers' House* (Amsterdam, Hist. Mus.). His reputation increased quickly, and he subsequently received commissions from outside Amsterdam, for instance for the group portrait of the *Officers of the Doelen in Gouda* (1653; Gouda, Stedel. Mus. Catharina Gasthuis). Although Bol had already lived for some time in Amsterdam, he became a citizen of the city suddenly in 1652, probably in connection with the decoration of Amsterdam's new town hall, for which the only candidates eligible were natives of the city. The following year he married Lysbeth Dell (*d* 1660), whose father, Elbert Dell, occupied a number of public offices, including ones at the Admiralty and the Wine Merchants' Guild. Bol received commissions from these institutions, probably through the intervention of his father-in-law. Bol lived with Lysbeth Dell on the Fluwelenburgwal,

in the prosperous part of the city. Their only child to survive to adulthood, Elbert Bol, was born the following year.

Among Bol's later commissions is a series of portraits of *Admiral Michiel de Ruyter*, painted between 1661 and 1663 on the occasion of the journey to Chatham. In 1669 Bol married Anna van Arckel (*d* 1680), the wealthy widow of the treasurer of the Admiralty. One of the witnesses at the wedding, which was held in the Zuiderkerk, Amsterdam, was Bol's brother-in-law from his first marriage, Elbert Dell the younger. After this marriage Bol moved to the Herengracht and apparently stopped painting; there is no surviving work after 1669.

2. Work

(i) History subjects. Bol was clearly very dependent on Rembrandt in his early paintings and drawings; he copied compositions by his master almost literally, such as the biblical scene that probably depicts *Rachel Being Shown to Jacob* (*c.* 1640; Brunswick, Herzog Anton Ulrich-Mus.), for which Rembrandt's *Danaë* (1636; St Petersburg, Hermitage; see col. pl. XXXI) served as the model. The *Three Marys by the Tomb* (1644; Copenhagen, Stat. Mus. Kst) is one of Bol's earliest dated paintings. Bol's talent was not at its best in this or his other narrative scenes. In general, they are rather statically conceived. Nevertheless, he received many such commissions for history paintings throughout his career, and he adapted his style over the years to conform to prevailing fashions.

After 1650 Bol turned away from Rembrandt's influence and adopted a new style of history painting, one that was more classicizing and elaborate and had recently been employed with great success in the decoration of the Huis ten Bosch near The Hague. The new town hall (now the Koninklijk Palais) in Amsterdam, the construction of which began in 1648, led to more commissions for this style of decorative painting, which suited the majestic character of the classicizing architecture. Bol was commissioned along with Govaert Flinck, another leading Amsterdam history painter, to decorate the burgomaster's office, one of the most important rooms in the new Stadhuis.

Each was asked to design an overmantel that would express the burgomaster's status, prestige and incorruptibility. Opposite Flinck's *Marcus Curtius Dentatus Refusing the Gifts of the Samnites* (1656; *in situ*) hangs Bol's *Pyrrhus and Fabricius* (1656; *in situ*).

The combination of *Pyrrhus* and *Dentatus* in a single room is unique in Netherlandish painting. Plutarch (*Fabricius Luscinus*, 21.20) recorded how the Roman consul Fabricius remained unmoved by the bribery of King Pyrrhus, who even tried to buy him off with the offer of an elephant. In an age when ancient culture was being revived, the burgomasters of Amsterdam were fond of comparing themselves to Roman consuls, whom they saw as prototypes of citizen–administrators of a republic. Bol's first compositional sketches are still fairly Rembrandtesque, and the standing figure at the extreme right of the final composition is derived from a figure in Rembrandt's '*Hundred Guilder Print*' (*c.* 1643–9; B. 74). The large figures and clear colours in this complex composition combine with surface divisions to achieve a spacious effect that was entirely to the taste of the commissioning body. An explicatory poem by Joost van den Vondel (1587–1679) is written on the wall under the two paintings. For another room in the Stadhuis, the aldermen's chamber, where trials were conducted, Bol painted another overmantel, *Moses with the Tablets of the Law* (*c.* 1664; *in situ*).

Bol was commissioned by the Admiralty to portray its guiding principles of reward and punishment in the same manner as he had done in his paintings for the new Stadhuis. For their council chamber he designed two overmantels: *Aeneas Distributing Prizes* (The Hague, Dienst Verspr. Rijkscol., on loan to Utrecht, Rijksuniv.) and *Consul Titus Manlius Torquatus Beheading his Son (Imperia Manliana)* (The Hague, Dienst Verspr. Rijkscol., on loan to Amsterdam, Rijksmus.). In 1661, instead of another group portrait, the regents of the Lepers' House commissioned a painting of a biblical theme to illustrate the regents' care for the sick. Instead of using the traditional comparison of Dives and Lazarus, Bol chose the Old Testament story from 2 Kings 5) of the *Prophet Elisha Refusing the Gifts of Naaman*

the Syrian (Amsterdam, Hist. Mus): the regents could identify with the incorruptible prophet Elisha, and his greedy servant Gehazi provided an example for the institution's attendants of behaviour to avoid.

Bol's *Offering of Gifts at the Building of Solomon's Temple* (1669; Amsterdam, Ned. Hervormde Gemeente), dating from the year of his second marriage, may have been painted to encourage churchgoers to emulate his own generosity: Bol made this large canvas, apparently his last work, a gift to the congregation. The work is not distinguished for its originality and is a variation on an earlier sketch that probably represents the *Incorruptibility of Fabricius* (1656; Amsterdam, Hist. Mus.).

(ii) Portraits. Bol's earliest signed and dated portraits, from 1642–4, include a series of portraits of women, dressed according to the prevailing fashion, with large lace ruffs (e.g. 1642; Berlin, Gemäldegal.). These early portraits are a continuation of the style of Rembrandt but without his ability to convey the individuality of the sitter. For this reason, the attribution to Bol of the vivid portrait of *Elisabeth Bas* (Amsterdam, Rijksmus.) cannot be correct.

Like Rembrandt, Bol painted many *tronies* (character heads) and also imitated Rembrandt's custom of portraying men in a hat or beret. Not until 1649, with his first major commission for a group portrait, did Bol's work become somewhat more independent: the *Four Regents of the Amsterdam Lepers' House* is less in the manner of Rembrandt than in the tradition of earlier painters such as Thomas de Keyser. Although it initially seems to be a completely natural group of people, it is actually a composed tableau. The Regents' duty to care for lepers is underlined by the presence of a little boy with leprosy and an inmate of the institution at the extreme left.

Bol's individual portraits follow prevailing trends, influenced especially by the elegant portraits of van Dyck and other Flemish artists (see fig. 7). By the 1650s Bol's palette included considerably more red, and several portraits from this period, such as the *Portrait of a Young Man* (1652;

7. Ferdinand Bol: *Portrait of a Man*, 1662 (Le Puy-en-Velay, Musée Crozatier)

The Hague, Mauritshuis), were painted against a landscape background. The sitter is painted in the Flemish manner; the background landscape is pure Rembrandt. More of Bol's portraits, however, are set in an interior rather than against a landscape background (see col. pl. v). Most of these show the sitter in three-quarter length, on a chair, with a table just visible and a curtain at the back. Examples include the *Self-portrait* and its pendant portrait of *Elisabeth Dell* (both 1653; Dell Park, Surrey, B. Schroeder priv. col., see Blankert, 1982, pl. 163). The best known of Bol's numerous self-portraits is his last (*c.* 1669; Amsterdam, Rijksmus.), with a frame embossed with sunflowers. It was probably painted on the occasion of his second marriage. The sleeping Cupid and the column are symbols of chastity, and the sunflower is meant to symbolize his honourable love for his second bride. The only one of Bol's many portraits that can be said to have an originality entirely its own is the *Portrait of a Boy* (1652; Castle Howard, N. Yorks). It is without a trace of Rembrandt's influence, and in it Bol showed a surprising talent,

which was never further developed, for still-life in the fruit and glass vessels at the lower right. Bol's later portraits became repetitious, in the same way as his history paintings. He made more portraits of men in berets and returned to Rembrandt's manner. In fact, Bol had little style of his own; he adapted to every new or changing fashion and to the taste of his patrons.

Bibliography

A. Blankert: *Kunst als regeringszaak in Amsterdam in de zeventiende eeuw: Rondom schilderijen van Ferdinand Bol* (Lochem, 1975)

W. Sumowski: *Drawings of the Rembrandt School*, i (New York, 1979)

E. de Jongh: 'Bol vincit amorem', *Simiolus*, xii (1981–2), pp. 147–62

A. Blankert: *Ferdinand Bol (1616–1680): Rembrandt's Pupil* (Doornspijk, 1982)

W. Sumowski: *Gemälde der Rembrandt-Schüler*, i (Landau, 1983)

B. Haak: *The Golden Age: Dutch Painters of the Seventeenth Century* (New York, 1984)

MARIJKE VAN DER MEIJ-TOLSMA

Bor, Paulus

(*b* Amersfoort, *c.* 1601; *d* Amersfoort, 10 Aug 1669). Dutch painter. He came from a prominent and wealthy Catholic family. In 1577 his grandfather Bor Jansz. was a member of the Treffelicxte, a group of the most exceptional citizens of Amersfoort. His father, also named Paulus Bor, was a textile merchant. Bor's style of painting shares elements with both the nearby Utrecht Caravaggisti and the so-called Haarlem classicists. The Haarlem architect and painter Jacob van Campen inherited a family estate in Amersfoort and was later in close contact with Bor, and some of his classicist works have been confused with those of Bor.

Bor's absorption of the influences of Caravaggio no doubt dates from when he studied in Italy. In 1623 he was recorded as living in a house in the Roman parish of S Andrea delle Fratte along with three other Netherlandish painters: Jan Hermans (*fl* 1623–59), possibly Willem Thins

(Guglielmo Tens) and a certain Stefano Aipxi. In the same year Bor was one of the founder-members of the Schildersbent, the association of Netherlandish artists in Rome, which gave him the Bent-name 'Orlando'. His portrait appears under this name in a well-known drawing *Bacchus with Drinking Members of the Schildersbent* (*c.* 1625; Rotterdam, Boymans–van Beuningen). In Rome, Bor apparently followed the peripatetic life of most young foreign painters. In 1624 he was recorded as living on the Piazza di Spagna in the same house as Michelangelo Cerquozzi, Hermans and Thins. The same group of artists was documented as living in a house in the Strada dell'Olmo in 1625.

About 1626 Bor returned to Amersfoort, where he joined the Brotherhood of St Luke, the city artists' guild, in 1630. His earliest definite work is a group portrait of the *Van Vanevelt Family Saying Grace* (1628), which was bequeathed by a member of the family to the St Pieter-en-Bloklands Gasthuis, Amersfoort, which still owns it. The next certain dated work is the signed *Vanitas Still-life* (1630; New York, art market, 1988). That Bor also had connections with Utrecht seems confirmed by his gift in 1631 of a bust-length painting of a 'devout woman' (untraced) to the St Jobsgasthuis in that city. The lost work must have resembled his somewhat unusual half-length portraits of women, for example *Female Allegorical Figure* (Rouen, Mus. B.-A.; see fig. 8) and *Mary Magdalene* (Liverpool, Walker A.G.), both dated by Jansen (see 1987 exh. cat.) to the early 1630s. In his starkly lit *Christ among the Doctors* (1635–6; Utrecht, Cent. Mus.), with its eccentric physiognomies, proportions and scale, Christ appears much too small. This work and paintings from the 1640s, with their dramatic chiaroscuro, suggest some possible contact with Rembrandt and his school in Amsterdam, which apparently tempered aspects of Bor's earlier style, derived from Haarlem and Utrecht sources.

In 1632 Bor married Aleijda van Crachtwijck, who also came from a prominent Amersfoort family. Despite her huge dowry and their combined wealth, Bor continued to work as a painter. In 1638, under the general supervision of van

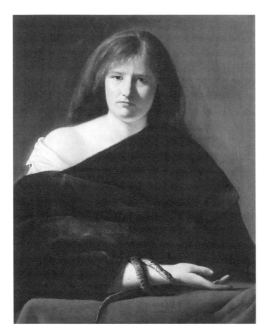

8. Paulus Bor: *Female Allegorical Figure* (Rouen, Musée des Beaux-Arts)

Bibliography

W. Croockewit: 'Paulus Bor', *Verslag van de werkzaamheden der vereeniging 'Flehite'* [Account of the activities of the 'Flehite' association] (1903), pp. 40, 74–7 [first study of Bor, who is neglected in early sources]

E. Plietzsch: 'Paulus Bor', *Jb. Preuss. Kstsamml.*, xxxvii (1916), pp. 105–15

G. J. Hoogewerff: *De Bentvueghels* (The Hague, 1952)

M. R. Waddingham: 'Notes on a Caravaggesque Theme', *A. Ant. & Mod.*, iv (1961), pp. 313–18

S. J. Gudlaugsson: 'Paulus Bor als portrettist', *Miscellanea I.Q. van Regteren Altena* (Amsterdam, 1969), pp. 120–22

D. P. Snoep: 'Honselaarsdijk: Restauraties op papier' [Honselaarsdijk: restorations on paper], *Oud-Holland*, lxxxiv (1969), pp. 270–94

J. W. von Moltke: 'Die Gemälde des Paulus Bor von Amersfoort', *Westfalen: Hft. Gesch., Kst & Vlksknd.*, lv (1977), pp. 147–61

B. Nicolson: *The International Caravaggesque Movement* (Oxford, 1979); review by L. J. Slatkes in *Simiolus*, xii (1981–2), pp. 167–83

Holländische Malerei im neuem Licht: Hendrick ter Brugghen und seine Zeitgenossen (exh. cat., ed. A. Blankert and L. J. Slatkes; Utrecht, Cent. Mus.; Brunswick, Herzog Anton Ulrich-Mus.; 1987), pp. 226–31 [entries on Bor by G. Jansen]

LEONARD J. SLATKES

Campen, he painted decorations at Honselaarsdijk (destr.), one of the restored hunting palaces of Prince Frederick Henry of Orange-Nassau, for which a design for a ceiling showing musicians and other figures, attributed to Bor, survives in the Rijksprentenkabinet, Amsterdam. Unlike his collaborators on this project, Gerrit van Honthorst, Caesar van Everdingen and Christiaen van Couwenberg (1604–67), Bor did not contribute to the decoration of another important palace, the Huis ten Bosch, near The Hague. Nevertheless, he did remain in close contact with van Campen, with whom he apparently collaborated on individual paintings, until the latter's death; six paintings by Bor were listed in the 1657 death inventory of van Campen's estate. In 1656 Bor was elected one of the regents of the Amersfoort religious foundation for the poor, De Armen de Poth, to which he donated a still-life painting *Bread and Butter and other Objects*; it is still owned by the foundation.

Borch, ter [Terborch]

Dutch family of painters and draughtsmen. They came from Zwolle, capital of the province of Overijssel. In the 17th century Zwolle enjoyed only modest prosperity, but the ter Borchs, long influential in the professional and administrative life of the city, were comparatively well off. The head of the family, (1) Gerard ter Borch (i), fathered thirteen children by three wives. He gave up his career as an artist to assume the position of Master of Customs and Licences. Throughout his life he actively encouraged the artistic gifts of his children, providing a stimulating home environment and practical instruction for the more talented among them. The eldest and most gifted son, (2) Gerard ter Borch (ii), became one of the foremost Dutch genre and portrait painters. Anna ter Borch (*bapt* 27 Oct 1622; *d* 11/12 Nov 1679), the eldest surviving daughter, became interested in

calligraphy as a child. The family preserved one writing book of hers containing quotations from well-known mythological and Christian texts. Another daughter, Gesina ter Borch (*b* 15 Nov 1631; *d* April 1690), though an amateur, actively engaged in calligraphy, drawing and watercolour from the 1640s to the 1670s. She entered many of her water-colours into albums, one of which, an anthology of favourite poems ranging from pastoral to drinking songs, she illustrated in a colourful minia-turist style. Another album became a scrapbook of family art and memorabilia. Gesina assumed the curatorship of the family collection of graphic art—numbering *c.* 700 sheets and 5 albums—which remained intact with descendants of the family until 1887, when it was auctioned and the major-ity purchased by the Rijksmuseum, Amsterdam. Residing unmarried in the family home in Zwolle her whole life, she served frequently as Gerard (ii)'s model. Harmen ter Borch (*bapt* 11 Nov 1638; *d* before Oct 1677), though a prolific draughtsman in his youth, enjoyed only modest talent and chose to succeed his father as Licence Master in 1661. Jenneken ter Borch (*bapt* 3 Sept 1640; *d* 13 or 23 Aug 1675) left no artistic works, but her marriage to Amsterdam merchant Sijbrand Schellinger brought the family important contacts in the capital. The last-born, (3) Moses ter Borch, early exhibited a fine artistic sensibility, especially as a portraitist.

Bibliography

A. Bredius: 'Die Ter Borch Sammlung', *Z. Bild. Kst*, xviii (1883), pp. 370–73 [report of the rediscovery of the ter Borch family estate in Zwolle]

J. J. van Doorninck: 'Het schildersgeslacht ter Borch', *Versl. & Meded. Ver. Beoefening Overijsselsch Regt & Gesch.*, xiii (1883), pp. 1–22

E. W. Moes: 'Gerard ter Borch en zijne familie', *Oud-Holland*, iv (1886), pp. 145–65

E. Michel: *Gérard Terburg et sa famille* (Paris and London, 1887)

A. Rosenberg: *Terborch und Jan Steen* (Bielefeld and Leipzig, 1897)

M. E. Houck: 'Mededelingen betreffende Gerard ter Borch en anderen, benevens aantekeningen omtrent hunne familieleden', *Versl. & Meded. Ver. Beoefening Overijsselsch Regt & Gesch.*, xx (1899), pp. 1–172

J. Verbeek: 'Tekeningen van de familie ter Borch', *Antiek*, i (1966), pp. 34–9

A. McNeil Kettering: *Drawings from the ter Borch Studio Estate in the Rijksmuseum* (The Hague, 1988)

For further bibliography *see* (2) below.

(1) Gerard [Gerhard] ter Borch (i)

(*b* Zwolle, 1582–3; *d* Zwolle, 20 April 1662). He was trained in Zwolle, perhaps by Arent van Bolten (*fl* Zwolle, *c.* 1580–1600). At the age of 18 he went to southern Europe, staying until *c.* 1612; he spent seven years in Italy, mostly in Rome, but also in Naples. In Rome he lived in the Palazzo Colonna, from the gardens of which he drew the *Temple of the Sun* (1610; Rotterdam, Boymans–van Beuningen), an ancient ruin. Most of his drawings (often dated between 1607 and 1610) were con-tained in a sketchbook, which he brought back to Zwolle and dismantled (Amsterdam, Rijksmus.). Executed with fine parallel pen hatching with a lively sense of accent and contour, these sheets follow the tradition of 16th-century Roman topo-graphical drawing established by Maarten van Heemskerck, Paul Bril and others. Like his fore-runners, Gerard recorded ancient buildings and ruins, sometimes with archaeological exactitude, sometimes with a more picturesque intent (e.g. *View of the Pincio, Rome*, 1609; Amsterdam, Rijksmus.). His most innovative drawings in terms of subject-matter depict scenes of everyday life and the landscape of the surrounding Roman Campagna. He also made intimate studies of the grounds of the Villa Madama outside Rome, to which he added watercolour washes for atmos-pheric effects. All the Roman drawings, even those executed solely in pen and ink, are characterized by subtlety of light and shadow. He also visited Naples, which he recorded in a view dated 1610. He had plans for a trip in 1611 from Naples to Spain in the company of the Spanish Viceroy, but he literally missed his boat (in the process losing a number of paintings on board). Several of his drawings indicate that while travelling en route to and from Italy he stayed in Nîmes and Bordeaux (possibly on his way south) and Venice (probably returning north).

By mid-1612 he was back in Zwolle, where on 28 March 1613 he married Anna Bufkens, who gave birth to (2) Gerard ter Borch (ii) four years later. Dated drawings from this period have survived in some numbers: they represent Old and New Testament subjects, devotional pieces and Ovidian love stories, all subjects associated with Amsterdam and Utrecht history painting (most now in Amsterdam, Rijksmus.). He abandoned the fine draughtsmanship of his Italian work for experimentation in some sheets with a relatively expressive linear vocabulary and in others with a tighter manner characterized by firm contours, emphatic wash modelling and increasing abstraction. By the late 1610s his style began to harden and become mannered. His one painting to survive, *Abraham's Sacrifice of Isaac* (1618; Zwolle, Prov. Overijssels Mus.), shows a connection with Utrecht Mannerism. He may have made other paintings, but Gerard certainly limited his artistic activity after 1621, by which time he had succeeded his father, Harmen, in the position of Licence Master.

Despite his professional responsibilities, Gerard found time in the 1620s for some artistic activity. Most of his creative energy seems to have been devoted to supervising his first-born's efforts at drawing, but he also produced a number of colourful, witty and lively drawings which were entered into a hand-written amatory songbook (now in the Atlas van Stolk, Rotterdam, Hist. Mus.), to which Roeland van Laer (*d* Genoa 1635) and Pieter van Laer later contributed watercolour drawings. Perhaps responding to his own pedagogical theory, he returned to drawing from life in the 1630s in a handful of renderings of children and the local landscape, but generally he seems to have practised his art vicariously through his talented offspring.

Bibliography

A. Bertolotti: *Artisti belgi ed olandesi a Roma nei secoli XVI e XVII* (Florence, 1880)

H. Egger: *Romische Veduten: Handzeichnungen aus dem XV–XVIII Jahrhundert* (Vienna, 1911)

J. M. Blok: 'Romeinsche teekeningen door G. Terborch, sr. en W. van Nieulandt II in 's Rijksprentenkabinet te Amsterdam', *Meded. Ned. Hist. Inst. Rome*, v (1925), pp. 128–9

J. Q. van Regteren Altena: *Vereeuwigde stad, Rome door Nederlanders getekend* [The eternal city of Rome drawn by Dutchmen] (Wormerveer, 1964)

D. P. Snoep: 'Een 17de eeuws liedboek met tekeningen van Gerard Ter Borch de Oude en Pieter en Roeland van Laer' [A 17th-century songbook with drawings by Gerard ter Borch the elder and Pieter and Roeland van Laer], *Simiolus*, iii (1968/69), pp. 77–134

J. Richard Judson: 'Jacob Isaacz. van Swanenburgh and the Phlegraean Fields', *Essays in Northern European Art Presented to Egbert Haverkamp Begemann* (Doornspijk, 1983), pp. 119–22

For further bibliography *see* (2) below.

(2) Gerard [Gerhard; Geraerdt; Geraert] ter Borch (ii)

(*b* Zwolle, Dec 1617; *d* Deventer, 8 Dec 1681). Son of (1) Gerard ter Borch (i).

1. Life and work

(i) **Early training, 1625–35.** A precocious child, he responded quickly to his father's instruction. The first of his preserved drawings, *A Horseman Seen from Behind* (Amsterdam, Rijksmus., A 782), was executed before his eighth birthday, as his father proudly recorded on the sheet: *Anno 1625. den.25.September. G. T. Borch de Jonge inventur.* The second, a depiction of an officer (Amsterdam, Rijksmus., A 783), bears the inscription *nae[r] het leven* ('after life') and the date 24 April 1626. These two sheets illustrate the father's practice of annotating the youthful drawings of his children and retaining them for the family estate. Only one early history subject by Gerard survives: *Judith and Holofernes* (Amsterdam, Rijksmus., A 796). His father encouraged him to make exacting copies (all Amsterdam, Rijksmus.) of prints by Hendrick Goltzius, Pieter Quast and Jacques Callot, and even of sculpture casts, such as the Farnese *Hercules*. But most of Gerard (ii)'s drawings depict scenes of everyday life.

In 1632 Gerard went to Amsterdam, presumably for an apprenticeship. He seems to have gone to Haarlem in 1633, then again in 1634 for an extended stay as apprentice to the landscape artist Pieter Molijn. The sketchbook Gerard kept from 1631 to 1634 (Amsterdam, Rijksmus., 1888: A 1797) charts his progress as he loosened the linear vocabulary he had inherited from his father, then

added wash and finally abandoned pen altogether for chalk, in order to render the atmospheric effects of the Haarlem landscape. Separate sheets of 1633 and 1634 show Gerard expanding his subject-matter to include scenes of skaters, soldiers and markets, many perhaps made for sale, as few remained in the family estate. The *Market Scene* (Amsterdam, Rijksmus., A 825), for example, is distinguished by the subtle spatial relationships of just a few compact motifs, which, strengthened by accents in ink, stand out against the receding street sketched lightly in chalk. The association with Molijn proved strong, continuing into the 1640s when the two collaborated on a few landscape paintings. The first of Gerard's extant independent paintings, probably dating from *c.* 1634, is *Rear View of a Rider* (V. de Steurs priv. col., see Gudlaugsson, 1959–60, cat. no. 1), in which the figure seen from the back not only recalls his very first drawing but establishes a leitmotif of his painted oeuvre. His earliest dated painting, the *Consultation* (Berlin, Gemäldegal.) of 1635, was probably Gerard's entrance piece for the Haarlem Guild of St Luke which he joined that year.

(ii) **Travel and residence abroad, 1635–48.** Later in 1635 Gerard began a series of journeys lasting a decade and a half. First he went to London, where by the summer of 1635 he joined the studio of his uncle, the engraver Robert van Voerst (1597–1636), who was closely associated with Anthony van Dyck and presumably acquainted with other Netherlandish portrait painters in England such as Daniel Molyn and Cornelis Jonson van Ceulen I. Gerard's father sent a trunk to him in London full of painting supplies, clothes, a mannequin and a letter urging his son to continue drawing, especially lively figural compositions, and if he painted to produce the 'modern kind of figure group' that he had learnt in Pieter Molijn's studio. All that remains from Gerard's time in England is one drawing, a portrait of *Robert van Voerst* (Amsterdam, Rijksmus.), which was undoubtedly influenced by the linear style of van Dyck, but is miniaturist in its description of features and characterized by warmth and personal involvement with the sitter.

Documentary evidence indicates that Gerard was back home by April 1636 (either before or after his uncle's death that year), but about 1637 he departed for southern Europe, where he stayed until about 1639, travelling to Italy and probably to Spain. At the Spanish court he may have been commissioned to paint a portrait of *Philip IV* (Amsterdam, priv. col., see Gudlaugsson, 1959–60, cat. no. 9; ?copy after lost original). During the early 1640s Gerard resided in Holland, probably in Amsterdam, with visits to Haarlem, interrupted by stays in the southern Netherlands and France. He concentrated on portraits and genre paintings. The portraits were either bust-length miniatures, such as the portrait of *Jan Six* (Amsterdam, Col. Six), or small full-length portraits of figures set in a barely defined, neutral space, a type he continued for the rest of his career. The genre pieces were guardroom scenes in the manner of the Amsterdam painters Pieter Codde and Willem Duyster, but characterized by a new subtlety of light and naturalism. The most impressive of these is *Soldiers Playing Trictrac* (Bremen, Ksthalle), in which the main figures are viewed from the back and side.

By late 1645 Gerard had moved to Münster to join the entourage of Adriaen Pauw, representative of the States of Holland to the peace negotiations between the Dutch Republic and Spain to end the Eighty Years War. Almost immediately he painted the *Entrance of Adriaen Pauw in Münster* (Münster, Westfäl. Landesmus.). He remained there throughout the signing of the Peace of Münster in May 1648, a ceremony he recorded in a fine, unusually small group portrait of over 70 delegates and their retainers (London, N.G.). By that time Gerard belonged to the household of the Spanish envoy, the Conde de Peñeranda, whose portrait he painted (Rotterdam, Boymans–van Beuningen). Despite Houbraken's assertion that Gerard journeyed to Spain immediately afterwards with Peñeranda, the count did not return to Madrid until 1650 and Gerard's trip probably took place a decade earlier.

(iii) **Genre painting, 1648–mid-1660s.** In the following years Gerard seems again to have spent some time

in the southern Netherlands, but his normal place of residence was probably Amsterdam. Documents place him there in November 1648 but also indicate stays in The Hague (1649), perhaps Kampen (December 1650) and Delft (22 April 1653), where he signed a document with Johannes Vermeer. He must also have visited Zwolle frequently between 1648 and 1654, for he painted a portrait of the schoolmaster *Joost Roldanus* (1648; untraced), and in the same year his stepsister Gesina's art began to show his influence. On 14 February 1654 he married his stepmother's sister, Geertruyt Matthys, and settled permanently in Deventer in the province of Overijssel. A year later he became a citizen of Deventer and in 1666 was appointed common councillor (*gemeensman*), in which capacity he served for life. But he maintained close contact with his native Zwolle. Gesina had started appearing in his paintings c. 1648 and in the following years other members of the family served as his models.

With his return to Overijssel, Gerard matured as a genre painter. From the late 1640s he created small upright panels usually featuring several half- or three-quarter figures, selectively lit against dark backgrounds. The figures talk, drink, make music, attend to their ablutions or lose themselves in thought. Among the most successful of these pictures are the close-up depictions of women involved in domestic activities, such as *Woman Spinning* (c. 1652–3; priv. col. S. W. van der Vorm, on loan to Rotterdam, Mus. Boymans–van Beuningen) or *The Apple Peeler* (1661; Vienna, Ksthist.; see fig. 9). Gerard's pictures draw their special strength from an intimate knowledge of middle-class virtues, rituals and concerns, as well as from his response to the expressive ordinariness of his own family's features. He may have used his stepmother as the model for the woman in these paintings and his stepbrother Moses for the child, but his stepsister Gesina was his favourite model. His genuine affection for her is evident in the sketches he made in the late 1640s and early 1650s (Amsterdam, Rijksmus.). In his paintings she usually assumed the guise expected of her class and situation, the most notable exceptions being the *Two Shepherdesses*

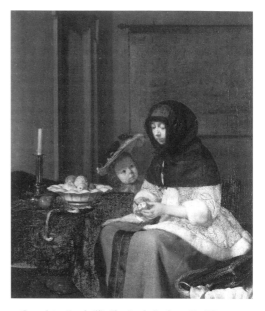

9. Gerard ter Borch (ii): *The Apple Peeler*, 1661 (Vienna, Kunsthistorisches Museum)

(c. 1652–4; ex-London, Lady Baillie priv. col., see Gudlaugsson, 1959–60, cat. no. 85) and its variant, *A Shepherdess*, in Anholt (Fürst Salm-Salm, Mus. Wasserburg–Anholt). The pastoral subject of these paintings relates to Gesina's own literary and artistic interests.

The most innovative of Gerard's pictures of c. 1650 is the *Woman at her Toilet* (New York, Met.), representing the full-length forms of a stylish lady and her maid. The panel is often considered the earliest example of a new type of genre painting that was to become fashionable in the third quarter of the century, the high-life interior. Gerard's development of this type can be seen in his masterpiece of c. 1654, the *'Parental Admonition'* (Amsterdam, Rijksmus.; later version in Berlin, Gemäldegal.; see col. pl. VI), with its well-to-do bourgeoisie in costly garments participating in a delicate and pschychologically nuanced exchange. Jean-Georges Wille's 18th-century engraving of the painting is responsible for the title, which was later adopted by, among others, Goethe for an episode in

Wahlverwandtschaften. Later, in the 20th century, the characters were identified not as a daughter and parents, but as a courtesan, a procuress and a gentleman client enacting the old theme of bought love. Towards the end of the 20th century the work was reinterpreted as a Petrarchan courtship ritual that conveys the prevailing ideals of 17th century middle-class social and sexual behaviour.

Throughout the 1650s and into the early 1660s Gerard developed the high life interior further, in paintings nearly as problematic to interpret as the '*Parental Admonition*' and no less formally rich and psychologically acute. Increasingly he chose subjects that allowed him to depict quiet figures caught in contemplative states of mind. His often solitary figures of women are shown writing letters (The Hague, Mauritshuis and London, Wallace), sealing envelopes (ex-Scarsdale, D. Bingham priv. col, see Gudlaugsson 1959–60, cat. no. 144), accepting letters delivered by messengers (Munich, Alte Pin. and Lyon, Mus. B.-A.) or contemplating the letter's content (Frankfurt am Main, Städel. Kstinst.). When the letter-writers are men they are always officers, waited on by trumpeters, and some clue is usually provided about the letter's amorous content (London, N.G. and Philadelphia, PA, Mus. A.). In the latter two paintings, the colourfully dressed trumpeters function as love objects themselves.

The letter-writing theme reached its culmination in two paintings of *c.* 1660. The first, '*Curiosity*' (New York, Met.), depicts a woman craning to read a letter penned by her seated companion. Competing with this anecdotal action is a third figure, clad in a shimmering low-cut satin gown, who stands prominently at the side absorbed in her own thoughts. In the second, even more masterful canvas (London, Buckingham Pal., Royal Col.) a similarly clad woman (modelled by Gesina) commands the viewer's attention by holding the letter and reading aloud from it to a woman and a boy. The figures are set in an exquisitely, though sparsely, appointed interior and are illuminated by sparkling light from a hidden source, which focuses on their subtly differentiated responses to the letter. This and other paint-

ings of the early 1660s are distinguished from the works of the previous decade by elegant interiors, splendid fashions and the attractiveness of the figures. The change may indicate an increasingly affluent buying public, yet Gerard consistently maintains an economic formal vocabulary and an unusually delicate sense of narrative action. For example, in the *Interior with Musical Company* (*c.* 1662; Polesden Lacey, Surrey, NT), in which the relationship between lady and gentleman remains deliberately ambiguous and the action unresolved: the gentleman has been interpreted as the lady's client, her dance partner and as a suitor greeting her with elaborate, ritualized courtesy. While Gerard was producing such pictures, Gesina, the model for this and so many of the other ladies in satin, was collecting and illustrating Petrarchan love poetry. The attitudes and images in the poetry may well have provided the pictures' original frame of reference. At least one extant drawing by Gerard from the Deventer period (Amsterdam, Rijksmus., GJr 86) suggests his thorough familiarity with Petrarchan imagery.

(iv) Portraiture, 1660s and 1670s. Gerard produced relatively few genre paintings after the mid-1660s, concentrating instead on portraiture for the bourgeoisie of the increasingly prosperous eastern provinces. Compared with those by artists from the western province of Holland, Gerard's portraits focused less on his sitters' status and more on their individuality, honesty and sobriety, qualities associated with an older generation of artists and patrons. Nevertheless he sometimes relaxed this austere style to suit sitters with a taste for rich clothing, as in the *Portrait of a Man* (*c.* 1664; London, N.G.; see fig. 10); the sitter, despite his exaggerated fashions, is still portrayed with straightforwardness. Gerard's only group portrait from his later years is the *Magistrates of Deventer* (1667; Deventer, Stadhuis). The artist's own appearance at this time can be seen in his *Self-portrait* (*c.* 1668; The Hague, Mauritshuis), which expresses a characteristic mixture of worldliness and reserve.

At the end of the 1660s and beginning of the 1670s, after a decade and a half of activity confined primarily to Deventer, Gerard began to

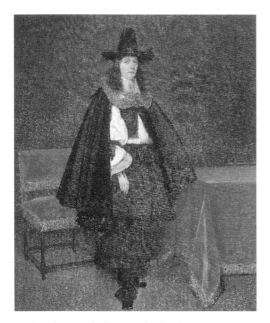

10. Gerard ter Borch (ii): *Portrait of a Man, c.* 1664 (London, National Gallery)

for his collection of painters' self-portraits (autograph copy of lost original, Berlin, Staatl. Museen N.G.). Until the end of his life Gerard continued to execute portraits, most notably that of *King William III and Mary Stuart* (untraced), which confirm the esteem he enjoyed, despite his continued use of a more reserved portrait style.

2. Critical reception and posthumous reputation

Gerard's genre paintings, more than his portraits, exercised a considerable influence on such contemporaries as Gabriel Metsu, Pieter de Hooch, Frans van Mieris (i), Eglon van der Neer and even Johannes Vermeer. His works were valued for their technique, striking figural motifs and the elegant lifestyle they idealized. His reputation was furthered by the many copies produced by his pupils, the most distinguished being Caspar Netscher who worked with him in Deventer *c.* 1654 and 1658–9. But because ter Borch resisted the trend in the later 17th century towards exaggeratedly virtuoso surfaces, crowded, restless compositions and complicated light effects, his influence was limited. Yet few 17th-century Dutch artists focused so compellingly and subtly on their figures as individuals, and fewer still placed them in narratives that so successfully combined the substance of psychological insight with the forms of elegant decorum.

spend more time in Amsterdam. This may have resulted from his wife Geertruyt's death (between 1668 and 1672) or from contact with his brother-in-law Sijbrand Schellinger, an Amsterdam merchant who had married his half-sister Jenneken in 1668. Around 1670 Gerard executed five portraits for Schellinger's relatives, the well-to-do Pancras family from Amsterdam's regent class. Perhaps the most influential of Gerard's patrons were members of the wealthy de Graeff family whom he painted in 1673–4. Their support may have been particularly welcome at this time, for Gerard had apparently fled Deventer in late spring 1672 on the eve of the invasion and subsequent two-year occupation by troops of the Archbishop of Cologne and Bishop of Münster, allies of Louis XIV. He left behind a portrait of the Dutch Stadholder Willem III, Prince of Orange Nassau (later King William III of England), who had visited Deventer in May 1672. Gerard stayed in Amsterdam, returning to Deventer only in the summer of 1674. Two years later Cosimo III de' Medici, Grand Duke of Tuscany, commissioned a self-portrait of ter Borch

Bibliography

A. Houbraken: *De groote schouburgh* (1718–21)

J. C. Weyerman: *De levens beschryvingen der Nederlandsche kunstschilders en kunstschilderessen*, ii (The Hague, 1729–69)

J. Smith: *A Catalogue Raisonné of the Works of the Most Eminent Dutch, Flemish and French Painters*, iv (London, 1833)

W. Bode: 'Der künstlerische Entwicklungsgang des Gerard Ter Borch', *Jb. Preuss. Kstsamml.*, ii (1881), pp. 144–5

C. Hofstede de Groot: *Holländischen Maler* (1907–28)

H. Leporini, ed.: *Handzeichnungen grosser Meister: Terborch* (Vienna, 1925)

J. G. van Gelder: 'Hollandsche etsrecepten voor 1645', *Oud-Holland*, lvi (1939), pp. 113–14

F. Hannema: *Gerard Terborch* (Amsterdam, [1943])

E. Plietzsch: *Gerard Ter Borch* (Vienna, 1944)

S. J. Gudlaugsson: 'Adriaen Pauw's intocht te Münster, een gemeenschappelijk werk van Gerard ter Borch en Gerard van der Horst', *Oud-Holland*, lviii (1948), pp. 39–46

——: 'De datering van de schilderijen van Gerard ter Borch', *Ned. Ksthist. Jb.* (1949), pp. 235–6

A. J. Moes-Veth: 'Mozes Ter Borch als sujet van zijn broer Gerard', *Bull. Rijkmus.*, iii (1955), pp. 36–7

——: 'Mozes of Gerard Ter Borch?', *Bull. Rijksmus.*, vi (1958), pp. 17–18

S. J. Gudlaugsson: *Gerard Ter Borch*, 2 vols (The Hague, 1959–60) [the principal monograph]

P. Pieper: 'Gerard Terborch in Münster', *Schöne Münster*, xxvi (1961), pp. 1–32

E. Haverkamp-Begemann, 'Terborch's *Lady at her Toilet*', *ARTnews* (Dec 1965), pp. 38–9

J. Q. van Regteren Altena: 'The Anonymous Spanish Sitters of Gerard Ter Borch', *Master Drgs*, x (1972), pp. 260–62

Gerard Ter Borch (exh. cat., ed. H. R. Hoetink and P. Pieper; Amsterdam, Rijksmus.; Münster, Westfäl. Landesmus.; 1974)

J. M. Montias: 'New Documents on Vermeer and his Family', *Oud-Holland*, xci (1977), pp. 267–87

S. A. C. Dudok van Heel: 'In Presentie van de Heer Gerard ter Borgh', *Essays in Northern European Art Presented to Egbert Haverkamp Begemann* (Doornspijk, 1983), pp. 66–71

A. McNeil Kettering: *The Dutch Arcadia: Pastoral Art and its Audience in the Golden Age* (Montclair, NJ, and Woodbridge, GB, 1983)

——: 'Ter Borch's Studio Estate', *Apollo*, cxvii (June 1983), pp. 443–51

Masters of Seventeenth-century Dutch Genre Painting (exh. cat., ed. P. Sutton; Philadelphia, PA, Mus. A.; Berlin, Gemäldegal.; London, RA; 1984)

A. McNeil Kettering: 'Ter Borch's Ladies in Satin', *A. Hist.*, xvi (1993), pp. 95–124

——: 'Ter Borch's Military Men: Masculinity Transformed', *Dutch Culture: Proceedings of the Symposium Sponsored by the Center for Renaissance and Baroque Studies, University of Maryland: College Park, 1993*

(3) Moses [Mosus; Mozes] ter Borch

(*bapt* Zwolle, 19 Jun 1645; *d* Harwich, 12 July 1667). Son of (1) Gerard ter Borch (i). He showed a precociousness in art rivalling that of his eldest stepbrother, (2) Gerard (ii). By the age of seven he was drawing scenes from everyday life (e.g. Amsterdam, Rijksmus., A 1111), and he proved more responsive than his brothers to his father's traditional method of training by copying the work of earlier artists. Between 1659 and 1661 he made copies of sculptural casts, of his father's drawings and of prints by such artists as Jan Saenredam, Annibale Carracci, Albrecht Dürer, Adam Elsheimer and Rembrandt. Moses rarely made exact copies of the originals; instead he concentrated on composition and anatomy in his copies of Italian and German prints and on characterization of emotion and chiaroscuro effects in those after Rembrandt's etchings.

Moses's artistry and insight can be seen in his chalk portrait head studies of members of his family, dated 1660–61. He also executed many self-portraits. The quality of one of these (Amsterdam, Rijksmus., A 1047), an introspective rendering in smudged and stippled chalks, is so high that it was mistakenly attributed to Gerard (ii). Moses also experimented with oil painting in three portraits (Amsterdam, Rijksmus.), but his feeling for sculptural volumes, chiaroscuro and introspective facial expressions is seen at its best in the late series of sensitive chalk studies portraying single figures in military clothes (e.g. Berlin, Kupferstichkab.). These works originally came from a single sketchbook but were later sold or given away separately, presumably by Moses himself. They are thought to have been drawn in the mid-1660s, around the time Moses joined the Dutch fleet (by at least 1666). He was killed during one of the final engagements of the second Anglo-Dutch War.

Bibliography

Dutch Figure Drawings from the Seventeenth Century (exh. cat. by P. Schatborn, Amsterdam, Rijksmus.; Washington, DC, N.G.A.; 1981–2), pp. 86–7, 131–2, cat. nos 22–3

For further bibliography *see* (2) above.

ALISON MCNEIL KETTERING

Borssom [Boresom; Borssum], Anthonie van

(*b* Amsterdam, *bapt* 2 Jan 1631; *d* Amsterdam, *bur* 19 March 1677). Dutch painter and draughtsman. There are no surviving documents to support the

common assumption that he was a pupil of Rembrandt, although some of his drawings show the influence of Rembrandt's landscape etchings of the 1640s (Bartsch: *Catalogue raisonné*, 1880, nos 222–8, 232). These compositions always followed a particular formula: water in the foreground, a farm, windmill or ramshackle barn among trees in the middle ground and, to one side, a distant view of buildings below a low skyline. Various landscapes with windmills bearing the signature *AVBorssom* have these characteristics (Amsterdam, Rijksmus.; Dresden, Kupferstichkab.; Frankfurt am Main, Städel. Kstinst.). Van Borssom's practice of applying pale watercolour washes to his drawings made them popular with collectors and imitators, especially in the 18th century. Although these drawings sometimes represent recognizable buildings, they are not intended to be topographical, unlike his drawings of churches, castles and city gates, which he must have made during a trip through Utrecht, Gelderland and the Lower Rhine area, including views of Naarden, Maartensdijk, Soest, Oosterbeek, Hoog-Elten and Cleves.

Van Borssom was far less productive as a painter. His paintings (mainly landscapes) are rather eclectic and have no personal, clearly recognizable character. They show no sign of Rembrandt's influence. Only five paintings are dated, making it difficult to establish a chronology or stylistic development. They include *Interior of a Church* (165(?)—the last number is illegible; The Hague, Rijksdienst Beeld. Kst; Sumowski, 1983, no. 210), which is painted in the manner of Gerrit Houckgeest and Hendrik van Vliet, and his earliest known dated work, a *Village Road* (1655; Hamburg, Ksthalle), which shows the influence of the early work of Jacob van Ruisdael. A *Panoramic Landscape with a View of the Schenkenschans and Hoog-Elten* (Düsseldorf, Kstsamml. Nordrhein-Westfalen) is dated 1666. This and a comparable undated panoramic landscape (Philadelphia, PA, Mus. A.), are reminiscent of the work of Philips Koninck, but the staffage of cattle is inspired by Paulus Potter, as are at least five painted cattle pieces, undated but signed *AVBorssom* (e.g. Bamberg, Neue Residenz, Staatsgal.; Cambridge,

Fitzwilliam; The Hague, Mus. Bredius). The composition and some details of *Cows in a Meadow* (Copenhagen, Stat. Mus. Kst) are obvious borrowings from Paulus Potter's famous *Bull* (1647; The Hague, Mauritshuis). Van Borssom's most successful works are the *Dune Landscape* (Hamburg, Ksthalle), *River View with a Rider* (Budapest, N. Mus.) and several *Moonlit Landscapes* (e.g. Amsterdam, Rijksmus.) painted in the manner of Aert van der Neer. His last known dated painting, *Panoramic Landscape with a Rider* (1671; Copenhagen, Stat. Mus. Kst), is reminiscent of the landscapes of Hendrick Vroom.

Bibliography

F. Robinson: *Netherlandish Artists* (1979), 5 [IV] of *The Illustrated Bartsch*, ed. W. Strauss (New York, 1987)

W. Sumowski: *Drawings of the Rembrandt School*, ii (New York, 1979), nos 287–367 [see also review by B. P. J. Broos in *Oud-Holland*, xcviii (1984), pp. 176–8]

——: *Gemälde der Rembrandtschüler*, i (Landau, 1983), pp. 426–56

B. P. J. BROOS

Bosschaert

Dutch family of painters of Flemish origin. (1) Ambrosius Bosschaert (i) was one of the first artists to specialize in Flower painting in the northern Netherlands. Other members of what has become known as the Bosschaert dynasty of fruit and flower painters include his three sons (2) Ambrosius Bosschaert (ii), Johannes Bosschaert (*b* ?Arnemuiden, 1610–11; *d* 1628 or later) and Abraham Bosschaert (*b* Middelburg, *c.* 1612–13; *d* Utrecht, 1643), as well as his brother-in-law Balthasar van der Ast and the latter's lesser-known brother Johannes van der Ast. Johannes Bosschaert seems from an early age to have been a talented painter, whose few surviving works are mostly horizontal in format and strongly influenced by his uncle Balthasar van der Ast. By contrast, Abraham Bosschaert apparently favoured an oval format and was a much less skilled artist, to judge from the equally small number of known paintings by him. It was, in fact, the eldest son and namesake who most closely followed the tradition

established by Ambrosius Bosschaert the elder, whose activities in Middelburg at the beginning of his career made it the centre of flower painting in the Netherlands. This switched to Utrecht after Ambrosius the elder's move there in 1616; all of his sons were active in Utrecht, as were van der Ast and other important exponents of the genre (e.g. Roelandt Savery).

(1) Ambrosius Bosschaert (i)

(b Antwerp, bapt 18 Nov 1573; d The Hague, 1621). Painter and dealer. He left Antwerp with his parents c. 1587 because as Protestants they were vulnerable to religious persecution; the family moved to Middelburg, where in 1593 Ambrosius became a member of the Guild of St Luke, of which he served as Dean on several occasions (1597, 1598, 1603, 1604, 1612 and 1613). In 1604 he married Maria van der Ast, the sister of Balthasar van der Ast who later became his pupil and possible collaborator. Bosschaert bought a house in Middelburg in 1611. There are flower-pieces by Bosschaert that are signed (with a monogram) and dated between 1605 and 1621, though there were two periods of artistic inactivity, in 1611–13 and 1615–16, when he was probably more active as a dealer in the art of both Dutch and foreign artists (e.g. Veronese and Georg Flegel). He was recorded in Bergen-op-Zoom in 1615 and became a citizen of Utrecht in 1616, where his name appears in the register of the Utrecht Guild of St Luke for the same year. In 1619 he was involved in a court case in Breda, where he lived from that year. He died during a journey to The Hague.

With his flower paintings Bosschaert founded a genre that continued unchanged in Middelburg until the mid-17th century: a symmetrically composed bunch of flowers, generally consisting of cultivated species, painted precisely and with an almost scientific accuracy. The vertically constructed bouquet generally consists of tulips—still a novelty at that time—in the centre, roses at the lower edge of the container and an exotic species, such as lilies, rounding off the top (e.g. *Bouquet in a Stone Niche*, Wassenaar, S. J. van den Bergh priv. col., see Bol, pl. 22). The vase, of glass, metal or painted china, stands on a monochrome surface on which isolated accessories, often costly rarities, are placed: small animals, rare shells, in some cases just a few drops of water or flower petals (e.g. *Flower Piece*, Madrid, Mus. Thyssen-Bornemisza). A simple niche or an arched window with a view over a flat, 16th-century style landscape forms the background (e.g. *Vase of Flowers in a Window*, c. 1620; The Hague, Mauritshuis). The *trompe-l'oeil* character of these pictures is particularly marked, although it is also emphasized by the volume of the flowers, which contrast with the flatly composed bouquets of Jan Breughel I.

Although Bosschaert's pictures combine flowers from different seasons, his floral compositions should be understood primarily as idealized depictions of flowers. Bol (1969) contended that they could not be interpreted symbolically, but subsequent research has inclined towards the view that, at least to some extent, the flower pictures of Bosschaert and his followers continue the 15th- and 16th-century Flemish tradition of using flowers as religious symbols. These pictures also served contemporary Dutch botanists and gardeners by providing an exact, true-to-life reproduction of foreign or hybrid species. This passion for exotic plants—which later culminated in what is known as the Dutch 'Tulip mania' (c. 1635–7)—was analogous to the interest in new and curious treasures (exotica, shells etc) which seafarers from Holland and Zeeland brought back from their travels in the Far East. Bosschaert may have painted his first flower-pieces as commissions for botanists and arrived at the deliberately composed floral bouquet by way of the individual studies required for such commissions.

About 50 works by Bosschaert are now known; they were highly esteemed in his lifetime, but in the 18th and 19th centuries they were disregarded. The interest of collectors and scholars in his work was not reawakened until the 20th century, particularly in the work of Bol.

(2) Ambrosius Bosschaert (ii)

(b Arnemuiden, Middelburg, 1609; d Utrecht, bur 19 May 1645). Son of (1) Ambrosius Bosschaert (i). He lived in Utrecht, where he married in 1634. His

work has been recognized only since 1935 when Piet de Boer succeeded in differentiating it from pictures by his father and his brother Abraham. Ambrosius the younger's early pictures are signed *AB* in Gothic lettering, but after 1633 he used a more calligraphic, rounded abbreviation, almost Baroque in effect, or even his name in full. The first period of his creative output falls between 1626 and 1635. His flower-pieces from that time are viewed from above and have a low vanishing point; there are often exotic accessories and shells (e.g. *Bouquet with Frog and Lizard*, The Hague, S. Nystad Gal., see Bol, pl. 52b), while on one occasion later a live snake is introduced. In later work the high viewpoint and stiff composition of the pictures, especially of the still-lifes combining fruit and flowers, become noticeably less symmetrical and more spacious. These works also reveal the strong influence of his brother Abraham, evident both in the choice of format and in the preference for blue and yellow, as well as in a darker background and more compactly organized still-life arrangements (e.g. *Flowers in a Glass Vase*, 1635; Utrecht, Cent. Mus.; *Fruits and Parrots*, 1635; The Hague, Dienst Verspr. Rijkscol.). It is possible that many of the pictures ascribed to Ambrosius the younger for this period were begun by Abraham and finished after his death by Ambrosius the younger.

Ambrosius Bosschaert the younger's paintings are also marked by their strong religious message; his *Bowl of Fruit with a Siegburg Beaker* (Amsterdam, A. A. Bosschaert priv. col., see Bol, pl. 57) can be interpreted as alluding to the Fall of Man, the Crucifixion and the Redemption. Ambrosius the younger also painted *vanitas* still-lifes (e.g. ex-Schaap priv. col., Monte Carlo) and a unique *memento mori*, a macabre little picture showing a *Dead Frog* lying on its back surrounded by four black flies (Paris, Fond. Custodia, Inst. Néer.). The extremely limited colour range (grey and brown with white highlights) is reminiscent of monochrome still-lifes from Haarlem and Leiden.

Bibliography

I. Bergström: *Dutch Still-life Painting in the 17th Century* (London and New York, 1956), pp. 54–68

L. J. Bol: *The Bosschaert Dynasty: Painters of Flowers and Fruit* (Leigh-on-Sea, 1960)

——: *Holländische Maler des 17. Jahrhunderts neben den grossen Meistern* (Brunswick, 1969)

P. Mitchell: *European Flower Painters* (London, 1973)

Stilleben in Europa (exh. cat., Münster, Westfäl. Landesmus., 1979), pp. 40–42, 57–9

I. Bergström: 'Composition in Flower Pieces of 1605–1609 by Ambrosius Bosschaert the Elder', *Tableau*, v (1982), pp. 175–6

Masters of Middelburg (exh. cat., Amsterdam, Waterman Gal., 1984)

M.-L. Hairs: *Les Peintres flamands de fleurs au XVII siècle* (Brussels, 1985), pp. 87–92, 196–9

IRENE HABERLAND

Both

Dutch family of painters, draughtsmen and etchers, active also in Italy. The brothers (1) Andries Both and (2) Jan Both were the sons of Dirck Both (*d* 1664), a glass painter from Montfoort, who by 1603 had settled in Utrecht, where he apparently specialized in painting coats of arms on windows. Andries and Jan were in Italy between 1638 and 1641, when they shared a house on the Via Vittoria in the parish of S Lorenzo in Lucina. In 1641 they set off together for Holland, but on the way home Andries drowned in a canal in Venice, and Jan returned alone. The 17th-century biographer Joachim von Sandrart, followed by later writers, claimed that the brothers had collaborated on the greater part of the production. This view, however, has been largely revised by late 20th-century critics, and the two artists are better understood independently.

(1) Andries Both

(*b* Utrecht, *c*. 1612; *d* Venice, 1641). After an apprenticeship in the workshop of Abraham Bloemart, where he is documented in 1624–5, Andries left Utrecht for Italy during the early 1630s. Among the works probably produced before his departure are a number of pen-and-ink landscape drawings such as the *Drawbridge near a Town Rampart* (Amsterdam, Rijksmus.). In 1633 he was at Rouen, as is confirmed by a signed, dated and inscribed drawing of *Four Peasants Eating and*

Drinking Outside (Weimar, Schlossmus.). Towards the end of 1634 or early in 1635 he probably arrived in Rome, where he is documented from 1635 to 1641.

Andries is recorded in documents mainly as a collaborator painting the figures in the landscapes of his brother (2) Jan Both, but any collaboration between the two was probably limited to the exchange of drawings and suggestions. Andries in fact produced independent, low-life genre paintings, influenced by the tradition of Pieter Bruegel the elder, which was then undergoing a revival, most notably in the work of Adriaen Brouwer. Andries was indebted to Brouwer for the rustic peasant subjects of such early paintings as his *Interior of a Tavern* (Rome, Pal. Corsini), completed in Rouen, his signed and dated *Peasants in a Tavern* (1634; Utrecht, Cent. Mus.) and the *Card Players* (Amsterdam, Rijksmus.). The influence of northern subject-matter and figure styles persists in the *Quack Dentist* and the *Charlatan*, both dated 1634 (ex-Duke of Bedford priv. col., see Waddingham, figs 21–2). These two paintings were probably executed shortly after Andries's arrival in Rome, as is shown by their intensely luminous quality and their Italianate landscape backgrounds. There is a related preparatory drawing (Leiden, Rijksuniv., Prentenkab.) for the *Quack Dentist*; drawn with a broad-nib pen and brown ink and wash, it is typical of Andries's rather crude draughtsmanship. The composition was etched by Jan as representing *Feeling* in a series of the *Five Senses* (Hollstein, nos 11–15). Another significant element of Both's early development was the work of the artist known as the Pseudo-Van de Venne (or Van der Vinnen), who was probably active in the southern Netherlands in the 1620s. From him Both apparently derived a marked propensity for the caricature-like distortion of the faces and poses of his figures.

Andries's development as a genre painter, together with his close links in Rome from 1635 with Pieter van Laer (il Bamboccio), placed him in the group of artists known as the Bamboccianti and meant that he favoured the *bambocciata*, a variety of low-life painting then increasing in

popularity through the late works of van Laer and the activities of other Bambocciante such as Jan Miel and Michelangelo Cerquozzi. During the 1640s Andries helped define the thematic and formal repertory of the *bambocciata* tradition, which under his influence was enriched with subjects inspired by the lives of tramps and beggars. Both's interest in such subjects is evident in his drawing *Distribution of Soup to the Poor* (1636; Amsterdam, Rijksmus.) and in a painting of the same subject (Munich, Alte Pin.). In this painting, in its companion, *Strolling Musicians in a Courtyard* (Munich, Alte Pin.), and in two tavern scenes (both Feltre, Mus. Civ.) Both breathed new life into his thematic repertory as a northern artist by observing the often harsh reality of his Italian surroundings more objectively and toning down the element of caricature typical of his early works. These paintings and, more especially, his *Barber* (*c*. 1640; U. Göttingen Kstsamml.) are distinguished mainly by the accentuated and sober realism that characterizes the setting in which the scene unfolds. In this aspect Both followed the example set by van Laer in such works as his *Flagellants* (Munich, Alte Pin.) or his *Halt of the Hunters* (ex-G. Caretto priv. col., Turin; see Briganti, Trezzani and Laureati, fig. 1.17). Andries Both's interest in the urban landscape was undoubtedly encouraged through contact with his brother Jan, whose drawings from life executed in Rome show a similar desire to record his surroundings. In his turn, Andries probably provided drawings for the small figures in Jan's landscapes, perhaps even intervening directly in the series now in the Prado.

(2) Jan Both

(*b* Utrecht, *c*. 1618; *d* Utrecht, Aug 1652). Brother of (1) Andries Both. He was one of the foremost painters among the second generation of Dutch Italianates. While working in Italy he specialized in genre scenes; however, on his return to the Netherlands he concentrated on wooded landscapes bathed in a golden light that illuminates the highly detailed foliage and trees. These realistic landscapes represent his most original contribution to Dutch painting and were much

imitated by his contemporaries and by later artists.

1. Life and work

(i) Before 1641: early training and work in Rome. Jan trained in Utrecht between 1634 and 1637 with Gerrit van Honthorst, according to Sandrart; Burke has suggested that his early development as a landscape artist was inspired by the work of Carel de Hooch (d 1638), who was active in Utrecht during the 1630s and whose Italianate but realistically formulated landscapes presented an important alternative to the more traditional models of Cornelis van Poelenburch and Bartholomeus Breenbergh.

Sometime after 1637 Jan joined his brother Andries in Rome. Jan is documented there from 1638 to 1641, during which time he befriended Herman van Swanevelt and Claude Lorrain. He collaborated with Claude in 1638–9, and again in 1640–41, on two series of large landscapes (Madrid, Prado) commissioned for the Buen Retiro Palace in Madrid by Don Manuel de Moura, Marqués de Castel Rodrigo and ambassador of Philip IV. Both is credited with four canvases of vertical format from the series (2059, 2060, 2061 and 2066). Like Claude and van Swanevelt, Both arranged his landscapes along diagonal lines in order to achieve a greater feeling of depth. He unified the composition by means of a glowing, golden light, which was also inspired by Claude and was later to characterize his entire output. Both's canvases stand out from the others, however, by virtue of their greater attention to naturalistic details, which in Claude's paintings are depicted in a more abstract and idealized way. The figures of horsemen in the foreground of one work by Jan in the series, the *View of the Rotunda of the Villa Aldobrandini at Frascati* (2062), were probably painted by his brother Andries, a rare example of collaboration between the two brothers. Waddingham suggested that Jan and Andries also worked together on versions of the *Landscape near the Calcara with Morra Players* (Munich, Alte Pin.; Budapest, N. Mus.), both previously, and occasionally still, attributed to Pieter van Laer.

From his arrival in Rome, Jan Both was associated with the Bamboccianti, or followers of Pieter van Laer (il Bamboccio), who specialized in low-life scenes (*bambocciate*). Jan devoted himself to painting genre scenes with small figures, initially imitating his brother's style, as for example in *Festivity in front of the Spanish Embassy* (Stockholm U., Kstsaml.). This painting depicts a party organized by the Marqués de Castel Rodrigo in February 1637 and was probably executed shortly after that date, perhaps for the ambassador himself. Another work from the same period is the *Distribution of Soup to the Poor* (Arles, Mus. Réattu), which is closely linked, both in style and subject, to the *bambocciate* of Andries Both (to whom it was attributed by Burke). The pair of canvases *Market at Campo Vaccino* (Amsterdam, Rijksmus.) and *Morra Players beneath the Campidoglio* (Munich, Alte Pin.) are later in date but were still completed in Rome. In these works Jan's search for a strong sense of realism is expressed through his meticulous observation of light effects rather than in the small anecdotal scenes of Roman life. Another feature of these pendants, also inspired by Claude's example, is the juxtaposition of a scene in the cool light of morning with another bathed in the warm golden light of evening. Sandrart recorded that Both liked to portray different hours of the day. In addition to Both's paintings of *bambocciate*, he made drawings of similar subjects, such as *Beggars and a Roast-chestnut Vendor amid Roman Ruins* (Haarlem, Teylers Mus.), which can be dated to the early 1640s.

In another pair of pendants, the *View of the Ripa Grande* (Frankfurt am Main, Städel. Kstinst.) and the *View of the Calcara on the Tiber near the Ripa Grande* (London, N.G.), both of which have a diagonal layout, the artist's interest in genre scenes yielded to his interest in the realistic representation of the urban landscape. These paintings are connected with drawings from life executed by Both during his stay in Rome, such as his *View of Ponte Rotto* (Frankfurt am Main, Städel. Kstinst.), a popular subject with the Dutch Italianates. By contrast, the location of his drawing *View of a Courtyard* (Leiden, Rijksuniv., Prentenkab.) cannot be precisely identified; its intensely realistic portrayal of the crumbling walls

caught by a bright light herald the work of the later Dutch Italianate Thomas Wijck, who specialized in courtyard views.

(ii) 1641 and after: the Netherlands. Jan probably returned to Utrecht in 1641, although the first record of his presence in the Netherlands is a drawing of a Dutch subject, *Wooded Landscape by a Stream* (Budapest, N. Mus.), dated 1643. He is documented with certainty in Utrecht in 1646 and 1649. After his return Jan Both completely abandoned low-life genre subjects and instead devoted himself to the realistic representation of Italianate landscapes. The lonely expanses of the Roman countryside and the paths that wind through the woods of the Apennines became the dominant themes of his work. None of Both's later paintings can be described as a view of an identifiable place, but all of them were based on studies and drawings brought back from Italy and convey an intense and convincing sense of realism, both in the clearly defined detail of the landscape and in the overall panoramic structure. The only dated work is *Landscape with Mercury and Argos* (1650; Schleissheim, Neues Schloss), completed in collaboration with Nicholas Knüpfer (*c.* 1603–?1660), who painted the figures. Burke has attempted to arrange Both's post-Italian works in chronological order on the basis of a comparison with the dated works by Herman Saftleven II that depend in part on Both's compositions; the latter can thus be dated as either contemporary or slightly earlier. Both's *Landscape with Travellers* (The Hague, Mauritshuis), which is still linked to the old Flemish landscape tradition of suggesting depth through the use of clearly defined layers of colour, dates from the early 1640s. So too does his *Wooded Landscape with River* (London, N.G.), in which, however, the different levels of the composition are linked together by a curving track, and the foreground is framed by trees. In *Landscape with Peasants on Muleback* (Montpellier, Mus. Fabre) the highly detailed vegetation in the foreground detracts from the overall coherence of the scene. A better integration between foreground and background was achieved by Both around the mid-1640s in two paintings of a *Rocky Landscape with*

Herdsman and Muleteers (both London, N.G.): in both works the composition is brought together by warm shades of green and brown and by the luminous atmosphere in which the individual details stand out against the light. Towards the end of his brief career the artist abandoned the sort of Italianate spatial structures that had often governed his compositions during the 1650s; in *Landscape with Travellers at a Ford* (Detroit, MI. Inst. A.), *Landscape with Riders* (Schwerin, Staatl. Mus.) and *Landscape with a Draughtsman* (Amsterdam, Rijksmus.) he composed broad sweeps of landscape that carry the eye in a variety of different directions. Both also practised etching and engraved a number of landscape compositions derived from his paintings, as well as the series of *Five Senses* based on drawings and paintings by his brother Andries.

2. Collaboration

On numerous occasions throughout his career Jan Both collaborated with other painters, the majority of whom specialized in figures and animals. Besides his brother Andries, Claude Lorrain and Nicholas Knüpfer, he worked with Cornelis van Poelenburch, Jan Baptist Weenix and Pieter Saenredam. With Knüpfer and Weenix he painted another *Landscape with Mercury and Argos* (*c.* 1650–51; Munich, Alte Pin.), the *Pursuit of Happiness* ('*Il contento*') (1651; Schwerin, Staatl. Mus.) and the *Seven Works of Mercy* (Kassel, Schloss Wilhelmshöhe); the figures that appear in these paintings are by Knüpfer, the animals by Weenix. Both's collaboration with van Poelenburch produced *Landscape with the Judgement of Paris* (London, N.G.). Unusually, however, Both provided the figures in Saenredam's *Interior of the Buurkerk in Utrecht* (1644; London, N.G.).

3. Influence and posthumous reputation

The subject-matter and compositional formulae used by Jan Both in his landscapes were the main source of inspiration for the third generation of Dutch Italianates, such as Willem de Heusch and Frederik de Moucheron, who during the second half of the 17th century repeated the

Apennine scenes made popular by Both. His drawing style was closely copied by his pupil Jan Hackaert.

Like many other Italianate artists, Both was greatly admired by his contemporaries and by 18th-century writers and collectors but was completely neglected during the second half of the 19th century and the first half of the 20th, when native Dutch landscapes were preferred. The critical reassessment of Jan Both began with Waddingham's studies of the 1960s, which were followed by Burke's careful revision of the artist's pictorial oeuvre.

Bibliography

Hollstein: *Dut. & Flem.*

C. de Bie: *Het gulden cabinet* (1661), pp. 156–8

J. von Sandrart: *Teutsche Academie* (1675–9); ed. A. R. Peltzer (1925), pp. 184–5

A. Houbraken: *De groote schouburgh* (1718–21), ii, p. 114

C. Hofstede de Groot: *Holländischen Maler* (1907–28), ix, pp. 418–517

L. de Bruyn: 'Het geboortjaar van Jan Both', *Oud-Holland*, lxvii (1952), pp. 110–12

M. R. Waddingham: 'Andries and Jan Both in France and Italy', *Paragone*, xv (1964), pp. 13–43

Nederlandse 17e eeuwse Italianiserende landschap-schilders (exh. cat., ed. A. Blankert; Utrecht, Cent. Mus., 1965); rev. and trans. as *Dutch 17th-century Italianate Painters* (Soest, 1978), pp. 112–28

W. Stechow: *Dutch Landscape Painting of the Seventeenth Century* (London, 1966/R 1981), pp. 150–58

E. Haverkamp-Begemann: 'The Youthful Work of Andries Both: His Landscape Drawings', *Pr. Rev.*, v (1976), pp. 88–95

J. D. Burke: *Jan Both: Paintings, Drawings and Prints* (New York, 1976)

L. Salerno: *Pittori di paesaggio del seicento a Roma*, ii (Rome, 1979), pp. 424–37

L. Trezzani: 'Andries and Jan Both', *The Bamboccianti: Painters of Everyday Life in 17th-century Rome*, ed. G. Briganti, L. Trezzani and L. Laureati (Rome, 1983), pp. 194–221

A. C. Steland: 'Beobachtungen zu frühen Zeichnungen des Jan Both und zum Verhältnis zwischen Jan Both und Jan Asselijn in Rom vor 1641', *Niederdeutsche Beiträge zur Kunstgeschichte*, xxvii (1988), pp. 115–38, figs 1–26

LUDOVICA TREZZANI

Bramer, Leonard [Leonaert; Leonardo delle Notti]

(*b* Delft, 24 Dec 1596; *d* Delft, *bur* 10 Feb 1674). Dutch painter and draughtsman. The first record of Bramer's career concerns his journey through France and Italy, which he began in 1614. In France he visited Arras, Amiens, Paris, Aix-en-Provence and Marseille. While in Aix he contributed a drawing and a dedicatory poem dated 15 Feb 1616 to the *Album Amicorum* (Leeuwarden, Prov. Bib. Friesland) of his compatriot Wybrand de Geest. This drawing, his earliest known work, depicts three figures in a landscape and shows similarities with the work of Adriaen van de Venne, his reputed teacher (an improbable hypothesis, since van de Venne worked outside Delft and was only 25 when Bramer left Holland). Bramer has also been erroneously described as a follower of Rembrandt.

In Italy, Bramer visited Genoa and Livorno before arriving in Rome, where he lived from 1619 to 1625. De Bie stated that he also visited Venice, Florence, Mantua, Siena, Bologna, Naples and Padua before returning to Delft in 1628 following trouble with the Italian police after a brawl. It is unlikely that Bramer stayed (in Parma) under the patronage of Mario Farnese (Wichmann), because Mario (*d* 1619), a member of a collateral branch of the Farnese family, the dukes of Latera, lived in Rome as general of the pontifical artillery. Another Roman patron of Bramer was the Dominican Cardinal Desiderio Scaglia, an influential member of the papal court under Gregory XV and Urban VIII.

In Rome, Bramer was influenced by the Caravaggesque painters, particularly Adam Elsheimer. His predilection for nightpieces with dramatic chiaroscuro earned him the nickname 'Leonardo delle Notti'. There are no dated paintings from this Italian period—his earliest is dated 1630—but the style of these works probably resembled his later datable works, as Bramer's style did not evolve greatly.

Most of Bramer's paintings feature many small figures set among antique buildings, ruins or thick, dark woods, dramatically lit from one side or from behind, for example *Hecuba* (1630;

Madrid, Prado). Bramer never concerned himself with details, which are often only sketched in, especially faces and architecture, but concentrated more on composition and preferred expressiveness to formal perfection. This caused later critics to consider him a good psychologist but a poor draughtsman; this, however, was due to Bramer's preoccupation with Italian Baroque art theory, with its emphasis on *Inventio* as the highest artistic quality and the *Concetto* as the basis of creation, ideas stronger in Italy than in the Netherlands.

Bramer's choice of subjects also reflects his preoccupations with Italian rather than Dutch art practice. His paintings generally depict mythological, allegorical, historical or biblical scenes (e.g. the *Allegory of Vanity*, Vienna, Ksthist. Mus.; see col. pl. VII.), rather than popular Dutch subjects such as landscapes, still-lifes, portraits and genre pieces. Even the Italianate pastoral scenes favoured by compatriots such as the Utrecht Caravaggisti are rare in his work. This was probably due to the influence of his patrons, first in Rome and later in the Netherlands, rather than to a lack of contact with other Dutch painters. Bramer was among the earliest members of the Bentvueghels or Schildersbent, the company of Dutch artists formed in Rome in the early 1620s; he was known under the *Bent*-name of Nestelghat.

Bramer became a member of the Guild of St Luke in Delft in 1629. His prominent position is shown by the commissions given to him before 1647 by Stadholder Frederick Henry and his nephew Prince John Maurice of Nassau-Siegen for their palaces at The Hague (now the Mauritshuis), Rijswijk and Honselaarsdijk (both destr.). Bramer also worked for public institutions in Delft and the surrounding cities from 1630 to 1670. He even tried to use the Italian fresco technique for some murals in the Gemeenlandshuis van Delfland, the Nieuwe Doelen and the corridor of the house of his neighbour Anthonie van Bronchorst in Delft; these did not survive the unsuitable Dutch climate despite Bramer's frequent restorations. In 1668 the artist painted an *Ascension* on the ceiling of the main hall of the Prinsenhof in Delft (*in situ*; now Delft, Stedel. Mus. Prinsenhof).

After 1635 Bramer produced many drawings. Only rarely are the drawings related to his paintings; most are independent works of art, often representing literary or historical scenes. Many form large cycles illustrating a particular book, for example the Bible (Amsterdam, Rijksmus.), Quevedo's *Sueños* and the picaresque novel *Lazarillo de Tormes* (both Munich, Staatl. Graph. Samml.), Ovid and Virgil, some containing up to 100 drawings. Most of these cycles are executed in ink or pencil, but some are watercolours painted in an original style showing the influence of Italian Mannerism. The illustrations always follow the text closely enough to show that Bramer was a discriminating reader and did not always follow pictorial conventions.

An album attributed to Bramer (Amsterdam, Rijksmus.) contains 56 drawings rapidly sketched in black chalk, which are copies of paintings by contemporary artists, most of whom are named on the bottom of each drawing. The owners of the works were mostly wealthy Delft burghers, artists and art dealers, as can be seen from an inscription on the back of one drawing. The artists whose works are represented include Jan Asselijn, Gerard ter Borch (ii), Adriaen Brouwer, Karel Dujardin, Gerrit van Honthorst, Roelandt Savery, Hercules Segers and Bramer himself. The album originally consisted of many more drawings, but it nevertheless gives a useful insight into the quality of mid-17th-century Delft art collections. The function of the album is uncertain, but it was probably intended as an illustrated catalogue of paintings to be sold by the named owners. No other album of its kind exists.

Bramer lived with his sister in a smart house in the centre of Delft. He is not known to have had any pupils. Adriaen Verdoel (*c.* 1620–*c.* 1690) and even Johannes Vermeer have been suggested, but there is no conclusive evidence, although Bramer and Vermeer's parents are known to have been friends. After his death, Bramer's fame declined quickly and steadily until the late 19th century.

Bibliography

Thieme–Becker

C. de Bie: *Het gulden cabinet* (Antwerp, 1661), pp. 252–3

H. Wichmann: *Leonaert Bramer, sein Leben und seine Kunst* (Leipzig, 1923) [Only extant monograph on Bramer, but partially outdated and incomplete]

G. J. Hoogewerff: *De Bentvueghels* (The Hague, 1952)

J. M. Montias: *Artists and Artisans in Delft: A Socio-economic Analysis of the Seventeenth Century* (Princeton, 1982)

J. ten Brink Goldsmith: 'From Prose to Pictures: Leonaert Bramer's Illustrations for the Aeneid and Vondel's Translation of Virgil', *A. Hist.*, vii/1 (March, 1984), pp. 21–37

M. Plomp: ' "Een merkwaardige verzameling teekeningen" door Leonaert Bramer' ['A remarkable collection of drawings' by Leonaert Bramer], *Oud-Holland*, c/2 (1986), pp. 81–153

J. W. NOLDUS

Bray [Braij], de

Dutch family of artists. (1) Salomon de Bray was the son of Simon de Bray, who moved to Holland from Aelst in the Catholic southern Netherlands. Salomon was a man of versatile talents, with interests ranging from painting to poetry and urban planning. He married in 1625 and three of his sons became artists: (2) Jan de Bray, Dirck de Bray (*fl* 1651–78), an engraver and painter, and Joseph de Bray (*d* 1664), a painter of still-lifes. Jan de Bray's *Banquet of Anthony and Cleopatra* (1669; Manchester, NH, Currier Gal. A.) is generally thought to depict his parents as Anthony and Cleopatra and himself and his siblings as their attendants. During the plague epidemic in Haarlem in 1664, Salomon de Bray, two of his sons and two daughters died.

Bibliography

W. Bernt: *Die niederländischen Maler des 17. Jahrhunderts*, 4 vols (Munich, 1948–62); Eng. trans. by P. S. Falla (New York and London, 1970, 3 vols), i, pp. 18–19, 179–82

S. Slive: *Frans Hals* (London, 1974), p. 61

B. Haak: *The Golden Age: Dutch Painters of the 17th Century* (New York and Amsterdam, 1984), pp. 254–5, 379–80, 392

Frans Hals (exh. cat. by S. Slive, Washington, DC, N.G.A.; London, RA; Haarlem, Frans Halsmus.; 1989–90)

(1) Salomon de Bray

(*b* Amsterdam, 1597; *d* Haarlem, 11 May 1664). Painter, draughtsman and designer, architect, urban planner and poet. From 1617 he was a member of the civic guard company of St Adriaen in Haarlem, where he is thought to have trained with Hendrick Goltzius and Cornelis Cornelisz. van Haarlem (though there is no evidence for this). He remained in Haarlem until his death. He was a sensitive and intelligent man who played an important role in various cultural projects and institutions in the city. In 1627 he was paid for sketches of the Zeylpoort in Haarlem; he co-founded the Haarlem Guild of St Hubert, for which he designed a drinking horn (drawing, 1630; Konstanz, Städt. Wessenberg-Gemäldegal.); in 1631 he helped reform the Haarlem Guild of St Luke, serving on its executive committee from 1633 to 1640; the same year he published a collection of engravings, with commentary, of the most important buildings by Hendrik de Keyser under the title *Architectura moderna*; in 1634 he supervised the repairs to an organ in a Haarlem church; and he took an interest in many architectural projects for the city, contributing, among other things, a plan for the enlargement of the city and models and drawings for the Nieuwe Kerk. In 1644–5 he was summoned to Nijmegen as a consultant architect to supervise the alterations to an orphanage and an old people's home, and in 1649–50 he contributed to the painted decoration of the Huis ten Bosch outside the Hague.

1. Drawings and designs

Salomon was active as a draughtsman throughout his career, beginning with a landscape drawing executed when he was 19 (Leipzig, Mus. Bild. Kst.), which foreshadows the work of Rembrandt. There are numerous drawings of religious subjects, of which one group of precise and carefully drawn sheets stands out; despite their high degree of finish, some were used as preliminary studies for paintings, such as *Judith and Holofernes* (1636; Konstanz, Städt. Wesenberg-Gemäldegal.) for the painting of the same subject (Madrid, Prado); a drawing of the *Annunciation* (1641; Carcassone, Mus. B.-A.) for a picture formerly on the Dutch art

market; and *Rebecca and Eliezer* (1660; Hamburg, Ksthalle), which served as a basis for the painting (Douai, Mus. Mun.). De Bray also left behind numerous architectural drawings, such as that for the rebuilding of the Haarlem Stadhuis (1629).

2. Paintings

Salomon's painted oeuvre includes landscapes (e.g. Berlin, Gemäldegal.) and numerous religious and mythological scenes, for example *Jael, Deborah and Barak* (1633; Utrecht, Catharijneconvent), a forceful rendering of the biblical text, in which Jael is seen resolutely preparing to kill Sisera with the hammer and nail in her hand. This painting is typical of de Bray's manner of composing a scene of three figures, and in its powerful colour and treatment of light it reveals similarities with the work of Caravaggio. In the two large paintings that de Bray contributed to the Oranjezaal at the Huis ten Bosch, he adopted, perhaps unconsciously, the fashionable Flemish style and colouring of the other painted decorations in the programme.

Salomon was also active as a portrait painter, the earliest known example being the *Portrait of a Nun* (1622; Berlin, Gemäldegal.). From the middle of his career is the small, but superbly painted *Portrait of a Woman in Profile* (1636; ex-Althorp House, Northants, see von Moltke, no. 82). An unusually harmonious example is the *Portrait of a Woman* (1652; ex-art market, London, see von Moltke, no. 87). In his capacity as a portrait painter, de Bray may have known Frans Hals, for he signed and dated (1628) the portrait of a small girl who appears in the left foreground of Hals's *Portrait of a Family in a Landscape* (c. 1620; Viscount Boyne, on loan to Cardiff, N. Mus., see 1989–90 exh. cat., no. 10); this child's portrait could, however, have been a later addition.

Salomon de Bray's skills at observation are also evident in his genre pieces, such as the *Shepherdess with a Straw Hat* and its pendant *Shepherd* (both 1635; Dresden, Gemäldegal. Alte Meister). Such subjects were interpreted by de Bray with freshness and great liveliness, qualities also apparent in *The Flute-player* (Brussels, priv. col., see von Moltke, no. 98) and the *Girl Combing her*

Hair (Paris, Schloss priv. col., see von Moltke, no. 104), the latter perhaps inspired by a composition by Caesar van Everdingen. Salomon's painting of a *View in a Temple* (c. 1630–35; ex-art market, Berlin, see von Moltke, no. 116) is the only known example of an architectural subject in his oeuvre.

Writings

Architectura moderna ofte bouwinga van osten tyt [Modern architecture in buildings of today] (Haarlem, 1631); ed. E. Taverne (Soest, 1971)

Bibliography

J. W. von Moltke: 'Salomon de Bray', *Marburg. Jb. Kstwiss.*, xi–xii (1938–9), pp. 202–420

E. Taverne: Salomon de Bray's ontwerp voor de drinkhoorn van Het Loffelijke Gilde van St Hubert te Haarlem' [Salomon de Bray's design for the drinking horn of the Haarlem Guild of St Hubert], *Ned. Ksthist. Jb.*, xxiii (1972), pp. 261–71

—: 'Salomon de Bray and the reorganisation of the Haarlem Guild of St Luke: 1631', *Simiolus*, vi (1972–3), pp. 56–69

(2) Jan de Bray

(*b* Haarlem, *c.* 1627; *bur* Haarlem, 4 Dec 1697). Painter, draughtsman and etcher, son of (1) Salomon de Bray. He spent virtually the whole of his career in Haarlem, except for the period 1686–8, when he lived in Amsterdam. After training with his father, Jan began working as a portrait painter in Haarlem in 1650, an activity he continued for the next 40 years. Between 1667 and 1684 he served on the committee for the Haarlem Guild of St Luke, whose leading members he portrayed in a picture dated 1675 (Amsterdam, Rijksmus.) that includes a self-portrait (Jan is seen standing and drawing on the left). He married three times, in 1668, 1670 and 1672. His first two wives died a year after their marriage, his third two years afterwards, and in each case the death was followed by disputes over the inheritance. Jan's bankruptcy of 1689 may have been a result of one of the lawsuits. He was 62 at the time, and from then onwards he seems to have lost his artistic drive, crushed by the financial blow and the consequent loss of social position.

1. Portraits

More than half of Jan's painted output consists of individual portraits; besides these, there are double portraits and five large, extremely important group portraits (1663–75) relating to the regent and the local militia company. Jan's earliest dated painting, a *Portrait of a Girl* (1650; Prague, N.G., Šternberk Pal.), is tentative and subdued in style. Better and more typical is the *Portrait of a Man* (1658; Paris, Louvre), for which a preparatory study also survives (London, BM). The picture shows a man in his prime, with an imposing physical presence, facing towards the right; he is wearing severe, black garments, with a white collar. The sitter's lively facial expression—especially his attentive gaze towards the viewer—adds to the sense of immediacy conveyed by the portrait. Thus, although it was still relatively early in Jan's career as a portrait painter (he was just over 30 when he painted it), he had clearly already acquired considerable skill. Over the years he developed this sureness of touch to great perfection, though at the same time his portraits began to suffer from a certain impersonal superficiality that detracted from their content.

Jan can be seen at his best in the portrait of *Andries van der Horne* (1662; Lisbon, priv. col., see von Moltke, no. 47, wrongly identified as *Jean de Chambre*), a much more elegant half-length depiction of a middle-aged man, who looks out at the viewer confidently and somewhat critically. He holds a document in his right hand, his gloves in his left. Secure in the knowledge of his position in Amsterdam society, van der Horne observes life around him in with a cool, measuring eye. De Bray has conveyed a face full of character and endowed the sober black dress worn at the time with a festive brilliancy.

The group portrait of the *Leading Members of the Haarlem Guild of St Luke* (1675; Amsterdam, Rijksmus.) is remarkable for its sense of realism: the guild members seem to be discussing and debating some contentious point of the agenda. The intrinsically dry subject of a group of men all dressed in black was enlivened by the artist's ability to break down the conventional framework.

One of his last-known works is the portrait of the Catholic priest *Johannes Groot* (1692; Haarlem, Bisschopp. Mus.), painted three years after his bankruptcy.

2. History subjects

Jan de Bray's painting of *Penelope and Odysseus* (1668; Louisville, KY, Speed A. Mus.), a double portrait of a married couple dressed up in Classical guise, is a cross between history painting and pure portraiture. Penelope is shown holding a loom on which she had been working for years, hoping that Odysseus would return to her from the Trojan War. The dog, Argus, has recognized his master, even though Odysseus is disguised as a beggar. Happily reunited at last, the couple lean towards each other with great reserve, for the estrangement resulting from their long separation has to be overcome. Although scenes from Homer's *Odyssey* were relatively rare as subjects for paintings in the northern Netherlands before the end of the 17th century, both Salomon and Jan found the story an important source of inspiration. Jan depicted the scene of the return of Odysseus with great delicacy and psychological insight, in a beautifully unified composition.

As the years went by, Jan adopted an increasingly academic style in his paintings: it was streamlined but correspondingly less spontaneous. His picture of *David with the Harp* (1674; Brunswick, Herzog Anton Ulrich-Mus.) is an example of the rigidity that gradually overtook his work. The composition, depicting the solemn procession of King David bearing the Ark of the Covenant to Jerusalem, is carefully worked out; each figure is placed according to his importance. From a formal point of view, the representation is achieved with great success, yet it is missing the sense of immediacy that would otherwise have endowed the picture with real life. From the mid-1670s until his death, the contemporary preference for a more classicizing concept of art dominated his work, and as a result his originality gradually waned. This development may also help to explain why he gave up painting creatively towards the end of his life. Only two works are known from the period after his

bankruptcy: besides the portrait of *Johannes Groot*, he painted the *Four Apostles* for a clandestine church in Amersfoort (1696; now Udenhout, parish church).

Bibliography

W. Martin: *De Hollandsche schilderkunst in die zeventiende eeuw* (Amsterdam, 1935), i, pp. 27, 49, 117–19

J. W. von Moltke: 'Jan de Bray', *Marburg. Jb. Kstwiss.*, xi–xii (1938–9), pp. 421–523

J. Rosenberg, S. Slive and E. H. ter Kuile: *Dutch Art and Architecture, 1600–1800*, Pelican Hist. A. (Harmondsworth, 1966/R 1982), p. 321

Gods, Saints and Heroes: Dutch Painting in the Age of Rembrandt (exh. cat., ed. A. Blankert; Washington, DC, N.G.A.; Detroit, MI, Inst. A.; Amsterdam, Rijksmus.; 1980–81), pp. 224–9

J. W. VON MOLTKE

Breenbergh, Bartholomeus

(*bapt* Deventer, 13 Nov 1598; *d* Amsterdam, *bur* 5 Oct 1657). Dutch painter, draughtsman and etcher. He was one of at least eight children of a wealthy Protestant family in Deventer, where his father was the town pharmacist. After his father's death in 1607, the family left Deventer, probably moving to Hoorn. No artist then living in Hoorn could plausibly have been Breenbergh's teacher, and given the fact that his earliest works reveal the stylistic influence of the Pre-Rembrandtists, it is more probable that he was apprenticed in Amsterdam. In 1619 he was called upon to give testimony in Amsterdam: on this occasion his profession was listed as 'painter'. His oeuvre can be divided stylistically and iconographically into two distinct groups. He belonged to the first generation of Dutch Italianates, northern artists who travelled to Italy in the 1620s and were inspired by the light and poetry of the southern landscape. The work of this period consists of numerous Italianate landscape drawings and paintings. On his return to the northern Netherlands he settled in Amsterdam, where he painted more severe and monumental landscapes, often with historical subjects, which were strongly influenced by the Pre-rembrandtists.

1. Life and work

(i) Italian period, *c*. 1619–*c*. 1629. Late in 1619 Breenbergh arrived in Rome, where he remained for longer than was usual for northern artists. He made contact with Paul Bril, the 65-year-old painter from Antwerp, who had been working in Rome since *c*. 1580. According to Breenbergh's own testimony in 1653, he 'spent seven years with Bril' and copied a number of his paintings. Breenbergh was one of the founder members of the Schildersbent, the association of northern artists active in Rome. He is portrayed in drawings of 1623 ascribed to Jan van Bijlert (Rotterdam, Boymans–van Beuningen), which represent the society's merry-making members, known as *Bentvueghels* ('birds of a feather'). His nickname within the fellowship was 'het fret' (Dut.: 'the weasel'). During his stay in Italy Breenbergh made many drawings in Rome and its environs, motifs that he later assimilated repeatedly into his paintings. His drawing style was influenced by Bril and CORNELIS VAN POELENBURCH, while his painting style owes much to the Pre-Rembrandtists, but also to van Poelenburch. Like them, Breenbergh painted landscapes in the new style introduced by Adam Elsheimer during the first decade of the 17th century and elaborated upon by Filippo Napoletano and Goffredo Wals. Their landscapes were directly inspired by nature, and they concentrated on the representation of light and space.

Breenbergh's earliest paintings, dating from 1622, are busy, overcrowded landscapes containing awkward, wooden figures (e.g. *Landscape with the Finding of Moses*, 1622; Stockholm, Hallwylska Mus.), clearly the work of an inexperienced artist. The early work of Breenbergh has long been confused with the early work of van Poelenburch. This confusion originated in France in the 18th century, when a number of van Poelenburch's paintings were attributed to Breenbergh. In Napoleon's inventory of 1813, several paintings, which since the 17th century had been considered to be by van Poelenburch, appeared under Breenbergh's name. Many related pieces have also been ascribed to him since then. It is only since 1969 that scholars have attempted to differentiate the two hands. Although it is now clear that the

differences are usually greater than the similarities, the problem has yet to be definitively solved.

Between 1625 and 1630 Breenbergh painted landscapes with gently sloping hills and Roman ruins (e.g. roundel of *Landscape with Ruins*; Cambridge, Fitzwilliam), which greatly resemble van Poelenburch's production during the early 1620s. The scale of the architecture in Breenbergh's works, however, is usually larger and the figures smaller and less numerous than in Poelenburch's. Breenbergh frequently placed a tall architectural element (often seen from the narrowest side) in or near the centre of the composition (see fig. 11) or, alternatively, completely to one side, while van Poelenburch's compositions, with accents on both sides, are calmer and more balanced. The subtle green and grey tints in the soft slopes of the landscape, the meticulous detail and the manner of execution in which the individual brushstrokes are barely perceptible are strikingly similar for both painters. After 1630 Breenbergh developed his style in other directions, ending the possibility of confusion between the two artists.

While only a small portion of Breenbergh's painted oeuvre was made in Italy, the majority of his drawings date from this period. Of the *c.* 200 drawings known, only about 35 were made after his return to the Netherlands; the rest date to the period 1624–9. The earliest, from 1624, are much more accomplished than the paintings from the same period. Breenbergh's drawings are not sketches or preliminary studies for paintings, but autonomous works of art, most of which are signed and/or dated. The drawings are almost exclusively executed in a delicate technique of pen and brown ink with a brown, or in a few cases grey, wash. The execution of line is lively; the artist rarely employed continuous contour lines, but rather series of dots, curlicues and small dashes. The wash adds a note of calmness or stability, although never to such an extent that the drawings might be termed 'classical'. The combination of spontaneity and detail bespeaks technical prowess.

Many drawings were made on the spot, others (the most complete compositions) were carried out in the studio. He often depicted the ruins of Rome

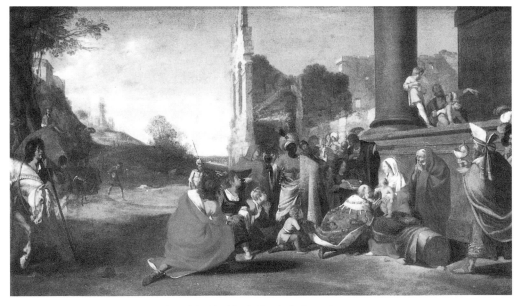

11. Bartholomeus Breenbergh: *Adoration of the Magi* (Paris, Musée du Louvre)

and the Campagna, usually set in a landscape, as in the large and impressive *Temple of the Sibyl at Tivoli* (New York, Pierpont Morgan Lib.) and *Ruins near Porta Metronia, Rome* (Oxford, Christ Church). He also made pure landscape drawings (e.g. Budapest, Mus. F.A., see Roethlisberger, 1969, fig. 66). In contrast to his paintings, his drawings rarely include figures. The way in which Breenbergh represented ruins and rock formations is often reminiscent of Bril's draughtsmanship. Breenbergh's compositions, however, are more naturalistic. Whereas Bril continued to make clear distinctions between foreground, middle ground and background, Breenbergh adopted more subtle perspectival conventions, often using an oblique viewpoint or a pronounced diagonal. It is probable that Conte Orsini of Bracciano commissioned some of Breenbergh's drawings, including the series of views near Bomarzo and Bracciano (ex-Bracciano priv. col., now scattered, e.g. Amsterdam, Rijksmus.; Paris, Louvre; London, BM), which are among the best examples within his drawn oeuvre.

(ii) Dutch period, c. 1629–57. Breenbergh probably left Italy in 1629. He settled in Amsterdam by 1633, the year he married Rebecca Schellingwou, and remained there until his death. The early 1630s were the most productive period of Breenbergh's career and the period during which drastic changes took place in his style and choice of subject-matter. Undoubtedly under the influence of his renewed acquaintance with the work of the Pre-Rembrandtists, Breenbergh began to introduce biblical and mythological figures into his landscapes (see fig. 12). The paintings are larger, the compositions more ambitious and the figures more emotive. His expressive figural types reveal affinities with those of the important Pre-Rembrandtist Pieter Lastman.

Breenbergh's choice of subject-matter, especially the interest in Old Testament themes, also seems to have been influenced by the Pre-Rembrandtists. In Breenbergh's representations (e.g. *Landscape with Tobias and the Angel*, 1630; St Petersburg, Hermitage), however, the biblical scenes are often placed further in the background,

12. Bartholomeus Breenbergh: *Parable of the Rich Young Man*, 1633 (Kassel, Staatliche Museen Kassel)

literally and figuratively assuming a smaller place within the composition. For this reason Breenbergh's paintings are difficult to categorize: most are not, strictly speaking, history pieces, but to term them 'landscapes with historical scenes' is to underrate the importance of the historical scenes within the compositions. The question is important in determining Breenbergh's position within 17th-century Dutch art in general and with respect to the Dutch Italianates in particular. Through the prominence of the historical scenes in the landscapes, Breenbergh and, to a lesser extent, van Poelenburch distinguish themselves from such later Dutch Italianates as Jan Both and Nicolaas Berchem, whose staffage consisted of non-narrative figures. Although such incidental figures are also found in works by Breenbergh and

van Poelenburch, they occur almost exclusively in earlier landscapes, painted during their stay in Italy.

A good example of Breenbergh's mature style is the *Landscape with Christ and the Woman of Samaria* (1636; Rome, Pal. Corsini). He represented the themes several times, with a different approach each time. Landscape, architecture and figures form a far more harmonious whole in this picture than was usual in his early work, and the composition is lucid and balanced. Characteristic is the dark foreground with on one side a low coulisse and a view into the distance, and on the other side monumental Classical architecture. The palette reveals a tendency towards the monochrome that was typical of the latter half of the 1630s and for Breenbergh was perhaps related to his contact with Nicolaus Knüpfer (?1603–55), who was then working in Amsterdam. The lighting in the painting is somewhat agitated, with several scattered illuminated areas; Breenbergh never employed the warm, all-encompassing southern light that characterized some of the work of van Poelenburch and the following generation of Dutch Italianates. With only a few exceptions, Breenbergh always remained closer to the Pre-Rembrandtists in his treatment of light and landscape, and he was more manneristic in his approach than van Poelenburch, whom he nevertheless surpassed in monumentality.

During the late 1630s and the 1640s Breenbergh also made some 50 prints after his own drawings, mostly of ruins in or near Rome (Hollstein, nos 1–52). His productivity diminished significantly during his last 15 years, probably partly due to his having taken on other obligations. In 1652 and 1655 he was named as a merchant. However, the quality of the approximately 25 paintings from this period reached even greater heights. The pictures varied in type and format, ranging from landscapes with only a few large figures to architectural pieces containing crowded scenes (e.g. *Martyrdom of St Lawrence*, 1647; Frankfurt am Main, Städel. Kstinst.). The compositions became more monumental and the figures more emotive, even to the point of caricature. He also painted several pastoral landscapes with bathing figures (e.g. Rome, priv. col., see Roethlisberger, 1981, fig. 209) or with the famous scene from *Cimon and Iphigenia*, a theme from Boccaccio's *Decameron* that enjoyed remarkable popularity in the northern Netherlands between 1630 and 1650. Seven paintings by Breenbergh representing this subject are known.

During these years Breenbergh also painted a number of portraits (e.g. *Portrait of a Man*, 1641; GB, priv. col., see Roethlisberger, 1981, fig. 202a) of high artistic value. After 1647 there are no more dated or datable paintings or drawings until 1654, the date of his *Jacob Selling Corn to the People* (Dumfries House, Strathclyde). This is the only painting in his entire oeuvre of which he (a year later) made a replica (U. Birmingham, Barber Inst.); he was probably commissioned to do so. These two large canvases form the apex of his late monumental style, so different from the charming landscapes of his Italian period.

2. Critical reception and posthumous reputation

It is curious that Breenbergh, whose production was considerable—there are more than 100 extant paintings—was so quickly forgotten in his own day. None of the contemporary artists' biographies mention him, and even Houbraken knew nothing more about this painter than his name and requested information from his readers. Few of his works appear in 17th-century Dutch inventories and auction catalogues; during the 18th century his name is encountered slightly more often. One of the reasons for this apparent neglect is the fact that, unlike van Poelenburch, he does not seem to have had any workshop or pupils, so that his style and subject-matter were not widely disseminated.

It is also quite possible that many of Breenbergh's paintings were sold abroad. Unfortunately nothing is known of his buyers and patrons, but in France he became famous. Not only are many of his works found in important 18th-century collections there, but he was also highly celebrated by French artists' biographers. His technique and choice of subject-matter influenced the drawing style of his near contemporary Claude Lorrain.

Like many Dutch Italianate painters, during the second half of the 19th century Breenbergh's paintings went out of fashion. However, by the end of the 1950s, when art historians ceased to concentrate all their attention on the so-called realist landscape painters of the Dutch golden age, his reputation began to recover.

Bibliography

Hollstein: *Dut. & Flem.*

W. Stechow: 'Bartholomeus Breenbergh, Landschafts- und Historienmaler', *Jb. Preuss. Kstsamml.*, li (1930), pp. 133–40

M. Roethlisberger: *Bartholomaus Breenbergh: Handzeichnungen* (Berlin, 1969)

——: *Bartholomeus Breenbergh: The Paintings* (Berlin and New York, 1981)

NICOLETTE C. SLUIJTER-SEIJFFERT

Brekelenkam, Quiringh [Quirijn] (Gerritsz.) van

(*b* ?Zwammerdam, nr Leiden, after 1622; *d* Leiden, ?1669 or after). Dutch painter. He probably trained in Leiden, possibly under Gerrit Dou. In 1648, with several other painters, he founded the Guild of St Luke in Leiden. He married for the first time in 1648 and again in 1656, a year after his first wife's death. In 1649 his sister Aeltge married the painter Johannes Oudenrogge (1622–53), and the couple soon moved to Haarlem while the Brekelenkam family remained in Leiden. About 1656 Brekelenkam apparently acquired a licence to sell beer and brandy, perhaps because his income as a painter was insufficient to support his large family (six children from his first marriage and three from his second). He continued to be active as an artist and paid his guild dues fairly regularly. The last dues were paid in 1667, and his last dated painting, the *Portrait of a Man Aged 33*, is from 1669.

Like many painters of his time, Brekelenkam was prolific, producing several hundred paintings of greatly varying quality. Most of these are genre scenes, although there are also individual and family portraits and some still-lifes. Other paintings show hermits praying (e.g. 1660; St

Petersburg, Hermitage) or reading, a popular subject in Leiden. The genre paintings include inn scenes and numerous images of market stalls, but the majority of them depict either domestic scenes (e.g. *Old Woman Combing a Child's Hair*, 1648; Leiden, Stedel. Mus. Lakenhal) or workshop scenes, which were his speciality. In his *Tailor's Workshop* (1653; Worcester, MA, A. Mus.), the craftsman and his apprentices sit atop a table on the left side of the picture, where a combination of strong light from the window and the off-centre vanishing-point activates the space. On the right, in a dark vertical area, a woman sits calmly preparing a meal by a fireplace.

Brekelenkam's early genre works, from the 1640s and 1650s, are related in subject-matter to the Leiden 'fine' painters, a group of artists centred around Dou. But Brekelenkam seldom employed the minutely finished technique for which the 'fine' painters were famed, preferring a looser manner of handling, which has been compared to that of Gabriel Metsu; he also avoided prettifying his scenes of 'simple folk'. In his works, meaning is usually conveyed by form and composition rather than by emblematic or literary reference.

In the 1660s Brekelenkam followed the current fashion in painting high-life genre scenes: elegant conversations and ladies receiving letters or at their toilets. His manner often approaches that of Gerard ter Borch (ii), whose influence he clearly acknowledged in his *Woman at her Toilet* (1662; Lübeck, priv. col.), which borrows motifs from two works by that master. In Brekelenkam's *Interior* (1663; Zurich, Ksthaus), the humble kitchens of his earlier works have given way to a finely appointed home where a maid waits, market pail on her arm, for the money her elegant mistress is about to give her for the shopping. Hanging on the wall is a portrait of a man, perhaps the provider of the wealth that supports such refined domestic economy.

Bibliography

H. Havard: *L'Art et les artistes hollandais*, iv (Paris, 1881), pp. 91–146

E. Plietzsch: *Holländische und flämische Maler des XVII. Jahrhunderts* (Leipzig, 1960), pp. 42–4

W. Stechow: 'A Genre Painting by Brekelenkam', *Allen Mem. A. Mus. Bull.*, xxx/2 (1973), pp. 74–84

Masters of Seventeenth-century Dutch Genre Painting (exh. cat., ed. P. C. Sutton; Philadelphia, PA, Mus. A., 1984), pp. 157–61 [with further bibliog.]

A. Lasius: *Quiringh Gerritsz. Brekelenkam* (diss., U. Göttingen, 1987)

<div align="right">ELIZABETH ALICE HONIG</div>

Bronchorst [Bronckhorst], van

Dutch family of artists.

(1) Jan (Gerritsz.) van Bronchorst

(*b* Utrecht, *c.* 1603; *d* Amsterdam, before 22 Dec 1661). Glass painter, etcher and painter. Son of a gardener, he was apprenticed aged 11 to the Utrecht glass painter Jan Verburch (*fl* early 17th century). He also studied in Arras with the otherwise unidentified Pieter Mathys. From Arras he went to Paris to work with Chamu (*fl* 1585–early 17th century), one of the leading glass painters there. After his return to the Netherlands he became a citizen of Utrecht and worked both as a glass painter and as a designer of coats of arms for tapestries and seals. In 1622 he married Catalijntje van Noort. By this time he was taking lessons in the workshop of Gerrit van Honthorst, a leading member of the Utrecht Caravaggisti. In the 1630s he produced etchings after Cornelis van Poelenburch and later also after his own designs. The *Siege of Breda* (1637), printed from six plates, is a high point of his graphic work.

Van Bronchorst subsequently concentrated on oil painting, though continuing to work as a glass painter, and in 1639 he became a member of the Utrecht Guild of St Luke. His earliest dated oil painting, the *Idolatry of Solomon* (1642; Greenville, SC, Bob Jones U. Gal. Sacred A.), is notable for combining Flemish and Utrecht sources. The theatrical composition clearly relies on martyrdom scenes in the tradition of Veronese and Peter Paul Rubens, while the combination of contrasting areas of shadow and light with cool colouring is reminiscent of the work of van Honthorst as well as that of Hendrick ter Brugghen, whose painterly approach and fluent brushwork seem to have served as an example for van Bronchorst. A compositional type exploited by van Bronchorst throughout his career is that of the *Music-making Party on a Balcony* (e.g. 1646; Utrecht, Cent. Mus.), in which the figures are seen illusionistically from below, set against a classicizing architectural background; the result is a friezelike decorative composition, unlike the rough genre scenes of the Utrecht Caravaggisti. He did, however, follow his fellow Utrecht painters in incorporating life-size figures in pastoral costumes into his history paintings and genre scenes. The plump proportions and round faces of these figures give the pictures a provincial charm. There are only a few known portraits, painted in a style indebted to van Honthorst and Paulus Moreelse.

From 1647 van Bronchorst received major commissions for monumental glass windows in Amsterdam. The fame of his four windows in the Nieuwe Kerk was widespread, but the only surviving part is a section from the north transept window depicting the *Donation of the Amsterdam City Coat of Arms by Count Willem IV*. In its illusionistic portrayals and the modelling of the figures by means of an accentuated chiaroscuro, this window resembles the style of his oil paintings. One drawing survives for a window (destr.) in the Amsterdam Oude Kerk (1656; Amsterdam, Gemeente Archf). Due to the increasing number of such commissions he moved, *c.* 1650, to Amsterdam, where he became a citizen in 1652.

In Amsterdam, van Bronchorst continued to be successful and was involved in the most important contemporary decorative painting schemes. In 1655 he decorated the shutters of the new organ in the Nieuwe Kerk with scenes from the *Life of King David*. His experience in mastering monumental picture areas in his glass paintings was put to good use in these exceptionally large works. The main scene, the *Anointment of David* (1655), despite its impressive size and magnificent colouring is an incoherent composition, consisting of figural motifs taken largely from works by Veronese and Titian. His works for the Amsterdam Stadhuis (now the Royal Palace) show a similarly eclectic classicism. In 1659 he signed his last major work, *Moses Appointing Judges over the People of*

Israel, which was installed above one of the fireplaces in the council chamber (*raadzaal*). In 1660 he was asked by the civic commissioners to improve this enormous work but by then was suffering from a severe illness that probably prevented him from doing so.

(2) Johannes (Jansz.) van Bronchorst

(*b* Utrecht, *bapt* 21 Aug 1627; *d* Amsterdam, *bur* 16 Oct 1656). Painter, son of (1) Jan (Gerritsz.) van Bronchorst. Johannes and his younger brother Gerrit (Jansz.) van Bronchorst (*b* Utrecht, *c.* 1636; *bur* Utrecht, 1 April 1673), who later worked in the style of Cornelis van Poelenburch, travelled together to Rome, where Johannes is documented between 1648 and 1650. There he developed a cool, academic style, which he combined with Caravaggesque light effects. Closest to the work of Caravaggio is his *St Bartholomew* (1652; Vaduz, Samml. Liechtenstein). The influence of his father is perhaps most obvious in *Bathsheba with David's Letter* (Rome, Pal. Barberini). Its composition of figures seen from below was inspired by Jan Gerritsz.'s balcony scenes, but the darker colouring, the elegantly elongated proportions and the contemplative air of his figures distinguish the work from that of his father, as does the different style of his signature. In Rome and later in Amsterdam, he was regarded as the creator of particularly refined portraits, in which the sitters are so stylized as to be lifeless (e.g. *Nicolaes Oetgens van Waveren*; 1656; Amsterdam, Hist. Mus.).

Johannes returned to the Netherlands *c.* 1652 and collaborated with his father on larger projects, including the decoration of the Amsterdam Stadhuis, where he painted the ceiling of the Burgomaster's chamber with *Allegories of the Powers of the Burgomaster* (1655–6). The magnificent *Allegory of Dawn and Night* (Hartford, CT, Wadsworth Atheneum), long considered the work of his father, must be regarded as Johannes's masterpiece. Strongly influenced by contemporary Italian sources and by van Poelenburch, the two-tiered composition depicts Aurora and her attendants hovering in a dark cloud above the bearded figure of Tithonus and two river gods, who are seated in a hazy golden landscape reminiscent of those painted by Dutch Italianate artists. Johannes left a small oeuvre of impressive quality, which anticipated the endeavours of the following generation of Dutch classicists, such as Gérard de Lairesse. By the 18th century, however, he had been forgotten, and until the mid-1980s his works were wrongly attributed to his father.

Bibliography

Hollstein: *Dut. & Flem.*

S. Colvin: 'Drie brieven van Jan Gerritsz. van Bronchorst', *Oud-Holland*, iv (1886), pp. 212–13

A. van der Boom: 'Monumentale glasschilderkunst in Zuid- en Noord Nederland in de zeventiende eeuw', *Kunstgeschiedenis der Nederlanden*, iii, ed. J. Duverger (Utrecht, 1956), pp. 239–47

G. J. Hoogewerff: 'Jan Gerritsz. en Jan Jansz. van Bronchorst: Schilders van Utrecht', *Oud-Holland*, lxxiv (1959), pp. 139–60

J. R. Judson: 'Allegory of Dawn and Night', *Wadsworth Atheneum Bull.*, vi/2 (1966), pp. 1–11

B. J. Buchbinder-Green: *The Painted Decorations of the Town Hall of Amsterdam* (diss., Evanston, Northwestern U., 1974, microfilm, Ann Arbor, 1975), pp. 92–3, 112, 125–6, 132–4

Holländische Malerei in neuem Licht: Hendrick ter Brugghen und seine Zeitgenossen (exh. cat., ed. A. Blankert and L. J. Slatkes; Utrecht, Cent. Mus.; Brunswick, Herzog Anton Ulrich-Mus.; 1986–7), pp. 236–44

T. Döring: 'Caravaggeske Aspekte im Werk Johannes van Bronchorsts', *Hendrik ter Brugghen und die Nachfolger Caravaggios in Holland: Beiträge eines Symposions im Herzog Anton Ulrich-Museum Braunschweig 1987*, ed. R. Klessmann (Brunswick, 1988), pp. 155–65

—: 'Between Caravaggism and Classicism: Bathsheba by Jan Gerritsz. and Johannes van Bronchorst', *Hoogsteder-Naumann Mercury*, vii (1988), pp. 51–67

—: *Studien zur Künstlerfamilie van Bronchorst* (Alfter, 1993)

THOMAS DÖRING

Brugghen [Terbrugghen], Hendrick (Jansz.) ter

(*b* ?The Hague, 1588; *d* Utrecht, 1 Nov 1629). Dutch painter and draughtsman. He was, with Gerrit van Honthorst and Dirck van Baburen, one of the

leading painters in the group of artists active in Utrecht in the 1620s who came to be known as the Utrecht Caravaggisti, since they adapted Caravaggio's subject-matter and style to suit the Dutch taste for religious and secular paintings. Ter Brugghen was an important innovator for later Dutch 17th-century genre painting; his recognition as an unorthodox, but significant influence on the work of Johannes Vermeer and others is a relatively recent, 20th-century phenomenon.

1. Life and work

(i) Background and training in The Hague and Utrecht, before c. 1605. His grandfather, Egbert ter Brugghen (d 1583), was a Catholic priest who came from a prominent Utrecht–Overijssel family and who, in the last years of his life, served as the pastor of the Utrecht village of Ter Aa. Hendrick's father, Jan Egbertz. ter Brugghen (c. 1561–?1626), though illegitimate, had a successful career as a civil servant: in 1581 he was appointed secretary to the court of Utrecht by Prince William of Orange and in 1586 he was first bailiff *ordinaris* of the chamber of the Provincial Council of Holland at The Hague. Hendrick's date of birth is derived from the biographical inscription placed on the four frames of his series of the *Four Evangelists* (1621; Deventer, Stadhuis) by Richard ter Brugghen (c. 1618–1708/10), the only survivor of his eight children, who presented the canvases to the city of Deventer in 1707.

Hendrick was probably born in The Hague rather than Utrecht, as previously believed, since his father appears regularly in The Hague documents from 1585 to 1602. The young Hendrick probably also received his earliest education in The Hague. However, between 1602—when Hendrick would have been 13 or 14—and 1613, Jan ter Brugghen is again intermittently recorded in Utrecht, where Hendrick studied with Abraham Bloemaert—an indisputable fact supported by such 17th-century sources as Sandrart (1675), who had known the painter while a student in Gerrit van Honthorst's Utrecht workshop c. 1625–8. (Bloemaert was also van Honthorst's teacher.) What is unknown, however, is whether ter Brugghen first studied with some as yet unidentified master in The Hague before finishing his training with Bloemaert, or whether, like Rembrandt, he first received a conventional Latin education in preparation for a career as a civil servant. The matter is of some importance since it raises the possibility that ter Brugghen was a relatively late or slow starter, which might account for the problems involved in identifying his early work. Exactly how long Hendrick spent in Bloemaert's workshop also remains unknown, but it is unlikely that his training began before 1602, when his father returned to Utrecht.

(ii) Italy, c. 1605–14. During the summer of 1614 ter Brugghen, along with another Utrecht artist, Thijman van Galen (b 1590), was in Milan preparing for his return journey through St Gotthard's Pass to the northern Netherlands. In a Utrecht legal deposition dated 1 April 1615, concerning a third Utrecht artist they had met on their return journey, Michiel van der Zande (c. 1583–before 1643), and his young servant, the future landscape painter Frans van Knibbergen (c. 1597–1665 or after), ter Brugghen and van Galen testified that they 'had spent some years in Italy exercising their art'. The ambiguous Dutch term *ettelicke* ('some') used by ter Brugghen in the document usually implies an amount less than ten, thus suggesting that the presently accepted sojourn of ten years should be modified. While ter Brugghen could have spent as little as two or three years in Bloemaert's studio before travelling to Italy c. 1604 or 1605, he probably left in the spring or summer of 1605—at the age of 16 or 17. He must have arrived in Rome by 1606, if Cornelis de Bie's statement (1708) that he knew Rubens in that city is correct. If so, then ter Brugghen would have been the only member of the Utrecht Caravaggisti to have arrived in Rome while Caravaggio was still active there. Unfortunately, unlike his compatriots van Honthorst and Dirck van Baburen, there is no trace of ter Brugghen's long stay in Italy—either in the form of a document or a work of art. It may be that his youthful style in Italy was sufficiently different from that which he developed after his return to the northern Netherlands to remain unrecognized.

(iii) **Early Utrecht period, 1615–24.** In 1616 ter Brugghen entered the Utrecht Guild of St Luke and on 15 October of the same year he married Jacomijna Verbeeck (*d* 1634), the stepdaughter of his elder brother Jan Jansz. ter Brugghen, a Utrecht innkeeper. Even though Utrecht was a predominantly Catholic centre, the marriage ceremony took place in a Reformed Church, and since the children of this marriage were also baptized in the Reformed Church, it seems likely that the artist was himself Protestant rather than Catholic, as was previously thought. This raises important questions about the subject-matter and function of several of the artist's most important works.

Ter Brugghen's earliest known work, a life-size *Supper at Emmaus* (1616; Toledo, OH, Mus. A.), reveals that he had studied Caravaggio's painting of the same theme (between 1596 and 1602; London, N.G.) as well as another version by an anonymous north Italian artist (Vienna, Ksthist. Mus.). Thus ter Brugghen turned not only to the works of Caravaggio himself but also to his north Italian sources and followers. Indeed, various works by members of the Bassano family and their workshop exerted an ongoing influence on ter Brugghen. The only other known dated painting by ter Brugghen from this early Utrecht phase of his development is the signed and dated *Adoration of the Magi* (1619; Amsterdam, Rijksmus.), an important picture that betrays the influence of such followers of Caravaggio as Carlo Saraceni.

Several undated works by ter Brugghen can be assigned on stylistic grounds to the period before 1620, including the strikingly coloured, full-length version of the *Calling of St Matthew* (Le Havre, Mus. B.-A.), which ter Brugghen repeated in a more compact, half-length composition with a modified colour scheme (1621; Utrecht, Cent. Mus.). These two paintings and other early works are remarkable for their utilization of early 16th-century Netherlandish physiognomic types and still-life details intermixed with formal elements drawn from Caravaggio's famous painting of the same subject in S Luigi dei Francesi, Rome. In another apparent attempt to modify the Italianate elements of his style and thus make his work more acceptable to conservative Utrecht tastes, ter Brugghen, in the unusual *Christ Crowned with Thorns* (1620; Copenhagen, Stat. Mus. Kst), again tempered his personal form of Caravaggism with native poses and physiognomic features, this time drawn from the prints of Lucas van Leyden.

These traditional Netherlandish insertions largely ended with the return of van Honthorst and van Baburen from Italy during 1620. Together with ter Brugghen, these artists quickly succeeded in transforming the nature of Utrecht art during the following year. Indeed, at the beginning of 1621 ter Brugghen was still producing works such as the *Four Evangelists* (Deventer, Stadhuis), which has the same unusual mixture of Caravaggesque elements and traditional 16th-century Netherlandish still-life details. Later that same year, however, when he came into contact with the latest Italian Caravaggesque ideas brought back by van Baburen (with whom he probably shared a workshop from *c.* 1621 until van Baburen's death early in 1624), ter Brugghen executed two lovely pendant versions of *The Flute-player* (both Kassel, Schloss Wilhelmshöhe), one depicted in a pastoral manner, wearing an *all'antica*, toga-like costume, and the other more theatrically dressed in a flamboyant outfit of the type usually described as 'Burgundian'. These influential works are dependent on the Italian Caravaggesque elements developed by Bartolomeo Manfredi in Rome after ter Brugghen had departed in 1614; they can thus only have been introduced into Utrecht by van Baburen and van Honthorst. Van Baburen, in particular, was an important iconographic and artistic innovator in Utrecht, who provided ter Brugghen and other members of the Utrecht Caravaggisti with both new themes and new approaches to old themes; these were quickly taken up and transformed by ter Brugghen.

Despite their varied sources, the two versions of *The Flute-player* do possess the hallmarks of ter Brugghen's style and personality: a subtle utilization of unusual colour harmonies, lively brushwork and paint surfaces, complex and varied drapery folds and, especially, a certain reticence in the compositional structure, which stands in marked contrast to the more extrovert types and

arrangements frequently found in the pictures of van Honthorst and van Baburen. From 1621 ter Brugghen often employed a cool, crisp light source and a sense of form derived as much from the direct observation of the movement of light across surfaces as from such prime Italian followers of Caravaggio as Orazio Gentileschi. A closely similar light quality is found in van Baburen's work, implying that both painters developed this characteristic aspect of their style from their study of Gentileschi in Italy. Interestingly, ter Brugghen only rarely deployed the kind of artificial illumination popularized by van Honthorst.

In an effort to account for the new and up-to-date Italianate elements in the two versions of *The Flute-player* as well as in others, it has been suggested that ter Brugghen made a second journey to Italy (Schuckman). However, the only time when the artist's presence in Utrecht is not documented is between the summer of 1619 and the summer of 1621, hardly long enough for him to accomplish the full agenda of stylistic contacts and influences that some scholars would like to assign to this unconfirmed second sojourn in Italy. Furthermore, since there are more dated works by ter Brugghen from 1621 than almost any other year, it is unlikely that he could have spent any part of that critical year travelling.

After 1621 ter Brugghen produced numerous single-figure genre pictures of the type usually associated with Utrecht: lute-players, musicians, drinkers etc. These are usually rendered with a sensitivity beyond the reach of his Utrecht colleagues (who had originated these themes) and with compositional reticence that is frequently in sharp contrast to the type of activities depicted: the theatrical *Singing Lute-player* (c. 1623; Algiers, Mus. N. B.-A.), for example, is depicted in lost profile with his back turned towards the viewer. In the pendant canvases (both 1623) of a *Boy Lighting a Pipe* (Erlau, Lyzeum) and a *Boy Holding a Glass* (Raleigh, NC Mus. A.), ter Brugghen introduced the northern Caravaggesque device of internal artificial illumination associated in Utrecht with van Honthorst. Characteristically, ter Brugghen imbued these apparently simple genre depictions with ideas developed from popular

Dutch beliefs concerning the complementary effects of smoking (hot and dry) and drinking (hot and moist), adding an unusually sensitive investigation of the movement of candlelight across the complex arrangement of fabric and form. Moreover, especially in the better-preserved *Boy Lighting a Pipe*, one of the earliest paintings to focus exclusively on the new activity of tobacco smoking, he introduced idiosyncratic colour relationships quite different from those found in his works from before 1621.

About the same time ter Brugghen took up the traditional northern theme of the *Unequal Lovers* (c. 1623; New York, priv. col., see 1986–7 exh. cat., no. 14) in an unusually compact, half-length composition that suggests that he had early 16th-century northern moralizing pictures in mind. Indeed, specific details of the depiction of the old man—including his costume—indicate that ter Brugghen had read the appropriate passages in Erasmus's famous *In Praise of Folly* (1511). Although no longer indulging in the same kind of borrowing of archaic motifs as before, ter Brugghen clearly continued to look to his northern artistic antecedents more than his Utrecht contemporaries. At the same time, the picture is also strongly dependent on van Baburen for various stylistic and thematic elements; the two artists obviously had an unusually close working relationship throughout the early 1620s.

In the lovely *Liberation of St Peter* (1624; The Hague, Mauritshuis), with colour and compositional patterns that seem to develop out of the *Boy Lighting a Pipe*, ter Brugghen returned to religious subject-matter and introduced new physical types for both the angel and the saint, types that continued to recur in his works until his death. The new type for the angel, with its declamatory gesture, was probably at least partly indebted to van Baburen, who had used a similar pose for an *Annunciation* (untraced; copy by Jan Janssens, Ghent, Mus. B.-A.).

(iv) Mature Utrecht period, 1625 and after. About 1625 ter Brugghen entered into a new and more mature phase of his artistic development with two of his most important and innovative paintings, the

Crucifixion with the Virgin and St John (New York, Met.) and St Sebastian Tended by Women (Oberlin, OH, Allen Mem. A. Mus.). Both have monumental compositions and the sort of steep perspective traditionally associated with altarpieces for Catholic churches, although it cannot be proven that either ever served such a religious function. Most striking is the Crucifixion, an unusually expressive, but obviously 17th-century recreation of a 15th-century northern Netherlandish work of art. The low horizon line, the simple iconic composition, the star-studded sky and the rendering of the body of Christ, as well as other details, suggest that ter Brugghen—or more likely his patron—wanted an old-fashioned picture that could pass, at least at first glance, for a 15th-century altarpiece. The St Sebastian, on the other hand, is a modern Caravaggesque work that clearly reflects elements of Caravaggio's Entombment (Rome, Pin. Vaticana) as well as his Incredulity of Thomas (Potsdam, Neues Pal.); notable in all these works is the use of powerful descending diagonals and the careful positioning of the three heads. Although the new theme of St Sebastian Tended by Women owes something to van Baburen's innovative painting of the same subject (Hamburg, Ksthalle), ter Brugghen's version is one of those rare pictures that completely transcends its formal and iconographic sources, a work whose unusually high level of artistic and expressive perfection was rarely matched in Dutch 17th-century religious painting before the mature works of Rembrandt.

One of the most unusual of the extremely varied group of history and genre pictures that ter Brugghen created during the second half of the 1620s is the Sleeping Mars (c. 1625 or 1626; Utrecht, Cent. Mus.). The picture was enormously popular during the 17th century; around 1650 and even later it was the subject of several didactic poems, although the theme was explained entirely in terms of Dutch political events of that later period. In fact, ter Brugghen's picture was executed a few years after the Twelve Years' Truce between Spain and the revolting northern provinces of the Spanish Netherlands had ended in 1621 and should thus be understood as a plea for peace after the resumption of hostilities.

Medallions and tokens with similar images of the sleeping god of war had been struck to commemorate the signing of the truce in Utrecht in 1609, and the artist and his patron would certainly have been aware of the symbolic message of these and other related works.

Ter Brugghen's most beautiful and successful genre paintings, also among his mature works, include the candlelit Musical Company (c. 1627; London, N.G.). The composition's unusual formality, in contrast to the everyday activities depicted, along with other details suggest that ter Brugghen was inspired by a musical allegory similar to that found in Caravaggio's Musicians (New York, Met.). The choice of the three essential categories of music-making (voice, winds and strings) and the elegantly placed wine and grapes—symbolic of the Bacchic origins of music—support such an interpretation.

In 1627 the great Flemish painter Peter Paul Rubens visited Utrecht and stayed in the inn owned by ter Brugghen's brother (lending some credence to de Bie's report that the two artists had met in Rome). He apparently praised the work of ter Brugghen above that of all the other Utrecht artists. This praise would not be difficult to understand even if Rubens had seen only ter Brugghen's Musical Company. Rubens's visit may be at least partly responsible for the renewed use of Italian elements in ter Brugghen's work at this time, as can be seen, for example, in the candlelit Jacob and Esau (c. 1627; Madrid, Col. Thyssen-Bornemisza), which, although formally structured like the Musical Group, is also strongly indebted to elements borrowed from the Bassano workshop, as is his second version of the same theme (c. 1627; Berlin, Bodemus.). The rich and varied surface of the Musical Company and other late pictures by ter Brugghen, for instance Melancholy (Toronto, A.G. Ont.), make it clear that the master's renewed interest in north Italian painting was not limited to composition alone. The layers of fluid, semi-transparent brushwork, unusually subtle colour harmonies and artificial illumination all combine to produce some of the artist's most engaging works. Furthermore, single-figure compositions such as the candlelit Old Man Writing

(Northampton, MA, Smith Coll. Mus. A.), with its close investigation of artificial light effects, show that ter Brugghen was still influenced by early 16th-century Netherlandish sources, such as Lucas van Leyden's prints and early Leiden school painting, without resorting to the more obvious stylistic archaisms found in his work before 1621.

In stark contrast to the various late candlelit depictions is another group of late paintings, also from 1627 onwards, such as the *Allegory of Taste* (1627; Malibu, CA, Getty Mus.), which introduce a renewed interest in cool, bright daylight. Although the colour is in some ways indebted to early works such as *The Flute-player* pendants, it also benefits from the master's ongoing investigation of artificially lit surfaces and forms. As ter Brugghen approached the age of 40, he entered a new and more mature phase of his development, which features the cool and pale flesh tones seen in the *Allegory of Taste* and in *The Singer* (1628; Basle, Kstmus.). Interestingly, it is this lesser-known late phase of his activity as a painter that seems to anticipate aspects of Vermeer's style even more than the better-known works of *c*. 1621 usually cited.

During 1628 this new phase manifests itself in the use of bright, but subtle colour harmonies in, for example, the signed and dated *Lute-player and Singing Girl* (1628; Paris, Louvre; see col. pl. VIII), as well as in the pendants of ancient philosophers, the *Laughing Democritus* and the *Weeping Heraclitus* (both 1628; Amsterdam, Rijksmus.). The *Democritus* especially, with its beautifully rendered cool yellow highlights on the velveteen drapery, reflects the new and innovative direction of the master's formal and colouristic interests during this late stage in his career.

During the last two years of ter Brugghen's life, with works such as the *Annunciation* (1629; Diest, Stedel. Mus.), the artist continuously experimented with increasingly rich and varied paint surfaces, complex arrangements of drapery folds, the growing use of richly patterned oriental rugs and fabrics and an unusually subtle study of the movement of light across form—all qualities later present in the works of Vermeer. Several of ter Brugghen's late works, for example the painting of *Jacob, Laban and Leah* (Cologne, Wallraf-

Richartz Mus.), also include exceptionally sensitive investigations of still-life elements. Their paint surfaces are also more complex, due to the use of increasingly loose and fluid brushstrokes, which frequently overlay more studied and carefully applied areas as, for example, in *Melancholy* and *The Singer*, suggesting that ter Brugghen's premature death, at the age of only 41, may have cut short the most innovative stage of his artistic development.

2. Working methods and technique

The recurrence of figures, poses, facial types and motifs in works dated four and five years apart would seem to indicate that drawings played an important role in the artist's working procedures. A good example of such a repetition is the figure of the angel that appeared first in the *Liberation of St Peter* of 1624. Ter Brugghen later used a closely related, though full-length figure of the angel for two other paintings, both dated 1629: the *Annunciation* (Diest) and an expressively composed second version of the *Liberation of St Peter* (Schwerin, Staatl. Mus.). Furthermore, a similar, half-length angel also appears in the much repeated *King David with Angels* (1628; Warsaw, N. Mus.), which includes a facial type for King David that resembles that of St Peter from the picture of 1624.

Unfortunately, only three drawings by ter Brugghen have survived, all of which are complete compositions (e.g. *Laughing Democritus*, Rouen, Mus. B.-A.) rather than studies for individual figures or heads. Nevertheless, the pattern of repetition in his paintings does seem to support a method of working similar to that utilized by his teacher, Abraham Bloemaert. Thus, despite the obviously Caravaggesque components of his style, ter Brugghen's working method appears to be rooted in Utrecht Late Mannerist workshop procedures more than that of either the younger van Baburen or van Honthorst, despite the fact that the latter had also been a student of Bloemaert.

Bibliography

J. von Sandrart: *Teutsche Academie* (1675–9); ed. A. R. Peltzer (1925), pp. 178, 401

C. de Bie: *Den spiegel van der verdrayde werelt* (Antwerp, 1708)

J. J. Dodt van Fl[ensburg]: 'Heyndrick ter Brugghen', *Ber. Hist. Gez. Utrecht*, i (1846), pp. 129–36

M. E. Houch: 'Hendrick Ter Brugghen en zijn *Vier Evengelisten* te Deventer', *Eigen Haard*, 32 (1900), pp. 519–23

H. Voss: 'Vermeer van Delft und die Utrechter Schule', *Mhft. Kstwiss.*, v (1912), pp. 79–83

C. H. Collins Baker: 'Hendrik Terbrugghen and Plein Air', *Burl. Mag.*, l (1927), pp. 196–202

R. Longhi: 'Ter Brugghen e la Parte Nostra', *Vita Artistica*, ii (1927), pp. 105–16

A. von Schneider: 'Entlehnungen Hendrick Ter-Brugghen aus dem Werk Caravaggios', *Oud-Holland*, xliv (1927), pp. 261–9

W. Stechow: 'Zu zwei Bildern des Henrick Terbrugghen', *Oud-Holland*, xlv (1928), pp. 277–81

A. von Schneider: *Caravaggio und die Niederländer* (Marburg, 1933)

G. Isarlo: *Caravage et le caravagisme européen* (Aix-en-Provence, 1941)

Caravaggio en de Nederlanden (exh. cat., Utrecht, Cent. Mus.; Antwerp, Kon. Mus. S. Kst.; 1952); review by H. W. Gerson in *Kunstchronik*, v (1952), pp. 287–93; and by B. Nicolson in *Burl. Mag.*, xciv (1952), pp. 247–52

B. Nicolson: *Hendrick Terbrugghen* (The Hague, 1958)

——: 'Second Thoughts about Terbrugghen', *Burl. Mag.*, cii (1960), pp. 465–73

Hendrick Terbrugghen in America (exh. cat. by L. J. Slatkes, Dayton, OH, A. Inst.; Baltimore, MD, Mus. A.; 1965–6)

B. Nicolson: 'Terbrugghen since 1960', *Album amicorum J. G. van Gelder* (The Hague, 1973), pp. 237–41

——: *The International Caravaggesque Movement* (Oxford, 1979); review by L. J. Slatkes in *Simiolus*, xii (1981–82), pp. 167–83

M. J. Bok and Y. Kobayashi: 'New Data on Hendrick ter Brugghen', *Hoogsteder-Naumann Mercury*, i (1985), pp. 7–34

C. Schuckman: 'Did Hendrick ter Brugghen Revisit Italy? Notes from an Unknown Manuscript by Cornelis de Bie', *Hoogsteder-Naumann Mercury*, iv (1986), pp. 7–22

Holländische Malerei in neuem Licht: Hendrick ter Brugghen und seine Zeitgenossen (exh. cat. by A. Blankert, L. J. Slatkes and others; Utrecht, Cent. Mus.; Brunswick, Herzog Anton Ulrich-Mus.; 1986–7); review by B. Schnackenburg in *Kstchronik*, xl (1987), pp. 169–77

LEONARD J. SLATKES

Buytewech, Willem (Pietersz.)

(*b* Rotterdam, 1591–2; *d* Rotterdam, 23 Sept 1624). Dutch painter, draughtsman and etcher. Although he was born and died in Rotterdam, stylistically he belongs to the generation of young artists working in Haarlem at the beginning of the 17th century. He was nicknamed 'Geestige Willem' (Dut.: 'inventive, or witty, Willem') by his contemporaries, and during his short career he made an important and highly personal contribution to the new approach to realism in Dutch art. He was one of the first to paint interiors with merry companies and is primarily known for his lively and spontaneous drawings and etchings on a wide range of subjects.

1. Life and work

The name Buytewech may derive from (Buiten)achterweg ('outer back road'), where Willem's father, the cobbler Pieter Jacobsz., was living on 3 February 1591 when he married Jutgen Willemsdr. Buytewech's earliest work, a signed engraving of the *Flute-player* (1606), carries an inscription that connects it with an inn just outside Rotterdam. In style it shows the influence of the previous generation of Dutch printmakers (Crispijn van de Passe I and Hendrick Goltzius, possibly through the work of Jacob Matham). Buytewech is next mentioned in 1612 when, with Esaias van de Velde (i) and Hercules Segers, he entered the Haarlem Guild of St Luke. Two years later the engraver Jan II van de Velde (i) also became a member. Buytewech remained in close contact with him for the rest of his life, even after returning to Rotterdam in 1617.

On 16 September 1624, in his early thirties, Buytewech—'sick in body'—drew up his will. He died a week later and was buried in Rotterdam's Grote Kerk. After his death his wife, Aaltje Jacobsdr. van Amerongen, whom he had married in Haarlem in 1613, gave birth to Willem Willemsz. Buytewech (*b* Rotterdam, *bapt* 4 Jan 1625; *bur* Rotterdam, between 20 and 26 April 1670), who also became an artist. Six landscape paintings, mostly on panel (London, N.G.), and at least one drawing (*Goats in a Landscape*, 1652; Vienna, Albertina) by him are known. His

speciality was Christmas nocturnes with animals (*Karsnagten en beesjes*), according to the painters index (1669–78) made by the Amsterdam city doctor Jan Sysmus (A. Bredius: 'Het schildersregister van Jan Sysmus, stads doctor van Amsterdam', *Oud-Holland*, viii (1890), pp. 1–8; xiii (1895), p. 113), such as the *Annunciation to the Shepherds* (1664; untraced, see Naumann, fig. 5), which is in the style of Benjamin Gerritsz. Cuyp. His landscapes show the influence of Jan Asselijn and Jan Wijnants (e.g. *Dune Landscape*, London, N.G.), under whose names many may still be known.

(i) **Drawings.** Buytewech's highly praised versatility emerges not only from his use of different techniques but also from his great range of subjects, especially in his drawings: religious and historical scenes, figures, interiors, scenes of everyday life, allegories, groups, architectural features, landscapes, designs for book illustrations etc. Only a few works are dated, making it difficult to establish a chronological and stylistic development, especially as they were produced over such a short period. Thus his oeuvre is usually treated thematically. The *c.* 125 drawings attributed to him include religious scenes with striking contrasts of light and dark (e.g. the *Holy Family*; Amsterdam, Rijksmus.). His sketches of fashionably dressed dandies and young women, some of which often seem almost grotesque (e.g. the *Standing Man*; Hamburg, Ksthalle; Haverkamp-Begemann, 1959, no. 53), are executed with great freedom, giving the impression of drawings from life. The same can be said of the *Sleeping Woman* (Paris, Fond Custodia, Inst. Néer.), a subject rarely depicted at that time. The carefully executed *Interior with a Family by the Fire* (1617; Hamburg, Ksthalle) also seems to represent an actual scene but was based on a much sketchier drawing (Berlin, Kupferstichkab.). The many corrections (done by means of overlaid pieces of paper) and altered details demonstrate the contrived nature of the final version. By contrast, Buytewech's drawing of the scene when a sperm whale was stranded on the beach between Scheveningen and Katwijk in January 1617 must have been done on the spot (Berlin, Kupferstichkab.). The same sketchy manner of drawing recurs in the *Anatomy Demonstration at Leiden* (Rotterdam, Boymans–van Beuningen). Two drawings representing a *Fool with Herrings and Sausages round his Neck* (both Paris, Fond Custodia, Inst. Néer.) show familiarity with the work of Frans Hals, as the figure in these drawings was taken from Hals's painting *Shrovetide Revellers* (*c.* 1615; New York, Met.).

Besides the many sketches showing groups of women and children there are a number of precise, detailed drawings intended for prints. Most of these date from Buytewech's period in Rotterdam when he had, apparently, given up making etchings. Among them is a series of designs for regional costumes, first engraved in Haarlem by Gillis van Scheyndel. A carefully worked-out scene of an *Interior with Dancing Couples and Musicians* (Paris, Fond Custodia, Inst. Néer.) served as a preparatory drawing for Cornelis Koning (*fl* 1608–33), another engraver and publisher working in Haarlem. Buytewech also provided designs for the title-pages of two books, Johan Baptist Houwaert's *Den handel der amoureusheyt* ('Amorous trade'; Rotterdam, 1621) and *Alle de spelen* ('The complete plays') by G. A. Bredero (Rotterdam, 1622). Both were engraved by Jan van de Velde. Apart from engraving a number of biblical or religious subjects after designs by Buytewech, van de Velde was also responsible for two series representing the *Four Elements*. Two of the designs for these series survive; one of them, the *Vinkebaan* (shooting and trapping range for small birds; Rotterdam, Boymans–van Beuningen), symbolizes *Air*. The figures are set in a landscape similar to that found near Haarlem. The drawing belongs to a small group in which the subject forms a remarkable unity with the landscape.

A different impression is created by a pair of drawings depicting a wooded landscape by a lake (both London, BM), which are regarded as Buytewech's earliest known landscapes. In these, the influence of Adam Elsheimer (undoubtedly transmitted through the engravings of Hendrick Goudt) is unmistakable. But the drawing of the trees, with their cauliflower-like crowns and twisted branches, is a distinctive and highly

personal feature of Buytewech's landscapes, in which the presence of human beings is entirely subordinated to the scenery (further examples, U. London, Courtauld Inst. Gals, Cambridge, Fitzwilliam, and Washington, DC, N.G.A.). Figures are omitted altogether in some drawings of buildings or landscape, for example *Landscape with a Row of Trees* (Berlin, Altes Mus.). In total contrast are the sketchy drawings of easily recognizable motifs in a more spacious setting (e.g. *View of Scheveningen*; Rotterdam, Boymans–van Beuningen).

(ii) **Etchings.** Buytewech's most original contribution to Dutch landscape imagery is his series of ten etchings (including the title-page) of *Various Little Landscapes* (c. 1616; Hollstein, nos 35–44). Made immediately after those of Esaias and Jan van de Velde (1612 and 1615), it exemplifies his new and highly personal interpretation of the landscape. Three of the nine sheets show a ruin; in the remaining six, trees are the main motif, their twisted trunks rhythmically rendered and their branches fanning out at the top.

In all, 32 prints by Buytewech are known. They were presumably made in Haarlem between 1612 and 1617 and are almost all pure etchings. Three prints with religious subjects are included among the early works; two of these, *Cain and Abel* (Hollstein, no. 1) and *St Francis* (Hollstein, no. 9), are copies after, respectively, Peter Paul Rubens and John Matham. Two of the three etchings of *Bathsheba* (c. 1615–16; Hollstein, nos 2–4) also demonstrate Buytewech's familiarity with Rubens's work. As with the drawings of biblical subjects, these prints show strong contrasts of lighting, particularly evident in the dramatic image of *Bathsheba Reading David's Letter* (c. 1616; Hollstein, no. 4). A comparable dynamic treatment can be found in *Lucelle and Ascagnes* (Hollstein, no. 17), which was intended as an illustration for Bredero's translation (1616) of François-Louis Le Jars's play *Lucelle* (Paris, 1576). In both prints the underlying theme is that of *vanitas*. The etchings of stranded sperm whales (1614, 1617; Hollstein, nos 14, 13) have also been given a moralizing interpretation, since the incidents were

regarded by contemporaries as bad omens or punishment for sin; but Buytewech's purpose would seem to have been mainly documentary. In the print of 1614 are the same elegantly dressed figures as in the series of *Seven Noblemen* (Hollstein, nos 21–7), which represents young noblemen of seven nationalities. These are Buytewech's most personal etchings. The lively manner in which the modish figures are depicted was unmatched in his time.

(iii) **Paintings.** Figures are also the subjects of all of Buytewech's paintings. His oeuvre is presently thought to comprise ten paintings, previously attributed to Frans or Dirck Hals. They are neither signed nor dated, but the costumes and stylistic parallels with his graphic work suggest that they were painted in the last years of his life, between 1616 and 1624. Although he borrowed subjects from Frans Hals (as in his *Merry Company in the Open Air*, c. 1616–17; Berlin, priv. col., on loan to Berlin, Gemäldegal.), he developed a genre of his own in four depictions of merry companies in interiors. In three of these paintings, fashionably dressed young men and women are set in a room, the main motif of which is a map on the back wall (Rotterdam, Boymans–van Beuningen; The Hague, Mus. Bredius; Budapest, Mus. F.A.). The activities portrayed, such as smoking, drinking and card playing, symbolized worldly pleasure, giving these pictures a moralizing message. Erotic allusions such as rosebuds, a fountain and a cobweb occur in the *Formal Courtship* (c. 1616–17; Amsterdam, Rijksmus.). A striking feature is the balanced, almost classical composition in which the exaggeratedly stylish figures are represented. In contrast to the apparent freedom with which he drew figures and their settings, his paintings are obviously contrived. The stiff appearance of the figures, which often seem large for the space, suggests that he used lay figures.

2. Working methods and technique
The majority of Willem Buytewech's drawings are executed in pen and ink. The religious scenes have strong lines and broadly washed areas in graduated tones. Pen sketches, apparently drawn from

life, are often reworked with a fine brush. The designs for his prints are carefully executed compositions in pen and brush, often in combination with black chalk, a medium he sometimes used on its own, for example in the *Surgeon* and the *Bleeding* (both 1616; Haarlem, Teylers Mus.). He used red chalk only occasionally. The group of landscape drawings without figures shows highly original handling: small loops and circles drawn with a pen to represent foliage, as found in Hercules Segers's etchings.

Buytewech's own etchings, which were initially executed with a mixed technique, display an exceptionally supple line. With Esaias van de Velde he was one of the first to use the etching needle alone, in a manner not suggestive of the burin. His use of pointillé next to heavy shadows and the combination of swelling lines and short, sharp hooks, lend great variety.

Buytewech's paintings on canvas show a remarkably thin use of paint, and the colours are clearly separated from each other. In comparison with Dirck Hals, his painting technique is crisper, and his figures look rather linear. His paintings lack the lively highlights so characteristic of Hals's work.

3. Critical reception and posthumous reputation

From an early date Buytewech's drawings and etchings and the prints made after his work were regarded as collectors' items. They are mentioned in Rembrandt's estate inventory of 1656 ('A ditto [book] full of prints by Frans Floris, Buijtewech, Goltseus, and Abraham Bloemer') and Jan van de Capelle's inventory of 1680 ('A ditto [portfolio] with 86 drawings by Willem Buijtewech' and 'a ditto [portfolio] with 161 sketches by Buijtewech and Gout'). The auction (14 May 1736) of the collection of Samuel van Huls (1655–1734), burgomaster of The Hague, included no less than 120 drawings by 'Geestige Willem'. The Delft collector Valerius Röver found the *Interior with a Family by the Fire* 'so far removed (*'buiten de weg'*) from the usual manner of drawing that I cannot think of anything like it'.

Little is said about Buytewech in early art-historical literature. Apart from Orlers's account of Jan Lievens, who made drawings in 1618 after 'prints of Geestighe Willem', the next reference is by Houbraken (1719), who described him as a painter of 'companies of young ladies, gentlemen and peasants'. After this the artist and his work seem to have been forgotten. His paintings were attributed to other artists, while his drawings and prints were dispersed in various collections. The 'rediscovery' of Buytewech at the beginning of the 20th century led to various publications (e.g. Goldschmidt, Martin and the catalogue raisonné of the etchings by van Gelder). Haverkamp-Begemann's catalogue of the complete works (1959) is now regarded as the standard reference work on 'Geestige Willem'.

Bibliography

Hollstein: *Dut. & Flem.*, iv, pp. 53–77

J. Orlers: *Beschrijvinge der stadt Leyden* . . . (Leiden, 1641), p. 376

A. Houbraken: *De groote schouburgh* (1718–21), ii, p. 90

A. Goldschmidt: 'Willem Buytewech', *Jb. Kön.-Preuss. Kstsamml.*, xxiii (1902), pp. 100–17

W. Martin: 'Hoe schilderde Willem Buytewech', *Oud-Holland*, xxxiv (1916), pp. 197–203

L. Burchard: *Die holländischen Radierer vor Rembrandt* (Berlin, 1917), pp. 52–9

G. Poensgen: 'Beiträge zur Kunst des Willem Buytewech', *Jb. Kön.-Preuss. Kstsamml.*, xlvii (1926), pp. 87–102

G. Knuttel Wzn: 'Willem Buytewech', *Meded. Dienst Kst & Wetsch. Gemeente 's-Gravenhage*, iv (1928), pp. 116–24

——: 'Willem Buytewech: Van manierisme tot naturalisme', *Meded. Dienst Kst & Wetsch. Gemeente 's-Gravenhage*, v–vi (1928), pp. 181–98

J. G. van Gelder: 'De etsen van Willem Buytewech', *Oud-Holland*, xlviii (1931), pp. 49–72

E. Haverkamp-Begemann: *Willem Buytewech* (Amsterdam, 1959)

J. S. Kunstreich: *Der geistreiche Willem: Studien zur Willem Buytewech, 1591–1624* (Cologne, 1959)

E. Haverkamp-Begemann: 'The Etchings of Willem Buytewech', *Prints*, ed. C. Zigrosser (New York, 1962), pp. 55–81

Willem Buytewech, 1591–1624 (exh. cat. by J. Giltay and others; intro. E. Haverkamp-Begemann; Rotterdam, Boymans–van Beuningen; Paris, Inst. Néer., 1974–5) [excellent plates of almost all the graphic work by and after Buytewech]

O. Naumann: 'Willem Buytewech the Younger', *Essays in Northern Art Presented to Egbert Haverkamp-Begemann*, ed. A. M. Logan (Doornspijk, 1983), pp. 194–8

J. A. Welu: 'The Maps of Willem Buytewech', *Hoogsteder-Naumann Mercury*, v (1987), pp. 21–8

Dawn of the Golden Age (exh. cat., ed. G. Luijten and others; Amsterdam, Rijksmus., 1993–4)

MARIA VAN BERGE-GERBAUD

Calraet [Kalraet], Abraham (Pietersz.) van

(*bapt* Dordrecht, 12 Oct 1642; *bur* Dordrecht, 12 June 1722). Dutch painter. He was the eldest son of Pieter Jansz. van Calraet (*c.* 1620–81), a sculptor from Utrecht. According to Houbraken, Abraham was taught by the Dordrecht sculptors Aemilius and Samuel Huppe, although nothing is known of his activity as a sculptor. Houbraken also stated that Abraham learnt to paint figures and fruit and that his brother Barent van Calraet (1649–1737), who specialized at first in horse paintings but later imitated the Rhine landscapes of Herman Saftleven, was a pupil of Aelbert Cuyp (*see* CUYP, (3)). The known signed works by Barent confirm this. A painting of two horses in a stable, initialled APK (Rotterdam, Mus. Boymans–van Beuningen), indicates that Abraham, too, must have been well acquainted with Cuyp and provides the basis for identifying Abraham's painting style. A large number of landscapes with horses, paintings of livestock in stables and still-lifes, all initialled A.C. and formerly attributed to Aelbert Cuyp, are now generally considered to be the work of van Calraet, although many of these are in fact copies after him.

In van Calraet's studio were several paintings by Cuyp and after him, as well as copies after Philips Wouwerman, Jan Both and other landscape artists. Van Calraet himself often painted cattle and horses (e.g. *Horse with a Saddle beside it*, London, N.G.) or *Horses before an Inn* (St Petersburg, Hermitage). Closely related to Cuyp's work, van Calraet's handling is nonetheless smoother, broader and more monochromatic. To some extent, the oeuvres of the two artists remain confused. Some works by van Calraet, such as the *River Landscape* (London, N.G., 53, as Cuyp), are

close in concept to Cuyp's work and must have been meant as imitations. His paintings of stable interiors (e.g. 1851; London, N.G.) are strongly indebted to Wouwerman. A *Battle Scene* (Amsterdam, Rijksmus.) is of a more independent impulse, although still based ultimately on Cuyp. Van Calraet showed greater willingness than Cuyp to tackle figural subjects, as in his *Christ Entering Jerusalem* (Glasgow, C.A.G.). Most original and striking among van Calraet's paintings are his delicate, deeply shadowed still-lifes, usually showing fruit on a table, with brilliantly coloured butterflies (e.g. Otterlo, Rijksmus. Kröller-Müller). Although these are widely believed to have been derived from Cuyp's work, in fact no securely attributable still-life by Cuyp has been located.

Van Calraet married Anna, daughter of the Dordrecht painter Cornelis Bisschop, on 30 June 1680.

Bibliography

Thieme-Becker

A. Houbraken: *De groote schouburgh* (1718–21), iii, pp. 181, 292

G. H. Veth: 'Aanteekeningen omtrent eenige, Dordrechtsche schilders: Barent van Kalraet', *Oud-Holland*, vii (1889), pp. 304–5

A. Bredius: 'Der Stillebenmaler Abraham (van) Calraet', *Kunstchronik*, xxv (1914), pp. 93–4

—: *Künstler-Inventare*, i (The Hague, 1915), pp. 307–20

—: 'The Still-life Painter Abraham Calraet', *Burl. Mag.*, xxx (1917), pp. 172–9

F. Schmidt-Degener: 'Kalraet in Boymans', *Oude Kst*, iv (1918–19), pp. 285–91

J. L. van Dalen: 'De familie van Calraet', *Oud-Holland*, xlii (1925), pp. 172–5

J. G. van Gelder: 'A. Calraet, niet Cuyp', *Ksthist. Meded. Rijksbureau Ksthist. Doc.*, i (1946), pp. 7–8

L. J. Bol: *Goede onbekenden*, ii (The Hague, 1979, 2/Utrecht, 1982), pp. 14–20

De zichtbaare wereld (exh. cat., Dordrecht, Dordrechts Mus., 1992), pp. 106–13

ALAN CHONG

Cappelle, Jan van de

(*bapt* Amsterdam, 25 Jan 1626; *bur* Amsterdam, 22 Dec 1679). Dutch businessman, collector, painter, draughtsman and etcher. Though now considered

the outstanding marine painter of 17th-century Holland, he was not a professional artist nor a member of the Amsterdam Guild of St Luke. His father owned a successful dye-works in Amsterdam, in which both Jan and his brother Louis were active. Their father enjoyed a long life and probably managed the firm until close to his death in 1674, when Jan inherited it. This left Jan with plenty of spare time to pursue his hobby, painting. He married Annetje Jansdr. (Anna Grotingh) before 1653. He died a widower, survived by his seven children, who inherited his considerable fortune. His last will shows that in addition to the dye-works and immense cash assets, van de Cappelle owned extensive properties and an art collection that must be rated among the most important of his time.

Apart from his involvement with the arts, Jan shared his countrymen's love of ships and sailing. He owned a pleasure yacht, moored in the 'oude yacht haven', which must have taken him on many trips along the Dutch coast and rivers, giving him an opportunity to sketch and draw from nature.

1. Art collection

The inventory of the collection, dated 1680, lists 200 paintings and more than 7000 drawings by a wide range of artists. The drawings included 798 by the artist's own hand (mostly untraced), 900 by Hendrick Avercamp, 300 by Esaias van de Velde, 400 by van Goyen and a few by Willem van de Velde the elder. By far the largest number of drawings, 1300, was by Simon de Vlieger, probably acquired after the artist's death in 1653. There were no less than 500 drawings by Rembrandt, most of them acquired at the artist's insolvency sale in 1658; they included nearly 300 (almost all) of Rembrandt's landscape sketches. Among the paintings were portraits of van de Cappelle and his wife by Rembrandt, Frans Hals, Gerbrandt van den Eeckhout and Jan van Noort (all untraced). There were in total seven paintings by Rembrandt, five by Hercules Segers and three by Rubens, as well as a copy by van de Cappelle after a painting by de Vlieger and another after Jan Porcellis, whose autograph work was represented by sixteen examples. Van de Cappelle may have used works in the

collection for his own study purposes, but most of the items were acquired long after he had developed his own style. The quality of the works shows the taste and discrimination of a true collector and patron.

2. Paintings

Van de Cappelle was a prodigy, whose own dated pictures range from as early as 1644 (*Winter Scene*; untraced) to 1663. In 1654 Gerbrand van den Eeckhout, Rembrandt's pupil and friend, wrote a quatrain in the *album amicorum* of the humanist Jacob Heyblocq, praising the 'art of Johannes van de Cappelle who taught himself to paint out of his own desire'. This confirms that van de Cappelle was self-taught, but the quality of his paintings suggests that he must have practised rigorously from an early age, seeking advice and guidance from established marine painters in Amsterdam. A close relationship with Simon de Vlieger in his formative years seems certain, but Willem van de Velde the elder, who shared van de Cappelle's enthusiasm for shipping, also seems to have played a part in his development. Van de Cappelle's oeuvre is small: fewer than 150 paintings are known, most of which are marine scenes, with a small proportion treating the subject of winter landscape. He greatly influenced the marine painters of his generation, particularly Hendrick Dubbels and Willem van de Velde II. His winter landscapes were copied and emulated by Jan van Kessel and others.

(i) Marine subjects. Van de Cappelle's early picture of *Shipping in a Calm* (1645; England, D. Robarts priv. col.) is a fully fledged masterpiece by an artist not yet 20, pioneering a new approach to Marine painting. While sharing the new luminosity of sky and water of de Vlieger's beach scenes of the 1640s, it introduces a novel compositional system, with a group of large ships set close to the picture plane and the diminishing forms of other ships leading in strict linear perspective towards the far horizon. This perspective device lends great depth to the picture space and is not seen in de Vlieger's paintings before 1649. However, a signed and dated sheet of perspective studies by de Vlieger (1645;

London, BM) indicates that he was also experimenting with ship perspective in the very year that van de Cappelle painted his picture. It seems that the young student translated into paint the older master's theoretical studies. Experiments based on new optical discoveries were probably, in fact, carried out jointly by de Vlieger and van de Cappelle. One of Jan's rare beach scenes (1651) seems to echo de Vlieger's earlier *Beach* (1643; both The Hague, Mauritshuis). However, van de Cappelle's painting transcends those of the older master by introducing new subtleties in the treatment of light and reflections. This new fascination with light effects culminated in van de Cappelle's masterpiece, *A Calm* (Cologne, Wallraf-Richartz-Mus.), in which the cool radiance of a rising sun over the water, accentuated by the single figure of a fisherman and two groups of small boats, is the dominating motif in a deceptively simple composition.

In the late 1640s and the early 1650s van de Cappelle perfected the type of marine painting first represented in the picture of 1645, which is known as a 'parade' (i.e. a formal gathering of ships for a ceremonial occasion). He was clearly interested in the pictorial effects of ships anchored in smooth water, their hulls and sails bathed in sparkling light and echoed in the luminous, faintly broken reflections underneath the surface. The geometric precision of the ships' alignment and the architectural clarity of their forms lend firm structure to a composition largely depending on vaporous skies filled with billowing clouds over a very low horizon. The contrast of rigid masts and hulls with the fluidity of light, reflections and atmosphere is epitomized in such 'parades' as the *River Scene with a State Barge* (1650; London, N.G.) and the *State Barge Saluted by the Home Fleet* (1650; Amsterdam, Rijksmus.). The 'parade' boats are filled with elegantly dressed people. Their costumes provide touches of local colour, but the figures are always carefully integrated into the overall composition.

Other paintings feature small craft and more humbly dressed fishermen at work or passenger barges peacefully drifting along the banks of a river (e.g. *River View with Boats*, 1651; Zurich, Ksthaus). These paintings are distinguished by an all-pervading luminous atmosphere that softens all outlines and unifies forms and local colours. Linear perspective in the formation of ships and boats is complemented by the masterly treatment of aerial perspective. The saturation of colours is reduced, while the brightness of light is increased towards the horizon. The intensity of light just above the horizon line suggests the infinite continuity of space. More than any other artist of his time, with the exception only of Rembrandt, van de Cappelle was a painter of light.

Van de Cappelle's earlier works recall the cool silvery hues of de Vlieger, but carefully controlled local colours in costumes, sails and coastal motifs, together with the rainbow tints of clouds and the fiery red of smoke billowing from gun salutes, combine to enliven the uniform greyness prevalent in marines of the so-called 'tonal school' of painting in Haarlem. In his later works van de Cappelle used a warmer golden tonality, exceptionally allowing himself a greater colouristic exuberance when setting the rosy glow of a sunset sky against water of a deep turquoise blue, as in the *River Scene with Sailing Vessels* (Rotterdam, Mus. Boymans–van Beuningen). This must be a late work, influenced by the sunsets of Salomon van Ruysdael's late paintings.

The majority of van de Cappelle's marine paintings feature ships or boats seen from an expanse of calm water. The view is flanked unobtrusively on one or both sides by a jetty, a narrow promontory or strip of beach with boats at anchor and fishermen at work. Only a handful of van de Cappelle's known works are scenes with rough water (e.g. *The Beach*; The Hague, Mauritshuis), and none shows a storm at sea. The painting of a 'Storm by the deceased' mentioned in the artist's inventory after his death has never been found.

(ii) **Winter scenes.** Fewer than 20 fully authenticated winter scenes by van de Cappelle are known; these range in date from 1652 to 1654 (the *Winter Scene* of 1644 being untraced). He derived his motifs and compositional ideas for winter landscapes from earlier Dutch masters, notably Hendrick Avercamp, Isaac van Ostade and Esaias van de Velde. His winter scenes have many affinities with

those of Aert van der Neer, but they are more austere. Only a few figures of skaters or players of *kolf* (a simple type of ice hockey) appear on the frozen canals or rivers, and they are incidental to the study of nature. The silvery sparkle of a winter sky, often mingled with the rosy hues of a sunset, is integrated with the reflecting surface of an expanse of frozen water. Light bounces off the snow-covered branches of bare trees, their diminishing forms leading the eye towards the far horizon in a perspective formation that resembles the rows of ships in the 'parade' pictures. Figures are arranged in depth strictly according to the rules demonstrated in de Vlieger's sheet of perspective studies (other masterpieces of this type of winter landscape are in Amsterdam, Rijksmus., and Madrid, Mus. Thyssen–Bornemisza.) Two winter landscapes in upright format—*Frozen Canal* (Enschede, Rijksmus. Twenthe) and *Winter Landscape* (England, priv. col., see Russell, fig. 30)—are pure studies of nature, eliminating the genre element of skating figures; they seem to belong to a later period, probably the late 1650s and early 1660s.

3. Drawings and prints

Most of the artist's drawings listed in the 1680 inventory have been lost, and signed and dated examples are extremely rare; only one of them, the *Barge with Soldiers* (16[4]6; Berlin, Kupferstichkab.), is a marine scene. This close-up study of a boat and figures demonstrates van de Cappelle's skill in rendering figures in convincing poses, with only a few delicate strokes of the pen. Subtle washes add the effects of atmosphere and diffused light. Even more atmospheric is the unsigned *Ferry Boat with Travellers and Three Horses* (Hamburg, Ksthalle), which is a preparatory drawing for the painted *Marine* (Antwerp, Kon. Mus. S. Kst.). Its careful execution implies that the artist worked painstakingly and slowly on even the simplest motifs to arrive at the mastery of his finished paintings.

Drawings of winter scenes are relatively more frequent. Of particular interest is the sketch of a frozen river with *kolf* players in Heyblocq's *album*

amicorum, which is accompanied by van den Eeckhout's rhyme. The same album contains one of the more crowded and animated winter scenes by Aert van der Neer, contrasting with the serene calm of van de Cappelle's composition. (More finished drawings are in Paris, Fond. Custodia, Inst. Néer., and Haarlem, Teylers Mus.) A late drawing (1662; Berlin, Kupferstichkab.), though still impressive in the treatment of light and reflections, is less delicate. Two other drawings of winter scenes (both Hamburg, Ksthalle) must also be late; they lack the compositional harmony of the 'golden' period, which culminated in the 1650s.

Only two etchings signed by van de Cappelle are known. One is of a *Wide River with Fishing Boats* (Hollstein, no. 1), signed in reverse *J. V. Capel*. The form of signature and manner of execution confirm a date before 1650. The *Winter Landscape with a Stone Bridge* (Hollstein, no. 2) must date from the 1650s. The composition is derived from Rembrandt's painting of a *Landscape near Ouderkerk* (Amsterdam, Rijksmus.). A third etching, also a winter scene (Hollstein, no. 3), seems to be by a follower. The eight etchings of pure landscapes attributed to van de Cappelle (Hollstein, nos 4–11) and variously carrying the signatures of Jan van Goyen and Jacob Esselens are uncharacteristic of the artist's style and are not accepted by Stechow and other experts.

Bibliography

Hollstein: *Dut. & Flem.*

A. Bredius: 'De schilder Johannes van de Cappelle', *Oud-Holland*, x (1892), pp. 26–40, 133–6

C. Hofstede de Groot: *Holländischen Maler*, vii (1918)

W. Stechow: *Dutch Landscape Painting in the Seventeenth Century* (London, 1968), pp. 95–8, 106–8

M. Russell: *Jan van de Cappelle, 1624/6–1679* (Leigh-on-Sea, 1975) [with full bibliog., docs & complete cat. rais. by Hofstede de Groot, with revisions and addenda]

Mirror of Empire: Dutch Marine Art of the Seventeenth Century (exh. cat. by G. S. Keyes, Minneapolis, MN, Inst. A.; Toledo, OH, Mus. A.; Los Angeles, CA, Co. Mus. A.; 1990–91), nos 10–12

MARGARITA RUSSELL

Claesz, Pieter

(*b* Burgsteinfurt, Westphalia, *c.* 1597; *d* Haarlem, 1660). Dutch painter of German birth. He apparently spent his entire career in Haarlem, where he specialized in still-life paintings. Well over 100 works survive, dating from 1621 to 1660. Most of his pictures are dated and monogrammed PC. Since those initials were shared by the Antwerp still-life painter Clara Peeters, several attributions are disputed.

Claesz's depictions of modest objects arranged on a table-top exemplify the development of Dutch still-life painting in the 17th century. Early in his career he was an outstanding exponent of the monochromatic still-life, which echoed the 'tonal' landscapes produced by contemporary Haarlem landscape painters. Claesz employed colour schemes unified by a predominating neutral tone, typically favouring warm browns, golds and olive greens, which he sparked with the yellows and reds of fruits or contrasted with the cool greys of silver and pewter. He experimented with both daylight and candlelight, often causing a shadow to fall diagonally on the background wall. Claesz's earliest known work, *Still-life with a Stoneware Jug* (1621; England, priv. col., see Bergström, fig. 100), is a 'breakfast piece' (*ontbijtje*) in the manner of Haarlem still-life painters Nicolaes Gillis (*fl* 1601–32), Floris van Dijck and Floris van Schooten. Bowls of fruits and berries, wine and olives are arranged at regular intervals beside a jug on a white damask tablecloth, in a compositional type that is usually termed 'additive'. Local colour is strong and the viewpoint high, so as to invite inspection of the deliberately placed objects, hardly any of which overlap. Already, however, Claesz's distinctive character is revealed in the unifying atmosphere, the convincing illusionism and the sense of space created by the diagonal arrangement.

The intimate grouping of fewer objects in a simple monumental design typifies Claesz's mature or middle period. His remarkably simple compositions of the 1630s and 1640s are tightly knit and ingeniously yet naturally constructed, often around a dominating formal motif, such as

the fanning diagonals in the *Still-life with Smoking Implements* (1638; priv. col., see Vroom, i, figs 39, 156). His works of this period often resemble those of his Haarlem colleague Willem Claesz. Heda in subject-matter, composition and monochromatic harmony, but Heda characteristically preferred cooler, more luminous effects captured with exceptional refinement. Claesz's technique is sometimes meticulous, as in the *Still-life with a Turkey Pie* (1627; Amsterdam, Rijksmus.), and sometimes vigorously free, as in the *Breakfast Piece with a Ham* (1643; Brussels, Mus. A. Anc.). He often painted *vanitas* still-lifes, with skulls, hourglasses and guttering flames that invite meditation on transience and death (example in The Hague, Mauritshuis). His breakfast pieces probably also have loosely constructed symbolic programmes, with complex meanings centred on the temptations of earthly goods. For example, wine might suggest the Eucharist, but it also connoted pleasurable indulgence and even drunkenness. Thus the viewer could contemplate the relative merit of spiritual and worldly values, an activity pertinent to Calvinist-dominated Dutch mercantile society.

In contrast to his earlier sober style and restrained palette, many of Claesz's late paintings depict luxurious displays with bright colours and grand compositional rhythms. *Still-life with a Basket of Grapes and a Crab* (1651; untraced, see Vroom, i, fig. 30), in which Claesz probably collaborated with Roelof Koets (?1592–1655), is a representative example.

Claesz may have painted directly from life, or he may have relied on memory, imagination or drawings (though none survives). His compositions look plausible yet are sometimes difficult to recreate with actual objects. He evidently used artistic licence, disguising the artifice of his inventions with verisimilitude, a common practice among Dutch 'realists'. The porcelain, glassware, metalwork and foods he depicted were of the sort found in the homes of the Dutch middle class, who in turn purchased Claesz's paintings. Pieter Claesz seems not to have used the surname Berchem adopted by his son, the landscape painter NICOLAES BERCHEM.

Bibliography

I. Bergström: *Holländskt stilleben maleri under 1600-talet* [Dutch still-life painting in the 17th century] (Göteborg, 1947; Eng. trans., New York, 1956/R 1983)

N. R. A. Vroom: *A Modest Message as Intimated by the Painters of the 'monochrome banketje'*, 2 vols (Schiedam, 1980)

S. Segal: *A Prosperous Past: The Sumptuous Still Life in the Netherlands, 1600-1700*, ed. W. B. Jordan (The Hague, 1988)

ANNE W. LOWENTHAL

Codde, Pieter

(*b* Amsterdam, 11 Dec 1599; *d* Amsterdam, 12 Oct 1678). Dutch painter and poet. Frans Hals was once thought to have been his teacher, but there is no evidence for this. It is possible that Codde studied with a portrait painter, perhaps Barent van Someren (1572/3–1632) or Cornelis van der Voort (1576–1624), since most of his earliest works, from the period 1623-7, seem to be portraits. His earliest known dated work is the *Portrait of a Young Man* (1626; Oxford, Ashmolean), which precedes by a year his earliest dated genre piece, the *Dancing Lesson* (1627; Paris, Louvre). He was particularly productive in the 1620s and 1630s, painting mainly interior genre scenes. After the mid-1640s only portraits and a few history paintings, such as the *Adoration of the Shepherds* (1645; Amsterdam, Rijksmus.), are known. It is not known how long he remained active as a painter.

Codde is best known as a painter of interiors with numerous figures, often either elegant ladies and gentlemen in merry or musical companies, tric-trac players or soldiers in guardrooms. The theme of the Merry Company, in which he particularly specialized, became increasingly fashionable in the first half of the 17th century, especially in Haarlem and Amsterdam. Such images often had a significant double meaning, as is the case with Codde's *Return of the Hunters* (1635; priv. col., on loan to Amsterdam, Rijksmus.), in which there is an intentional play on the Dutch verb '*jagen*', which means to hunt and, colloquially, to make love. The comparison between the hunt and the love-chase or love-making was very common at the time. Codde's amorous companies are always richly clothed in gleaming silk. His palette is characterized by cool grey-brown tones, and he employed a fine, rather dry brush technique. He often reused the same compositions, placing his figures along a diagonal. One or two figures are presented centrally, for instance a dancing couple in the *Dancing Party* (1636; The Hague, Mauritshuis), while the other men and women are grouped informally, their fashionable clothing painted with the utmost attention to detail. Similar subjects were painted by Willem Duyster, who is probably incorrectly referred to as Codde's only pupil.

Among Codde's other portraits are the double *Portrait of a Betrothed Couple* (1634; The Hague, Mauritshuis) and the group portrait of the *Officers of a Corps of the Crossbowmen's Company under Capt. Reynier Reael and Lt Cornelis Michielsz. Blaeuw*, a picture always known as the '*Meagre Company*' (Amsterdam, Rijksmus). The latter was begun in 1633 by Frans Hals and completed in 1637 by Codde, who obtained the commission as the result of disagreements between Hals and his patrons. This was despite the fact that the style of the two artists differed greatly, Hals having started the work in rough, loose, agitated strokes, completely unlike Codde's smooth, almost invisible brushwork.

Bibliography

Thieme–Becker

W. Bode: *Studien zur Geschichte der holländischen Malerei* (Brunswick, 1883), pp. 141–53

C. M. Dozy: 'Pieter Codde, de schilder en de dichter', *Oud-Holland*, ii (1884), pp. 34–67

A. Bredius: 'Iets over het leven van Pieter Codde en Willem Duyster', *Oud-Holland*, vi (1888), pp. 187–94

F. Würtenberger: *Das holländische Gesellschaftsbild* (Schwarzwald, 1937)

P. Brandt jr: 'Notities over het leven en werk van den Amsterdamschen schilder Pieter Codde', *Historia* [Utrecht], xii (1947), pp. 27–37

S. Béguin: 'Iets over Pieter Codde en Jacob Duck', *Oud-Holland*, lxvii (1952), pp. 112–16

C. Bigler Playter: *Willem Duyster en Pieter Codde: The 'Duystere Werelt' of Dutch Genre Painting, ca. 1625-1635* (diss., Cambridge, MA, Harvard U., 1972)

Tot lering en vermaak: Betekenissen van Hollandse genrevoorstellingen uit de zeventiende eeuw (exh. cat. by E. de Jongh, Amsterdam, Rijksmus., 1976), pp. 73–9

Masters of Seventeenth Century Dutch Genre Painting (exh. cat. by P. C. Sutton, Philadelphia, PA, Mus. A.; Berlin, Gemäldegal.; London, RA; 1984), pp. 174–9

B. Broos: *Meesterwerken in het Mauritshuis* (The Hague, 1987), pp. 101–5

Schutters in Holland: Kracht en zenuwen van de stad (exh. cat., Haarlem, Frans Halsmus., 1988), pp. 381–3

Frans Hals (exh. cat. by S. Slive, Washington, DC, N.G.A.; London, RA; Haarlem, Frans Halsmus.; 1989–90), pp. 103–8, 252–7

NETTY VAN DE KAMP

Cornelisz. van Haarlem, Cornelis

(*b* Haarlem, 1562; *d* Haarlem, 11 Nov 1638). Dutch painter and draughtsman. He came from a wealthy family. During the Spanish siege and occupation of Haarlem (1572–7), his parents moved elsewhere, leaving their son and large house in the protection of the painter Pieter Pietersz. (1540/41–1603), who became Cornelis's teacher. In 1579 Cornelis travelled to France by sea, but the journey terminated at Rouen because of an outbreak of plague. He then became a pupil of Gillis Congnet in Antwerp, with whom he stayed for one year. In 1580–81 he returned permanently to Haarlem, and in 1583 he received his first official commission from the city, a militia company portrait, the *Banquet of the Haarlem Civic Guard* (Haarlem, Frans Halsmus.). Around 1584 he befriended Hendrick Goltzius and Karel van Mander, with whom he is said to have established a kind of academy (*see* MANDER, VAN, (1)), which became known as the Haarlem Academy. Cornelis later became city painter of Haarlem and received numerous commissions from the town corporation. He worked for the Commanders of the Order of St John and also for the Heilige Geesthuis. He married Maritgen Arentsdr Deyman (*d* 1606), the daughter of a burgomaster, some time before 1603. In 1605 he inherited one third of his wealthy father-in-law's estate. Cornelis also had one illegitimate daughter (*b* 1611), who married Pieter Jansz. Bagijn, a silversmith, and whose son was the painter Cornelis Bega. From 1626 to 1629 Cornelis Cornelisz. was a member of the Catholic Guild of St Jacob. In 1630, along with several other artists, he drew up new regulations for the Guild of St Luke, which brought to an end its essentially medieval organization and conferred a higher status on art. The surviving inventory of his estate contains valuable information about his art collection. Iconographically, Cornelis van Haarlem—as he is usually known—had a wider range than his Haarlem colleagues. Besides conventional religious and mythological subjects, he produced a few portraits as well as kitchen scenes and still-lifes.

1. Drawings

Only about 15 of the artist's drawings survive, which seems very little compared to the 500 or more examples left by his contemporaries Goltzius and Jacques de Gheyn II. One explanation is that, unlike them, Cornelis was not a printmaker himself. There are, however, 23 engravings based on his designs from before *c*. 1608. In his drawings the principal motif is the naked figure. Whether or not he drew directly from life is unclear; it is thought that he used plaster casts of parts of the body, since these are listed in the inventory of his studio. He was inspired, among other things, by the drawings of Roman views by Maarten van Heemskerck (Berlin, Kupferstichkab.), which were once in his possession.

Three stylistic phases can be distinguished in Cornelis's drawings. The first is a rather rough and old-fashioned style, as in the *Sketch for a Civic Guard Banquet* (*c*. 1583; ex-F. Winkler priv. col., Berlin; see Reznicek, i, pl. VIII). After 1585 the work is noticeably influenced by Goltzius and Bartholomeus Spranger, one good example being the large drawing (402×603 mm) of *Athletic Games* (shortly after 1590; U. Warsaw, Lib.). Later the rendering of anatomy and movement gradually becomes less exaggerated, as in his beautiful figure drawings in red chalk, very few of which have been preserved (e.g. the *Study of a Man Undressing, Seen from the Back*, *c*. 1597; Darmstadt, Hess. Landesmus.). They remained in the family and were later used by the artist's illegitimate grandson Cornelis Bega to develop his own masterly red-chalk technique.

2. Paintings

According to van Thiel, some 280 paintings by Cornelis Cornelisz. survive. The early works still reveal certain Flemish influences from his Antwerp period, for example that of Jan Massys. Cornelis's powerful, vigorous Goltzius–Spranger style is at its best c. 1588 (see col. pl. IX). In that year Goltzius made engravings (Hollstein, nos 4–8) of five of the artist's paintings, which brought Cornelis fame and public recognition. Four show the fall of the legendary figures Tantalus, Icarus, Phaeton and Ixion. The only extant painting is that of *Ixion* (Rotterdam, Mus. Boymans–van Beuningen). Because the giants are seen from below, floating in the air as they fall, it seems possible that the large paintings were originally intended as ceiling decorations. The fifth engraving represents the dramatic story of *Two Followers of Cadmus Devoured by a Dragon*. In 1961 the original painting was rediscovered in the National Gallery, London, having previously been put aside by the museum as a copy. It is painted with remarkable vivacity, with vigorous brushstrokes reminiscent of the Venetian masters. It seems likely that Cornelis acquired this 'Italian' manner from van Mander.

In 1590 the burgomasters of Haarlem awarded Cornelis an unprecedented commission to decorate the interior of the Prinsenhof with paintings. The building, originally a Dominican abbey, served as a residence for the Prince of Orange. Cornelis made a series of four paintings, alluding to recent events in the history of the young Dutch Republic. The largest of these paintings—covering a wall 4 m wide—shows the *Marriage of Peleus and Thetis* (Haarlem, Frans Halsmus.). This masterpiece was painted in an elegant, fluent style, with a large number of Spranger-like nudes in soft tones. The scene is intended as a moralistic warning against discord, which would inevitably lead to the dissolution of the state and could be prevented only by a wise and powerful ruler such as the Prince of Orange.

From 1594, the year of the *Unequal Lovers* (Dresden, Gemäldegal. Alte Meister), the artist became less outspokenly 'Mannerist', making less use of exaggerated musculature in his nudes and adopting what might be called a pseudo-classical style. After c. 1610 Cornelis's forms became increasingly weak compared with his earlier work, and the execution was rather careless. The overall quality of his later works is mediocre, with the occasional splendid exception, such as *Venus, Bacchus and Ceres* (1614; Dresden, Gemäldegal. Alte Meister).

Bibliography

Hollstein: *Dut. & Flem.*
W. Stechow: 'Zum Werk des Cornelis Cornelisz. van Haarlem', *Z. Bld. Kst*, lix (1925–6), pp. 54–6
—: 'Cornelis van Haarlem en de Hollandsche laat-maniëristische schilderkunst', *Elsevier's Geïllus. Mdschr.*, xlv/90 (1935), pp. 73–91
E. K. J. Reznicek: *Die Zeichnungen von Hendrick Goltzius*, 2 vols (Utrecht, 1961)
P. J. J. van Thiel: 'Cornelis Cornelisz. van Haarlem as a Draughtsman', *Master Drgs*, iii (1965), pp. 123–54
Gods, Saints and Heroes: Dutch Painting in the Age of Rembrandt (exh. cat., ed. D. F. Mosby; Washington, DC, N.G.A.; Detroit, MI, Inst. A.; Amsterdam, Rijksmus.; 1980–81), pp. 80–85
P. J. J. van Thiel: 'Cornelis Cornelisz. van Haarlem: His First Ten Years as a Painter, 1582–1592', *Netherlandish Mannerism: Papers Given at a Symposium in Nationalmuseum, Stockholm, 1984*, pp. 73–84
J. L. McGee: *Cornelis Corneliszoon van Haarlem, 1562–1638: Patrons, Friends and Dutch Humanists* (Nieuwkoop, 1991)
Dawn of the Golden Age: Northern Netherlandish Art, 1580–1620 (exh. cat., ed. G. Luijten and others; Amsterdam, Rijksmus., 1993–4), p. 304, *passim*

E. K. J. REZNICEK

Cuyp [Cuijp; Kuyp]

Dutch family of artists. Gerrit Gerritsz. (c. 1565–1644), whose father (d 1605) was probably an artist, was a glass painter from Venlo who moved to Dordrecht around 1585. He married and joined the Guild of St Luke there that same year, serving as the Guild's deacon in 1607 and 1608. He designed and executed numerous stained-glass windows in Dordrecht and other towns until 1639, but only his cartoon for a window in St Janskerk, Gouda, survives (1596; Gouda, Archf Ned. Hervormde Gemeente). His eldest son, Abraham

Gerritsz. (1588–c. 1647), was also a glass painter; his second son, (1) Jacob Gerritsz., was a painter. Gerrit Gerritsz. married a second time in 1602; children from this marriage included the artists Gerrit Gerritsz. the younger (1603–51), also a glass painter, and the painter (2) Benjamin Gerritsz. By 1617 Jacob Gerritsz. had adopted the surname Cuyp, and the rest of the family seems eventually to have followed this practice. (3) Aelbert Cuyp, the most important artist in the family, was the only child of Jacob Gerritsz. Cuyp.

Bibliography

A. Houbraken: *De groote schouburgh* (1718–21), i, pp. 237–8, 248
G. H. Veth: 'Aelbert Cuyp, Jacob Gerritsz. Cuyp en Benjamin Cuyp', *Oud-Holland*, ii (1884), pp. 233–90; vi (1888), pp. 131–48 [documentary evidence]
Aelbert Cuyp en zijn familie (exh. cat., intro. J. M. de Groot; Dordrecht, Dordrechts Mus., 1977) [source mat. and a surv. of the fam.]
De zichtbaere werelt [The visual world] (exh. cat., Dordrecht, Dordrechts Mus., 1992)

(1) Jacob (Gerritsz.) Cuyp

(*b* Dordrecht, Dec 1594; *d* Dordrecht, ?1652). Painter and draughtsman. Probably taught by his father, he entered the Guild of St Luke in Dordrecht in 1617, the same year that he executed an important commission to portray the masters of the Holland Mint (Dordrecht, Mus. van Gijn). He was the Guild's bookkeeper in 1629, 1633, 1637 and 1641 and, according to Houbraken, led Dordrecht's fine painters in their separation from the Guild in 1642. Jacob married Aertken van Cooten from Utrecht in 1618; his only child, (3) Aelbert Cuyp, was born two years later.

Much of Jacob's work consists of single bust-length portraits, executed in a direct, rather sober style. These date from throughout his career and include at least two sets of portraits of the powerful Dordrecht merchant Jacob Trip and his wife, Margaretha de Geer (e.g. Amsterdam, Rijksmus., and Denver, A. Mus., on loan); they were also portrayed by Nicolaes Maes and by Rembrandt. Jacob Cuyp also painted a few portraits of children in landscapes, occasionally accompanied by animals

(e.g. the *Portrait of Two Children*, 1638; Cologne, Wallraf-Richartz-Mus.), but many such portraits are assigned to him incorrectly.

Around 1627 Jacob's work began to be strongly influenced by Utrecht painters, especially Abraham Bloemaert and Hendrick ter Brugghen. Houbraken stated that Jacob actually studied with Bloemaert. A number of pastoral landscapes with shepherds (e.g. Amsterdam, Rijksmus.) and history paintings betray the effects of Utrecht Mannerism. A series of Jacob's animal drawings, etched by Reinier van Persijn (c. 1615–88) in 1641, closely resemble similar print series after Bloemaert. Also from c. 1627 are several paintings, for example the *Man with a Jug* (Stockholm, Nmus.), done in the Caravaggesque style practised by Hendrick ter Brugghen and other Utrecht Caravaggisti. The man's face in the picture is strongly lit from the side by candlelight, a convention favoured by the Utrecht artists. Their influence is also apparent in Cuyp's simple, yet dramatic half-length depictions of the apostles *Peter* and *Paul* (both Dordrecht, Dordrechts Mus.) and the evangelist *Luke* (Karlsruhe, Staatl. Ksthalle). Perhaps his most remarkably Caravaggesque conception is his genre scene of *Two Cavaliers Seated at a Table* (St Petersburg, Hermitage), in which careful attention is paid to the still-life details of the setting.

By 1630 Jacob Cuyp's style of figural painting had altered under the influence of Claes Moyaert and Pieter Lastman, resulting in compositions that arranged weighty, bulky figures in landscapes. An allegory of the capture of the city of 's Hertogenbosch (1630; 's Hertogenbosch, Stadhuis) depicts the stadholder Frederick Henry as David holding the head of the slain Goliath (symbolizing Spain), surrounded by Muses representing the seven provinces of the united Netherlands. This work may have been commissioned by the government or court since it appears in an inventory (1751) of a royal Dutch collection.

Jacob Cuyp's extremely varied output also included numerous still-lifes and genre scenes, two forms of subject-matter that are combined in the *Fish Market* (1627; Dordrecht, Dordrechts Mus.). The artist also painted kitchen, flower and poultry still-lifes. Curious examples of the latter

are the pairs of paintings of a *Boy Holding a Goose* and a *Girl Holding a Chicken* (e.g. Paris, Louvre), with an inscription *Mon oye faict tout* (a French pun on money and goose).

Jacob provided instruction not only for his half-brother (2) Benjamin Cuyp and his son Aelbert, but also for Ferdinand Bol, Paulus Lesire (1611–after 1656) and others. He collaborated with Aelbert on several paintings: three group portraits, two dated 1641 and another of 1645, and several landscapes with shepherds. In such works, Jacob painted the figures and Aelbert the landscapes.

Jacob's last signed and dated work, *Boy with a Wineglass and Flute* (priv. col., see bibliog. above, 1992 exh. cat., no. 28), is from 1652; later the same year his wife is referred to as a widow.

Bibliography

M. Balen: *Beschryvinge der stad Dordrecht* [Description of the town of Dordrecht] (Dordrecht, 1677), pp. 666, 682

J. Heyligers: *Jacob Gerritsz. Cuyp: Porträt, Genre- und Historienmaler zu Dordrecht* (diss., U. Rostock, 1924)

Portret van een meester (exh. cat., Dordrecht, Dordrechts Mus., 1975)

A. Chong: 'De *Apostel Paulus* uit 1627 door Jacob Cuyp', *Dordrechts Mus. Bull.*, xiii/4–5 (1988); Eng. trans. in *Hoogsteder-Naumann Mercury*, 7 (1989), pp. 10–18

(2) Benjamin (Gerritsz.) Cuyp

(*bapt* Dordrecht, Dec 1612; *d* Dordrecht, *bur* 28 Aug 1652). Painter, half-brother of (1) Jacob Cuyp. Houbraken stated that he studied with his half-brother Jacob. Benjamin entered the Guild of St Luke on 27 January 1631, at the same time as his brother Gerrit Gerritsz. the younger. In 1641 Benjamin gave evidence in a medical affair, which has prompted speculation that he may have trained as a doctor, but in 1643 he is twice recorded in The Hague as a painter, living with other artists. Seventeen of his paintings appeared at auction at Wijk-bij-Duurstede in 1649. At the time of his death, he was living in Dordrecht with another half-brother, who was a glassmaker.

As no dated works by Benjamin are known, it is difficult to chart the artist's development accurately, although several different styles of paint-ing can be isolated. In his handling of religious subjects, Benjamin may be considered an important follower of Rembrandt, with whom, however, he seems to have had no direct contact. His fellow townsmen Paulus Lesire (1611–after 1656) and Hendrik Dethier, who also entered the Guild in 1631, were also strongly influenced by Rembrandt's early work, as indeed were such later Dordrecht artists as Ferdinand Bol, Nicolaes Maes, Samuel van Hoogstraten and Aert de Gelder. Benjamin constructed several variations of Rembrandt's compositions from the late 1620s and early 1630s, in particular *Judas and the Thirty Pieces of Silver* (1629; GB, priv. col., see J. Bruyn and others, *A Corpus of Rembrandt Paintings*, i (The Hague, 1982), no. A15), an especially common source for Rembrandt's early followers. Benjamin borrowed not only Rembrandt's deeply shadowed lighting but also his characteristic huddled figures and piled-up compositions (see Ember, figs 5–7). Benjamin's paintings of the *Flight into Egypt* (ex-art market, Paris, 1951, see Ember, fig. 1) are similarly derived from the nocturnal setting of a Rembrandt school painting (Tours, Mus. B.-A., see Bruyn and others, no. C5).

In other paintings tentatively assigned to Benjamin's early career, the influence of Leonaert Bramer can be felt in dark monochromatic works consisting of a few figures (Ember, figs 2–3). These various stylistic elements are combined in the large, ambitious *Adoration of the Magi* (Dordrecht, Dordrechts Mus.), which displays free, quick brushwork and deeply saturated colours. The influence of Adrian Brouwer and Adrian van Ostade is added to that of Rembrandt and Bramer. Benjamin's achievement was the marriage of a sketchy brush technique with an intensity of light and colour. He came to favour biblical and historical scenes featuring dramatic bursts of light, such as the Annunciation to the Shepherds, the Raising of Lazarus, the Resurrection, the Liberation of St Peter and the Conversion of Saul. A tumble of figures, one boldly silhouetted, and dramatic flashes of light characterize, for example, the *Conversion of Saul* (Vienna, Gemäldegal. Akad. Bild. Kst.. Another group of Benjamin's paintings, also conceived in a

painterly style but employing delicate pastel shades of blue, pink and orange, seems to have been strongly influenced by Adrian van Ostade, for example the *Liberation of Peter* (Kassel, Schloss Wilhelmshöhe), which is more brightly and evenly lit than the majority of Benjamin's paintings.

Benjamin Cuyp also painted religious and history scenes in a monochrome palette with heavy impasto highlights, for example the *Annunciation to the Shepherds* (Hannover, Niedersächs. Landesmus., see Ember, fig. 37), which is constructed in various shades of brown. These works resemble grisailles, with a complex overlay of sketchy white strokes, as in the *Adoration of the Shepherds* (Berlin, Gemäldegal.). In smaller-scale interior scenes the influence of Adrian Brouwer and Daniel Teniers can be felt. These include biblical subjects (e.g. *Tobias*; Dordrecht, Dordrechts Mus.) but more often are genre paintings, usually of peasants, inn scenes (e.g. Budapest, Mus. F.A.) or depictions of soldiers (e.g. Cologne, Wallraf-Richartz-Mus.). Benjamin also painted a number of battle or encampment scenes in a loose style influenced by painters such as Gerrit Claesz. Bleker and more generally Esaias van de Velde. Closely connected with these are Benjamin's beach scenes, which usually feature the unloading of fish from boats overseen by gentlemen on horseback. The landscapes that form the settings for these themes show some influence from (1) Jacob Cuyp and, in turn, may have influenced (3) Aelbert Cuyp's early work.

Bibliography

K. Boström: 'Benjamin Cuyp', *Ksthist. Tidskr.*, xiii (1944), pp. 59–74

I. Ember: 'Benjamin Gerritsz. Cuyp', *Acta Hist. A. Acad. Sci. Hung.*, xxv (1979), pp. 89–141; xxvi (1980), pp. 37–73

Gods, Saints and Heroes: Dutch Painting in the Age of Rembrandt (exh. cat., ed. A. Blankert; Washington, DC, N.G.A., 1980), pp. 253–4, 270–71

W. Sumowski: *Gemälde der Rembrandt-Schüler*, i (Landau, 1983)

(3) Aelbert [Albert] Cuyp

(*b* Dordrecht, *bapt* late Oct 1620; *d* Dordrecht, *bur* 15 Nov 1691). Painter and draughtsman, son of (1)

Jacob Cuyp. One of the most important landscape painters of 17th-century Netherlands, he combined a wide range of sources and influences, most notably in the application of lighting effects derived from Italianate painting to typical Dutch subjects. Such traditional themes as townscapes, winter scenes, cattle pieces and equestrian portraits were stylistically transformed and given new grandeur. Aelbert was virtually unknown outside his native town, and his influence in the 17th century was negligible. He became popular in the late 18th century, especially in England.

1. Life and work

No record exists of his training or entry into the painters' guild, but it is clear that he was taught by his father, for whom he painted the landscape backgrounds in two family group portraits from 1641 (Jerusalem, Israel Mus.; and priv. col., see Reiss, nos 16–17). By this time Aelbert had begun to travel in Holland and along the Rhine, making sketches of Rhenen, Arnhem, Amersfoort, Utrecht, Leiden and The Hague. In late 1651 or in 1652 he again journeyed up the Rhine and the Waal past Rhenen to Nijmegen, as far as Cleve, Elten and Emmerich. The numerous drawings made on this trip provided motifs for many of the painter's later landscapes. In 1658 Cuyp married Cornelia Boschman (1617–89), the widow of Johan van den Corput (1609–50), a wealthy regent by whom she already had three children. In 1663 the family bought a larger house in the Wijnstraat. Cuyp's marriage left him financially well-off and socially prominent, and he and his wife owned large tracts of land around Dordrecht. He became a deacon (1660) and an elder (1672) of the Reformed Church, a regent of the sickhouse (1673) and a member of the High Court of South Holland (1679). With the fall of the de Witt brothers and their faction in 1673, Cuyp's name was put on a list of 100 candidates approved by supporters of the stadholder William III, although he did not actually assume municipal office. At the death of his wife, Cuyp's estate was worth 42,000 guilders. Their only child, a daughter, Arendina (*b* 1659), married Pieter Onderwater (1651–1728) in 1690; she died in 1702, her only son having died at the age of four.

(i) Early work, 1639–c. 1645. Cuyp's earliest works are three landscape paintings signed and dated 1639: a *Farm Scene* (Besançon, Mus. B.-A.), a *Harbour Scene* (London, Johnny van Haeften Ltd) and a *River Valley with a Panorama* (the Netherlands, priv. col., see 1992 exh. cat., no. 15), the last of which shows his interest in the work of Josse de Momper II, Hercules Segers and Esaias van de Velde. The only works that can be convincingly dated before these paintings are a *Rocky Landscape with Cows* (ex-art market, Brussels, 1928; see Chong, 1991, fig. 42) and a similar drawing (Bremen, Ksthalle), which are especially close to de Momper's work. A painting dated 1640 with shepherds, tall cliffs and a distant panorama (USA, priv. col., see Chong, 1991, fig. 45) shows the clear influence of Cornelis van Poelenburch. Directly related in style and composition are two paintings of *Orpheus in a Landscape* (Dessau, Staatl. Gal.; the other sold at London, Sotheby's, 6 July 1994), the first of Cuyp's historical subjects. At about the same time he also painted the distant background in his father's *Landscape with Two Shepherds* (Montauban, Mus. Ingres).

The bulk of Cuyp's output from the early 1640s until c. 1645 is based on the tonal landscapes of Jan van Goyen, Salomon van Ruysdael and Herman Saftleven II, although Cuyp constantly sought brighter and stronger contrasts of light. Van Goyen seems to have visited Dordrecht on numerous occasions, and his son-in-law Jacques de Claauw (fl 1642–76) was a Dordrecht artist associated with Jacob Cuyp. Aelbert may therefore have had direct contact with van Goyen. Cuyp commonly depicted quiet waterways and inlets (e.g. *River Scene with Distant Windmills*; London, N.G.). Several paintings, for instance the *View of the Mariakerk, Utrecht* (Salzburg, Residenz Gal.), are based on sketches made in Utrecht. Cuyp must have visited the city on several occasions; his mother was from Utrecht, his father had studied there, and he himself seems to have been influenced by a series of Utrecht painters, including Poelenburch, Saftleven and, later, Jan Both. Cuyp also began to depict his home town of Dordrecht in paintings delicately tinged with pastel colours (e.g. Malibu, CA, Getty Mus., and Leipzig, Mus. Bild. Kst.). Much larger in scale is a *Farm Scene* (Melbury House, Dorset, see 1987–8 exh. cat., no. 20), rendered in rich green tones and showing greater compositional complexity. Closely connected with this is the *Baptism of the Eunuch* (Houston, TX, Menil Col.).

(ii) Mature work, c. 1645–mid-1650s. Around 1645 Cuyp became influenced by the light and compositions of Dutch Italianate landscape painters, especially Jan Both and, to a lesser degree, Saftleven and Herman van Swanevelt. Cuyp's first Italianate landscapes are cast with a smoky orange sunlight, with shepherds and their flocks occupying a prominent place in the composition. The treeless rocky plains he painted resemble the work of Jan Asselijn and Nicolaes Berchem, although, in fact, he predated these two Italianate artists. *Two Herdsmen and Cattle in a Wide Landscape* (London, Dulwich Pict. Gal.) shows a brilliant sun *contre-jour* over a misty landscape; the *Ruins on a Hill with Sheep and Two Horsemen* (Amsterdam, Rijksmus.) introduces the theme of horsemen that Cuyp so often used later in his career. Also among Cuyp's first Italianate paintings is another painting of *Orpheus* (priv. col., see Reiss, no. 48).

Two paintings are dated 1645: a *Portrait of Four Children in a Landscape* (Devon, priv. col., see Chong, 1991, fig. 54), signed and dated by both Jacob and Aelbert Cuyp, Jacob again being responsible for the figures; and a *View of Rijnsburg Abbey* (priv. col., see Chong, 1991, fig. 51). These introduce a series of landscapes lit by a strong, almost monochromatic sun, but with clear blue skies. Milking became a dominant theme in Cuyp's work in the years just after 1645 (e.g. *Milking Scene near a River*; Karlsruhe, Staatl. Ksthalle). The *Distant View of Dordrecht* (the 'Large Dort', London, N.G.) combines a milking scene with a profile of the artist's native city. These scenes were succeeded c. 1650 by very simple landscapes consisting almost wholly of herds of cattle, placed on river banks (e.g., Paris, Louvre, see col. pl. X) or actually in a river (e.g. Budapest, N.G.). Cuyp also paired paintings of cows in a river with representations of bulls on a river bank (e.g. GB, priv. col., see 1987–8 exh. cat., p. 294). The

dairy industry near Dordrecht was expanding in the mid-1600s through ambitious land reclamation programmes, and these paintings must have reminded viewers of this.

Around 1650 Cuyp also painted a number of figural scenes and portraits (e.g. 1649; London, N.G.). A *Portrait of a Man with a Rifle* (Amsterdam, Rijksmus.) has a pendant showing a *Woman Dressed as a Huntress* (1651; priv. col., on loan to Boston, MA, Mus. F.A.). Cuyp also portrayed *Jacob Trip* (the Netherlands, priv. col., see 1977 exh. cat., no. 20), whom Jacob Cuyp, Nicolaes Maes and Rembrandt also painted. Cuyp's last dated work is a *Portrait of a Child with a Sheep* (1655; London, John Mitchell & Sons). There are also a few paintings of poultry (e.g. London, Leger Gals) and several stable interiors with cattle in their stalls, the latest of which shows a *Woman Scouring a Pot* (Dordrecht, Dordrechts Mus.), with brilliant light entering from an open door. Around this time Cuyp also painted two copperplates showing *Apollo* and *Mercury* (both priv. col., see de Mirimonde, figs 1 and 2), which were originally fitted as doors to a cabinet. He also painted two versions of the *Conversion of Saul*, based generally on the many representations by his uncle (2) Benjamin Cuyp. The example in Amiens (Mus. Picardie), full of brilliant light and gesticulating figures, is Aelbert's only true figural composition (the other version is in the Netherlands, priv. col., see 1977 exh. cat., no. 27).

Cuyp's first equestrian portrait is of *Pieter de Roovere* (The Hague, Mauritshuis); the sitter died in 1652, and the style of the portrait resembles the cattle pictures of *c.* 1650. De Roovere is depicted inspecting a large fish held by a boy, a motif often used by Benjamin Cuyp in his beach scenes. Here it takes on added significance, since fishing and the smoking of fish were major industries in the area around Dordrecht, including de Roovere's estate at Hardinxveld. Aelbert's chronology after *c.* 1652 is impossible to determine with any certainty. Nevertheless, the portrait of de Roovere must soon have been followed by the equestrian portrait of *Michiel and Cornelis Pompe van Meerdervoort with their Tutor and Coachman* (*c.* 1652–3; New York, Met.), the background of

which is derived from a sketch of Elten (Paris, Fond. Custodia, Inst. Néer.), which also served as the basis for the *Draughtsman near Elten* (Woburn Abbey, Beds). Inventories in 1680 and 1749 provide a precise identification of the Pompe van Meerdervoort boys, the elder of whom died in 1653. Hunting forms the primary theme in most of Cuyp's equestrian portraits, to which figures in Turkish garb lend an exotic as well as elegant atmosphere No less prestigious African pages appear in other portraits of riders (e.g. London, Buckingham Pal., Royal Col., and Birmingham, Barber Inst.). Another double portrait, of a *Lady and Gentleman on Horseback* (Washington, DC, N.G.A.), is problematic since the figures were repainted by Cuyp at a later stage, and hunting figures in the distance were altered. Related to these works is a painting, perhaps a portrait, of an *Officer Tying Ribbons on his Horse* (London, Buckingham Pal., Royal Col.). Cuyp's second version of the *Baptism of the Eunuch* (Anglesey Abbey, Cambs, NT) is based on treatments of the subject by Rembrandt and Benjamin Cuyp, but its Italianate landscape with numerous riders is indebted to Jan Both's painting of the same subject (London, Buckingham Pal., Royal Col.). Aelbert also painted a *Riding School* (Toledo, OH, Mus. A.) near a Romanesque church and surrounded by Classical statuary. In all these equestrian paintings, well-dressed riders are represented with accessories that enhance their status and lend an elegant, almost classicizing atmosphere to the scene.

One of Aelbert Cuyp's favourite motifs in his later career was the town of Nijmegen in Gelderland. The town, especially the medieval citadel Valkhof, was familiar from maps and prints and the many paintings of van Goyen and Salomon van Ruysdael: the popularity of the site was due to its importance in the history of the Netherlands, especially as the supposed seat of Claudius Civilis, leader of the Batavian revolt against the Romans. The subject thus had strongly patriotic associations for citizens of the newly independent Dutch State. On the journey of 1651 or 1652 Cuyp made numerous sketches of Nijmegen from different vantage-points. He

painted two versions of the *View of the Valkhof from the North-east* (Woburn Abbey, Beds, and Indianapolis, IN, Mus. A.), based on a drawing (sold Amsterdam, Sotheby's, 25 April 1983, lot 73); these are similar to van Goyen's pictures but arranged with greater classical repose and rendered in Cuyp's rich Italianate light. The earlier of Cuyp's versions with pastoral herders (Indianapolis) has as its pendant a *View of Nijmegen from the East* (USA, priv. col., see Reiss, no. 129). The second and larger view from the north-east (Woburn Abbey) shows elegant gentlemen on horseback; its pendant is a deeply shadowed *View of the Valkhof from the South-east* (Edinburgh, N.G.). A scene of *Ships before the Valkhof* (Scotland, priv. col.), similar to depictions of the fleet at Dordrecht, completes the group of depictions of Nijmegen and probably refers to the visit in 1647 of the Stadholder Frederick Henry in the company of Elector Friedrich Wilhelm of Brandenburg.

Cuyp meanwhile continued to paint ships and views of Dordrecht. Occasionally shown in stormy weather (e.g. London, Wallace), the town is more typically seen with glassily still water. Two views of *Dordrecht at Sunset* (London, Kenwood House, and Ascott, Bucks, NT) are early contributions to the development of the pure townscape, preceding, for example, Vermeer's *View of Delft* (c. 1661; The Hague, Mauritshuis). The careful attention Cuyp paid to the fall and reflection of light and to the calm shapes of the ships and floating log rafts is especially striking. In the *Gathering of the Fleet at Dordrecht* (mid-1650s; Washington, DC, N.G.A.) Cuyp depicted the arrival of a dignitary, perhaps an evocation of a rendezvous of 1646 (a type of picture favoured by Simon de Vlieger and Jan van de Cappelle), which Frederick Henry did not himself attend but which was marked by great festivities and celebrations. The work may, however, also recall other visits of the Stadholder and his family to the town. Cuyp twice painted winter scenes near Dordrecht. Although other Dutch Italianate artists occasionally painted winter landscapes (e.g. Asselijn and Berchem), Cuyp uniquely was able to impart a golden glow to ice landscapes. The *Ice Scene near the Huis te Merwede* (Brocklesby Park, Lincs) is based on a sketch of the ruins (London, BM) and shows skaters on the ice; the other winter landscape shows *Fishing under the Ice* (Woburn Abbey, Beds).

(iii) **Last works, late 1650s and after.** Costumes or other forms of external evidence provide little clue as to when Cuyp stopped painting, although his marriage in 1658, with its increasing social responsibilities, seems to have marked a slowing of production. His last works, probably from the late 1650s, consist of broad, open landscapes populated by elegant riders and shepherds: the *River Landscape with Two Horsemen* (Amsterdam, Rijksmus.) is directly transcribed from a sketch made near Cleve, but other works are imaginary, although still based on Rhineland scenery. *Peasants on a Road* (London, Dulwich Pict. Gal.) shows a screen of trees with mountains in the distance; the composition and the crystalline Italianate light are derived directly from the work of Jan Both. Unlike Both, however, Cuyp almost always employed a flat foreground on which to arrange his staffage. In what are probably Cuyp's last landscapes, a strong silvery light casts a monochromatic glow over the entire scene. This is clearly seen in the *Hilly Landscape with Shepherds and Travellers* (London, Buckingham Pal., Royal Col.), in which the ridges and horsemen are influenced by an etching by Jan Both. The same light gilds the *River Landscape with Horseman and Peasants* (London, N.G.), Cuyp's largest landscape, in which the distant mountains and the town on the far side of the lake are not topographically accurate transcriptions but evocations of an idyllic pastoral land, populated by a hunter, an elegant rider and shepherds.

2. Working methods and technique

Most of Cuyp's early paintings are based on drawings of rivers, forests and towns, rendered in black chalk and usually worked up in green, brown and a characteristic mustard-yellow wash. More than most Dutch landscape artists, Cuyp made drawings as an integral part of his creative process, beginning with sketches made on the spot, later worked up in the studio and then transformed into paintings. He also produced a number of

figure studies (e.g. Paris, Fond. Custodia, Inst. Néer.) that were used in the same fashion. During his 1652 journey up the Rhine and the Waal, he filled sketchbooks with dozens of drawings done on the spot, often continuing a sketch across to the back of the adjacent page, allowing the sequence of drawings to be partially reconstructed. Most of Cuyp's later paintings can be connected with these sketches or similar ones made in or near Dordrecht. The first painting that appears to show high cliffs above the Rhine (Rotterdam, Mus. Boymans–van Beuningen) has no preliminary drawing, but, instead, a sketchier version in oil (Paris, Fond. Custodia, Inst. Néer.); dendrochronology indicates that the work dates from just after 1649. Cuyp's drawing of *Ubbergen Castle near Nijmegen* (Vienna, Albertina), used for the painted version (London, N.G.) of the site where an important battle against the Spanish took place in 1591, shows how the artist elaborated the original sketch (1652) from nature, later adding the background hills and framing trees.

The broken, blond brushwork in Cuyp's early painted work shows his indebtedness to Jan van Goyen, as does the monochromatic colouring; this is clearly evident by 1641 in the two group portraits with figures by Jacob Cuyp. Aelbert gradually replaced the brushwork of this van Goyen phase with deeper colours and greater contrasts of light, allied to a greater solidity of structure. Many paintings are devoted to nature's specialized light effects: his evening and night scenes, typically set in harbours, are highlighted with rich pastel tones (Toledo, OH, Mus. A., and Cologne, Wallraf-Richartz-Mus.), and he painted two storm scenes streaked with lightning (*c*. 1644; Zurich, Stift. Samml. Bührle; and early 1650s; Paris, Louvre,; see fig. 13). Cuyp's later technique seems to have moved from a brushy calligraphic touch towards a harder style.

13. Aelbert Cuyp: *Boats on the Estuary of Holland's Diep during a Storm*, early 1650s (Paris, Musée du Louvre)

3. Critical reception and posthumous reputation

In his own lifetime Cuyp seems to have been almost unknown outside Dordrecht. His principal pupil was probably ABRAHAM VAN CALRAET (a number of whose works were previously attributed to Cuyp), although Houbraken recorded Abraham's brother Barent van Calraet (1650–1737) as a student. Houbraken provided the first account of the career of his fellow-townsman in 1718, and for nearly a century this brief discussion remained the only biography of the artist. Although a few paintings attributed to Cuyp began to appear at auctions in the Netherlands and London in the 1750s, Cuyp escaped the attention of nearly all 18th-century writers of lexica and landscape surveys. Richard Wilson noted that Cuyp was still little known and appreciated. Towards the end of the 18th century the situation altered dramatically: in 1774 a sale catalogue termed Cuyp the equal of Claude; and in Dordrecht, Johan van der Linden van Slingeland's sale (22 Aug 1785) of 41 works catalogued as being by Cuyp (of which at least 17 are genuine) fetched high prices, as did paintings occasionally sold in England. By the late 18th century writers had already begun to complain of numerous imitations and copies being passed off as genuine works by Cuyp; in Dordrecht, artists such as Dionys van Dongen (1748–1819), Arie Lamme (1748–1801), Aert Schoumann and Jacob van Strij were responsible for copies and pastiches of Cuyp's work.

John Smith's remarkable catalogue of 1834 was the first attempt to define Cuyp's oeuvre systematically; Waagen's survey of British collections added significantly to this. Set against these works, which catered primarily for art dealers and aristocratic collectors, were critics who felt that living artists were being ignored in the scramble to buy Old Masters. Pamphleteers attacked collectors and criticized Cuyp's work, although painters themselves, most notably J. M. W. Turner and John Constable, praised Cuyp and borrowed from his pictures. John Ruskin, while conceding Cuyp's value as a pastoral landscape painter, found him lacking in realism when compared with British painters, especially Turner.

Bibliography

J. Smith: *A Catalogue Raisonné of the Works of the Most Eminent Dutch Flemish and French Painters*, v (1834), pp. 279–368, 443–52; suppl. ix (1942), pp. 649–67, 868–70

G. F. Waagen: *Treasures of Art in Great Britain*, 3 vols (London, 1854)

C. Hofstede de Groot: *Holländische Maler*, ii (1908), pp. 5–246

A. P. de Mirimonde: 'Un Phébus énigmatique de Cuyp', *Oud-Holland*, lxxx (1965), pp. 181–8

J. Nieuwstraten: 'Een ontlening van Cuyp aan Claude Lorrain' [Cuyp's borrowing from Claude Lorrain], *Oud-Holland*, lxxx (1965), pp. 192–5

W. Stechow: *Dutch Landscape Painting of the 17th Century* (London, 1966), pp. 40, 61–4, 161, 181

D. G. Burnett: 'The Landscapes of Aelbert Cuyp', *Apollo*, lxxxix (1969), pp. 372–80 [gen. survey, with some inaccuracies]

J. G. van Gelder and I. Jost: 'Vroeg contact van Aelbert Cuyp met Utrecht' [Aelbert Cuyp's early contact with Utrecht], *Miscellanea I. Q. van Regteren Altena* (Amsterdam, 1969), pp. 100–03

——: 'Doorzagen op Aelbert Cuyp' [Comments about Aelbert Cuyp], *Ned. Ksthist. Jb.*, xxiii (1972), pp. 223–39

S. Reiss: *Aelbert Cuyp* (London, 1975); review by C. Brown in *TLS* (28 Nov 1975) [best source for illus., but controversial]

Aelbert Cuyp en zijn familie (exh. cat., intro by J. M. de Groot, Dordrecht, Dordrechts Mus., 1977)

Masters of 17th-century Dutch Landscape Painting (exh. cat., ed. P. Sutton; Amsterdam, Rijksmus.; Boston, MA, Mus. F.A.; Philadelphia, PA, Mus. A.; 1987–8) [entries on Cuyp by A. Chong]

A. Chong: '"In 't verbeelden van slachtdieren"' [Depicting farm animals], *Meesterlijk vee* [Masterly cattle] (exh. cat., Dordrecht, Dordrechts Mus.; Leeuwarden, Fries Mus.; 1988–9)

——: 'New Dated Works from Aelbert Cuyp's Early Career', *Burl. Mag.*, cxxxiii (1991), pp. 606–12

——: *Social Meanings in the Paintings of Aelbert Cuyp* (diss., New York U., 1992)

De zichtbaere werelt [The visual world] (exh. cat., Dordrecht, Dordrechts Mus., 1992)

ALAN CHONG

Delen, Dirck (Christiaensz.) van

(*b* Heusden, nr 's Hertogenbosch, 1604–5; *d* Arnemuiden, 16 May 1671). Dutch painter. When he married in 1625 he was a citizen of Middelburg,

but he settled in nearby Arnemuiden, where he became master of the toll-house. From 1628 until his death he was almost continually a member of the town council, mostly as burgomaster. He was widowed three times and had at least one son, though no children survived him. The inventory of his estate testifies that he was well-to-do.

Van Delen devoted his painting entirely to architectural subjects. His earliest works, particularly the views of palaces, borrow heavily from the graphic work of Hans Vredeman de Vries and Paul Vredeman de Vries. The architecture is Renaissance but not governed by classical rules. The buildings look more heavily constructed than the Vredeman de Vries prototypes and are decorated in a more modern manner, based on that found in such Italian prints as Bernadino Radi's sepulchre designs and Michelangelo's porch of the Campidoglio reproduced in the Vignola editions. He also painted church interiors, for the earliest of which (e.g. 1627; St Petersburg, Hermitage) he used the print by Johannes van Londerseel after a painting by Hendrick Aertsn (d Gdańsk, 1603) as a point of departure. Other sources for his gothicizing church architecture may have been the work of Antwerp architectural painters, although he did not adopt their rigid tunnel perspective. His style seems closer to that of church interiors by his contemporary Bartholomeus van Bassen. Certainly some of van Bassen's works served as models for the interior views that van Delen produced from 1628. The architecture in these is massive, more suited to the exterior of a building, with rooms covered by heavy coffered ceilings. The use of colour, too, is heavy, with many dull brownish tints. The figures, traditionally thought to have been painted by others, are almost all by van Delen and until c. 1630 were often inspired by or copied from Dirck Hals, as in *Interior with Ladies and Cavaliers* (1629; Dublin, N.G.).

After 1630 van Delen's style became more exuberant, and his output was dominated by palace exteriors. In making his courtyard scenes more spacious he was influenced by the work of Hendrick van Steenwijck II, whose *Courtyard of a Renaissance Palace* (1609; London, N.G.) he copied, adding his own staffage (c. 1632; St Petersburg,

Hermitage, falsely signed *HvSteenw 1623*). Van Delen's palette became lighter and brighter, the paint surface glossier. In the architecture, predominant features are pink, black and white marble and an excess of sculpture, in which he was influenced by the Antwerp Baroque style. The figures, often copied from prints by Abraham Bosse, Marcantonio Raimondi, Gian Jacopo Caraglio, Annibale Carracci and others, are rich and fashionable.

Around 1640 van Delen produced his most ambitious works, after which his output rapidly declined. These compositions become more sober, the colours softer and yellowish. In the foreground of his larger compositions there is usually a palace, receding diagonally from the left or right, as in *Architectural View with the Return of the Prodigal Son* (1649; Cologne, Wallraf-Richartz-Mus.). A similar composition, *Exterior of a Palace* (after 1660; Lille, Mus. B.-A.), was formerly attributed to Willem van Ehrenberg (1630–76), who is likely to have been van Delen's pupil. Known pupils were Daniël de Blieck (fl 1648–73) and Hans Jurriaensz. van Baden (1604–63). Van Delen was the most important inspirational force to succeeding architectural painters in Antwerp.

Bibliography

H. Jantzen: *Das niederländische Architekturbild* (Leipzig, 1910/R Brunswick, 1979)
W. A. Liedtke: 'From Vredeman de Vries to Dirck van Delen: Sources of Imaginary Architectural Painting', *RI Des. Bull.* (Winter 1970), pp. 15–25
T. Trent Blade: *The Paintings of Dirck van Delen* (diss., U. MN, 1976; microfilm, Ann Arbor, 1980)

BERNARD VERMET

Delff [Delft], Willem Jacobsz.

(*b* Delft, 15 Sept 1580; *d* Delft, 11 April 1638). Dutch engraver. He was the son of the Delft portrait painter Jacob Willemsz. Delff the elder (c. 1550–1601), from whom he presumably received his earliest artistic instruction. Because his earliest known work, an engraved portrait of *Christianus Goesius* ('Bailiff in Delft'; 1600; Hollstein, no. 29), was made after a drawing by the

Antwerp engraver Johan Wierix, it has sometimes been assumed that Delff studied engraving under this Flemish artist. This, however, is unlikely since the original drawing had been made over 20 years earlier. It is far more probable that Delff was taught engraving by a Dutch artist, possibly Hendrick Goltzius. In the first part of his career Delff devoted himself primarily to producing book illustrations. He also produced portrait prints after the work of such painters as Michiel Jansz. van Mierevelt and Jan Anthonisz. van Ravesteyn.

As far as is known Delff worked exclusively as a reproductive engraver; there are no known prints made after his own designs. His excellent technique produced portrait prints that are among the best of their type ever made in Holland; they are worthy replicas of paintings by prominent portrait painters of the first half of the 17th century.

Delff's career as a successful portrait engraver began only after his marriage in 1618 to Geertruid van Mierevelt, daughter of the well-known Delft portrait painter Michiel van Mierevelt. After his marriage, Delff became the exclusive engraver of the portraits painted by his father-in-law. In the next 20 years about 50 engraved likenesses were made by Delff after examples by van Mierevelt, some of them portraits of Delft burghers, others portraits of prominent figures from Holland and abroad. During the same period Delff also made a number of portrait prints after other artists, including Adriaen van de Venne, David Bailly and Daniel Mijtens the elder.

Delff's portrait prints of rulers and high-ranking nobles are generally in a large format, c. 420×300 mm. The majority are busts. The painter obtained an eight-year licence from the Dutch government for his portraits of famous people, protecting him against copies by others. His best-known prints include the various engraved portraits of the Dutch stadholders: *William the Silent of Nassau* (1623; Hollstein, no. 55, and 1624; Hollstein, no. 56), *Maurice* (Hollstein, no. 59) and *Frederick Henry, Prince of Orange Nassau* (1624; Hollstein, no. 61)—the portraits of William after van de Venne and Cornelis Visscher, the others after van Mierevelt. He engraved portraits of

Charles I of England (1628; Hollstein, no. 2) and his consort *Henrietta Maria* (1630; Hollstein, no. 3) after paintings by Daniel Mijtens the elder, while paintings by van Mierevelt served as the model for the prints of *Frederick V of Bohemia* (1622 and 1623; Hollstein, nos 8 and 10), his consort, *Elizabeth Stuart* (1623 and 1630; Hollstein, nos 9 and 11), and their sons, *Frederick Henry* (1629; Hollstein, no. 12) and *Charles Louis* (1634; Hollstein, no. 67). Other internationally famous persons of whom Delff made portrait prints after paintings by van Mierevelt were *George Villiers, 1st Duke of Buckingham* (1626; Hollstein, no. 13), *Sir Dudley Carlton* (1620; Hollstein, no. 26), *Hugo Grotius* (1632; Hollstein, no. 30), *Ernest, Count of Mansfeld* (1624; Hollstein, no. 43), *Axel, Count Oxenstierna* (1636; Hollstein, no. 66) and *Gustav II Adolf of Sweden* (1633; Hollstein, no. 87).

In addition to portraits, Willem Delff also produced illustrations for books after 1618, including those for the famous edition of *L'Académie de l'espée* by Gérard Thibault (1628), for which he provided three engravings (Hollstein, nos 102–4).

Delff's work was highly successful, and he was awarded the title of engraver to the King of England. Records also indicate that he was a prosperous man. In 1638, the year that he died, his portrait was painted by his father-in-law (Schwerin, Staatl. Mus.). His son Jacob Willemsz. Delff the younger (1619–61) was trained as a portrait painter in the workshop of his grandfather, continuing van Mierevelt's work after he died in 1641.

Bibliography

Hollstein: *Dut. & Flem.*; Thieme–Becker; Wurzbach

D. Franken: *L'Oeuvre de Willem Jacobsz. Delff* (Amsterdam, 1872) [with cat. rais.]

H. Havard: *Michiel van Mierevelt et son gendre* (Paris, 1894)

RUDOLF E. O. EKKART

Doomer, Lambert (Harmensz.)

(*b* Amsterdam, *bapt* 11 Feb 1624; *d* Amsterdam, 2 July 1700). Dutch painter, draughtsman and collector. He was trained to be a joiner by his father,

Harmen Doomer (1595–1650), a prosperous manu-facturer of ebony picture frames and cabinets. Doomer's father supplied frames to Rembrandt, who in 1640 painted his portrait (New York, Met.) and that of his wife *Baertge Martens* (St Petersburg, Hermitage). Lambert probably spent some time in Rembrandt's studio *c.* 1644, where he developed his skill as a draughtsman.

In 1646 Doomer sailed via the Isle of Wight to Nantes, where his brothers Maerten and Hendrik were living. From July to September 1646, together with the Dutch landscape painter and draughts-man Willem Schellinks, Doomer travelled along the Loire to northern France, visiting and record-ing châteaux and towns such as Angers, Saumur, Tours, Amboise and Orléans, as well as Dieppe and Le Havre. Back in Amsterdam, Doomer led a finan-cially secure life on the income of the factory run by one of his brothers. He made several journeys through the Netherlands (visiting Utrecht, Enkhuizen, Arnhem and Nijmegen), and in 1663 he travelled up the Rhine via Cleve, Mönchengladbach and Cologne to Bingen. A year after his marriage in 1668 to Metje Harmens, he moved to Alkmaar, where the house in which he lived still exists. From 1673 to 1681 he lived at the *mannengasthuis* (old men's home) in Alkmaar, marrying his second wife, Geesje Esdras, in 1679. In 1695 he returned to Amsterdam.

Of the more than 300 drawings by him that have survived, most are topographical views of the Netherlands, France and Germany, executed with subtle watercolour washes and some white gouache over black chalk. Doomer is one of the most important and characteristic of Dutch topographical draughtsmen, comparable to Roelant Roghman, Willem Schellinks and Herman Saftleven II. However, his drawings surpass those of his contemporaries in their special quality of atmosphere and in their pictorial and Romantic treatment of subject-matter. The topographical drawings are also interesting from a historical viewpoint, since they show the 17th-century appearance of buildings and monuments that no longer exist, for example several castles on the Rhine destroyed by French troops in 1689. In later years Doomer made numerous copies of his own topographical views. About 1671–3 he produced an extensive group of replicas on account-book paper; these second versions constitute almost a quarter of his surviving drawings. In 1665 Doomer pro-vided 11 drawings for the important collection of topographical landscape drawings assembled by the Amsterdam lawyer Laurens van der Hem, now preserved in the Atlas van der Hem (Vienna, Öster-reich. Nbib.). Doomer was himself a collector and purchased items from the sale of Rembrandt's art collection in 1658, including an album of draw-ings by Roelandt Savery (now dispersed), some of which he copied (e.g. *Alpine Landscape*; Berlin, Kupferstichkab.). He also copied drawings by Jan Hackaert (e.g. *The Glärnisch*, 1692; Bremen, Ksthalle). Although some of these landscapes depict alpine mountains, Doomer apparently never visited Switzerland.

Doomer's achievements as an amateur painter are less important than his achievements as a draughtsman. He was inspired by such contempo-rary Amsterdam artists as Ferdinand Bol. There are at least 25 surviving oil paintings by Doomer, dating from *c.* 1644 to *c.* 1684, and there are ref-erences to others in the artist's will, old invento-ries and in 18th- and 19th-century sale catalogues. Some paintings, such as *Farmhouse and Well* (Amsterdam, Rijksmus.) and *Pont Neuf in Angers* (Paris, Louvre), are presumably based on topo-graphical drawings; others, such as *The Ford* (Strasbourg, Mus. B.-A.) and *Shepherd Couple* (Oldenburg, Landesmus.), seem to use individual motifs from his sketches. Doomer copied Rembrandt's portraits of his parents and produced group portraits, for example the *Young Couple by a Globe* (?1684; Burlington, U. VT, Fleming Mus.), the *Regentesses of the Proveniershuis at Alkmaar* and the *Regents of the Proveniershuis at Alkmaar* (completed in 1680 and 1681 respectively; both Alkmaar, Stedel. Mus.), for which a rare pre-liminary study survives (Amsterdam, Chr. P. van Eeghen priv. col., see Schulz, 1974, no. 43). Doomer's best work as a painter is *Hannah and Samuel before Eli* (1668; Orléans, Mus. B.-A.), with its highly individualized, portrait-like depictions of the main characters. Doomer's portraits and biblical pictures reveal his antiquarian interests,

for example in the figures' old-fashioned clothing. His genre pictures and still-lifes, such as *Still-life with Thistles* (1675; Copenhagen, Stat. Mus. Kst), not only emphasize elements of still-life but, like the *Expulsion of the Prodigal Son* (1695; Oelde, Egon Rusche priv. col., see Bernt, no. 342), also contain veiled sexual allusions.

Bibliography

H. van den Berg: 'Willem Schellinks en Lambert Doomer in Frankrijk', *Oudhdknd. Jb.*, xi (1942), pp. 1–31

W. Schulz: 'Zur Frage von Lambert Doomers Aufenthalt in der Schweiz', *Z. Schweiz. Archäol. & Kstgesch.*, xxvii (1970), pp. 5–20

—: 'Doomer and Savery', *Master Drgs*, ix (1971), pp. 253–9, pls 28–43

—: *Lambert Doomer, 1624–1700: Leben und Werke*, 2 vols (diss., Free U. Berlin, 1972)

—: *Lambert Doomer: Sämtliche Zeichnungen*, (Berlin, 1974); review by P. Schatborn in *Simiolus*, ix (1974), pp. 48–55

—: 'Zu einigen Zeichnungen des Rembrandt-Schülers Lambert Doomer in den Staatlichen Museen zu Berlin', *Forsch. & Ber. Staat. Mus. Berlin*, xvii (1976), pp. 73–95

—: 'Lambert Doomer als Maler', *Oud-Holland*, lxxxii (1978), pp. 69–105

W. Bernt: *Die niederländerischen Maler* (Munich, 1979)

WOLFGANG SCHULZ

Dou, Gerrit [Gerard]

(*b* Leiden, 7 April 1613; *d* Leiden, *bur* 9 Feb 1675). Dutch painter. The first and most famous member of the group of artists referred to as the Leiden 'fine' painters, he specialized in small-format paintings, the details and surfaces of which are carefully observed and meticulously rendered. He was greatly praised as a painter of artificial light by Samuel van Hoogstraten in 1678, and he was responsible for popularizing both the night scene and the 'niche' format, pictorial devices ultimately derived from the art of his famous master, Rembrandt. Dou used them in images of ordinary people ostensibly engaged in mundane activities.

1. Life and work

Dou was the youngest son of a glazier who probably belonged to the Dutch Reformed Church. From an early age he was trained in his father's profession, first with the engraver Bartolomäus Dolendo, then with the glazier Pieter Couwenhorn. Dou is mentioned in the records of the Leiden glaziers' guild in 1625 and 1627, the years in which he worked on a commission to repair and make new windows for the church-wardens of Oestgeest. On 14 February 1628 he was sent to Rembrandt to study painting. According to Orlers, Dou was an 'excellent master' by the time he left Rembrandt's studio three years later, and his work was widely admired. He was a founder-member of the Leiden Guild of St Luke and served as ensign (*vaendrager*) in the local militia company, a position indicative of his elevated social status and his bachelorhood. He died a wealthy man and was buried in the St Pieterskerk.

In the 1630s Dou painted three types of picture: *tronies* (uncommissioned physiognomic studies), portraits and single, full-length figures. *Tronies* were popular in Rembrandt's Leiden circle, and the same elderly models who posed for Dou, often in exotic dress, were also depicted by Rembrandt and Jan Lievens. Portraits, which comprise most of Dou's early work, were an essential source of income for many artists and may have been so for Dou, at least initially. His sitters are usually shown in half- or three-quarter length, conservatively dressed and, for the most part, lacking animation. The third type of picture featured figures absorbed in or distracted from their everyday activities. His earliest dated painting, the *Young Violinist* (1637; Edinburgh, N.G.), is an example of this type. The thinly and finely painted surface, the prevalence of meticulously observed and rendered still-life objects of various materials, the subtle chiaroscuro and interest in light reflections and effects and the arrested movement are character-istic of Dou's early style.

By the mid-1640s Dou was painting fewer por-traits while enlarging his genre repertory. The signed and dated *Village Grocer* (1647; Paris, Louvre) marks the change. The large number of figures in this painting is unusual for Dou, whereas the inclusion of accumulated still-life accessories is common in his art. He also introduced the so-called 'niche' format into his

painting, a device previously reserved almost exclusively for portraiture. In this favoured format, figures and objects are placed beyond the framing arch of a *trompe-l'oeil* window, giving the artist an opportunity to display his skills of illusionism and providing a simple aid to spatial organization: the window ledge functions both to establish the foreground plane, opening up the pictorial space behind, and to support objects that seem to project forward into the viewer's space (see fig. 14).

From the early 1650s Dou's paintings attain a certain monumentality. His figures become larger in scale, his choice and arrangement of still-life objects more judicious. In such works as *The Doctor* (1653; Vienna, Ksthist. Mus.; see col. pl. XI) or the *Woman with a Basket* (1657; Waddesdon Manor, Bucks, NT) he meticulously rendered the frozen attitude of a figure in its environment, the surface qualities of varied materials and the descriptive properties of light. A painted curtain draped across the picture functions like the niche by symbolically separating the deceptively naturalistic figures and action from the real world. Dou's tendency to place equal emphasis on all the elements in his paintings is in striking contrast to the more unified narrative and integrated atmosphere presented in the contemporary genre scenes of Gerard ter Borch (ii), Pieter de Hooch and Johannes Vermeer. By the late 1650s Dou had developed his interest in light effects by translating two types of subject-matter into night scenes: artificially-lit genre scenes and, more commonly, single female figures standing at a window, peering into darkness and illuminated only by a candle or lantern. His *Woman Laying a Table* (Frankfurt am Main, Städel. Kstinst.) is an exercise in virtuosity in which a lantern, a candle and a fire are depicted together, each throwing light in its characteristic way.

Two further types of subject-matter were introduced in his paintings of the 1660s. First, he decorated the shutters designed to protect his paintings from dust and strong light with still-life paintings, only a few of which survive. They are known as *bedriegertjes* (scenes populated with illusionistically-rendered objects meant to deceive the eye). In the *Still-life* (Dresden, Gemäldegal. Alte Meister) that once protected a night scene set in a cellar, the emphatically tangible objects, some of which seem to spill out into the spectator's space, are placed in a niche. As in his genre scenes, an illusionistic curtain in front of the niche refers to the actual practice of using curtains to protect paintings and heightens the *trompe-l'oeil* effect of the image (see fig. 15). Secondly, he explored the possibilities of depicting the nude. As the subject of an independent painting, the nude was rare in the north in the 17th century and was usually restricted to drawings, prints and a few history paintings. The four known nudes by Dou (three in St Petersburg, Hermitage; one in The Hague, Rijksdienst Beeld. Kst.) are unidealized and unclassical; there are no attributes to identify them as specific personages or personifications, nor are they engaged in a particular activity. Dou's last dated works are from 1672. In his late style, exemplified by *The Dentist* (Dresden, Gemäldegal. Alte Meister), the still-life objects are masterfully

14. Gerrit Dou: *Woman Hanging a Rooster from a Window* (Paris, Musée du Louvre)

15. Gerrit Dou: *The Dropsical Woman*, 1663 (Paris, Musée du Louvre)

painted, but the last few paintings lack Dou's earlier microscopic detail, and the overall finish tends to be hard.

2. Symbolism and meaning

Dou's paintings depict the everyday life of the Dutch bourgeoisie, without the obvious picturesque trappings of a rustic or theatrical nature. Many of the popular images that he created and developed, however, contain veiled symbolism, usually derived from traditional moralizing or didactic themes, allowing them to be read on more than one level. In keeping with the rhetorical character of Dutch representations of artists in the 17th century, Dou presented himself as teacher and admonisher in his *Self-portrait Aged Fifty* (1663; Kansas City, MO, Nelson–Atkins Mus. A.). The *Old Woman Peeling Apples* (Berlin, Gemäldegal.), surrounded by attributes of her domestic industry, can be seen as the exemplar of the pious and virtuous life. The objects in the *Still-life* in Dresden are primarily associated with

vanitas depictions, which emphasize the transitoriness of earthly life, in keeping with the strong tradition for such themes in Leiden. Yet some of Dou's paintings are iconographically more complex: for example, his famous *Triptych* (known through a copy by William Joseph Laquy, Amsterdam, Rijkmus.), which came to be known as *The Nursery*, has been interpreted as representing Aristotle's three stages of learning—nature, teaching and practice. He also used the still-lifes on the shutters of his paintings to comment on or add to the meaning of the picture inside. The visual richness of his imagery and the possibilities of multi-layered interpretation must have played a large part in the appeal of his paintings to contemporary audiences.

3. Working methods and technique

Sandrart, with Pieter van Laer, visited Dou *c.* 1639, but his description of his studio and his working method included in the *Teutsche Academie*, written some 35 years later, is suspect. In it he claimed that Dou needed eyeglasses from the age of 30 and took days to paint the smallest detail; that he was extremely fastidious concerning his tools, materials and working conditions; and that he was a failed portrait painter because of his slow working method.

Dou worked on oak panels, usually of small dimensions and often prepared with a warm, reddish-brown ground. The palette in his earliest works consists of aqua, lilac, rose and green, with the gradual introduction of gold. These colours, applied in thin glazes, and the enveloping chiaroscuro echo those in Rembrandt's Leiden paintings. By the mid-1640s Dou had changed to saturated golds, reds and blues, although he still frequently retained the warm chiaroscuro learnt in Rembrandt's studio. His last paintings are marked by strong local colour and by a more roughly painted surface, particularly in the skin and clothing.

Only a few drawings have been attributed, somewhat controversially, to Dou, who apparently, unlike his master and many of his contemporaries, did not use them regularly as part of the preparatory process. Sumowski has identified what he

believes to be a rare preliminary sketch in pencil (England, priv. col., see Sumowski, 1980, no. 531) for the painting of the *Venison Shop* (London, N.G.) and an autograph copy in red and white chalk (Paris, Louvre) after a lost picture of a *Woman Cooking Sausages*, which, according to the inscription of the drawing's *verso*, was sent to the Elector of Mainz in 1650. The few drawings surely by the artist are independent portrait studies, such as the signed and dated *Portrait of the Artist's Mother* (1638; Paris, Louvre) and the signed and dated portrait of '*Anne Spiering*' (1660; priv. col., see Sumowksi, 1980, no. 530).

The precise role played by pupils in Dou's studio practice is not known, but from as early as 1645 he attracted a large number of students, among them his nephew Domenicus van Tol, Rans van Mieris (i), Pieter van Slingeland, Godfried Schalken and possibly Gabriel Metsu.

4. Critical reception and posthumous reputation

Dou's ability as a painter was recognized early in his career. In Angel's address to the artists of Leiden in 1641, published the following year, Dou's painting style was held up as a paradigm to his fellow painters. He was also lauded as a contemporary artist who, like the great masters of antiquity, had a patron (Pieter Spiering) willing to pay handsomely for the right of first refusal to his paintings. Spiering (*d* 1652) was the son of the most important tapestry manufacturer in Delft and was Swedish minister to The Hague from the mid-1630s to his death. He ostensibly bought Dou's paintings for Queen Christina, but the works were clearly more to Spiering's taste for the finished than to Christina's taste for the Italianate. Dou charged for his paintings at the rate of one Flemish pound per hour. According to Sandrart, his small paintings sold for the then substantial price of 600–1000 Dutch guilders.

Dou's fame was international by 1660. When the Dutch States General decided to make a gift to Charles II on his accession to the English throne, Dou was appointed an appraiser for the States and, in addition, the States acquired three paintings from him for the new monarch. When the paintings given by the Dutch were exhibited at Whitehall, London, Charles singled out Dou, Titian and Elsheimer for praise. Dou's painting skills impressed Charles so much that he invited the artist to his court; Dou, however, chose to remain in Leiden. Visits to Dou's studio by such foreign scholars and aristocrats as the Dane Ole Borch (1662), the Frenchman Balthasar de Monconys (1663) and Cosimo III de' Medici (1669) are further indications of his popularity. In addition, a painting by Dou appeared in the inventory of 1662 of the Archduke Leopold William of Austria, who had been Governor of the Netherlands from 1646 to 1656.

Dou was no less highly regarded at home. In July 1669 the Burgomasters of Leiden commissioned a painting by Dou, 'whose art was famous and held in great esteem'; the commission was later withdrawn, however. Eleven paintings by Dou appeared in the collection of François de la Boë Sylvius, professor of chemistry and medical science at Leiden University, on his death in 1672. Dou's greatest patron in the second half of his career was Johan de Bye, a prominent Leiden citizen and pious Remonstrant. De Monconys, who visited de Bye during his Leiden sojourn, saw there 'a large quantity of paintings by Dou'. On 18 September 1665 de Bye exhibited 27 of his paintings by Dou, representing all types of subject-matter from every phase of Dou's career.

Dou's students and followers varied in talent and in what they took from their master. Van Mieris, whom Dou considered the 'prince of his pupils', derived his style from Dou and even amplified Dou's polished surface finish; Pieter van Slingeland was primarily interested in Dou's subject-matter; van Tol was content merely to repeat and imitate his compositions; and Schalken single-mindedly pursued one aspect of Dou's work, the candlelight scenes. Moreover, the work of many minor Leiden artists, for example Jacob van Spreeuwen (*b* 1661) and Jan Adriaensz. van Staveren (*c.* 1625–after 1668), reveals the influence of Dou, although there is no evidence that they worked directly with him. The popularity of Dou's pictures, reflected in market prices, the demand of collectors and the influence of his

style, pictorial devices and subject-matter continued to grow well into the 19th century.

Bibliography

J. Orlers: *Beschrijvinge der stadt Leyden* (2/Leiden, 1641)

P. Angel: *Lof der schilder-konst* (Leiden, 1642/R Utrecht, 1969, facs. Amsterdam, 1972), p. 56

J. von Sandrart: *Teutsche Academie* (1675–9); ed. A. R. Peltzer (1925), pp. 195–6

S. van Hoogstraten: *Inleyding tot de hooge schoole der schilderkonst, anders de zichtbaere werelt* [Introduction to the academy of painting, or the visible world] (Rotterdam, 1678/R Soest, 1969, Ann Arbor, 1980), pp. 262, 268

J. Smith: *A Catalogue Raisonné of the Works of the Most Eminent Dutch, Flemish and French Painters*, i (London, 1829), and suppl. (1842)

W. Martin: *Het leven en de werken van Gerrit Dou beschouwd met het schildersleven van zijn tijd* (Leiden, 1901); abridged Eng. trans. by C. Bell (London, 1902); expanded Fr. trans. by L. Dimier (Paris, 1911)

C. Hofstede de Groot: *Hollandischen Mäler*, i (1907)

W. Martin: *Gerard Dou*, Klass. Kst Gesamtausgaben (Stuttgart and Berlin, 1913)

A. Wheelock jr: 'A Reappraisal of Gerard Dou's Reputation', *The William A. Clark Collection* (Washington, DC, 1978), pp. 60–67

W. Sumowski: *Drawings of the Rembrandt School*, iii (New York, 1980)

—: *Gemälde der Rembrandtschüler*, i (Landau, 1983)

Leidse fijnschilders: Van Gerrit Dou tot Frans van Mieris de jonge, 1630–1760 (exh. cat., ed. E. J. Sluijter and others; Leiden, Stedel. Mus. Lakenhal, 1988)

De Hollandse fijnschilders: Van Gerard Dou tot Adriaen van der Werff (exh. cat. by P. Hecht, Amsterdam, Rijksmus., 1989)

R. Baer: *The Paintings of Gerrit Dou* (diss., New York, Inst. F.A., 1990)

RONNI BAER

Drost, Willem

(*b* ?Germany, *c.* 1630; *d* ?Amsterdam, after 1680). Dutch painter, draughtsman and printmaker, possibly of German origin. According to Houbraken, he was a pupil of Rembrandt, possibly in or shortly before 1650. An early etching signed *w drost 1652* is probably a self-portrait, in which Drost portrayed himself as a young man drawing. His earliest dated paintings are two pendants of 1653: the *Portrait of a Man* (New York, Met.) and the *Portrait of a Woman* (The Hague, Mus. Bredius). The man's portrait is signed *Wilhelmus Drost F./ Amsterdam 1653*; the form of the first name implies that he was of German descent.

The painting of *Bathsheba with Daniel's Letter* (Paris, Louvre), signed and dated *Drost F. 1654*, is considered to be his masterpiece, with its subtle palette of soft flesh tones harmonizing with the varying shades of white and grey in which the cloth and the fur are splendidly rendered. Dating from the same period is his *Portrait of a Young Woman* (London, Wallace), which bears the false signature *Rembrandt ft*. Two works of contrasting styles are also dated 1654: the *Portrait of a Woman with a Fan* (Zurich, E. Haab-Escher priv. col.) and the *Woman with a Knife in a Window* (ex-Brod Gal., London). The former is polished and detailed; the second is executed in a much looser manner with broad brushstrokes. These paintings show not only Drost's ability to paint in these two different traditional ways but also his participation in the stylistic debate topical around 1650: many of Rembrandt's pupils were faced with the choice of continuing to paint in the broad virtuoso manner of their master or adopting a smoother, more up-to-date style. For commissioned works such as portraits the smoother style was usually chosen, as Drost did in the *Portrait of a Woman* of 1654, whereas the *Woman with a Knife* of the same year is a more freely painted genre scene. After 1660 Drost changed definitely to the elegant, polished style of, for example, Nicolaes Maes, evident from his only dated work of this period, the portrait of *Hillegonda van Beuningen* (1663; The Netherlands, priv. col.). Around 1662 Drost must have been in Italy, where, according to Houbraken, he became friends with Jan van der Meer of Utrecht (*c.* 1640–after 1691) and Johann Carl Loth; Drost's *Self-portrait* (*c.* 1662; Florence, Uffizi) is in the manner of Loth, with heavy shadows and warm brown and red tones.

Apart from portraits and a few half-length figures in historical costume, such as the *Man in a Cuirass* (Kassel, Schloss Wilhelmshöhe), Drost painted mainly biblical scenes with full-length figures: a *Noli me tangere* (Kassel, Schloss

Wilhelmshöhe); the *Young Daniel* (Copenhagen, Stat. Mus. Kst); the *Virgin Annunciate* (Prague, N.G., Šternberk Pal.); and *Ruth and Naomi* (Oxford, Ashmolean), the only painting for which there is a directly connected preparatory drawing (Bremen, Ksthalle). On stylistic grounds another 45 or so pen and ink drawings have been attributed to Drost, all characterized by profuse and remarkably even hatching.

The reconstruction of Drost's painted and drawn oeuvre by Sumowski (1980 and 1983) does not yet seem complete. A number of history paintings with large figures depicting biblical subjects, previously ascribed to Rembrandt, are apparently (or may yet prove to be) by Drost. If the attribution to Drost of *Manoah's Sacrifice* (Dresden, Gemäldegal. Alte Meister), which bears the false signature of *Rembrandt f. 1641*, is accepted, then the basis for the attribution of similar works may be formed.

Bibliography

A. Houbraken: *De groote schouburgh* (1718–21), iii, p. 61

D. Pont: 'De composities "Ruth en Naomi" te Bremen en te Oxford: Toeschrijving aan Willem Drost', *Oud-Holland*, lxxv (1960), pp. 205–21

W. Sumowski: *Drawings of the Rembrandt School*, iii (New York, 1980), nos 546–69

—: *Gemälde der Rembrandtschüler*, i (Landau, 1983), pp. 608–51; review by J. Bruyn in *Oud-Holland*, xcviii (1984), pp. 153–8

B. P. J. BROOS

Du Jardin [Dujardin; Du Gardijn], Karel [Carel]

(*b* Amsterdam, 27 Sept 1626; *d* Venice, before 9 Oct 1678). Dutch painter, etcher and draughtsman. His father was Chaarles de Jardin (Gardyn; *c.* 1599–before 1650), a fat-renderer, and his mother was Catalyn Borchout (1588–before 1650). They had at least one other child, Herbert, who must have died by 1651 and about whom nothing is known.

Du Jardin's artistic training remains a mystery. From Houbraken on he is described as Nicolaes Berchem's ablest pupil, although there is no evidence for this other than a similarity in subject-matter. Pieter van Laer and Paulus Potter have also been mentioned as teachers, but again this is sheer supposition. Du Jardin may have received early stimulus from his brother-in-law, Johannes Pauwelsz. Schors, a painter from Augsburg and husband of Du Jardin's half-sister Tryntje, about whom nothing is known. More directly relevant is Du Jardin's second cousin, the portrait painter Pieter Nason. There is no evidence confirming that they knew each other, but ties between the Du Jardin and Nason families were strong. If Du Jardin did not study with Nason, he may at least have been exposed by him to the rudiments of the craft.

Du Jardin is best known for the Italianate landscapes he painted throughout his career. It has been presumed on the basis of his subject-matter that he travelled to Italy in the 1640s, yet no proof for such a trip exists. He probably travelled to France as a merchant in 1650, an idea supported both by a document and a drawing signed *Dujardin fecit Paris* (Berlin, Kupferstichkab.). Du Jardin met his wife, Suzanne van Royen, in Lyon. They were living on the Rozengracht in Amsterdam by 1652, when Du Jardin made his will. Still in Amsterdam in 1655, by October 1656 Du Jardin had moved to The Hague, where he became a founder-member of De Pictura, the artist's confraternity. He appears in the confraternity's records of 1657 and 1658, at which time his probable first pupil, Martinus Laeckman, is recorded.

Characteristic paintings by Du Jardin of the 1650s, such as the *Landscape with Waterfall and Resting Animals* (1655; Paris, Louvre) or *Farm Animals in the Shade of a Tree, with a Boy and a Sleeping Herdswoman* (1656; London, N.G.), show a strong debt to Paulus Potter's paintings of animals rendered with great precision and naturalism. Du Jardin's small, simply constructed scenes of herders and cattle resting in meadows or travelling through the landscape and travellers halting at an inn are marked by refined detail and bright colours with a sensitive interpretation of light and shade.

Du Jardin made a number of drawings, mainly studies in chalk of cattle, sheep and other

animals, as well as a few red chalk portraits (e.g. *Self-portrait*, 1659; London, BM) and a series of Italianate landscape drawings, mostly in brush and wash. The *View of the Piazza di S Maria Maggiore, Rome* (Paris, Fond. Custodia, Inst. Néer.) is dated 1653, suggesting that it was copied from either a print or another artist's drawing, since Du Jardin was back in Amsterdam by 1651. Du Jardin's activity as an etcher also dates from the 1650s. In 1653 he published a series of prints of resting animals, shepherds and related pastoral motifs. Despite the Italianate settings, his etchings appear to have been made in the Netherlands and are close in conception to Pieter van Laer's innovative series of 1636. About 50 etchings by Du Jardin are known.

By May 1659 Du Jardin was again back in Amsterdam, where he is documented in 1670, 1671 and 1674. During the 1660s he continued to paint Italianate landscapes but also painted portraits of important members of Amsterdam society, such as the *Regents of the Spinhuis and the Nieuwe Werkhuis* (1669; Amsterdam, Rijksmus.), as well as a number of remarkable history paintings. These large, impressive works (e.g. the *Conversion of St Paul*, 1662; London, N.G.) reflect the artist's response to the stylistic innovations of the Amsterdam Town Hall commissions of the 1650s, particularly the introduction of Flemish and classicizing elements. They also bear witness to Du Jardin's awareness of Italian Baroque paintings by such artists as Guido Reni. The spectacular *Hagar and Ishmael* (*c.* 1665–7; Sarasota, FL, Ringling Mus. A.) displays Du Jardin's command of large-scale, dynamic yet stable compositional formulae and his ability to render imposing figures convincingly with sensitive physiognomies. He used cool, modulated tonalities to create smooth surfaces and brilliant fabrics.

In 1675 Du Jardin sailed to Italy from Texel Island accompanied by Joan Reynst, whose father, a member of Amsterdam's patriciate, had assembled one of the most important collections of Venetian 16th-century painting in the Netherlands. (Du Jardin probably knew the Reynst collection, for in 1672 he was a witness in a legal proceeding concerning the authenticity and worth of some of the paintings.) Reynst and Du Jardin stopped in Tangiers in October 1675, and, although Reynst returned to the Netherlands, Du Jardin continued his journey to Rome, where he signed and dated his *Landscape with Herders and Animals* (1675; Antwerp, Kon. Mus. S. Kst.). A number of late landscapes grouped around this painting reveal a drastic change in style. He abandoned his large figure types, replacing them with small, agitated figures situated in large Italian riverside settings; his brilliant, creamy technique and light, clear tonalities gave way to dark, smoky colours with rougher brushwork, harsher contrasts and fewer highlights. Though definitive proof that Du Jardin joined the Schildersbent, the Netherlandish artists' society founded in Rome in 1623, is lacking, like other members he was given the nickname 'Bokkebaard' (Dut.: 'goatbeard'). He came into contact with the classicizing Dutch painter Johannes Glauber. Works dated 1675, 1676 and 1678 attest to Du Jardin's productivity in Rome, where he painted his last known work, the *Riding School* (1678; Dublin, N.G).

Du Jardin achieved a measure of fame in his own day: he was praised by Cornelis de Bie, and his small, multi-figured scene of *Calvary* (1662; Paris, Louvre) was lauded in a poem by the leading Dutch poet, Jan Vos. Du Jardin also designed the portrait frontispiece to the collected edition (1662) of Vos's poetry. Besides Laeckman, Du Jardin's only other recorded pupil was Erick Wilke (or Van der Weerelt), an orphan under the care of the Civil Orphanage in Amsterdam. He went to study with Du Jardin in Amsterdam in March 1668 for the fee of 80 guilders a year.

Bibliography

Hollstein: *Dut. & Flem.*

A. Houbraken: *De groote schouburgh* (1718–21), ii, pp. 85, 112, 214, 277; iii, pp. 43–7, 158, 171, 261, 333

C. Hofstede de Groot: *Verzeichnis* (1907–28), ix, pp. 295–417

E. Brochhagen: 'Dujardins späte Landschaften', *Bull. Mus. Royaux B.-A. Belgique*, vi (1957), pp. 236–55

——: *Karel Dujardin: Ein Beitrag zum Italianismus in Holland im 17. Jahrhundert* (diss., U. Cologne, 1958)

Nederlandse 17e eeuwse Italianiserende landschap-schilders [Dutch 17th-century Italianate landscape painters] (exh. cat., ed. A. Blankert; Utrecht, Cent. Mus., 1965/*R* 1978)

JENNIFER M. KILIAN

Dusart [du Sart], Cornelis

(*b* Haarlem, 24 April 1660; *d* Haarlem, 1 Oct 1704). Dutch painter, draughtsman and printmaker. He was the son of the organist at St Bavo in Haarlem and one of the last pupils of Adriaen van Ostade. He became a member of the Haarlem Guild of St Luke on 10 January 1679 and served as its dean in 1692. Dated pictures by Dusart have survived from almost every year between 1679 and 1702. Two of his earliest pictures of peasants relied heavily on compositions by van Ostade: *Mother and Child* (1679; Dresden, Gemäldegal. Alte Meister) and *Woman Selling Milk* (1679; sold Amsterdam, Muller, 16 Oct 1928, lot 9; the original drawing by van Ostade is in Paris, Fond. Custodia, Inst. Néer., see Schnackenburg, 1981, no. 132).

Over the next few years Dusart remained one of his teacher's closest followers, and in *Peasants outside an Inn* (Vienna, Ksthist. Mus.; see fig. 16) and *Farm with a Donkey* (St Petersburg, Hermitage), both dated 1681, the only distinguishing feature is Dusart's more delicate representation of foliage. Shortly after, works such as *Siblings with a Cat* (1682 or 1683; Nijmegen, Esser priv. col., see Trautscholdt, fig. 8) reveal Jan Steen as another source of inspiration. With Steen as his model, Dusart developed figure types whose faces are expressive to the point of grimacing and who make exaggerated movements and wear fantastic clothing (e.g. *Dance outside the Inn*, 1684; Haarlem, Frans Halsmus.). Dusart's figures are often aggressively ugly, as in *St Nicholas's Day* (1685; Basle, Dr T. Christ priv. col., see Trautscholdt, fig. 10) His forte was not so much comedy as broad farce, and it is doubtful that there was any moralizing purpose in his depictions of vice. A graphic scene entitled *Drunken Woman in a Brothel* (1699; sold Göteborg, 9 Nov 1977, lot 1716 with illus.) reveals the influence of

16. Cornelis Dusart: *Peasants outside an Inn*, 1681 (Vienna, Kunsthistorisches Museum)

Cornelis Bega, examples of whose prints were owned by Dusart. Dusart used lighter and more varied colours, the intense light blue, yellow and red of the costumes predominating over the tonality of the surrounding space (as in the *Pipe Smoker*, 1684; USA, priv. col., see 1984 exh. cat., no. 41), which does not achieve the sensitivity and atmospheric density of van Ostade's work.

After van Ostade's death in 1685, Dusart took over the contents of his studio. Among the works left behind were unfinished paintings by Adriaen van Ostade, some of which Dusart completed (e.g. *Peasant Festivity*; The Hague, Mauritshuis), and paintings by Adriaen's brother Isaack van Ostade, who had died *c.* 1649. The material influenced Dusart profoundly, so that in *Quarrel over a Card-game* (1697; Dresden, Germäldegal. Alte Meister), for instance, the figures resemble those of Steen, but the composition is based on a drawing by Adriaen van Ostade called the *Knife Fight* (Paris, École N. Sup. B.-A.). Dusart also made exact copies of paintings by Adriaen van Ostade (sold Vienna, Dorotheum, 10 Sept 1959, lot 38 with illus.). He

also seems to have either completed or adapted some of Steen's oil paintings. Important late paintings include turbulent pictures of fairs with a wealth of figures, such as *Village Kermesse* (1697; sold Amsterdam, Muller, 4–5 Dec 1912, lot 179 with illus.) and the *Quack Doctor* (1702; Bremen, Ksthalle).

Cornelis Dusart was an immensely productive and versatile draughtsman. His most original works are his figure studies drawn from life in black and red chalk, some with watercolour washes (e.g. *Seated Boy Reading*; Amsterdam, Rijksmus.) and some on coloured paper and parchment. Not surprisingly, Dusart also adopted the drawing techniques of the van Ostade workshop. Dusart's numerous pen-and-ink drawings, among the best of which were his preparatory studies for prints, often have a distinctive and boldly applied dark brown wash background. Dusart made skilful and systematic use of the stock of drawings the van Ostades left behind, either by copying them or by expanding brief sketches into finished works; in the process he emulated exactly Adriaen's and Isaack's style and stages of development. Dusart frequently copied the preliminary drawings before reworking the pictures. He also used Steen's figure style, leading scholars to attribute certain drawings to Steen himself.

Dusart's extensive graphic oeuvre consists of some 119 etchings and mezzotint engravings. An early group of 12 etchings is dated 1685, the year in which Dusart completed his first mezzotints. There are such series as the *Months*, the *Ages of Man*, the *Five Senses* etc, as well as individual sheets depicting scenes of peasant life. Some of the preparatory drawings were provided by Jacob Gole of Amsterdam, who also acted as publisher. In his prints Dusart vividly expressed the satirical side of his art, reflecting the popular theatre of the Society of Rhetoricians. Dusart's graphic work was his most influential contribution to Dutch art, especially in its impact on caricature.

Dusart remained unmarried and apparently suffered from a weak constitution. The inventory in his will, dated December 1704, included not only his own works and the residue of the van Ostade estate but also a remarkable collection of paintings, drawings and prints by Italian and Dutch artists including Bega, Gerrit Berckheyde and Adriaen van de Velde. His estate was auctioned in Haarlem on 21 August 1708.

Bibliography

Bénézit; Hollstein: *Dut. & Flem.*; Thieme–Becker

A. Bredius: *Künstler-Inventare*, i (The Hague, 1915), pp. 27–73

J. Q. van Regteren Altena: 'De voorvaderen van Cornelis Dusart', *Oud-Holland*, lxi (1946), pp. 130–33

E. Trautscholdt: 'Beiträge zu Cornelis Dusart', *Ned. Ksthist. Jb.*, xvii (1966), pp. 171–200

O. Naumann: *Netherlandish Artists*, 7 [v/ii] of *The Illustrated Bartsch*, ed. W. Strauss (New York, 1978), pp. 288–325

B. Schnackenburg: *Adriaen van Ostade, Isack van Ostade, Zeichnungen und Aquarelle*, i (Hamburg, 1981), pp. 60–64

Dutch Figure Drawings from the Seventeenth Century (exh. cat. by P. Schatborn; Amsterdam, Rijksmus.; Washington, DC, N.G.A.; 1981–2), pp. 110–12

Dutch Prints of Daily Life: Mirrors of Life or Masks of Moral? (exh. cat. by L. Stone-Ferrier, Lawrence, U. KS, Spencer Mus. A., 1983)

Masters of Seventeenth-century Dutch Genre Painting (exh. cat., ed. P. Sutton; Philadelphia, Mus. A.; London, RA; W. Berlin, Gemäldegal.; 1984), cat. no. 41

B. SCHNACKENBURG

Duyster, Willem (Cornelisz.)

(*b* Amsterdam, *bapt* 30 Aug 1599; *d* Amsterdam, *bur* 31 Jan 1635). Dutch painter. Duyster was the eldest of four children of Cornelis Dircksz. and his second wife, Hendrikge Jeronimus, from Gramsberge, Norway. His father is recorded as a textile cutter, house carpenter and minor Amsterdam official. In 1620 the family, which also included two children from Cornelis's first marriage, moved into a house in the Koningstraat named 'De Duystere Werelt' ('The Dark World'), which gave Duyster and his half-brother Dirck their adopted surname. The family name first appears in a document dated 1 July 1625 concerning a violent quarrel between Duyster and Pieter Codde, a fellow Amsterdam artist. The argument took place at Meerhuysen, a country house rented by Barent van Someren (c. 1572–1632), the

painter, dealer and inn-keeper who was a patron of Adriaen Brouwer and a good friend of Frans Hals.

An inventory from 16 October 1631, taken after the death of Duyster's parents, testifies that the family was financially comfortable and lists several anonymous paintings, mainly of popular biblical and mythological subjects. Although Duyster appears to have been living in the family house at the time the inventory was taken, no mention is made of a studio or any of his works.

In September 1631 he married Margrieta Kick, a cousin of the Haarlem painters Jan and Salomon de Bray. The double wedding ceremony also united Margrieta's younger brother, the Amsterdam genre painter Simon Kick (1603–52), and Duyster's youngest sister, Styntge. Eventually each couple came to live in 'De Duystere Werelt'.

Bredius suggested that Duyster studied under Pieter Codde, but this is unlikely, since the artists were exact contemporaries. It is more probable that either Barent van Someren or the portrait painter and collector Cornelis van der Voort (c. 1576–1624) taught them both.

Duyster's limited oeuvre includes genre scenes and portraits. Together with Codde he helped to develop and popularize the interior soldier scene. His *Cortegaerdjes* (guardroom pieces), which are often characterized by an underlying psychological tension, include depictions of soldiers looting, taking hostages or skirmishing among themselves. More frequently, the quieter side of military life is illustrated, with soldiers smoking, gaming, making music, dancing or romancing. These activities are also depicted in his merry company scenes, set in stable, barn or inn interiors. Signed or attributed portraits are rare.

Duyster's paintings are on a small scale with full-length figures and are carefully detailed. Angel (1642) particularly praised his skill at painting silks. In both subject-matter and style his works are similar to those of Pieter Codde. However, Duyster's are more innovative in terms of compositional effects, format and iconography. He experimented successfully with artificial light effects (especially evident in his nocturnal pieces), handling of space and unusual angles of vision.

While most of his interiors are quite plain, shadows, angles of walls or openings into subsidiary spaces are often used to create an abstract counterpoint of light and shadow against which the figures are set. The play of tonal values against rich, dark colour accents in his early works, particularly his genre portraits, shows the influence of Amsterdam portrait painters of the 1620s, such as Thomas de Keyser. His later works have quieter tonal harmonies, though they are almost always reinforced with strong colour areas.

Only three extant works ascribed to Duyster are dated: *Portrait of a Man* (1627; Amsterdam, Rijksmus.), *Portrait of a Woman* (1629; Amsterdam, Rijksmus.) and *Officer and Soldiers* (1632; Dublin, N.G.). His *Soldiers beside a Fireplace* (1632; ex-Werner Dahl priv. col., Düsseldorf) is probably a copy after two authentic versions (Philadelphia, PA, Mus. A., John G. Johnson Art Col.; St Petersburg, Hermitage). A lost portrait, dated 1628, of Joseph del Medico, the noted Jewish physician and writer, is known through an engraving after the original by Willem Delff. No pupils of Duyster are known: his closest direct follower was the little-known painter Daniel Cletcher (d 1632), who worked in The Hague. Duyster died of the plague that swept through the Netherlands in early 1635.

Bibliography

Hollstein: *Dut. & Flem.*; Thieme–Becker; Wurzbach

P. Angel: *Lof der schilderconst* (Leiden, 1642/R 1969), p. 55

A. Houbraken: *De groote schouburgh* (1718–21/R 1976), ii, p. 145

A. Bredius: 'Iets over Pieter Codde en Willem Duyster', *Oud-Holland*, vi (1888), pp. 187–94

H. F. Wijnman: 'De Amsterdamsche genreschilder Willem Cornelisz. Duyster', *Amstelodamum*, xxii (1935), pp. 33–4

C. B. Playter: *Willem Duyster and Pieter Codde: The 'Duystere wereld' of Dutch Genre Painting, c. 1625–35* (diss., Harvard U., 1972)

Tot lering en vermaak: Betekenissen van Hollandse genrevorstellingen uit de 17de eeuw [For instruction and pleasure: meanings of Dutch genre paintings of the 17th century] (exh. cat. by E. de Jongh and others, Amsterdam, Rijksmus., 1976), pp. 104–11

Masters of 17th-century Dutch Genre Painting (exh. cat. by P. Sutton and others; Philadelphia, PA, Mus. A.; W. Berlin, Gemäldegal.; London, RA; 1984), pp. 198–9

C. VON BOGENDORF RUPPRATH

Eeckhout, Albert

(b Groningen, c. 1610; d Groningen, 1666). Dutch painter and draughtsman. Eeckhout and Frans Post were the two most important artists who travelled to Brazil in 1637 in the entourage of the newly appointed governor-general, Johan Maurits, Count of Nassau-Siegen, on whose initiative Eeckhout was assigned to paint people, plants and animals as part of a scientific study of the country. Eeckhout's studies are characterized by an objectivity that is sober, direct and without artistic embellishment. In 1644 Johan Maurits, nicknamed 'the Brazilian', returned to the Netherlands where he published the collected scientific material as *Historia naturalis Brasíliae* (1648). He also used this material as a diplomatic tool; in 1654 he presented Frederick III of Denmark with a series of room decorations that Eeckhout had partially painted in Brazil between 1641 and 1643. This series comprised nine large portraits of aboriginal Indians, twelve still-lifes with Brazilian fruit and three portraits of Congolese envoys (Copenhagen, Stat. Mus. Kst).

The only painting by Eeckhout in a Dutch public collection, *Two Brazilian Turtles* (The Hague, Mauritshuis), was probably one of the works of art sold by Johan Maurits in 1652 to Frederick William, the Great Elector. This group included 800 chalk, oil and watercolour drawings of fish, reptiles, birds, insects, mammals, Indians, mulattos, fruits and plants, most of them presumably by Eeckhout. They were collected into seven books, the *Libri picturati*, of which four volumes containing 400 oil sketches were entitled *Theatrum rerum naturalium Brasíliae* (Kraków, Jagiellonian U. Lib.). In 1679 Maurits gave Louis XIV of France a present of eight paintings of Indians and animals in imaginary landscapes with still-lifes of Brazilian and African fruits and plants painted by Eeckhout after his return to the Netherlands. In 1668 Maximilian van der Gucht of The Hague made a series of tapestries after these paintings for the Great Elector, and a second series, the 'Tenture des Indes', was woven in 1687 by the French firm later known as Manufacture Royale des Gobelins (Paris, Mobilier N.). The paintings are no longer extant, but the cartoons for the tapestries were used until the 18th century. The many surviving tapestry series woven after 'Les anciennes Indes' (e.g. Amsterdam, Rijksmus.; Valletta, Pal. Grand Masters) testify to the popularity of these representations. At Maurits's recommendation, Eeckhout entered the service of John-George I, Prince-Elector of Saxony, in 1653, and he remained in Dresden for the next ten years. His most important commission was for the ceiling decorations in the Hofflössnitz hunting lodge, for which he used his Brazilian studies or drew from memory. During this period he also made a series of large oil paintings of exotic, mainly Asiatic peoples (Schwedt, Schloss). In 1663 he returned to Groningen, where he was awarded citizenship.

Bibliography

T. Thomsen: *Albert Eeckhout* (Copenhagen, 1938)
Soweit der Erdkreis reicht (exh. cat., Cleve, Städt. Mus. Haus Koekkoek, 1979)
Zowijd de wereld strekt (exh. cat., The Hague, Mauritshuis, 1979–80)

B. P. J. BROOS

Eeckhout, Gerbrand [Gerbrandt] van den

(b Amsterdam, 19 Aug 1621; d Amsterdam, bur 29 Sept 1674). Dutch painter, draughtsman and etcher. He was the son of the goldsmith Jan Pietersz. van den Eeckhout and 'a great friend' as well as a pupil of Rembrandt, according to Houbraken, who commented that van den Eeckhout painted in the style of his master throughout his career. This is certainly true of van den Eeckhout's (biblical) history paintings (see col. pl. XII), but less so of either his portraits, which gradually displayed more Flemish elegance, or his genre pieces (from 1650), in which he followed various trends; he adapted his style to suit his subject with sensitive versatility. He was also a gifted colourist and an artist of great imagination, superior in both these respects to such better-known Rembrandt pupils as Ferdinand Bol and Nicolaes Maes. Moreover, he was extremely productive, and there is at least one dated painting for virtually every year between 1641 and 1674. In addition, he created a large body of drawings comprising histories, figures, landscapes and

genre scenes executed in various media, including watercolour. He also made several etchings, mostly studies of heads, such as the *Self-portrait* (1646; B. 66). He died a bachelor, aged 53.

1. History paintings

(i) 1640–50. It is generally assumed that van den Eeckhout studied with Rembrandt from 1635 to 1640, as his first independently signed piece, the *Presentation in the Temple* (Budapest, Mus. F.A.), is dated 1641. By 1642 he was hard at work, producing four biblical subjects in that year, including *Gideon's Sacrifice* (untraced; see Sumowski, 1983, no. 392), which reveals that Rembrandt's pupils shared their master's unflagging enthusiasm for his teacher Pieter Lastman, whose bright palette is employed in this work alongside a Rembrandtesque chiaroscuro. The *Dismissal of Hagar* (1642; ex-Edzard priv. col., Munich; see Sumowski, 1983, no. 393) is based on a Rembrandt etching dated 1637 (B. 30). Lastman's palette and Rembrandt's lighting and formal language are again combined in van den Eeckhout's *Jacob's Dream* (1642; Warsaw, N. Mus.) and *Isaac Blessing Jacob* (1642; New York, Met.). Conspicuous in the latter is the depiction of a famous silver-gilt ewer (1614) by Adam van Vianen, which was owned by the Silversmiths' Guild to which van den Eeckhout's father belonged. (In homage to van Vianen, he drew a variant of this ewer as the first of a series of ornamental designs (e.g. Amsterdam, Hist. Mus.; Schwerin, Staatl. Mus.) that were published as prints c. 1651 by Michiel Mosyn and intended as patterns for silversmiths, sculptors and painters.) Van den Eeckhout's interest in his father's craft was occasionally expressed in still-lifes with decorative vases, which appeared as subsidiary motifs in history paintings, for example in two different versions of the *Meeting of Abraham and Melchizedek* (1646, Mänttä, Serlachius A. Mus.; 1664, Budapest, N. Mus.).

In the exceptionally large canvas depicting *The Levite and One of his Wives at Gibeah* (1645; Berlin, Gemäldegal.), van den Eeckhout anticipated similar 'Flemish'-style works of the type that brought acclaim to Bol and Govaert Flinck in the 1650s. As early as the 1640s a kind of artistic competition seems to have existed between Bol and van den Eeckhout, judging from their choice of rare biblical subjects depicted in related ways, such as *Gideon's Sacrifice* (van den Eeckhout's versions, 1644, Stockholm, Nmus.; 1647, Milan, Brera; Bol's version, 1641, The Hague, Rijksdienst Beeld. Kst). By the end of the 1640s the influence of Lastman's colourful compositions began to wane, as is evident, for example, in *Elisha and the Shunammite Woman* (1649; Warsaw, N. Mus.).

(ii) 1650–74. During the 1650s van den Eeckhout inclined increasingly towards a more detailed style, as in *Boaz and Ruth* (1651; Bremen, Ksthalle; see fig. 17), in which he showed himself for the first time to be a proficient landscape painter. Less successful is the landscape in *Granida and Daifilo* (1652; Milan, Mus. A. Ant.; splendid preparatory drawing in Brunswick, Herzog Anton Ulrich-Mus.). The life-size *Rest on the Flight into Egypt* (1653; Milwaukee, WI, A. Bader priv. col., see Sumowski, 1983, no. 415) recalls Rembrandt's very 'Flemish' *Holy Family* (c. 1633; Munich, Alte Pin.), while the motif of Mary showing the Christ Child to Joseph is borrowed from Rembrandt's etching of the same subject (1645; B. 58). Rembrandt's etching of *Medea* (B. 112) may have been the basis for van den Eeckhout's *Idolatry of Solomon* (1654; Brunswick, Herzog Anton Ulrich-Mus.). During this period van den Eeckhout painted in both a broad and a more detailed manner, as can be seen, for example, in the two versions of *Boaz and Ruth* (1655; Rotterdam, Mus. Boymans–van Beuningen; and 1656; Beerse, Bert van Deun priv. col., see Sumowski, 1983, no. 423). In 1658 he even used three different methods: he painted an even larger, 'Flemish'-sized version of *The Levite and One of his Wives at Gibeah* (Moscow, Pushkin Mus. F.A.), the small *Christ and his Disciples* (Dublin, N.G.), painted in Rembrandt's broad manner, and the *Continence of Scipio* (Toledo, OH, Mus. A.), which is executed in a polished, detailed style. He had immediate success with the last subject, for a year later he made a variant of it (Philadelphia, PA, Mus. A.) with the two lovers as portraits of his (probable) patrons.

17. Gerbrand van den Eeckhout: *Boaz and Ruth*, 1651 (Bremen, Kunsthalle)

During the early 1660s van den Eeckhout made an attractive series of small-scale biblical history paintings (comparable to the one in Dublin), executed with a loose brush and in warm red and brown tints. These include *Christ Teaching in the Temple* (1662; Munich, Alte Pin.), the *Widow's Mite* (1663; Turin, Gilberto Zabert priv. col., see Sumowski, 1983, no. 437), *Eliezer and Rebecca* (1663; Leipzig, Mus. Bild. Kst.), *Elisha and the Shunammite Woman* (1664; Budapest, N. Mus.), *Christ and the Woman Taken in Adultery* (probably 1664; Amsterdam, Rijksmus.) and the *Adoration of the Magi* (1665; Moscow, Pushkin Mus. F.A.). A number of large-format works include such *tours de force* as *Sophonisba Receiving the*

Cup of Poison (1664; Brunswick, Herzog Anton Ulrich-Mus.) and *Jacob's Dream* (1669; Dresden, Gemäldegal. Alte Meister), painted in a much broader manner. During this period he also reverted to Lastman's palette and manner of composing in such works as the *Dismissal of Hagar* (1666; Raleigh, NC Mus. A.). Painted in variegated colours but with Rembrandt's broad touch are *SS Peter and John Healing the Cripple* (1667; San Francisco, CA, de Young Mem. Mus.), as well as several undated, rather summarily executed works, including the *Presentation in the Temple* (ex-C. J. K. van Aalst priv. col., Hoevelaken; see Sumowski, 1983, no. 450) and *Vertumnus and Pomona* (Indianapolis, IN, Herron Mus. A.). Van

den Eeckhout's later paintings are of variable quality but reach a highpoint with the *Calling of St Matthew* (1674; Munich, Alte Pin.), painted in the year of his death.

2. Other painted subjects

Although history pieces form the great majority of his painted oeuvre, van den Eeckhout also addressed other subjects. During the 1650s he produced interior genre scenes in the vein of Gerard ter Borch (ii) and Pieter de Hooch, though employing a very personal manner of composition. Among these are the *Company on a Terrace* (1652; Worcester, MA, A. Mus.), the *Lute-player and Singers* (1653; The Hague, Gemeentemus.) and the *Music Lesson* (1655; Copenhagen, Stat. Mus. Kst). These glimpses of the leisure time of the affluent reveal a more naturalistic conception of elegance than was held by such predecessors in the genre as Willem Buytewech and anticipate the greater elegance of Dutch genre painting of the 1660s and 1670s. They also demonstrate van den Eeckhout's sensitivity as a narrator. He also painted guardroom scenes, such as the *Soldiers in a Guardroom* (Boston, MA, Mus. F.A.) and *Soldiers in an Inn* (1655; Petworth, priv. col., see Sumowski, 1983, no. 511).

Van den Eeckhout's clear preference for history painting is further demonstrated by the scarcity of his portraits. Contemporary art theory accorded portraiture, which could often be profitable, a very low status, compared with history subjects, and it is interesting to note that a number of his portraits were intended to double as history paintings (e.g. the *Continence of Scipio*). He made several striking portraits of children in arcadian surroundings (e.g. 1667; Hartford, CT, Wadsworth Atheneum; *Portrait of a Family as Shepherds and Shepherdesses*, 1667; Budapest, N. Mus.). Among the more traditional portraits, the most appealing are those of his father, *Jan Pietersz. van den Eeckhout* (1664; Grenoble, Mus. B.-A.), and his stepmother, *Cornelia Dedel* (1664; the Netherlands, priv. col., see Sumowski, 1983, no. 521). The placing of the figures in a semicircular niche with one arm leaning on a sill is borrowed from Rembrandt's *Self-portrait* (1640; London,

N.G.) or the variants that Rembrandt and his pupils painted in the 1640s. In later portraits van den Eeckhout employed international formulae that recall Anthony van Dyck's prototypes, for example the portrait of a *Governor of the Dutch East Indies Company* (1669; Grenoble, Mus. B.-A.). He also painted the group portrait of the *Four Officers of the Amsterdam Coopers' and Winerackers' Guild* (versions, 1657; London, N.G., and 1673; Amsterdam, Hist. Mus.), a guild to which his brother Jan van den Eeckhout belonged. In the later version the imaginary marble background with St Matthew, patron saint of the coopers, in a niche is an innovation within the genre.

On a few occasions van den Eeckhout chose landscape as an independent subject: the bright, southern sunlight forms a striking element in the *Mountain Stream with Men Bathing* (Amsterdam, Rijksmus.). He took landscapes by his friend (according to Houbraken) Roelant Roghman as a point of departure for the *Mountain Landscape* (1663; Amsterdam, W. Russell priv. col., see 1987–8 exh. cat., p. 304).

3. Drawings

Landscape was one of van den Eeckhout's favourite subjects for drawings. His earliest sheets are rather Rembrandtesque, but between 1650 and 1655 he produced decorative landscapes intended for sale, in the style of Roghman and Antoni Waterlo, drawn in chalk and heavily washed with the brush (e.g. *Hollow Lane Bordered by Trees, with Ruins on the Left*, 1650; Paris, Fond. Custodia Inst. Néer.). It is unclear whether these are topographically accurate, as are his panoramic landscapes of the early 1660s, such as the *View along the River Rhine in the Vicinity of Arnhem* (1661; Cambridge, Fitzwilliam) and the *View of Haarlem* (Berlin, Kupferstichkab.). Very characteristic of van den Eeckhout is the use of watercolour washes, also evident in the views near Rhenen, Arnhem and Cleves (e.g. Amsterdam, Rijksmus.; Berlin, Kupferstichkab.; Dresden, Kupferstichkab.; Haarlem, Teylers Mus.; London, BM) made during a trip along the River Rhine with Jacob Esselens and Jan Lievens in 1663; all three artists drew at the same locations. Van den Eeckhout also drew

biblical scenes, often as studies for his paintings, figure studies in chalk, detailed portraits (some on parchment), ornamental drawings and designs for book illustrations. A distinct group of drawings, executed exclusively with the brush and brown wash, comprises figure studies of boys and women (often after the same models) and a dog (e.g. Amsterdam, Rijksmus.; London, BM; Paris, Fond. Custodia, Inst. Néer.).

Bibliography

A. Houbraken: *De groote schouburgh* (1718–21), i, p. 174; ii, p. 100

A. von Bartsch: *Le Peintre-graveur* (1803–21) [B.]

W. Sumowski: 'Gerbrand van den Eeckhout als Zeichner', *Oud-Holland*, lxxvii (1962), pp. 11–39

—: *Drawings of the Rembrandt School*, iii (New York, 1980), pp. 601–819

—: *Gemälde der Rembrandtschüler*, ii (Landau/Pfalz, 1983), pp. 719–909

Masters of Dutch 17th-century Landscape Painting (exh. cat., ed. P. C. Sutton; Amsterdam, Rijksmus.; Boston, MA, Mus. F.A.; Philadelphia, PA, Mus. A.; 1987–8)

B. P. J. BROOS

Esselens, Jacob

(*b* Amsterdam, *c.* 1627; *d* Amsterdam, *bur* 15 Jan 1687). Dutch draughtsman and painter. He was referred to as a 'painter' on the occasion of his (late) marriage on 11 April 1668, but in the will drawn up after the death of his wife in 1677 he is called a 'merchant'. He did indeed trade in silks and velvets. As an artist, he was self-taught and should probably be considered an amateur. His textile business occasioned visits, among other places, to Italy, France, England and Scotland, where he made accomplished landscape drawings. Panoramic views of English towns (Chatham, Greenwich, London, Rochester and Rye) dating from the 1660s were later included in the Atlas van der Hem (Vienna, Österreich, Nbib.). In 1663 he journeyed along the Rhine with Gerbrand van den Eeckhout and Jan Lievens, as is evident from the many drawings by all three artists of the same locations, including Rhenen, Arnhem and Cleve (e.g. Amsterdam, Rijksmus.; Edinburgh, N.G.; Haarlem, Teylers Mus.; St Petersburg, Hermitage). Besides these topographical views, Esselens also drew imaginary landscapes, for example of riverbanks and coastlines with fishermen or tradesmen in the manner of Simon de Vlieger, woody landscapes suggesting the influence of Anthoni Waterlo and hilly landscapes in the style of his travelling companions van den Eeckhout and Lievens. Some works seem to have been inspired by etchings and drawings of the Dutch countryside made by Rembrandt in the 1640s and 1650s. It would, however, be an exaggeration to consider Esselens a pupil of Rembrandt, as has often been suggested since the 19th century. Despite a clearly recognizable personal style of drawing, Esselens was often inspired by the work of other draughtsmen. This is also true of his paintings, which are somewhat eclectic in nature but sometimes of a surprisingly high artistic standard. His seaside views (e.g. Amsterdam, Rijksmus.; Copenhagen, Stat. Mus. Kst), with their characteristic atmosphere, betray the influence of Adriaen van de Velde, but the use of silver-grey tints also suggests that of Simon de Vlieger. He painted arcadian landscapes, in a rather uninspired style, that are reminiscent of Cornelis van Poelenburgh (e.g. Brunswick, Herzog Anton-Ulrich-Mus.), but he also occasionally produced charming landscapes bathed in southern light, for instance the *Landscape with Hunters* (Amsterdam, Rijksmus.) and the '*Scottish*' *Landscape* (The Hague, Mus. Bredius). In his non-topographical landscapes, animals and, especially, figures play an important role: fishermen or townspeople are seen buying fish in his beach views, while in other works elegantly dressed ladies and gentlemen are involved in recreational pursuits (e.g. *Elegant Hunting Party on the Bank of a River*; Rotterdam, Mus. Boymans–van Beuningen). He died a wealthy man; his friend and fellow silk merchant Abraham Rutgers (*b* Amsterdam, 1632; *d* Amsterdam, 1699), who was also an avid amateur draughtsman, was appointed guardian of his children. Rutgers was also the administrator of Esselens's estate, which included many of the latter's drawings, which he repeatedly copied.

Bibliography

P. H. Hulton: 'Drawings of England in the Seventeenth
 Century by Willem Schellinks, Jacob Esselens and
 Lambert Doomer', *Walpole Soc.*, xxxv (1954-6), 2 vols
Rembrandt en tekenaars uit zijn omgeving [Rembrandt
 and draughtsmen of his circle] (exh. cat. by B. P. J.
 Broos, Amsterdam, Hist. Mus., 1981), pp. 118-26

B. P. J. BROOS

Everdingen, van

Dutch family of painters and draughtsmen. The
brothers (1) Caesar van Everdingen and (2) Allart
van Everdingen were the sons of Pieter van
Everdingen, a notary and solicitor in Alkmaar;
their mother, Aechte Claesdr., was a midwife in
the city. Houbraken claimed that Caesar was a
pupil of the Utrecht artist Jan van Bronchorst;
though there is no documentary evidence to prove
this, the noticeable influence on his work of paint-
ings by Utrecht artists does seem to suggest that
he served his apprenticeship in that town.
Moreover, the van Everdingen family had long-
standing ties with Utrecht, and Allart also even-
tually trained with a painter from Utrecht. Caesar
is best known as a history painter who worked in
the classicizing style that became fashionable in
Haarlem in the mid-17th century, while Allart
made his name as a landscape artist, the first to
depict Scandinavian motifs in his paintings and
drawings.

(1) Caesar (Bovetius) [Boetius] van Everdingen

(*b* Alkmaar, 1616 or 1617; *bur* Alkmaar, 13 Oct
1678). In 1632, at a very early age, he entered
Alkmaar's Guild of St Luke. There are a number of
unsigned but dated works by him from the 1630s.
The earliest signed and dated painting is the
group portrait of the *Officers of the Orange
Company of the Alkmaar Civic Guard* (1641;
Alkmaar, Stedel. Mus.), both the execution and the
composition of which are rather weak. From 1641
to 1643 Caesar lived in Amersfoort, where, under
the supervision of the painter and architect Jacob
van Campen, he worked on a modello for the exte-
rior decoration of the organ shutters of Alkmaar's
Grote Kerk. The size and shape of these shutters,

as well as the great height at which they were to
be placed, forced the artist to make allowances for
possible distortions of perspective. The highly suc-
cessful finished result, representing the *Triumph
of Saul after David's Victory over Goliath* (1644; *in
situ*) was partly executed on panel and partly on
canvas. The figures forming the procession and
the women playing music behind the balustrades
have much in common with figures that appear
in paintings by the Utrecht Caravaggisti.

In 1646 Caesar van Everdingen married Helena
van Oosthoorn in Heiloo; they had no children.
After 1648 Caesar lived in Haarlem, where he
probably worked on two paintings for the Oranje
Zaal in the Huis ten Bosch, commissioned through
van Campen. Of Caesar's two contributions to
this vast collaborative programme, the *Birth of
Frederick Hendry* and the *Rewards of Parnassus*
(both *in situ*), the second is the better of the two:
it has a well-balanced composition showing the
winged horse Pegasus and four muses with
musical instruments.

During the 1650s Caesar painted several splen-
did works in the classicizing style that became
typical of Haarlem history painting at that time,
such as *Count William II of Holland Issuing the
Charter* (1655; Leiden Rijnlandshuis), in collabo-
ration with Pieter Post, and *Jupiter and Callisto*
(1655; Stockholm, Nmus.). The actual event in
these pieces—the granting of privileges in 1255 to
the Rhineland district water-control board in the
first instance—is presented rather statically, and
the large figures are idealized; the rendering of
details is meticulous, and the colours tend to be
bright. The same is true of paintings by Pieter de
Grebber and Salomon de Bray, who together with
Caesar van Everdingen are sometimes referred to
as the Haarlem Classicists or Haarlem Academics.
Apart from these stately history pieces, they also
produced genre pictures; Caesar van Everdingen
repeatedly depicted courtesans, for instance
playing musical instruments or combing their
hair.

Caesar was dean of the Haarlem Guild of St
Luke in 1655 and 1656. A year later he returned to
Alkmaar, where—apart from a brief stay in
Amsterdam in 1661—he remained until his death.

Quite a few signed and dated works from this Alkmaar period have survived, including the portrait of the *Officers and Ensigns of the Old Civic Guard* (1657; Alkmaar, Stedel. Mus.), a successful composition in which the members of the Civic Guard are rendered with an air reminiscent of the elegant portraits of Bartholomeus van der Helst. In 1662 van Everdingen finished his *Lycurgus and the Fruits of Education* (Alkmaar, Stedel. Mus.), destined for the Prinsenkamer in the town hall at Alkmaar. Of the many other portraits from this period, especially touching is that of a *Child with an Apple* (1664; Barnsley, Cannon Hall Mus.).

Caesar van Everdingen usually signed his work with the monogram CVE. After 1655 he signed various documents *Caesar Bovetius van Everdingen*. References in old inventories suggest that he also made many drawings, but no signed examples are known at present. Various civil actions seem to indicate that Caesar van Everdingen was reasonably wealthy.

Bibliography

A. Houbraken: *De groote schouburgh* (1718–21), ii,
 p. 94
D. van der Poel: *Caesar van Everdingen (1617–1678)*
 (diss., Rijksuniv. Utrecht, 1975)
*Gods, Saints & Heroes: Dutch Painting in the Age of
 Rembrandt* (exh. cat. by A. Blankert and others,
 Washington, DC, N.G.A.; Detroit, MI, Inst. A.;
 Amsterdam, Rijksmus., 1980–81), pp. 214–19
*Nieuw licht op de Gouden Eeuw: Hendrick ter Brugghen
 en tijdgenoten* (exh. cat. by A. Blankert and L. J.
 Slatkes, Utrecht, Cent. Mus.; Brunswick, Herzog Anton
 Ulrich-Mus., 1986–7), pp. 252–6

<div align="right">D. B. HENSBROEK-VAN DER POEL</div>

(2) Allart [Allaert, Allert] van Everdingen

(*b* Alkmaar, *bapt* 18 June 1621; *d* Amsterdam, *bur* 8 Nov 1675). Painter, draughtsman, etcher and dealer, brother of (1) Caesar van Everdingen. According to Houbraken, Allart was the pupil of Roelandt Savery in Utrecht and Pieter de Molyn in Haarlem; both painters certainly influenced his work. In 1644 Allart travelled to Norway and Sweden, a trip that was to have profound consequences on his art; his annotated sketches document visits to the south-east Norwegian coast and to Bohusland and the Göteborg area in western Sweden. He returned to the Netherlands by 21 Feb 1645, when he married Janneke Cornelisdr Brouwers in Haarlem. He became a member of the Reformed Church in Haarlem on 13 Oct 1645, joined the Haarlem Guild of St Luke in 1646 and, along with his brother Caesar, enlisted in the Haarlem Civic Guard of St George in 1648. From 1646 to 1651 four of Allart's children, a son and three daughters, were baptized in Haarlem; four additional children were born later in Amsterdam. In 1652 he moved to Amsterdam and on 10 April 1657 became a citizen. A visit he made about 1660 to the Ardennes in the southern Netherlands is documented by his painting *View of Montjardin Castle* (The Hague, Mauritshuis) and by his drawings and etchings of Spa and its surroundings. The artist probably forwent a return trip to Sweden in order to execute the commissions he received from the Trip family in the 1660s to paint the four overdoors decorating the Trippenhuis in Amsterdam (*in situ*), as well as the large *Cannon Foundry of Julitabroeck, Södermanland* (Amsterdam, Rijksmus.). In 1661 van Everdingen joined Jacob van Ruisdael and Willem Kalf to judge the authenticity of a seascape by Jan Porcellis; Meindert Hobbema served as a witness to the proceedings. The sale of his widow's estate on 16 April 1709 suggests that the artist, like many of his colleagues, had a second profession as an art dealer; the sale catalogue lists works by Raphael, Giorgione, Annibale Carracci, Titian, Veronese, Holbein, Savery, Porcellis, Hals and Rembrandt. The master's only known pupil was the seascape painter Ludolf Bakhuizen.

Allart's earliest dated painting, *Rough Sea* (1640; untraced), establishes his beginnings as a marine painter in the tradition of Jan Porcellis. Although his production of seascapes was small (19 are known) and occurred early in his career, his contribution to the genre was notable. His monochrome paintings emphasized the dramatic aspect of heaving waves and darkened sky, both at open sea, as in the small *Stormy Sea* (Leipzig, Mus. Bild. Kst.), and in topographical views, such as the *Stormy View of Flushing* (St Petersburg, Hermitage). The impact of his naturalistic marine

paintings on van Ruisdael's seascapes is especially significant.

In 1644, the year of his trip north, van Everdingen painted a Dutch dunescape in the style of his second teacher, de Molijn (1644; untraced; with the dealer A. van der Meer, 1964). The earliest known date on a Nordic landscape is 1646 (sold, Stockholm, 1981; untraced). The influence of Savery's Tyrolean views on van Everdingen's Scandinavian landscapes is clear in his next dated works, the four majestic mountain views of 1647, exemplified by the *Mountain Landscape with a River Valley* (Copenhagen, Stat. Mus. Kst.). By 1648 van Everdingen had introduced his countrymen to his full repertory of Nordic motifs—mountain views, rock and water scenes, and waterfalls. He continued to paint rocky terrains, fir trees, cascades, water-mills and blockhouses for the remainder of his career.

His early Nordic works are characterized by a Flemish landscape colour scheme (soon followed by a monochromatic grey-brown), by delicate touches of thinly applied paint and by the diagonal organization of overlapping light and dark planes (possibly indebted to Hercules Segers) in a horizontal format. The Haarlem painter Cornelis Vroom probably inspired his silhouettes of dark trees against a light sky. One dated *Waterfall* (1648; priv. col., on loan to Hannover, Niedersächs. Landesmus.) has a vertical design, which became the artist's preferred and most influential composition type. His early upright waterfalls, best represented by the *Scandinavian Waterfall with a Water-mill* (1650; Munich, Alte Pin.), had a formative effect on Jacob van Ruisdael, who started painting the subject shortly after his own move to Amsterdam c. 1657. The *Swedish Scenery* (1655; Amsterdam, Rijksmus.) shows van Everdingen's next shift to a more decorative style relying on fluid brushwork and a lighter palette; his occasional collaborator Nicolaes Berchem probably added the staffage. The overwhelming majority of van Everdingen's paintings after 1660 were waterfalls, some pastel in colour and others predominantly brown, with the paint applied broadly in large zones. The *Scandinavian Landscape* (1670; Rouen, Mus. B.-A.) reveals the artist's working

methods, as it exactly repeats the composition of a sketch he executed 26 years earlier during his visit to the waterfall at Mölndal (Mölndal, Gunnebo). Van Everdingen also painted topographical Dutch landscapes, such as the *View of Zuylen Castle in Winter* (Haarzuilens, Kasteel de Haar) and the *View of Alkmaar* (Paris, Fond. Custodia, Inst. Néer.), but these are exceptional cases (9 examples are known).

Allart was a talented and prolific draughtsman; over 500 Scandinavian and Netherlandish landscape drawings by him are found in European public collections. At least seven sets of drawings of the *Twelve Months* are known. The artist's reputation as an innovative printmaker rests largely on his experiments with mezzotint. His 166 catalogued etchings include a set of illustrations for the fable *Reynard the Fox* (drawings, London, BM) and landscapes exclusively devoted to Nordic subjects.

Besides van Ruisdael, Allart van Everdingen's waterfalls influenced Jan van Kessel, Roeland Roghman, Pieter de Molijn and the 19th-century Norwegian painter J. C. Dahl. In his own day they were appraised at relatively high values. Although his prices and regard fell in the 18th century, when Dutch Italianate landscapes were favoured, by the end of that century his drawings and watercolours were highly prized, and van Everdingen was singled out for praise by Goethe in 1784 and enjoyed a revival of interest by 1820.

Bibliography

Hollstein: *Dut. & Flem.*

A. Houbraken: *De groote schouburgh* (1718–21), ii, pp. 95–6

W. Drugulin: *Allart van Everdingen: Catalogue raisonné de toutes les estampes qui forment son oeuvre gravé* (Leipzig, 1873)

C. W. Bruinvis: 'De van Everdingens', *Oud-Holland*, xvii (1899), pp. 216–22

O. Granberg: *Allart van Everdingen och hans 'Norska' landskap: Det gamla Julita och Wurmbrandts kanoner* [Allart van Everdingen and his 'Norwegian' landscape: the old Julita and Wurmbrandt's cannons] (Stockholm, 1902)

K. E. Steneberg: *Kristinatidens måleri* [Painting in the time of Queen Christina] (diss., Malmö U., 1955), pp. 118–25

A. I. Davies: *Allart van Everdingen* (New York, 1978)

Hollandse schilderkunst: Landschappen 17de eeuw (exh. cat. by F. J. Duparc, The Hague, Mauritshuis, 1980), pp. 29–31

Masters of 17th-century Dutch Landscape Painting (exh. cat., ed. P. C. Sutton; Amsterdam, Rijksmus.; Boston, MA, Mus. F.A.; Philadelphia, PA, Mus. A.; 1987–8), pp. 307–12

ALICE I. DAVIES

Fabritius

Family of Dutch artists. Pieter Carelsz. (1598–1653) was a teacher and talented amateur painter, who apparently used the nickname 'Fabritius' (from Lat. *faber*: 'craftsman'). His son (1) Carel Fabritius was one of Rembrandt's most gifted and imaginative pupils, who, despite his early death, had a great influence on late 17th-century Dutch painting. Pieter's second son (2) Barent Fabritius was a lesser artist, much influenced by Rembrandt and by his own brother. A third son, Johannes Fabritius (1636–after 1693), was a still-life painter.

(1) Carel Fabritius

(*bapt* Midden-Beemster, nr Hoorn, 27 Feb 1622; *d* Delft, 12 Oct 1654). Painter. His oeuvre consists of a scant dozen paintings, since research has rigorously discounted many previously attributed works. These few paintings, however, document the painter's unique development within his brief 12-year career. He is often mentioned as being the link between Rembrandt and the Delft school, particularly Pieter de Hooch and Jan Vermeer, whose depiction of light owes much to Fabritius's late works in which his use of cool silvery colours to define forms in space marks a radical departure from Rembrandt's use of chiaroscuro.

1. Life and career

Carel Fabritius was probably taught painting by his father, after having first learnt the craft of carpentry and worked in Midden-Beemster, a rapidly expanding suburb of Hoorn. In October 1641 Carel married his neighbour's daughter, Aeltge Hermannsdr., moving shortly after the wedding to Amsterdam, where he lived until his

wife's premature death in April 1643. During this short period he trained in Rembrandt's studio: his presence there is documented by Samuel van Hoogstraten, who was also an apprentice with Rembrandt and mentioned Fabritius in his notes on studio conversations.

Following the death of his wife (and both their children), Fabritius moved back to his parents' home in Midden-Beemster. He lived there for the next few years, except for the occasional visit to Amsterdam. Little is known about the years from 1643 until 1650, when he married his second wife, Agatha van Pruyssen, a widow from Amsterdam. Fabritius may have worked exclusively as a painter or as a carpenter again. There are only three known paintings from this period: the portrait of *Abraham Potter* (1648; Amsterdam, Rijksmus.), who was a close friend of Fabritius's family, the *Mercury and Argus* (c. 1645–7; New York, Richard L. Feigen) and a *Portrait of a Family* (1648; ex-Boymans Mus. Rotterdam, destr. by fire, 1864). Fabritius lived with his second wife in Delft, where on 29 October 1652 he joined the Guild of St Luke. The couple must have been badly off financially, as on 4 July 1654 Fabritius was commissioned by the town council to paint both a large and a small version of the city arms, for which he was paid the meagre sum of 12 guilders. Fabritius no doubt accepted the small salary because of the prospect of further commissions from the town. Tragically, however, he was killed only three months later, when there was an explosion at the gunpowder warehouse in Delft, which was situated close to Fabritius's house. He was buried in the Oude Kerke in Delft.

2. Work

In his early works, Fabritius adopted Rembrandt's thick, impastoed brushstrokes, but he was quick to move away from the chiaroscuro colours of Rembrandt's scenes to his own characteristic lighter palette. The *Raising of Lazarus* (c. 1642–3; Warsaw, N. Mus.), probably painted during Fabritius's stay in Rembrandt's studio, already shows the beginnings of the artist's painterly style. The composition adopts the main motifs from Rembrandt's *Raising of Lazarus* (c. 1630–31;

Los Angeles, CA, Co. Mus. A.) and the 'Night Watch' (1642; Amsterdam, Rijksmus.). Fabritius employed a wealth of different poses in this picture; however—unlike Rembrandt's biblical themes—the link between the inner meaning and the action is missing. The figures remain isolated, scarcely reacting to one another. Nevertheless, even in this early work Fabritius adopted a palette that is luminous and achieves new effects from surprising colour combinations.

In the exceptionally large Portrait of a Family (1.61×2.37 m) of 1648, now known only from a 19th-century watercolour copy by Victor de Steurs (Rotterdam, Mus. Boymans–van Beuningen), Fabritius again concentrated on the composition, which was unprecedented in the 17th century. The portrait was divided into three distinct groups in front of an elaborate architectural background: three people are walking down a staircase in the background; on the right a young man is sitting at a table covered with vanitas symbols and behind him there is a view of a palatial property; on the left are two small girls. The loose grouping of the sitters opened up new possibilities for portraiture, later taken up by Pieter de Hooch in particular. Surpassing by far traditional Dutch family portraits, the composition anticipates the 'conversation pieces' of the 18th century. The detail with which Fabritius depicted the interior is also completely new, as is the distant view in the right-hand background.

The painter's artistic development can be clearly followed in his series of individual portraits from 1648 to 1654. In the portrait of Abraham Potter, also of 1648, the sitter is depicted in dark tones in front of a light background. This treatment was used again in two portraits traditionally thought to be self-portraits—the Portrait of a Man (c. 1648–50; Rotterdam, Mus. Boymans–van Beuningen) and the Portrait of a Man in a Fur Cap and a Breastplate (1654; London, N.G.). The earlier self-portrait is completely innovative in both form and concept. The head was placed relatively low down on the canvas, with almost a third of the picture above it devoted to the background. More importantly, the idea of portraying himself with an open collar and as a worker and

artisan (perhaps a play on the name Fabritius) was new compared to traditional portrayals of an artist either as a 'gentleman', in half length, or as a painter standing by his easel. The later self-portrait is often considered to be a pendant to a Portrait of a Woman with a Feather Cap and Pearls (1654; Hannover, Niedersächs. Landesmus.), which is assumed to represent Agatha van Pruyssen, Fabritius's second wife. The attribution of the latter was doubted by Brown (1981), but the handling and colouring of the picture fit in with other known examples of Fabritius's work from this year.

Besides portraits, there are three other late paintings, dating from the artist's last years of activity, which demonstrate his skill as a painter. All three focus on problems of perspective and illusionism, problems that Fabritius tried to solve with new painting techniques rather than with the help of traditional mathematical solutions. This is most clearly illustrated in The Sentry (also known as 'The Guard', 1654; Schwerin, Staatl. Mus.), in which the deep perspective of a staircase at upper right is conveyed by graduated colour tones going from light to dark. The rest of the picture is painted in very light tones, predominantly white and shades of grey, which, blended with strong local colours, give the impression of intense, bright sunlight. Such effects appear to anticipate the work of Vermeer. The spatial arrangement, with the architecture framing a distant view in the background, also had a decisive influence on the work of Pieter de Hooch.

Fabritius seems to have tackled the problem of illusionism in a different way in The Goldfinch (1654; The Hague, Mauritshuis; see col. pl. XIII). Although there has been much discussion about the interpretation of the picture's iconography, it does not appear to hold any special meaning, since the goldfinch is depicted alone, without any attributes. It is more plausible that it was simply an exercise in trompe l'oeil. The realistic play of light and shadow, which plays so important a role in The Sentry, also features prominently here.

In the slightly earlier View of Delft (1652; London, N.G.), Fabritius had confronted quite another problem of perspective. It is now assumed

that the unusual and distorted perspective of this picture of a Dutch street and church is due to the fact that it came from a diorama with a curved back wall. Fabritius was certainly interested in paintings that united science and artistic aims, as was his fellow pupil van Hoogstraten, who painted similar pictures and also described Fabritius's picture in his *Inleyding tot de hooge schoole der schilderkonst* (1678). The *View of Delft* is the only example of this type of work in Fabritius's oeuvre; however, since the workshop was destroyed in the explosion, it is possible that he produced similar works.

Fabritius apparently painted some large-scale frescoes in Delft (all destr.), and the single documentary reference to them alludes to the fact that he dealt with problems of foreshortening and perspective, obviously more so than is evident in the few easel pictures that have survived. After his death, his widow reported that he was also commissioned to paint some large-scale perspective murals for the Prince of Orange. Unfortunately, however, there is no longer any record of this sort of commissioned work. According to van Hoogstraten, Fabritius's wall paintings were comparable to those of Baldassare Peruzzi or to Guilio Romano's work in the Palazzo del Te, Mantua; he further reported that Fabritius had painted pictures like them in the house of the art lover and connoisseur Dr Valentius.

3. Critical reception and posthumous reputation

It is interesting to note that when Fabritius joined the Delft Guild of St Luke in 1652, he described himself as a history painter; he obviously considered himself to be capable of the highest type of painting, history painting, although only two examples survive: the *Raising of Lazarus* and the *Mercury and Argus*. There are also no fully authenticated drawings by Fabritius (for a catalogue of sheets falsely attributed to him see Sumowski, 1981). During Fabritius's short period of activity in Delft, he apparently did not have any pupils, and although a certain Matthias Spoor presumably helped him in his workshop, he also died in the gunpowder explosion and no works by him have survived.

Jan Vermeer is often named as a 'successor' to Fabritius, but he was almost certainly not his direct pupil, as Fabritius did not come to Delft until 1650, when Vermeer was 18 years old. Vermeer was nonetheless impressed and influenced from an early age by Fabritius's luminous, light colouring in his work. The inventory of Vermeer's estate lists two works by Fabritius, which were kept in the younger artist's studio. Fabritius's approach to painting perspective was adopted mainly by Pieter de Hooch and his own brother, Barent.

In the 17th century Fabritius's work was scarcely known outside Delft. Within Delft, however, even in the 1660s he was praised, alongside Vermeer, as the most outstanding painter of his time. For the next 200 years his pictures were ignored by art historians, until Théophile Thoré [Wilhelm Bürger] mentioned them again in the introduction of the Arenberg collection in 1856. It was also Thoré (1864) who first distinguished the work of Carel and Barent Fabritius, which was still often confused. Thoré, who himself owned *The Goldfinch*, described Fabritius as a first-rate artist. Research on Fabritius in the 20th century has shown him to be one of Rembrandt's most brilliant pupils.

(2) Barent Fabritius

(*bapt* Midden-Beemster, nr Hoorn, 16 Nov 1624; *d* Amsterdam, 20 Oct 1673). Painter and draughtsman, brother of (1) Carel Fabritius.

1. Life and career

Like Carel, he was first taught painting by his father, also learnt carpentry and practised as an artisan in Midden-Beemster in 1641. He is documented in Amsterdam in 1643 and 1647, though it is not known if, like his brother, he was also a pupil of Rembrandt. Nevertheless, his style is similar to that of the Rembrandt school. He must have been trained in the second half of the 1640s. His work is reminiscent of the style of his brother, who clearly influenced and may also have instructed him. In 1652 Barent lived in Amsterdam and married Catharina Mussers [?Mutsart] in Midden-Beemster. In the following years he is

documented alternately in Midden-Beemster and Amsterdam. He painted a group portrait of the town master builder, *Willem Leenderstsz. van der Helm and his Family* (1656; Amsterdam, Rijksmus.), in Leiden, and in 1660–61 he received further commissions for the Lutheran church in Leiden. From 1669 Barent lived with his family in Amsterdam, where he died at the age of 49. He was buried in the churchyard in Leiden that was usually reserved for the poorer inhabitants of Amsterdam. He left behind a wife, who lived until 1701, and six children.

2. Work

Barent's surviving oeuvre of at least 44 paintings is substantially more extensive than Carel's. It is dominated by history paintings with biblical or mythological themes; in addition, there are several allegories and a few portraits, including his first dated work, a *Self-portrait* (1650; Frankfurt am Main, Städel. Kstinst. & Städt. Gal.), in which the composition was influenced by Rembrandt but the lightening of the background recalls the work of Barent's brother, Carel. Like Rembrandt, Barent also painted numerous individual figures, mainly half-length studies of characterful heads known as *tronies*, carried out mostly in the 1660s.

Barent often chose unusual or rarely depicted biblical themes, some of which he used repeatedly, for instance the *Naming of John the Baptist* (London, N.G., and Frankfurt am Main, Städel. Kstinst. Städt. Gal.), *Roman Charity* (e.g. York, C.A.G.) and the *Satyr with Farmers* (Hartford, CT, Wadsworth Atheneum, and Bergamo, Gal. Accad. Carrara). His earliest history painting depicts the *Expulsion of Hagar* (c. 1650; San Francisco, CA, de Young Mem. Mus.; additional versions, New York, Met., and Hull, Frerens A.G.). Like Carel, Barent concentrated first and foremost on colour: the figures are depicted in clear local colours (red, yellow, black and white) in front of a chiaroscuro landscape. The composition and individual motifs, on the other hand, were borrowed from other masters. For example the motif of the group around Hagar and the background elements recall Lastman's version of the theme (1612; Hamburg,

Ksthalle), which Barent must have known through a drawn copy by Rembrandt (Vienna, Albertina).

In the 1652 version of *Satyr with Farmers* (Hartford, CT, Wadsworth Atheneum) Barent seems already to have moved away from Rembrandtesque brushwork. Instead, the pigments are applied evenly across the surface, and the way in which light is depicted is more refined. A year later Barent painted a family group portrait in a historicizing mode, *Peter in the House of Cornelius* (1653; Brunswick, Herzog Anton-Ulrich Mus.), in memory of the family's father, who had just died and who was portrayed as the Apostle Peter. By treating the family portrait as a history painting, it was possible to depict a larger variety of action poses, which would not have been the case with a traditional family portrait. The 15 people in the picture—some standing, some kneeling—form a rhythmic composition that is high on each side and low in the middle. The classicizing style of dress, with long folds and linear curves, already points to Barent's late style. The whole work appears rather archaic, as if Barent were using a late Mannerist style to break away completely from all of his earlier models. Another striking characteristic of this picture is the exaggerated vanishing-point, a feature also found in the work of other Delft masters in the early 1650s. This interest in painting perspectives also clearly links Barent's work to that of his brother Carel.

Carel's influence is also evident in Barent's *Blind Tobias with his Wife and the Goat* (c. 1654–60; Innsbruck, Tirol. Landesmus.), in which Barent has succeeded in creating a picture with an atmosphere similar to that of *The Sentry* by Carel, even down to the way in which the wall behind Tobias is painted. The picture was long thought to be by Carel (e.g. Bode, 1882, and Hofstede de Groot, 1907). Valentiner (1932) and Pont (1958) correctly recognized it as Barent's work, drawing attention in particular to the typical way in which the folds of the clothes were painted by applying dark lines to a coloured background (not by colour gradations, as Carel would have done).

The five paintings of *Parables* commissioned for the Lutheran church in Leiden are among

Barent's most important works of the 1660s (see Liedtke, 1977). Only three of the five *Parables* survive (all Amsterdam, Rijksmus.). They are distinguished by their 'strip format' (0.93×2.85 m) and were originally installed in 1661 on the western choir loft, under the organ. Their vivid colour has occasionally been attributed to Venetian influences, but this has not been proven and, in any case, the strong, colourful impression must have been necessary for the pictures to be effective from a great distance. The *Parables* are arranged to be read from left to right, like a book, with the moment of healing and relief always on the right-hand side. A uniform horizontal line contributes to the effect of overall coherence, an effect not impaired by a deep perspective more strongly emphasized in some places than in others.

Among Barent's last history paintings is the signed and dated *Presentation in the Temple* (1668; Copenhagen, Stat. Mus. Kst), a masterpiece comparable to *Peter in the House of Cornelius* in terms of the maturity of the composition. The following year Barent painted four large-scale murals in the triangular spandrels at Zwaansvliet, a country house near Beemster (2.8×4.3 m; 1669; now on movable wooden panels, Haarlem, Frans Halsmus.); these decorations consisted of putti and allegorical and personified images of the Seasons, with their attributes, on fields of clouds.

Carel Fabritius's influence, while not so apparent in Barent's history paintings, was much stronger in the case of his few known portraits and genre pieces. This is certainly true of Barent's *Self-portrait in an Exotic Costume* (c. 1656–7; Munich, Alte Pin.) and the *Self-portrait as a Shepherd* (c. 1658; Vienna, Gemäldegal. Akad. Bild. Kst.). The light colours in the background and the lighting of the head in the latter are reminiscent of Carel's presumed self-portrait of 1654 (London, N.G.). Barent's *Smoking Sentry* (1653–4; Rome, Pal. Barberini) definitely refers back to Carel's picture in Schwerin or to a similar untraced composition. Finally, Barent's two versions of the *Butchered Pig* (Rotterdam, Mus. Boymans-van Beuningen, and Berlin, Gemäldegal.) also show a clear debt to Carel's work. Barent seems also to have been inspired by the paintings of Nicolas Maes, whom he knew in the 1650s, as can be seen in the late *Visit to the Doctor* (1672; Bremen, Ksthalle), which should be interpreted as an allegory of the *natura passiva*.

Unlike Carel's, Barent's personality as a draughtsman has begun to be identified and his drawings distinguished from those by Maes and van Hoogstraten. Barent's drawings, as catalogued by Sumowski (1981), relate closely to the subjects and style of his paintings; they use relatively wide brushstrokes and are frequently washed. A few of the drawings are preparatory studies for his pictures.

3. Critical reception and posthumous reputation

Though Carel was already honoured by academics in the 17th century, Barent and his work were forgotten almost immediately. None of the important early sources mentions his name, and his work was not rediscovered until Théophile Thoré studied it and Bredius wrote an essay (1883) about the *Parables*. In the course of the 20th century his artistic output was gradually distinguished from that of his more important brother and its quieter nature was revealed.

Bibliography

S. van Hoogstraten: *Inleyding tot de hooge schoole der schilderkonst* [Introduction to the high school of painting] (Rotterdam, 1678), pp. 11–12

W. Bürger [T. Thoré]: 'Notes sur les Fabritius', *Gaz. B.-A.*, ii (1864), pp. 100–04

C. Hofstede de Groot: *Holländischen Maler* (1907–28)

—: *Jan Vermeer en Carel Fabritius* (The Hague, 1930)

H. F. Wijnman: 'De schilder Carel Fabritius (1622–1654): Een reconstructie van zijn leven en werk', *Oud-Holland*, xlviii (1931), pp. 100–41

K. E. Schuurman: *Carel Fabritius* (Amsterdam, [1947])

D. Pont: *Barent Fabritius* (Utrecht, 1958)

W. Sumowski: 'Zum Werk von Barent und Carel Fabritius', *Jb. Kstsamml. Baden-Württemberg*, i (1964), pp. 188–98

A. K. Wheelock jr: 'Carel Fabritius: Perspective and Optics in Delft', *Ned. Ksthist. Jb.*, xxiv (1973), pp. 63–83

W. A. Liedtke: '*The View of Delft* by Carel Fabritius', *Burl. Mag.*, cxviii (1976), pp. 61–73

—: 'The Three *Parables* by Barent Fabritius with a Chronological List of his Paintings Dating from 1660 Onward', *Burl. Mag.*, cxix (1977), pp. 316–27

C. Brown: *Carel Fabritius: Complete Edition with a Catalogue Raisonné* (Oxford, 1981)

W. Sumowski: *Drawings of the Rembrandt School*, iv (New York, 1981)

The Impact of a Genius: Rembrandt, his Pupils and Followers in the 17th Century (exh. cat. by A. Blankert and others, Amsterdam, Waterman Gal.; Groningen, Groninger Mus.; 1983)

W. Sumowski: *Die Gemälde der Rembrandt-Schule*, ii (Laudau-Pfalz, 1983)

C. Brown: 'Mercury and Argus by Carel Fabritius: A Newly Discovered Painting', *Burl. Mag.*, cxxviii (1986), pp. 797–9

F. J. Duparc: 'A Mercury and Aglauros Reattributed to Carel Fabritius', *Burl. Mag.*, cxxviii (1986), pp. 799–802

D. R. Smith: 'Carel Fabritius and Portraiture in Delft', *A. Hist.*, xiii (1990), pp. 151–71

IRENE HABERLAND

Flinck

Dutch family of artists and collectors. Govaert Flinck, the son of a draper from Cleve (a Prussian territory in the 17th century), was a well-known pupil and follower of Rembrandt. He was a gifted painter, capable of producing work of considerable beauty, but his ambition and desire for success led him to paint superficially elegant works that lacked individual character and pandered to the tastes of the increasingly ostentatious and affluent Dutch merchant class of the 17th century. He also formed a small art collection, which was inherited by his son Nicolaes Anthonis Flinck, who considerably augmented it, specializing in particular in drawings.

(1) Govaert Flink

(*b* Cleve, 25 Jan 1615; *d* Amsterdam, 2 Feb 1660). Painter and draughtsman. At the age of 14 he was apprenticed in Leeuwarden to the painter and Mennonite preacher Lambert Jacobsz. There Flinck met Jacob Backer, who had been in Jacobsz.'s studio since 1622. Many of Flinck's early works, especially his drawings, resemble those of Backer.

In 1633, after Flinck had acquired practical and technical skills with Jacobsz., he moved to Amsterdam, the financial and artistic centre of the northern Netherlands, to complete his train-ing with Rembrandt. Flinck presumably worked in Rembrandt's studio for three years, setting up on his own in 1636, the date of his first known paintings, *Rembrandt as a Shepherd* (Amsterdam, Rijksmus.; on loan to the Rembrandthuis) and *The Shepherdess* (Brunswick, Herzog Anton Ulrich-Mus.), both of which demonstrate his artistic dependence on Rembrandt. While still under the influence of Rembrandt, he painted his first large-scale history picture, *Isaac Blessing Jacob* (c. 1638; Amsterdam, Rijksmus.). This work, in which both the colouring and the composition are successfully worked out, justifiably created high expectations for the artistic future of the 23-year-old Flinck. Isaac is portrayed as a venerable figure on his death bed, giving his blessing to his illegitimate heir, Jacob. The subject was unusual within the context of the Rembrandt school, indicating that Flinck was striving for artistic independence. Yet this was not always the case: the composition of the *Annunciation to the Shepherds* (1639; Paris, Louvre) reflects Rembrandt's etching of the subject (1634; B. 44), but Flinck failed to capture the spiritual content of his master's work.

In the 1640s and 1650s Flinck, in common with many other Dutch painters, began to incorporate elements of Flemish style into his work. A note of fashionable elegance was introduced into his portraits in particular, as can be seen, for instance, in the double *Portrait of a Lady and a Gentleman* (1646; Karlsruhe, Staatl. Ksthalle). At the same time, in his history pictures, he adopted a range of colours that was more typically Flemish. This trend is discernible in the *Crucifixion* (1649; Basle, Kstmus.): though the composition can certainly be traced back to Rembrandt, the colouring is more similar to that of Flemish painting. In 1649 Flinck was also commissioned by Frederick William, Elector of Brandenburg (*reg* 1640–88), to paint the allegory of the *Birth (Death) of Prince William Hendrick III of Nassau* (Potsdam, Neues Pal.), which was completed in 1650, after the Prince's death. This commission was carried out according to the then fashionable Baroque ideas, with pathos and routine skill; it satisfied Flinck's royal patron and was a milestone in the artist's successful career. The citizens of Amsterdam now

thronged to have their portraits painted by him or at least to buy one of his history paintings. The current vogue for pomp and Baroque forms is also evident in Flinck's allegory of the *Mourning of Stadholder Frederick Henry* (1654; Amsterdam, Rijksmus.), which depicts the grief of his widow, Amalia von Solms. The virtues of the Stadholder are commemorated in a large-scale painting originally intended for the Huis ten Bosch, the residence of the Orange family near The Hague.

In 1655 the new Amsterdam Stadhuis was completed, and Flinck, along with other leading history painters such as Ferdinand Bol, was commissioned to decorate its walls. Flinck's first commission was for the burgomaster's office, where his *Marcus Curtius Dentatus Refusing the Gifts of the Samnites* (1656; *in situ*) was intended to celebrate the virtues of incorruptibility. The large-scale composition, with its overt pathos, must have appealed to the taste of his contemporaries: it was artistically unchallenging and theatrically presented. It was installed opposite Bol's *Pyrrhus and Fabritius* (1656; *in situ*). Flinck's initial success led to his being commissioned to paint another 12 monumental works for the town hall. Unfortunately, Flinck died suddenly four months after signing the contract giving him sole responsibility for the decoration of the town hall and before he had really started on this important commission. (Meanwhile Rembrandt's *Conspiracy of the Batavians under Claudius Civilis* (1662; Stockholm, Nmus.) was rejected.)

Bibliography

Hollstein: *Dut. & Flem.*

A. Houbraken: *De groote schouburgh* (1718–21)

H. Gerson: *Het tijdperk van Rembrandt en Vermeer* [The age of Rembrandt and Vermeer] (Amsterdam, 1952)

Govaert Flinck: Der Kleefsche Apelles (exh. cat. by F. Gorissen, Cleve, Städt. Mus. Haus Koekkoek, 1965)

J. W. von Moltke: *Govaert Flinck, 1615–1660* (Amsterdam, 1965) [with cat. rais.]

J. Rosenberg, S. Slive and E. H. ter Kuile: *Dutch Art and Architecture, 1600–1800*, Pelican Hist. A. (Harmondsworth, 1966/R 1982), pp. 151–2

W. Sumowski: *Drawings of the Rembrandt School*, iv (New York, 1981)

——: *Gemälde der Rembrandt-Schüler*, ii (Landau, 1983), pp. 998–1151 [with comprehensive bibliog.]

——: 'Three Drawings by Govaert Flinck', *Essays in Northern European Art Presented to E. Haverkamp-Bergmann* (Doornspijk, 1983)

The Impact of a Genius: Rembrandt, his Pupils and Followers in the 17th Century (exh. cat. by A. Blankert and others, Amsterdam, Waterman Gal.; Groningen, Groninger Mus.; 1983), pp. 154–61

J. W. VON MOLTKE

Geest, Wybrand (Symonsz.) de, I

(*b* Leeuwarden, 16 Aug 1592; *d* Leeuwarden, *c.* 1662). Dutch painter. He was the son of Symon Juckes de Geest (*d* before 1604), a painter of stained-glass windows. He studied with Abraham Bloemaert in Utrecht and then travelled to France and Italy. There he became a member of the colony of Dutch artists active in Rome that later developed into the Schildersbent, who gave him the nickname 'the Frisian eagle'. He made a copy after Caravaggio's *Mary Magdalene* (untraced) in Rome in 1620 (ex-S. Alorda priv. col., Barcelona; see Arnaud). He returned to Leeuwarden in 1621 and became the favourite portrait painter of the Frisian stadholders and the landed gentry. His marriage to Hendrickje Uylenborch, who was related to Rembrandt's wife Saskia, strengthened his contacts with artistic centres outside Friesland.

De Geest's early work is somewhat conventional, adhering to the style of Michiel van Mierevelt and Paulus Moreelse. Changes in fashion and artistic influences from Amsterdam lent more elegance and refinement to his later works. He is best known for his portraits of children, many of whom are dressed in pastoral costume, in the Utrecht tradition of Moreelse and Bloemaert, and for his life-size full-length portraits of influential Frisian noblemen. His most original works are three life-size group portraits of the Frisian counts of Nassau-Dietz and their relatives (Leeuwarden, Fries Mus.; Amsterdam, Rijksmus.). This series was made around 1630 for the Frisian stadholder Ernst Casimir (1573–1632) and stresses the common descent of all Nassaus and their role in the war

against Spain. (Significantly, no prince of the Orange Nassau branch of the family was depicted.) The architectural backgrounds are reminiscent of Moreelse, but the elegant composition, influenced by the work of van Dyck, has no precedent in the art of the northern Netherlands.

Notwithstanding his relation to the Protestant Nassau court, de Geest remained a Catholic; some of his portraits depict Catholic patrons. His *Album amicorum* (Leeuwarden, Prov. Bib. Friesland) is an important source for the circle around Bloemaert and for the members of the Schildersbent. His son, Julius Felix de Geest (known as Julius Franciscus; *d* 1699), was also a painter; two books with botanical drawings and some provincial portraits by him are known. Julius's son, Wybrand de Geest II (*d* before 1716), was a mediocre poet and possibly a draughtsman who published his grandfather's travel guide to Rome, 'Den getrouwen leidtsman in Romen', in his collection of writings *Het kabinet der statuen* (Amsterdam, 1702).

Bibliography

C. Hofstede de Groot: 'Het vriendenalbum van Wibrand Symonszoon de Geest', *Oud-Holland*, vii (1889), pp. 235–40

J. Arnaud: 'Ribalta y Caravaggio', *An. & Bol. Mus. A. Barcelona*, v (1947), pp. 345–413

A. Wassenbergh: *De portretkunst in Friesland in de zeventiende eeuw* [Portraiture in seventeenth-century Friesland] (Lochem, 1967), pp. 30–45

L. de Vries: *Wybrand de Geest* (Leeuwarden, 1982)

N. C. Sluijter-Seijffert: *Cornelis van Poelenburch* (Leiden, 1984), pp. 27–9

LYCKLE DE VRIES

Gelder, Arent [Aert] de

(*b* Dordrecht, 26 Oct 1645; *d* Dordrecht, 27 Aug 1727). Dutch painter and draughtsman. He was the son of a wealthy Dordrecht family and probably became a pupil of Samuel van Hoogstraten in 1660. Apparently on the advice of van Hoogstraten, de Gelder moved to Amsterdam and entered Rembrandt's workshop, possibly *c.* 1661. It is commonly assumed that he stayed there about two years. He was Rembrandt's last pupil. After completing his apprenticeship, de Gelder returned

to Dordrecht, where he worked for the rest of his long career. Considering that de Gelder was active for more than half a century, his output of just over 100 paintings seems low, probably because he was financially independent. Of those paintings accepted as by him, only 22 are dated, creating considerable problems in establishing a chronology.

De Gelder was influenced most of all by Rembrandt's painting technique. Like that of his famous master, de Gelder's brushwork was sometimes broadly applied and his colours thickly layered. On occasion, he too scratched the paint surface with the blunt end of his brush. By contrast, he hardly ever imitated Rembrandt's compositions, with one exception: the *Ecce homo* (1671; Dresden, Gemäldegal. Alte Meister, see Sumowski, 1983, no. 723 and Moltke, no. 66), an early composition derived from the third or fourth state of Rembrandt's etching of 1655 (A. von Bartsch: *Le Peintre-graveur*, 1803–21; 76). The extent to which de Gelder's artistic personality later developed independently is evident in the composition, subject-matter and colour scheme of a *Temple Entrance* (1671; The Hague, Mauritshuis, s 724, M 54). This becomes more obvious in the paintings he created in the 1680s, when no fewer than 12 dated paintings are recorded. Many of these depict scenes from the Old Testament, for instance *Judah and Tamar*, a theme never dealt with by Rembrandt. Possibly de Gelder knew such a composition by Pieter Lastman, Rembrandt's teacher. Other subjects from the Old Testament played an important role in Rembrandt's oeuvre, although *Esther and Ahasuerus*, so often depicted by de Gelder, was only once dealt with by Rembrandt in a painting of *c.* 1661 (Moscow, Pushkin Mus. F.A.), done at the time de Gelder entered his studio. De Gelder treated the theme nearly a dozen times, a good example being the imposing *Esther at her Toilette* (1684; Munich, Alte Pin., s 743, M 29). The story of Esther's life interested de Gelder more than any other biblical event, possibly because of the human dimension. Most of the pictures are centred on the interactions between a few protagonists; however, narrative details are emphasized rather than psychological relationships.

De Gelder also executed numerous portraits during the 1680s, some of which are dated, others datable on stylistic grounds. Some are official commissions, such as the portrait of *Ernestus van Beveren* (1685; Amsterdam, Rijksmus., S 804, M 84), while others are clearly of friends, such as the *Portrait of an Actor* (1687; Detroit, MI, Inst. A., S 791, M 92). De Gelder was a man of independent financial means and thus never worried about securing commissions. From the same decade there is also a fine *Self-portrait* (1685; Frankfurt am Main, Städel. Kstinst. & Städt. Gal., S 749, M 83), which might have been inspired by Rembrandt's *Self-portrait* of two decades earlier (1665; Cologne, Wallraf-Richartz-Mus.).

In the 1690s de Gelder continued to produce paintings of biblical themes as well as some fine portraits, including that of the sculptor *Hendrik Noteman* (1698; Dordrecht, Dordrechts Mus., S 806, M 86). The gradual emergence of 18th-century features is apparent in this work, not only in the sitter's clothing, hairstyle and pose but also in the greater refinement and subtler choice of colours in the painting technique. Early in the 18th century de Gelder's colour scheme changed still further. For the first time a brilliant emerald and other shades of green made their appearance. The previous lack of such colours demonstrates how slowly he abandoned the Rembrandtesque palette. A typical example of this vivid new approach is the large canvas depicting *Ahimelech Giving the Sword of Goliath to David* (Malibu, CA, Getty Mus., S 752, M 20). The same brilliant palette is found in the *Portrait of a Young Man* (Hannover, Niedersächs. Landesmus., S 812, M 94); rather than a specific likeness, it is a spirited description of a seated youth looking out at the viewer.

Towards the end of his life, c. 1715, de Gelder created a number of paintings of the *Passion*. Of a projected series of 22 pictures, 12 survive (10 in Aschaffenburg, Schloss Johannisburg, Staatsgal., and 2 in Amsterdam, Rijksmus.). They were probably not painted on commission: de Gelder, a religious man, may simply have been taking stock of his life. The paintings vary greatly in quality, the finest being the *Way to Golgotha* (Aschaffenburg, S 772, M 67). Some of them were inspired in parts by Rembrandt's etchings, transposed into de Gelder's personal idiom.

At the very end of his life de Gelder executed a remarkable and affectionate group portrait of the famous *Doctor Boerhaave of Leiden with his Wife and Daughter* (c. 1722; Amsterdam, Rijksmus., S 817, M 100); the apparent bond with the sitter—something very rare in de Gelder's portraits—suggests that the subject might have been de Gelder's own doctor. The artist was then nearly 80 years old at the time, but his powers of observation were undiminished.

De Gelder did not adopt the artistic trends of the latter half of the 17th century or the early part of the 18th, nor was he interested in painting elegant portraits in the fashionable Flemish style (like Govaert Flinck and Ferdinand Bol). He did not experiment with either the precise 'Fine' painting style of Gerrit Dou or the artificially illuminated candlelit scenes popularized by Godfried Schalcken. Although de Gelder in many ways continued the painterly technique of Rembrandt, his choice of subject-matter, imaginative presentation and brilliant colour schemes reveal a fine aesthetic sensibility, ensuring him a special place in Dutch painting of the 17th and 18th centuries.

Bibliography

S. van Hoogstraten: *Inleyding tot de hooge schoole der schilderkonst* [Introduction to the great school of painting] (Rotterdam, 1678/R Utrecht, 1969)

A. Houbraken: *De groote schouburgh* (1718–21)

K. Lilienfeld: *Arent de Gelder: Sein Leben und seine Kunst* (The Hague, 1914)

J. Rosenberg, S. Slive and E. H. ter Kuile: *Dutch Art and Architecture, 1600–1800*, Pelican Hist. A. (Harmondsworth, 1966/R 1982), pp. 163–6

W. Sumowski: *Drawings of the Rembrandt School*, v (New York, 1981), pp. 2335–444

—: *Gemälde der Rembrandt-Schüler*, ii (Landau, 1983) [S]

The Impact of a Genius: Rembrandt, his Pupils and Followers in the 17th Century (exh. cat. by A. Blankert and others, Amsterdam, Waterman Gal.; Groningen, Groninger Mus.; 1983)

J. W. von Moltke: *Arent de Gelder, Dordrecht 1645–1727*, ed. K. L. Belkin (Doornspijk, 1994) [chapters by C. Tümpel, G. Pastoor and A. Chong; with cat. rais.] [M]

J. W. VON MOLTKE

Gheyn, de

Dutch family of artists. Jacques de Gheyn I (*b* on board ship on the Zuyder Zee, 1537–8; *d* Antwerp, ?1581), the first of three generations of artists of the same name, was a glass painter, engraver and draughtsman. He is known to have designed stained-glass windows in Antwerp and Amsterdam, but these are now lost, as are the miniatures he executed. A few allegorical etchings and drawings survive, but these are also ascribed to his son (1) Jacques de Gheyn II. The latter, the most renowned artist of the family, was a gifted draughtsman and engraver, whose work spans the transition from late 16th-century Mannerism to the more naturalistic style of the early 17th century. His importance lies in his originality and creative inventiveness, which was allied to a poetic imagination, and in his role as a recorder of contemporary events at a time when the new Dutch Republic was creating a national identity. He was held in high regard by the central Dutch government and the court of Prince Maurice of Orange Nassau and by the representatives of the Dutch cities in the States General. His son, (2) Jacques de Gheyn III, was a close follower, and it is often difficult to distinguish their work. De Gheyn III is best known for his etchings.

(1) Jacques [Jacob] de Gheyn II

(*b* Antwerp, 1565; *d* The Hague, 29 March 1629). Draughtsman, engraver and painter. He was taught first by his father and then from 1585 by Hendrick Goltzius in Haarlem, where he remained for five years. By 1590–91 de Gheyn II was in Amsterdam, making engravings after his own and other artists' work (e.g. Abraham Bloemaert and Dirck Barendsz.). There he was visited several times by the humanist Arnout van Buchell [Buchelius]. De Gheyn received his first official commission in 1593—an engraving of the *Siege of Geertruitenberg* (Hollstein, no. 285)—from the city and board of the Admiralty of Amsterdam. In 1595 he married Eva Stalpaert van der Wiele, a wealthy woman from Mechelen. From 1596 to 1601–2 he lived in Leiden, where he began collaborating with the famous law scholar Hugo de Groot [Grotius], who wrote many of the inscriptions for the artist's

engravings. During this period he also began working for Prince Maurice of Orange. In 1605 de Gheyn was a member of the Guild of St Luke in The Hague, where he remained until his death. Once he had settled in The Hague, de Gheyn's connections with the House of Orange Nassau were strengthened. Among other commissions, he designed the Prince's garden in the Buitenhof, which included two grottoes, the earliest of their kind in the Netherlands. After the Prince's death in 1625, de Gheyn worked for his younger brother, Prince Frederick Henry.

Although originally a Catholic, de Gheyn seems to have turned to Calvinism and gradually abandoned orthodox Catholic themes. His subject-matter was also influenced by his contact with the newly established university at Leiden. He never travelled to Italy and, apart from an interest in Pisanello, there is little evidence in his work (except in his garden designs) of the influence of Classical antiquity or the Italian Renaissance, both of which were so attractive to many of his northern contemporaries. Much information about both de Gheyn II and de Gheyn III is provided in the autobiography of Constantijn Huygens the elder, secretary to Frederick Henry. Jacques II is also mentioned by van Mander, for whom he worked as a reproductive engraver. Van Mander wrote of de Gheyn II, among other things, that he 'did much from nature and also from his own imagination, in order to discover all available sources of art'. Indeed, some of his images are completely fictitious, while others are based on reality. Often his works are a mixture of these two components.

1. Drawings

Altena (1983) catalogued 1502 drawings by de Gheyn II, including designs that survive only in prints. For his drawings de Gheyn used a quill pen and dark brown ink with white heightening, black or red chalk or brush and wash. Those intended to be reproduced as prints are often indented with a metal stylus for transfer on to the plate. Before 1600 his style was clearly dominated by the influence of Goltzius, whose small silverpoint and metalpoint portraits on ivory-coloured tablets de Gheyn imitated, although he used a yellow ground

and rendered his sitters more gracefully and dynamically than the simple and unadorned portraits of Goltzius. The majority of de Gheyn's portraits date from before 1598. He was particularly skilled in his use of both the pen and the brush. While his free, sketchy studies in pen and ink are usually made without wash, his preparatory drawings for engravings, such as those for the *Exercise of Arms* (c. 1597; various locations, see Altena, 1983, nos 346–459), commissioned by Prince Maurice of Orange and published in The Hague in 1608, are elaborately washed and sometimes heightened with white. Initially de Gheyn's drawings imitated Goltzius's engraving style, as can be seen in the *Portrait of a Young Man Holding a Hat in his Hand* (Berlin, Kupferstichkab.), which may, according to Altena, represent Matheus Jansz. Hyc. De Gheyn's draughtsmanship, like that of Goltzius, belongs to the tradition of Dürer, Pieter Bruegel the elder and Lucas van Leyden; it is also related to the undulating graphic style of Venetian woodcuts by Titian and Domenico Campagnola.

In his landscape drawings de Gheyn was also influenced by Paul Bril and Hans Bol. These seem to have been based mostly on his imagination and contain no evidence of direct visual contact with nature. In some cases, such as the grand *Mountain Landscape* (New York, Pierpont Morgan Lib.; see col. pl. XIV), which reflects a type of alpine landscape traditionally associated with Pieter Bruegel, it is difficult to distinguish reality from fantasy. De Gheyn did not make realistic landscapes in the style of Goltzius, but occasionally accurate elements of the Dutch landscape appear in the background of his narrative scenes with figures. An exceptional case is his *Landscape with a Canal and Windmills* (Amsterdam, estate of J. Q. van Regteren Altena, see Altena, 1983, iii, p. 59), which he made after the drawing by Hans Bol (1598; London, BM).

Around 1600 de Gheyn gradually began to dissociate himself from the influence of Goltzius. His pen lines are more fluent, sometimes grow quite wild and tend to have a recognizable curly rhythm. The extensive use of hatching and crosshatching reflect his skill as an engraver. He rarely used red chalk, preferring black chalk and occasionally the combination of chalk with pen and ink, as in the *Studies of a Donkey* (c. 1603; Paris, Fond. Custodia, Inst. Néer.).

De Gheyn II also produced carefully coloured drawings on parchment in a naturalistic style. In these he would often use watercolour as well as bodycolour, with occasional highlights in gold. A splendid example is the *Old Woman on her Deathbed with a Mourning Cavalier* (1601; London, BM). This miniaturist technique can be best compared with the English 'Arte of Limning', described in a treatise by Nicholas Hilliard, and it is possible that, through Constantijn Huygens, de Gheyn may have known these colourful miniatures. A magnificent album from 1600–04 (Paris, Fond. Custodia, Inst. Néer.), once in the possession of Rudolf II, consists of 22 watercolour drawings on parchment, executed in this miniaturist technique. Among the almost photographic representations of natural objects are flowers, mostly roses, insects and also a crab and a mouse. The studies are part of a long-standing tradition of natural history illustrations, of which Dürer, Joris Hoefnagel and Georg Flegel were key exponents. The scientific value of the album leaves lies in the fact that they represent rare examples or newly cultivated varieties of flower. The famous scholar Carolus Clusius is thought to have been de Gheyn's adviser in these matters. As in other works, symbolism apparently plays an important role in this album.

De Gheyn also represented the female nude in drawings. Two of the seven known examples are certainly after the same model (Altena, 1983, ii, nos 803 and 804); the others seem more or less realistic in conception. Together with similar works by Goltzius, they are among the earliest nudes in Dutch art. Another iconographic innovation by de Gheyn was the realistic portrayal of domestic scenes, as in the drawing of *Johan Halling and his Family* (1599; Amsterdam, Rijksmus.) and the *Mother and Son Looking at a Book by Candlelight* (c. 1600; Berlin, Kupferstichkab.). Such genre scenes were not to be painted regularly on a larger scale in Holland until the 17th century.

A number of de Gheyn's drawings are allegorical, although often unclear or complex, for

example the *Allegory of Equality in Death and Transience* (1599; London, BM) and the related engraving (Hollstein, no. 98), for which the 16-year-old Hugo de Groot wrote the caption. Also allegorical in meaning is the *Archer and Milkmaid* (c. 1610; Cambridge, MA, Fogg), a preparatory study for a print that carries the legend 'Beware of him who aims in all directions lest his bow unmasks you'.

Perhaps de Gheyn's most original inventions iconographically were his '*spookerijen*' ('spooks'), the drawings of sorcery and witchcraft. The meaning of, for example, the *Two Withered Rats* (1609; Berlin, Kupferstichkab.) or of his drawings of monstrous, crawling rats remains a mystery. The enormous *Witches' Sabbath* (Stuttgart, Württemberg. Landesbib.) is reminiscent of the work of Hans Baldung and of contemporary literature on witchcraft. His drawings of strange knotted tree trunks, surely imaginary rather than realistic, are related to the grotesque ornamental style, for the curious, gnarled bark seems to contain hidden figures. There are also some drawings that seem to fall outside any particular iconographical category; they are strange, fantastical scenes, sometimes bordering on the magical, such as the *Naked Woman in Prison* (Brunswick, Herzog Anton Ulrich-Mus.), the meaning of which, if any, is unclear.

2. Prints

The 430 engravings and etchings catalogued by Hollstein include prints after de Gheyn's own designs as well as those of other artists. From 1585 until the end of the 16th century he imitated Goltzius's burin manner in his engravings; the lines cut into the copperplate vary in thickness, with the density of the hatchings and cross-hatchings suggesting passages of light and dark as well as volume. In some cases dots intensify the density of crosshatchings. Before Goltzius's departure for Italy in 1590, de Gheyn was already using this engraving technique, known as the 'zebra effect', in his series of *Standard-bearers* (1589; Hollstein, nos 144–5). A proof state of one of these plates (Amsterdam, Rijksmus.) shows de Gheyn's masterly handling of the burin. He also used a finer engraving technique with short hatchings, strokes and dots, as can be seen in the portrait of the numismatist *Abraham Gorlaeus* (1601; Hollstein, no. 313); this old-fashioned type is reminiscent of the portraits of learned humanists at the time of Hans Holbein.

As in the drawings, after c. 1600 a gradual change took place. De Gheyn's engraving style became more mature, with lines more evenly spread over the whole of the copperplate. His exceptional talent is seen at its height in the *Fortune-teller* (Hollstein, no. 105), datable shortly after 1600. He more or less abandoned engraving after 1600, but this print can only have been made by him. The tree is certainly based on one of his preparatory tree studies. He depicted relatively few biblical or mythological subjects in his engraved work, preferring, instead, to concentrate on series depicting contemporary events, for example the *Battle of Turnhout* (1594; Hollstein, no. 286) and his striking large print of *Prince Maurice's Land Yacht* (1603; Hollstein, no. 63).

The most important change after 1600 was that de Gheyn began to experiment with etching, a technique that was not fully exploited in its own right until the work of Rembrandt in mid-century. Even though with etching it is not possible to vary the thickness of lines, de Gheyn's etching style hardly differs from that of his engraving. According to Burchard, there are two etchings certainly by Jacques de Gheyn II: the *Farm at Milking Time* (Hollstein, no. 293), which looks like a Venetian-style woodcut, and the *Happy Couple* (Hollstein, no. 97), which is remarkable for its effective division of light and dark, achieved by, among other things, a fine use of stippling. However, these attributions are not universally accepted. Konrad Oberhuber attributed the *Happy Couple* to de Gheyn III (*Jacques Callot und sein Kreis*, exh. cat., Vienna, Albertina, 1968–9, pp. 67–8); and Altena (1983) described the *Farm at Milking Time* as 'Anonymous after J. de Gheyn II'. They may have been made after drawings (both Amsterdam, Rijksmus.) by Jacques de Gheyn II. The engravers Jan Saenredam and Zacharia Dolendo were both pupils of de Gheyn II.

3. Paintings

Like Goltzius, Jacques de Gheyn II did not take up painting until *c.* 1600, about the time he stopped engraving. Of the 47 works catalogued by Altena (1983), at least 21 survive, while the rest are known from documents and old sale catalogues. The figure paintings are reminiscent of the drawings but lack the conception behind the large academic nudes painted by Goltzius, as well as his 'burning' reddish-brown colour. The unnaturally posed *Seated Venus* (*c.* 1604; Amsterdam, Rijksmus.) is closer to the Mannerist style of Bartholomäus Spranger than to examples from antiquity or the Renaissance. De Gheyn's history paintings have not been extensively studied. The best known is his painting of *Prince Maurice's White Horse* (1600; Amsterdam, Rijksmus.), the artist's first commission from the Prince. There are also a few paintings with obscure subjects, such as the *Woman in Mourning Clothes Lamenting over Dead Birds* (Sweden, priv. col., see Altena, 1983, ii, no. P16).

De Gheyn's best-known paintings, the *vanitas* still-lifes and flower-pieces with butterflies, caterpillars, shells and the like, which are painted in the Flemish tradition, are of better quality. The earliest, the still-life *Allegory of Mortality* (1603; New York, Met.), bears the explanatory caption: HVMANA VANA. In such works as the *Bouquet in a Glass Vase* (1612; The Hague, Gemeentemus.), the roses are almost withered and recall the emblematic motto 'rosa vita est'. The unsigned painting on copper of a *Vase of Flowers* (ex-Brian Koetser Gal., see Altena, 1983, ii, no. P31) is a special case: all the flowers recur in the Paris album of miniatures. His flowers, mostly roses and tulips, are all on the verge of withering and are painted with a dynamism not found in freshly cut flowers; this could also be an allusion to the transience of life. This stylization of nature often recurs in the artist's oeuvre.

(2) Jacques de Gheyn III

(*b* ?Amsterdam, ?1596; *d* Utrecht, 5 June 1641). Draughtsman, etcher and possibly painter, son of (1) Jacques de Gheyn II. He worked in The Hague and later in Utrecht, where he became canon of the St Mariakerk. In 1618 he was travelling in England with Constantijn Huygens the elder, and in 1620 he went to Sweden, taking eight of his father's works. His drawings are sometimes indistinguishable from those of his father. The work of Jacques de Gheyn III is generally of less importance than his father's, with the exception of some of the early etchings, for example the dramatically lit series of *Seven Wise Men from Greece* (1616; Hollstein, nos 10–17), or the *Triton Blowing a Shell* (Hollstein, no. 23) and a few drawings in which he did not imitate his father. Jacques III's etching style was still largely based on the engraving technique used by Goltzius and by his own father, but the dramatic treatment of light and dark seems related to the tenebrist style of Adam Elsheimer and of his follower Hendrik Goudt, who was active in Utrecht from 1611.

De Gheyn III's later works suggest a sudden breakdown, something also indicated in Huygens's autobiography, in which he deplored the apparent inertia of an artist who had shown such promise as a young man. Few works are known from after the death of his father. Although a number of paintings have been attributed to de Gheyn III, some were certainly painted by other artists, such as the *Schoolmaster with Three Children* (untraced, Altena, 1983, p. 233) by Willem van Vliet (*c.* 1584–1642). Jacques de Gheyn III also collected: he owned works by Rembrandt, who painted his portrait (1632; London, Dulwich Pict. Gal.).

Bibliography

Hollstein: *Dut. & Flem.*K. van Mander: *Schilder-boeck* ([1603]–1604), fols 293*v*–295*r*
C. Huygens: *De jeugd van Constantijn Huygens door hemzelf beschreven* (MS., 1629–31); ed. A. H. Kan (Rotterdam and Antwerp, 1946)
L. Burchard: *Die holländische Radierer vor Rembrandt* (diss., U. Halle, 1912)
J. Q. van Regteren Altena: *Jacques de Gheyn: An Introduction to the Study of his Drawings* (Amsterdam, 1936)
J. R. Judson: *The Drawings of Jacob de Gheyn II* (New York, 1973)
F. Hopper Boom: *An Album of Flower and Animal Drawings by Jacques de Gheyn II* (diss., Rijksuniv. Utrecht, 1976)

J. Q. van Regteren Altena: *De Gheyn, Three Generations*, 3 vols (The Hague, 1983); review by E. K. J. Reznicek in *Oud-Holland*, cii (1983), pp. 78–87

Dessins et gravures de Jacques de Gheyn II et III (exh. cat. by C. van Hassel and M. van Berge-Gerbaud, Paris, Fond. Custodia, Inst. Néer., 1985)

Jacques de Gheyn II, 1565–1629: Drawings (exh. cat. by A. W. F. M. Meij and J. A. Poot, Rotterdam, Mus. Boymans-van Beuningen; Washington, DC, N.G.A.; 1985–6)

Dawn of the Golden Age: Northern Netherlandish Art, 1580–1620 (exh. cat., ed. G. Luijten and others; Amsterdam, Rijksmus., 1993–4), p. 305, *passim*

E. K. J. REZNICEK

Glauber, Johannes [Jan; Polidor(o)]

(*b* Utrecht, *bapt* 18 May 1646; *d* Schoonhoven, nr Gouda, 1726). Dutch painter, draughtsman and printmaker of German descent. In the mid-1660s he served a nine-month apprenticeship with Nicolaes Berchem in Amsterdam and then found employment copying Italian paintings for the Amsterdam art dealer Gerrit Uylenburgh. In 1671, accompanied by his sister Diana (1650–after 1721) and brother Jan Gottlieb (1656–1703), both painters, Glauber embarked on an extended journey to Italy. *En route* he worked for the Flemish painter and art dealer Jean-Michel Picart in Paris for one year, and possibly met Abraham Genoels II and Jean-François Millet at this time. About 1672–4 Glauber studied with the expatriate Dutch landscape painter Adriaen van der Cabel in Lyon. Glauber was in Rome by 1675, and on joining the Schildersbent received the nickname 'Polidor' in recognition of his artistic debt to the landscapes of Polidoro da Caravaggio. A member of the third generation of Dutch Italianates in Rome, Glauber became friends with Karel Dujardin and Aelbert Meyeringh; the latter accompanied him on subsequent travels to Padua, Venice, Hamburg and finally Copenhagen, where Glauber spent six months in the service of the Danish Count Ulrik Frederik Gyldenløve (1638–1704).

Glauber returned to Amsterdam in 1684 and resided with the history painter and theoretician Gérard de Lairesse, who in *Het Groot Schilderboek* (Amsterdam, 1707) cited Glauber as one of the few contemporary landscape painters worthy of emulation. Glauber shared de Lairesse's classicizing tastes and presided with him at meetings of the literary society Nil Volentibus Arduum. He also etched a series of thirty prints after compositions by de Lairesse. Most importantly, however, the two artists collaborated on numerous commissions during the 1680s, including decorative projects for the stadholder William III of Orange, later King William III of England and Scotland, and for the wealthy Dutch bourgeoisie, with de Lairesse providing the staffage for Glauber's Italianate landscapes. Products of this successful partnership include landscapes with mythological scenes, for example *Landscape with Mercury and Io* (c. 1685-7), for the palace at Soestdijk, near Hilversum (figures by de Lairesse and Dirk Maas; now The Hague, State Col.), and for the audience hall at Het Loo (*Arcadian Landscape*; c. 1685; Apeldoorn, Pal. Het Loo), and four paintings for the Amsterdam home of Jacob de Flines (e.g. *Italian Landscape with Shepherd and Shepherdess*; c. 1687; Amsterdam, Rijksmus.). As well as the several other decorative landscape cycles mentioned by Houbraken, Glauber painted Italianate landscapes of a more modest format.

Possibly in connection with his work for the stadholder's court, Glauber joined the painters' confraternity Pictura in The Hague on 12 December 1687, although he continued to live in Amsterdam. He married Susannah Vennekool, sister of the architect Steven Vennekool, on 28 March 1704. In 1721 Glauber retired to the Proveniershuis in Schoonhoven, where he died.

The scarcity of dated works hampers an accurate reconstruction of Glauber's stylistic development. His two dated works—a landscape drawing in black chalk of 1685 (Dresden, Kupferstichkab.) and a painting of 1686, *Landscape with Shepherds and Flute Player* (Paris, Louvre)—show the influence of Gaspard Dughet in their strong diagonal compositions and cool, subdued colouring. Dughet's impact is also evident in Glauber's use of specific motifs and themes; for example, his *Storm Landscape* (Vienna, Ksthist. Mus.) is inspired by the tempestuous landscapes perfected by Dughet. Glauber's series of six etchings after

landscape compositions by Dughet, as well as his own compositions in a similar vein, probably also date from the late 1680s, when Dughet's influence seems to have been strongest in his work.

Other, presumably later works, such as the *Ideal Landscape with Obelisk* (Brunswick, Herzog Anton Ulrich-Mus.), or the *Landscape with King Midas Judging the Musical Contest between Pan and Apollo* (Boston, MA, Mus. F.A.), are closer to the landscapes of Nicolas Poussin in their strict, almost geometric organization of planar space and the use of figures robed in clear primary colours to accent the grey-green tonalities of the surrounding landscape. Glauber was perhaps the most popular proponent of idealized classical landscape in the Netherlands during the late 17th and early 18th centuries and became known as the 'Poussin de la Hollande'.

Bibliography

Hollstein: *Ger.*, x, pp. 65–130

A. Houbraken: *De groote schouburgh* (1718–21), iii, pp. 216–19

D. P. Snoep: 'Gerard de Lairesse als plafond- en kamer-schilder' [Gérard de Lairesse as ceiling and mural painter], *Bull. Rijksmus.*, xviii (1970), pp. 159–217

A. Zwollo: *Hollandse en Vlaamse veduteschilders te Rome 1675–1725* [Dutch and Flemish *vedutisti* in Rome] (Assen, 1973), pp. 10–19

C. Kämmerer: *Die klassisch-heroische Landschaft in der niederländischen Landschaftsmalerei, 1675–1750* (diss., Berlin, Freie U., 1975), pp. 81–100

MARJORIE E. WIESEMAN

Goltzius [Gols; Goltius; Goltz; Golzius], Hendrick [Hendrik]

(*b* Mülbracht [now Bracht-am-Niederrhein], Jan or Feb 1558; *d* Haarlem, 1 Jan 1617). Dutch draughtsman, printmaker, print publisher and painter. He was an important artist of the transitional period between the late 16th century and the early 17th, when the conception of art in the northern Netherlands was gradually changing. Goltzius was initially an exponent of Mannerism, with its strong idealization of subject and form. Together with the other two well-known Dutch Mannerists, Karel van Mander I and Cornelis Cornelisz. van Haarlem, he introduced the complex compositional schemes and exaggeratedly contorted figures of Bartholomäus Spranger to the northern Netherlands. These three artists are also supposed to have established an academy in Haarlem in the mid-1580s, but virtually nothing is known about this project. In 1590 Goltzius travelled to Italy, thereafter abandoning Spranger as a model and developing a late Renaissance style based on a broadly academic and classicizing approach. Later still, his art reflected the growing interest in naturalism that emerged in the northern Netherlands from *c.* 1600. In fact, Goltzius's ability to emulate the style and technique of different artists and to adapt to current trends earned him distinction as a 'Proteus of changing shapes'.

The intellectual milieu in which Goltzius worked was formed by the humanist printmaker Dirck Volkertsz. Coornhert, with whom he studied, and the learned Latin schoolmasters Franco Estius (*b c.* 1545) and Cornelis Schonaeus (1540–1611), who provided inscriptions for his engravings. Besides the art theories of van Mander (e.g. the latter's firm conviction of the affinity of painting and poetry), Goltzius was influenced by the *Idea de' pittori, scultori ed architetti* (1607) of Federico Zuccaro, whom he had met in Rome. In his lifetime Goltzius's fame, in the Netherlands and elsewhere, was based largely on the technical skill and virtuosity of his engravings, which influenced many artists, including the young Rubens. By 1596–7 examples of his prints had found their way to places as remote as the Arctic island of Novaya Zemlya, and in 1612 the English writer Henry Peachum recommended in *The Gentleman's Exercise*: 'For a bold touch, variety of posture, curious and true shadow, imitate Goltzius, his prints are commonly to be had in Pope-head-alley'.

1. Life

Goltzius's great-grandfather, Hubrecht Goltz von Hinsbeck (*fl* 1494), was a painter at Venlo, as was his grandfather, Jan Goltz I (*fl* 1532–50). When Hendrick was three years old, his father, Jan Goltz II (1534–after 1609), moved from Mülbracht to Duisburg, where he worked as a glass painter.

According to van Mander, as a child Hendrick apparently burnt his hand and thereafter was unable to extend his fingers fully. About 1574 Goltzius became a pupil of Coornhert's in Xanten. In 1577, after Haarlem had declared for William the Silent, Prince of Orange, Goltzius followed Coornhert to that city, where he worked until his death. In 1577–8 he executed large commissions as an engraver for the Antwerp publisher Philip Galle. In 1579 Goltzius married Margaretha Jansdr (*d* after 1628), a shipbuilder's daughter and a widow, who brought with her an eight-year-old son by her previous marriage, Jacob Matham; the Goltzius marriage was childless. In 1582 Goltzius opened his own graphic printing house. He became a patron and a close friend of van Mander after the latter settled at Haarlem in 1583, and in those years he negotiated with the Jesuits of Rome over an engraving commission. Jacob Matham, Jacques de Gheyn II and Jan Muller were among his pupils in the late 1580s.

Van Mander, Goltzius's chief biographer, recorded that he fell ill (probably of consumption) and that, apparently for health reasons, he went to Italy at the end of October 1590; the progress of this illness can be seen in his self-portraits. In Italy Goltzius visited Rome and Naples and, on both the outward and return journeys, Venice and Florence. There he drew a number of artists' portraits and also recorded the wonders of Rome, from famous antique statues to the façade paintings of Polidoro da Caravaggio, as well as works by other important Italian artists. By the end of 1591 Goltzius was back in Haarlem. During this period Jan Saenredam, among others, worked as an engraver in his studio. Although his health again worsened, Goltzius continued to work vigorously; his prints were on sale everywhere, including foreign countries. Then, in or about 1600, he turned to painting and more or less gave up engraving. In 1605 he was duped by an alchemist whom he had taken into his house on the strength of his claims to be able to make gold. In June 1612 Goltzius and his fellow guild artists entertained Rubens when the latter visited Haarlem. In 1614 a scandal was caused by Goltzius's alleged 'carnal' relationship with a

maid. In October 1616 Sir Dudley Carleton wrote of his visit to Haarlem: 'Goltzius is yet living, but not like to last owt an other winter; and his art decays with his body'. The day after Goltzius's death, the Haarlem funeral bell tolled half an hour for him, at a cost of 7 guilders.

2. Work

(i) Drawings

(a) Technique and media. Goltzius was a versatile and masterly draughtsman, skilled in the use of several different instruments and media: metalpoint, quill pen and ink, brush and wash, and red and black chalk. He does not seem to have had any preference but became famous chiefly as a 'master of the pen'.

Goltzius's metalpoint technique was inherited from the traditional practice of Dürer, in which pieces of paper or parchment were first primed with a pulp of bone-ash and glue and then prepared with a light brown or yellow ground, on which the artist could work in metalpoint with great accuracy. It is often hard to know which metal is used since the lines oxidize over time, but in Goltzius's case it was mainly silverpoint. However, he used leadpoint, which is softer, leaves traces more easily and can be recognized by its shiny effect, in the portrait of *Jean Niquet* (c. 1595; Amsterdam, Rijksmus.). By incising the upper layer of coloured preparation, the white ground was sometimes used to create highlights, as in Goltzius's portraits of his parents-in-law, *Jan Baertsen* and *Elizabeth Waterland* (both 1580; Rotterdam, Mus. Boymans–van Beuningen). Sometimes the hard primed sheets were bound together to form a drawing-book. No actual books are known to have survived, but there are individual leaves, such as the portrait of his father, *Jan Goltz II* (1579; Copenhagen, Stat. Mus. Kst.), which are drawn on both sides. Goltzius's early realistic portrait drawings in metalpoint are the continuation of an older Netherlandish tradition: they are executed with great precision, sober and unadorned. After 1590 their handling is looser and less detailed, as was made possible especially with the softer leadpoint. After 1600 Goltzius seems, with a few exceptions, to have practically

abandoned metalpoint: an example of his later style, freer and more sketchlike, is the *Portrait of a Man with a Long Grey Beard* (c. 1610; Haarlem, Teylers Mus.). Goltzius used metalpoint not only for small finished portraits intended as independent works of art but also for head studies, such as that of the Polish envoy *Stanislas Sobocki* (1583; Amsterdam, Rijksmus.). This carefully executed study was then placed on a full-length body, intentionally schematic and not based on visual observation, for Goltzius's portrait engraving of the envoy (Strauss, no. 174). That metalpoint drawings also served as records of observed reality is evident from the spontaneous drawings of the artist's dog, a Drent spaniel, in various attitudes (e.g. c. 1596; Paris, Fond. Custodia, Inst. Néer.) and by sketches of more exotic animals, such as the *Study of a Camel* (c. 1589; London, BM).

Goltzius was also skilled at drawing in chalk. Even before his visit to Italy in 1590, he executed several sheets in this medium, then very little used in the northern Netherlands. His complete command of this technique is apparent in the *Four Studies of a Hand*, perhaps showing his own crippled right hand (c. 1588; Frankfurt am Main, Städel. Kstinst. & Städt. Gal.), a drawing in red and black chalk. Even more elaborate in technique is the drawing of a *Lumpfish (Cyclopterus lumpus)* (1589; Brussels, Bib. Royale Albert 1er), with green chalk as well as red and black, and watercolour wash and stumping. In early chalk portraits, such as that of *Gillis van Breen* (1588; Frankfurt am Main, Städel. Ksthist. & Städt. Gal.), the technique is closer to the French *à trois crayons* method than to any Italian model. Goltzius's chalk technique was enriched by his visit to Italy and his exposure to chalk drawings by Federico Zuccaro and Federico Barocci. Goltzius's portrait of *Giambologna* (1591; Haarlem, Teylers Mus.) is a true masterpiece, the equal of any chalk study by Zuccaro; it is remarkable for its expressive painterly quality, achieved by the use of black and red chalk and a light application of chestnut-brown wash to the eyes and beard. Some drawings, such as the two of the *Holy Family* (late 1590s, Otterlo, Rijksmus. Kröller-Müller; and c. 1600, Weimar, Schlossmus.), were clearly made in imitation of Barocci. After 1600 Goltzius's chalk technique became softer and more refined. Red and black chalk are used for lightly hatched strokes, but much of this is then dissolved through extensive stumping, as in a series of realistic, yet idealized portraits of women (e.g. c. 1605–10; Oxford, Ashmolean), which reveal a tenderness and feeling for female charms not previously found in Goltzius's work.

Although the technique of many of Goltzius's pen-and-ink drawings is closely related to the practice of engraving with the burin, he also made rapid, summary pen sketches, such as that of the pose of *William of Orange* (1581; Darmstadt, Hess. Landesmus.), a study for the portrait engraving (B. 178). This figure sketch was, in fact, of incidental importance: Goltzius was mainly concerned with the allegorical figures in the border and with the cartouche for the inscription, which are carefully elaborated with pen and brush. Both during and after his lifetime, Goltzius was famous for his *Federkunststücke* (or 'pen works'), a term introduced by Joseph Meder in *Die Handzeichnung* (Vienna, 1923). These are large and impressive imitations of engravings, drawn in pen and ink. One such example is a portrait, drawn two years after the chalk study, of *Gillis van Breen* (1590; Haarlem, Teylers Mus.); another was recorded in Rudolf II's collection in Prague—a *Head of Mercury*, probably the drawing now in Oxford (Ashmolean). In 1604 Goltzius produced a unique, astonishing specimen of this technique: on a prepared canvas measuring 2.28×1.78 m he drew *Venus, Bacchus and Ceres with Cupid* ('*Sine Cerere et Libero friget Venus*'; St Petersburg, Hermitage), which once had pride of place in the collection of Pierre Crozat. Drawings in brush and wash alone are rare in Goltzius's work, but he used the brush and white highlights for his working drawings for engravings, such as those (e.g. three sheets of c. 1590; all Hamburg, Ksthalle) for an anonymous series of prints of Ovid's *Metamorphoses*. Among the known artists who made engravings after his drawings are his pupils de Gheyn, Matham and Saenredam.

(b) Style. Goltzius's draughtsmanship before 1590 is relatively straightforward: first he drew in the

manner of Maarten van Heemskerck, later in that of Anthonie Blocklandt and, from 1585 onwards, that of Spranger. He had no clear style of his own but followed current fashion for commercial reasons. The only group that could be described as original is the fine series of small metalpoint portraits (see §(a) above). His journey to Italy in 1590–91 led to a new, broader approach. Besides the work of Zuccaro and Barocci, his models were the prints of Titian and Domenico Campagnola, as well as Dürer, Lucas van Leyden and those after Pieter Bruegel I. What is remarkable is that he was now able to imitate several styles simultaneously. From c. 1600 his draughtsmanship became so heterogeneous that it defies classification. Some studies of female nudes (e.g. 1594; USA, priv. col., see Reznicek, 1993, fig. 69) and two landscapes of views around Haarlem (both 1603; Paris, Fond. Custodia, Inst. Néer.; Rotterdam, Mus. Boymans–van Beuningen) seem to have been drawn from life, anticipating later examples of naturalistic Dutch art. In exploring different artistic sources, Goltzius seems to have ignored the work of Rubens as a draughtsman, although his magnificent red and black chalk drawing of a *Man with a Long Grey Beard and Bowed Head* (1610; Amsterdam, Rijksmus.) has an expressive force not inferior to anything Rubens could achieve.

(ii) Prints

(a) Engravings and etchings. In his pioneering study of 1921 Hirschmann catalogued 361 prints by Goltzius, mostly engravings and only a few etchings. Those designed by Goltzius himself numbered 291, while the remainder were made by him after the work of other artists. Before his journey to Italy, he engraved designs by Blocklandt, Joannes Stradanus, Dirck Barendsz., Marten de Vos, Spranger and Cornelisz. van Haarlem; after his return, he made reproductive prints of ancient sculpture and Italian paintings, such as those by Raphael, Palma Giovane and Annibale Carracci. Goltzius used drawings or copies of drawings by all these artists, which stimulated the development of his engraving style.

In his early years as an apprentice in Xanten with Coornhert, who was a mediocre engraver working mostly after drawings by van Heemskerck, Goltzius does not seem to have designed engravings of his own. Afterwards he worked for Philip Galle and probably executed, anonymously, less important parts of copperplates.

Goltzius's earliest signed engravings (e.g. the *Annunciation*, 1578; s 23), dating from after he had settled in Haarlem, are in the Flemish style that then prevailed in Galle's circle. The large engraving of the *Venetian Ball* (1584; s 182), printed from two plates after Dirck Barendsz., marks the beginning of a new technique with a more balanced distribution of light and dark and a more dynamic use of the burin. This development can also be seen in the early portrait engravings. Goltzius's resourcefulness as a businessman is apparent from the series of prints illustrating the *Funeral of William of Orange* (s 192–203), who died on 3 August 1584; before the end of the year Goltzius, who calculated that an etching needle was faster than the burin, etched the funeral procession on 12 sheets, measuring nearly 5 m in length.

From 1585 Goltzius engraved for Spranger. To convey the dynamism of the latter's nudes, he developed a new burin technique in which the grooves cut in the copper gradually swelled or became thinner according to the pressure of the burin. The varying thickness of the parallel hatchings and crosshatchings determined the distribution of light and dark, the 'colour' or tone and the volumetric effect of the print. Sometimes the areas of shade were strengthened by stippled dots between the crosshatchings. This technique reached its height in 1587–8, in engravings such as the very large *Wedding of Cupid and Psyche* after Spranger (1587; s 255), a kind of pattern-card of the influential Mannerist style, and the five prints after Cornelisz. van Haarlem, a series of the *Four Disgracers of Heaven* (s 257–60) and *Two Followers of Cadmus Devoured by a Dragon* (s 310). A year later the *Great Hercules* (1589; s 283) appeared, with its strange-looking bruiser with swollen muscles, who came to be known in Holland as the *Knolleman* ('Bulb Man').

After Goltzius returned from Italy, he never again engraved after Spranger, Cornelisz. van

Haarlem or any other compatriot. After a period of dynamism, technically and stylistically, he now sought a greater sense of harmony and restfulness. He toned down the unnatural proportions of his earlier figures, and the engravings of what have become known as the master years (1590–98) generally appear smoother. The back of the *Farnese Hercules* (c. 1592; s 312; see fig. 18), with its strong contrasts of light and dark, however, still recalls the 'bulbous' style of c. 1588. The engraving was made after two drawings Goltzius made and brought back from Rome (both 1591; Haarlem, Teylers Mus.). The *Triumph of Galatea* (1592; s 288) after Raphael is, in its perfect sensibility, one of the finest engravings after fresco. The *Meisterstiche* or *Master Engravings* is the name given to six large engraved scenes from the *Life of the Virgin* (1593–4; s 317–22). From the outset, they were regarded as models of several different styles: those of Raphael, Parmigianino, Jacopo Bassano,

18. Hendrick Goltzius: *Rear View of the Farnese Hercules*, c. 1592 (London, Victoria and Albert Museum)

Barocci, Lucas van Leyden and Dürer. They are not direct imitations of these masters but deliberate compositions in their character and style. The *Circumcision* (s 322) comes so close to Dürer that, according to van Mander, it was mistaken for his work. Other engravings followed in the style of Dürer and Lucas van Leyden. Goltzius's ability to enter into the style of other masters is also seen in the *St Jerome* (1596; s 335) after Palma Giovane, a masterpiece dedicated to his friend the sculptor Alessandro Vittoria. The latter made a portrait bust of *Palma Giovane* (Vienna, Ksthist. Mus.), of which Goltzius made a drawing (Berlin, Kupferstichkab.)—thus shedding light on Goltzius's circle of friends in Venice.

After 1590 Goltzius made relatively few portrait engravings, although the portrait of *Dirck Volkertsz. Coornhert* (c. 1591–2; s 287), printed from an unusually large copperplate and commemorating the humanist's death in 1590, shows Goltzius at the height of his powers. He also engraved a number of small portrait medallions on silver, none of which is now traceable, although there are prints from them, which bear the inscription in reverse. The original silver plate of *Venus, Ceres and Bacchus* (1595; Vienna, Ksthist. Mus.), which was also intended as an independent work of art, was formerly in the collection of Rudolf II (for prints taken from it, see s 325). After 1600 Goltzius made few engravings. Most late examples are questionable and were in some cases probably engraved by his stepson, Jacob Matham.

(b) Chiaroscuro woodcuts. There are also 25 chiaroscuro woodcuts in Goltzius's oeuvre (s 401–25), some in several states. He introduced this technique in the northern Netherlands, following the example of Hans Baldung and such Italians as Ugo da Carpi and Andrea Andreani. The earliest and only dated woodcut is the *Hercules and Cacus* (1588; s 403). *The Magicians* (or 'Cave of Eternity' is not only the most imaginative but also the most brilliant in technique and colour. There is only one state, known in c. twenty impressions, printed from a line block in black and two colour blocks, the darker of which is olive green or sepia, the other different shades of green and beige.

Sometimes Goltzius obtained special effects by printing the line block by itself on to blue paper, as in the impressions of the single-state *Arcadian Landscapes* (s 407), unnatural especially in their colouring. The same technique stressed the fantasy quality of his seascapes (s 413–14; for illustration of his woodcut *Seascape with Sailing Vessels* after Cornelis Claesz. van Wieringen *see* WIERINGEN, CORNELIS CLAESZ. VAN). They were important models for the landscape drawings of the young Esaias van de Velde and the brothers Jan and Jacob Pynas and, above all, for the experimental prints of Hercules Segers, but the technique had no subsequent exponents among Dutch artists.

(iii) **Paintings.** In 1916 Hirschmann catalogued 18 paintings attributed to Goltzius; the number has since risen to 39. In 1600 Goltzius, already famous as an engraver, suddenly decided, like Jacques de Gheyn II, to take up oil painting. His reasons are not known but were probably a combination of his deteriorating eyesight, his belief, shared with van Mander, that painting was the noblest of the arts and, finally, the competition from Flemish artists migrating northwards. The earliest known example is the small painting on copper of the *Dead Christ on a Stone Slab* (1602; Providence, RI Sch. Des., Mus. A.); this was followed the next year by the impressive portrait of the flabby-looking shell-collector *Jan Govertsen* (1603; Rotterdam, Mus. Boymans–van Beuningen), Goltzius's only known painted portrait.

Most of Goltzius's paintings are large; the quiet, somewhat wooden composition is usually dominated by one or two monumental religious or mythological figures, as in the *Ecce homo* (1607; Utrecht, Cent. Mus.) or *Jupiter and Antiope* (1616; Paris, Louvre; see col. pl. XV). The conception of the painted nude is quite different from that in drawings and engravings of the Spranger period: the new, academic style is rooted, first of all, in Goltzius's knowledge and admiration of the Classical statuary he drew in Rome and, second, in the life drawings he made from 1594 onwards. The poses and movements are rather stiff; the colouring, a fiery reddish-brown, is

pseudo-Venetian. He does not seem to have painted landscapes or still-lifes. Few, if any, drawings can be connected with paintings.

Goltzius's painting was much admired by his contemporaries, such as van Mander, but later sharply criticized: Constantijn Huygens the elder, for instance, thought it a failure. The poet Joost van den Vondel said nothing about him as a painter. Goltzius's pictorial work was long overshadowed by his world-famous engravings and the subsequent popularity of his drawings. In 1935 Willem Martin, in his pioneering account of 17th-century Dutch painting, devoted only one line to Goltzius. In 1981 three of Goltzius's paintings were shown in the *Gods, Saints and Heroes* exhibition (see 1980–81 exh. cat.). It was only then that he was rightly recognized as the earliest representative of the Dutch classicizing school and his reputation began to be restored. His chief pupil, as a painter, was Pieter de Grebber.

3. Cultural context and subject-matter

It is not certain whether Goltzius belonged to the Catholic Church. However, his wife and stepson were loyal Catholics, and his personal and commercial relations with the Church were good. Two of his most important series of prints, the *Life of the Virgin* and the *Passion* (1596–9; Hirschmann, nos 21–32), were dedicated to prominent Catholics, the first to William V of Bavaria and the second to Cardinal Federico Borromeo. Works by Goltzius were also owned by the Catholic rulers Philip II and Rudolf II, the latter having bought drawings and also an engraved copperplate direct from the artist. From the days when Goltzius was a pupil of Coornhert's he was also influenced by the latter's liberal philosophy, according to which anyone who holds Christ in his heart does not need a church. Goltzius's non-political stance and pragmatic commercial outlook as a print publisher is seen from his engraved portrait of Philip II's opponent, the Protestant sovereign *William of Orange* and that of his third wife *Charlotte of Bourbon* (1581; s 143) and from the 12-plate etching of William's funeral procession. The degree of Goltzius's interest in religious subjects reflects the changing political situation in the

nascent Dutch Republic, particularly in Haarlem. Around 1578 or somewhat earlier he engraved large series of elaborate Christian allegories, which could be regarded as supporting the Counter-Reformation cause. In the 1580s, after Haarlem had declared itself on the side of the Calvinists, there were fewer commissions from Catholics for works such as altarpieces; only after 1590 did Goltzius's interest in religious themes revive.

Mythological subjects are richly represented in Goltzius's work, for which van Mander must have played a considerable part as adviser. Goltzius made many drawings of scenes from Ovid's *Metamorphoses*, which were engraved as Christian moral exempla. Van Mander, for instance, explained the scene of the *Two Followers of Cadmus Devoured by a Dragon*, depicted in Goltzius's engraving after Cornelisz. van Haarlem, as symbolizing the contrast between Cadmus, the model of the God-fearing man, who is seen killing the dragon in the background, and his two unfortunate companions, who represent the idle pursuits of youth. Goltzius's work is permeated with such allegorical and symbolic meanings, giving visual form to abstract ideas and edifying thoughts. Another representative example is the remarkable triptych painted on canvas (Haarlem, Frans Halsmus.), with nearly life-size figures of a Haarlem citizen attired as the half-naked *Hercules Overcoming Cacus* (1613) in the centre, flanked by *Mercury* (1611) and *Minerva* with their symbolic attributes. Allusions are also present in secular works: a music-making couple accompanied by a heart usually signifies Hearing, a right hand represents Work, bagpipes Gluttony and so forth.

In a different category are those works that record Goltzius's surroundings—although even some of these are not devoid of allegorical significance. The academic copies of ancient statues that Goltzius made in Rome, the first of their kind in Dutch art, are of considerable interest archaeologically and from the point of view of cultural history. They are carefully executed and give a reliable indication of the condition of the statues in 1591. They also provide documentary evidence for the reconstruction of the papal sculpture garden of the Belvedere. However, sometimes they constitute more than a simple record of what the artist had seen; for instance, the *Farnese Hercules* was probably represented from the back because Pliny the younger (*Natural History*, XXXV.xciv) praised a '*Hercules aversus*' painted by Apelles.

With the exception of the three realistic drawings made in the neighbourhood of Haarlem, most of Goltzius's landscapes are imaginary, in the style associated with Bruegel and the Venetians. It is difficult to be certain of the symbolic significance of those pure landscapes that contain no accessory elements, but in other cases the landscape forms the setting for a narrative, although, as in the landscapes engraved after Bruegel, the figures are sometimes so small as almost to escape attention. The tiny figure of Mercury with his caduceus is seen hovering, upper left, in the wide, fantastic landscape drawing at Besançon (?1596; Mus. B.-A.). Landscapes could also have a historical or patriotic significance, as in the *Ruins of Bredero Castle* (1600; Amsterdam, Rijksmus.), which formerly belonged to Count Arnolphus of Holland.

The drawing of the *Lumpfish* would certainly not be out of place as an illustration in a book on zoology, and Goltzius's scientific interest in botany is apparent in his drawings of plants, such as the metalpoint *Study of a Tobacco Plant* (c. 1585; Rotterdam, Mus. Boymans–van Beuningen). Although it records an actual event that took place between Scheveningen and Katwijk on 3 February 1598, the drawing of a *Beached Whale* (1598; Haarlem, Teylers Mus.), engraved by Matham the same year (B. 61), was interpreted as an omen portending war with Spain. The *Study of a Camel* symbolized, according to van Mander, a patient, virtuous man and was probably intended to represent the artist struggling with his illness. The delightful coloured drawing of a *Little Monkey* (c. 1605; Amsterdam, Rijksmus.; formerly attributed to Roelandt Savery; see Reznicek, 1993, fig. 60) stands for wickedness or the chained devil. The informal metalpoint studies of the artist's dog served as the basis for an elaborate chalk *Portrait of Goltzius's Dog* (c. 1597; Haarlem, Teylers Mus.), which was conceived more like a human portrait, and for the engraving of Goltzius's young pupil

Frederik de Vries with a Dog and a Pigeon, generally known as '*Goltzius's Dog*' (1597; s 344). According to van Mander, the dove in the engraving stands for childlike innocence, while the dog is the kindly teacher who keeps watch over human souls.

Van Mander took a lowly view of realistic portraits, the making of which, he thought, cramped the imagination. This may explain why, despite numerous sober portraits from life, Goltzius also made engravings in which the central personage is surrounded by allegorical figures and motifs expressing his or her virtues, as is true of the engravings of *William of Orange* and *Dirck Volkertsz. Coornhert*.

Bibliography

K. van Mander: *Schilder-boeck* ([1603]–1604)

A. von Bartsch: *Le Peintre-graveur* (1803–21) [B.]

O. Hirschmann: *Hendrick Goltzius als Maler, 1600–1610* (The Hague, 1916)

—: *Hendrick Goltzius*, Meister der Graphik (Leipzig, 1919)

—: *Verzeichnis des graphischen Werks von Hendrick Goltzius* (Leipzig, 1921)

E. K. J. Reznicek: 'Het begin van Goltzius' loopbaan als schilder' [The beginning of Goltzius's career as a painter], *Oud-Holland*, lxxv (1960), pp. 30–49

—: *Die Zeichnungen von Hendrick Goltzius*, 2 vols (Utrecht, 1961); review by A. E. Popham in *Burl. Mag.*, civ (1962), pp. 395–6

W. L. Strauss: *Hendrik Goltzius: The Complete Engravings and Woodcuts*, 2 vols (New York, 1977) [cat. rais.] [S]

Gods, Saints and Heroes (exh. cat., ed. A. Blankert; Washington, DC, N.G.A.; Detroit, MI, Inst. A.; Amsterdam, Rijksmus.; 1980–81), pp. 94–9

L. W. Nichols: '*Job in Distress*: A Newly Discovered Painting by Hendrick Goltzius', *Simiolus*, xiii/13–14 (1983), pp. 182–8

—: *The Paintings of Hendrick Goltzius* (PhD diss., New York, Columbia U., 1990)

—: 'The "Pen Works" of Hendrick Goltzius', *Bull. Philadelphia Mus. A.* (Winter 1992) [whole issue devoted to exh. held at Philadelphia, 1991–2]

'Goltzius: Studies', *Ned. Ksthist. Jb.*, xlii–xliii (1991–2) (Zwolle, 1993) [18 articles by specialists, and bibliography]

E. K. J. Reznicek: 'Drawings by Hendrick Goltzius, Thirty Years Later: Supplement to the 1961 *Catalogue raisonné*', *Master Drgs*, xxxi/3 (1993), pp. 215–78

Dawn of the Golden Age: Northern Netherlandish Art, 1580–1620 (exh. cat., ed. G. Luijten and others; Amsterdam, Rijksmus., 1993–4), p. 305, *passim*

E. K. J. REZNICEK

Goudt, Hendrik

(*b* The Hague, 1583; *d* Utrecht, 1648). Dutch engraver, draughtsman and painter. He was the illegitimate son of Arend Goudt and Anneken Cool. On 10 January 1604 the marriage—and hence the son—was legitimized. Hendrik's mother suffered from hysteria, which may account for his later insanity. He possibly trained in The Hague under Simon Frisius but modelled his style on Jacques de Gheyn II, who was in The Hague from 1598, and Hendrick Goltzius, whose engraved figures Goudt adapted. It is likely that Goudt's skill in calligraphy—shown in the elaborate inscriptions on his engravings—was learnt from Jan van de Velde II, who dedicated one of the pages of the *Spieghel der schrijftkonst* (1605) to Goudt. The only authenticated works from this period appear to be such drawings as the *Mocking of Christ* (Berlin, Kupferstichkab.), a possibly signed *Female Nude* (sold London, Christie's, 7 April 1981, lot 122) and a signed copy (Amsterdam, Rijksmus.) after Lucas van Leyden's engraving *Virgilius the Magician in a Basket* (B. 136). What Goudt produced between these works and his better-known engravings of 1608 remains a mystery.

In 1604 Goudt went to Rome and, according to census records, lived in the household of Adam Elsheimer from 1607. In 1609 he is recorded in a house of a neighbouring street. Early sources seem to imply that he was both Elsheimer's pupil and patron, subsidizing the family and accepting works by Elsheimer in lieu, and finally consigning him to the debtors' prison, where he caught his fatal illness. Whether this is true or not, Goudt did at least one great service to Elsheimer, through the seven engravings he made after some of his works; these were widely disseminated throughout Europe and helped to spread Elsheimer's fame. The quality of the engravings is something of a miracle, as no previous works by

Goudt anticipate such masterpieces, which with their strong sense of chiaroscuro foreshadow the technique of mezzotint. Two of the plates were made in Rome during Elsheimer's lifetime and bear his name as *inventor* (designer): *Tobias and the Angel* (the '*Small Tobias*', 1608; Hollstein, no. 1, drawing in Paris, Mus. Petit Pal.) and the *Mocking of Ceres* (1610; Hollstein, no. 5). The remainder were done in 1612 and 1613, after Goudt returned to the northern Netherlands, and have Elsheimer's name suppressed. Hence it is likely that Goudt actually possessed the original paintings, which he also showed to Sandrart when he visited him in Utrecht in 1625 and 1626. These later prints were another version of *Tobias and the Angel* (the '*Large Tobias*', 1613; Hollstein, no. 2; signed drawing in New York, Pierpont Morgan Lib.); *Aurora* (1613; Hollstein, no. 7); *Philemon and Baucis* (1612; Hollstein, no. 6); *Flight into Egypt* (1612; Hollstein, no. 3); and the little *Beheading of St John* (Hollstein, no. 4)—the only print without a date.

Goudt's drawing style was (deliberately or not) based on that of Elsheimer, so that many of his drawings have been ascribed to his master: for example all the sheets in the *Klebeband* (Frankfurt am Main, Städel. Kstinst. & Städt. Gal.) are now accepted as being by Goudt. His style, with its broad ink-strokes, is undisciplined and his compositions lack originality, relying on those of other artists. (Drost's idea (1957) that some of the drawings show the hands of both Elsheimer and Goudt cannot be accepted.) In the Utrecht Guild of St Luke Goudt was registered as an engraver (1611), but Italian sources refer to him as a painter. However, the only painting that can be attributed to him is *Philemon and Baucis* (Vånas, Wachmeister Col.), for which a drawing exists in the *Klebeband* album. Goudt was inordinately proud of receiving the Papal Order ('Palatinus comes et aurea militiae eques'), which, in fact, was freely distributed at the time and could even have been conveyed by a patron such as Cardinal Scipione Borghese, to whom the engraving of the *Mocking of Ceres* was dedicated. Drawings by Goudt are listed in the inventory of Jan van de Cappelle (1680).

Bibliography

Hollstein: *Dut. & Flem.*

J. von Sandrart: *Teutsche Academie* (1675–9); ed. A. R. Peltzer (1925), p. 180

H. Weizsäcker: 'Hendrik Goudt', *Oud-Holland*, xlv (1928), pp. 110–22

W. Drost: 'Hendrik Goudt', *Adam Elsheimer und sein Kreis* (Potsdam, 1933), pp. 165–70

H. Weizsäcker: 'Das Rätsel des Hendrik Goudt', *Adam Elsheimer: Der Maler von Frankfurt* (Berlin, 1936), i, pp. 272–87

——: 'Ein Gemälde von Hendrik Goudt', *Oud-Holland*, lvi (1939), pp. 185–92

J. J. ten Hove [D. Hoek]: *Het raadsel van Arend en Hendrik Goudt* (Amsterdam, 1944)

M. Eger: *Der Stil der Handzeichnungen des Hendrik Goudt* (diss., U. Erlangen, 1952)

W. Drost: *Adam Elsheimer als Zeichner: Goudts Nachahmungen Weiterleben bei Rembrandt* (Stuttgart, 1957)

H. Möhle: 'Das Problem "Elsheimer oder Goudt?"', *Die Zeichnungen Adam Elsheimers* (Berlin, 1966), pp. 52–107

D. Hoek: 'Biografische bijzonderheden over Hendrik Goudt', *Oud-Holland*, lxxxv (1970), pp. 54–5

K. Andrews: *Adam Elsheimer* (Oxford, 1977), p. 38

F. Stampfle: 'Goudt's Drawings of *Tobias and the Angel*', *Essays in Northern European Art Presented to Egbert Haverkamp-Begemann* (Doornspijk, 1983), pp. 257–60

KEITH ANDREWS

Goyen, Jan (Josephsz.) van

(*b* Leiden, 13 Jan 1596; *d* The Hague, 27 April 1656). Dutch painter and draughtsman. He ranks as one of the leading and most prolific Dutch 17th-century landscape artists.

1. Life

His father, Joseph (Jansz.) van Goyen (*d* 1625), was a cobbler. The Leiden chronicler J. J. Orlers reported that Jan was only ten when he was apprenticed first to the painter Coenraet A. van Schilperoort (*c.* 1577–1635/6), then to Isaac van Swanenburgh, Jan (Arentsz.) de Man (*fl* 1587) and Hendrick Clock in Leiden before spending two years with Willem Gerritsz. (*fl* 1587) in Hoorn. After a year spent travelling through France (1615–16), he trained for a year (1617–18) in

Haarlem with Esaias van de Velde (i), who was six years older. On his return to Leiden, he married Anna Willemsdr. van Raelst (5 Aug 1618) and lived in the Zonneveldsteeg. In 1632 he moved to the capital, The Hague, where he settled and in 1634 acquired rights of citizenship. In 1638 and 1640 he was head of the Guild of St Luke there. From 1639 he lived in his own house on the Singelgracht (now Dunne Bierkade 16) next door to the painter Johannes Schoeff (1608–66). From 1649 to 1652 he let the adjoining house to Paulus Potter. Of van Goyen's three daughters, Maria married the still-life painter Jacques de Claeuw (fl 1642–76) in 1649 and in the same year Margaretha married the genre painter Jan Steen. Around 1652–3 Gerard ter Borch (ii) painted a portrait of van Goyen (Vaduz, Samml. Liechtenstein).

An important feature of van Goyen's life was his ambitious striving for prosperity and recognition. Artistic work was generally poorly paid and he was therefore also intermittently active as an art dealer and collector, auctioneer, estate agent and picture valuer. In 1637 he lost a lot of money speculating in tulips. Despite producing more than 1200 paintings and 800 drawings, he was unable to cover his debts. In 1652 and 1654 he had to sell his possessions at public auction. He then moved to the Wagenstraat, but so many debts remained after his death that his widow (d 1672) had to auction all his remaining assets, including the house.

2. Work

(i) Paintings. Van Goyen's early landscapes, produced between 1620 and 1626, clearly show the influence of Esaias van de Velde. Following Flemish examples, he painted some in circular format as pendants (e.g. *Summer* and *Winter*, both 1625; Amsterdam, Rijksmus.). For other landscapes he adopted an elongated rectangular format (e.g. *Village Street with Soldiers in De Bilt*, 1623; Brunswick, Herzog Anton Ulrich-Mus.), which offered a broader setting for the narrative content. These village or beach scenes (e.g. *Round Tower on the Beach*, 1625; Poznań, N. Mus.) are full of bustling activity, with numerous figures set under a cloudy, blue-white sky. In keeping with

the warlike times, soldiers are often included, but unlike van de Velde and Pieter de Neyn, van Goyen did not depict raids or cavalry skirmishes. He enlivened summer and winter scenes alike with bright local colour. The viewer's eye is drawn into the depth of the painting by gradations of perspective—for example by means of a tall tree dividing the composition down the middle or serving as a screen to one side with farms in the middle distance (e.g. *River*, 1625; Bremen, Ksthalle). The backgrounds typically consist of buildings, brush and dunes.

Around 1626 van Goyen's art changed, going well beyond van de Velde's example. The change is closely linked to contemporary Haarlem artists' creation of a specifically Dutch style of landscape painting that emphasized tonality and realism. Pieter Molijn, Salomon van Ruysdael and Pieter Dircksz. van Santvoort (1603/4–35) were the other principal exponents of this new development, which used native subject-matter and more natural colours. This phenomenon is known by modern art historians as the 'tonal phase'. Jan Porcellis (known to van Goyen in Leiden), also experimented with tonality in his marine pictures. From 1629 and through the 1630s van Goyen produced simple landscapes showing dunes and rivers in brown and green tones, which achieve an impression of depth with the help of diagonals. He sometimes softened the effects of this compositional device by moving the tallest tree from the edge towards the centre, as in *Angler on a Small Wooden Bridge* (1634; Pretoria, A. Mus.). The scarcity and small size of the figures in these 'tonal' pictures add to the desolation and bleakness of the dune scenery. In slightly later paintings (e.g. *Recreation on the Ice by the Ruin of the Huis te Merwede*, 1638; Leiden, Stedel. Mus. Lakenhal), travellers and carriages or fishermen on land and in boats restored an element of animation, and van Goyen began to open up the background by means of a misty horizon.

In 1637 there was a pause in van Goyen's creative activity, perhaps due to his speculation in tulips. Then, at the end of the 1630s, he began a period of classical harmony that unified picture and paint, producing works in which an idealized

overall impression outweighs local colour. Until about 1638 a subtly differentiated silvery-grey tone predominated (e.g. *Two Fishermen*, 1638; London, N.G.) but in the 1640s this gave way to austerely monochromatic paintings in yellowy golden-brown, with a tonal range that, though unrealistic, used colour attractively. He gradually abandoned this style from 1643 and in 1650–51, especially in his paintings on paper (e.g. *Ferry with Two Cows and Five Passengers*, 1651; Dresden, Kupferstichkab.), employed a distinctly brown monochrome, finally returning, towards the end of his life, to a more natural colour range.

In the 1640s van Goyen tended to adopt a horizontal format, especially in his distant views (e.g. *Extensive Panorama*, (1646; New York, Met.), though he still produced landscapes with a disguised diagonal structure (e.g. *Old Tall Tower*, 1646; New York, Met.). Buildings assume an important role, from churches, castles, ruins, gates and towers (see fig. 19) to monumental town views, such as the *View of Dordrecht* (1644; Washington, DC, N.G.A.). Seascapes in vertical format, such as *Old Watch-tower in a River Delta* (1646; The Hague, Dienst Versp. Rijkscol.), in which a high, cloudy sky contrasts with flat terrain, and distant panoramic views in oblong format, such as *Flat Landscape with a Windmill* (1641; Schwerin, Staatl. Mus.), are impressive pictorial achievements. Clouds cast shadows over the earth or lakes (van Goyen never painted the open sea, only inland waters such as the Haarlemer Meer) and display the contrasting effects of light. Sailing boats occupy an important place in his compositions: in works of the early 1630s they appear in the background of quiet river scenes; by the 1640s they occupy an increasingly prominent foreground position as the river banks were made to

19. Jan van Goyen: *River Landscape with a Windmill and a Ruined Castle*, 1644 (Paris, Musée du Louvre)

recede (e.g. *Seascape, View of Dordrecht in the Background*, 1644; Vienna, Ksthist. Mus.; see col. pl. XVI). In seascapes with level banks in the background, such as *Fishing Boats in an Estuary* (1655; Hamburg, Ksthalle), they are essential to the illusion of perspective.

In keeping with van Goyen's inventive and experimental temperament, he made several seascapes that include dramatic natural events, such as an approaching thunderstorm and lightning flashing across a pale yellow horizon (e.g. *Storm over the Sea*, 1647; Karlsruhe, Staatl. Ksthalle). In his freely composed seascapes of the 1650s he reached the apex of his creative work, producing paintings of striking perfection. A calm sea in the still of the evening (e.g. *Fishing Boats on a Wide Inland Lake*, 1656; Frankfurt am Main, Städel. Kstinst.) and a distant frigate firing a salute anticipate works by Willem II van de Velde (ii), the great master of Dutch marine painting. At the end of his life, van Goyen painted seascapes in silvery grey with grey-blue shadows and touches of local colour in the figures of fishermen, the sails and the flags on the boats.

In van Goyen's paintings his signature, often followed by a date, usually stands out boldly in the landscape or on a beam. He signed his early works I.V. GOIEN, which, from 1630, he changed to VGOYEN, and sometimes, on large works, to J. VGOYEN (in each case linking the letters VG). Usually, however, he adopted the monogram VG, first used in 1628. Dendrochronological research has shown that, unlike his contemporaries, van Goyen preferred to paint on wood panels made from freshly felled trees.

(ii) **Drawings**. Van Goyen is as important as a draughtsman as he is for his paintings. His output began in 1624 with small-scale drawings in brown ink: summer landscapes (e.g. *Ferry with Cart*, 1624; Hamburg, Ksthalle) and seascapes. At the same time he produced humorous genre scenes of everyday life, executed in brush and coloured washes (e.g. *Mussel Seller*, 1625; Leiden, Rijksuniv.). From 1626 he found black chalk the ideal medium to suit his fluent technique; he often brushed over the chalk outlines with grey wash, although in 1651 he used brown tones. He animated the scenes with wittily drawn figures, whose outlines capture their restless vivacity.

Van Goyen travelled the length and breadth of the Netherlands recording details of landscape and topography in chalk sketches, and his studies filled many sketchbooks (e.g. Dresden, Kupferstichkab.; others dispersed). In 1648 he ventured further afield, via the mouth of the River Scheldt to Antwerp and Brussels. In 1650 he was in Cleve and Arnhem and in 1651 in Haarlem and Amsterdam, where he drew the devastation resulting from the collapse of the St Anthonis Dike. Once home, he used the results of his travel sketches to create paintings and drawings. Time and again these works demonstrate how van Goyen was able to combine different actual motifs into imaginary landscape compositions. He was not attempting to depict accurate views but rather landscapes in which topographical elements happened to feature. Drawings survive for every year of van Goyen's creative life; in 1631, 1647, 1649 and 1651–3 he was particularly prolific. Especially popular with collectors are winter, beach and market scenes, an example of the last being *Market-day near a Canal* (1651; Chicago, IL, A. Inst.). His preferred paper sizes were approximately 110×190 mm and approximately 170×270 mm, and he used fine white paper; he sketched on somewhat coarser paper with different watermarks (from which dates, where missing on the drawings, can be established).

3. Influence and reputation

According to Houbraken, van Goyen's pupils were Jan Steen (his son-in-law), Nicolaes Berchem and Adriaen van der Cabel. Several of Steen's early landscape paintings reveal the effects of van Goyen's tuition. Some of Berchem's early chalk drawings also show the influence of his teacher. Many other artists were inspired by van Goyen's compositions, painting style and draughtsmanship. A. J. van der Croos (1606/07–1663), Jacob Moscher (*fl* 1635–55) and C. S. van der Schalcke (1611–71) drew in a similarly relaxed manner. The etched landscapes of Simon de Vlieger and Anthoni Waterlo owe a debt to him. Etchings of

landscapes, signed *Jan van Groye* and previously attributed to van Goyen (e.g. Hollstein, nos 3–7) have since been attributed to Jan van de Cappelle. In the medium of oil paint his influence can be seen in the early landscapes of Aelbert Cuyp, which adhere closely to van Goyen's muted palette and modest, simple subject-matter. Other successors, including Jan Coelenbier (1610–77), Frans de Hulst, Maerten Fransz. van der Hulft, Wouter Knijff, Willem Kool (1608/09–66), Pieter de Neyn and Johannes Schoeff (1608/9–62/6), developed their own recognizable painting style, while many anonymous artists merely imitated him.

In common with the art of many of his contemporaries, the low prices van Goyen's works commanded during his lifetime and for several generations thereafter make it difficult to assess earlier opinions of his artistic standing. He appears to have received commissions only occasionally, such as for the large *View of the Valkhof at Nijmegen* (1641; Nijmegen, Stadhuis) or *Huis Rouwkoop on the Vliet* (1642; Heemskerk, Gevers van Marquette priv. col.; see Beck, G488). Around 1651 he received two public commissions: he was paid 650 guilders for a large *Panoramic Landscape with View of The Hague* (The Hague, Gemeentemus.) for the Burgomaster's room in the Town Hall, and for the royal palace Honselaersdijk he produced a landscape depicting one of the royal estates in Burgundy. Not until Charles Sedelmeier's exhibitions in Vienna (1873) and later in Paris did he achieve international recognition; after the first van Goyen exhibition in Amsterdam, held by Frederik Muller & Cie (1903), his works began to enter public collections.

Bibliography

J. J. Orlers: *Beschrijvinge der stadt Leyden* . . . (Leiden, 1641), pt i, pp. 373–4
A. Houbraken: *De groote schouburgh* (1718–21), i, pp. 170–71
P. Mantz: 'Jan van Goyen', *Gaz. B.-A.*, xii (1875), pp. 138–51, 298–311
H. U. Beck: *Jan van Goyen: 1596–1656: Ein Oeuvreverzeichnis*, i and ii (Amsterdam, 1972–3); iii (Doornspijk, 1987)
C. Wright: 'Van Groyen: A History of British Taste', *Jan van Goyen, 1596–1656: Poet of the Dutch Landscape* (exh. cat., London, Alan Jacobs Gal., 1977)
M. L. Wurfbain: 'Van Goyen: The Leyden Years', *Jan van Goyen, 1596–1656: Conquest of Space* (exh. cat., Amsterdam, Ksthandel K. & V. Waterman, 1981)
Dutch Landscape: The Early Years, Haarlem and Amsterdam, 1590–1650 (exh. cat. by C. Brown, London, N.G., 1986), pp. 146–50
Masters of 17th-century Dutch Landscape Painting (exh. cat. by P. C. Sutton and others, Amsterdam, Rijksmus.; Boston, MA, Mus. F.A.; Philadelphia, PA, Mus. A.; 1987–8), pp. 317–32
H.-U. Beck: *Künstler um van Groyen* (Doornspijk, 1991)

H.-U. BECK

Grebber, Pieter (Fransz.) de

(*b* Haarlem, *c.* 1600; *d* Haarlem, 1652–4). Dutch painter. Together with Salomon de Bray, he was a pioneer among the Haarlem Classicists—a group of artists who have often been unjustly overshadowed by other history painters, notably Rembrandt and his school, who are regarded as more indigenously Dutch. De Grebber was the son of the Haarlem painter and art dealer Frans Pietersz. de Grebber (1573–1643), who, among his other activities, served as Rubens's agent with the English Ambassador to The Hague, Sir Dudley Carleton. Pieter studied with his father, who painted militia company portraits and history subjects. The young de Grebber travelled to Antwerp with his father in 1618; there he may have met Rubens, whose art was a factor in the formation of his early style. Pieter also studied with the local Haarlem artist Hendrick Goltzius, whose history paintings probably had a formative effect on several of the Haarlem Classicists. De Grebber's earliest dated work is a *Portrait of a Woman* (1621; Delft, Klaeuwshofje). A *Caritas* (Houston, TX, Mus. F.A.) and a *Mother and Child* (Haarlem, Frans Halsmus.) both date from 1622, and the following year he executed a life-sized *Musical Company* (Washington, DC, priv. col.), a genre scene in the tradition of the Utrecht Caravaggisti. However, most of his paintings are religious scenes, and by 1625 these were executed in his own version of international Baroque Classicism (e.g. *Adoration of the Magi*, 1632; Turin, Gal. Sabauda). He also produced numerous portraits of Roman Catholic

priests, nuns or beguins. He joined the Haarlem Guild of St Luke in 1632, and two years later he bought a house in the Beguinhof; throughout his life he remained closely allied to the Catholic community in the Netherlands, producing altarpieces for local recusant churches as well as for Catholic churches in Flanders and elsewhere (e.g. the *Annunciation*, 1633; Hannover, Amir Palczad priv. col., see 1980–81 exh. cat., p. 195). Despite his faith, he was elected dean of the Haarlem Guild of St Luke in 1642, was praised by the authors Samuel Ampzing (1628), Philips Angel (1642) and Petrus Schrevelius (1648), and received the official patronage of the Haarlem city fathers, Stadholder Frederick Henry (for whom he produced paintings for Honselaarsdijk Palace (destr.) in 1638) and the latter's widow, Amalia von Solms (who commissioned decorations for the Oranjezaal in the Huis ten Bosch, The Hague, 1648–50). De Grebber published his theory of art in 11 rules, printed on a single broadsheet in 1649. He was also active as an amateur poet and composer.

Bibliography

P. Dirkse: 'Pieter de Grebber: Haarlems schilder tussen begijnen, kloppen en pastoors', *Jb. Haarlem* (1978), pp. 109–27

R. Hazelegger: *Pieter Fransz. de Grebber, schilder tot Haarlem* (diss., Rijksuniv. Utrecht, 1979)

Gods, Saints and Heroes: Dutch Painting in the Age of Rembrandt (exh. cat. by A. Blankert, Washington, DC, N.G.A.; Detroit, MI, Inst. A.; Amsterdam, Rijksmus.; 1980–81), pp. 192–5

PETER C. SUTTON

Hackaert, Jan [Johannes]

(*bapt* Amsterdam, Feb 1628; *d* Amsterdam in or after 1685). Dutch painter, draughtsman and etcher. The earliest information about Hackaert indicates that he visited Switzerland several times between 1653 and 1656; he probably did not go to Italy, as was long supposed. By 1658 he was back in Amsterdam. When in Switzerland, he made several large topographical drawings, for example the *View of the Via Mala* (pen and brown ink and brown wash, 750×560 mm, 1655; Vienna, Österre-

ich. Nbib.). Many of these drawings, which give a good sense of space but are somewhat dry in execution, were probably made for the multi-volume atlas of Laurens van der Hem, an Amsterdam lawyer who commissioned topographical views from several artists.

Hackaert's paintings may be broadly divided into two categories: Italianate landscapes and woodland scenes. Both genres were much influenced by the landscapes of the Dutch Italianates Jan Both and Jan Asselijn, especially in the treatment of colour. An example of the first category is the *Lake of Zurich* (*c.* 1660–64; Amsterdam, Rijksmus.); this masterpiece is exceptional in depicting a topographical view in an idealized style. The only comparable work is Hackaert's *View of Cleve* (Groningen, Groninger Mus.), in which the influence of Both and Asselijn is evident in the rendering of the abundant golden light. In the later *Landscape in the Campagna with Cattle* (*c.* 1670; Berlin, Gemäldegal.), the slender, graceful trees, with their light foliage bathed in brilliant southern sunshine, are again reminiscent of Both. Similar trees and sunlight can be seen in Hackaert's woodland scenes, in which he generally made use of a *sous-bois* composition: painting the underside of the leafy canopy has the effect of drawing the spectator into the forest. The *Deerhunt in a Wood* (*c.* 1660; London, N.G.), despite the density of the foliation, achieves an impressive sense of space by the depiction of sunlight penetrating the trees. Hackaert's staffage, which in this case was painted by Nicolaes Berchem (who also signed the picture), is often attributed to other artists (e.g. Adriaen van de Velde and Johannes Lingelbach). The *Avenue of Birches* (*c.* 1675–80; Amsterdam, Rijksmus.) is an example of Hackaert's more open woodland views. It depicts a hunting party in an avenue alongside a stretch of water bordered by slender birch trees; a soft golden light suffuses the whole view. Hackaert's forest landscapes with hunting scenes show more originality than his Italianate landscapes and were very popular on the contemporary art market, largely because they reflected the prosperity and affluent leisure pursuits, real or coveted, of the prospective buyers.

Besides the Swiss topographical drawings, Hackaert made several other drawings in the style of Jan Both, some of whose works he owned and copied (e.g. the *Italianate Landscape* by Hackaert, 1661; Groningen, Groninger Mus.). These drawings are sketchier, broader and lighter in execution than his topographical work. Seven etchings by him are also known, all showing northern European landscapes. According to Hofstede de Groot, Hackaert's latest signed work dates from 1685, in which year, or soon after, he is assumed to have died.

Bibliography

Hollstein: *Dut. & Flem.*

C. Hofstede de Groot: *Holländischen Maler* (1907–28), ix, pp. 1–47

S. Stelling-Michaud: *Unbekannte schweizer Landschaften aus dem XVII Jahrhunderts: Zeichnungen und Schilderungen von Jan Hackaert und anderen holländischen Malern* (Zürich and Leipzig, 1937) [reconstruction of Hackaert's journey through Switzerland; good illus]

G. Solar: *Jan Hackaert: Die schweizer Ansichten, 1653–55; Zeichnungen eines niederländischen Malers als frühe Bilddokumente der Alpenlandschaft* (Zürich and Leipzig, 1981)

Masters of 17th-century Dutch Landscape Painting (exh. cat., ed. P. C. Sutton; Amsterdam, Rijksmus.; Boston, MA, Mus. F.A.; Philadelphia, PA, Mus. A.; 1987–8), pp. 338–42 [complete bibliog.]

LUUK BOS

Hals

Dutch family of painters of Flemish origin. The brothers (1) Frans Hals and (2) Dirck Hals were the sons of Franchoys Hals, a clothworker from Mechelen, who moved to Antwerp, where Frans was born. They left Antwerp in 1585 and by 1591 had settled in Haarlem. Frans Hals was one of the first great artists in the new Dutch Republic and is generally regarded as an outstanding portrait painter. His brother Dirck, who, according to Houbraken, trained under him, was noted for small genre paintings. Five of Frans's sons were painters: Harmen Hals (*bapt* Haarlem, 2 Sept 1611; *bur* Haarlem, 15 Feb 1669), Frans Hals the younger (*bapt* Haarlem, 16 May 1618; *d* Haarlem, April 1669) and Reynier Hals (*bapt* Haarlem, 11 Feb 1627; *d* Amsterdam, 1671) were all genre painters, while Nicolaes [Claes] Hals (*bapt* Haarlem, 25 July 1628; *bur* Haarlem, 17 July 1686) specialized in landscape printing, and Johannes [Jan] Hals (*fl* 1635–74) painted portraits, genre and history subjects. (2) Dirck Hals had seven children by his wife, Agneta Jans (*d* 1662), the eldest of whom, Anthonie Hals (*b* Haarlem, 1621; *d* before 25 Aug 1702), became a painter and, like his father, executed genre subjects.

Bibliography

Thieme–Becker

(1) Frans Hals

(*b* Antwerp, 1581–5; *d* Haarlem, 29 Aug 1666). In the field of group portraiture his work is equalled only by that of Rembrandt. Hals's portraits, both individual and group, have an immediacy and brilliance that bring his sitters to life in a way previously unknown in the Netherlands. This effect, achieved by strong Baroque designs and the innovative use of loose brushstrokes to depict light on form, was not to the taste of critics in the 18th century and the early 19th, when his work was characterized as lazy and unfinished. However, with the rise of Realism and, later, Impressionism, Hals was hailed as a modern painter before his time. Since then his works have always been popular.

1. Life and Work

The introduction to the second edition of Karel van Mander's *Schilderboeck* (1618) mentions Hals as one of his pupils. This apprenticeship would have lasted until 1603 at the latest. Hals may have begun his career by painting scenes of merry companies, such as the *Banquet in a Park* (c. 1610; ex-Kaiser Friedrich Mus., Berlin; destr.). In 1610 he became a member of the Guild of St Luke in Haarlem and married Annetgen Harmensdr. (*d* 1615); their first son, Harmen, was born in 1611, the year of Hals's earliest dated painting, a portrait of *Jacobus Zaffius* (1534–1618), of which only a portion survives (1611; Haarlem, Frans Halsmus.).

Hals's distinctive style can already be seen in this work: the loose brushstrokes, applied 'wet on wet' without erasure, the lively characterization and the strong illumination of the head, the light always coming from the left.

During the second decade of the 17th century Hals painted single and double portraits, a civic guard piece and genre paintings. The portraits adhere strictly to Dutch conventions established by such artists as Cornelis Ketel and Paulus Moreelse. Hals also borrowed from the portrait engraving tradition such motifs as the oval *trompe-l'oeil* stone frame, which he used several times up to 1640. From 1616 to 1625 he was a member of the Haarlem chamber of rhetoric called De Wijngaertrancken. His connection with this organization is reflected in a portrait (1616; Pittsburgh, PA, Carnegie) of *Pieter Cornelisz. van der Morsch* (1583–1628), a rhetorician in Leiden, as well as in genre scenes of Shrove Tuesday revellers. Also in 1616 he painted his first militia piece: the *Banquet of the Officers of the St George Civic Guard Company* (Haarlem, Frans Halsmus.; see col. pl. XVII), of which he himself had become a member in 1612. Its composition is borrowed from a militia piece by Cornelis Cornelisz. van Haarlem (1599; Haarlem, Frans Halsmus.) and a design for a civic guard banquet in a drawing (c. 1600–1610; Amsterdam, Rijksmus.) by Hendrick Goltzius. However, Hals enlivened the effect by giving each of the diners more individual space.

The first of a long list of creditors' claims on Hals dates from 6 August 1616; it relates to purchases of paintings, indicating his activity as a dealer or collector. On that date Hals was in Antwerp, probably on family business; he was back at Haarlem by 11 November. In 1616 his cousin and namesake Frans Hals was in trouble with the Haarlem authorities for being drunk and ill-treating his wife; he afterwards settled in Antwerp. (This cousin was confused with his more famous relative by van der Willigen.) On 12 February 1617 the painter Frans Hals married Liesbeth Reyniers, and in 1621 he and his brother Dirck were mentioned for the first time in a literary source (Ampzing). While in Antwerp, Frans probably came under the influence of Rubens, for his *Portrait of*

a *Married Couple in a Garden* (early 1620s; Amsterdam, Rijksmus.) resembles the latter's *Rubens and his Wife Isabella Brant in the Honeysuckle Bower* (1609–10; Munich, Alte Pin.). Hals's sitters were probably the Haarlem diplomat and cartographer Isaac Massa (*b* 1587) and Beatrix van der Laen, who were married in 1622. Other paintings from the 1620s include a *Portrait of a Family in a Landscape* (c. 1620; Viscount Boyne, on loan to Cardiff, N. Mus.) and numerous genre pieces of children and young men drinking, smoking and making music. The portrait of *Jonker Ramp and his Sweetheart* (1623; New York, Met.) has been interpreted as representing the Prodigal Son, while the children drinking and making music are usually interpreted as standing for the Five Senses or the Cardinal Sins. The prominent role of children is new in Dutch painting. Typical of Hals's genre work is its portrait-like character: most consist of only one or two figures and practically no background (which was emphasized more by other contemporary genre painters). Hals's portraits and genre pictures of the 1620s are also marked by their vivid colouring, *plein-air* effects, shifting contours and foreshortenings. The tonality is lighter than in the previous decade, probably under the influence of the Utrecht Caravaggisti, which affected both Hals's style and his subject-matter: it was Caravaggisti who set the fashion for drinkers, lute-players and life-size, half-length single genre figures. Hals also cut the figures off and used a *di sotto in sù* viewpoint, with strong contrasts of light and dark in the hands and faces, though not in the figures' clothing.

Apart from the supposed scenes of the Prodigal Son, Hals's only other known biblical paintings are his *St Luke* and *St Matthew* (both c. 1625; Odessa, A. Mus.), from a series of the Four Evangelists; a third picture from the series, of *St Mark* (priv. col., see 1989–90 exh. cat., p. 193), was discovered in 1974. Sources also mention a *Cain*, a *Magdalene* and a *Denial of St Peter* (all untraced). Hals painted his second and third militia pieces c. 1627 (both Haarlem, Frans Halsmus.), depicting the civic guard companies of St Hadrian and St George, and about the same time executed the portrait of

Verdonck Holding a Jawbone (*c.* 1627; Edinburgh, N.G.). The latter was one of several of Hals's works that were altered at a later date: in this case a hat was added and the jawbone replaced by a wineglass. The original composition is a unique example of a contemporary sitter portrayed with the attribute of a biblical character (Samson).

Frans also continued to trade in works of art. On 17 May 1627 Dirck stood surety for his purchases at an auction of paintings, and in 1630 Frans paid 89 guilders in Amsterdam for Hendrick Goltzius's painting of *Tityus* (1613; Haarlem, Frans Halsmus.) and sold it through an intermediary to the city of Haarlem for 200 guilders. In 1629, for 24 guilders, he cleaned some canvases for the monastery of St John at Haarlem.

About 1630 Frans painted several outdoor genre scenes of fisher boys and girls (e.g. Dublin, N.G.; these are not accepted by Grimm, 1972), the subjects of which have been interpreted as symbolizing laziness. Dating from about the same period or slightly earlier are the *Malle Babbe* (*c.* 1633–5; Berlin, Gemäldegal.), the *Gypsy Girl* (*c.* 1628; Paris, Louvre; see fig. 20), the *Pickled Herring*

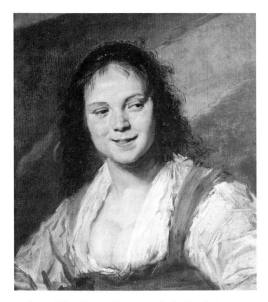

20. Frans Hals: *Gypsy Girl*, *c.* 1628 (Paris, Musée du Louvre)

(*c.* 1628–30; Kassel, Schloss Wilhelmshöhe), '*The Mulatto*' (*c.* 1628–30; Leipzig, Mus. Bild. Kst.; see fig. 21) and the *Merry Drinker* (*c.* 1628–30; Amsterdam, Rijksmus.). The 1630s also marked the peak of Hals's career as a portrait painter. The early bright colours have been abandoned in favour of a more monochrome effect; the composition is more unified and simple, the poses more frontal. Besides the many single and double portraits, there is a small family group of *c.* 1635 (Cincinnati, OH, A. Mus.). Hals also painted the civic guard company of St Hadrian again, this time in the open air (*c.* 1633; Haarlem, Frans Halsmus.); in contrast to the earlier version, the officers are not placed in order of rank. In 1633 he received a commission from Amsterdam to paint another militia piece, the *Company of Capt. Reynier Reael and Lt Cornelis Michielsz. Blaeuw* (the '*Meagre Company*'; Amsterdam, Rijksmus.), for which he was at first offered 60 guilders per person, afterwards 66 guilders. The work led to a dispute, as Hals could not get the group of men to pose together in Amsterdam; subsequently he refused to return there, and they would not go to Haarlem. Consequently Pieter Codde took over the commission, which he completed in 1637. In 1635 Hals was also involved in a dispute with Judith Leyster, who had been his pupil *c.* 1630 and stood godmother to his daughter Maria in 1631. Contrary to Guild regulations, Hals took over a pupil of hers. Also in 1635 he was in arrears with his Guild contributions. A few years later he painted himself in the background of the *Officers and Sergeants of the St George Civic Guard Company* (*c.* 1639; Haarlem, Frans Halsmus.). This is his only known self-portrait, apart from a painting known only from copies (e.g. Indianapolis, IN, Clowes Fund Inc., priv. col., on loan to Indianapolis, IN, Mus. A.).

After these peak years, the 1640s show a falling-off in commissions. Public taste increasingly favoured the smooth manner of such painters as Ferdinand Bol, Govaert Flinck and Bartholomeus van der Helst, all active in Amsterdam. Probably under their influence, Hals began to paint portraits with a more aristocratic air, and more static and less ostentatious poses. The backgrounds are

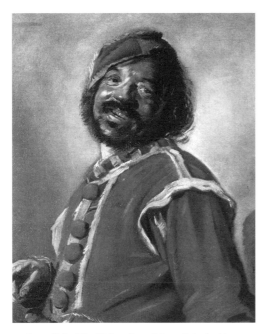

21. Frans Hals: 'The Mulatto', c. 1628–30 (Leipzig, Museum der Bildenden Künste)

darker, usually golden-brown or olive-green, and the clothing is predominantly black. It seems that he no longer painted genre scenes. Large commissions were for the sober portrait of the *Regents of the St Elizabeth Hospital at Haarlem* (c. 1641; Haarlem, Frans Halsmus.), the composition of which was probably borrowed from Thomas de Keyser, and two family portraits in a landscape (both c. 1648; Madrid, Mus. Thyssen-Bornemisza, and London, N.G.).

In 1642 family problems arose. Hals's feeble-minded son Pieter was locked up as a public danger; and on 31 March the painter's wife tried to have their daughter Sara committed to a workhouse owing to her loose morals. In 1644 Hals became an inspector (*vinder*) of the Guild of St Luke in Haarlem. His last dated works are of 1650. Those ascribed later dates are for the most part dark and sober in coloration, the paint is thin and the brushstrokes loose and broad. The poses are static and frontal, in line with the new classicizing trend. Unique in the portrait iconography of

17th-century Holland are the pendant portraits (both *c.* 1650) of *Stephanus Geraerdts* (Antwerp, Kon. Mus. S. Kst.) and *Isabella Coymans* (Paris, Baronne Edouard de Rothschild priv. col.): the two paintings are linked by the wife's gesture, as she hands her husband a rose.

In 1652, on account of an unpaid baker's bill of 200 guilders, a distraint was levied on Hals's furniture and meagre collection of paintings: two of his own works, two by one of his sons, one by van Mander and another by Maarten van Heemskerck. The last documented creditor's demand dates from 1661 and relates to purchased paintings. In the same year Hals was exempted from Guild contributions on account of his age. In 1662 the burgomasters of Haarlem made a lump sum payment of 50 guilders and granted him a pension of 150 guilders a year, which was raised to 200 guilders in 1663. On 22 January 1665 he stood surety for a debt of 458 guilders incurred by his son-in-law, Abraham Hendrix Hulst. He was probably able to do so because of the commissions for two group portraits: the *Regents of the Old Men's Almshouse* and the *Regentesses of the Old Men's Almshouse* (both *c.* 1664; Haarlem, Frans Halsmus.). (It is sometimes supposed that Hals became an inmate of the same old men's home, but there is no documentary evidence for this.) These and other late works are marked by a very summary use of colour, loose brushwork in flowing paint and very imprecise outlines. Some critics see this as the climax of Hals's virtuosity as a painter; others put it down to old age, stiffness and failing sight.

2. Working methods and technique

Hals's oeuvre consists of oil paintings on canvas or panel and three small portraits on copper. The works vary in size from very small portraits (145×120 mm) to life-size portrait groups. No drawings or prints can be ascribed to him with certainty. He probably painted directly from the model, and very fast. In correspondence concerning the '*Meagre Company*', he promised that the sittings would not take long. No underdrawing has been detected. No doubt some small portraits were intended as preliminary studies for larger ones.

Pigment analysis has shown that, especially in the flesh parts, there is no clear division between the layers of paint, indicating that he painted *alla prima* or 'wet on wet'. Before *c.* 1626, Hals applied a ground of white and grey under the flesh colours. His priming generally consisted of a light-coloured layer, with a thinner, darker one above it, the colour of which varied from one painting to another. His colour schemes, which developed from bright to monochrome, were achieved with a fairly limited palette. In the *Portrait of a Lady* (1627; Chicago, IL, A. Inst.), only six pigments have been identified. The umber-coloured background seen in many of his portraits was achieved with a mixture of lead white, yellow ochre and black. In his later work, only four colours have been found: black, white, Venetian red and light ochre.

Hals's work derives its specific character from the loose brushwork and thin, flowing paint applied *alla prima*; the texture of the canvas is generally still clearly visible. Ht is also typical of him that the thickness of the pigment, the amount of detail and the style of brushwork can vary considerably in one and the same work. The faces in the portraits are invariably more carefully painted than the hands and clothing; the brush-strokes often flow so smoothly into one another that the separate strokes can scarcely be perceived. However, the hands and clothing are painted with parallel strokes varying in length and breadth. The somewhat 'frayed' appearance of his outlines, increasingly evident in the late work, is achieved by consecutive overlapping strokes. His genre scenes are much more loosely painted than the portraits of the same period, with clearly visible brushstrokes, although in Hals's later period this looser technique was also found in the portraits. Until *c.* 1626 the colour is generally thin and half transparent, with opaque, wax-like highlights; subsequently, the pigment becomes more opaque and less contrasting. In the 1650s it again becomes more transparent; while the latest works, from the 1660s, are characterized by the use of opaque and transparent colour in a single painting. Although the poses and grouping of figures used by Hals are broadly traditional, nevertheless his portraits make a much livelier impression than those of his contemporaries: this is due not only to his handling of the paint, but also to the sense of unfinished movement: heads turn away and somewhat to one side, half-open mouths seem about to speak, laugh or smile (quite unusual in contemporary portraiture). All of this contributes to the sense of animation, as do the suggestion of movement in hands and the way in which the sitters lean slightly back, forward or sideways.

Hals evidently had apprentices, as is shown by the dispute with Judith Leyster. His son-in-law Pieter van Roestraten stated in 1651 that he had worked with Hals for five years, and during Hals's lifetime copies of his works, perhaps from his own studio, were already in circulation. Sometimes he collaborated with other painters: the female figure in *Fruit and Vegetable Seller* (*c.* 1630; Burwarton Hall, Salop), by Claes van Heussen (*c.* 1600–after 1630), is thought to be by Hals. A document of 1651 states that Willem Buytewech executed the painted borders for two of Hals's portraits, and Slive has ascribed the background of some of Hals's landscapes to Pieter de Molyn.

3. Character and personality

Since the early 18th century, Hals has been persistently represented as a profligate and toper. The earliest account of his character is given by the German artist Mattias Scheits (see Bode), who claimed Hals was 'somewhat high-spirited in his youth'. His reputation as a drunkard originated with Houbraken, who said he was so drunk every evening that his pupils had to help him home. According to Houbraken, Hals exploited his pupil Adriaen Brouwer; he further related that Hals once met Anthony van Dyck, on which occasion the two artists painted each other's portrait. The many claims for debt, and the grants made to Hals at the end of his life, appeared to confirm this reputation. Due to a confusion of identity with his namesake and cousin, Hals continued to be regarded as an alcoholic, and as a wife-beater. His supposedly unappealing portraits of the regents and regentesses of the old men's home were thought by some to be a form of revenge on the authorities who had treated him callously in his impoverished old age.

The truth is hard to determine. Hals's alleged chronic drunkenness is hardly confirmed by two outstanding bills of 1644, amounting to about 5 guilders altogether, and another of 1650 for 31 guilders, which in any case he refused to acknowledge. The many demands for arrears of rent, provisions and footwear illustrate the regular financial troubles of a large family, but do not prove constant poverty. His output was relatively small, and his income therefore probably irregular. It is unclear whether or not he was impoverished in later life: he received an official grant, but was then suddenly able to stand surety for more than twice the amount. His behaviour over the Amsterdam militia piece seems to show that he had little ambition to extend his clientèle beyond Haarlem. His membership of a militia company and a chamber of rhetoric may testify to his social standing, while, as Scheits observed, the later grants may have been made in recognition of his eminence as a painter.

Hals's artistic connections were evidently limited to his Haarlem colleagues. In 1629, in his capacity as a guild official, together with Pieter de Molyn and Jan van de Velde the younger, he carried out an inspection of the conditions of imprisonment of their fellow artist Johannes Torrentius, and in 1642, with Frans Pietersz. de Grebber (1573–1649), Pieter de Molyn, Cornelis van Kittensteijn (fl c. 1600) and Salomon van Ruysdael, he presented a petition concerning a sale of paintings for the benefit of Haarlem artists. His only conflict with the guild was over the dispute with Judith Leyster; he was not its only member to be in arrears or in default over contributions, and this did not prevent his being appointed an inspector in 1644.

4. Patrons and clients

The majority of Hals's portraits were commissioned, but he may have had an intermediary for the sale of his genre paintings; in 1631 his landlord Hendrik Willemsz. den Abt offered a number of pictures for sale, including four of Hals's works and copies of others by him. (These may have been in his possession as a pledge in respect of board and lodging.) In 1634 two equestrian portraits and

a *Vanitas* by Hals were offered as lottery prizes. Some of his portraits were engraved at a very early date and may have been painted for that purpose: most of the prints, however, particularly the genre subjects, were not made until after his death. Hals's clients were the wealthiest and most influential people in the city of Haarlem, including the Olycan family of brewers. There were only a few exceptions to this, René Descartes being the most notable; Hals painted his portrait *c.* 1649 (Copenhagen, Ny Carlsberg Glyp., on loan to Copenhagen, Stat. Mus. Kst). Members of the Amsterdam banking family of Coymans were among his faithful customers. Isaac Massa, who had his portrait painted three times by Hals, and perhaps his wedding portrait also, was present at the baptism of Hals's daughter Adriaentgen in 1623. Hals also painted portraits of his fellow-artists, including *Adriaen van Ostade* (Washington, DC, N.G.A.), *Vincent Laurensz. van der Vinne* (*c.* 1655–60; Toronto, A.G. Ontario) and *Frans Post* (USA, priv. col., see 1989–90 exh. cat., no. 77).

5. Critical reception and posthumous reputation

Hals's characteristic loose brushwork was imitated only for a time by his son Jan Hals and by Judith Leyster. Houbraken listed as his pupils Frans's brother Dirck, his sons, his son-in-law Pieter van Roestraten, Adriaen Brouwer, Dirck van Delen, Adriaen van Ostade, Vincent van der Vinne and Philips Wouwerman; the last-named was mentioned as Hals's pupil by Cornelis de Bie as early as 1661. Many painters are said to have been influenced by Hals: Jan Miense Molenaer, Hendrick Pot, Thomas de Keyser, Jan Verspronck, Pieter Codde, Pieter Claesz. Soutman, Bartholomeus van der Helst, Jan de Bray, Gabriel Metsu, Gerard ter Borgh and finally Jan Steen, who represented the *Pickled Herring* by Hals in his *Christening Party* (Berlin, Gemäldegal.).

Hals's individual style and the liveliness of his portraits were recognized already in his lifetime. Samuel Ampzing described the *Banquet of the St Hadrian Civic Guard Company* (*c.* 1627) as 'very boldly painted after life'. In 1647 Theodorus Schrevelius (1572–1653), whom Hals painted in

1617 (Ascona, Bentinck-Thyssen priv. col., on loan to Luxembourg, Mus. N. Hist. & A.), drew attention to Hals's forceful manner and declared that his portraits seemed to breathe. De Bie described him as 'miraculous excellent at painting portraits or counterfeits which are rough and bold, nimbly touched and well-ordered. They are pleasing when seen from afar, seeming to lack nothing but life itself.' However, in 1660 H. F. Waterloos (d 1664) criticized Hals's portrait of the Amsterdam clergyman *Herman Langelius* (c. 1660; Amiens, Mus. Picardie): Hals, he said, was too old, his eyes too weak, his 'stiff hand too rude and artless'; he added, however, that Haarlem was proud of Hals's skill and early masterpieces. It was even said that van Mander himself moved to Amsterdam because his pupil Hals was more famous than he.

Despite such praise, there is reason to doubt Hals's status among his contemporaries, and his fame was fairly localized. Notwithstanding the great demand for portraits, they were regarded as an inferior form of art; Hals signed his full name only on his genre pieces. He received only average sums for his painting: the 66 guilders for each figure he was offered for the *'Meagre Company'* contrasts with the 100 guilders per figure Rembrandt received for the *'Night Watch'* (Amsterdam, Rijksmus.). Until the 19th century Hals's paintings continued to fetch low prices, about 15 guilders on average. He painted few self-portraits, which were an important means of enhancing status. For such a rapid worker, his output seems very slight: even at its peak, fewer than ten portraits a year, although it may be that as his work was undervalued after his death, much of it has been lost.

Hals's rough style of painting did not appeal to 18th-century taste. Joshua Reynolds and Goethe thought his work lacking in finish, and on the few occasions when Hals is mentioned in literature before the 1860s, this lack of finish is blamed on his dissolute way of life. From the 1860s onwards, however, opinions rapidly changed under the influence of Théophile Thoré. Both Hals's style and his way of life were now considered artistic, spontaneous, full of joy and individuality—qualities taken to exemplify the new Dutch Republic of the 17th century. After long neglect, he was ranked next to Rembrandt and hailed as an exponent of modern ideas of painting: 'Frans Hals est un moderne' (*L'Art moderne*, 1883, p. 302). Gustave Courbet copied his *Malle Babbe* (1869; Hamburg, Ksthalle), and van Gogh extolled his sense of colour and lively characterization. The prices paid for his works (and the number of forgeries) rose rapidly; in 1865 the 4th Marquess of Hertford and Baron Rothschild competed at auction for the *Laughing Cavalier* (1624; London, Wallace) and bid up the price to an unprecedented level for a painting. Although the 19th-century estimation still persists, since the 1960s critics have endeavoured to place Hals's work in the 17th-century context as regards both style and iconography. The frequent lack of a signature and date on his works has provoked much dispute: Valentiner ascribed c. 290 works to Hals, Trivas 109, Slive c. 220, Grimm 168. There is, however, much more agreement on issues of chronology, although the early critics generally dated the genre pieces later than do more recent ones.

Bibliography

early sources

S. Ampzing: *Het lof der stadt Haerlem in Hollant* [The praise of the city of Haarlem in Holland] (Haarlem, 1621)

—: *Beschrijvinge ende lof der stadt Haerlem in Holland* [Description and praise of the city of Haarlem in Holland] (Haarlem, 1628), iv, p. 383

T. Schreveli: *Harlemias, ofte om beter te seggen, de eerste stichtinghe der stadt Haerlem* [The Harlemiad, or rather the first foundation of the city of Haarlem] (Haarlem, 1648)

H. F. Waterloos: *Hollandsche Parnas* [Dutch Parnassus], i (Amsterdam, 1660)

C. de Bie: *Het gulden cabinet* (1661)

A. Houbraken: *De groote schouburgh*, i (1718–21), pp. 90–95

A. van der Willigen: *Geschiedkundige aantekeningen over Haarlemsche schilders en andere beoefenaren van de beeldende kunsten voorafgegaan door eene korte geschiedenis van het Schilder- of St. Lucas Gild aldaar* [Historical notes on Haarlem painters and other artists, preceded by a short history of the painters' Guild of St Luke in Haarlem] (Haarlem, 1866), pp. 116–23

modern studies

W. Bode: 'Frans Hals und seine Schule', *Jb. Kstwiss.*, iv (1871), pp. 1–66 [p. 64 transcription of Scheits on Hals (1679)]

A. Bredius: 'De geschiedenis van een schuttersstuk' [The history of a militia-piece], *Oud-Holland*, xxxi (1913), pp. 81–4

W. R. Valentiner: *Frans Hals: Des Meisters Gemälde in 322 Abbildungen* (Stuttgart, Berlin and Leipzig, 1923)

A. Bredius: 'Archiefsprokkels betreffende Frans Hals' [Gleanings from the archives concerning Frans Hals], *Oud Holland*, xli (1923–4), pp. 19–31

N. S. Trivas: *The Paintings of Frans Hals* (London, 1941)

C. A. van Hees: 'Archivalia betreffende Frans Hals en de zijnen' [Archival records concerning Frans Hals and his family], *Oud-Holland*, lxxiv (1959), pp. 36–42

E. de Jongh and P. J. Vinken: 'Frans Hals als voortzetter van een emblematische traditie' [Frans Hals as the continuer of an emblematic tradition], *Oud-Holland*, lxxvi (1961), pp. 117–52

P. J. J. van Thiel: 'Frans Hals' portret van de Leidse rederijkersnar *Pieter Cornelisz. van der Morsch*, alias Piero (1583–1628)' [Frans Hals's portrait of the Leiden rhetoricians' jester *Pieter Cornelisz. van der Morsch*, alias Piero], *Oud-Holland*, lxxvi (1961), pp. 153–72

M. Butler: '*Portrait of a Lady* by Frans Hals', *Mus. Stud.*, v (1970), pp. 6–21

S. Slive: *Frans Hals*, 3 vols (London, 1970–74)

C. Grimm: *Frans Hals: Entwicklung, Werkanalyse, Gesamtkatalog* (Berlin, 1972)

J. van Roey: 'De familie van Frans Hals: Nieuwe gegevens uit Antwerpen' [The family of Frans Hals: new data from Antwerp], *Jb.: Kon. Mus. S. Kst.* (1972), pp. 145–70

C. Grimm: '*St Markus* von Frans Hals', *Maltechnik, Rest.*, 80 (1974), pp. 21–31

F. S. Jowell: 'Thoré-Bürger and the Revival of Frans Hals', *A. Bull.*, lvi (1974), pp. 101–17

S. Koslow: 'Frans Hals's Fisherboys: Exemplars of Idleness', *A. Bull.*, lvii (1975), pp. 418–32

H. Miedema, ed.: *De Archiefbescheiden van het Lucasgilde te Haarlem, 1497–1798*, 2 vols (Alphen aan den Rijn, 1980)

P. J. J. van Thiel: 'De betekenis van het portret van *Verdonck* door Frans Hals' [The significance of Frans Hals's portrait of *Verdonck*], *Oud-Holland*, xciv (1980), pp. 112–37

N. Middelkoop and A. van Grevenstein: *Frans Hals: Leven, werk, restauratie* (Amsterdam and Haarlem, 1988)

Frans Hals (exh. cat., ed. S. Slive; Washington, DC, N.G.A.; London, RA; Haarlem, Frans Halsmus.; 1989–90)

INGEBORG WORM

(2) Dirck Hals

(*b* Haarlem, *bapt* 19 March 1591; *d* Haarlem, *bur* 17 May 1656). Brother of (1) Frans Hals. From 1618 to 1624 and again in 1640 he was an amateur of the Haarlem chamber of rhetoric known as De Wijngaertrancken, to which Frans also belonged. He was enrolled in the Guild of St Luke in Haarlem from 1627 to his death. As Blade has established on stylistic grounds, Dirck collaborated with the architectural painter Dirck van Delen from that year until 1634, with Hals painting the figures (e.g. *Banquet Scene in a Renaissance Hall*, 1628; Vienna, Gemäldegal. Akad. Bild. Kst.). On 4 April 1634 a lottery of paintings was announced, organized by Dirck Hals (who sent some of his own pictures) and Cornelis van Kittensteijn in the inn De Basterdpijp in Haarlem. The following year, on 20 June 1635, the notary van Leeuwen at Leiden authorized Dirck Hals to collect moneys for Pieter Jansz. van den Bosch of Leiden in connection with the proceeds of paintings sold at Haarlem. On 2 March 1643 Dirck Hals signed as a witness in the presence of the notary Willem van Vredenburch at Leiden. Although both documents were signed in Leiden, Dirck's residence is given as Haarlem.

Almost all Dirck Hals's paintings are of merry companies in and out of doors, with numerous symbolic motifs. His earliest dated work, *Merry Company out of Doors* (1621; Budapest, Mus. F.A.) was painted two years before his earliest known interior (1623; St Petersburg, Hermitage). The subject-matter of these early works seems to be more influenced by Willem Buytewech than by that of his brother Frans. There is often a table in the centre of the composition, parallel to the picture plane, at or beside which there are amorous couples and figures eating and drinking, smoking and making music. The space is not deep and the perspective is uncertain. Until 1628 Dirck adopted figures from Buytewech literally, as in his *Fête champêtre* (1627; Amsterdam, Rijksmus.). The depiction of worldly pleasures is often given added significance by the addition of comic or foolish figures (e.g. Paris, Louvre, 4160; Frankfurt am Main, Städel. Kstinst. & Städt. Gal. 1587), attributes of the Five Senses (e.g. Amsterdam, E. Douwes priv.

col., see 1976 exh. cat., no. 26) or a chained monkey (see 1976 exh. cat., no. 27).

After 1630 Dirck's works show a more tonal use of colour. With a broader touch he painted merry companies and also genre pieces with one or two figures, for instance the *Woman Tearing up a Letter* (1631; Mainz, Landesmus.) and the *Seated Woman with a Letter* (1633; Philadelphia, PA, Mus. A.). His later works are very varied in quality. He also painted a number of figure sketches in oil on paper, in the fluent manner of his brother Frans. Engravings after Dirck Hals's work were made by Cornelis van Kittensteijn (e.g. the *Five Senses*; see Hollstein: *Dut. & Flem.*, ix, pp. 246–7), Salomon Savery (Hollstein, xxiv, p. 25) and Gillis van Scheyndel (Hollstein, xxiv, p. 210).

Bibliography

NKL; Thieme–Becker

A. Houbraken: *De groote schouburgh* (1718–21), i, p. 322

A. van der Willigen: *Les Artistes de Harlem* (Haarlem, 1870), p. 149

W. Martin: 'Hoe schilderde Willem Buytewech' [How Willem Buytewech painted], *Oud-Holland*, xxxiv (1916), pp. 197–203, 199

A. Bredius: 'Archiefsprokkels betreffende Frans Hals' [Gleanings from the archives concerning Frans Hals], *Oud-Holland*, xli (1923–4), pp. 19–31; xli (1923–4), pp. 60–61

F. Würtenberger: *Das holländische Gesellschaftsbild* (Schramberg im Schwarzwald, 1937), pp. 58–63

E. Plietzsch: 'Randbemerkungen zur holländischen Interieurmalerei am Beginn des 17. Jahrhunderts', *Wallraf-Richartz-Jb.*, xviii (1956), pp. 174–86

E. Haverkamp Begemann: *Willem Buytewech* (Amsterdam, 1959), pp. 49–50

I. Linnik: 'Vnov' otkritaya kartina Dirka Halsa' [A rediscovered painting by Dirck Hals], *Omagiu lui George Oprescu* (Bucharest, 1960), pp. 327–30 [Rus. text]

S. Slive: *Frans Hals*, 3 vols (London, 1970–74)

P. Schatborn: 'Olieverfschetsen van Dirck Hals' [Oil sketches by Dirck Hals], *Bull. Rijksmus.*, xxi (1973), pp. 107–16

T. T. Blade: *The Paintings of Dirck van Delen* (diss., Minneapolis, U. MN, 1976; microfilm, Ann Arbor, 1980), p. 127

Tot lering en vermaak [For instruction and pleasure] (exh. cat., ed. E. de Jongh and others; Amsterdam, Rijksmus.; 1976), nos 25–7

H. Miedema: *De archiefbescheiden van het St Lukasgilde te Haarlem* [The archives of the Guild of St Luke, Haarlem] (Alphen aan de Rijn, 1980)

Haarlem: The Seventeenth Century (exh. cat. by F. Fox Hofrichter, New Brunswick, NJ, Rutgers U., Zimmerli A. Mus., 1983), no. 65

A. Groot: 'Drank en minne: Een vroeg zeventiende-eeuwse gezelschap van Dirck Hals' [Drink and love: an early 17th-century merry company by Dirck Hals], *Kunstlicht*, xv (1985), pp. 10–16

AGNES GROOT

Hanneman, Adriaen

(*b* The Hague, *c.* 1604; *d* The Hague, *bur* 11 July 1671). Dutch painter. He came from a family of Catholic government officials. In 1619 he became a pupil of the portrait painter Anthonie van Ravesteyn (1580–1669), brother of Jan van Ravesteyn. Hanneman's only known early work is a *Portrait of a Woman* (1625; ex-St Lucas Gal., Vienna; see ter Kuile, no. 1), which is entirely in the style of the van Ravesteyn brothers. Around 1626 he settled in London, where he married Elizabeth Wilson in 1630. It is possible that Hanneman worked for some time as an assistant in the workshop of Anthony van Dyck, who settled in England in 1632. The few signed pieces that have been preserved from Hanneman's years in London, and his later paintings, show the strong influence of van Dyck's style of portraiture.

In or around 1638 Hanneman returned to The Hague, where he joined the painters' guild in 1640. In the same year he was married for a second time, this time to his master's niece, Maria van Ravesteyn. Soon after his return to The Hague he must have started his large portrait of *Constantijn Huygens and his Children* (1640; The Hague, Mauritshuis). The main design of the painting, with the placement of the figures in separate medallions, was probably worked out some years earlier by the architect and painter Jacob van Campen. Records indicate that Hanneman had already completed the painting in 1639, but the painting itself bears the date 1640. Although executed after his return to the northern Netherlands the influence of van Dyck still predominates.

Hanneman's oeuvre after 1640 consists almost exclusively of portraits, most of which are deeply inspired by van Dyck. Yet Hanneman was more than a mere uncritical epigone of the Flemish master; he was a significant artist in his own right, who played a major role in disseminating van Dyck's influence throughout Holland.

Hanneman drew his clientele primarily from English citizens staying in the Netherlands, particularly from the many Royalist exiles who spent periods of time in The Hague from the late 1640s onward. English subjects painted by Hanneman include *Charles II when Prince of Wales* (1648–9; known only by a number of copies and reproductions, see ter Kuile, no. 14), his brother *Henry, Duke of Gloucester* (1653; Washington, DC, N.G.A.) and *Sir Edward Nicholas* (1653; priv. col., see ter Kuile, no. 19). The portrait of the *Duke of Gloucester* is one of the artist's best works and is so close in style to Anthony van Dyck that it was attributed to him for many years. Hanneman's subjects in the 1650s also included the young *William of Orange*, later the Stadholder-King (1654; Amsterdam, Rijksmus.), and his mother *Mary Stuart* (1659 and 1660; a number of known variants, including Edinburgh, N.P.G., and Windsor Castle, Berks, Royal Col.), as well as various prominent Dutch government officials. Compared to portraits painted by other artists in The Hague at this time, his portraits are remarkable for their elegance and for the numerous borrowings of poses and gestures from the work of van Dyck.

Besides portraits Hanneman painted two allegories that were commissioned by government institutions. In 1644 he painted an *Allegory of Justice* (The Hague, Oude Stadhuis) for the town council of The Hague and in 1664 an *Allegory of Peace* (The Hague, Binnenhof) for the States of Holland.

Hanneman lived in an impressive house and for many years was taxed at a level indicating a growing fortune. In 1643 he became a member of the governing board of the painters' guild and in 1645 its dean. In 1656, when the painters and sculptors dissociated themselves from the guild and set up their own artists' organization, Pictura,

Hanneman became its first dean (1656–9). After his retirement he was several times a member of the confraternity's governing board, and in the years 1663–6 he was once again its dean. Hanneman also apparently had a good name as a teacher; he trained many young artists, the best known of whom were Jan Jansz. Westerbaen the younger (1631–*c.* 1672) and Reinier de la Haye (*c.* ?1640–95).

In his last years Hanneman's fortunes began to decline. At the time of his third marriage with Alida Besemer in 1670, his capital had already dwindled considerably, and when he died in 1671 the estate proved to be of only minor value. The reasons for this reversal are not clear. Until 1668 the artist was still receiving many important commissions: for example, in 1664 he received the sum of 500 guilders for two copies of a portrait of *William of Orange* (London, St James's Pal. and Kensington Pal., Royal Col.) and 400 guilders for a posthumous portrait of the Prince's mother, *Mary Stuart* (The Hague, Mauritshuis). Hanneman was still popular among the foremost members of society in The Hague, as is evident from the surviving paintings of various members of court circles and of prominent citizens. No works dated after 1668 are known, possibly suggesting that the artist's career was broken off by illness. In addition to the many late portraits still completely in the style of van Dyck, there are a few portraits in the far more arid and sober traditional Dutch portrait style of the 17th century (e.g. the portrait of *Cornelia van Wouw*, 1662; The Hague, van Wouw almshouse, see ter Kuile, no. 72).

Bibliography

A. Bredius and E. W. Moes: 'Adriaen Hanneman', *Oud-Holland*, xiv (1896), pp. 203–18

M. Toynbee: 'Adriaen Hanneman and the English Court in Exile', *Burl. Mag.*, xcii (1950), pp. 73–80; c (1958), pp. 249–50

The Age of Charles I: Painting in England, 1620–1649 (exh. cat. by O. Millar, London, Tate, 1972), p. 52

O. ter Kuile: *Adriaen Hanneman, 1604–1671: Een Haags portretschilder* (Alphen aan den Rijn, 1976) [with illustrated catalogue of works]

RUDOLF E. O. EKKART

Heda, Willem (Claesz.)

(*b* Haarlem, 1594; *d* Haarlem, 1680). Dutch painter. He was a still-life painter, who, like Pieter Claesz., is noted for his monochrome breakfast-pieces, which are, however, more opulent than those of Claesz. Heda's earliest dated work is a *Vanitas* (1621; The Hague, Mus. Bredius), which shows a still-life from a high viewpoint, composed of various objects bearing *vanitas* associations (e.g. a bowl of glowing embers, smoker's requisites, an overturned glass and a skull); the colouring is in brownish-grey tones and represents one of the earliest examples of a Dutch monochrome still-life ('monochrome' refers to the range of tones, rather than of colours). Even in this early work Heda's skill at painting textures is evident. A more balanced composition is achieved in another *Still-life* (1629; The Hague, Mauritshuis) and in the *Breakfast Table* (1631; Dresden, Gemäldegal. Alte Meister), in both of which the objects, set against a neutral background, are linked by a strong diagonal. The Mauritshuis still-life also gives an early indication of Heda's interest in painting the effects of light. In 1631 he became a member of the Haarlem Guild of St Luke (of which he served as deacon on several occasions after 1637).

By the mid-1630s Heda's work had matured, and his compositions were now built up by means of a larger number of objects, mostly in the foreground, whereas elements of his earlier works had been disposed more towards the background. In paintings such as the *Still-life with a Gilt Goblet* (1635; Amsterdam, Rijksmus.), a fallen tazza or a vase often links the horizontal and vertical accents of the composition. This work also demonstrates Heda's skill in accurately depicting reflections: not only can a cross-bar window outside the picture be seen in the glass and the salt-cellar, but within the picture the goblet is reflected in the pewter jug, and the knife picks up light on its decorated handle.

Despite his limited subject-matter and the inevitable repetition of themes, Heda managed to create individual pictures on each occasion, and he experimented with a vertical format as well as the more conventional horizontal format for his still-lifes. In his *Still-life with Plates and Dishes* (1638; Hamburg, Ksthalle) the accumulation of tall objects is emphasized by the vertical draped folds of the white tablecloth. In later years, perhaps under the influence of Willem Kalf, Heda chose to paint more sumptuous objects: Venetian fluted glasses, brightly ornamented silverware and costly porcelain are arranged on the tables in an apparently disciplined disorder. The placement of each object, however, was carefully considered, and a plate balanced on the edge of a table conveys both a sense of dynamism and depth for the composition. Even though the objects of his later pictures were richer, Heda's work does not have the sense of exuberance found in similar work by Abraham van Beyeren and Willem de Heem, and his last known paintings of 1664 and 1665 lack the perfection and subtlety he achieved in the 1630s. Heda painted on panel and canvas, but panel paintings predominate. His colours are mainly greys, browns and greens with the addition of silvery tones. His brushwork is assured and controlled, and his paint solid and rich, but not too heavy. Two of his still-life paintings have landscape backgrounds (1634; Ghent, Mus. S. Kst.; and 1654; sold Amsterdam, Sotheby Mak van Waay, Oct 1979), but it seems likely that the landscapes are later additions. Some portraits and other figure studies have also been ascribed to the artist.

Heda seems to have been reasonably affluent, and his work was much in demand during his lifetime; Rubens owned two paintings by him, and copies after Heda appear in other Antwerp inventories. Jan de Bray painted his portrait in 1678 (untraced). Heda's son and pupil Gerrit Willemsz. Heda (*b* Haarlem, *c.* 1620; *d* Haarlem, before 1702) became a member of the Haarlem Guild of St Luke in 1642 and painted still-lifes so like those of his father that their work has often been confused. Other pupils included Maerten Boelema (*c.* 1620–?after 1664), Arnold van Beresteyn (*c.* 1620–54) and Hendrick Heerschoop (1620/21–after 1672).

Bibliography

A. P. A. Vorenkamp: *Bijdrage tot de geschiedenis van het Hollandsche stilleven in de 17de eeuw* (Leiden, 1933)
H. E. van Gelder: *W. C. Heda, A. van Beyeren, W. Kalf* (Amsterdam, [1941])

I. Bergström: *Dutch Still-life Painting in the Seventeenth Century* (London, 1956), pp. 123–34, 139–43

L. J. Bol: *Holländische Maler des 17. Jahrhunderts nahe den grossen Meistern* (Brunswick, 1969), pp. 67–70

W. Bernt: *The Netherlandish Painters of the Seventeenth Century* (London, 1970), i, p. 51

N. R. A. Vroom: *A Modest Message as Intimated by the Painters of the 'Monochrome banketje'*, 2 vols (Schiedam, 1980) [incl. chronological cat. of works]

B. Haak: *The Golden Age: Dutch Painting in the 17th Century* (New York and Amsterdam, 1984), pp. 247–9

H. G. DIJK KOEKOEK

Heem, de, Jan Davidsz.

(*b* Utrecht, April 1606; *d* Antwerp, 1683–4). Dutch painter. Born as Johannes van Antwerpen, the painter called himself Johannes de Heem but has always been mentioned as Jan Davidsz. de Heem in the literature. His father, a musician, died in 1612. His mother, two sisters and stepfather moved to Leiden in 1625. The following year Jan married Aletta van Weede (*d* 1643), who bore him three children, including Cornelis de Heem. During the early 1630s Jan moved to Antwerp, where he spent most of the rest of his life. He married Anna Ruckers in 1644, the year after his first wife died. Six children were born of this second marriage, including Jan Jansz. de Heem. Jan the elder went to Utrecht quite often and lived there from 1667 until 1672, when he returned to Antwerp. He had a workshop in Utrecht with collaborators and pupils, the most famous being Abraham Mignon.

1. Work

Jan Davidsz.'s early works, produced in Leiden in the late 1620s, show the influence of interiors by Rembrandt and Jan Lievens, both active locally, as well as of tonal fruit-pieces by Balthasar van der Ast from Utrecht and 'monochrome' banquet-pieces by Pieter Claesz. from Haarlem. During the 1630s de Heem integrated elements of the local Antwerp painters of monumental kitchen-pieces and still-lifes Frans Snyders and Adriaen van Utrecht and later of the flower garlands and cartouches of Daniel Seghers.

De Heem's paintings include fruit-pieces, *vanitas* still-lifes and flower-pieces, but he became most famous for his ornate or sumptuous still-lifes (*pronkstilleven*). Like the book still-life, a special type of *vanitas* painting produced in Leiden, the sumptuous still-life, which de Heem started in his Antwerp period, was one of his own inventions. Several other subjects painted by him, even if only occasionally, constitute new iconographic forms, for instance a stable-piece (1631; Leiden, Stedel. Mus. Lakenhal) and herb-pieces (i.e. paintings with flowers or fruit in the open air, a ruin or a grotto). Characteristic of Jan Davidsz.'s work, however, are combinations of several types into one complex composition, such as a flower bouquet with fruit and *vanitas* objects. The sumptuous still-lifes are, in fact, examples of such combinations. They include precious objects, such as gold- and silversmith's work, Venetian glass and exotic shells, beside fruit and other food. The meaning of several of the paintings is made explicit by inscribed texts, usually referring to *vanitas* and Christian symbolism. Proverbs about moderation (e.g. 'Not how much, but how noble') are contrasted with the abundance of the sumptuous still-lifes.

De Heem's innovations are not limited by theme and combination only. Already in his earliest paintings he experimented with composition, brushstroke, light and colour. The compositions are given depth by means of architectural features in the background and foreground and through the effects of highlights and shadows. This can be seen, for example, in the *Sumptuous Still-life with a Great Tit* (The Hague, Rijksdienst Beeld. Kst, on loan to Utrecht, Cent. Mus.), which shows a chair and a small table with objects on a terrace; depth is suggested by the sky in the vista and the curtain-covered wall and pillars behind the table. This picture also features de Heem's subtly refined repetitions of basic shapes, such as triangles and ovals (e.g. the striped lute and melon). As far as technique is concerned, he sometimes painted broadly but also used delicate glazes, often in the same painting. The skimming light is concentrated on essential objects. Harmonious colour pattern with subtle transitional shades is the result of a

development from 'monochrome' and 'tonal' approaches using shades of grey and brown. De Heem integrated the large and colourful Flemish style, with its strong contrasts, with the relatively small, simple, sober and intimate paintings more typical of the northern Netherlands.

2. Critical reception and posthumous reputation

No painter had such an influence on the development of Netherlandish still-life painting during the 17th century as Jan Davidsz. de Heem. His large sumptuous still-lifes of the 1640s made a particularly profound impression. Nearly all the still-life painters since, including great figures such as Willem Kalf and Abraham van Beyeren, were affected by him, and many tried to imitate his work. The impact of his art was strongest in three centres: Antwerp, Utrecht and Leiden. Only a small number of pupils are documented, among them Alexander Coosemans (1627–89) in Antwerp. Joris van Son (1623–67) was one of the most successful followers there. Important followers in Utrecht were Jacob Marrell (1614–81) and, especially, Abraham Mignon, who collaborated on several of de Heem's paintings. Local substitutes in Leiden included Pieter de Ring (1615–60) and a circle around him. Foremost among de Heem's collaborators, however, were his sons Cornelis and Jan Jansz. de Heem. A *Flower-piece with a Crucifix and Vanitas Objects* (Munich, Alte Pin.) is signed by Jan Davidsz. de Heem, Jan Jansz. de Heem and the Antwerp still-life painter Nicolaes van Veerendael. Jan Davidsz. de Heem's influence was still apparent throughout the 18th century, for instance in works by the still-life painters Rachel Ruysch and Jan van Huysum.

Jan Davidsz. de Heem was also considered one of the greatest painters by his contemporaries. He was well paid for his work: a portrait of *Prince William III* surrounded by a cartouche of flowers and fruit (Lyon, Mus. B.-A.) was sold for 2000 guilders, one of the highest prices ever paid for a painting during the Golden Age. His works have been appreciated ever since, both in the literature and on the art market. They are among the most expensive Dutch paintings.

Bibliography

I. Bergström: *Dutch Still-life Painting in the Seventeenth Century* (London, 1956)

Jan Davidsz. de Heem en zijn kring (exh. cat. by S. Segal; Utrecht, Cent. Mus.; Brunswick, Herzog Anton Ulrich-Mus.; 1991)

SAM SEGAL

Helst, Bartholomeus van der

(*b* Haarlem, *c.* 1613; *d* Amsterdam, *bur* 16 Dec 1670). Dutch painter. He was the son of a Haarlem inn-keeper and presumably undertook part or all of his training in Amsterdam. His earliest works suggest that the painter Nicolaes Eliasz. Pickenoy was his master. Although van der Helst had probably already established himself as an independent master by the time he married Anna du Pire in Amsterdam in 1636, his earliest known work, a portrait of *The Regents of the Walloon Orphanage, Amsterdam* (Amsterdam, Maison Descartes), dates from 1637. Stylistically it is close to the work of Pickenoy. His portrait of a *Protestant Minister* of 1638 (Rotterdam, Boymans–van Beuningen) reveals the influence of Rembrandt. The young artist must have risen rapidly to fame in Amsterdam, for as early as 1639 he received the prestigious commission for a large painting for the Kloveniersdoelen (Arquebusiers' or Musketeers' Hall): *The Civic Guard Company of Capt. Roelof Bicker and Lt Jan Michielsz. Blaeuw* (Amsterdam, Rijksmus.), which formed part of the same series as Rembrandt's '*Night Watch*' (Amsterdam, Rijksmus.). Van der Helst may not have completed this commission until 1642 or 1643. The ingenious arrangement of the figures in a broad composition shows the artist's special talent for composing large groups. Pickenoy's influence is less noticeable here than in the portrait of 1637; the self-assured poses of the individual figures were to become a characteristic feature of van der Helst's work. The successful execution of this portrait established van der Helst's reputation: from 1642, when he began to receive an increasing number of commissions for individual portraits, until 1670 he was the leading portrait painter of the ruling class in

Amsterdam. From 1642 his technique in portrait painting gradually became more fluent and the rendering of costume materials more detailed. Some typical portraits of his earlier period are those of *Andries Bicker* (Amsterdam, Rijksmus.), his wife *Catharina Gansneb Tengnagel* (Dresden, Gemäldegal. Alte Meister) and their son *Gerard Bicker* (Amsterdam, Rijksmus.), all of 1642, and the *Portrait of a Young Girl* (1645; London, N.G.). In 1648 van der Helst painted a second civic guard portrait, *The Celebration of the Peace of Münster at the Crossbowmen's Headquarters, Amsterdam* (Amsterdam, Rijksmus.), a superbly composed and well painted portrait that, until the late 19th century, was considered one of the masterpieces of the Golden Age but later lost popularity because of its smooth and modish execution. It can nevertheless still be regarded as one of the most important group portraits of the 17th century. Its technical perfection, characterized by a well-modelled rendering of the figures and a smooth handling of the brush, dominated the rest of van der Helst's oeuvre.

Van der Helst's considerable reputation led to commissions from prominent people outside Amsterdam, a rare phenomenon in the history of 17th-century Dutch portraiture. In 1652 he was even commissioned—it is not known by whom—to paint the official portrait of *Mary Henrietta Stuart* (Amsterdam, Rijksmus.), widow of William II of Orange Nassau. This was a rare case of the court commissioning a portrait from an artist who worked primarily for the ruling class in Amsterdam—a class ill-disposed towards the court.

In 1650 van der Helst painted the portrait of *Two Governors and Two Governesses of the Spinning House* (a house of correction for women) (Amsterdam, Hist. Mus.), and between 1653 and 1656 he produced three more group portraits of high-ranking officers of Amsterdam's civic guard (Amsterdam, Hist. Mus. and Rijksmus.), the last contributions to an impressive series of Amsterdam militia pieces completed in 1656. All four group portraits are outstandingly well composed and technically well-executed representations of important sitters, in which the liveliness of the composition is enhanced by the addition of a few genre-like details. Among van der Helst's best works is the double portrait of *Abraham del Court and his Wife, Maria Keerssegieter* (1654; Rotterdam, Boymans–van Beuningen), in which the artist casually included a number of emblematic motifs and achieved an unrivalled rendering of surface textures (e.g. satin).

Van der Helst's individual portraits, of which there are over a hundred, many of them pendants, can be seen in many museums both in Europe and the USA; they consist of shoulder-length portraits, half-length figures and monumental three-quarter-length pieces. He also painted some life-size family portraits, such as the *Portrait of a Couple with their Daughter* (1654; London, Wallace) and *Anthonie Reepmaker and his Family* (1669; Paris, Louvre). The latter was painted towards the end of van der Helst's life. Also from his final period are a number of single portraits, such as that of *Vice-Admiral Aert van Nes* and his wife, *Geertruida den Dubbelde*, and *Vice-Admiral Johan de Liefde* (all 1668; Amsterdam, Rijksmus.). In each of these portraits the background was executed by Ludolf Bakhuizen.

Besides portraits, van der Helst painted a few genre pictures, for example *Woman Selling Vegetables on the Nieuwmarkt in Amsterdam* (1666; St Petersburg, Hermitage), and a few biblical scenes and mythological subjects (see fig. 22). In all these paintings, however, the portrait element is dominant.

Documents mention hardly any pupils of van der Helst. His son Lodewijk van der Helst (1642–after 1684) trained with him; the father's influence can be clearly recognized in the son's work. Little is known about van der Helst as a master, but it is clear that he strongly influenced his contemporaries both in Amsterdam and elsewhere—artists such as Abraham van den Tempel, Nicolaas de Helt Stocade (1614–69) and Paulus Hennekyn (1611/14–72). In the past works by his followers have been wrongly attributed to van der Helst, resulting in a distorted view of his oeuvre.

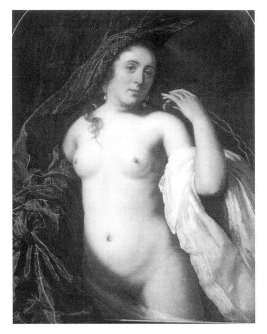

22. Bartholomeus van der Helst: *Venus* (Paris, Musée du Louvre)

Bibliography

J. J. de Gelder: *Bartholomeus van der Helst* (Rotterdam, 1921)

W. Martin: *De Hollandsche schilderkunst in de zeventiende eeuw*, 2 vols (Amsterdam, 1935–6)

E. Plietzsch: *Holländische und flämische Maler des XVII. Jahrhunderts* (Leipzig, 1960)

C. J. de Bruyn Kops: 'Vergeten zelfportretten van Govert Flinck en Bartholomeus van der Helst', *Bull. Rijksmus.*, xiii (1965), pp. 20–29

B. Haak: *The Golden Age: Dutch Painters of the Seventeenth Century* (New York, 1984), pp. 290–91, 371

RUDOLF E. O. EKKART

Heyden, Jan van der

(*b* Gorinchem, 5 March 1637; *d* Amsterdam, 28 March 1712). Dutch painter, draughtsman, printmaker and inventor. In 1650 he moved to Amsterdam with his family; his father, a Mennonite, who had pursued various occupations rather unsuccessfully, died that year. Jan's artistic training may have begun with drawing lessons in the studio of a relative, perhaps his eldest brother, Goris van der Heyden, who made and sold mirrors; Jan may also have studied the reverse technique of glass painting with an artist in Gorinchem. Painting occupied relatively little of his time, however, although he continued to pursue it throughout his long life. His prosperity was mainly due to his work as an inventor, engineer and municipal official. He designed and implemented a comprehensive street-lighting scheme for Amsterdam, which lasted from 1669 until 1840 and was adopted as a model by many other towns in the Netherlands and abroad. In 1672, with his brother Nicolaes van der Heyden, he invented a fire engine fitted with pump-driven hoses, which transformed the efficiency of fire-fighting.

As an artist, van der Heyden is best known as one of the first Dutch painters to specialize in the Townscape; architectural motifs certainly dominate his compositions, though he also painted village streets, country houses and some forty landscapes, at least two of which are painted on glass (e.g. *View of the Woods*; Amsterdam, Rijksmus.). His later works are mainly still-lifes (e.g. *Corner of a Room with Rarities on Display*; Budapest, Mus. F.A.). Unlike the Haarlem-based brothers Job and Gerrit Berckheyde, whose townscapes were influenced by traditions of genre, *bambocciate* and architectural painting, van der Heyden's approach was closer to 'pure' landscape. His main subjects were Amsterdam and the region near the Dutch–German border, which he visited for business and recreation. A group of 14 paintings is connected with the village of Maarssen, some probably made for Joan Huydecoper II, the Amsterdam burgomaster who developed real estate around that village. In 1674 he commissioned van der Heyden to execute paintings of his house and estate at Goudstein (version, London, Apsley House).

Van der Heyden's townscapes are only loosely based on actual views, topographical accuracy being the least of his concerns. He seems to have attempted instead to distil into a single concentrated image the distinctive character of a town, in such a way that the experience of visiting it

would be enhanced. A notable exception is his architectural 'portrait' of the *Westerkerk, Amsterdam* (London, Wallace). All other townscapes show the buildings only partially depicted, with much attention paid to surrounding structures and open spaces (see fig. 23). He delighted in picturesque contrasts between modern (mostly imaginary) buildings and historical settings, between buildings and trees, as in *Architectural Fantasy with the Old Stadhuis, Amsterdam* (c. 1667–72; London, Apsley House) and between large structures and open spaces, as in *View of the Heerengracht, Amsterdam* (Paris, Louvre) and *View of the Huis ten Bosch* (London, N.G.). Despite his naturalistic style, these are all idealized views,

deliberately lacking up-to-date items from the real world, such as the street lamps and fire engines he himself invented. It is impossible, moreover, to distinguish between townscapes with identifiable elements and those that are completely imaginary.

The great clarity of incidental detail in van der Heyden's paintings, such as the rendering of brickwork, is impressive and must have been achieved with the aid of a magnifying glass. Yet it is so skilfully handled that it does not distract attention from the impact of the whole scene. He may have made use also of a camera obscura, lenses and mirrors, but this is unlikely since he was rarely recording actual views. Only one preparatory drawing connected with a painting is known.

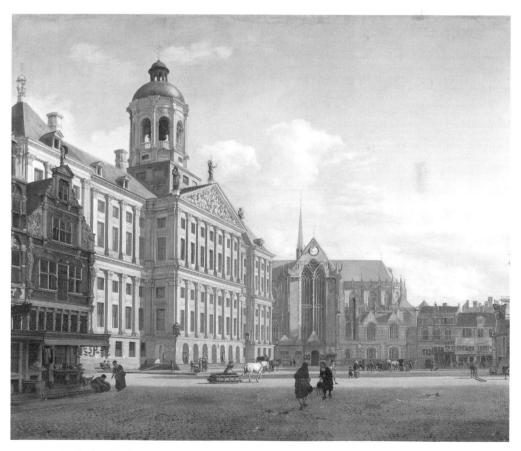

23. Jan van der Heyden: *The Dam Square and the New City Hall at Amsterdam*, 1688 (Paris, Musée du Louvre)

Adriaen van de Velde and Johannes Lingelbach sometimes provided the figures in his painted works.

In the drawings van der Heyden made as designs for etchings, all of which advertise his inventions, he took unusual care, as is clear from surviving preliminary studies (e.g. Amsterdam, Rijksmus.) for illustrations to his book on the new fire engine, *Beschryving der nieuwlyks uitgevonden en geoctrojeerde slang-brand-spuiten en hare wyze van brand-blussen* ('Description of the newly discovered and patented hose fire engine and her way of putting out fires'; Amsterdam, 1690). His first sketches are rather awkward; each subsequent step in the creative process added detail, refinement and quality, which he seems to have conquered painstakingly, without any trace of spontaneity or virtuosity. He made extensive use of counterproofs of his drawings so that the images, once transferred to the etching plate, would be depicted correctly in the final print. For instance, after working up his original drawing of a burnt-out house with brush and wash to establish the light and shade effects, he introduced small figures separately on to a counterproof. The final prints also provide rare historical documentation of poor and industrial areas of Amsterdam not seen in townscapes of the period. In the production of these and other publications, van der Heyden collaborated with other artists, including the printmaker Jan van Vianen (1660–after 1726) and his own son Jan van der Heyden the younger. Van Vianen, for example, drew the figures in van der Heyden's largest print (1699) illustrating a technical development in fire-fighting equipment. Van der Heyden died a wealthy man, with over 70 paintings in his possession. Although no pupils or immediate followers are recorded for him, he was an important influence on the development of townscape painting in the mid-18th century.

Bibliography

H. Wagner: 'Jan van der Heyden als Zeichner', *Jb. Berlin. Mus.*, xii (1970), pp. 111–50

——: *Jan van der Heyden, 1637–1712* (Amsterdam and Haarlem, 1971)

I. H. van Eeghen: 'Archivalia betreffende Jan van der Heyden', *Amstelodamum*, lx (1973), pp. 29–36, 54–61, 73–9, 99–106, 128–34

L. de Vries: 'Post voor Jan van der Heyden', *Oud-Holland*, xc (1976), pp. 267–75

Opkomst en bloei van het Noordnederlandse stadsgezicht in de 17de eeuw/The Dutch Cityscape in the 17th Century and its Sources (exh. cat. by B. Bakker and others, Amsterdam, Hist. Mus.; Toronto, A.G. Ont.; 1977)

Dutch Figure Drawing from the Seventeenth Century (exh. cat. by P. Schatborn, Amsterdam, Rijksmus.; Washington, DC, N.G.A.; 1981–2), pp. 124–6

G. Schwartz: 'Jan van der Heyden and the Huydecopers of Maarsseveen', *Getty Mus. J.*, xi (1983), pp. 197–220

L. de Vries: *Jan van der Heyden* (Amsterdam, 1984)

<div align="right">LYCKLE DE VRIES</div>

Hobbema, Meindert [Meyndert]

(*b* Amsterdam, *bapt* 31 Oct 1638; *d* Amsterdam, 7 Dec 1709). Dutch painter. Although limited in subject-matter and working from a remarkably narrow repertory of motifs and compositional devices, he nonetheless managed to imbue his area of specialization—the wooded landscape—with memorable vitality.

1. Life and work

(i) **Early career, before 1663.** The son of Lubbert Meyndertsz., a carpenter, Meindert adopted the surname 'Hobbema' at an early age, although it appears to have had no family precedent. In 1653, together with his younger brother and sister, he was taken into the care of the Amsterdam orphanage. Two years later he had left this institution, and it was then, or shortly after, that he entered the studio of the Haarlem landscape painter Jacob van Ruisdael, who had recently moved to Amsterdam. On 8 July 1660 Ruisdael testified that Hobbema had 'served and learned with him for some years'. In spite of his period of apprenticeship with Ruisdael, Hobbema's paintings from the 1650s are river scenes that show the impact of Cornelis Vroom and Salomon van Ruysdael. His earliest dated work is a *View of a River* (1658; Detroit, MI, Inst. A.). This modest painting, executed when the artist was only 20, reveals a

tranquil setting with a diagonally slanting river-bank along which slender, insubstantial trees, cottages and several figures are placed at gentle intervals. It is broadly painted with muted greens, browns and greys. The general composition of the painting, in particular the silhouetting of the somewhat awkward trees against a light sky, is reminiscent of Salomon van Ruysdael's works of the mid-1650s.

Around 1662 the influence of his famous master Jacob van Ruisdael became markedly visible in Hobbema's work. In particular, a number of landscapes with water-mills from this year take their central motif and other elements from Ruisdael's *Water-mill* (1661; Amsterdam, Rijksmus.). A typical example of Hobbema's dependence is *Landscape with Water-mill* (Toledo, OH, Mus. A.), undated but evidently painted during 1662, which is an almost exact copy of Ruisdael's painting. Hobbema's touch, however, is broader and his tones brighter, especially in the light-filled middle distance; the melancholic, more brooding quality that infuses Ruisdael's work with so much mystery is absent.

(ii) Middle period, 1663–8. The period of close alignment with Ruisdael was short-lived. Hobbema's later paintings from the 1660s, which are on a larger, more ambitious scale, show a greater spatial clarity and expansiveness, a more fluid touch and a heightened sense of colour. The years between 1663 and 1668 were the most productive in his career. In his *Wooded Landscape: The Path on the Dyck* (1663), the strong vertical accent of the central cluster of spindly trees with their lacy foliage is relieved by the two pathways, which plunge in diverging directions and on plateaux of varying levels into the distance. This double vanishing-point is frequently repeated in Hobbema's work and gives his compositions a feeling of freshness they would otherwise lack. By reducing the horizon line, greater emphasis is given to the sky with its huge billowing clouds, which echo the sprawling mass of trees and shrubbery below. His palette is full of subtle variations of bright green, yellow, grey and brown, which produce an overall silvery tonality. Also characteristic of Hobbema is

the shaded foreground, with occasional flickers of half-light that lengthen the cast shadows of figures and cows and contrast with an area of intense light in the background. As with much of Hobbema's work, this painting gives the impression that although he has taken his original inspiration from nature, his final conception is formed by a desire to present landscape as an idyllic environment, ordered and regulated by man. The staffage was painted by Adriaen van de Velde, who often collaborated with Hobbema.

In a number of paintings from *c.* 1665, among them *The Water-mill* (Paris, Louvre; see fig. 24), Hobbema returned to a theme with which he is closely associated. The subject of the water-mill was a particular favourite of Hobbema and he painted it on over 30 occasions. Variously interpreted as a symbol of the transience of human life and as a wonder of modern industry, it is difficult to determine with certainty what associations the water-mill evoked for a contemporary audience. A number of Hobbema's landscapes have also been shown to be representations of actual mills found

24. Meindert Hobbema: *The Watermill*, *c.* 1665 (Paris, Musée du Louvre)

on the estate of Singraven near Denekamp in the province of Overijssel, and he may have accompanied Ruisdael on a sketching trip to this area. The specific mill in the above-mentioned painting and that in a close variant (Chicago, IL, A. Inst.) have not been identified. Unlike his earlier paintings of this subject, which were closely based on Ruisdael, the water-mill is placed less conspicuously in the middle distance and flooded by a brilliant light that spreads to the distant prospect glimpsed through the slender tree-trunks and feathery leafage.

With the *Wooded Landscape* (1667; Malibu, CA, Getty Mus.) the beginning of a new period of restraint and stillness can be detected. A greater freedom of brushstroke is apparent also, and foliage that was previously more precisely delineated is now summarily indicated. The juxtaposition of a darkened foreground, where shadows shimmer on the glassy surface of the water, with the sunlit fields beyond, greatly accentuates the sense of distance. The lively figures punctuating the banks of the pool, together with the billowing clouds and soaring birds, successfully create the impression of a wild and blustery day. In his *Forest Pond* (1668; Oberlin Coll., OH, Allen Mem. A. Mus.), Hobbema created an even more simplified composition with less elaborate trees carefully placed around a gently rippling brook. Also noticeable is the sketchy manner in which the grass and vegetation in the right foreground is painted. The mood here is again one of calm, achieved through a harmonious distribution of the pictorial elements.

Townscape is a rarity in Hobbema's oeuvre and the *View of the Haarlem Lock and the Herringpackers' Tower, Amsterdam* (London, N.G.) is his only widely accepted work in this genre. This marvellously vivid glimpse of Amsterdam canal life is an accurate portrayal of one of the city's principal sluice-gates and surrounding architecture. Although it has been dated to before 1662 (since it is known from later topographical sources that alterations were made to some of the buildings in that year), it is much more likely on stylistic grounds to have been executed in the latter half of the decade.

(iii) **Late works, 1668–1709.** In October 1668, Hobbema married Eeltje Pieters Vinck, four years his elder and kitchen-maid to the Amsterdam burgomaster Lambert Reynst. Hobbema must have maintained his links with his teacher during these years, as Ruisdael acted as a witness to the marriage. At this time also, Hobbema became a wine-gauger to the Amsterdam customs; this was a minor salaried post (which he held until his death), involving the supervision of the weighing and measuring of imported wines. It was long thought that Hobbema all but ceased to paint after his marriage and his subsequent municipal appointment. However, a revised reading of previously accepted dates on a number of established paintings and the discovery of new works has resulted in the reassessment of a small body of late landscapes. Nevertheless, it is apparent that Hobbema's activity as a painter greatly declined after 1668, and there are no certain paintings from the last two decades of his long life.

A decline in his artistic powers is also discernible in some of these late works. His painting of the *Ruins of Brederode Castle* (1671; London, N.G.), a picturesque structure near Haarlem that had suffered great damage in the Eighty Years War, lacks the inventiveness of earlier designs and is contrived in appearance. The trees that frame the ruined castle on a hill in the middle distance are thin and lifeless, their outlines brittle against a pale sky. There is a lack of modulation in the painting of the ruins and the general effete approach is emphasized by the awkward variations in tone and harsh colouring. The ducks, placed prominently in the foreground, are by a different hand, probably that of Dirck Wijntrack (before 1625–78). However, Hobbema still had one last ace to play, and his best-known work from these later years is the *Avenue of Trees at Middelharnis* (1689; see col. pl. XVIII). Hobbema's conception of a tree-lined avenue with a view of a distant town beyond receding perpendicularly from the picture plane is markedly in contrast to similar landscape compositions by Aelbert Cuyp and Jan van Kessel, a fellow pupil of Ruisdael with whom Hobbema is known to have remained in contact. Greater spaciousness is achieved by

minimizing the number of trees to two slender rows that define both the depth and the height of the composition. The painting differs from other 17th-century Dutch landscapes not only in its highly organized and symmetrical design but also in the inclusion of a gardener actively engaged in tending saplings. Indeed, attention has been drawn to the contrast between the more rugged view of nature on the left and the nurtured plantation in the right foreground. Hobbema's final years must have been difficult, not only financially but also because he had to endure the deaths of his two children and that of his wife in 1704. He was buried in a pauper's grave.

Hobbema was also apparently active as a draughtsman, although no signed drawings by him are known. Giltay has attributed a group of seven drawings to him, including five of watermills. Given the paucity of surviving work by Hobbema in this medium compared to other 17th-century Dutch landscape artists, preparatory drawings may only have played a minor part in his working method.

2. Critical reception and posthumous reputation

To judge from the few followers he attracted and from his failure to receive even a brief mention by Arnold Houbraken, Hobbema's achievements as painter must have been overlooked by his contemporaries. His name seldom appears in 17th- or 18th-century auction catalogues and his work often realized quite low prices. Indeed, it was well into the 19th century before he was rescued from obscurity; as late as 1859 the French art historian Théophile Thoré [pseud. Willem Bürger], who did much to rekindle interest in overlooked Dutch masters, bemoaned the lack of appreciation of Hobbema. However, it was in England in the second half of the century that the taste for Hobbema, and for his master Ruisdael, reached new heights, stimulated in part by the praise heaped on naturalistic Dutch landscape painting by artists such as Turner and Constable. Earlier, Hobbema had also been held in great affection by the Norwich school of landscape painters, especially by John Crome, whose *Poringland Oak* (London, Tate) recalls the work of the Dutch

master in its treatment of a gnarled oak against a glowing sky with vistas into the distance. The collecting of Hobbema's work also grew apace during these years, and in 1850 at The Hague, Richard Seymour-Conway, 4th Marquess of Hertford, paid what was then a record price for a landscape when he bought *The Water-mill* (London, Wallace) for 27,000 guilders.

Bibliography

W. Stechow: 'The Early Years of Hobbema', *A. Q* [Detroit], xxii (1959), pp. 3–18
—: *Dutch Landscape Painting of the Seventeenth Century* (London, 1966)
J. Giltay: 'De tekeningen van Jacob van Ruisdael', *Oud-Holland*, xciv (1980), pp. 141–208 [with Eng. summary]
Masters of 17th-century Dutch Landscape Painting (exh. cat., ed. P. C. Sutton; Amsterdam, Rijksmus.; Boston, MA, Mus. F.A.; Philadelphia, PA, Mus. A.; 1987–8)

JOHN LOUGHMAN

Hondecoeter, Melchior d'

(*b* Utrecht, 1636; *d* Amsterdam, 3 April 1695). Dutch painter, grandson of Gillis de Hondecoutre. His first teacher was his father Gijsbert Gillisz. de Hondecoutre, after whose death Melchior was taught by his uncle Jan Baptist Weenix. Melchior apparently became an assistant in his uncle's studio, and his earliest signed and dated work *Dog Defending Dead Game against a Bird of Prey* (1658; Le Havre, Mus. B.-A.) is in the style of Weenix.

Hondecoeter is mentioned as active in Pictura, The Hague painters' confraternity in 1659–63; his presentation piece was originally a seascape, which he withdrew and replaced with an animal painting. If the signature is correct on a painting dated 1661, *Still-life with Fish Pail* (Brunswick, Herzog Anton Ulrich-Mus.), he also experimented with a style and subject most closely associated with Abraham van Beyeren. While at The Hague he had a student, Willem Frederik van Royen (1645–1723), who became painter to the court at Potsdam.

On 9 February 1663 Hondecoeter married Susanna Tradel in Amsterdam. There is one dated picture of ducks and poultry from that year, but

no further dated works are known until 1668. That year, on 16 March, he was granted citizenship of Amsterdam; he lived on the Lauriergracht there until his death. In 1668 he painted two pictures, *Animals and Plants* (Amsterdam, Rijksmus.) and *Birds, Butterflies and a Frog among Plants and Fungi* (London, N.G.), which borrow heavily from works by Abraham Begeyn. But most of the paintings dated 1668 and thereafter are either game-pieces (often confused with those of Hondecoeter's cousin Jan Weenix) or the magnificent pictures of live birds most associated with his name.

Hondecoeter's mature style owes much to Frans Snyders, the important Flemish animal and still-life painter of a generation earlier, whose work he collected. From him, Hondecoeter borrowed a compositional formula that he used consistently from the late 1660s: birds and animals seen close up in the centre of the canvas, others entering from the left or right, their bodies sometimes cropped by the frame, the middle ground blocked by a wall, fence, tree or architectural ruins across one half of the canvas, the remaining side opening to a distant vista. Hondecoeter treated the latter in a variety of ways: a hilly landscape, a seascape, an Italianate mansion, the grounds of an estate, a forest or a farmhouse. The primary subject also varied: bird fights, birds being frightened or attacked, birds at rest. A white hen crouching with a chick protected under one wing and other chicks near by was a popular subject, repeated by Hondecoeter many times, for example *Hen and her Chicks* (c. 1657; Caen, Mus. B.-A.). In variations on this maternal theme, the hen protects her chicks from the feet of clumsy, larger birds, or from an approaching predator, or scolds them for having strayed too far from her.

Hondecoeter also painted what appear to be inventories of animals that focus on rare species, such as the pelican in the *Floating Feather* (e.g. Amsterdam, Rijksmus.). *Noah's Ark* (e.g. Brunswick, Herzog Anton Ulrich-Mus.) and Aesop's fable the *Vain Jackdaw* (e.g. The Hague, Mauritshuis) were other favourite subjects, together with occasional works based on popular Dutch proverbs or sayings. There are two extant portraits: *Anne Reijnst as a Young Woman* (c. 1680–85; Reims, Mus. St Denis) and *Johan Ortt on Horseback*, one of three equestrian subjects commissioned by Ortt in 1687 (London, Buckingham Pal., Royal Col.). Two splendid and highly unusual allegorical works, traditionally entitled the *Emblematic Representations of King William's Wars*, are in Holkham Hall, Norfolk. Both of these depict, in the upper half, battles fought in the air between birds (eagles, storks, herons and hawks), hideous monsters and demon bats, and, in the lower half, naval battles and the wreckage and destruction of war.

Hondecoeter supplied large paintings for the town houses and country mansions of rich Amsterdam burghers. Some are of such extravagant scale and sublime visual quality that they must be counted with the great mural decorations of the 17th century, for example *Park with Birds*, formerly in a house in Driemond, near Weesp (3.38×5.24 m; now Munich, Alte Pin.).

Hondecoeter does not seem to have made preparatory drawings, and there are few of certain authentication. Instead he recorded birds and animals from life in oil on canvas; he copied these whenever a certain species was required. Although 14 of these modelli were included in the inventory of his studio at the time of his death, only one is known: *Birds and Animal Sketches* (Lille, Mus. B.-A.), which is covered with detailed studies of 17 birds and a squirrel against a neutral grey ground. From 1668 throughout the rest of his career, Hondecoeter used many of these birds and the squirrel in his paintings, posed exactly as in the model. He habitually repeated entire passages from one painting to another and often made copies of compositions with only minor variations. From his vast output and its occasionally uneven quality, it appears that he was assisted in his studio. A contemporary, Adriaen van Oolen (d 1694), made a small industry of copying Hondecoeter's paintings, many of which van Oolen signed with his own name. Hondecoeter was also copied in the 18th century by Aert Schouman and many others of lesser skill. His work remained highly popular long after his death; in the 19th century he was known as the 'Raphael of bird painters'.

Bibliography

Thieme–Becker

A. Houbraken: *De groote schouburgh* (1718–21), iii, p. 68

A. Bredius: 'De schilders Melchior de Hondecoeter en
Johan le Ducq', *Archf Ned. Kstgesch.*, v (1882–3),
pp. 288–92

——: *Künstler-Inventare*, iv (The Hague, 1921)

M. Poch-Kalous: *Melchior de Hondecoeter* (exh. cat.,
Vienna, Gemäldegal. Akad. Bild. Kst., 1968)

RICHARD C. MÜHLBERGER

25. Abraham Hondius: *Pigeon Seller* (Paris, Musée du Louvre)

Hondius [de Hondt], Abraham (Danielsz.)

(*b* Rotterdam, 1625–30; *bur* London, 17 Sept 1691). Dutch painter, etcher and draughtsman, active also in England. He was the son of Daniel Abramsz. de Hondt, the city stone mason of Rotterdam. He is said to have received his first training from Pieter de Bloot (1601–58) and Cornelis Saftleven. This is confirmed by parallels between early paintings by Hondius and Saftleven, who worked in Rotterdam from 1637. Also in favour of this assumption is the fact that works by Hondius are often confused with those of Ludolf de Jongh, another pupil of Saftleven. Hondius successfully combined various stylistic influences in his compositions, without, however, developing a style of his own. More than two thirds of his paintings, etchings and drawings are animal pieces: hunting scenes, animals fighting and animal studies. He also represented landscapes, genre (see fig. 25), religious and mythological scenes such as *Pyramus and Thisbe* (*c.* 1600–65; Rotterdam, Boymans-van Beuningen), for which there is a rare preparatory drawing of the two main figures (sold Amsterdam, Sotheby's, 26 Nov 1984, lot 16).

He lived in Rotterdam until 1659, but as early as 1651 works such as *Hunter Offered Refreshment outside an Inn* (1651; sold London, Christie's, 11 April 1986, lot 26) reveal the influence of Flemish painting, in particular animal pieces by Frans Snyders and Jan Fyt. How Hondius came in touch with these Flemish examples remains speculative. One unlikely theory is that he was inspired by Carl Ruthart, the German painter of hunting scenes who has sometimes, wrongly, been called his teacher. Another possible intermediary was

Juriaen Jacobsz. (1625/6–95), a pupil of Frans Snyders, who lived in Amsterdam from 1658 to 1668 (Hentzen). Yet Hondius moved to Amsterdam only in 1659, which does not explain the pictures pre-dating that year that seem to indicate the artist's familiarity with Flemish models. The most likely possibility is that Hondius knew etchings by Fyt and prints after compositions by Snyders: these he might have seen in the studio of Cornelis Saftleven, who stayed in Antwerp for some time around 1632–4. Flemish influence can also be seen in Hondius's *Bear Hunt* (1655; ex-Delaroff priv. col., 1908, see W. Bernt: *Die niederländischen Maler des 17. Jahrhunderts*, ii (Munich, 1948), no. 394), which bears resemblances to engravings after Rubens, in particular those by Pieter Soutman. The source of the Flemish elements in his *Adoration of the Shepherds* (1663; Amsterdam, Rijksmus.) is the representation of the same

theme by Adriaen van Stalbemt (1622; Berlin, Gemäldegal.). Hondius was also influenced by Dutch artists, including Joachim Wtewael, Gerrit van Honthorst, Herman Saftleven (ii) and Karel Dujardin. The *Rest after the Hunt* (1662; Ansbach, Residenz & Staatsgal.) is usually considered his best work.

It is generally assumed that Hondius moved to London in 1666, where he spent the rest of his life. He painted views of London such as *A Frost Fair on the Thames at Temple Stairs* and *London Bridge* (1677; both London, Mus. London). The latest dated work is *Ape and Cat Fighting over Dead Poultry* (1690; sold London, Sotheby's, 11 July 1945, lot 151). He produced the majority of his rare 14 animal etchings in London. A series of eight appeared in 1672 (Hollstein, nos 1–8), but *A Wild Boar Attacked by Dogs* (Hollstein, no. 10) might be earlier. In the etchings and paintings of this period Hondius enlarged his animal representations in proportion to the picture surface area; the violent effect of the hunts and animal fights is thus intensified. Hondius often reused details from his own compositions, as in the *Hunt for Wild Boar and Deer* (1664; Hamburg, Ksthalle) where the dog lying on its back was repeated from the etching *A Wild Boar Attacked by Dogs*.

Bibliography

Hollstein: *Dut. & Flem.*; *NKL*; Thieme–Becker

A. Hentzen: 'Abraham Hondius', *Jb. Hamburg. Kstsamml.*, viii (1963), pp. 33–56

CHRISTIAAN SCHUCKMAN

Honthorst, Gerrit [Gérard] (Hermansz.) van [Gherardo delle Notti; Gherardo Fiammingo]

(*b* Utrecht, 4 Nov 1592; *d* Utrecht, 27 April 1656). Dutch painter and draughtsman. He came from a large Catholic family in Utrecht, with several artist members. His grandfather, Gerrit Huygensz. van Honthorst (*fl c.* 1575–9), and his father, Herman Gerritsz. van Honthorst (*fl c.* 1611–16), were textile and tapestry designers (*kleerschrijvers*); his father is also occasionally mentioned in documents as a painter. Both his grandfather and

father held official positions in the Utrecht artists' guilds, Gerrit Huygensz. from 1575 to 1579, and Herman Gerritsz. in 1616. Two of Gerrit Hermansz.'s brothers were also trained as artists. Herman Hermansz. van Honthorst (*fl* 1629–32) was trained to be a sculptor but later became a priest, and Willem Hermansz. van Honthorst (1594–1666) studied painting under Gerrit Hermansz., whose style he frequently emulated. Gerrit Hermansz. was the most successful artist in the family and the most famous member of the group of Utrecht Caravaggisti, the Dutch followers of Caravaggio. His predilection for turning the great Italian painter's dramatic patterns of natural light and shadow into nocturnal scenes with cleverly rendered effects of artificial illumination won him the Italian nickname 'Gherardo delle Notti'.

1. Life and work

(i) Training and visit to Italy, before mid-1620. Gerrit trained as a painter in the Utrecht studio of Abraham Bloemaert. He must have travelled to Italy between *c.* 1610 and 1615. It is probable that he arrived closer to 1610, given his numerous surviving Italian period commissions and the fact that he attracted the attention of such important Roman art patrons as Vincenzo Giustiniani, in whose palace he lived, Scipione Borghese and, in Florence, Cosimo II de' Medici, Grand Duke of Tuscany. According to the Italian art critic Giulio Mancini, who included a biography of van Honthorst in his *Considerazioni sulla pittura* (Rome, *c.* 1619–20), the young artist attended an academy for life drawing in Rome, a fact confirmed by a dated drawing of a *Male Nude* (1619; Dresden, Kupferstichkab.). Mancini also mentioned several paintings by him with unusual light effects. These include a *Nativity* (1620; Florence, Uffizi; see fig. 26), painted for Cosimo II, with the light source emanating from the Christ Child, and the important altarpiece of the *Beheading of St John the Baptist*, painted for the church of S Maria della Scala, Rome (1618; *in situ*), in which the scene is illuminated by torchlight. The masterpiece of van Honthorst's Roman period, *Christ before the High Priest* (*c.* 1617; London, N.G.), painted for

26. Gerrit van Honthorst: *Nativity*, 1620 (Florence, Galleria degli Uffizi)

Giustiniani, using a candle as light source, has been praised as an anticipation of Rembrandt's psychological insights, as well as of the works of Georges de La Tour. Not all of van Honthorst's Italian works employ artificial lighting; some, such as the striking *Liberation of St Peter* (c. 1616–20; Berlin, Bodemus.), also painted for Giustiniani, use the dramatic raking daylight often found in Roman period paintings by Caravaggio, for example the influential *Calling of St Matthew* (Rome, S Luigi dei Francesi), in which the light enters the composition from the right as it does in the van Honthorst painting.

(ii) Utrecht, mid 1620 28. In spring 1620 van Honthorst, together with another artist, one of the Colijn de Nole family of sculptors from Utrecht, left Rome for the northern Netherlands. His home-coming was celebrated on 26 July at the inn

'De Poortgen' in Utrecht, owned by his future mother-in-law, Bellichgen van Honthorst, a distant relative. The event was recorded in the diary of the Utrecht scholar Arnhout van Buchell; among those present were the painters Abraham Bloemaert and Paulus Moreelse, the engraver Crispijn de Passe I, the sculptors Robrecht (d 1636) and Jan (d 1624) Colijn de Nole and the artist and dealer Herman van Vollenhoven (fl 1611–27). In October of the same year van Honthorst married Sophia Coopmans, the daughter of a wine merchant. Several members of the Coopmans family, including Sophia's brother Dominicus, were artists. Soon after their marriage the van Honthorsts took up residence in a house on the Snippevlucht, a small street in the centre of Utrecht where Hendrick ter Brugghen also lived. It is uncertain, however, if the two artists were actually neighbours as it is not possible to document ter Brugghen's residence on

the Snippevlucht until 1627, the year van Honthorst moved to another part of Utrecht.

In 1622 van Honthorst became a member of the Utrecht Guild of St Luke, for which he served as dean in 1625, 1626, 1628 and 1629. As early as 1621, even before he had become a member of the Guild, van Honthorst began to attract international attention. A painting of *Aeneas Fleeing from the Sack of Troy* (untraced) was described enthusiastically in a letter of 1621 from Dudley Carleton, British Ambassador to The Hague, to the Earl of Arundel, in London. Van Honthorst's most important pictures of the early 1620s are his numerous artificially illuminated representations of both genre and religious subjects. Among the largest and most interesting of these is the full-length, life-size *Christ Crowned with Thorns* (c. 1622; Amsterdam, Rijksmus.). He also executed a number of paintings usually described as a *Merry Company* (e.g. 1622; Munich, Alte Pin.). Such compositions probably represent aspects of the parable of the Prodigal Son, rather than being pure genre depictions. The earliest example of this theme (1620; Florence, Uffizi), the picture described by Mancini as a *'cena di buffonarie'* ('meal of buffoonery'), was executed in Italy for Cosimo II rather than in Utrecht. In such compositions van Honthorst, like his Utrecht compatriot Dirck van Baburen, was probably strongly influenced by Bartolomeo Manfredi's interpretation of Caravaggio's style. Van Honthorst also painted numerous genre scenes illuminated by artificial light, such as the *Young Man Blowing on a Firebrand* (c. 1622; Brussels, priv. col., see Judson, 1959, fig. 16), apparently a re-creation of a lost antique picture described by Pliny the elder, and the *Dentist* (1622; Dresden, Staatl. Kstsammlungen), a Caravaggesque version of the traditional Netherlandish theme, painted for George Villiers, Duke of Buckingham.

In contrast to van Honthorst's various candle-light depictions are a number of musical subjects, all executed on either panel or canvas, which utilize the steep *di sotto in sù* perspective associated with Italian ceiling and wall frescoes. The most interesting and unusual of these paintings is the *Musical Ceiling* (1622; Malibu, CA, Getty Mus.), actually a fragment of what must have been a much larger ceiling decoration van Honthorst perhaps executed for one of the rooms in his own house. A piece of what was once an extremely tall, narrow canvas depicting *Venus and Adonis* (4.00×2.12 m, cut down in the early 20th century; Utrecht, Cent. Mus., where it is incorrectly attributed to Jan van Bijlert), with the same provenance as the *Musical Ceiling*, seems to indicate that as early as 1622 van Honthorst may have decorated an entire room in the Italian manner, thus anticipating the kind of large-scale painted decorative programme with which he was later to become involved for the various palaces of the House of Orange Nassau.

Although van Honthorst continued to paint Caravaggesque works, by 1624 a number of his pictures began to depart from the usual stylistic formulae of his fellow Utrecht Caravaggisti, and artificial illumination was used less frequently in his major compositions. In such single-figure compositions as the *Merry Violinist* (1623; Amsterdam, Rijksmus.) and its pendant, the *Singing Flautist* (Schwerin, Staatl. Mus.), the subject-matter and the composition owe their origins to various related paintings by the Utrecht artists Hendrick ter Brugghen and Dirck van Baburen. Van Honthorst added a strong sense of illusionistic space, however, by providing a window-like architectural framework. Neither painting uses the dramatic patterns of light and shade characteristic of van Honthorst's earlier development.

During the mid-1620s van Honthorst's style continued to fluctuate between his typically Caravaggesque, artificially illuminated compositions, such as the large and impressive *Denial of St Peter* (c. 1623; England, priv. col., see Nicolson, fig. 135), which reveals the influence of the French Caravaggesque artist Valentin de Boullogne, and such pictures as the *Concert Group* (1624; Paris, Louvre; see fig. 27), with its steep illusionistic perspective, cool daylight effects and bright colours. This work may have been executed as an overmantel for the Dutch stadholder's palace, Noordeinde, in The Hague, which would make it the first in a long series of commissions for the House of Orange Nassau. The diverse aspects of van

27. Gerrit van Honthorst: *Concert Group*, 1624 (Paris, Musée du Louvre)

Honthorst's style are still clearly apparent in two of his more important works from 1625: *The Procuress* (Utrecht, Cent. Mus.), a typically Utrecht Caravaggesque composition on panel, with a candle as light source, contrasting physiognomic types, a Manfredi-inspired *profil perdu* and a compact, half-length compositional format; and the full-length canvas *Granida and Daifilo* (Utrecht, Cent. Mus.), based on the first Dutch pastoral play, *Granida* (1605) by Pieter Cornelisz. Hooft (1581–1647). This pastoral theme had been introduced into Dutch art only two years earlier by another of the Utrecht Caravaggisti, Dirck van

Baburen. Van Honthorst's picture seems also to have been painted for one of the stadholder's palaces, indicating the growing courtly taste for pastoral and Classical themes in Dutch art at this time. Despite their differences in subject-matter and support, both pictures from 1625 reveal a crispness in the paint surface, and sharper outlines and edges than van Honthorst's earlier works. This stylistic tendency was to dominate his later artistic production.

During the summer of 1627 Peter Paul Rubens spent several days in Utrecht and, according to Joachim von Sandrart who was then a pupil of van

Honthorst, visited the studio of van Honthorst and also met other prominent Utrecht artists. The account is difficult to confirm: Rubens stayed at the Utrecht inn owned by ter Brugghen's brother rather than at 'De Poortgen', suggesting that Sandrart, in relating the facts about this visit, was biased in favour of his master. During the same year van Honthorst was paid for two paintings for the royal hunting-lodge at Honselaarsdijk: *Diana Hunting* (1627; ex-Berlin, Grunewald, Jagdschloss, untraced since 1945, see Judson, 1959, fig. 40), and probably a recently discovered *Diana Resting* (New York, priv. col.). These pictures are the earliest works that firmly document van Honthorst's association with the House of Orange Nassau, which was to play a significant part in the painter's artistic development after the mid-1630s.

(iii) England, 1628. From April until early December 1628 van Honthorst was in England. In addition to the large historiated portrait of King Charles I, his wife, Queen Henrietta Maria, and the Duke of Buckingham depicted as *Mercury Presenting the Liberal Arts to Apollo and Diana*, originally commissioned by Charles I for the Banqueting House in Whitehall, London (3.57×6.40 m; London, Hampton Court, Royal Col.), he also painted several portraits, including one of *Charles I* (London, N.P.G.), which may have served as the model for the Apollo in the Hampton Court picture. It is possible that van Honthorst's earlier contacts with the Duke of Buckingham, who appears as Mercury in the Hampton Court painting, as well as with Rubens, who later painted the ceiling in the Banqueting House and had also worked for the Duke of Buckingham, were instrumental in his obtaining this important commission. The picture was extremely well received, to judge by Sandrart's statement that van Honthorst was paid 3000 guilders and given many other costly gifts. On 28 November 1628 van Honthorst was made an English citizen and provided with a lifetime pension of £100 a year.

(iv) Utrecht, The Hague and international courtly circles, 1629–56. Van Honthorst probably received another important commission from Charles I, which he executed only after his return to Utrecht: a large historiated portrait of *Frederick V, King of Bohemia, and his Queen, Elizabeth Stuart, Daughter of James I, and their Children* (1629; Marienburg, Prinz Ernst August von Hannover). The picture may be the one that is mentioned in an early inventory of St James's Palace and is said to be based on Honoré d'Urfé's pastoral work *L'Astrée*, one of the favourite poems of Frederick V of Bohemia (1596–1632). The success of the works painted for the English court were important factors in diverting van Honthorst's talents in two new directions: towards an insipid but financially rewarding style of courtly portraiture and towards the more successful allegorical works in large-scale decorative schemes. With the death of Hendrick ter Brugghen in 1629 and van Honthorst's abandonment of Caravaggism in the early 1630s, Caravaggesque history and genre painting in Utrecht began to lose much of its vitality.

During the first half of the 1630s van Honthorst's international reputation continued to grow, especially in royal and courtly circles in England and elsewhere. In 1630, for example, his brother and assistant, Willem van Honthorst, was sent to England to deliver a group of paintings in person. When Kronborg Castle at Helsingør burnt down in 1629, Christian IV, King of Denmark and Norway, commissioned van Honthorst to paint various works including a series of four pictures based on the *Aethiopica* of Heliodorus of Emesa (*fl c.* 220–50), and four illusionistic ceiling paintings depicting flying putti carrying royal monograms for the decorations of the redesigned and rebuilt castle, all eight of which were apparently completed by 11 October 1635 (*in situ*). There are numerous other works by van Honthorst commissioned for Kronborg, some of which are dated as late as 1643.

Van Honthorst was firmly established in the courtly circles of The Hague during the early 1630s, although he continued to reside in Utrecht until 1637. He was patronized by King Frederick V and painted numerous portraits for Prince Frederick Henry and his family (e.g. *Portrait of William II, Prince of Orange*; see col. pl. XIX). Between 1636 and 1639 van Honthorst was part of

a team of artists involved with painting the decoration for the palaces of Honselaarsdijk and Rijswijk. He was paid the large sum of 6800 guilders for painting the ceiling decorations (untraced) for the grand hall at Rijswijk. It is likely that his work for the House of Orange Nassau was instrumental in his decision to move to The Hague, where he became a member of the Guild of St Luke in 1637. Among the best of the portraits painted at this time is the full-length double portrait of *Prince Frederick Henry and Amalia van Solms* (The Hague, Mauritshuis), executed shortly after van Honthorst took up residence in The Hague. In 1638, when Marie de' Medici, Queen of France, made a state visit to the northern Netherlands, Frederick Henry had van Honthorst paint a portrait of her (Amsterdam, Hist. Mus.), which she presented to the burgomasters of Amsterdam during her visit to that city. Van Honthorst was elected dean of the guild in 1640.

In 1649 Constantijn Huygens, secretary to Prince Frederick Henry, and the architect and painter Jacob van Campen invited van Honthorst to help decorate the Oranjezaal of the Huis ten Bosch, the most important extant large-scale painted hall in the Netherlands. The iconographic programme celebrated the long-awaited peace that had been concluded at the Treaty of Münster in 1648, which at last brought about official recognition of the United Provinces. Prince Frederick Henry did not live to see this historic event, having died in 1647, but in the centre of the hall's cupola, painted by van Honthorst and his workshop, he is glorified almost to the point of deification, as in *Frederick Henry's Steadfastness* (*in situ*). His widow, Amalia van Solms, who oversaw the completion of the project, also appears prominently, dressed in mourning and holding a skull. Van Honthorst's contributions to the Oranjezaal consisted only of allegorical portraiture, the best of which are the large *Allegory on the Marriage of Frederick Henry and Amalia van Solms* and the *Allegory on the Marriage of William II and Maria Henrietta Stuart* on the south wall (both *in situ*; see Judson, 1959, fig. 46).

In 1652 van Honthorst retired to Utrecht. There are relatively few works from after this date;

almost all are portraits, the most interesting of which are the pendant portraits of the artist and his wife (1655; Amsterdam, Rijksmus.). The compositional and secondary elements suggest that these works celebrate the 35th anniversary of the marriage of van Honthorst and Sophia Coopmans.

2. Working methods and technique

(i) **Workshop and pupils.** Soon after van Honthorst joined the Utrecht Guild of St Luke in 1622 he established a large and flourishing workshop and art academy, which attracted numerous students. Joachim von Sandrart, who studied with van Honthorst from *c.* 1625 until 1628, recorded that there were approximately 25 students in the studio when he was there and that each one paid 100 guilders a year for tuition, a considerable sum for the period. In 1627 van Honthorst purchased a large house on the Domkerkhof (Cathedral cemetery), apparently to house his growing atelier. Among van Honthorst's numerous pupils were Jan Gerritsz. van Bronchorst, Robert van Voerst (1597–*c.* 1636), Gerard van Kuijll (1604–73) and, according to Sandrart, the Dutch Italianate landscape painter Jan Both.

(ii) **Drawings.** Unlike his fellow Utrecht Caravaggisti, van Honthorst left a relatively large number of drawings. Since a number of these can be related to paintings it is clear that especially after *c.* 1625 he followed the working methods of his teacher Abraham Bloemaert rather than those of Caravaggio, who eschewed drawing in favour of direct painting. One of the most interesting surviving sheets is a signed and dated copy (1616; Oslo, N.G.) of Caravaggio's *Martyrdom of St Peter* in S Maria del Popolo, Rome. Among those drawings that can be directly related to paintings is the *Prodigal Son* (Vienna, Albertina) for the *Merry Company* (1622; Munich, Alte. Pin.; see fig. 2). Most of the drawings, however, reveal similar preoccupations with Caravaggesque themes and artificial light effects, the contrasting areas of shadow being rendered in bold brown washes, as in *Brothel Scene* (*c.* 1623; Oxford, Ashmolean) and *Old Woman Illuminating a Young Girl with a Candle* (*c.* 1625; Leipzig, Mus. Bild. Kst.).

3. Character and reputation

It is surprising, given van Honthorst's early artistic and social success among the Roman aristocracy, to find him described by Mancini as 'very reserved and melancholic'; but Mancini also praised him as 'a man of his word' who could be 'trusted to deliver a painting on the date promised'. Van Honthorst was equally successful after his return to the northern Netherlands, especially in courtly circles. Constantijn Huygens, in his autobiographical notes (c. 1630), included the artist along with Abraham Bloemaert, Dirck van Baburen and Hendrick ter Brugghen as one of the most important Dutch history painters of the time. He was considered 'one of the most famous painters of this [the 17th] century' by Jean Puget de La Serre, a member of Marie de' Medici's French entourage, who was impressed by van Honthorst's portrait of her (Amsterdam, Hist. Mus.). The same portrait was glorified in a poem by the Dutch writer Jan Vos. When van Honthorst's brother Herman, a Catholic priest, was thrown into a Utrecht prison in 1641 for his religious activities, no less a person than Prince Frederick Henry intervened on his behalf, a clear indication of the stadholder's high personal regard for the painter. He was a natural choice for the group of artists chosen by Huygens and van Campen in 1649 to decorate the Oranjezaal of the Huis ten Bosch. But a letter Huygens wrote the same year to Prince Frederick Henry's widow, Amalia van Solms, makes it clear that van Honthorst's reputation was by then beginning to slip, especially among the other artists working on the Huis ten Bosch decorations. Despite van Honthorst's declining reputation towards the end of his career, he had already become extremely rich through his artistic endeavours. When he sold his house to the city of The Hague in 1645, he received the princely sum of 17,250 guilders. About the same time he lent Elizabeth, Princess of Hohenzollern (1597–1660), no less than 35,000 guilders. Various other contemporary sources attest to the fact that van Honthorst lived in The Hague like a grand seigneur rather than an artist or artisan.

Bibliography

M. Nissen: 'Rembrandt und Honthorst', *Oud-Holland*, xxxii (1914), pp. 73–80

G. J. Hoogewerff: 'De werken van Gerard Honthorst te Rome', *Onze Kst*, xxxi (1917), pp. 37–50, 81–92

——: 'Honthorst in Italië: Een naschrift' [Honthorst in Italy: a postscript], *Onze Kst*, xxxi (1917), pp. 141–4

A. von Schneider: 'Gerard Honthorst und Judith Leyster', *Oud-Holland*, xl (1922), pp. 169–73

G. J. Hoogewerff: *Gerard van Honthorst* (The Hague, 1924; It. trans., Rome, 1924)

A. von Schneider: *Caravaggio und die Niederländer* (Marburg, 1933)

G. Isarlo: *Caravage et le caravagisme européen* (Aix-en-Provence, 1941)

J. G. van Gelder: 'De schilders van de Oranjezaal', *Ned. Ksthist. Jb.*, ii (1948/9), pp. 119–54

Caravaggio en de Nederlanden (exh. cat. by J. G. van Gelder, Utrecht, Cent. Mus.; Antwerp, Kon. Mus. S. Kst.; 1952)

O. Miller: 'Charles I, Honthorst and van Dyck', *Burl. Mag.*, xcvi (1954), pp. 36–9

E. K. J. Reznicek: 'Een vroeg portret van Gerard van Honthorst' [An early portrait by Gerard van Honthorst], *Oud-Holland*, lxx (1955), pp. 134–6

J. R. Judson: *Gerrit van Honthorst: A Discussion of his Position in Dutch Art* (The Hague, 1959) [incl. cat. rais.]

H. Braun: *Gerard und Willem van Honthorst* (diss., U. Göttingen, 1966)

J. R. Judson: 'The Honthorst Acquisition: A First for America', *Montreal Mus. Bull.* (1970), pp. 4–7

E. K. J. Reznicek: 'Hont Horstiana', *Ned. Ksthist. Jb.*, xxii (1972), pp. 167–89

J. A. L. de Meyere: 'Nieuwe gegevens over Gerard van Honthorst's beschilderd plafond uit 1622' [New facts about Gerard van Honthorst's painted ceiling of 1622], *Jb. Oud-Utrecht* (1976), pp. 7–29

B. Nicolson: *The International Caravaggesque Movement* (Oxford, 1979); review by L. J. Slatkes in *Simiolus*, xii (1981–2), pp. 167–83

H. Peter-Raupp: *Die Ikonographie des Oranjezaal* (Hildesheim and New York, 1980)

L. Derks, M. Plomp and J. Speth: *'De dood van Seneca': Door Gerard van Honthorst?* ['The Death of Seneca': by Gerard van Honthorst?] (Utrecht, 1982)

M. J. Bok and J. A. L. de Meyere: 'Schilders aan hun ezel: Nieuwe gegevens over het schilderij van Gerard van Honthorst' [Painters at their easels: new facts about the painting of Gerard van Honthorst], *Mdbl. Oud-Utrecht*, lviii (1985), pp. 298–301

Portretten van echt en trouw [Marriage portraits] (exh. cat. by E. de Jongh, Haarlem, Frans Halsmus., 1986)

Holländische Malerei in neuem Licht: Hendrick ter Brugghen und seine Zeitgenossen (exh. cat., ed. A. Blankert and L. J. Slatkes; Utrecht, Cent. Mus.; Brunswick, Herzog Anton Ulrich-Mus.; 1986–7), pp. 30–32, 276–302, nos 60–67 [entries on van Honthorst by M. J. Bok and M. Vermeer]

LEONARD J. SLATKES

Hooch [Hoogh; Hooghe], Pieter de

(*bapt* Rotterdam, 20 Dec 1629; *bur* Amsterdam, 24 March 1684). Dutch painter. He was one of the most accomplished 17th-century Dutch genre painters, excelling in the depiction of highly ordered interiors with domestic themes and merry companies and pioneering the depiction of genre scenes set in a sunlit courtyard. The hallmarks of his art are an unequalled responsiveness to subtle effects of daylight, and views to adjoining spaces, either through a doorway or a window, offering spatial as well as psychological release.

1. Life and work

(i) **Early life and early work in Delft, 1629–c. 1661.** De Hooch was the son of a bricklayer and a midwife. According to Houbraken, he was a pupil of the Haarlem landscape painter Nicolaes Berchem at the same time as Jacob Ochtervelt, a fellow Rotterdamer. Little or nothing of Berchem's style is detectable in de Hooch's early works, which mostly depict guardroom scenes. However, Ochtervelt went on to paint genre scenes with perspectival effects similar to those created by de Hooch. In 1652 de Hooch signed a document in Delft with the painter Hendrick van der Burgh, who subsequently became his follower and was probably his brother-in-law. De Hooch's early career as an artist seems to have required, as was commonly the case, a second career, and in 1652 he was described as both a painter and servant to a linen merchant, Justus de La Grange. An inventory of the latter's collection completed in 1655 lists 11 paintings by the artist. In the same year de Hooch joined the Delft Guild of St Luke and he made additional payments to the Guild in 1656 and 1657. De Hooch's paintings of guardrooms have plausibly been dated to the artist's early

career; they follow the tradition initiated by such artists as Pieter Codde, Willem Duyster and Anthonie Palamedesz., and they seem to reflect recent developments in the subject introduced by Gerbrand van den Eeckhout and Ludolf de Jongh. The latter's style is more fluid than de Hooch's but could have inspired not only his subjects but also aspects of his increasingly colourful palette.

De Hooch's paintings of guardrooms and peasant interiors are not as accomplished in terms of design and technique nor so sophisticated in their exploration of the expressive effects of light and space, although they often include a nascent interest in views to adjacent spaces, as in the artist's earliest dated paintings: six works from 1658, all depicting rectilinear interior genre scenes or sunny courtyard views with Delft motifs. These are the works of a mature master; indeed they include some of the greatest and best-known works by de Hooch, for example the *Card-players in a Sunlit Room* (London, Buckingham Pal., Royal Col.) and the *Courtyard in Delft with a Woman and Child* (London, N.G.). By 1658 de Hooch was a leading practitioner of the so-called Delft school style, the sources of which are still open to discussion; the style is characterized by a light tonality, dramatic perspectival effects and an exceptional responsiveness to natural light. Delft's greatest painter, Johannes Vermeer, who is also associated with this school, began painting carefully composed, light-filled interior genre scenes with couples and single figures at almost the same time as de Hooch. The two artists undoubtedly knew one another, but in the early years de Hooch (who was three years older) was probably the first to master the illusion of space and subtle lighting effects; Vermeer's only dated painting from the 1650s is *The Procuress* (1656; Dresden, Gemäldegal. Alte Meister)—a life-sized genre scene in the tradition of the earlier Utrecht Caravaggisti. However, Vermeer went on to refine de Hooch's ideas, reducing the elements of his art to a single, still, three-quarter-length figure in the corner of a light-filled room. By the time that de Hooch painted his *Woman Weighing Coins* in the mid-1660s (Berlin, Gemäldegal.), it was in deliberate emulation of, possibly even in competition with,

Vermeer's *Woman Holding a Balance* of several years earlier (Washington, DC, N.G.A.).

The subjects of de Hooch's mature Delft period were more conventional than their treatment. Merry companies with elegantly dressed young men and women gaming or sharing a drink (e.g. *Woman Drinking with Soldiers*, 1658; Paris, Louvre) were by this time standard themes in Dutch genre. More innovative was his contribution to the tradition of domestic subjects—images of women performing household chores, ministering to children or supervising maidservants, as in, for example, *Woman Nursing an Infant* (San Francisco, CA, Pal. Legion of Honor). De Hooch's celebration of domesticity is no doubt related to the sanctity and centrality of the home in Dutch society. In the Protestant Republic of the United Netherlands, the home rather than the church became the primary forum for moral instruction and pedagogy. By the mid-17th century the social history of the family had also changed, as the old medieval extended family was increasingly replaced by a smaller, more intimate nuclear family group. De Hooch's orderly spaces perfectly complemented this new celebration of domesticity, the walls and their light-filled windows and doorways creating a comforting framework for chores and nurturance. By the same token, his small courtyards are an extension of the home and are constructed with virtually the same spatial formulae as his interiors (e.g. *Interior of a Courtyard in Delft*, c. 1660; The Hague, Mauritshuis; see col. pl. XX). Some of these scenes include identifiable buildings, for example the Oude Kerk and Nieuwe Kerk in Delft, but are in fact imaginary compositions. Although independent inventions, de Hooch's courtyards, too, are related to the rise (especially in Delft) of the Townscape as an independent sub-genre of landscape painting.

Iconographic studies of Dutch genre paintings have often revealed 'hidden meanings', or what Erwin Panofsky called 'disguised symbolism', in outwardly naturalistic scenes. De Hooch did not share the metaphorical and highly moralizing approach of some of his contemporaries, notably Jan Steen and, closer at hand, Vermeer, but he would occasionally employ time-honoured symbolic devices, such as the painting-within-the-painting, to comment on his scenes. The meanings of his art usually arise from the associations of the subjects depicted, such as his images of domestic virtue, rather than through covertly encoded ideas. When he introduced symbols, they usually functioned as supplementary footnotes rather than the central theme of his works of art.

(ii) **Amsterdam, c. 1661 and after.** De Hooch had settled in Amsterdam by April 1661, or perhaps as much as 11 months earlier. There he apparently remained for the rest of his life except for a visit to Delft in 1663. Although he never abandoned his favourite domestic themes (e.g. *Interior with Women beside a Linen Chest*, 1663; Amsterdam, Rijksmus.), de Hooch painted increasingly elegant subjects and wealthier households after his move. After c. 1663 his interior spaces, following the earlier examples of Gabriel Metsu and Jan Steen, became richer; his figures, in the manner of Gerard ter Borch, more refined; and his touch, like that of the Leiden 'Fine' painters, more minute (e.g. *The Cardplayers*, 1663–5, Paris, Louvre; see fig. 28). His simple Delft courtyards were replaced by the gardens of country villas, and his earlier cottage interiors by palatial halls, some of which are partly based on the galleries of the new Town Hall (now Royal Palace) in Amsterdam (e.g. the *Musical Company*, c. 1664–6; Leipzig, Mus. Bild. Kst.). In the late 1660s and 1670s de Hooch's palette became darker and his technique broader, and he often executed larger canvases. His address in these years suggests that he lived in a poor quarter of the town, although he continued occasionally to receive important portrait commissions (e.g. the portrait of the *Jacott–Hoppesack Family*, c. 1670; untraced, see Sutton, no. 92). The quality of his execution wavered increasingly in the late 1670s and after c. 1680 deteriorated alarmingly. It is unknown whether these developments were related to the painter's final illness: de Hooch died in the *Dolhuis* (Dut.: 'Bedlam'). However, the splendid twilit *Musical Party in a Courtyard* (1677; London, N.G.) proves that the artist was capable of outstanding work even late in his career.

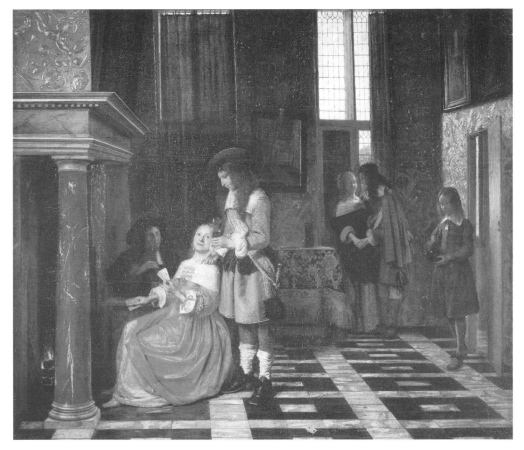

28. Pieter de Hooch: *The Cardplayers*, 1663–5 (Paris, Musée du Louvre)

2. Influence

Since de Hooch had no known pupils, the 'de Hooch School' is a misnomer. However, several artists worked in his style; the closest of these followers was Hendrick van den Burgh; Pieter Janssens Elinga (1623–before 1682) painted highly ordered interiors, but more rigidly than de Hooch, and he seems to have relied heavily on perspective recipes. The interest in interior perspectives exhibited by Cornelis de Man (1621–1706) probably acknowledges a debt to his younger Delft colleagues de Hooch and Vermeer. The work of Esaias Boursse and Jacobus Vrel also resembles aspects of de Hooch's paintings (and many of Vrel's paintings bear signatures altered to de Hooch's), but these two painters were essentially independent artists with no known contacts with the master. Jacob Ochtervelt was a highly accomplished painter in his own right who perhaps borrowed from de Hooch in conceiving his foyer scenes, but he ultimately created his own style, one that owes as much to Leiden and Frans van Mieris as to Delft. In the 20th century Han van Meegeren painted two 'de Hooch's', one of which was acquired in 1941 by Daniel van Beuningen, who always refused to accept that it was a forgery.

Bibliography

A. Houbraken: *De grote schouburgh* (1718–21), ii, pp. 27, 34

C. Hofstede de Groot: *Catalogue of Dutch Painters*, i (London, 1908), pp. 471–570

A. de Rudder: *Pieter de Hooch et son oeuvre* (Brussels and Paris, 1913)

C. H. Collins Baker: *Pieter de Hooch* (London, 1925)

C. Brière-Misme: 'Tableaux inédits ou peu connus de Pieter de Hooch', *Gaz. B.-A.*, n.s. 4, xv (1927), pp. 361–80; xvi (1927), pp. 51–79, 258–9

W. R. Valentiner: *Pieter de Hooch*, Klass. Kst. Gesamtausgaben, xxxv (Stuttgart, 1929)

F. W. S. van Thienen: *Pieter de Hoogh*, Palet Series, v (Amsterdam, n.d. [*c.* 1945])

P. C. Sutton: *Pieter de Hooch: Complete Edition with a Catalogue Raisonné* (New York, 1980)

<div align="right">PETER C. SUTTON</div>

Hooghe, Romeyn de

(*bapt* Amsterdam, 10 Sept 1645; *bur* Haarlem, 15 June 1708). Dutch etcher, draughtsman, painter, sculptor, medallist and writer. He is best known for his political caricatures of Louis XIV of France and for his prints glorifying William III, Stadholder of the Netherlands and King of England. De Hooghe is an important representative of the late Dutch Baroque. His style is characterized by strong contrasts of lights and darks and an expressive composition. In his prints he combined contemporary personalities with allegorical figures. His prints are numerous, but few of his drawings survive and his paintings are rarer still. De Hooghe's first commission for an etching probably came from Constantijn Huygens the elder, secretary to William III; this was *Zeestraet* (1667; Hollstein, no. 287). In 1668 de Hooghe was in Paris, where he produced some book illustrations, but he returned to Amsterdam, where from 1670 to 1691 he illustrated the annual newsheet *Hollandsche Mercurius*. He regularly produced such political prints as *William III Sworn in as Commander-in-Chief of the Republican Forces* (1672; Hollstein, no. 84); this event took place after Louis XIV had invaded the Netherlands, and thereafter de Hooghe was kept busy producing prints reflecting the course of the war (e.g. *Admiral de Ruyter's Victories over the English and French Fleets*, 1673; Hollstein, nos 75–6). De Hooghe also executed prints glorifying the exploits of John Sobieski, King of Poland (e.g. *John III of Poland*, 1673; Hollstein, no. 101), as well as an etching of the *Wedding of Franciscus Mollo* (1674; Hollstein, no. 388), who later became King John's representative in Amsterdam (1676–1721). In 1675 de Hooghe was created a Polish peer, possibly due to Mollo. From 1675 there are a number of prints of the new Portuguese Synagogue in Amsterdam (Hollstein, nos 116–18). On 18 February 1676 de Hooghe signed a contract to make 22 views of Delft and its surroundings for the book dealer J. Rammazijn of The Hague. Early in 1687 he was living in Haarlem following a dispute with the Amsterdam Church Council. In 1687–8 he was a Commissioner of Justice in Haarlem, and in 1688 he built a house and a drawing school. He also made a large map of the city of Haarlem.

De Hooghe commemorated the joint coronation of William III and Mary Stuart in England in 1689 (Hollstein, nos 149–51), and in the same year the King appointed him commissioner in charge of the exploration of stone quarries in the German town of Lingen in order to provide building material for the royal hunting lodge of Het Loo, for which he also designed garden statues and ponds (see Hollstein, nos 308–21). On 3 June of the same year he became a Doctor of Law at Harderwijk University. For the next three years (1689–91) de Hooghe, a passionate royalist, waged a pamphlet war with the Republicans in Amsterdam. He remained a dedicated Orangist and designed triumphal arches for the occasion of William III's official entry to The Hague in February 1691.

From 1692 to 1694 de Hooghe worked in Alkmaar, designing a medallion for the city corporation, a painting on panel in the Grote Kerk (the St Lawrenskerk) and ceiling and grisaille paintings for the town hall. In 1699 he made a series of 138 biblical engravings for Basagne's illustrated Bible and a ceiling painting in the Doelen building in Rotterdam. Between 1701 and 1703 he designed church windows for Zaandam and Hoorn and in 1707 mural paintings for the town hall in Enkhuizen. These latter were

executed by others after his death. De Hooghe also wrote several political and historical treatises, including the *Spiegel van staat des Verenigde Nederlands*, for which he executed a number of allegorical illustrations (Hollstein, nos 737–52).

Writings

Spiegel van staat des Verenigde Nederlands [Mirror of the state of the United Netherlands,], 2 vols (Amsterdam, 1706–7)

Bibliography

Hollstein: *Dut. & Flem.*; *NKL*; Thieme–Becker

M. D. Henkel: 'Romeyn de Hooghe als illustrator', *Mdbl. Beeld. Kst.*, iii (1926), pp. 261ff and 300ff

J. Landwehr: *Romeyn de Hooghe as Book Illustrator: A Bibliography* (Amsterdam, 1970)

——: *Romeyn de Hooghe the Etcher: Contemporary Portrayal of Europe, 1662–1707* (Leiden, 1973)

W. H. Wilson: *The Art of Romeyn de Hooghe: An Atlas of Late European Baroque Culture* (diss., Cambridge, MA, Harvard U., 1974) [includes cat. of drgs]

——: '*The Circumcision*: A Drawing by Romeyn de Hooghe', *Master Drgs*, xxii (1975), pp. 250–58

<div align="right">M. J. C. OTTEN</div>

Hoogstraten [Hoogstraeten], Samuel van

(*b* Dordrecht, 2 Aug 1627; *d* Dordrecht, 19 Nov 1678). Dutch painter, draughtsman, engraver and writer. His multi-faceted art and career testify amply to the unflagging ambition attributed to him as early as 1718 by his pupil and first biographer, Arnold Houbraken. During his lifetime van Hoogstraten was recognized as a painter, poet, man of letters, sometime courtier and prominent citizen of his native city of Dordrecht, where he served for several years as an official of the Mint of Holland. Today he is remembered not only as a pupil and early critic of Rembrandt, but also as a versatile artist in his own right. His diverse oeuvre consists of paintings, drawings and prints whose subjects range from conventional portraits, histories and genre pictures to illusionistic experiments with *trompe-l'oeil* still-lifes, architectural perspectives and perspective boxes. He also wrote the major Dutch painting treatise of the late 17th century, the *Inleyding tot de hooge schoole*

der schilderkonst, anders de zichtbaere werelt ('Introduction to the academy of painting, or the visible world'; Rotterdam, 1678).

1. Life and work

(i) Training and early work in Amsterdam and Dordrecht, before 1651.

Samuel was the eldest of seven children born to Dirck van Hoogstraten (1596–1640) and Maeiken de Coninck (1598–1645). Both parents belonged to Mennonite families of skilled artisans and had emigrated from Antwerp to Dordrecht about the turn of the 17th century. Van Hoogstraten's maternal grandfather and great-grandfather were silversmiths who held hereditary titles to positions at the Mint of Holland, titles later passed on to Samuel and his brother François (1632–96). The privileges of this office helped Samuel raise his family's social and economic status. Several of van Hoogstraten's relatives, including his paternal grandfather, Hans (1568–1605), were recorded as members of the Guild of St Luke in Antwerp during the 16th century. Samuel's father Dirck, initially trained as a gold- and silversmith, later took up painting and by 1624 was registered as a painter in the Guild of St Luke in Dordrecht. His marriage in 1626 to Maeiken, daughter of the silversmith Isaac de Coninck, suggests that Dirck remained within the high artisanal milieu that his son increasingly left behind. The few surviving paintings, prints and drawings that bear Dirck's signature suggest that he specialized in figures and historical subjects.

According to his own testimony, van Hoogstraten was apprenticed to his father until Dirck's death in 1640. That Dirck taught his son the rudiments of drawing and the technique of engraving is evident in Samuel's earliest extant work, a signed engraving of a medicinal plant, known as scurvy-grass, used in the treatment of that disease. This little print served as an illustration to the Dordrecht physician Johan van Beverwijck's medical treatise on scurvy, *Van de blaauw Schuyt* (Dordrecht, 1642).

Van Hoogstraten entered Rembrandt's studio in Amsterdam, probably in 1642, and remained there for several years. He was recorded again in Dordrecht in 1648, for his adult baptism in the

Mennonite community. His years of training in Rembrandt's studio brought van Hoogstraten into contact with such diverse talents as Bernard Keil from Denmark, Juriaen Ovens from Germany, Philips Koninck, a distant relative of van Hoogstraten's mother, Abraham Furnerius and Carel Fabritius. His surviving work from the 1640s consists of paintings, etchings and drawings that imitate Rembrandt's manner so closely that in the past a number of them have been attributed to Rembrandt himself. Van Hoogstraten's earliest dated paintings, both from 1644, are the *Self-portrait Wearing a Turban* (The Hague, Mus. Bredius) and the *Young Man Reading (Self-portrait with Vanitas)* (Rotterdam, Boymans–van Beuningen). These costumed self-portraits reveal an obvious debt to Rembrandt in their richly worked paint surfaces and theatrical approach to self-portrayal and show early evidence of the interest in self-representation that van Hoogstraten retained throughout his life. Unlike his teacher, who portrayed himself in a wide variety of roles and guises, van Hoogstraten presented a relatively consistent self-image in his portraits, one that owed much to the imagery of the ideal courtier. His *Self-portrait Wearing a Medallion and Chain* (Vaduz, Samml. Liechtenstein) of 1645 is the first of several self-representations to feature those tokens of wealth and princely esteem.

The elaborately finished *Birth of the Virgin* (Paris, Fond. Custodia, Inst. Néer.) is a fine example of a van Hoogstraten drawing long thought to be the work of Rembrandt, but its typically finicky draughtsmanship, with overworked outlines and rigidly hemmed-in forms, distinguishes van Hoogstraten's style from that of his teacher. Numerous student compositional exercises and life drawings offer valuable documentation of Rembrandt's pedagogical practice in the studio. During the mid-1640s van Hoogstraten produced many fully signed drawings, resembling paintings on paper, that follow Rembrandt's practice of rehearsing narrative subjects in highly elaborated drawings. *Bileam Blessing the Israelites* (1646; London, BM) and the *Visitation* (1648; Amsterdam, Hist. Mus.) are typical of this group in their careful attention to details of setting and the combined use of ink, chalks and washes to create a wide range of textual and tonal effects. The illustrative quality of these works, which resembles that of Rembrandt's small biblical narratives of the 1630s and 1640s, also characterizes van Hoogstraten's narrative paintings of the period (e.g. *Adoration of the Shepherds*, 1647; Dordrecht, Dordrechts Mus.). Rembrandt's style dominated van Hoogstraten's art for several years after his return to Dordrecht in the late 1640s. Dated works, such as the etching of the *Jews before Pilate* (1648), a small panel of *Christ Appearing to his Disciples* (1649; Mainz, Landesmus.) and such drawings as the *Circumcision* (*c.* 1649; Dresden, Kupferstichkab.) and the *Street Scene with Quarrelling Women* (1650; Amsterdam, Rijksmus.) show how strongly van Hoogstraten remained under his teacher's artistic influence during these years.

In Dordrecht, van Hoogstraten's activities were motivated by closely linked social and professional ambitions. He made his entry into Dordrecht's literary circles as early as 1649 with the publication of occasional poems and of presentation verses in books by local writers. In 1650 he published his first book, *Schoone Rosalin* ('Beautiful Rosalin'), a combined prose pastoral and epistolary novel. In 1648 and 1650 he published rhymed tributes to the House of Orange on the occasions of the Peace of Münster, the death of William II and the birth of William III, possibly in connection with court commissions he sought or had obtained. He also presented himself as a portrait painter to the court in a pen drawing of 1649 (Munich, Staatl. Graph. Samml.), which shows him holding a cartouche inscribed with verses by the Dordrecht poet Carel van Nispen, praising van Hoogstraten as painter of the princes of Orange. A letter of 1671 (Paris, Fond. Custodia, Inst. Néer.) indicates that van Hoogstraten at some time made several portraits for the court, including one of Princess Juliana Catharina of Nassau Portugal. His cultivation of court patrons went hand in hand with his adoption of certain aristocratic practices, then fashionable among Holland's wealthy urban patriciate. He was, for example, the first in his family to display a coat of arms. The family crest appears

as part of a witty inscription, which he wrote in 1650, in the *album amicorum* of Johan Mulheuser (The Hague, Kon. Bib.). He also adopted the aristocratic fashion of wearing a sword, thereby alienating himself from the Mennonite community, which looked unfavourably on courtly affectations and forbade its members to bear arms of any sort. Van Hoogstraten's open defiance of the community's proscriptions ultimately led to his public reprimand.

(ii) Work abroad and in Dordrecht, 1651–78. On 16 May 1651, two weeks after his reprimand, van Hoogstraten departed for Germany, Italy and the court of Emperor Ferdinand III in Vienna and did not return to Dordrecht until 1655. The trip marked a turning-point in his career, for during this sojourn he developed the interest in the artifice of *trompe l'oeil* that would remain central to his mature art and his professional identity (see fig. 29). He also made the acquaintance of several men well-connected in artistic circles. According to his own account, he joined the Schildersbent,

29. Samuel van Hoogstraten: *Trompe l'oeil*, 1655 (Vienna, Akademie der Bildenden Künste)

an association of Dutch artists in Rome, where his host was the Dutch painter-naturalist, Otto Marseus van Schrieck. He was received by the painter-publisher Matthäus Merian in Frankfurt. In Regensburg he made the acquaintance of several clerics, including Gabriel Bucelinus, the Benedictine abbot who helped van Hoogstraten secure the commission for the *Vision of St Benedict* (Weingarten Basilica). Most decisive for van Hoogstraten's career was his decoration at the Habsburg court in Vienna in 1651, when he received a gold chain and medallion of honour from Ferdinand III in recognition of his talents as a painter of *bedriegertjes* ('little deceivers' or *trompe-l'oeil* pictures), such as the *View of the Imperial Palace* (1652) and the *Head of a Man at a Window Trellis* (1653; both Vienna, Ksthist. Mus.; see col. pl. XXI). The witty *Feigned Cabinet Door* (1655; Vienna, Gemäldegal. Akad. Bild. Kst.) is the first of several self-reflexive *trompe-l'oeil* pieces in which van Hoogstraten presents his imperial medallion and chain as a personal trademark within a display of the mimetic virtuosity it honours.

Van Hoogstraten was recorded again in Dordrecht on his investiture as master of the Mint of Holland in May 1656. His assumption of this post and its privileges, along with his marriage three weeks later to Sara Balen, the niece of the town historian Matthys Balen, situated the artist squarely within the city's most important political and social institutions. For marrying into this prominent Dordrecht family van Hoogstraten was expelled from the Mennonite community. In January 1657 he and his wife officially joined the Dutch Reformed Church. In that year, too, he enlisted the patronage of Adriaen van Blyenburgh, burgomaster of Dordrecht, in publishing *Den eerlijk jongeling, ofte de edele konst van zich by groote en kleyne te doen eeren en beminnen* ('The honourable youth, or the noble art of making oneself honoured and esteemed by one and all'), a courtier's manual, adapted from Nicolas Faret's *Honneste Homme ou l'art de plaire à la cour* of 1631. Of particular interest in this text are van Hoogstraten's remarks on 'Painting, Poetry and the Knowledge of Geography and Languages',

which replace Faret's passing reference to painting with a discussion of the value of both pictorial and verbal literacy.

News of van Hoogstraten's professional successes abroad, along with his family and government connections, soon brought him several commissions for portraits, including a large portrait of the *Masters and Officers of the Mint* (Dordrecht, Dordrechts Mus.), which he completed in 1657. He continued to paint portraits and histories as well as more experimental pictures dealing with domestic themes explored in works of genre painters like Gabriel Metsu, Gerard ter Borch (ii) and Johannes Vermeer. The haunting *Interior Viewed through a Doorway ('The Slippers')* (c. 1657; Paris, Louvre), which presents a covert view into a woman's boudoir, exemplifies van Hoogstraten's interest in curious perspectives. This clandestine view, which centres on a painting of a woman receiving a letter, also serves as van Hoogstraten's pictorial commentary on the images of letter reading and writing which figured so prominently in mid-century Dutch genre painting. Van Hoogstraten's experimentation with perspective's illusionistic effects culminated with his ingenious *Perspective Box of a Dutch Interior* (c. 1657–61; London, N.G.). This device, which van Hoogstraten celebrated in his treatise for its compelling illusions of scale, offers a delightful demonstration of how the eye is deceived through the artifices of vision and painting. Experiments of this sort and instructional performances played an important part in the lessons given by van Hoogstraten in the teaching studio which he opened in his home sometime after his return to Dordrecht in the mid-1650s. His pupils, according to Houbraken, included Godfried Schalcken, Cornelis van der Meulen and Aert de Gelder.

Despite his apparent success in Dordrecht, van Hoogstraten again left his home town in 1662, this time for London. A letter that he wrote in that year to the Dordrecht merchant and writer Willem van Blyenburgh suggests that he was lured to England by the prospect of lucrative commissions at the court of the newly restored Stuart monarch, Charles II. During his stay in England, van Hoogstraten established contacts with various aristocratic patrons, for whom he painted portraits, and with members of the Royal Society, including Thomas Povey, Secretary to the Duke of York. In 1662 van Hoogstraten painted the *View down a Corridor* (Dyrham Park, Avon, NT) for Povey's house in London. This piece of perspective, admired by Samuel Pepys in his diary, was one of several large works of this kind devised for English patrons. Among the most intriguing of these pictures are the *'Tuscan Gallery'* (Innes House, Grampian) and the portraits of aristocrats set into complicated architectural perspectives, such as his *Sir John Finch Reading in a Courtyard* (Salisbury, priv. col., see Sumowski (1983), no. 898).

Van Hoogstraten remained in England until after the Great Fire of London in 1666, which he both witnessed and commemorated in verse. In January 1668 he was recorded as a member of Pictura, the painters' confraternity in The Hague, where he lived until 1671. His most impressive commission from these years was for a set of eight three-quarter-length portraits of the family of Maerten Pauw (1616–80), Receiver General of Holland, which was completed in 1671 (Zeist, Pauw van Wieldrecht, priv. col., see Sumowski (1983), nos 870–71). The aristocratic taste for elegance that these portraits display characterizes van Hoogstraten's work in other genres at this time, such as the *Woman, Nurse and Child by a Cradle* (1670; Springfield, MA, Mus. F.A.) and the *Perspective of a Courtyard with a Woman Reading a Letter* (The Hague, Mauritshuis). During these years van Hoogstraten also celebrated his accomplishments of the previous decades in his most accomplished *trompe-l'oeil* paintings. The culmination of these is the *'Trompe-l'oeil' of a Letter-rack Painting* (c. 1670; Karlsruhe, Staatl. Ksthalle). In this *tour de force* of illusionist artifice, van Hoogstraten represents his professional and social identity through the illusionistic depiction of a variety of objects—writing implements, books he has written, documents, personal insignia, including the imperial medallion and chain—all of which call attention to his status and achievements as poet, courtier and painter of highly valued deceptions.

In 1671 van Hoogstraten purchased a house in Dordrecht, where he resided until his death in 1678. As Provost of the Mint of Holland from 1673 to 1676 the artist took a more active role in the affairs of the Mint than he had during the previous two decades. His change in status is clearly reflected in his portrait of the *Officers and Masters of the Mint* (1674; Dordrecht, Dordrechts Mus.), in which he featured himself prominently displaying his medallion and chain. As his health declined during these years, so did his pictorial output. His only dated pictures from this time, apart from a few patrician portraits, are the illustrations for his painting treatise and for Matthys Balen's monumental descriptive history of the city, the *Beschryvinge der stadt Dordrecht* ('Description of the city of Dordrecht'; Dordrecht, 1677). Both of these projects offer rich testimony to the artist's overriding concern with self-perpetuation in his later years.

2. Theoretical writing

The *Inleyding tot de hooge schoole der schilderkonst, anders de zichtbaere werelt*, van Hoogstraten's long treatise on painting (nearly 400 pp.), published just months before he died in 1678, was his last and most ambitious accomplishment. With its lively intermingling of art theoretical topoi and anecdotes of the artist's own life, the *Inleyding* is both a compendium of received knowledge about painting and a concerted effort to validate van Hoogstraten's art and the pictorial tradition to which it belongs. The treatise is of particular value for its first-hand accounts of Rembrandt and his studio, and as one of a handful of vernacular writings by Dutch artists offering keen commentary on the nature and assumptions of Dutch painting.

Van Hoogstraten compiled his text, which purports to be a step-by-step introduction to all that is known about painting, from a wide range of literary sources, both ancient and modern. Its apparent breadth of erudition owes much to the two most important vernacular compendia on painting, Karel van Mander's *Schilder-boeck* (Haarlem, [1603]–1604) and Francis Junius's *De schilderkonst der oude* ('The Painting of the

Ancients'; Middelburg, 1641), from which van Hoogstraten drew most of his citations. He also incorporated material from Albrecht Dürer's writings, from the recently published Dutch treatises on painting and drawing by Willem Goeree and from a variety of other sources not specifically concerned with painting. From the standpoint of literary history, it is significant that with few minor exceptions van Hoogstraten's compilation relies entirely on vernacular writings and translations.

Van Hoogstraten was spurred in this ambitious undertaking by the formidable example of Karel van Mander, the artist-writer whose seminal *Schilder-boeck* remained the most widely-read and authoritative of the few Dutch art treatises published during the 17th century. Van Hoogstraten sought to revise his predecessor's work by reintegrating pieces of van Mander's didactic poem on painting and his biographies of the painters with numerous other texts to form an academy in book form, where 'one might learn everything pertaining to the art and through practice become a master in it'.

Van Hoogstraten linked the pedagogical and compilatory aims of his 'academy' by way of a carefully elaborated structure: he divided the work into nine books or 'classrooms', each of which he dedicated to one of the Muses, following the encyclopedic tradition that saw the Muses as the overseers of all fields of human endeavour and knowledge. He further clarified the treatise's structure by furnishing each book with an etched title-page illustration and verses of his own devising that explain the conceit of each print and announce the contents of the book it introduces.

The academic framework of the *Inleyding* and its extensive borrowings from Junius give it a superficial resemblance to the classicizing writings on art by French and Italian theorists of the 17th century. While it shares their academic preoccupation with codifying the precepts by which art can be learnt, van Hoogstraten's analysis of painting is not informed by a similarly classicist aesthetic. As its subtitle suggests, the *Inleyding* treats painting first and foremost as the means of representing the entire visible world. Both in its

aims and in its encyclopedic organization, the treatise has more fundamental ties to the projects and goals of England's Royal Society. These links are most evident in van Hoogstraten's emphasis on the pedagogical importance of devising and following a clearly gradated, sequential method of instruction, and in the ways his text consistently values 'know-how' above abstract knowledge, echoing the experimental values of the new-style science.

The *Inleyding* was published in a single edition by the author's brother, François, and appeared only at the close of the great age of Dutch painting. Although it did not enjoy the popularity and influence of van Mander's *Schilder-boeck* in its own time, van Hoogstraten's treatise continues to interest students of Dutch art, both for its contemporary critical appraisal of Rembrandt's art and teaching and for its telling commentary on the specific concerns and character of 17th-century Dutch painting. The best-known passages of the treatise include van Hoogstraten's remarks on Rembrandt's '*Night Watch*', on the use of emblems in painting, the hierarchy of pictorial subjects, the camera obscura and the perspective box. Of special interest are his lesser-known commentaries on pictorial literacy, likeness and difference in portraiture, truth and accuracy in history painting, and the symbiotic relationship of form and colour in the perception and representation of the visible world. Throughout these discussions, van Hoogstraten liberally recast the traditional rhetoric of art to emphasize the descriptive and illusionistic aspects of painting that he explored so assiduously in his own art. With this unusual focus on the imitative and deceptive properties of pictures, van Hoogstraten's *Inleyding* provides a fascinating defence of its author's artistic achievement and of the Netherlandish pictorial tradition as a whole.

Writings

Den eerlyken jongeling of de edele konst van zich by groote en kleyne te doen eeren en beminnen [The honourable youth, or the noble art of making oneself honoured and esteemed by one and all] (Dordrecht, 1657); adapted from N. Faret: *Honneste Homme ou l'art de plaire à la cour* (Paris, 1631)

Inleyding tot de hooge schoole der schilderkonst, anders de zichtbaere werelt [Introduction to the academy of painting, or the visible world] (Rotterdam, 1678/*R* Soest, 1969; Ann Arbor, 1980)

Bibliography

Hollstein: *Dut. & Flem.*; *NNBW*; Thieme–Becker

general

S. Slive: *Rembrandt and his Critics, 1639–1730* (The Hague, 1953)

J. A. Emmens: *Rembrandt en de regels van de kunst* (Utrecht, 1967)

Rembrandt after 300 Years (exh. cat., Chicago, IL, A. Inst., 1969)

Rembrandt and his Pupils (exh. cat., Montreal, Mus. F.A., 1969)

Tot lering en vermaak; Betekenissen van Hollandse genrevorstellingen uit de zeventiende eeuw [To instruct and delight: meanings of Dutch genre painting in the 17th century] (exh. cat., ed. E. de Jongh; Amsterdam, Rijksmus., 1976), pp. 14–20, 134–7

Stilleben in Europa (exh. cat., Münster, Westfäl. Landesmus.; Baden-Baden, Staatl. Ksthalle; 1980)

J. Bruyn and others, eds: *A Corpus of Rembrandt Paintings*, i (Boston, London and The Hague, 1982)

Still-life Painting in the Age of Rembrandt (exh. cat., ed. E. de Jongh and others; Auckland, C.A.G., 1982)

Das Stilleben und sein Gegenstand (exh. cat., ed. H. Seifertova and others; Dresden, Albertinum, 1983)

B. Haak: *The Golden Age: Dutch Painters of the Seventeenth Century* (New York, 1984)

G. Schwartz: *Rembrandt: His Life, his Paintings* (New York, 1985)

E. van de Wetering: 'Problems of Apprenticeship and Studio Collaboration', *A Corpus of Rembrandt Paintings*, ed. J. Bruyn and others, ii (Boston, London and The Hague, 1985), pp. 45–90

Masters of Seventeenth Century Dutch Genre Painting (exh. cat., ed. P. Sutton; Philadelphia, PA, Mus. A.; W. Berlin, Gemäldegal.; London, RA; 1985)

Portretten van echt en trouw: Huwelijk en gezin in de Nederlandse kunst van de zeventiende eeuw [Portraits of marriage and fidelity: marriage and household in the Dutch art of the 17th century] (exh. cat., ed. E. de Jongh; Haarlem, Frans Halsmus., 1986)

C. Brown and others: 'Samuel van Hoogstraten: Perspective and Painting', *N. G. Tech. Bull.*, ii (1987), pp. 60–85

S. Alpers: *Rembrandt's Enterprise: The Studio and the Market* (Chicago, 1988)

early sources

A. Houbraken: *De groote schouburgh* (1718–21), ii,
pp. 155–70

W. Strauss and M. van der Meulen: *The Rembrandt
Documents* (New York, 1979); review by B. P. J. Broos in
Simiolus, xii/4 (1981), pp. 245–62

catalogues raisonnés

W. Sumowski: *Drawings of the Rembrandt School*, viii
(New York, 1981)

——: *Gemälde der Rembrandt-Schüler*, ii (Landau, 1983)

representational theory

U. Schneede: 'De wonderlijcke Perspectiefkas:
Hoogstraten's perfekte Tauschungen', *Artis*, xviii
(1966–7), pp. 25–6

S. Koslow: 'De wonderlijke perspectyfkas', *Oud-Holland*,
lxxxii/1–2 (1967), pp. 35–56

E. de Jongh: 'Realisme en schijn-realisme in de
schilderkunst van de zeventiende eeuw', *Rembrandt
en zijn tijd* (exh. cat., Brussels, Mus. A. Anc., 1971),
pp. 143–94

F. Leeman, ed.: *Hidden Images: Games of Perception,
Anamorphic Art and Illusion* (New York, 1975)

H. Vey: 'Samuel van Hoogstraten (1627–78):
Augenbetrüger', *Jb. Staatl. Kstsamml. Baden-
Württemberg*, xii (1975), pp. 282–3

A. K. Wheelock jr: *Perspective, Optics and Delft Artists
around 1650* (New York, 1976)

S. Alpers: *The Art of Describing* (Chicago, 1983), pp. 38–9,
58–64, 76–9, 141–2

C. Brusati: *The Nature and Status of Pictorial
Representation in the Art and Theoretical Writing
of Samuel van Hoogstraten* (diss., Berkeley, U. CA,
1984)

H. Seifertovà: 'Augenbetrüger und ihre Motivation im
17. Jahrhundert', *Dresdn. Kstbl.*, lxxxiv/2 (1984),
pp. 49–56

J. Muylle: 'Schilderkunst en kunstenaarsbiografieën als
specula: Metafoor, fictie en historiciteit' [Painting
and artist biographies as *specula*: metaphor,
fiction and historicity], *17de eeuw*, ii/1 (1986),
pp. 41–56

E. J. Sluiter: 'Beleering en verhulling? Enkele 17de eeuwse
teksten over de schilderkunst en de iconologische
benadering van Noordnederlandse Schilderijen uit
deze periode' [Teaching and concealing: 17th-century
texts on painting and the iconological approach of
North Netherlandish paintings of the period], *17de
eeuw*, iv/2 (1988), pp. 3–28

drawings

*Rembrandt and his Century: Dutch Drawings of the
Seventeenth Century from the Collection of Fritz Lugt*
(exh. cat., ed. C. van Hasselt; New York, Pierpont
Morgan Lib.; Paris, Fond. Custodia, Inst. Néer.; 1977–8),
pp. 83–5

*Figure Studies: Dutch Drawings of the Seventeenth
Century* (exh. cat. by P. Schatborn, Amsterdam,
Rijksmus.; Washington, DC, N.G.A.; 1981)

Rembrandt en de tekenaars uit zijn omgeving [Rembrandt
and the draughtsmen from his circle] (exh. cat. by
B. P. J. Broos, Amsterdam, Hist. Mus., 1981)

Bij Rembrandt in de leer/Rembrandt as Teacher (exh. cat.
by P. Schatborn, Amsterdam, Rembrandthuis, 1984–5)

specialist studies

G. H. Veth: 'Dirck van Hoogstraten', *Oud-Holland*, iv
(1886), pp. 272–7

——: 'Aantekeningen omtrent eenige Dordrechtsche
schilders: XVII. Samuel van Hoogstraten' [Some notes
on Dordrecht painters: XVII. Samuel van Hoogstraten],
Oud-Holland, vii (1889), pp. 125–48

A. G. van Hamel: 'François van Hoogstraten (1632–96)',
Rotterdam. Jb., 2nd ser., ix (1921), pp. 49–66

W. Sumowski: 'Hoogstraten und Elsheimer', *Kunstchronik*,
xix (1966), pp. 302–4

E. J. Wolleswinkel: 'De portrettenverzameling van Mr Jan
Willem van Hoogstraten (1722–70)', *Jb. Cent. Bureau
Geneal.* (1980), pp. 68–95

M. Roscam Abbing: *Van Hoogstraten: Iconographie van
een familie* (Amsterdam, 1987)

R. Schillemans: 'Gabriel Bucelinus and "The Names of the
Most Distinguished European Painters"', *Hoogsteder-
Naumann Mercury*, vi (1987), pp. 25–38

C. BRUSATI

Houckgeest [Hoeckgeest], Gerrit [Geraert; Gerard]

(*b* The Hague, ?1600; *d* Bergen op Zoom, Aug
1661). Dutch painter. He was a nephew of the
conservative portrait painter Joachim (Ottensz.)
Houckgeest (*b c.* 1585; *d* before 13 June 1644), but
he was probably a pupil of the architect and archi-
tectural painter Bartholomeus van Bassen at The
Hague. Houckgeest joined the painters' guild
there in 1625. By 1635 he had moved to nearby
Delft, where he was married in 1636; he was men-
tioned as a member of the local guild in 1639. In

the same year he re-entered the guild at The Hague and in 1640 was cited as the designer of tapestries for the assembly hall of the States General there.

No picture by Houckgeest is known to date from before 1635, when he painted *Charles I and Henrietta Maria Dining in Public* (London, Hampton Court, Royal Col.). The composition represents a few dozen figures in an imaginary palace and is similar to van Bassen's *The King and Queen of Bohemia Dining in Public* (1634; sold London, Sotheby's, 27 March 1974). Other early works by Houckgeest, such as the *Open Gallery in an Imaginary Palace* (1638; Edinburgh, N.G.), also follow van Bassen in favouring arbitrarily arranged Baroque classical architectural elements on a monumental scale. As in the mostly imaginary Gothic church interiors painted in Antwerp by Houckgeest's near contemporary Pieter Neeffs (i), Houckgeest used a central or somewhat off-centre vanishing point to draw the eye to the deepest area of space; full-length architectural forms in the foreground act as repoussoirs, creating the impression of a self-contained and inaccessible stage set. Houckgeest continued to paint imaginary palace views and church interiors during the 1640s. The precise draughtsmanship and local colouring in his work contrast with the tonal palette and the choice of real buildings as subjects in the work of another contemporary, Pieter Saenredam. However, Saenredam's portraits of churches appear to have inspired a few of Houckgeest's less conventional compositional schemes, such as the *Imaginary Catholic Church* (1640; The Hague, Schilderijenzaal Prins Willem V). Houckgeest's church interiors of the 1640s reveal a gradual development towards more accessible space and more realistic qualities of light and atmosphere.

In 1650 Houckgeest shifted suddenly from depicting imaginary architecture to portraying the interiors of the Nieuwe Kerk and Oude Kerk in Delft. It appears likely that Houckgeest's new approach originated in a commission, probably for the large panel *Interior of the Nieuwe Kerk in Delft with the Tomb of William the Silent* (1650; Hamburg, Ksthalle). The famous monument, an Orangist (royalist) and national symbol, was depicted by van Bassen in 1620 and by Dirck van Delen in 1645, in both cases in imaginary settings. Houckgeest, by contrast, represented the monument *in situ*, within the choir of the church, taking an oblique view through the colonnade from the ambulatory. He employed an expansive perspective scheme that seems to extend beyond the limits of the picture field. The near photographic fidelity of his architectural views dating from 1650 and 1651 may indicate that he used a 'perspective frame'. This mechanical drawing device, familiar from treatises such as Samuel Marolois's *Perspectiva* (Amsterdam, 1628), could have been used both to record the view and to determine the composition. Houckgeest also introduced a lighter and more uniform colour scheme, convincingly suggesting daylight and atmosphere.

Houckgeest's new compositional scheme, consisting of a 'two-point' recession to the sides with a low horizon and usually a tall format, was applied again to the choir of the Nieuwe Kerk (e.g. two panels, both dated 1651; The Hague, Mauritshuis); to the Oude Kerk with the tomb of Piet Hein (as recorded in a copy by Hendrick van Vliet, Amsterdam, Rijksmus.); and to views centred on the pulpits of the two Delft churches. Fewer than a dozen views of actual church interiors from the early 1650s are known, but these pictures provided indispensable models for the early works of Hendrick van Vliet and Emanuel de Witte.

From 1653 until his death Houckgeest lived in the small port of Bergen op Zoom in North Brabant, where he painted an interior view of the local cathedral (1655; Copenhagen, Stat. Mus. Kst), but this and his few late quayside scenes of imposing houses are in a distinctly retardataire style, perhaps because Houckgeest was closer to Antwerp than to any centre of Dutch art.

Bibliography

L. de Vries: 'Gerard Houckgeest', *Jb. Hamburg. Kstsamml.*, xx (1975), pp. 25–56

W. A. Liedtke: *Architectural Painting in Delft: Gerard Houckgeest, Hendrick van Vliet, Emanuel de Witte* (Doornspijk, 1982)

WALTER LIEDTKE

Jonson [Janson; Johnson] van Ceulen, Cornelis [Cornelius], I

(*b* London, 14 Oct 1593; *d* Utrecht, 5 Aug 1661). English painter of Flemish descent, active also in the northern Netherlands. He was the son of Cornelis Jonson of Antwerp and Jane Le Grand, who had fled to London to escape religious persecution. His grandfather Peter Jansen originally came from Cologne, so the family often used the name Jonson van Ceulen. Cornelis Jonson probably trained as a painter in the northern Netherlands, returning to London about 1618, where he worked for the next 25 years as a portrait painter. In 1622 he married Elizabeth Beck [Beek, Beke] of Colchester, a woman of Dutch origin who bore him two sons. The couple are portrayed with their son, Cornelis van Ceulen II (1634–1715), in a portrait by Adriaen Hanneman (*c.* 1637; Enschede, Rijksmus. Twenthe).

1. England, c. 1618–43

A few signed works by Jonson survive from 1617, but the majority of signed or monogrammed portraits, which number several hundred, date from 1619 and the following decades. Jonson is the first English-born painter known to have produced such a large number of signed portraits. Although he was certainly not a pace-setting portrait painter in early Stuart London, he still received many commissions. In addition to original paintings, he produced copies after the work of other artists, for example a monogrammed copy (1631; Chatsworth, Derbys) of the portrait of *Charles I* by Daniel Mijtens I (1629; New York, Met.). Since Jonson signed the painting it is clear that he was not simply one of Mijtens's studio assistants but rather an independent painter who was commissioned, either through Mijtens or directly, to copy the original. This type of work probably explains the mention of him in 1632 as 'his Majesty's servant in the quality of Picture drawer'.

Most of Jonson's original works during his London period are portraits of people in the higher, but not the highest, social circles. A large majority of these portraits are busts, simple in composition and ably reproducing the sitters' features. Some are set in a *trompe l'oeil* oval, painted to imitate a stone niche. Many of these bust portraits are in English public, and particularly private, collections, for example the portrait of *Sir Thomas Hanmer* (1631; Cardiff, N. Mus.) and the two small pendants *Portrait of a Man* and *Portrait of a Woman* (*c.* 1629; London, Tate).

In spite of Jonson's somewhat conservative style, he absorbed some influence from such artists as Daniel Mijtens I and Anthony van Dyck, particularly in his more ambitious works, such as the three-quarter-length portraits that he painted regularly and the group portrait of the *Family of Arthur, Lord Capel* (*c.* 1639; London, N.P.G.), which is strongly inspired by van Dyck. In addition to large-scale paintings, Jonson also produced miniatures in oil on copper, including some signed examples, such as the *Portrait of a Man* (1639; Welbeck Abbey, Notts, see 1972 exh. cat., no. 205) and the portraits of *Peter Vanderput* and his wife *Jane Hoste* (London, Lord Thomson of Fleet priv. col.; see London, Sotheby's, 6 March 1967, lot 75). Some of the miniatures are reduced reproductions of full-size paintings.

2. The Netherlands, 1643–61

The painter and his household left England in 1643 at the start of the Civil War, settling first in Middelburg. In 1646 Jonson was living in Amsterdam while he painted a large group portrait of the *Magistrates of The Hague* (1647; The Hague, Oude Stadhuis). In subsequent years he painted portraits of the citizens of various Dutch cities, including Middelburg, suggesting that he led an itinerant life for some time. His final place of residence was probably Utrecht.

In the many portraits produced during his Dutch period, Jonson brought his personal style to its greatest perfection. Besides a few group portraits, his paintings were primarily half-length and three-quarter-length portraits notable for their elegance and their accurate rendering of the sitter's features and clothing. The paintings frequently use blue and green backgrounds, not a practice then currently fashionable. Representative examples of Jonson's later portrait paintings include *Helena Leonora de Sieveri* (1650; Utrecht, Cent. Mus.); *Jasper Schade* and *Cornelia*

Strick (both 1654; Enschede, Rijksmus. Twenthe); the *Portrait of a Woman* (1655; London, N.G.); *Prince William III of Orange Nassau as a Child* (1657; Knole, Kent, NT); and the *Portrait of a Woman* (1659; London, Tate). Jonson's most important student was his son Cornelis II, whose style initially resembled his father's but whose later work declined sharply to a mediocre level.

Bibliography

Foskett; Thieme–Becker; *Waterhouse: 16th & 17th C.*
A. J. Finberg: 'A Chronological List of Portraits by Cornelius Johnson', *Walpole Soc.*, x (1922), pp. 1–37
E. Waterhouse: *Painting in Britain, 1530 to 1790*, Pelican Hist. A. (London, 1953)
M. Whinney and O. Millar: *English Art, 1625–1714*, Oxford Hist. Eng. A. (Oxford, 1957)
The Age of Charles I: Painting in England, 1620–1649 (exh. cat. by O. Millar, London, Tate, 1972), nos 31–8, 140, 205–7
M. Edmond: 'Limners and Picturemakers: New Light on the Lives of Miniaturists and Large-scale Portrait Painters Working in London in the Sixteenth and Seventeenth Centuries', *Walpole Soc.*, xlvii (1978–80), pp. 60–242
D. Foskett: *Collecting Miniatures* (Woodbridge, 1979)

RUDOLF EKKART

Kalf [Kalff], Willem

(*b* Rotterdam, 1619; *d* Amsterdam, 31 July 1693). Dutch painter, art dealer and appraiser. He was thought for a long time to have been born in 1622, but H. E. van Gelder's important archival research established the artist's correct place and date of birth. Kalf came from a prosperous patrician family in Rotterdam, where his father, a cloth merchant, also held municipal posts. In the late 1630s he travelled to Paris and spent a long time in the circle of Flemish artists in St Germain-des-Prés, Paris. In Paris he painted mostly small-scale rustic interiors and still-lifes. Kalf's rustic interiors are dominated by accumulations of buckets, pots and pans and vegetables, which he arranged as a still-life in the foreground (e.g. *Kitchen Still-life*, Dresden, Gemäldegal. Alte Meister). Figures usually appeared only in the obscurity of the background. Though painted in Paris, these pictures belong to a pictorial tradition practised primarily in Flanders in the first half of the 17th century by such artists as David Teniers. The only indications of their French origin are a few objects that Flemish exponents of the same genre would not have incorporated into their works. Kalf's rustic interiors had a major influence on French art in the circle of the Le Nain brothers. The semi-monochrome still-lifes Kalf produced in Paris form a link with the *banketjes* or 'little banquet pieces' painted by the Dutch artists Pieter Claesz., Willem Claesz. Heda and others in the 1630s. During the course of the 1640s Kalf developed the *banketje* into a new form of sumptuous and ornate still-life (*pronkstilleven*), depicting rich accumulations of gold and silver vessels. Like most still-lifes of this period, these were usually *vanitas* allegories.

Kalf returned to Rotterdam from Paris in 1646 but did not stay there. He moved to Hoorn, West Friesland, where in 1651 he married Cornelia Pluvier (*b c.* 1626; *d* 6 Feb 1711), a cultivated young woman in the circle of Constantijn Huygens. There are no dated works between 1646 and 1653. By 1653 he was in Amsterdam, where he remained until his death.

It was not until after 1653 that he produced his most elaborate and colourful still-lifes (e.g. *Still-life with a Chinese Bowl*; Berlin, Gemäldegal.), which established his central position in the history of Dutch still-life painting. These still-lifes also had their roots in the *banketje* tradition, but Kalf refined the type he had developed in Paris still further. He focused on a limited number of valuable objects: silver vessels, Chinese porcelain dishes or plates, expensive cut glass, gold goblets, Persian carpets, lobsters, oranges, peaches and the ubiquitous partially peeled lemons, which he arranged in differing positions according to a strictly axial compositional pattern. He was a master at capturing the effects of light, whether reflected through a glass or on the edge of a silver platter. His paintings create the illusion of reality with such virtuosity that his work is often compared to that of Vermeer. An essential feature of Kalf's still-life paintings was the fact that he often produced his compositions in series. He frequently rearranged or replaced a number of

objects within the same basic pattern, allowing the viewer to interpret the composition in various ways. Several objects in his still-lifes can still be identified as specific individual items, for example the drinking-horn (Amsterdam, Rijksmus.) of the Amsterdam St Sebastian or Arquebusiers' Guild (*Cloveniersgilde*), which appears in the still-life of c. 1653 in the National Gallery, London, or a 16th-century rock-crystal bowl (Munich, Residenzmus.) designed by Hans Holbein the younger for Henry VIII, which appears in the still-life of 1678 in the Statens Museum for Kunst, Copenhagen. It is not certain whether these pictures were commissions.

Among his late works is a small group of still-lifes with mussels (e.g. Zurich, Ksthaus). He lived to the age of 73, but after 1663 he appears to have painted less and less. According to Houbraken, he became an art dealer and appraiser towards the end of his life. Kalf ranks as the most accomplished painter of the third generation of 17th-century Dutch still-life artists, who were active in the 1650s when the genre reached its height. Owing to his remarkable pictorial skills, he extended the illusionistic possibilities of the genre, but in so doing he deprived it of some of its traditional iconographic intent.

Bibliography

A. Houbraken: *De groote schouburgh* (1718–21)

H. E. van Gelder: *W. C. Heda, A. van Beyeren, W. Kalf* (Amsterdam, [1941])

——: 'Aantekeningen over Willem Kalf en Cornelia Pluvier' [Notes concerning Willem Kalf and Cornelia Pluvier], *Oud-Holland*, lix (1942), pp. 37–46

R. von Luttervelt: 'Aantekeningen over de ontwikkeling van W.K.' [Notes concerning the development of W.K.], *Oud-Holland*, lx (1943), pp. 60–68

I. Bergström: *Dutch Still-life Painting in the Seventeenth Century* (London, 1956)

L. Grisebach: *Willem Kalf, 1619–1693* (Berlin, 1974/*R* 1978); review by S. A. C. Dudok van Heel in *Mdbl. Amstelodamum*, lxi (1974), pp. 94–6; review by B. Haak in *Antiek*, ix/6 (1975), pp. 645–6

Still-life in the Age of Rembrandt (exh. cat. by E. de Jongh and others, Auckland, C.A.G., 1982)

LUCIUS GRISEBACH

Keyser, de

Dutch family of artists. They originated from Utrecht and were active mainly in Amsterdam, Delft and London. Cornelis Dirxz. de Keyser was a cabinetmaker in Utrecht, and his youngest son, Hendrick de Keyser I, became a talented sculptor and architect and the most renowned member of the family. Hendrick's sons, Pieter de Keyser and Willem de Keyser, followed in his footsteps but did not reach the heights of his artistic accomplishments, while Thomas de Keyser became a significant portrait painter. The fourth son, Hendrick de Keyser II (*b* Amsterdam, 1613; *d* Amsterdam, *bur* 26 Sept 1665), worked from 1633 to 1647 in London in the studio of Nicholas Stone I, the English sculptor and architect with whom Hendrick de Keyser I had become acquainted during a short stay in London in 1606–7; Stone had gone back to Amsterdam with Hendrick I to finish his training, had married Hendrick's daughter Maria de Keyser, returned to London and eventually became Master Mason to Charles I of England (1632). Huybrecht de Keyser (*b* Utrecht, 1592; *d* Amsterdam, *bur* 20 Dec 1678), Hendrick de Keyser I's nephew, was also a sculptor and mason in Amsterdam.

PAUL H. REM

(1) Thomas (Hendricksz.) de Keyser

(*b* ?Amsterdam, 1596–7; *d* Amsterdam, *bur* 7 June 1667). Painter, son of Hendrick de Keyser I. Following an apprenticeship with an unidentified master in painting, he trained from 1616 to 1618 with his father in architecture. Although he ultimately followed his father and two brothers, Pieter and Willem, into service for the city of Amsterdam as city mason (1662–7), no designs for buildings by Thomas are known, with the exception of an unbuilt triumphal arch published in Salomon de Bray's *Architectura moderna* (1631). Thomas de Keyser turned to painting, producing highly original portraits. He played a significant role in creating innovative portrait types that were favoured by members of the newly risen class of Dutch burghers. He worked in nearly every type of portrait format produced in the northern Netherlands in the 17th century.

While there is little chronological development in de Keyser's work, there are nonetheless distinct stylistic differences in his portrait types. Throughout his career he worked over the surfaces of his panels with a free, yet meticulous, touch that distinguishes his work from the transparent glazes of Gerrit Dou and the work of the Leiden 'fine' painters, which his small interiors otherwise recall. He possessed a delicate sensibility for unusual colour contrasts and for gradations of tone, even within the greys and blacks of his more soberly dressed patrons. In contrast to the dusky interiors of Gerard Terborch (ii)'s genre scenes (similar in theme to many of de Keyser's small-scale portraits), the clear, airless rooms in which de Keyser's sitters stand or sit are crisply delineated; such attention to architectural detail no doubt reflects in part his training and continued exposure to the building activities of his family.

Circumstantial evidence indicates that his teacher may have been Cornelis van der Voort (1576–1624), a leading Amsterdam portrait painter of the previous generation. De Keyser seems also to have been aware of the work of Werner van den Valckert and his near contemporary Nicolaes Eliasz. Pickenoy. The *Anatomy Lesson of Sebastiaen Egbertsz. de Vrij* (1619; Amsterdam, Hist. Mus.), for many years considered de Keyser's earliest dated painting, has been convincingly reattributed to Pickenoy (see 1993–4 exh. cat., no. 268). De Keyser seems to have obtained the commissions for several of his paintings through the patrons of his family's architectural practice.

During the second half of the 1620s de Keyser evolved the genre for which he is best known: the small-scale full-length portrait of a figure in a contemporary interior. In these works he combined the prestige of traditional compositions and attributes of court portraiture with everyday objects to produce a highly original type. His portrait of *Constantijn Huygens and his Clerk* depicts the Stadholder's secretary seated at a table, accepting a letter from a deferential youth. The image recalls works such as Titian's *Paul III and his Grandsons* (Naples, Capodimonte), but de Keyser placed Huygens in a realistically rendered study, surrounded by objects that refer to his wide-ranging interests and pursuits. De Keyser's largest and most important portrait commission was his *Company of Captain Allaert Cloeck and Lieutenant Lucas Jacobsz. Rotgans*, finished in 1632 (Amsterdam, Rijksmus.). His two early designs for the work (Copenhagen, Stat. Mus. Kst; ex-Albertina, Vienna) depict the men in active poses and a variety of military costume that presage some of the innovative conventions of Rembrandt's '*Night Watch*'. The more traditional treatment of the painting as finished may have responded to the desire of the predominantly Remonstrant group to align themselves with the prestige of their 16th-century predecessors. De Keyser probably obtained the commission through his brother Pieter de Keyser, who at the time was enlarging the Kloveniersdoelen in which it was to hang.

By the mid-1630s, when his own children were young, de Keyser painted several innovative family portraits in the small-scale format. Such paintings as *Portrait of a Couple and Two Children* (1639; Oslo, N.G.) are among the earliest examples in the northern Netherlands to treat the family in a secular context. Much later, in the early 1660s, de Keyser once again reduced a full-length court portrait type, the equestrian portrait, for his patrons with patrician pretensions (see below). He also created several portraits of figures in historical settings, including a highly unusual portrait subject, a *Biblical Scene*, possibly representing Tobias with Tobit regaining his sight, with a portrait of a man (1633; Utrecht, Catharijneconvent). While almost exclusively a portrait painter, de Keyser painted a number of religious subjects around 1635, including a *Crucifixion* (Moscow, Pushkin Mus.) and a pendent pair, an *Entombment* (Antwerp, priv. col., see Adams, no. 62) and a *Resurrection* (see Adams, no. 63). These lack the originality of his portraits and were probably composed with the aid of prints.

Like many artists in the volatile economy of the northern Netherlands during the 1640s, de Keyser turned much of his energy to another profession, joining his brother Pieter in the trading of building stone and marble. Both their sources and their markets were international, including substantial

dealings with their brother-in-law Nicholas Stone in London. The resultant contact with contemporary English court portraiture may have inspired certain elements in de Keyser's work, specifically his use of the small-scale full-length format. Although his production declined in the 1640s, de Keyser did not cease painting altogether. The portraits from these years most often represent colleagues of his new activities: architects, sculptors and engineers. In 1652 he obtained the commission for an important history painting, *Ulysses Beseeching Nausicaa*, for Amsterdam's new Stadhuis (now Royal Palace) at the time when his brother Willem was overseeing its construction. De Keyser's last known painting, *Equestrian Portrait of Two Men* (Dresden, Zwinger, Gemäldegal. Alte Meister), dates from 1661. De Keyser's compositions and iconography had considerable impact, not only on subsequent Dutch portraiture but also on Dutch genre painting; there is a reciprocal influence, for example, between the imagery of his small-scale full-length portraits and that of the portraits and genre paintings of Pieter Codde and Willem Duyster during the 1620s.

Bibliography

A. Riegl: 'Das holländische Gruppenporträt', *Jb. Ksthist. Samml. Wien*, xiii (1902), pp. 71–278; rev. by L. Munz, 2 vols (Vienna, 1931)
R. Oldenburgh: *Thomas de Keysers Tätigkeit als Maler* (Leipzig, 1911)
A. J. Adams: *The Paintings of Thomas de Keyser (1596/7–1667): A Study in Portraiture in Seventeenth-century Amsterdam* (diss., Cambridge, MA, Harvard U., 1985)
Dawn of the Golden Age: Northern Netherlandish Art, 1580–1620 (exh. cat., ed. G. Luijten and others; Amsterdam, Rijksmus., 1993–4), no. 268 [entry by R. E. O. Ekkart]

ANN JENSEN ADAMS

Koninck

Family of Dutch painters, draughtsmen and printmakers. (1) Salomon Koninck was the son of Pieter de Koninck, a goldsmith from Antwerp, and was related to Aert de Coninck (*d* 1639), who was also a goldsmith and the father of (2) Jacob Koninck I and (3) Philips Koninck, but the exact relationship between the two families is not clear. Salomon, Jacob and Philips, all of whom were painters, draughtsmen and etchers, may have been cousins.

Bibliography

Hollstein: *Dut. & Flem.*; Thieme–Becker
W. Sumowski: *Drawings of the Rembrandt School*, vi (New York, 1982), pp. 2883–3445
—: *Gemälde der Rembrandt-Schüler*, iii (Landau-Pfalz, 1983), pp. 1516–710

(1) Salomon Koninck

(*b* Amsterdam, 1609; *d* Amsterdam, *bur* 8 Aug 1656). He began his training in 1621 with David Colijns (*c.* 1582–after 1668), who gave him drawing lessons. He was then apprenticed to François Venant (brother-in-law of Pieter Lastman) and completed his training with Claes Cornelisz. Moeyaert. By 1632 Salomon was a member of the Amsterdam Guild of St Luke. His wife Abigail was the daughter of the painter Adriaen van Nieulandt. Some time around 1653 Bernart van Vollenhoven (1633–after 1691) was Salomon's pupil.

By the mid-1630s Salomon had perfected his skills in the technique of 'Fine' painting. This is particularly noticeable in the rendering of fabrics and armour, for which he was much admired. For instance, Jan de Vos, in his poem 'The Struggle between Death and Nature, or the Triumph of Painting', named Salomon Koninck as one of the most important painters of the time. Koninck devoted special attention to costumes, many of which were unusual and Oriental. The painting of *Daniel Explaining Nebuchadnezzar's Dream of the Four Kingdoms* (mid-1630s; ex-Kedleston Hall, Derbys) demonstrates that Salomon was familiar with Rembrandt's late Leiden and early Amsterdam work, and, in fact, Salomon's entire oeuvre is strongly influenced by Rembrandt, although he never achieved Rembrandt's quality, partly because he indulged too much in an approach in which all detail, no matter how minor, was rendered with the same meticulous care. He apparently continued to follow Rembrandt's development with interest;

Rembrandt's work from the 1640s, with its spatial effects and strong use of chiaroscuro, was clearly of influence on paintings such as the *Remorseful Judas* (untraced; see Sumowski, 1983, p. 1655). However, Salomon's paintings remain theatrical scenes that express no religious involvement (e.g. the *Adoration of the Magi*, The Hague, Mauritshuis). The *Descent from the Cross* (1635; Bad Tölz, Ulrich K. Holzermann priv. col., see Sumowski, 1983, p. 1671) is a transitional work, noticeably influenced by both Rembrandt and Rubens. The influence of Rubens becomes even more prominent in the painting *Sophonisba Receiving the Cup of Poison* (Los Angeles, CA, USC, Fisher Gal.). Apart from religious and historical scenes, Salomon Koninck also painted many scholars and church fathers reading or writing, men weighing their gold, counting their money or trimming quills. An important role in these images is played by accessories such as books, papers and money—all executed with minute precision. A painting such as the *Old Man Weighing his Gold* (1654; Rotterdam, Mus. Boymans–van Beuningen) displays the influence of Gerrit Dou.

Salomon Koninck's drawings are clearly influenced by Rembrandt (e.g. *Standing Woman*, Paris, Fond. Custodia, Inst. Néer.) and Jan Lievens (e.g. *Head of a Bearded Old Man*, Berlin, Kupferstichkab.) and have often been attributed to these and other artists. There are also a few etchings by him, mostly heads of old men (e.g. *Bust of a Man with Turban, Facing Left*, 1638; Hollstein, no. 2).

Bibliography

C. de Bie: *Het gulden cabinet* (1661), p. 250

A. Bredius: *Künstler-Inventare: Urkunden zur Geschichte der holländischen Kunst des XVIten, XVIIten und XVIIIten Jahrhunderts*, i (The Hague, 1915), p. 170

H. Gerson: *Philips Koninck: Ein Beitrag zur Erforschung der holländischen Malerei des XVII. Jahrhunderts* (Berlin, 1936), p. 86

W. Martin: *Rembrandt en zijn tijd*, ii of *De Hollandse schilderkunst in de zeventiende eeuw* (Amsterdam, 1936), p. 110

W. Sumowski: *Gemälde der Rembrandt-Schüler*, iii (Landau-Pfalz, 1983), pp. 1516–710

B. Haak: *The Golden Age: Dutch Painters of the 17th Century* (New York, 1984), p. 289

(2) Jacob Koninck I

(*b* Amsterdam, 1614–15; *d* Amsterdam, after 3 June 1690). Two works by Jacob I appear in the inventory of his father, the goldsmith Aert de Coninck (*d* 1639): a 'Bacchus Drawn in Pen' and a 'Head'. In 1633 Jacob was living in Dordrecht. From 1637 to 1645 he was in Rotterdam, where his first wife, Maria Cotermans, died in 1637. By 1647 Jacob had moved to The Hague, where, in the following year, he married Susanna Dalbenij. Their son Jacob Koninck II (?1648–1724), who later became a painter, was probably born the same year. Throughout his life, Jacob the elder struggled against financial difficulty. In 1651 he left his wife's house and moved to Amsterdam, where his name appears twice, in 1652 and 1659, in connection with debts. He went to Copenhagen *c.* 1676, having fallen out with fellow painters of the Amsterdam guild, who accused him of unfair competition. In his absence they confiscated his paintings; on 27 May 1676 he wrote to Christian V of Denmark asking for help to retrieve his work. On 3 September 1682 his nephew Daniël Koninck (1668–after 1720) was apprenticed to him. On 3 August 1690 Daniël paid off his apprenticeship fee 'to my Uncle Jacob de Koninck, Painter in Copenhagen'.

Jacob I left behind a modest oeuvre. His landscape paintings, for instance the *Pasture with Trees, Cows and a Sheep* (Rotterdam, Mus. Boymans–van Beuningen), the *Panorama with a Church by a River* (Leipzig, Mus. Bild. Kst.) and *Panorama with a River* (Basle, Kstmus.), reveal the influence of his younger brother Philips and of Jan Lievens. Jacob I's drawings are also primarily landscapes (e.g. *Wooded Landscape*, 1665; Paris, Fond. Custodia, Inst. Néer.), but also include a number of rural scenes and studies of farm buildings, which reflect the influence of Pieter de With, as well as again Jan Lievens and Philips Koninck. Jacob's three known engravings have often been attributed to Rembrandt (e.g. *Landscape with a Full Hay Barn*, Hollstein, no. 2).

Bibliography

A. D. de Vries Az.: 'Aanteekeningen naar aanleiding van Rembrandt's etsen' [Notes on Rembrandt's etchings], *Oud-Holland*, i (1883), pp. 304–10

A. Bredius: *Künstler-Inventare: Urkunden zur Geschichte der holländischen Kunst des XVIten, XVIIten und XVIIIten Jahrhunderts* (The Hague, 1915–22), i, pp. 149–69; iv, pp. 1366–70

H. Gerson: *Philips Koninck: Ein Beitrag zur Erforschung der holländischen Malerei des XVII. Jahrhunderts* (Berlin, 1936), pp. 83–6

(3) Philips (de) Koninck

(*b* Amsterdam, 5 Nov 1619; *d* Amsterdam, *bur* 6 Oct 1688). Brother of (2) Jacob Koninck I. He is best known for his landscapes, although he also produced portraits, history and genre scenes.

1. Life and work

He was apprenticed to his older brother Jacob I in Rotterdam, probably in 1637. On 2 January 1640 Jacob received Philips's last apprenticeship fee. The inventory of property left by his father, Aert Coninck (*d* 1639), mentions two works by Philips: a 'Head of a Woman' and a 'portrait'. On 1 January 1641 Philips Koninck married Cornelia Furnerius, the daughter of a Rotterdam surgeon and organist and the sister of Abraham Furnius, a pupil of Rembrandt. In the same year, or in 1642 at the latest, Philips returned to Amsterdam. On 16 May 1657 Philips married his second wife, Margaretha van Rijn. They had four daughters and a son. In a document of 1687 he is mentioned as the owner of a boat service from Amsterdam to Leiden and Rotterdam; he also owned an inn. His wife Margaretha owned the ferry service to Gouda; both contracted the work out to leaseholders. Philips was thus financially independent and could afford to concentrate on landscape painting (unlike many landscape painters who were forced to accept portrait commissions to secure an income for themselves).

The first inn scenes by Philips date from the 1640s and were painted under the influence of Adriaen Brouwer (e.g. *Four Merry Peasants in an Inn*, 1646; Schwerin, Staatl. Mus.). The figures in these paintings are usually described as peasants, although Gerson (1936) believed they might be bargemen (recognizable by their hats), in which case Philips may have owned the boat service and inn as early as the 1640s.

Although many sources regard Philips Koninck as a pupil of Rembrandt, there is, in fact, no documentary evidence to support this. However, there is no doubt that his landscapes were influenced by Rembrandt. Philips's early work in particular is strongly influenced by Rembrandt's landscapes of the late 1630s (e.g. *Landscape with Town in the Distance*, c. 1645; Madrid, Mus. Thyssen-Bornemisza). A remarkable feature of Philips as a landscape painter is that he restricted himself to one type of landscape: the idealized Dutch panorama. His landscapes are basically flat, with a high viewpoint and a river winding towards the horizon; although imaginary, they are often reminiscent of the landscape in Gelderland. In the late 1640s Koninck began to paint in a larger format and by the early 1650s he had a fully developed individual style. During the period that followed (1654–65) he is thought to have produced his best works. Until the 1660s he adhered strictly to one scheme, consisting of a diagonal pattern in the foreground, which contrasted with the horizontal orientation of the background. Trees and shrubs seldom cut through the horizon and are used to emphasize the horizontal axis. As a result, the landscapes divide into two equal parts: the sky above and the earth below. Human figures tend to be of secondary importance in Koninck's landscapes. One of his finest pictures from this period is the *Panorama with Cottages Lining a Road* (1665; Amsterdam, Rijksmus.). This painting rivals the landscapes of Hercules Segers, Jacob van Ruisdael and Rembrandt. In the 1660s Koninck abandoned his scheme of contrasting diagonals and horizontals, and his paintings show more spatial unity. Motifs such as dunes and huts are used to create contrasts (e.g. *Landscape with a Flock of Sheep under Trees*, Frankfurt am Main, Städel. Kstinst. & Städt. Gal.). At the same time Philips also introduced a new type of landscape, with large trees in the foreground, offering glimpses into the distance in between—a combination of panorama and park landscape (e.g. *Tall Trees in Front of a Flat River Landscape*, 1668; Leerdam, Hofje van Aerden). In the 1670s Philips used the two pictorial schemes he had developed side by side, as in the *Panorama with a Couple*

Riding (c. 1676; untraced, see Sumowski, 1983, p. 1625).

Although Philips's qualities as a portrait painter were limited, there are one or two highly successful exceptions, including the portrait of the Rembrandt pupil *Heiman Dullaert* (mid-1650s; St Louis, MO, A. Mus.) and two portraits of the poet *Joost van den Vondel* (1665; Amsterdam, Rijksmus., on loan to Mus. Amstelkring, and 1674; Amsterdam, Rijksmus.), who wrote poems in praise of Koninck's portraits and history scenes. As a history painter, however, Philips's output is rather scant. An example of his early work is *Bathsheba with David's Letter* (1642; untraced, see Sumowski, 1983, p. 1552). Van den Vondel devoted several poems to scenes painted by the artist after 1660, among them the monumental *Allegory of Peace* (1666; Schloss Moyland, Baron G. A. Sleerigracht priv. col., see Sumowski, 1983, p. 1554).

Philips Koninck also produced some 300 drawings, most in pen and ink and often with a coloured wash. There are a few religious and genre subjects (e.g. the *Intoxicated Schoolmaster*, 1661; Berlin, Kupferstichkab.), as well as numerous landscapes (e.g. *Windmills outside the Raamport in Amsterdam*, early 1660s; Amsterdam, Gemeente Archf.) and some figure studies. Hollstein listed a few engravings by Philips, mostly landscapes (e.g. *Landscape with a Canal and a Church Tower*, Hollstein, no. 7).

2. Critical reception and posthumous reputation

Philips Koninck was held in high esteem in Amsterdam. Art dealers consulted him on the attribution of dubious paintings. His popularity as a painter can also be measured in the prices paid for his work. After 1676, however, he seems to have given up painting and rapidly passed into oblivion. Although there is no evidence that he ever travelled abroad, his reputation reached far beyond the Dutch borders. This emerges, for example, from the fact that his *Self-portrait* (1667; Florence, Uffizi)—in fact, a rather weak painting—was purchased in 1667 by Cosimo III de' Medici, Grand Duke of Tuscany, for the painters' gallery in Florence.

Bibliography

Hollstein: *Dut. & Flem.*

A. D. de Vries Az.: 'Aanteekeningen naar aanleiding van Rembrandt's etsen' [Notes on Rembrandt's etchings], *Oud Holland*, i (1883), pp. 304–10

N. de Roever and A. Bredius: 'Rembrandt, nieuwe bijdragen tot zijn levensgeschiedenis' [Rembrandt, new material concerning his life story], *Oud-Holland*, iii (1885), p. 89

A. Bredius: 'Kunstkritiek der XVIIe eeuw', *Oud-Holland*, vii (1889), pp. 41–4

P. Haverkorn van Rijsewijk: 'Jacob Koninck', *Oud-Holland*, xx (1902), pp. 9–15

H. Floerke: *Studien zur niederländischen Kunst- und Kulturgeschichte* (Munich and Leipzig, 1905), pp. 104, 106, 111

A. Bredius: *Künstler-Inventare: Urkunden zur Geschichte der holländischen Kunst des XVIten, XVIIten und XVIIIten Jahrhunderts*, i (The Hague, 1915), pp. 149–69

H. Gerson: *Philips Koninck: Ein Beitrag zur Erforschung der holländischen Malerei des XVII. Jahrhunderts* (Berlin, 1936)

W. Martin: *Rembrandt en zijn tijd*, ii of *De Hollandse schilderkunst in de 17e eeuw* (Amsterdam, 1936), pp. 290–91

S. Slive: 'Reconstruction of Some Rejected Rembrandt Drawings', *A. Q.* [Detroit], xxvii (1964), pp. 274–97

P. J. J. van Thiel: 'Philips Konincks *Vergezicht met hutten aan de weg*' [Philips Koninck's *Panorama with Cottages Lining a Road*], *Bull. Rijksmus.*, xv (1964), pp. 109–15

H. Gerson: 'Bredius 447', *Festschrift für Dr. H. C. E. Trautscholdt* (Hamburg, 1965), pp. 109–11

W. Stechow: *Dutch Landscape Painting of the Seventeenth Century* (London, 1966), pp. 44–6

J. M. Nash: *The Age of Rembrandt and Vermeer* (London, 1972), pp. 49, 248–9, 255

G. Falck: 'Einige Bemerkungen über Philips Konincks Tätigkeit als Zeichner', *Festschrift für Max J. Friedländer* (Leipzig, 1977), pp. 168–80

W. Sumowski: *Gemälde der Rembrandt-Schüler*, iii (Landau-Pfalz, 1983), pp. 1530–1626

B. Haak: *The Golden Age: Dutch Painters of the 17th Century* (New York, 1984), p. 374

Masters of 17th-century Dutch Landscape Painting (exh. cat. by P. Sutton, Amsterdam, Rijksmus.; Boston, MA, Mus. F.A.; Philadelphia, PA, Mus. A.; 1987), pp. 117, 366–71

TRUDY VAN ZADELHOFF

Laer, Pieter (Boddingh) van
[il Bamboccio]

(*bapt* Haarlem, 14 Dec 1599; *d* ?1642). Dutch painter and printmaker. Active mainly in Rome, he established a reputation as the inventor of the *bambocciata* (Fr. *bambocciade*), a variety of low-life painting characterized by its small size, naturalistic style and references to contemporary Italian popular culture. He attracted many followers in Italy, known as the Bamboccianti.

1. Life and work

He was the second son of Jacob Claesz. Boddingh of Haarlem and Magdalena Heyn of Antwerp. His surname, van Laer, adopted later in life, was probably taken from his brother's godfather. Early in his career van Laer knew the work of Esaias van de Velde and Jan van de Velde II, indicated by a group of monogrammed pen-and-wash drawings illustrating a songbook (Rotterdam, Hist. Mus.), to which his brother Roeland (*d* ?1635) also contributed drawings. These sheets, mostly depicting amatory scenes, are sketched in an awkward, summary style reminiscent of those masters. A pen-and-wash drawing of *Horsemen Awaiting a Ferry* (Leiden, Rijksuniv., Prentenkab.) and a canvas depicting a *Rest on the Hunt* (c. 1625; ex-Caretto priv. col., Turin, see Briganti, Laureati and Trezzani, 1983, fig. 1.5), both datable to about 1625, also show the influence of Esaias van de Velde.

About 1625 van Laer went to Italy, presumably accompanied by Roeland. According to Sandrart, the trip was made via France. Although van Laer is not securely documented in Rome until 1628, he probably arrived there as early as 1625 or 1626 (Hoogewerff, 1932). Initially he may have lived on the Via Margutta in the parish of S Maria del Popolo with fellow northerners Cornelis Schut, Jacob de Bisschop and Alexander van Welinckhoven (1606–29). Later he lodged with Stephano Cortes (*d* 1635) and Giovanni del Campo (Jean Du Champs; *b c.* 1600), the latter cited by Sandrart as van Laer's teacher. Van Laer became a leading figure in the Schildersbent, the society of Dutch and Flemish artists in Rome whose members called themselves *Bentveughels* ('birds of a feather'), taking part in their activities, including their notorious initiation ceremonies ('baptisms') and their lawsuit of 1631 against the Roman Accademia di S Luca over the issue of taxation (Hoogewerff, 1926, 1952). According to Passeri it was van Laer's compatriots in the Bent who first dubbed him 'il Bamboccio' (var. Bambotio, Bamboots), meaning 'ugly puppet' or 'doll', which Sandrart attributed to his odd physique: unusually long legs, short chest and almost no neck.

Among the subjects of van Laer's *bambocciate*, which, according to Passeri, constituted a distinct genre, were blacksmiths shoeing horses in grottoes (Schwerin, Staatl. Mus.; Haarlem, Teylers Mus.), brigands attacking travellers (St Petersburg, Hermitage; Rome, Gal. Spada), military actions (Naples, Banca Sannitica), idlers around Roman lime-kilns (Budapest, Mus. F.A.) and travellers before inns (Paris, Louvre; Rome, Gal. Spada). Vignettes of men playing popular games of chance such as *morra* are found in his works, as are depictions of excretory functions. He also painted herds and herdsmen in pastoral settings and other landscape scenes (Paris, Louvre; Amsterdam, Rijksmus.). One religious picture by him is known, an *Annunciation* (The Hague, Mus. Bredius). The street scenes with tradesmen, once thought to be van Laer's most characteristic works (e.g. the *Pretzel-seller* and the *Brandy-seller*; both Rome, Pal. Corsini; see fig. 30), were rejected by Janeck (1968) and have been attributed to Lingelbach or the anonymous Master of the Small Trades (Briganti, Laureati and Trezzani, 1983). About 30 paintings can be confidently attributed to van Laer. He was also an accomplished printmaker, with about 20 small-scale etchings to his credit, all related in subject to his painted work. These include a series of barnyard animals in rural settings and a set of horses (1636; Hollstein: *Dut. & Flem.*, nos 1–8, 9–14).

Only three dated works survive from van Laer's Italian period: a drawing of a horse and rider (1628; Hamburg, Ksthalle), the *Blacksmith in a Grotto* in Schwerin (1635) and the aforementioned engraved series of domestic animals, too few to establish a comprehensive chronology. However,

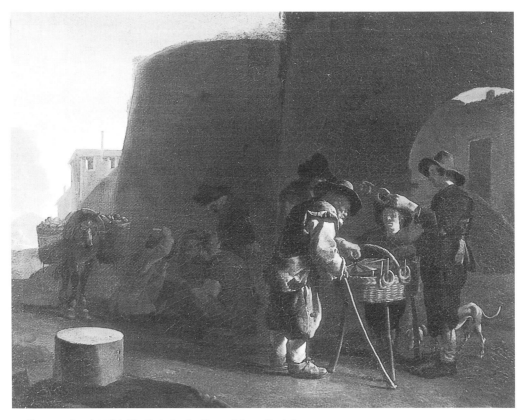

30. Pieter van Laer (attrib.): *The Pretzel-seller* (Rome, Palazzo Corsini)

small panels of a *Halt at an Inn*, *Highway Assault* and *Sack of a Village* (all Rome, Gal. Spada), and the tiny *Two Horsemen* (Vienna, Gemäldegal. Akad. Bild. Kst.), can be assigned to an early period in Rome (1628–32) because they still adhere to northern compositional prototypes and have stylistic affinities to the work of Esaias van de Velde. Works such as the *'Pistol-shot'* (St Petersburg, Hermitage), the *Assault on a Convoy* (Naples, Banca Sannitica) and the *Large Lime-kiln* (untraced), with their emphasis on narrative elements and more complex compositional schemes, are closer to the Schwerin *Blacksmith* and were probably painted between 1634 and 1637.

Van Laer rendered his low-life scenes in a naturalistic manner, with accurately observed detail and colour (Passeri praised his 'gusto di tingere').

The illusion of reality is heightened by the vivid chiaroscuro (see fig. 31). Yet although they may appear uncontrived, the *bambocciate* were dependent upon northern artistic conventions and even incorporate elements derived from Classical statuary and grand-manner paintings. The signed *Shepherd and Washerwomen* (Amsterdam, Rijksmus.) is a characteristic example of van Laer's mature work. Painted in oil on copper and measuring only 290×430 mm, it depicts a small group of peasants and animals gathered around a stream that runs through a cave or grotto. The mundane activities, the seemingly casual poses and the detailed, sculptural rendering of the figures reveal that humble reality was van Laer's chief source of inspiration; but the painting also shows two borrowings from the

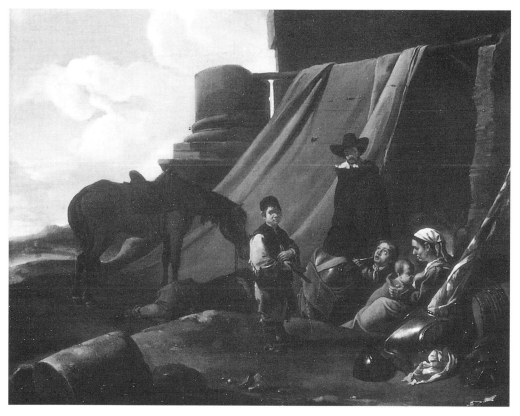

31. Pieter van Laer: *The Encampment* (Private Collection)

Classical tradition in art: the pose of the seated shepherd is derived from the ancient bronze *Spinario* (Rome, Mus. Capitolino), while the pose of the woman entering the scene from the rear repeats a motif commonly found on Roman sarcophagi.

Van Laer presumably embarked for the Netherlands *c.* 1637, when he is last documented in Rome. Sandrart reported seeing him in Amsterdam in 1639 and said that van Laer lived with his brother Nicolaes in Haarlem after his homecoming. Only one work, a drawing dated 1641 in the songbook in Rotterdam, can be securely assigned to his post-Roman years. In 1642 van Laer left Haarlem, according to Schrevelius on a second journey to Rome, and was not heard of again.

2. Critical reception and influence

Van Laer's works were evidently in high demand in Rome. A legal testimony concerning a theft of art from Herman van Swanevelt in 1631 shows that van Laer's paintings were fetching from 25 to 35 scudi each, a significant sum considering their small size. Passeri also remarked upon their popularity. Although some of his works were evidently meant for sale on the open market, van Laer also enjoyed noble patronage. His early supporters included Cardinal Francesco Maria Brancaccio and Ferdinand Afan de Ribera, the Viceroy of Naples. Moreover, Salvator Rosa reported that the *bambocciate* were 'highly appreciated' by the nobility in general. However, both van Laer and the genre he introduced were violently condemned by some painters and critics in Rome. Rosa, Andrea Sacchi

and Francesco Albani reviled the *bambocciata* as a debased form of art, the latter referring to works of this genre as 'monstrous abortions' (Malvasia). Passeri condemned van Laer for having 'destroyed and violated' painting. The term *bambocciata* was also used as a synonym for childish scribble. At the root of this hostility was the fact that van Laer did not idealize visual reality in the way prescribed by the classicists: instead of selecting the best in nature, he deliberately chose the worst. He was, as Bellori implied, a modern-day Peiraikos, who rejected the standard hierarchy of values imposed by conventional art theory. Not until the end of the 17th century was the *bambocciata* defended on the grounds that art should be judged on intrinsic qualities rather than on the nobility of the subjects represented (Baldinucci, Boschloo).

Despite these criticisms, the best indication of van Laer's prominence was the influence of both his style and his subject-matter on other painters. The most important Bambocciati were Jan Miel, Michelangelo Cerquozzi, Johannes Lingelbach, Thomas Wijck and Michiel Sweerts, but many other lesser-known and anonymous painters carried on his manner far into the 17th century. Van Laer made his greatest impact in Rome, but he was also important for the development of painting in the northern Netherlands in the 17th century, contributing to the vogue for low-life subjects. He strongly influenced artists of the second generation of Dutch Italianate landscapists, including Nicolaes Berchem, Jan Asselijn and Karel Dujardin, as well as such later artists as Philips Wouwerman who, according to Houbraken, possessed many of Bamboccio's drawings.

3. Content and meaning

Until recently van Laer's *bambocciate* were described as 'objective', as 'scenes of everyday life', 'pictures of humble reality' and 'realistic views of lower-class life'. However, the view that they are literal transcriptions of reality is currently undergoing transformation. Briganti (1983) has modified his earlier position, acknowledging that the *bambocciate* represent specific themes and cannot

therefore be fully realistic. Other scholars have come to view van Laer as a self-conscious painter aware both of artistic traditions and of his own place in art. Salerno portrays him as a dissident whose work polemicized against accepted artistic and social norms. Levine maintained that van Laer was a cerebral ironist who deliberately chose low and vulgar subject-matter with the combined intention of mocking the authority of high art and expressing transcendental ideas. Because the *bambocciate* merge high stylistic elements such as figures in classical poses with low subjects, van Laer's works are like ironic encomia and other formal paradoxes with a dual purpose.

Bibliography

EWA: 'Bamboccianti'; Hollstein, *Dut. & Flem.*; *NKL*; Thieme–Becker

early sources

T. Schrevelius: *Harlemum* (Haarlem, 1647; Dut. trans., 1648)

C. de Bie: *Het gulden cabinet* (1661)

S. Rosa: *Satire* (Amsterdam, c. 1664); ed. G. A. Caesareo (Naples, 1892)

G. P. Bellori: *Vite* (1672); ed. E. Borea (1976)

J. von Sandrart: *Teutsche Academie* (1675–9); ed. A. R. Peltzer (1925)

S. van Hoogstraten: *Inleyding tot de hooge schoole der schilderkonst, anders de zichtbaere werelt* [Introduction to the academy of painting, or the visible world] (Rotterdam, 1678/R Soest, 1969; Ann Arbor, 1980)

C. C. Malvasia: *Felsina pittrice* (1678); ed. M. Brascaglia (1971)

G. B. Passeri: *Vite* (1679); ed. J. Hess (1934)

F. Baldinucci: *Notizie* (1681–1728); ed. F. Ranalli (1845–7)

A. Houbraken: *De groote schouburgh* (1718–21), i, p. 359

general works

A. C. Bertolotti: *Artisti belgi ed olandesi a Roma nei secoli XVI e XVII* (Florence, 1880)

G. J. Hoogewerff: *Nederlandsche kunstenaars te Rome: Uittreksels uit de parocchiale archieven* (The Hague, 1942–3)

F. Haskell: *Patrons and Painters: A Study of the Relations between Italian Art and Society in the Age of the Baroque* (London, 1963)

Nederlandse 17e eeuwse Italianiserende landschap-schilders (exh. cat. by A. Blankert, Utrecht, Centraal Mus., 1965); rev. and trans. as Dutch 17th-Century Italianate Landscape Painters (Soest, 1978)

L. Salerno: Pittori di paesaggio del seicento a Roma, 3 vols (Rome, 1976–80)

R. Trnek: Niederländer und Italien: Italianisante Landschafts- und Genremalerei von Niederländern des siebzehnten Jahrhunderts in der Gemäldegalerie der Akademie der Bildenden Künste in Wien (Vienna, 1982)

Die Niederländer in Italien: Italianisante Niederländer des 17. Jahrhunderts aus österreichischen Besitz (exh. cat. by R. Trnek, Salzburg, Residenzgal., 1986)

monographs

A. Janeck: Untersuchung über den holländischen Maler Pieter van Laer, genannt Bamboccio (diss., U. Würzburg, 1968)

studies of the bamboccianti

G. J. Hoogewerff: 'De Nederlandsche kunstenaars te Rome in de 17de eeuw en hun conflict met de Academie van St. Lucas', Meded. Kon. Akad. Wet., Afd. Lettknd., ser. B, lxii/4 (1926), pp. 117–18

—: 'Pieter van Laer en zijn vrienden', Oud-Holland, xlix (1932), pp. 1–17, 205–20; l (1933), pp. 103–17, 250–62

—: 'Pieter van Laer en zijn vrienden, een akte', Meded. Ned. Hist. Inst. Rome, 2nd ser., vi (1936), pp. 119–28

—: 'Nederlandsche kunstenaars te Rome, 1600–1725: Uittreksels uit de parochiale archieven: I. Parochie van Santa Maria del Popolo', Meded. Ned. Hist. Inst. Rome, 2nd ser., viii (1938), pp. 49–125

I Bamboccianti: Pittori della vita popolare nel seicento (exh. cat. by G. Briganti, Rome, Pal. Massimo alle Colonne, 1950)

G. J. Hoogewerff: De Bentveughels [Birds of a feather] (The Hague, 1952)

J. Michalkowa: 'Bamboccio i Bamboccianti: Krytyka i teoria sztuki wobec "komicznego" malarstwa rodzajowego' [Bamboccio and the Bamboccianti: criticism and art theory in relation to 'humorous' genre painting], Myśl o sztuce i sztuka XVII i XVIII wieku, ed. J. Białostocki (Warsaw, 1970)

A. W. A. Boschloo: 'Over Bamboccianten en kikvorsen' [About the Bamboccianti and frogs], Ned. Ksthist. Jb., xxiii (1972), pp. 191–200

G. Briganti, L. Laureati and L. Trezzani: The Bamboccianti: The Painters of Everyday Life in 17th-century Rome (Rome, 1983), pp. 39–77

D. A. Levine: The Art of the Bamboccianti (diss., Princeton U., 1984)

D. A. Levine and E. Mai, eds: I Bamboccianti: Niederländische Malerrebellen im Rom des Barock (Milan, 1991)

specialist studies

A. Welcker: 'Pieter Boddinck alias Pieter van Laer, Orlando Bodding alias Roeland of Orlando van Laer, Nicolaes Bodding alias N. Boddingh van Laer of ds. Nic. Boddingius', Oud-Holland, lix (1942), pp. 80–89

—: 'Pieter Boddink alias Pieter van Laer', Oud-Holland, lxii (1947), pp. 206–8

G. Briganti: 'Pieter van Laer e Michelangelo Cerquozzi', Proporzioni, iii (1950), pp. 185–98

A. Blankert: 'Over Pieter van Laer als dier- en landschap-schilder', Oud-Holland, lxxxiii (1968), pp. 117–34

D. P. Snoep: 'Een 17de eeuws liedboek met tekeningen van Gerard ter Borch de Oude en Pieter en Roeland van Laer', Simiolus, iii (1968–9), pp. 77–134

J. Michalkowa: 'Quelques remarques sur Pieter van Laer', Oud-Holland, lxxxvi (1971), pp. 188–95

A. Janeck: 'Naturalismus und Realismus: Untersuchungen zur Darstellung der Natur bei Pieter van Laer und Claude Lorrain', Stor. A., xxviii (1976), pp. 285–307

T. Kren: 'Chi non vuol Baccho: Roeland van Laer's Burlesque Painting about Dutch Artists in Rome', Simiolus, xi (1981), pp. 63–80

D. A. Levine: 'Pieter van Laer's Artists' Tavern: An Ironic Commentary on Art', Holländische Genremalerei im 17. Jahrhundert: Symposium, Berlin, 1984, pp. 169–91

—: 'The Roman Limekilns of the Bamboccianti', A. Bull., lxx (1988), pp. 569–89

DAVID A. LEVINE

Lairesse, Gérard de

(b Liège, 11 Sept 1640; d Amsterdam, bur 28 July 1711). Painter, draughtsman and printmaker from Liège. A contributor to the 'gallicizing' of Dutch art in the second half of the 17th century, he was a talented painter who served a wealthy, cultivated bourgeoisie for whom he painted complex allegories. He was not only a great painter but also a first-class draughtsman and engraver, and an influential theorist whose books reflect the pros-elytizing zeal of the late 17th-century promoters of classicism.

1. Life and artistic career

He was the second son of the painter Renier de Lairesse (1597–1667), who probably also taught his son. Gérard de Lairesse's early works, for example *Orpheus in the Underworld* (Liège, Mus. Ansembourg), the *Conversion of St Augustine* (Caen, Mus. B.-A.) and the *Baptism of St Augustine* (Mainz, Landesmus.), show the overpowering influence of Bertholet Flémal, then the dominant painter in Liège; great importance is given to Classical architectural settings and strong colour, while the works also show a distinct taste for gesture and a predilection for atmospheric lighting. During these early years Lairesse received numerous religious commissions, but in 1664 a love affair forced his sudden departure from Liège. He took refuge at 's Hertogenbosch, then in Utrecht for several months, and in 1665 or 1666 he moved to Amsterdam, possibly persuaded by the picture dealer Gerrit van Uylenburg. His arrival in Amsterdam plunged him into an artistic, religious and social milieu very different from that of Liège, but he integrated very quickly into the life of the commercial centre.

In 1667 Lairesse acquired citizenship and developed friendships with the city's intellectual élite, who were greatly attracted by the brilliance of French civilization and art. They founded a society of artists, which was regularly attended by Lairesse, who was appointed their engraver and illustrated the plays of the society's founder, Andries Pels (1631–81): the *Death of Dido* (Timmers, nos 61–4) and *Julfus* (1668; Timmers, nos 93–5). Lairesse rapidly became famous in Amsterdam both for the many pictures he executed for collectors and for the large numbers of plates he engraved. He rejected the naturalistic style of Dutch art and produced instead works of considerable theatricality, particularly of subjects from Ovid and Virgil (e.g. *Venus Offering Arms to Aeneas*, 1668; Antwerp, Mus. Mayer van den Bergh). In the early 1670s he produced works that were even more classical in character, with monumental figures evocative of ancient statues and an increasingly refined sense of composition. These paintings tended to be moralizing in subject-matter (e.g. *Antiochus and Stratonica*; Amsterdam, Rijksmus.).

Lairesse's success as the 'Dutch Poussin' brought him to the attention of the city authorities. In 1667 he produced an elegant allegorical painting celebrating the *Benefits of the Peace of Breda* (The Hague, Gemeentemus.), and in 1674 he celebrated the military victories of William III, Stadholder and Prince of Orange-Nassau, in several large plates, including an *Allegory of the Peace of Westminster* (Timmers, no. 71). Lairesse was soon in demand for more ambitious commissions and undertook decorative schemes for patrician houses on the Herrengracht; many of these had complex allegorical ceilings extolling the virtues of their owners (e.g. the ceiling of the Leprozenhuis, c. 1675; Amsterdam, Hist. Mus.). Lairesse's style became increasingly elegant, and he made greater use of light colours. Great attention was paid to the appearance of the work within the overall context of its setting. This pursuit of formal elegance is found in most works of this period, for example *Amsterdam Receiving the Homage of the World* (Amsterdam, Hist. Mus.).

At the same time Lairesse continued his printmaking activities, producing plates that display his extraordinary command of the technique of etching and into which he could sometimes channel his religious inspiration, little favoured by Dutch Protestantism (e.g. the *Ecstasy of St Theresa*, c. 1675; Timmers, no. 15). It was during this period that Lairesse produced his most popular works, including *Achilles with the Daughters of Lycomedes* (Brunswick, Herzog Anton Ulrich-Mus.) and the *Death of Germanicus* (Kassel, Schloss Wilhelmshöhe).

From 1680 Lairesse began to simplify his compositions, increasing their solemnity by isolating larger, weightier figures against architectural backgrounds. The colour became more subtle with an elaborate shot-silk effect (e.g. *Hagar and the Angel*; St Petersburg, Hermitage). New themes appeared, scenes of satyrs and maenads in unfettered bacchanals, combining unbridled paganism with a remarkable sense of classical reconstruction (e.g. *Bacchanal*, c. 1680; Kassel, Schloss Wilhelmshöhe). Another aspect of his decorative talent is seen in his series of grisailles painted for patrician houses in Amsterdam: he invented a new

type of allegorical *trompe l'oeil* décor, exemplified by the *Four Ages of Man* (1682; Orléans, Mus. B.-A.). Lairesse was also involved in the decoration of William III's castles at Soestdijk, for which he painted a *Bacchus and Ariadne* (c. 1682; The Hague, Mauritshuis), and at Het Loo (e.g. the ceiling of Queen Mary's Bedroom, c. 1686; *in situ*). At the request of Archdeacon de Liverloo of Liège, Lairesse resumed his religious painting with a monumental *Assumption* (Liège Cathedral), painted in 1687 for the high altar of St Lambert's Cathedral (destr. 1794); this painting shows the artist's virtuoso treatment of traditional Christian iconography within a classical composition.

In 1684 the landscape artist JOHANNES GLAUBER arrived in Amsterdam; he collaborated with Lairesse on several commissions and brought out an even greater emphasis on classicism in Lairesse's later work. The most striking example of their collaboration is probably the decorations for a room in the home of the merchant Jacob de Flines (Amsterdam, Rijksmus.), in which the walls were hung with canvases featuring great Italianate landscapes populated in the foreground by half-length figures painted by Lairesse; they look directly at the viewer, thus linking the real and the fantasy worlds. Between 1685 and 1690 Lairesse's activity was particularly varied and included the decoration of the new theatre of Amsterdam (destr. 18th century) and the decoration of the organ shutters (1686; *in situ*) in the Westerkerk, Amsterdam. His last great monumental work was a series of seven large canvases (c. 1688) for the Council Room of the Binnenhof in The Hague. Lairesse's composition illustrates the Prince's virtues (Justice, Prudence etc) with scenes from Roman history. The composition is rigorous, the architecture classical; the figures are vigorously modelled and give the impression of sculptures fixed in timeless gestures. The artist was preparing to participate in the decoration in the Burgerzaal of the new town hall in Amsterdam and had already executed the sketch for an *Allegory of the Glory of Amsterdam* (c. 1687; Amsterdam, Hist. Mus) when, in 1690, he was suddenly struck by blindness, putting a stop to a pictorial career as brilliant as it was fruitful.

2. Art theory

Deprived of his sight and thus of his livelihood, Lairesse spent the last ten years of his life giving art lectures, which seem to have been a great success. His sons brought out the first volume of these talks in 1701 under the title *Grondlegginge der teekenkunst* ('Principles of design'), followed in 1707 by a much larger work entitled *Het groot schilderboek* ('Great book of painters'). This subsequently went into many editions, both in Amsterdam and elsewhere in Europe, and played an important role in the origin of Neo-classical ideas. In the book Lairesse defended the most intransigent form of academicism, which in his eyes was embodied only by Poussin and Le Brun; Rubens and Rembrandt are hardly mentioned. He also strongly advocated the slavish copying of the Antique and nature because, according to him, 'art proceeds from reason and judgement'. Lairesse had nothing but contempt for such minor realist painters as Adriaen van Ostade, Adriaen Brouwer or David Teniers the younger, all of whom he considered vulgar; the painter's preference should be for historical, mythological or allegorical subjects, genres that could educate the mind and move the heart. A manual for artists rather than a proper treatise on painting, *Het groot schilderboek* is still an important work, as much for the information it provides on the artist himself (he sometimes referred to his own work) as for the knowledge it imparts of Dutch art in the second half of the 17th century.

3. Critical reception and posthumous reputation

Regarded as a painter of the highest rank by his contemporaries, Lairesse continued to be admired and appreciated throughout the 18th century, when his pictures fetched high prices. He fell into scornful disfavour and was pronounced 'superficial' during the 19th century, a time when Realism made its appearance and when the Impressionist painters, who rejected all iconography, were violently opposed to academic art.

Writings

Grondlegginge der teekenkunst [Principles of design], 2 vols (Amsterdam, 1701)

Het groot schilderboek [Great book of painters], 2 vols (Amsterdam, 1707/*R* Soest, 1969)

Bibliography

BNB; Hollstein: *Dut. & Flem.*; Thieme–Becker

J. van Sandrart: *Teutsche Academie* (1675–9); ed. A. R. Pelzer (1925), pp. 364–6

L. Abry: *Les Hommes illustres de la nation liégeoise* (Liège, 1715); ed. H. Helbig and S. Bormans (Liège, 1867), pp. 243–69

A. Houbraken: *De groote schouburgh* (1718–21), iii, pp. 106–33

J. C. Weyerman: *De levens-beschryvingen der Nederlandsche konst-schilders en konst-schilderessen*, iii (The Hague, 1729), pp. 405–12

P. L. de Saumery: *Les Délices du pais de Liège*, v (Liège, 1744), pp. 273–83

A.-G. de Becdelièvre-Hamal: *Biographie liégeoise*, ii (Liège, 1837), pp. 194–208

J. Helbig: *La Peinture au pays de Liège et sur les bords de la Meuse* (Liège, 1903), pp. 295–319

J. Philippe: *La Peinture liégeoise au XVIIe siècle* (Brussels, 1942), pp. 29–33

J. J. M. Timmers: *Gérard Lairesse* (Amsterdam, 1942) [first vol. only]

G. Barnaud: 'Sur quelques tableaux de Gérard de Lairesse', *Rev. Louvre*, ii (1965), pp. 59–67

D. P. Snoep: 'Gérard de Lairesse als plafond- en kamer-schilder', *Bull. Rijksmus.*, iv (1970), pp. 159–220

J. Hendrick: *La Peinture liégeoise au XVIIe siècle* (Gembloux, 1973), pp. 49–58

A. Roy: *Gérard de Lairesse, 1640–1711* (Paris, 1992)

ALAIN ROY

Lastman, Pieter (Pietersz.)

(*b* Amsterdam, 1583; *d* Amsterdam, *bur* 4 April 1633). Dutch painter and draughtsman. He was the son of the goldsmith Pieter Segersz. His older brother Seeger Pietersz. [Coninck] became a goldsmith like his father, while his younger brother Claes Lastman became an engraver and painter. Pieter trained as a painter under the Mannerist artist Gerrit Pietersz., brother of the composer Jan Pietersz. Sweelinck. In June 1602 Lastman travelled to Rome, like so many of his contemporaries. Van Mander, in his biography of Gerrit Pietersz., mentioned his pupil 'Pieter Lasman [*sic*] who shows great promise, being presently in Italy'. While there, Lastman made two drawings of an *Oriental in a Landscape* (both 1603; Amsterdam, Rijksmus.), which betray his continuing stylistic dependence on his master (as can also be seen in three drawings made before his trip to Italy). Related to the drawings made in Italy is a series of 12 prints after designs by Lastman of figures in Italian costumes (Hollstein, nos 11–22). Lastman also visited Venice, as is documented by a drawing (Cambridge, Fitzwilliam) after Veronese's *Adoration of the Shepherds* in the church of SS Giovanni e Paolo. Lastman was apparently in Italy until March 1607 but thereafter spent the rest of his life in Amsterdam. About 1619 he took on Jan Lievens of Leiden as a pupil, and for six months in 1624 he trained Lievens's fellow townsman Rembrandt.

The personal style that Lastman gradually developed after his trip to Italy was greatly admired and imitated by his contemporaries, including the group of Amsterdam history painters known by the slightly derogatory term Pre-rembrandtists. As this name suggests, the subsequent fame of Lastman's pupil overshadowed that of his teacher and his teacher's colleagues and fellow travellers to Rome (including his brother Claes Lastman, his brother-in-law François Venant (1591/2–1636), Jan Tengnagel, Tengnagel's brothers-in-law Jan and Jacob Pynas, and Claes Moeyaert). Nevertheless, Lastman was one of the most important artists of his day. One of his outstanding skills was his ability to translate successfully the allure of large Italian frescoes into small-sized cabinet pictures in the manner of Adam Elsheimer, who had made a profound impression on him in Italy. Characteristic of Lastman was his predilection for small, multi-figured history paintings, with subjects from the Bible, secular history or mythology, many of which had previously been depicted only in the graphic arts, if at all.

1. Life and painted work

Lastman's earliest, though undated, painting is thought to be the *Massacre of the Innocents* (Brunswick, Herzog Anton Ulrich-Mus.), which is partly based on a work by Hans Rottenhammer, who worked in Venice until 1606. A good example

of Lastman's Italian style is provided by his earliest dated painting, the *Adoration of the Magi* (1606; Prague, N.G., Šternberk Pal.), in which the rather bright palette reflects the influence of Elsheimer's meticulously executed oil paintings on copper. It became particularly evident in Lastman's later career that in Italy he had also studied the monumental compositions of Raphael and his followers.

Particularly striking is the linear quality of Lastman's painted figures, his predilection for representing animals and ornately decorated objects and his settings of wooded landscapes with Classical buildings or ruins. The influence of Elsheimer is evident not only in his bright, vivid palette, but also in the landscape settings of many of his history paintings. Landscape plays a significant part, for instance, in the small Elsheimer-like panel depicting the *Flight into Egypt* (1608; Rotterdam, Mus. Boymans–van Beuningen), and there is an extensive, detailed landscape in the *Baptism of the Eunuch* (Berlin, Gemäldegal.) of the same year. Lastman painted similar highly decorative landscape backgrounds in *Odysseus and Nausicaa* (1609; Brunswick, Herzog Anton Ulrich-Mus.) and a *Pastoral Scene* (?'*Angelica and Medoro*', 1610; Rotterdam, priv. col.). Although these last two themes were a novelty in the Netherlands at that date, pastoral scenes became commonplace there ten years later through the influence of the Utrecht Caravaggisti.

After 1610 Lastman placed less emphasis in his paintings on landscape settings and more on the principal figures, either deploying them in the foreground and letting them fill the entire picture plane, as in *David and Uriah* (1611; Detroit, MI, Inst. A.) and *The Entombment* (1612; Lille, Mus. B.-A.), or isolating them from their surroundings, as in the *Expulsion of Hagar* (1612; Hamburg, Ksthalle). He continued, however, to paint multi-figured compositions, such as *Joseph Distributing Grain in Egypt* (1612; Dublin, N.G.), in which the buildings and obelisk in the background are a reminder of his stay in Rome. The Eternal City is also recalled in his most daring *tour de force*, a large canvas depicting the *Battle of Constantine and Maxentius* (1613; Bremen, Ksthalle), inspired

by Raphael's frescoes in the Sala di Costantino in the Vatican. Lastman used an Italian form of his name in the signature *Pietro Lastman fecit A° 1614* on *SS Paul and Barnabas at Lystra* (Warsaw, N. Mus.), the figures in which are borrowed from the tapestry series after Raphael's design in the Sistine Chapel. The signature *Pietro Lastman* is also found on two other pictures of 1614: *Orestes and Pylades Disputing at the Altar* (Amsterdam, Rijksmus.), the profane variant of, and possibly the pendant to, the *SS Paul and Barnabas*; and *God Appearing to Abraham on the Road to Sichem* (St Petersburg, Hermitage). It appears again on other Italianate works, including the later version of *SS Paul and Barnabas* (1617; Amsterdam, Hist. Mus.) and *Juno Discovering Jupiter with Io* (1618; London, N.G.), both characterized by profuse detail (e.g. expensive cloth, luxury objects in silver and gold, flowers, animals etc), which was particularly admired during the 17th century.

Only a few of Lastman's history paintings are of traditional subjects, for example the *Crucifixion* (1616; Amsterdam, Rembrandthuis) and the *Annunciation* (1618; St Petersburg, Hermitage). Lastman was a powerful narrator with a penchant for drama, and he expressed himself most fully within the realm of the anecdotal: in *Jephthah and his Daughter* (c. 1610; The Hague, S. Nystad priv. col.; see 1992 exh. cat.), for example, the tragedy of the story is enhanced by the introduction of a number of 'historically accurate' details. Recurrent themes in his work are confrontations between man and God, or between the powerful and their subordinates, as in *The Angel Raphael Takes Leave of Old Tobit and his Son* (Copenhagen, Stat. Mus. Kst; see fig. 32), *Christ and the Woman of Canaan* (1617; Amsterdam, Rijksmus.) and *David and Uriah* (1619; Groningen, Groninger Mus.). Lastman apparently chose his subjects himself, for few of his patrons are known. The most notable was Christian IV, King of Denmark (*reg* 1588–1648), for whom he executed three biblical scenes on copper (1619; destr. 1859) for the King's private chapel at Frederiksborg Palace (a drawn copy exists of the panel depicting *Christ Blessing the Children*).

In 1619 Lastman was asked to authenticate a painting by Caravaggio, an artist whose realism,

32. Pieter Lastman: *The Angel Raphael Takes Leave of Old Tobit and his Son* (Copenhagen, Statens Museum for Kunst)

with its emphasis on the human figure, was another source of inspiration. Two years earlier Caravaggio's *Madonna of the Rosary* (Vienna, Ksthist. Mus.) had been in the gallery of the Amsterdam art dealer Abraham Vinck, and the work must have provided a new artistic stimulus for Lastman, for the composition, the grouping and gestures of the figures, the handling of light and even some of the details in another version of *Odysseus and Nausicaa* (1619; Munich, Alte Pin.) are derived from Caravaggio's example.

In 1628 Lastman began to amend his will annually, suggesting that he no longer enjoyed good health. He ceased to produce paintings with the regularity that had characterized his output of 1615–25, a period that included several masterpieces such as *Coriolanus and the Roman Women* (1625; Dublin, Trinity Coll.). It was only in 1630 that he made amother multi-figured history painting along the lines of these masterpieces: the *Sacrifice of Juno* (Stockholm, Nmus.), one of his many works with borrowings from Raphael. The

quality of his last dated painting, the *Triumph of Joseph* (1631; San Francisco, CA, de Young Mem. Mus.), hardly commends it as the culmination of his career: it is overcrowded, the figures and gestures are overdramatic and the composition lacks elegance. Lastman died a bachelor. In his house on the St Anthoniesbreestraat he left a sizeable art collection.

2. Drawings

Lastman made drawings in red chalk on tinted paper as preliminary studies for figures in his paintings, several of which survive: the *Study of a Reclining Woman* (Oxford, Ashmolean) for the figure of Rachel in *Laban Seeking his Idols* (1622; Boulogne, Mus. Mun.; see col. pl. XXII), and two figure studies (before *c.* 1622; Hamburg, Ksthalle; Hannover, Kestner-Mus.) for *Coriolanus and the Roman Women*. These studies became part of his studio repertory and were repeatedly consulted and revised, so that a permanent vocabulary of gestures and attitudes became one of the most

characteristic elements of Lastman's painted work. Comparable studies in red chalk are in Amsterdam (J. Q. van Regteren Altena priv. col., and Rijksmus.), London (J. Byam Shaw priv. col.) and Rotterdam (Mus. Boymans–van Beuningen). In 1656 Rembrandt owned several such red-chalk drawings by his teacher, as well as a good number of pen-and-ink sketches. It is difficult to determine which pen drawings Rembrandt may have had in his possession, for the remainder of Lastman's drawn oeuvre consists of doubtful attributions. Authentic pen-and-ink sheets are rare. The very early date of 1600 appears on a pen-and-wash drawing of *Hagar and the Angel in the Desert* (New Haven, CT, Yale U. A.G.), the style of which is wholly that of Gerrit Pietersz. Dating from 1611 is a design for a stained-glass window in the Zuiderkerk, Amsterdam, representing *King Cyrus Returning the Treasures from the Temple to the Jews* (Berlin, Kupferstichkab.). There is also a drawn portrait of *Nicolaas Lastman* (Paris, Fond. Custodia, Inst. Néer.), which is dated *16 Oktober 1613*.

3. Influence and posthumous reputation

Rembrandt's first biographer, Jan Orlers, in his description of Leiden (*Beschrijvinge der stadt Leyden*, 1641), stated that Rembrandt went to Amsterdam to continue his education with 'the famous painter P. Lasman [*sic*]'; this was undoubtedly because Rembrandt wished to specialize in history painting. Lastman's history paintings such as *Coriolanus and the Roman Women*, the composition of which is borrowed from the *Vision of Constantine* by Giulio Romano after Raphael's design in the Sala di Costantino in the Vatican, made a lasting impression on his pupil. The rules Rembrandt applied to his early *History Piece* (1626; Leiden, Stedel. Mus. Lakenhal)—the use of repoussoirs, groups deployed at various levels, with one central figure—are Lastman's, practised according to the best theoretical directives in the *Coriolanus*. The same year Rembrandt painted a *Baptism of the Eunuch* (1626; Utrecht, Catharijneconvent), in which the subject, palette and composition were inspired by Lastman's representations of the same subject, of which at least four are known: of 1608

(Berlin, Gemäldegal.), 1616 (Paris, Fond. Custodia, Inst. Néer.), 1620 (Munich, Alte Pin.) and 1623 (Karlsruhe, Staatl. Ksthalle). From this last work in particular Rembrandt borrowed many details.

As a draughtsman Lastman also had a profound effect on his most famous pupil and, through him, on a whole generation of artists. Two years after Lastman's death, as a sort of *in memoriam*, Rembrandt made drawn copies (Bayonne, Mus. Bonnat; Berlin, Kupferstichkab.; Vienna, Albertina) after paintings by his former teacher: the *Expulsion of Hagar* and *Joseph Distributing Grain in Egypt* (both 1612) and two of 1614, *Susanna and the Elders* (Berlin, Gemäldegal.) and *SS Paul and Barnabas at Lystra* (Warsaw, N. Mus.).

Lastman's fame was extensive during his own lifetime, confirmed by the high prices commanded by his pictures at auction and by the mention of his name as one of the most important painters in Amsterdam in Rodenburgh's hymn to the city of 1618. Thirty years later Rembrandt's friend, Jan Six, who once owned the Warsaw *SS Paul and Barnabas*, commissioned Joost van den Vondel to write a poem about it. Vondel praised, above all, its 'richness and variety [of detail]'; both concepts (*copia* and *varietas*) were considered by Italian art theoreticians as essential requisites for the proper composition of a historical piece, and throughout his career Lastman showed himself to have been well-educated, both theoretically and practically. Indicative of the esteem in which Lastman continued to be held after his death is that Rembrandt's pupils, especially Gerbrand van den Eeckhout, were often inspired by his work.

Bibliography

Hollstein: *Dut. & Flem.*

K. Freise: *Pieter Lastman: Sein Leben und seine Kunst* (Leipzig, 1911)

K. Bauch: 'Frühwerke Pieter Lastmans', *Münchn. Jb. Bild. Kst*, n. s. 2, ii (1951), pp. 225–37

—: 'Entwurf und Komposition bei Pieter Lastman', *Munchn. Jb. Bild. Kst*, n. s. 2, vi (1955), pp. 213–21

A. Tümpel: 'Claes Cornelisz. Moeyaert', *Oud-Holland*, lxxxviii (1974), pp. 35–56

The Pre-Rembrandtists (exh. cat., ed. A. Tümpel; Sacramento, CA, Crocker A. Mus., 1974)

W. Sumowski: 'Zeichnungen von Lastman und aus dem Lastman-kreis', *Giessen Beitr. Kstgesch.*, iii (1975), pp. 149–86

B. P. J. Broos: 'Rembrandt and Lastman's *Coriolanus*: The History Piece in Theory and Practice', *Simiolus*, viii (1975–6), pp. 199–228

S. A. C. Dudok van Heel: 'Pieter Lastman (1583–1633): Een schilder in de Sint Anthoniesbreestraat', *Kron. Rembrandthuis*, ii (1991), pp. 2–15

Pieter Lastman: Leermeester van Rembrandt (exh. cat. by A. Tümpel and P. Schatborn, Amsterdam, Rembrandthuis, 1991)

Pieter Lastman (exh. cat., Amsterdam, Rembrandthuis, 1992)

Dawn of the Golden Age: Northern Netherlandish Art, 1580–1620 (exh. cat., ed. G. Luijten and others; Amsterdam, Rijksmus., 1993–4), pp. 309–10 and *passim*

<div align="right">B. P. J. BROOS</div>

Leyster, Judith

(*b* Haarlem, *bapt* 28 July 1609; *d* Heemstede, *bur* 10 Feb 1660). Dutch painter. She painted genre scenes, portraits and still-lifes, and she may also have made small etchings; no drawings by her are known. She specialized in small intimate genre scenes, usually with women seated by candlelight, and single half-length figures set against a neutral background. She was influenced by both the Utrecht Caravaggisti and Frans Hals.

Leyster may have worked in Hals's shop (*c.* 1626–8 and *c.* 1629–33), where she copied and adapted several of his paintings, although the nature of her work in his shop has been disputed. These possible works include *The Jester* (Amsterdam, Rijksmus.), a copy after Hals's *Lute Player* (Paris, Louvre), and the *Rommel-pot Player* (Chicago, IL, A. Inst.), after Hals's lost work. However, it is also possible that her early career began in the shop of the Haarlem portrait painter Frans Pietersz. de Grebber, with whom she is mentioned in Samuel Ampzing's poem about Haarlem of 1627/8. This would also explain the somewhat passé nature of her few known later portraits, for example *Portrait of a Woman* (1635; Haarlem, Frans Halsmus.), the shallow space of which seems to push the woman forward on to the picture plane.

In 1628 Leyster's family moved to Vreeland, near Utrecht, where, it is assumed, she came under the direct influence of the Utrecht Caravaggisti Hendrick Terbrugghen and Gerrit van Honthorst. The influence of the Caravaggisti can be seen in subsequent night-scenes, including those executed in Haarlem, such as *The Serenade* (1629; Amsterdam, Rijksmus.), which depicts a lute player illuminated by flickering yet unseen candlelight. The broad brushstrokes of the costume and the face also show the influence of Hals and give an illusion of monumentality to this small painting (455×350m). The upward glance of the lute player is a typical device of Leyster's.

Leyster is credited with introducing a visible light source to nocturnal painting in Haarlem, for example the lit candle between a drinker and a smoker in the *Last Drop* (*c.* 1629; Philadelphia, PA, John G. Johnson priv. col.) and the lit lamp in *The Proposition* (1631; The Hague, Mauritshuis; see col. pl. XXIII). In this painting, the lamplight illuminates the scene of a man offering money to a woman for her sexual favours, a style and subject common among the Caravaggisti; but Leyster's woman does not appear to be a courtesan, nor is she encouraging this overture, unlike a copy of the work (ex-Amédée Provost priv. col.; sold Brussels, 20 June 1928, lot 56) where such additional motifs as a wine-glass and a map over the woman's head imply that she is a *vrouwe-wereld* (Dut.: 'woman of the world'). In adapting this common theme, Leyster seems to have questioned the usual assumption of the woman as temptress.

By 1633 Leyster had become a member of the Haarlem Guild of St Luke. As her admission piece she may have submitted her *Self-portrait* (Washington, DC, N.G.A.), which shows her seated at her easel in formal dress, wielding a palette and 18 brushes and painting a fiddler; a fiddler also appears in her *Merry Company* (1630; Paris, Louvre; see fig. 33). On 1 June 1636 she married the Haarlem genre and portrait painter JAN MIENSE MOLENAER; they lived in Amsterdam until October 1648, when they moved to Heemstede. They also owned several properties in Amsterdam and Haarlem, which they seem to have rented out for additional income. They had five children between

33. Judith Leyster: *Merry Company*, 1630 (Paris, Musée du Louvre)

after her death, and Arnold Houbraken's *Groote schouburgh* of 1718–21. By the end of the 19th century she was virtually unknown, so much so that no works were ascribed to her. Her monogram was thought either indecipherable or, as in a court case in 1892 involving her painting the *Carousing Couple* (1630; Paris, Louvre), was said to contain all the letters of Hals's name. This painting of a vivid, buoyant couple drinking, smoking and making music in a canopied arbour, marks the turning-point in Leyster's reputation. Discoveries of other paintings by her followed, many previously ascribed to Hals; others, such as her masterpiece of light and still-life elements, the *Young Flute Player* (Stockholm, Nmus.), were once attributed to Jan de Bray. Leyster's paintings of mothers and children and women with their lovers may have served as prototypes for genre painters of the second half of the 17th century, such as Gerard ter Borch II, Gabriel Metsu and Pieter de Hooch. Also, 18th-century artists such as Alexis Grimou based some of their single half-length figures on her work.

Three students are recorded in Leyster's shop: Willem Woutersz. in 1634, Davidt de Burry and Hendrick Jacobs. Although no works by them are known, it is assumed that they made many copies of her paintings. Woutersz. was also the subject of a dispute between Leyster and Hals when the latter accepted him as a student, without permission of the Guild, and when he was already in Leyster's shop.

1637 and 1650, but only two survived their parents. Leyster's *Tulip* pages (1643; Haarlem, Frans Halsmus.), possibly part of a tulip-bulb catalogue and executed in watercolour and silverpoint on vellum, suggest a scale and change of medium and subject that may have been more adaptable to her new domestic situation. Many paintings by Leyster are recorded in the inventory of Molenaer's possessions after his death in 1668. Included are several other still-lifes as well as many works now lost. Leyster's output after her marriage and after her children were born seems greatly reduced, although it cannot be discounted that she may have collaborated with her husband.

In 1647–8 she was praised by Theodore Schrevel in his book on Haarlem, in which he makes a pun on her name, calling her Ley/sterr (Dut.: 'lodestar'), a 'leading star' in art. Leyster also used this pun in her monogram, formed by her conjoined initials and a star shooting out to the right. Despite praise from her contemporaries, she was not mentioned in other early sources, such as Cornelis de Bie's *Het gulden cabinet*, published only a year

Bibliography

S. Ampzing: *Beschryvinge ende lof der stad Haerlem* [Description and praise of the town of Haarlem] (Haarlem, 1628/R Amsterdam, 1974), p. 370

T. Schrevel: *Harlemum* (Haarlem, 1647), p. 292; Dut. trans. as *Harlemias* (Haarlem, 1648), p. 445

C. Hofstede de Groot: 'Judith Leyster', *Jb. Preuss. Kstsamml.*, xiv (1893), pp. 190–98, 232

A. Bredius: 'Een conflict tusschen Frans Hals en Judith Leyster', *Oud-Holland*, xxxix (1917), pp. 71–3

A. von Schneider: 'Gerard Honthorst and Judith Leyster', *Oud-Holland*, xl (1922), pp. 169–73

J. Harms: 'Judith Leyster: Ihr Leben und ihr Werk', *Oud-Holland*, xlix (1927), pp. 88–96, 113–26, 145–54, 221–42, 275–9

H. F. Wijnman: 'Het geboortejaar van Judith Leyster',
Oud-Holland, xlix (1932), pp. 62–5

F. F. Hofrichter: 'Judith Leyster's *Proposition*: Between
Virtue and Vice', *Fem. A. J.*, iv (1975), pp. 22–6; repr. in
Feminism and Art History: Questioning the Litany, ed.
N. Broude and M. D. Garrard (New York, 1982), pp.
173–82

Women Artists, 1550–1950 (exh. cat. by A. S. Harris and
L. Nochlin, Los Angeles, Co. Mus. A., 1976)

F. F. Hofrichter: 'Judith Leyster's *Self-portrait: Ut pictura
poesis*', *Essays in Northern European Art Presented to
Egbert Haverkamp-Begemann on his 60th Birthday*
(Doornspijk, 1983), pp. 106–9

Masters of Seventeenth-century Dutch Genre Painting
(exh. cat. by P. Sutton and others, Philadelphia, Mus.
A.; W. Berlin, Gemäldegal.; London, RA; 1984)

F. F. Hofrichter: 'Games People Play: Judith Leyster's *A
Game of Tric-trac*', *Worcester A. Mus.*, vii (1985),
pp. 19–27

—: *Judith Leyster: A Woman Painter in Holland's Golden
Age* (Doornspijk, 1989)

Judith Leyster: A Dutch Master and her World (exh. cat. by
J. A. Welu and others, Haarlem, Frans Halsmus.;
Worcester, MA, A. Mus.; 1993)

FRIMA FOX HOFRICHTER

Lievens [Lievensz.], Jan

(*b* Leiden, 24 Oct 1607; *d* Amsterdam, 4 June 1674).
Dutch painter, draughtsman and printmaker. His
work has often suffered by comparison with that
of Rembrandt, with whom he was closely associated from 1625 to 1631. Yet Lievens's early work is
equal to that of Rembrandt, although in later
years he turned more towards a somewhat facile
rendering of the international Baroque style
favoured by his noble patrons, thus never fully
realizing his early promise. Nonetheless, he
became a renowned portrait painter and draughtsman, and his drawings include some of the finest
examples of 17th-century Dutch portraiture in the
medium.

1. Leiden, 1607–31

He was, the son of Lieven Hendricxz. [De Rechte]
(*bur* Leiden, 8 May 1612), an embroiderer, hatmaker and hatseller in Leiden, and his wife,
Machteld Jansdr. van Noortsant (*bur* Leiden, 6
March 1622). According to Orlers, at the age of
eight Jan became a pupil of the Leiden painter
Joris van Schooten (*c.* 1587–*c.* 1653) and *c.* 1617–19
studied in Amsterdam with the history painter
Pieter Lastman. The latter's influence is evident in
Lievens's earliest known works, *c.* 1625. Lievens
returned to Leiden and settled there as an independent master. Orlers recorded that Lievens's
work after his return (e.g. a portrait of his mother,
1621; untraced) won him general admiration.
From 1625 to 1631 Lievens worked closely with his
fellow townsman REMBRANDT VAN RIJN, possibly
sharing a studio with him. The rivalry between the
two young painters is revealed in their earliest
works, which show mutual borrowings of composition and subject. The two used such a similar
painting technique that it is extremely difficult
to ascribe their unsigned works of this period correctly. Rembrandt began his training *c.* 1620,
much later than Lievens, who therefore had the
initial advantage. From 1628, however, Rembrandt
overtook Lievens. In these first Leiden years,
Lievens and Rembrandt repeatedly painted portraits of each other.

Apart from Lastman, the clearest influence on
Lievens's earliest paintings was the work produced
by the Utrecht Caravaggisti, particularly Gerrit
van Honthorst. This is evident in Lievens's preference at that time (one shared by Rembrandt) for
half-length figures and for strong chiaroscuro
effects from artificial light sources (e.g. the
Allegory of Smell, Warsaw, N. Mus.). Around 1625
both Lievens and Rembrandt made their first
prints, which were published by the Haarlem publisher Jan Pietersz. Berendrecht.

After 1628 Lievens's technique changed. His use
of colours tended to be more monochromatic,
moving away from Lastman's early influence, with
an increasing use of impasto to define form, as in
the grisaille oil sketch of *Samson and Delilah*
(*c.* 1628; Amsterdam, Rijksmus.). In the same
year Lievens began to achieve recognition from
outside Leiden and supplied various paintings to
Stadholder Frederick Henry and his wife Amalia
van Solms, including *The Oriental* (Potsdam,
Bildergal.) and another version, in oil on canvas,
of *Samson and Delilah* (Amsterdam, Rijksmus.).
Orlers said that Lievens also executed a life-size

painting of a *Man Reading by a Fire* (untraced), which won him such praise that the Stadholder ordered the picture to be bought for the English ambassador Sir Robert Kerr, 1st Earl of Ancram (1578–1654), who, in turn, gave it to Charles I of England.

Constantijn Huygens the elder, the Stadholder's secretary, was the first to write about the duo of Lievens and Rembrandt. In his autobiography, written between 1629 and 1631, Huygens praised the two young painters highly and compared their talents. He wrote that Lievens was better than Rembrandt because his magnificent invention and daring subjects and designs were greater, while Rembrandt, in his view, exceeded Lievens in precision and vitality of emotions. Huygens also praised Lievens for his strength of mind and very mature, sharp and profound sense of judgement. The portrait of himself (Douai, Mus. Mun.; on loan Amsterdam, Rijksmus.; see col. pl. XXIV) that Huygens commissioned from Lievens and described in his autobiography was probably executed during the winter of 1629–30.

In his last two years in Leiden, Lievens executed a number of works that can be regarded as the highpoints of his oeuvre, including three from 1631: *Job on the Dung-hill* (Ottawa, N.G.), the *Raising of Lazarus* (Brighton, A.G. & Mus.) and *Eli and Samuel* (Malibu, CA, Getty Mus.). From 1628 the collaboration with Rembrandt became less close, and in late 1631 Rembrandt moved to Amsterdam.

2. England and Amsterdam, 1632–43

Although Orlers claimed that Lievens went to England in 1631, a document signed by Lievens in Leiden on 2 February 1632 suggests that he left Leiden just after that date. He remained in England until 1635, during which time it seems that he was less productive than in Leiden; scarcely any dated works are known from his English period. From a poem written by Huygens in 1633, it is known that Lievens painted portraits of members of the English royal family and court; however, none has survived. In London, Lievens met Anthony van Dyck, who painted his portrait (untraced; known only through the engraving by Lucas Vorsterman), for van Dyck's *Iconography* (*c*. 1632–44). During this time Lievens's style was influenced by van Dyck, and his modified use of colour suggests he was able to study Italian paintings in English collections.

In 1635 Lievens was registered as a member of the Guild of St Luke in Antwerp. There he eliminated the last remnants of his Leiden style from his work and adopted completely the Flemish Baroque style of van Dyck and Rubens, in paintings such as his large altarpiece (*in situ*) of the *Holy Family with the Young Baptist* for the Jesuit church of S Carlo Borromeo in Antwerp. On 1 May 1636 Lievens took on Hans van den Wijngaard (1614–79) as his pupil. Jan Davidsz. de Heem and Adriaen Brouwer, both painters active in Antwerp, were involved in the contract, and it is also known that Lievens collaborated with the Antwerp still-life painter Jan van der Hecke (1620–84). In 1638, still in Antwerp, Lievens married Susanna de Nole, daughter of the sculptor Andries Colyn de Nole. Lievens interrupted his stay in Antwerp once to visit Leiden, probably *c*. 1639–40, when he painted an overmantel for the Leiden Stadhuis depicting the *Justice of Scipio Africanus* (destr. 1929) and etched the portrait of *Daniel Heinsius*, who was a professor in Leiden.

In his painted, drawn and etched portraits Lievens sought to emulate the international style of van Dyck and in his portrait drawings and prints, in particular, he occasionally achieved a level rarely equalled by his contemporaries. In his landscape drawings and paintings, a genre Lievens probably first attempted in England, he produced high-quality works characterized by a very subtle use of colour in the paintings (e.g. *Landscape with Pollarded Willows*, *c*. 1640; Paris, Fond. Custodia, Inst. Néer.) and a boldly hatched linear approach in the pen-and-ink drawings (e.g. *Wooded Landscape with an Angler*; Haarlem, Teylers Mus.). Several of his painted landscapes were long taken to be by Adriaen Brouwer or one of Brouwer's followers, and the attribution of a few is still controversial. Despite Lievens's many commissions, he still had financial problems and on 3 October 1643 his property in Antwerp was seized. He decided to leave the city, moving to Amsterdam in 1644,

shortly after the baptism of his son Jan Andrea (*b* Antwerp, *bapt* 20 Jan 1644; *d* Amsterdam, *bur* 30 Jan 1680), who became an artist after training with his father. Susanna de Nole probably died soon after the birth of her son.

3. Amsterdam, 1644–74

Lievens lived in Amsterdam for the rest of his life, although he visited The Hague (1650 and again in 1670), Berlin (*c.* 1653–5), Cleves (1664) and Leiden (1670–72). On 2 August 1648 he married Cornelia de Bray, daughter of the Haarlem painter Jan de Bray. Altogether Lievens had nine children from his two marriages, three of whom died young. On his return to the northern Netherlands, Lievens received many important commissions and was able to achieve an important position through his readiness to adapt to the prevailing classicizing taste. In 1650 he was commissioned by Amalia van Solms, by then widow of the Stadholder, to collaborate on the decoration of the Oranjezaal in the Huis ten Bosch. The large figures in the *Five Muses* (*in situ*) are closely in keeping with the classicizing Flemish style Lievens had developed in Antwerp. This style also brought him international acclaim; in 1653–4 he worked in Berlin for Amalia van Solms's daughter Louisa Henrietta and her husband Frederick William, Elector of Brandenburg, who commissioned *Mars and Venus* (1653; Berlin, Jagdschloss Grunewald) and *Diana with her Nymphs* (1654; Potsdam, Bildergal.). Sir Robert Kerr, then in exile in Amsterdam, who had his portrait painted by Lievens shortly before the artist's trip to Berlin (*c.* 1653; Edinburgh, N.P.G.), called Lievens 'the Duke of Brandenburg's painter', in a letter of 1654 to his son in Scotland, adding that Lievens had such a high opinion of himself that he thought no painter in the northern and southern Netherlands or Germany could match him.

Back in Amsterdam, Lievens was commissioned to paint an overmantel in the Burgomaster's room in the new Stadhuis (now Royal Palace) on the Dam. This large picture (1656; *in situ*) shows the Roman consul Suessa commanding his father Quintus Fabius Maximus to dismount from his horse before he speaks to him. Lievens received a second commission for the same building in January 1661. This belongs to the Claudius Civilis series in the Great Gallery on the theme of the Batavians' uprising against the Romans and shows *Brinio Promoted to General* (1661; *in situ*). The colossal piece (5.46×5.38 m) was painted in great haste, and he received his payment in March of the same year. Lievens executed two paintings for the Rijnlandshuis, Leiden: *The Mathematician* (1668; *in situ*), which was completed to his design by his son Jan Andrea, and the allegorical overmantel *Justice Receiving the Body of the Law from Time* (1670; *in situ*), which was almost entirely overpainted by the Leiden painter Karel de Moor during restoration.

Lievens also obtained various portrait commissions during his Amsterdam years (see fig. 34). He painted the portrait of *Adriaan Trip* (1644; The Hague, S. Laman Trip priv. col., for illustration see Sumowski, *Gemälde der Rembrandt-Schüler*, 1983, p. 1929), some years later a posthumous portrait of the *Vice-Admiral Maerten Harpertzs. Tromp* and his wife *Cornelia Teding van Berkhout* (both after 1653; Amsterdam, Rijksmus.) and the poet and artist *Anna Maria Schuurman* (1649; London, N.G.). The black chalk portrait drawing of the

34. Jan Lievens: *Portrait of a Young Man Surrounded by Flowers*, 1644 (Vienna, Kunsthistorisches Museum)

lawyer *Johannes Wtenbogaert* (1650; Amsterdam, Hist. Mus.) and the etching of the poet *Joost van den Vondel* (*c.* 1644–50; Hollstein, no. 21) are particularly successful. Lievens was also responsible for the design of a number of woodcuts (an unusual medium in the 17th century); those of figures and heads were probably cut by a professional woodcutter, while one of a *Landscape with Trees* (Hollstein, no. 100) is so close to the style of his landscape drawings that it has been suggested that Lievens cut the block himself.

Bibliography

Hollstein: *Dut. & Flem.*

J. J. Orlers: *Beschrijvinge der Stadt Leyden* [Description of the town of Leyden] (Leiden, 1641), pp. 375–7 [Eng. trans. in Vogelaer, ed., 1991, pp. 138–9]

J. W. Worp: 'Constantijn Huygens over de schilders van zijn tijd' [Constantijn Huygens on the painters on his time], *Oud-Holland*, ix (1891), pp. 106–36 [first Dut. trans. of Huygens's remarks on Rembrandt and Lievens in his biography, 1629–31; for Eng. version see Vogelaer, pp. 132–4]

E. W. Moes: 'Jan Lievens', *Leids Jb.*, iv (1907), pp. 136–64

A. Bredius: *Künstler-Inventare: Urkunden zur Geschichte der holländische Kunst des XVIten, XVIIten and XVIIIten Jahrhunderts*, i (The Hague, 1915), pp. 186–227

H. Schneider: *Jan Lievens: sein Leben und seine Werken* (Haarlem, 1932); rev. with suppl. by R. E. O. Ekkart (Amsterdam, 1973)

K. Bauch: 'Rembrandt und Lievens', *Wallraf-Richartz-Jb.*, xi (1939), pp. 239–68

—: *Der frühe Rembrandt und seine Zeit: Studien zur geschichtlichen Bedeutung seines Frühstils* (Berlin, 1960)

E. Larsen: 'Brouwer ou Lievens: Etude d'un problème dans le paysage flamande', *Rev. Belge Archéol. & Hist. A.*, xxix (1960), pp. 37–48

Jan Lievens: Ein Maler im Schatten Rembrandts (exh. cat., ed. R. Klessmann; Brunswick, Herzog Anton Ulrich-Mus., 1979)

W. Sumowski: *Drawings of the Rembrandt School*, vii (New York, 1983), pp. 3143–708

—: *Gemälde der Rembrandt-Schüler*, iii (Landau-Pfalz, 1983), pp. 1764–950

Jan Lievens, 1607–1674: Prenten & tekeningen/Prints & Drawings (exh. cat. by P. Schatborn, Amsterdam, Rembrandthuis, 1988–9)

C. Vogelaer, ed.: *Rembrandt & Lievens in Leiden* (Zwolle and Leiden, 1991) [pubd. to coincide with exh. at Leiden, Stedel. Mus. Lakenhal, 1991–2]

ERIC DOMELA NIEUWENHUIS

Maes, Nicolaes

(*bapt* Dordrecht, Jan 1634; *bur* Amsterdam, 24 Dec 1693). Dutch painter. The son of the prosperous Dordrecht merchant Gerrit Maes and his wife Ida Herman Claesdr., Nicolaes Maes learnt to draw from a 'mediocre master' (Houbraken) in his native town before he studied painting with Rembrandt in Amsterdam. His training in Rembrandt's studio must have taken place between 1648/50 and 1653. By December 1653 Maes had settled in Dordrecht and made plans to marry, while a signed and dated picture of 1653 confirms that the 19-year-old artist had completed his training and embarked on an independent career. Maes continued to reside in Dordrecht until 1673.

1. Work

(i) Genre and history paintings. Maes's few pictures of biblical subjects and all his approximately 40 genre paintings date from *c.* 1653 to *c.* 1660 (see fig. 35). Though indebted to Rembrandt's example, the early religious works exhibit a precocious originality in the interpretation of the sacred text

35. Nicolaes Maes: *Christ before Pilate* (Budapest, Museum of Fine Arts)

and iconographic tradition. For instance, in the *Expulsion of Hagar* (1653; New York, Met.) Hagar's inconsolable response to her dismissal and the characterization of Ishmael as a prematurely embittered outcast mark it as one of the most poignant renderings of a theme that was especially popular among Rembrandt's students. This and other biblical pictures are of cabinet size; *Christ Blessing the Children* (London, N.G.) is Maes's only religious work with lifesize figures.

For a brief period in the mid-1650s Maes ranked among the most innovative Dutch genre painters, owing to his talent for pictorial invention and for devising expressive poses, gestures and physiognomies. He adapted Rembrandt's brushwork and chiaroscuro to the scenes of domestic life that provided the favourite subject-matter for genre artists working in the third quarter of the century. The poetic deployment of light and shade and the adeptly designed figures invest his paintings of interior scenes with women absorbed in household tasks with an atmosphere of studious concentration. In pictures of spinners, lacemakers (e.g. *The Lacemaker*, 1655; Ottawa, N.G.) and mothers with children, dating from 1654 to 1658, household work assumes the dignity and probity claimed for it by contemporary authors of didactic literature on family life. Maes also executed a small group of works that show everyday events taking place on the doorstep of a private house. Some depict milkmaids ringing the doorbell or receiving payment for a pot of milk (e.g. London, Apsley House); others represent boys asking for alms from the residents. As in the interior scenes, Maes's pictorial gifts transformed these mundane transactions into events of solemn dignity. Another type of genre painting from the mid-1650s shows a single, nearly lifesize female figure in half or three-quarter length. An elderly woman says grace before a modest meal, prays amid *vanitas* symbols or dozes over a Bible (e.g. Brussels, Mus. A. Anc.), exemplifying, respectively, spiritual vigour and spiritual lassitude in old age.

Maes's most renowned genre paintings feature an interior with an eavesdropper who exposes the peccadilloes of another member of the household (e.g. London, Apsley House). Dated or datable between 1655 and 1657, the six pictures of eavesdroppers and the closely related *Idle Servant* (1655; London, N.G.) and *Woman Picking the Pocket of a Sleeping Man* (Bangor, North Wales, Lady Janet Douglas-Pennant priv. col., see Sumowski, 1983, fig. 1344) employ gentle satire and an ingenious narrative structure to ridicule the vices of sloth, lust or anger. The eavesdropper or other principal figure smiles engagingly at the viewer and directs attention to a housewife scolding her husband, a kitchen maid asleep on the job or a servant entangled in the embrace of a lover. In these pictures and in the *Woman Plucking a Duck* of 1655 or 1656 (Philadelphia, PA, Mus. A.), Maes developed an innovative approach to the representation of interior space. He was among the first Dutch genre painters to depict the domestic interior not as a shallow, three-walled box but as a suite of rooms. His new disposition of domestic space resulted primarily from the narrative requirements of these paintings. While he demonstrably perused perspective handbooks, he resorted neither to a mathematically constructed space nor—with one exception—to *trompe l'oeil* illusionism. Maes pursued his experiments for only a brief period (1655–7), but his achievement exercised a decisive influence on the Delft painters Johannes Vermeer and Pieter de Hooch and thus had lasting consequences for the representation of interior space in 17th-century Dutch painting.

(ii) **Portraits.** While concentrating on his genre and history paintings, Maes embarked on a productive, 35-year career as a portrait painter. During the second half of the 1650s, when his output of subject pictures gradually diminished, his production of portraits steadily increased. Some 25 single, pendant and group portraits from the period 1655–60 have been preserved.

However, from *c.* 1660 until the end of his career, Maes worked exclusively as a portraitist. He settled in Amsterdam in 1673, making a bid to fill the vacancy left by the deaths of the portrait specialists Bartholomeus van der Helst and Abraham van den Tempel. Soon, wrote Houbraken, 'so much work came his way that it was deemed a favour if

one person was granted the opportunity to sit for his portrait before another, and so it remained for the rest of his life'. Hundreds of surviving portraits from the 1670s and 1680s corroborate Houbraken's report (see col. pl. XXV). Most are pendants in one of two favourite formats: a smaller rectangular canvas with a half-length figure within a painted oval; and a larger canvas with a three-quarter-length figure, usually shown leaning against a fountain, rock or column. In both types, the setting is often a garden or terrace before a sunset sky. There are several group portraits of children or families, depicting the sitters full length in landscape settings, but only one corporate group, the *Six Governors of the Amsterdam Surgeons' Guild* (1680–81; Amsterdam, Rijksmus.), is known.

2. Working methods and technique

(i) Paintings. During his 40-year career, Maes's painting technique evolved continuously, but his exceptional skill with the brush never faltered. In the genre and history pictures of the prolific period 1653–5, his colour, chiaroscuro and brushwork owe a clear debt to Rembrandt's work of the mid-1640s, particularly to the latter's *Holy Family in the Carpenter's Shop* (1645; St Petersburg, Hermitage). Maes restricted his palette to blacks, browns, whites and reds and employed techniques ranging from a meticulous 'fine painting' style in the description of wooden furniture or a wicker cradle to a grainy—occasionally even pastose—application of richly graduated tones in the execution of fabric and flesh. After the middle of the decade, he increasingly favoured a clearer light, smoother textures and more definite contours.

The early portraits developed differently. Apart from the evocative shadows that enrich a few of them, they scarcely recall the legacy of Rembrandt's teaching. Rather, Maes initially accommodated his style to the conservative Dordrecht tradition represented in the 1650s by Jacob Gerritsz. Cuyp, his son Aelbert Cuyp and the older Rembrandt pupil Samuel von Hoogstraten. Simple frontal poses, restrained conventional gestures, sober facial expressions, dark clothing rendered with tones of white, black and grey, and plain backgrounds or austere domestic settings characterize Maes's first essays in this field, dating from 1655–7 (e.g. the portrait of *Jacob de Witt*, 1657; Dordrecht, Dordrechts Mus.). In the portrait of the Dordrecht shipper *Job Cuijter and his Family* (1659; Raleigh, NC Mus. A.), which shows the family on a quay in Dordrecht harbour, Maes began to employ the lighter tonality, the pale red hues and the white highlights that also distinguish his latest subject picture, *Winter and Spring* (c. 1659–60; Oxford, Ashmolean).

Maes's mature style developed gradually during the 1660s in response to the Flemish mode of portraiture developed by van Dyck and introduced into the northern Netherlands in the previous decade by such artists as Govaert Flinck, Adriaen Hanneman and Jan Mijtens. From the early 1660s onwards, Maes regularly employed staging and accessories derived from Flemish portraiture. Although Houbraken reported that Maes once travelled to Antwerp, direct contact with Flemish painting contributed less to his development than his study of works by Mijtens, whose colouring and technique evidently inspired the glistening reds and blues and brilliant brushwork of his later paintings. Despite the general trend of his style, in some of his most sympathetic portraits of the 1660s Maes continued to utilize a plain background and a subdued palette (e.g. the *Portrait of a Widow*, 1667; Basle, Kstmus.).

The portraits of the 1670s and 1680s generally feature the same imaginary garden or architectural setting with a foreground composed of columns, fountains, terraces and billowing curtains, but they exhibit a novel repertory of graceful poses and refinements in technique and colouring. The pale, solidly modelled countenances preserve—according to Houbraken's reliable testimony—an accurate likeness of the sitter, but the brilliantly rendered hair and clothing increasingly dominate the image. Satiny fabrics in a broader and brighter range of reds, blues, oranges, golds and violets shimmer with dashing, scumbled highlights, while the elaborate curls of the period's long hairstyles are described with a breathtaking show of tonal painting in greys and browns (e.g. the *Portrait of a Young Man*; Munich, Alte Pin.).

(ii) Drawings. About 160 drawings by Maes have survived, making him one of the few outstanding Dutch genre painters of his generation whose practice as a draughtsman can be partially reconstructed. Many are working drawings, both compositional sketches and figure studies, for his genre and history paintings—only one rough design for a portrait survives (Besançon, Mus. B.-A & Archéol.), along with a few landscape drawings. For the compositional projects Maes used a variety of media: red chalk, pen and ink and combinations of chalk and wash or ink and wash. Most are cursory sketches, for example the study in pen and wash (Berlin, Kupferstichkab.) for *The Lacemaker* (1655; Ottawa, N.G.). The figure studies also exhibit a wide variety of media and techniques. They range from spare contours delineated with the pen or brush to exquisitely refined studies in red chalk (e.g. another study, Rotterdam, Boymans–van Beuningen, for *The Lacemaker*) to broadly pictorial drawings executed in a combination of chalk, ink, wash and bodycolour.

3. Patrons and followers

While early collectors of Maes's subject pictures remain unidentified, the known sitters in his portraits attest that in this field Maes enjoyed from the outset the patronage of Dordrecht's political and mercantile élite. Jacob de Witt, whom he portrayed in 1657, was a member of the city's Old Council and the father of Grand Pensionary Johan de Witt, the political leader of the United Provinces. A contract of 1658 records that Maes acquired a house from Job Cuijter in exchange for a cash payment and the portrait of Cuijter with his family. In 1659 or 1660 Maes painted a portrait of *Jacob Trip* (The Hague, Mauritshuis), the first of several pendant portraits with Trip's wife Margaretha de Geer (both of whom were portrayed by Rembrandt about the same time). Among Holland's wealthiest families, the Trips and de Geers amassed fortunes from Swedish iron mines and the manufacture of armaments.

During his last years in Dordrecht and during his Amsterdam period, Maes continued to work for a varied clientele at the highest social levels, including the Utrecht University professor of theology Gijsbert Voet; the preacher Cornelis Trigland; Hieronymus van Beverningk, Treasurer-General of the United Provinces, diplomat and one time close confidant of Johan de Witt; the Amsterdam burgomaster Gerrit Hendriksz. Hooft; the Lieutenant-Admiral of Zeeland, Cornelis Evertsen; Laurent de Rasiere, a sea-captain in the service of the West India Company; and the Rotterdam burgomaster, silk-merchant and director of the East India Company Jan de Reus. A few of these portraits were reproduced in prints.

Maes's closest followers were the Dordrecht painters of portraits and genre scenes Reinier Covijn and Cornelis Bisschop (1630–74). Bisschop studied with Ferdinand Bol, but Covijn may have been Maes's pupil. Houbraken mentioned four minor artists as Maes's students: Jacob Moelaert (1649–c. 1727), Jan de Haen, Johannes Vollevens (1649–1728) and the poetess Margaretha van Godewijk (1627–77).

Bibliography

A. Houbraken: *De groote schouburgh* (1718–21), ii, pp. 273–7

J. Veth: 'Aantekeningen omtrent eenige Dordrechtse schilders', *Oud-Holland*, viii (1890), pp. 125–42

C. Hofstede de Groot: *Holländischen Maler* (1907–28), vi (1915), pp. 479–622

A. Bredius: 'Bijdragen tot een biografie van Nicolaes Maes', *Oud-Holland*, xli (1923–4), pp. 207–14

W. Valentiner: *Nicolaes Maes* (Stuttgart, 1924)

W. Sumowski: *Gemälde der Rembrandt-Schüler*, iii (Landau in der Pfalz, 1983), pp. 1951–2174

——: *Drawings of the Rembrandt School*, viii (New York, 1984), pp. 3951–4489

W. Robinson: 'The Eavesdroppers and Related Paintings by Nicolaes Maes', *Holländische Genremalerei im 17. Jahrhundert, Symposium: Berlin 1984*, pubd in *Jb. Preuss. Kultbes.*, special issue iv (1987), pp. 283–313

——: 'Nicolaes Maes as a Draughtsman', *Master Drgs*, xxvii (1989), pp. 146–62

——: 'Nicolaes Maes: Some Observations on his Early Portraits', *Rembrandt and his Pupils: Papers Given at a Symposium in Nationalmuseum Stockholm, 2–3 October 1992* (Stockholm, 1993), pp. 98–118

WILLIAM W. ROBINSON

Mander, van

Dutch family of artists of Flemish origin. The most famous member of the family, Karel van Mander I, although a noted painter and draughtsman, is known primarily as the author of the *Schilder-boeck* ('Book of painters'), which follows the example of Vasari's *Vite* (van Mander is sometimes referred to as the 'Dutch Vasari') and includes biographies of Italian and northern European artists as well as containing practical advice. His son Karel van Mander II (*b* Courtrai, *c.* 1579; *d* Delft, 13 June 1623) was a tapestry designer who worked for Christian IV of Denmark, and his grandson Karel van Mander III also worked at the Danish court, as a portrait painter and decorative artist.

(1) Karel van Mander I

(*b* Meulebeke, nr Courtrai, West Flanders, 1548; *d* Amsterdam, 11 Sept 1606). Poet, writer, painter and draughtsman.

1. Life

Before 1568 van Mander was apprenticed to Lucas de Heere, a painter and poet in Ghent, and afterwards to Pieter Vlerick (1539–81) in Courtrai and Doornik. Between *c.* 1570 and 1573 he lived in his native Meulebeke, where he applied himself to writing plays and poetry. In 1573 he went to Italy, where he first paid a brief visit to Florence; in Terni he was commissioned to paint a fresco for a count of the *St Bartholomew's Night Massacre*, in which the death of Gaspard de Coligny in 1572 was represented. Three sections of the fresco, restored and partly overpainted, are still extant in the Palazzo Spada Terni. In Rome he met Bartholomeus Spranger and became a close friend of Gaspard Heuvick (1550–after 1590) from Oudenaarde, who was working in Bari and elsewhere. In 1577, or shortly afterwards, van Mander was working in Basle; he then moved on to Krems. Spranger encouraged him to go to Vienna, where he worked with Hans Mont on the triumphal arch on the Bauermarkt, erected for the occasion of Rudolph II's arrival in July 1577. After this, van Mander returned to Meulebeke, passing through Nuremberg on the journey. Because of the

religious turmoil and uprising against the Spanish, van Mander and his family, who were Mennonites, kept wandering from place to place; he stayed in Courtrai and Bruges and finally fled from the southern Netherlands to Haarlem, where he arrived penniless but remained for 20 years.

In 1584 van Mander became a member of Haarlem's Guild of St Luke. He is said to have set up a sort of academy in Haarlem at this time with Hendrick Goltzius and Cornelis Cornelisz. van Haarlem, but hardly anything is known about this project. In 1586 he worked on a gateway for the entry of Robert Dudley, Earl of Leicester, into the city; after a difficult beginning, he established his reputation with this project. In 1603 he retreated to Zevenbergen, a house between Haarlem and Alkmaar, where he wrote the greater part of his *Schilder-boeck*. In June 1604 he moved to Amsterdam, where he died a poor man with outstanding debts. Jacques de Gheyn II made a drawing of him on his deathbed (Frankfurt am Main, Städel. Kstinst. & Städt. Gal.). No fewer than 300 mourners accompanied his coffin to the Oude Kerk, where he is buried.

2. Writings

(i) **Poet and man of letters.** Van Mander initially followed the style of the *rederijkers* (rhetoricians) but soon changed his manner under the influence of Renaissance literature. In Haarlem he was an important member of the Flemish chamber of rhetoricians called De Witte Angieren (The White Carnations), founded in 1592, for which he designed a blazon. Van Mander had a good command of Latin and Greek as well as French and Italian. Among the works he translated were Virgil's *Bucolics and Georgics* (1597), Ovid (1604) and the *Iliad* (1611); his own writings include *De harpe* ('The harp'; 1599), the *Kerck der deught* ('Church of virtue'; *c.* 1600) and the *Olijfbergh* ('Mount of Olives'; 1609). He also devised numerous inscriptions for prints, to which he always added his own motto, *Eén is nodigh* ('One thing is necessary'). Van Mander was a broad-minded spirit for his time; he took a stand against Calvinism as well as Roman Catholicism. With Jan Baptiste van der Noot (*c.* 1540–*c.* 1595) and Jan van Hout

(1542–1609), he is one of the best poets of the early Dutch Renaissance, whose work influenced Bredero (1585–1618) and others.

(ii) The 'Schilder-boeck'. The first edition was published in Haarlem in 1604; the second edition, which includes an anonymous biography of van Mander, appeared in 1618. The *Schilder-boeck*, regarded as an art-historical source of great importance, consists of six sections.

(a) 'Het leerdicht' ('The didactic poem'). This is a treatise (in verse) on the theory of painting rather than a technical guide based on practice. Also known as the *Grondt der edel vry schilderconst* ('Foundations of the noble free art of painting'), it comprises 14 chapters: an introduction in which the poet addressed himself to young artists, followed by chapters on drawing, the rules of proportion, pose, composition, invention, disposition (temperament), the handling of light, landscape, animals, drapery, the combination of colours, painting, colour and the meanings of colour. Van Mander based his *Leerdicht* on the medieval tradition of didactic poetry and on the French *poésie scientifique*. He used a great many literary sources, Classical as well as later, the most important of which were Alberti, Vasari and Walter Rivius. Van Mander's approach can be described as scientific, historical, philosophical and astrological. In order to illustrate the various aspects of painting, he often referred to famous works of art or celebrated artists, who excelled in one way or another. For example, he used the Farnese *Flora* (Naples, Capodimonte) to illustrate drapery, Titian as the champion of brilliant flesh tone and Pieter Bruegel the elder as the master of landscape painting. In between, the poet offered various allegorical interpretations and explanations for the meaning of numerous symbols. He was the first art theorist to devote a whole chapter exclusively to landscape. In essence, the *Leerdicht* was an attempt to establish the superiority of the 'free and noble art of painting' over the crafts and trades; a similar argument ran through contemporary Italian art theory. Van Mander complained bitterly about the fact that as a painter he was forced to be a member of the same guild as tinkers, tinsmiths and rag-and-bone men, something he regarded as humiliating.

(b) 'Het leven van de antieke schilders' ('The lives of the ancient painters'). This section of the *Schilder-boeck*, dated 1603, is largely based on part XXXV of Pliny the elder's *Natural History*. Pliny's encyclopedia existed in a number of edited versions with explanatory notes, a number of which were known to van Mander, though he seems to have drawn primarily on the French translation by Antoine du Pinet (1562). After the introduction, in which van Mander commented on the origins of painting and sculpture—citing Homer and the reckoning of years by Olympiads—he gave biographical descriptions of Greek and Roman painters, beginning with Gyges, the first painter in Egypt. He also provided accounts of the earliest examples of Etruscan sculpture in Chiusi, Viterbo and Arezzo. The longest description is devoted to Apelles. Apart from discussing the work of ancient artists, van Mander included numerous anecdotes about the deceptive nature of realistic or naturalistic painting: Zeuxis deceived birds with real-looking painted grapes, while Parhasius deceived Zeuxis with a *trompe l'oeil* painted cloth apparently covering a painting. In the 16th century and early 17th Pliny's book was mainly influential as an iconographical source; one good example is his description of Apelles' *Hercules aversus*, the hero seen from behind, which gave rise to a number of such images, including Hendrick Goltzius's famous engraving of the Farnese *Hercules* seen from behind (B. 143).

(c) 'Leven van moderne beroemde Italiaanse schilders' ('Lives of famous contemporary Italian painters'). This section is a translated and adapted version of Vasari's *Vite*. Van Mander made a critical selection from the original text, cut down the longer passages and left out most of the portrait painters, whom he thought less important; he also discarded all decorative artists. His translation is reliable and demonstrates his good command of Italian. In the final chapters van Mander added a number of artists who had not been included by Vasari (who died in 1574). These final chapters form van Mander's most original contribution to the discussion of contemporary Italian artists; they introduce Jacopo Bassano,

Federigo Zuccaro, Federigo Barocci, Palma Giovane and Cavaliere d'Arpino. The section is rounded off with two general chapters, one about Italian artists 'now working in Rome', the other about Italian painters 'working in Rome in my time, between 1573 and 1577'. Van Mander collected the material for these two chapters himself; he assembled information from Dutch artists active in Italy after 1577, such as Goltzius and Jacob Matham. Van Mander is notable for being the first literary source for Caravaggio, whose innovative naturalism he strongly opposed; he made no attempt to conceal this bias, for he believed that artists should be selective and copy only what seemed most beautiful in nature. This idealism in the representation of reality was a legacy of the Italian Renaissance, the prime exponent of which was Raphael.

(d) 'Levens van de beroemde Nederlandse en Hoogduitse schilders' ('The lives of famous Netherlandish and High German painters'). This is the most original and important part of the *Schilder-boeck*. It laid the foundations of the history of Dutch and German painting before 1604. Among the author's sources were the writings of Domenicus Lampsonius, Lucas de Heere, Marcus van Vaernewijck and Pieter Coecke van Aelst, as well as letters, manuscripts, anecdotes he had heard and his own experience and memories. The first biography deals with Hubert and Jan van Ecyk. Jan is compared to Masaccio and deemed the pioneer and innovator of early Netherlandish painting due to his legendary invention of oil paint. The next two chapters are about the south Netherlandish artists Hugo van der Goes and Rogier van der Weyden. In the discussion of 15th-century artists, the emphasis is placed primarily on Haarlem as the cradle of north Netherlandish painting, with Albert van Ouwater, 'Dirck van Haarlem' (i.e. Dieric Bouts) and Geertgen tot Sint Jans as the key figures. Haarlem seems to have been to van Mander, who, after all, worked there for 20 years, what Florence was to Vasari. The discussion of 16th-century painters is longer and more informative. There are important chapters on Dürer, Holbein and Pieter Bruegel the elder. The work of the 'prodigy' Lucas van Leyden he thought to equal Dürer's achievements. Van Mander was concerned with the glory of Dutch art, for, as he proudly declared, he did not travel abroad to learn about art, 'although Vasari wrote otherwise'. There are further important chapters largely devoted to the lives and works of contemporary artists such as Goltzius and Cornelis van Haarlem. The elaborate description of Spranger, who became a friend of van Mander's in Rome and Vienna, is also full of vital information. This section, moreover, provides numerous facts about collectors and about paintings destroyed by iconoclasts or subsequently lost. The section ends with a discussion of some younger Dutch painters active shortly after 1600, such as Paulus Moreelse, who by 1604 had already achieved fame as a portrait painter. The index includes the names of almost 200 Netherlandish painters active before 1604, arranged alphabetically by their Christian names.

(e) 'Uitleg en verklaring van de symboliek van de Metamorphosen van Ovidius' ('Interpretation and explanation of the symbolism in Ovid's 'Metamorphoses'''). The importance of this part lies in its useful iconological information. In the artist's biography incorporated in the second edition of the *Schilder-boeck*, van Mander is reported to have taught his colleagues in Haarlem 'the Italian method, something which can be seen from the *Metamorphoses* designed by Goltzius'. Goltzius worked on these illustrations in close collaboration with van Mander; they began in 1587-8 but never got beyond the fourth book. There are 52 anonymous engravings, but only 6 of the original drawings have survived (Reznicek, nos 99-104; and the drawing of *Apollo and Daphne*, Amiens, Mus. B.-A.). The explanations in this section of the *Schilder-boeck* make it possible to interpret the symbolic and moral significance of a number of van Mander's own drawings, for example that of *Ixion* (Paris, Louvre), which deals with punishment, ingratitude and false wisdom.

(f) 'Hoe de figuren worden uitgebeeld, hun betekenis en wat zij voorstellen' ('How to render figures, what they mean and what they represent'). In this part of the book van Mander provided his readers with iconographical-iconological guidelines in the manner of Cesare Ripa and others. Mythological gods and animals are dealt with first, then the various parts of the body, then trees and plants. Finally, van Mander

discussed the abstract notions underlying these images. For instance, c. 1600 a tortoise alluded not only to slowness but also to the idea that women should stay indoors; a pair of bent knees indicated subjection; and a reed meant lack of resolution.

3. Artistic work

Van Mander's own work as an artist reflects his theoretical writings, and although there are only a few paintings by him, a considerable number of his drawings have been preserved, as well as at least 150 engravings after his designs. These show that he was interested primarily in 'instructive history'—that is religious, mythological and moral- allegorical subjects (see col. pl. XXVI)—and in peasant scenes. That he believed that artists should not blindly follow nature explains why he himself never aimed at achieving realistic effects in his work. Most important to him was the poetic approach of 'historia'; his dictum was Horace's 'Ut pictura poesis'. His drawings and paintings thus include neither portraits (with the exception of a signed *Portrait of a Man*, Vienna, Ksthist. Mus.) nor domestic scenes of the kind drawn by Goltzius and Jacques de Gheyn II, nor, for that matter, pure landscapes, animal or still-life pictures. He regarded portrait painting as an inferior, profit-seeking affair, citing Michiel van Mierevelt as an example. Landscapes could be amusing, 'droll' in his view, for instance the farm landscapes near Utrecht by Abraham Bloemaert. As an artist, and as a theorist, van Mander was one of the last serious followers of the Italian Renaissance in the Netherlands. When, c. 1600, a new generation of artists began to move in the direction of 'realism', van Mander no longer took part in artistic developments.

(i) Drawings. There are c. 70 surviving drawings by van Mander, 46 of which were catalogued by Elisabeth Valentiner in 1930. Only one drawing can be attributed to him with certainty from the period before 1583, the year he came to Haarlem: the *Flight into Egypt* (Dresden, Kupferstichkab.), which corresponds to an engraving of the same subject by Cherubino Alberti (b. 15). The early style points to the influence of Jan Speeckaert and Spranger. Later, van Mander seems to have been especially influenced by Cavaliere d'Arpino, as can be seen in the red chalk drawing of *Neptune* (Berlin, Kupferstichkab.; not accepted by Valentiner). After Goltzius's return from Italy in 1591, van Mander gradually reduced the amount of exaggerated movement in his figures, and his compositions generally became more balanced, with a greater sense of depth. Among his finest drawings are those of *Apollo and Daphne* and *Pan and Syrinx* (both Florence, Uffizi), which are in the manner of Spranger, and that of *Diana and Actaeon* (Bremen, Ksthalle), which shows a splendid use of colour and seems related in concept to van Mander's lost tapestry designs. Besides religious and mythological subjects, he also represented peasant scenes in imitation of Pieter Bruegel. His brilliant watercolour sketches in the Italian manner were based on woodcuts after Parmigianino.

Most of van Mander's designs for engravings, which were executed by Jacques de Gheyn II, Jacob Matham, Zacharias Dolendo and others, have been lost, but the prints show him to have been an imaginative inventor. The captions underneath the prints often help elucidate the symbolical meaning of the image, which usually has some underlying Christian moral; they were written either by van Mander himself or by Latin schoolmasters in Haarlem, such as Franco Estius (b c. 1544) and Theodore Schrevelius.

Van Mander's drawings include no academic studies of nudes, which is curious, given his alleged involvement with an academy in Haarlem where artists could draw models and make use of other facilities. His drawing of a *Male Nude* (Amsterdam, estate of J. Q. van Regteren Altena, see Valentiner, no. XI), seen from behind in an elegant pose, seems to have sprung from the artist's imagination rather than anything he might have seen in reality. And although there are a number of academic drawings of Classical statues by Goltzius, no such works by van Mander survive. Possibly they were lost *en bloc*.

(ii) Paintings. There are approximately 30 surviving paintings by van Mander, on copper, panel and canvas; they were catalogued by Leesberg in 1994. The earliest painting—the altarpiece of *St*

Catherine—was made for the clothmakers' guild in the St Maartenskerk in Courtrai (1582; *in situ*). It was painted shortly before the artist moved from Flanders to Haarlem. Stylistically, it is close to the work of the so-called Flemish Romanists, such as Michiel Coxie, who were influenced by 16th-century Italian art. The overall impression is rather stiff and old-fashioned, as if the artist had learnt practically nothing in Italy. Van Mander seems to have deliberately adapted his style to what was then the fashionable taste in Flanders.

Most of van Mander's paintings, however, were carried out in the northern Netherlands after 1583. Yet his colours continue to betray his Flemish background; they are similar to those of the Bruegel family: usually brown in the foreground, green in the centre and pale blue in the background. The figures are clothed in gentle tones, with sufficient contrasts of yellow, red and blue. The compositions are schematic and follow the rules set out in the *Schilder-boeck*: clusters of trees on the edges, a distant view in the middle (often showing a river winding through a landscape) and the narrative taking place in the foreground. Typical examples are the *Continence of Scipio* (Amsterdam, Rijksmus.) and *Mankind before the Flood* (Frankfurt am Main, Städel. Kstinst. & Städt. Gal.). On the *verso* of the former, van Mander painted an appropriate allegorical scene, something he did in a few other cases as well. His landscapes reveal the influence of Gillis van Coninxloo, with whom he collaborated on several occasions; van Mander, for example, painted the figures in van Coninxloo's *Judgement of Midas* (Dresden, Gemäldegal. Alte Meister).

Writings

Het schilder-boeck, waer in voor eerst de leerlustighe iueght den grondt der edel vry schilderconst in verscheyden deelen wort voorghedraghen: Daer nae in dry deelen t'leuen der vermaerde doorluchtighe schilders des ouden, en niewen tyds [The book of painters, in which firstly the foundation of the noble free art of painting is set out in several parts for the eager student: then in three parts the lives of the celebrated illustrious painters of old and new times] (Haarlem, [1603]–1604; rev. Amsterdam, 1618/*R* Utrecht, 1969)

Bibliography

general

H. E. Greve: *De bronnen van Carel van Mander* [The sources of Carel van Mander] (The Hague, 1903)

R. Jacobsen: *Carel van Mander (1548–1606): Dichter en prozaschrijver* (Rotterdam, 1906)

H. Miedema: *Karel van Mander: Het bio-bibliografisch materiaal* (Amsterdam, 1972)

the 'schilder-boeck'

Het leerdicht

O. Hirschmann: 'Beitrag zu einer Kommentar von Karel van Manders *Grondt der edel vry schilderconst*', *Oud-Holland*, xxxiii (1915)

R. Hoecker: *Das Lehrgedicht des Karel van Manders*, Quellen & Stud. Holland. Kstgesch., viii (The Hague, 1915)

H. Miedema: 'Karel van Mander's *Grondt der edel vry schilder-const*', *J. Hist. Ideas*, xxxiv (1973), pp. 653–68

——: *Karel van Mander: 'Der grondt der edel vry schilder-const'*, 2 vols (Utrecht, 1973); review by E. K. J. Reznicek in *Oud-Holland*, lxxxix (1975), pp. 102–28; and by L. de Pauw-de Veen in *Simiolus*, ix (1977), pp. 183–6

Leven van de antieke schilders

H. Miedema: *Karel van Mander: 'Het leven der oude antijcke doorluchtighe schilders'* (Amsterdam, 1977)

Leven van de Italiaanse schilders

H. Noe: *Karel van Mander in Italie* (The Hague, 1954)

Leven der moderne beroemde Italiaansche schilders; ed. H. Miedema (Alphen aan den Rijn, 1984)

Leven van de Nederlandse en Hoogduitse schilders

Levens van de beroemde Nederlandse en Hoogduitse schilders; ed. and Fr. trans. by H. Hymans, 2 vols (Paris, 1884–5); ed. and Ger. trans. by H. Floerke, 2 vols (Munich and Leipzig, 1906); ed. and Eng. trans. by C. van de Wall (New York, 1936) [unreliable]

A. F. Mirande and G. S. Overdiep: *'Het schilder-boeck' van Karel van Mander* (Amsterdam and Antwerp, 1950)

W. Waterschoot: *Ter liefde der const* [For the love of art] (Leiden, 1983)

artistic works

Thieme–Becker; Wurzbach

E. Valentiner: *Karel van Mander als Maler* (Strasbourg, 1930)

W. Bernt: *Die niederländischen Maler des 17. Jahrhunderts*, 4 vols (Munich, 1948–62); Eng. trans., 3 vols (London and New York, 1970), ii, pp. 73–7

—: 'Die niederländischen Zeichner des 17. Jahrhunderts,
 2 vols (Munich, 1957–8), ii, no. 386
E. K. J. Reznicek: Die Zeichnungen von Hendrick Goltzius,
 2 vols (Utrecht, 1961)
—: 'Een en ander over van Mander', Oud-Holland, cvii
 (1993), pp. 75–83
M. Leesberg: 'Karel van Mander as a Painter', Simiolus, xii
 (1993/4), pp. 5–57

E. K. J. REZNICEK

Matham, Jacob

(b Haarlem, 15 Oct 1571; d Haarlem, 20 Jan 1631).
Dutch engraver, draughtsman and painter. When
the pre-eminent engraver Hendrick Goltzius
married Matham's mother in 1579, he took Jacob
on as an apprentice. Matham worked more closely
with Goltzius than others of his circle, engraving
many of the master's drawings and paintings and
closely imitating his teacher's manner. Despite
Matham's prolific output, his artistic personality
does not emerge clearly, and the oeuvres of both
engravers contain unsigned works, which deserve
reattribution.

Matham's early engravings from c. 1588 reflect
the impact on the Haarlem Mannerists of
drawings by Bartholomeus Spranger and Jan
Speeckaert. His series of the Standing Virtues and
Vices (B. 264–77) and the Four Elements (B. 278–85)
capture the strong chiaroscuro, as well as the
abrupt, hooked contours of limbs and muscula-
ture and frozen swags of drapery in these artists'
figure drawings. Matham's most ambitious work
is his Tablet of Cebes, after a Goltzius design (1592;
B. 139) re-creating an ancient painting described
by Plato. In the richly detailed image, pilgrims
move along a twisting path leading from past
temptations to the domain of virtue. In this print,
made from three folio-sized plates, Matham shows
a more fluent and subtle burin technique. Even
here, however, he does not fully master the device
of building up secondary patterns and textures,
such as the reflective surface of satin, with cross-
hatching.

After his stepfather's return from Italy,
Matham himself went there between 1593 and
1597, working mainly in Venice and Rome in the
company of the painter Frans Badens (1571–1618).
Several prints after Tintoretto, Palma Giovane,
Taddeo Zuccaro and other Italian painters occu-
pied him for decades afterwards, as did engrav-
ings after Abraham Bloemaert and the revered
earlier masters Pieter Aertsen and Albrecht Dürer.
He became dean of the Guild of St Luke, Haarlem,
in 1605, and the signature on his engraving of
Moses and Aaron (Hollstein, XI, no. 5) indicates
that he was court engraver in The Hague one year
before his death.

A systematic catalogue of Matham's drawings
has not been attempted. However, a small group
of signed and dated drawings reveals the influ-
ence of Goltzius and Spranger on both his pen and
chalk techniques. Some pen drawings of mytho-
logical or fantastic figures (e.g. Head of a Man with
a Peaked Cap, Edinburgh, N.G.; Fantastic Portrait,
U. London, Courtauld Inst. Gals) show his interest
in the bold, burin-like use of the pen as developed
by Goltzius and Jacques de Gheyn II. Matham
displayed his virtuosity as a draughtsman in the
remarkable 'pen painting' of the Brewery and
Country House of Jan Claesz. Loo (1627; Haarlem,
Frans Halsmus.). This imaginary scene, juxtapos-
ing Loo's country and city properties, is the pre-
cursor of a group of works that created the same
effects of a linear painting on a gessoed panel by
counterproofing a print. While there is no evi-
dence that Matham also painted extensively, one
still-life by this master is now in a Dutch private
collection.

Jacob Matham trained his sons to engrave
according to techniques learnt from Goltzius's
shop. Adriaen Matham (b Haarlem, c. 1599; d The
Hague, 23 Nov 1660) recorded a diplomatic trip to
Morocco in drawings and engravings and engraved
political events at the Hague court. Jan Matham
(b Haarlem, Jan 1600; d Haarlem, July 1648) made
prints of genre scenes after Adriaen Brouwer and
other artists and was a still-life painter. Theodor
Matham (b Haarlem, 1605/6; d Amsterdam, 1676)
engraved numerous figural scenes and portraits
and participated in large projects for reproducing
in prints the Giustiniani sculpture gallery in
Rome and the art collection of Gerrit and Jan
Reynst in Amsterdam.

Bibliography
Hollstein: *Dut. & Flem.*; Thieme–Becker
E. K. J. Reznicek: *Die Zeichnungen von Hendrick Goltzius* (Utrecht, 1961)
Graphik der Niederlande, 1508–1617 (exh. cat. by K. Renger, Munich, Staatl. Graph. Samml., 1979), pp. 61–2
W. Strauss: *Netherlandish Artists*, 4 [XII/ii] of *The Illustrated Bartsch*, ed. W. Strauss (New York, 1980) [R.]
D. Freedberg, A. Burnstock and A. Phenix: 'Paintings or Prints? Experiens Sillemans and the Origins of the *Grisaille* Sea Piece', *Prt Q.*, i/3 (1984), pp. 148–68
L. Widerkehr: 'Jacob Matham Goltzij Privignus. Jacob Matham graveur et ses rapports avec Hendrick Goltzius,' *Ned. Ksthist. Jb.*, xlii–xliii (1991–2), pp. 219–60

<div style="text-align:right">DOROTHY LIMOUZE</div>

Metsu, Gabriel

(*b* Leiden, 1629; *d* Amsterdam, *bur* 24 Oct 1669). Dutch painter. He was the son of Jacques Metsue (1587/9–1629), a Flemish painter in Leiden. Gabriel Metsu was one of the leading figures in the founding of the Leiden Guild of St Luke of which he became a member in 1648. According to guild records, Metsu was absent from Leiden *c.* 1650–52; probably some of this time was spent in Utrecht. In 1657 he settled permanently in Amsterdam. The following year he married Isabella de Wolff, a native of Enkhuizen who was a descendant on her mother's side of the Haarlem de Grebber family of painters. There is a *Portrait of the Artist and his Wife* (1661; Dresden, Gemäldegal. Alte Meister), which was clearly inspired by Rembrandt's *Self-portrait with Saskia* (*c.* 1635; Dresden, Gemäldegal. Alte Meister). The Rotterdam painter Michiel van Musscher became one of Metsu's pupils in 1665.

The chronology of Metsu's oeuvre is difficult to establish since most of the *c.* 150 works ascribed to him are undated. He generally painted interiors with figures, although his youthful works consist mainly of street and market scenes (see fig. 36) and religious subjects. Like most of his contemporaries, he also painted portraits, but these were usually in the form of conversation pieces, the best-known of which is the portrait of the *Geelvinck Family* (*c.* 1662; Berlin,

36. Gabriel Metsu: *Vegetable Market in Amsterdam* (Paris, Musée du Louvre)

Gemäldegal.). He also produced graphic work, little of which has survived. Some of Metsu's lost works have survived in the form of reproduction mezzotints by Wallerant Vaillant.

1. Utrecht and Leiden, before 1657

Metsu's probable sojourn in Utrecht is suggested by several features of his work after *c.* 1650: for example, both the *Justice Protecting the Widows and Orphans* (*c.* 1652; The Hague, Mauritshuis) and the *Exile of Hagar and Ishmael* (*c.* 1653; Leiden, Stedel. Mus. Lakenhal) are painted with a broad, somewhat flat technique, which, like the figures and their flexible poses, is reminiscent of the style of such Utrecht painters as Nicolaus Knüpfer (*c.* 1603–*c.* 1660) and Jan Baptist Weenix. The focal-point of Metsu's *Brothel Scene* (St Petersburg, Hermitage) is significantly like Knüpfer's version of the same subject (Amsterdam, Rijksmus.) from which the motif of the reclining man with his legs spread is taken almost literally. It is not clear whether Metsu's piece was intended primarily as a narrative painting with genre traits (e.g. a

scene from the parable of the Prodigal Son) or as
a pure genre scene. Metsu also painted several
scenes of smithies during the early 1650s (e.g.
The Blacksmith, London, N.G.), a subject that was
popular among Utrecht painters.

During his 'second' Leiden period, Metsu spe-
cialized increasingly in the depiction of interiors.
Like the paintings of Gerrit Dou, the pacesetting
genre painter in Leiden in the 1650s, Metsu's inte-
riors from after 1652 always show a visible source
of light—a burning candle or a window. Metsu was
also certainly familiar with the work of Jan Steen,
also active in Leiden at this time. The dramatic
power Steen was able to infuse into his scenes
must have appealed to the younger artist. The nar-
rative elements in Metsu's work, as well as his
early market and peasant scenes, can also be
ascribed to the influence of Steen.

2. Amsterdam, 1657 and after

Later, in Amsterdam, Metsu attempted to achieve
a synthesis between the visible light source of Dou
and the indirect light source common in the work
of Gerard ter Borch the younger. For example, the
light in these paintings comes from half-opened
shutters or a curtained window. Metsu's tavern
scenes are also drawn from ter Borch's repertory.
After c. 1665 Metsu also painted outdoor scenes,
which required yet another type of lighting, as in
the *Sleeping Huntsman* (London, Wallace) and the
Woman Selling Herrings (Amsterdam, Rijksmus.).
Other important later influences were Nicolaes
Maes and the Delft painters Pieter de Hooch and
particularly Vermeer. Around 1660 Metsu's tech-
nique became more refined, and details, especially
the depiction of drapery, were rendered more suc-
cessfully (see fig. 37). The painter also became
more original in his choice of subjects, with works
such as the *Sick Child* and the 'Cat's Breakfast'
(both c. 1662; Amsterdam, Rijksmus.), both of
which are unique themes in 17th-century Dutch
painting. Though not entirely typical of his style,
the *Sick Child* is probably Metsu's best-known
work. The composition shows the unmistakable
influence of the Delft school, but its unforced sim-
plicity shows Metsu's talent at its best. Here he
avoided any distracting details and succeeded in

37. Gabriel Metsu: *A Lady and a Knight* (Florence, Galleria
degli Uffizi)

holding the viewer's attention by means of the
child's expression, even though the child does not
look out from the picture.

The cooler palette and style of the later paint-
ings reveals the influence of Vermeer, whose work
clearly inspired the pendant paintings of the
Man Writing a Letter and the *Woman Reading a
Letter* (both ex-Russborough, Co. Wicklow; now
Dublin, N.G.). Especially reminiscent of Vermeer
are the women, with their high foreheads,
dressed in yellow robes bordered with white fur.
Nevertheless, the harmony so clearly present in
Vermeer's work is often conspicuous by its absence
from Metsu's paintings (the *Sick Child* being an
exception). There are usually too many details that
distract the viewer's attention from the main
point of the scene. For instance, in the *Hunter's
Gift* (c. 1658; City of Amsterdam, on loan to
Amsterdam, Rijksmus.), the hunt is metaphori-
cally interpreted as the chase between man and
woman, and to eliminate any possible ambiguity

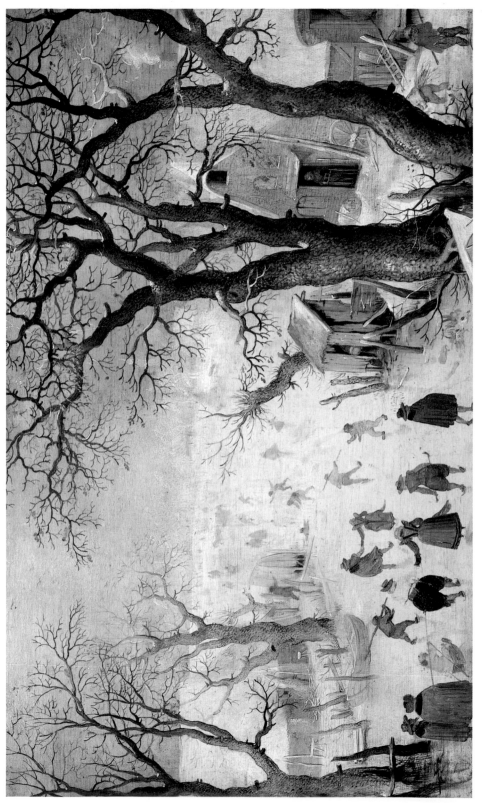

I. Hendrick Avercamp: *Winter Landscape*, before 1610 (Vienna, Kunsthistorisches Museum)

II. Nicolaes Berchem: *Cowherds and Herd*, 1680 (Vienna, Kunsthistorisches Museum)

III. Gerrit Berckheyde: *Marketplace in Haarlem, Holland* (Florence, Galleria degli Uffizi)

IV. Abraham Bloemaert: *Adoration of the Shepherds*, 1612 (Paris, Musée du Louvre)

V. Ferdinand Bol: *An Astronomer*, 1652 (London, National Gallery)

VI. Gerard ter Borch (ii):
The Parental Admonition
(Berlin, Gemäldegalerie)

VII. Leonard Bramer: *Allegory of Vanity*, early 1640s (Vienna, Kunsthistorisches Museum)

VIII. Hendrick ter Brugghen: *Lute-player and Singing Girl*, 1628 (Paris, Musée du Louvre)

IX. Cornelis Cornelisz. van Haarlem: *Baptism of Christ*, 1588 (Paris, Musée du Louvre)

X. Aelbert Cuyp: *Landscape near the Rhine*, c. 1650 (Paris, Musée du Louvre)

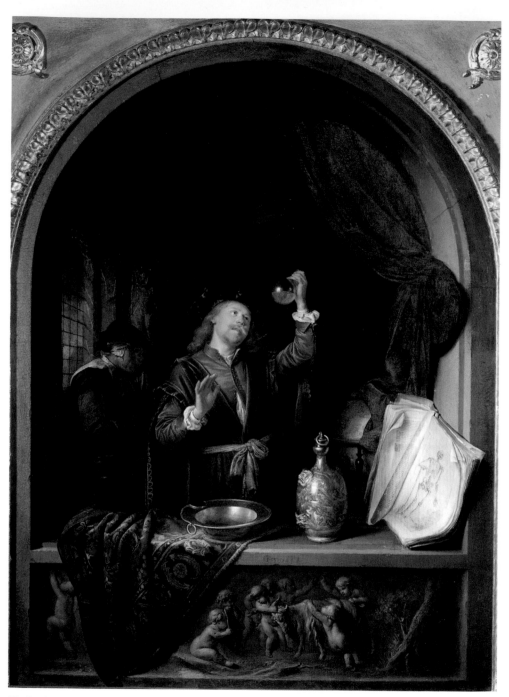

XI. Gerrit Dou: *The Doctor*, 1653 (Vienna, Kunsthistorisches Museum)

XII. Gerbrand van den Eeckhout: *The Angel Appearing to Aaron* (Milan, Pinacoteca di Brera)

XIII. Carel Fabritius: *The Goldfinch,*
1654 (The Hague, Mauritshuis)

XIV. Jacques de Gheyn II: *Mountain Landscape* (New York, Pierpont Morgan Library)

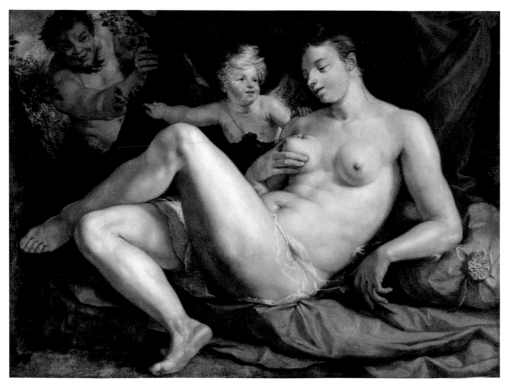

XV. Hendrick Goltzius: *Jupiter and Antiope*, 1616 (Paris, Musée du Louvre)

XVI. Jan van Goyen: *Seascape, View of Dordrecht in the Background*, 1647 (Vienna, Kunsthistorisches Museum)

XVII. Frans Hals: *Banquet of the Officers of the St George Civic Guard Company, 1616* (Haarlem, Frans Halsmuseum)

XVIII. Meindert Hobbema: *Avenue of Trees at Middelharnis*, 1689 (London, National Gallery)

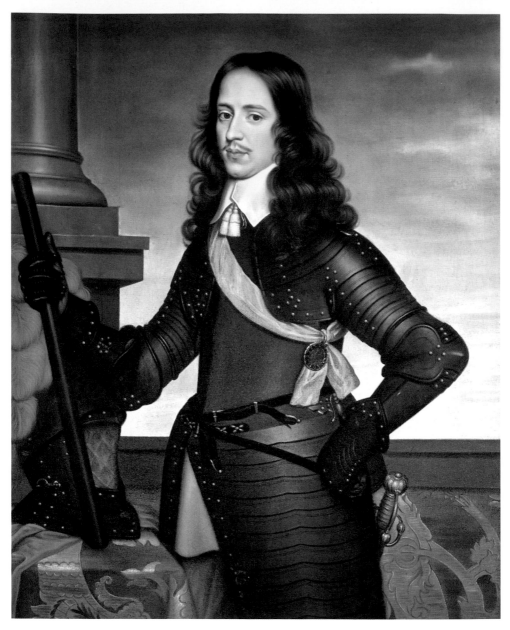

XIX. Gerrit van Honthorst: *Portrait of William II, Prince of Orange* (The Hague, Mauritshuis)

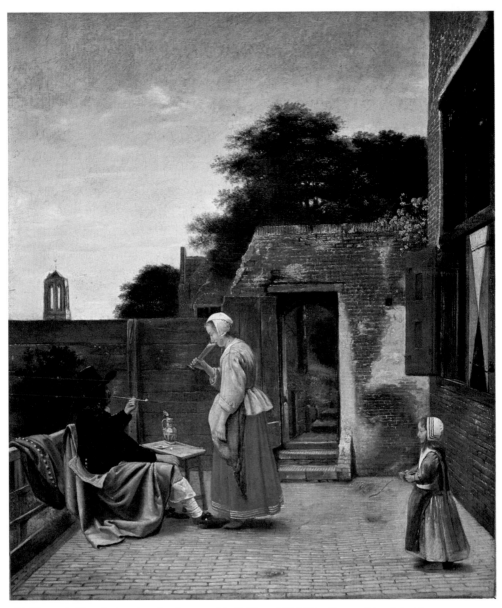

XX. Pieter de Hooch: *Interior of a Courtyard in Delft*, *c.* 1660 (The Hague, Mauritshuis)

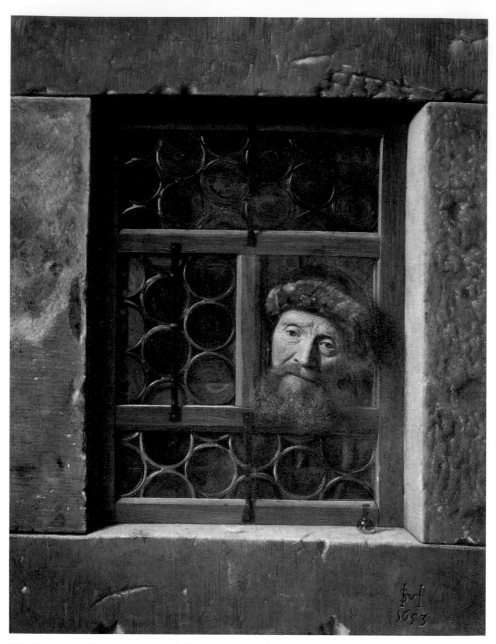

XXI. Samuel van Hoogstraten: *Head of a Man at a Window Trellis*, 1653 (Vienna, Kunsthistorisches Museum)

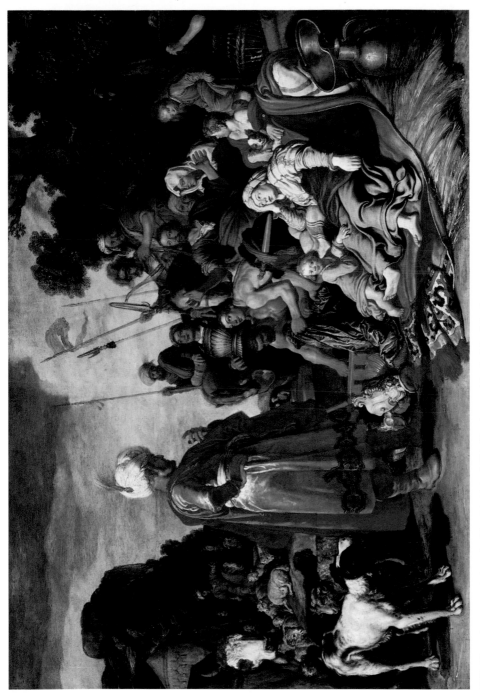

XXII. Pieter Lastman: *Laban Seeking his Idols*, 1622 (Boulogne, Musée Municipal)

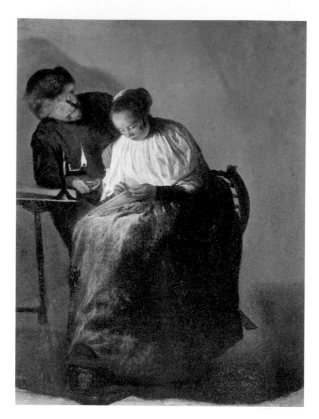

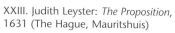

XXIII. Judith Leyster: *The Proposition*, 1631 (The Hague, Mauritshuis)

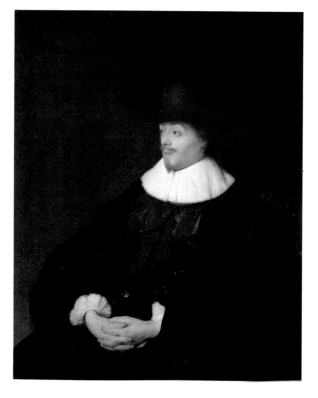

XXIV. Jan Lievens: *Constantijn Huygens*, c. 1629–30 (Douai, Musée Municipal)

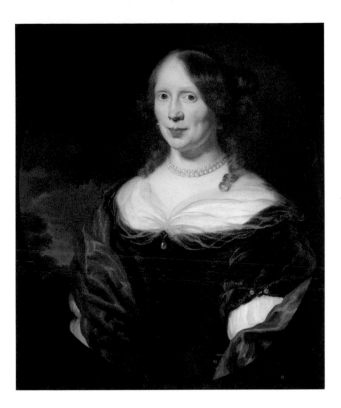

XXV. Nicolaes Maes: *Portrait of Sara Ingelbrechts*, 1675 (Vienna, Kunsthistorisches Museum)

XXVI. Karel van Mander I: *Suffer the little children to come unto me* (Düsseldorf, Kunstakademie)

XXVII. Adriaen van Ostade: *Strolling Violinist at an Alehouse Door* (New York, Pierpont Morgan Library)

XXVIII. Cornelis van Poelenburch: *Mercury and Battus* (Florence, Galleria degli Uffizi)

XXIX. Adam Pynacker: *Landscape with Rising Sun* (Paris, Musée du Louvre)

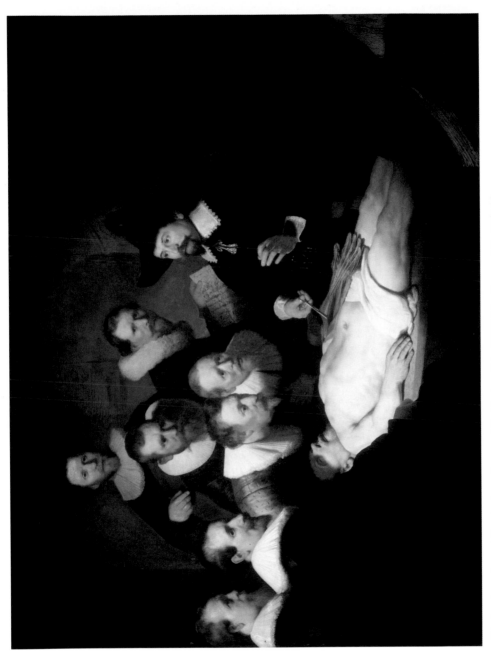

XXX. Rembrandt van Rijn: *Anatomy Lesson of Dr Nicolaes Tulp*, 1632 (The Hague, Mauritshuis)

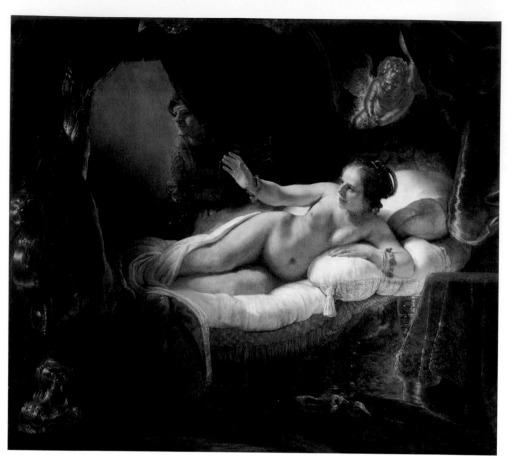

XXXI. Rembrandt van Rijn: *Danaë*, 1636 (St Petersburg, Hermitage Museum)

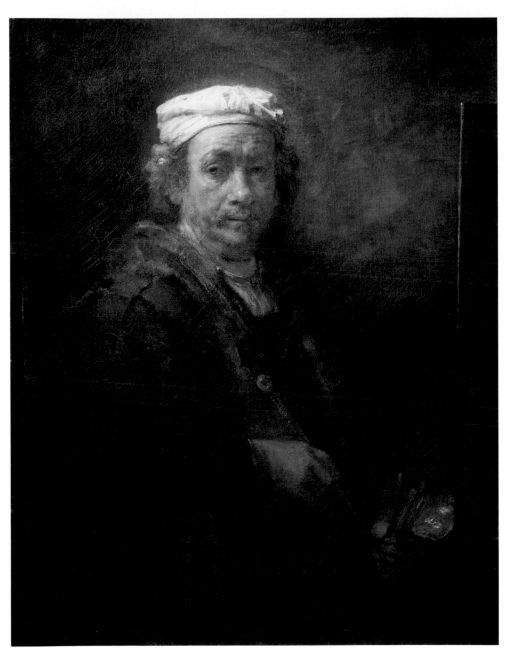

XXXII. Rembrandt van Rijn: *Self-portrait with Easel*, 1660 (Paris, Musée du Louvre)

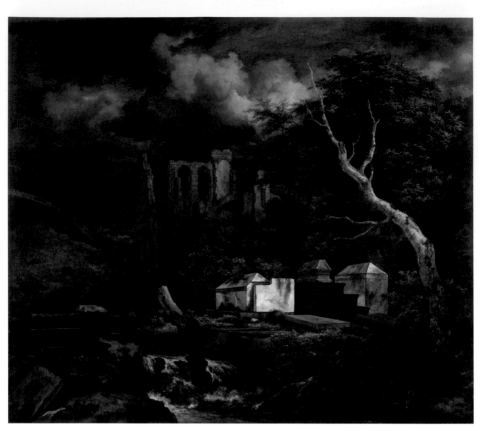

XXXIII. Jacob van Ruisdael: *Jewish Cemetery*, c. 1665–8 (Dresden, Gemäldegalerie Alte Meister)

XXXIV. Pieter Saenredam:
*Interior of the Church of St
Bavo at Haarlem*, 1638 (Paris,
Musée du Louvre)

XXXV. Hercules Segers: *Mountain Landscape, c.* 1620–25 (Florence, Galleria degli Uffizi)

XXXVI. Willem van de Velde II: *Vessels Close Hauled* (London, National Gallery)

XXXVII. Adriaen van de Venne: *Celebration in Honour of the Truce of 1609*, 1616 (Paris, Musée du Louvre)

XXXVIII. Johannes Vermeer: *View of Delft, c.* 1661 (The Hague, Mauritshuis)

XXXIX. Johannes Vermeer: *Head of a Girl with a Pearl Earring*, c. 1665 (The Hague, Mauritshuis)

XL. Jan Weenix: *Still-life with Dead Hare*, 1682 (Karlsruhe, Staatliche Kunsthalle)

in such an interpretation, a wealth of iconographic and emblematic symbols (Cupid, dog, shoes, weapon, sewing, birds) has been added, emphasizing the work's erotic message. The result is so fragmented that its cumulative effect is lost. In other cases, the figures themselves are not always fully concentrated on what they are doing. They are distracted from their occupations in one way or another, or else they try to make contact with the viewer. The figure in the *Woman Playing the Virginals* (Rotterdam, Boymans-van Beuningen) is disturbed by a little barking dog, those in the *Music Party* (New York, Met.) barely get a chance to make any music, and in the scene of the *Woman Reading a Letter* a servant is intrusively present. There is frequently a little dog, either jumping up and barking or demanding attention, resulting in the calm of the actual composition and any repose in the action it portrays being disturbed in different ways.

Several of Metsu's paintings of interiors contain recurring elements. For example, the table in *A Smoker and the Woman Innkeeper* (New York, Met.) is the same as that portrayed in the *Young Couple at Breakfast* (1667; Karlsruhe, Staatl. Ksthalle). According to Metsu's Amsterdam inventory, it was the painter's own table. The chimneypiece in the *Young Woman with Pitcher and Wine Glass* (Paris, Louvre) reappears several times, and the drinking horn in the *Oyster-eaters* (St Petersburg, Hermitage) has been identified as that of the Amsterdam St Sebastian's or Archery Guild. A blonde woman posed frequently for Metsu and appears in several paintings, including the *Apple-peeler* (Paris, Louvre) and *The Lacemaker* (Vienna, Ksthist. Mus.). Another characteristic of Metsu's work is his representation of the paintings of other artists in his own paintings, as in the above-mentioned pendants and the *Man and Woman beside a Virginal* (c. 1658; London, N.G.). This is nothing new in the work of 17th-century painters; it can also be found in the work of other artists, including Steen and Vermeer.

Bibliography

Gabriël Metsu (exh. cat., Leiden, Stedel. Mus. Lakenhal, 1966)

S. J. Gudlaugsson: 'Kanttekeningen bij de ontwikkeling van Metsu', *Oud-Holland*, lxxxiii (1968), pp. 13–44

U. M. Schneede: 'Gabriël Metsu und der holländische Realismus', *Oud-Holland*, lxxxiii (1968), pp. 45–61

F. W. Robinson: *Gabriël Metsu (1629–1667): A Study of his Place in Dutch Genre Painting of the Golden Age* (New York, 1974)

C. Brown: *Niet ledighs of ydels: Nederlandse genreschilders uit de 17e eeuw* (Amsterdam, 1984)

B. Haak: *The Golden Age: Dutch Painters of the Seventeenth Century* (New York, 1984), pp. 431–2, 489–90

Masters of Seventeenth-century Dutch Genre Painting (exh. cat. by P. C. Sutton and others, Philadelphia, PA, Mus. A.; Berlin, Gemäldegal.; London, RA; 1984), pp. XLII–XLIII, 248–53

MARIJKE VAN DER MEIJ-TOLSMA

Mierevelt [Miereveld], Michiel (Jansz.) van

(*b* Delft, 1 May 1567; *d* Delft, 27 June 1641). Dutch painter. The son of a Delft goldsmith, he received his first training as a painter under Willem Willemsz. and Augustus, two otherwise unknown masters. In 1581 he continued his training with Anthonie Blocklandt in Utrecht, where he remained for two years. He then returned to Delft where, as early as 1589, he became an officer of the Guild of St Luke.

At first van Mierevelt worked in the style of Blocklandt, as in the *Judgement of Paris* (1588; Stockholm, Nmus.), but he soon turned to portraiture, in which he was influenced by his fellow-townsman Jacob Willemsz. Delff the elder. Van Mander praised van Mierevelt as a portrait painter, but very little work from his early period is known. He worked steadily from about 1607, the date of his portrait of *Prince Maurits of Orange Nassau* (Delft, Stadhuis). The same year he became official painter to the stadholder court and began to produce many portraits of members of the House of Orange Nassau. He was the most popular portrait painter with the leading citizens of Delft and soon also received commissions from other noble families of the Dutch Republic as well as from foreign diplomats based in The Hague. He was one of the relatively few Dutch portrait painters in the

first half of the 17th century whose patrons were not limited to his own place of residence. Among his foreign sitters were the English ambassador *Sir Dudley Carleton* (later 1st Viscount Dorchester; 1620; Montacute House, Somerset, NT) and *Edward Cecil, Viscount Wimbledon* (1631; London, N.P.G.). Van Mierevelt's portraits are characterized by a rather dry, linear style that, without flattery, accurately portrays his sitters' features.

During this, his most prolific period, van Mierevelt must have had a large workshop with many pupils, including his own sons, Pieter van Mierevelt (1596–1623) and Jan van Mierevelt (1604–33). His assistants painted the subordinate motifs in his portraits and also made replicas in various formats. Such copies could be made on demand, but replica portraits of the most popular sitters were also kept in stock. Van Mierevelt often had copies made of his portraits of private citizens for circulation within the family, a practice not unknown in 17th-century Holland but especially common with van Mierevelt (e.g. the portraits of *Paulus van Beresteyn* and *Volckera Knobbert* and those of *Maerten Ruychaver* and *Aletta van der Laen*; all Amsterdam, Rijksmus.).

Van Mierevelt influenced many other Dutch portrait painters, including Jan van Ravesteyn, and his works were widely known through the prints engraved after them by WILLEM DELFF, who became his son-in-law in 1618. On van Mierevelt's death his workshop was transferred to his grandson Jacob Willemsz. Delff the younger. Although many later copies after his works have been mistaken for originals, during his lifetime van Mierevelt painted at least a thousand portraits with the help of his assistants, of which several hundred are extant. The number of works executed entirely by his own hand is far lower. During his later years he was gradually driven from his position as court painter to the Prince of Orange by the rising popularity of the more modish Gerrit van Honthorst.

Bibliography

K. van Mander: *Schilder-boeck* ([1603]–1604), fols 281–2

H. Havard: *L'Art et les artistes hollandais*, i (Paris, 1879), pp. 11–82

——: *Michiel van Mierevelt et son gendre* (Paris, 1894)

A. Bredius: 'Michiel Jansz. van Mierevelt, een naleezing', *Oud-Holland*, xxvi (1908), pp. 1–17

J. M. Montias: *Artists and Artisans in Delft: A Socioeconomic Study of the Seventeenth Century* (Princeton, 1982)

Dawn of the Golden Age: Northern Netherlandish Art, 1580–1620 (exh. cat., Amsterdam, Rijksmus., 1993–4), pp. 310–11, 592–4

RUDOLF E. O. EKKART

Mieris, van

Dutch family of artists. The earlier generation includes three brothers, Frans (Bastiaensz.) van Mieris (*c.* 1576–before 1625), Dirck (Bastiaensz.) van Mieris (*d* 1638) and Jan (Bastiaensz.) van Mieris (*c.* 1586–1650), all of whom were gold- and silversmiths in Leiden, as was Frans's son, Willem (Fransz.) van Mieris (*c.* 1600–1656). The most important artist of the family was Jan's son, the painter Frans van Mieris (i), who had two sons who also became painters: the eldest Jan [Johannes] van Mieris (1660–90), and the fourth child, the more famous Willem van Mieris. Both were apprenticed to their father. Only a few works are known by Jan, who died in Rome aged 30; those that survive (e.g. *Self-portrait of the Artist in his Studio*, 1688; Hamburg, Ksthalle) show that he was a talented painter whose style resembles that of his father's later work. Frans van Mieris (ii), grandson of Frans van Mieris (i) and son of Willem van Mieris, also became a good painter, who left behind an extensive oeuvre.

Bibliography

O. Naumann: *Frans van Mieris the Elder (1635–1681)*, 2 vols (Doornspijk, 1981)

E. J. Sluijter: 'Een Zelfportret en "de schilder in zijn atelier": Het aanzien van Jan van Mieris', *Leids Ksthist. Jb.*, vi (1987), pp. 287–307

Leidse fijnschilders: Van Gerrit Dou tot Frans van Mieris de jonge, 1630–1760 (exh. cat., ed. E. J. Sluijter, M. Enklaar and P. Nieuwenhuizen; Leiden, Stedel. Mus. Lakenhal, 1988)

De Hollandse fijnschilders: Van Gerard Dou tot Adriaen van der Werff (exh. cat. by P. Hecht, Amsterdam, Rijksmus., 1989)

(1) Frans van Mieris (i)

(*b* Leiden, 16 April 1635; *d* Leiden, 12 March 1681). Painter and draughtsman. Along with Gerrit Dou, he was the most important artist among the Leiden 'fine' painters, famous for his small-scale genre scenes, which were painted with exceptional refinement. The prices paid for his work during his lifetime were among the highest for Dutch paintings in the 17th century.

1. Life and work

Frans (i) seemed destined to follow in the family tradition of gold- and silversmith work when he was apprenticed at the age of 12 to his cousin and guardian, Willem (Fransz.) van Mieris. However, by 1651 (assuming he was the 'Frans' who was paid that year for making a painting of *St Eloy* for the guild of gold- and silversmiths), he had already begun to paint. According to Houbraken, he received his training as a draughtsman and painter first from Abraham Toorenvliet (*c.* 1620–92), a drawing-master and glass-engraver, then from the Leiden 'Fine' painter Gerrit Dou, then from the portrait and history painter Abraham van den Tempel and finally from Dou again. In all, this probably lasted from *c.* 1649 to *c.* 1654. Van Mieris adopted Dou's meticulous manner and never used the broader technique that he must have learnt from van den Tempel. He entered the Leiden Guild of St Luke in 1658 but was apparently active as an independent painter for several years before then, since his earliest dated works are from 1657 and a considerable number of paintings, mostly signed, were presumably made before that (see Naumann, 1981, nos 1–19). He followed Dou closely in his earliest known works, probably painted before the mid-1650s. Works such as the *Elderly Couple Sitting down to a Simple Meal, Seen through an Arched Window* (Florence, Uffizi) and the *Pen Grinder by an Arched Window* (Dresden, Gemäldegal. Alte Meister) are distinguished from those of his master by the placement of the figures further back in the window space and especially by the more powerful use of light, with its lively reflections cast over all surfaces. The slightly later *Inn Scene with Two Peasants and a Maid* (*c.* 1655–6;

Leiden, Stedel. Mus. Lakenhal), with its warm light dancing over the surfaces and reflected in bright colours, departs even further from Dou's concentrated chiaroscuro. This stylistic development was probably prompted by the early paintings of Gabriel Metsu and perhaps also by the work of an Italianate painter such as Jan Baptist Weenix. The choice of subject (also a departure from Dou's practice) reveals the influence of Adriaen van Ostade, and the spatial structure of the scene that of Quiringh van Brekelenkam, an older Leiden artist.

In 1657–9 van Mieris produced some of the best paintings of his career, including the *Doctor's Visit* (1657; Vienna, Ksthist. Mus.; see fig. 38), the *Lute-player with a Young Woman Playing the Virginal* (1658; Schwerin, Staatl. Mus.), the *Inn Scene with an Officer and Maid* (1658; The Hague, Mauritshuis) and the *Man Offering Oysters to a Young Woman* (1659; St Petersburg, Hermitage).

38. Frans van Mieris (i): *Doctor's Visit*, 1657 (Vienna, Kunsthistorisches Museum)

Stylistically they are a continuation of his previous work, but technically they are suddenly of exceptionally high standard. In them he strove to make his brushstrokes invisible, unlike Dou whose brushstrokes can always be distinguished on close scrutiny. Van Mieris's extremely subtle and lively handling of light prevented his paintings from becoming stiff in character. Whereas Dou's interiors are largely shrouded in darkness, van Mieris's are filled with light, which defines everything precisely. Van Mieris often employed a rigidly geometrical layout, with emphatic horizontal and vertical lines that clearly outline the spatial structure. He expanded significantly the range of subjects commonly depicted by Leiden artists: his prosperous and sophisticated figures move in elegant surroundings (usually in an amorous context) and are strongly reminiscent of those by Gerard ter Borch (ii). Thematically and stylistically, van Mieris's paintings of the late 1650s and early 1660s soon influenced other masters, as is obvious from the work of Metsu, Jan Steen, Jacob Ochtervelt, Johannes Vermeer and Eglon van der Neer. The immediacy of this effect and the fact that his *Cloth Shop* (1660; Vienna, Ksthist. Mus.) sold almost at once to Archduke Leopold Wilhelm for an unusually high price of 2000 guilders (Sandrart) shows the high esteem in which his work of this period was held.

During the first half of the 1660s van Mieris maintained this high level of achievement in, for example, *Teasing the Pet* (1660), *Offering Oysters* (1662) and *Boy Blowing Bubbles* (1663; all The Hague, Mauritshuis). He occasionally repeated Dou's niche motif and sometimes recalled it in the arched top of the panel. In the late 1660s his colours became darker and the figures more stylized, as in *Young Woman at her Toilet* (1667; Dresden, Gemäldegal. Alte Meister) and *Sleeping Courtesan* (1669; Florence, Uffizi). This trend continued in the 1670s, the enamel-like smoothness and the harsh, restless reflections of the light becoming, seemingly, an end in themselves, and the figures more stereotyped (e.g. the *Family Concert*, 1675; Florence, Uffizi; the *Young Woman at her Toilet*, 1678; Paris, Louvre; and the *Young Woman Writing a Letter*, 1680; Amsterdam,

Rijksmus.). Unlike most other Dutch genre painters, he left a substantial number of drawings, mostly highly detailed works in black chalk, probably intended as independent works of art, such as the *Seated Old Woman* (London, BM), the *Sick Woman* (Vienna, Albertina) and the *Cavalier Playing the Lute* (Haarlem, Teylers Mus.).

2. Critical reception and posthumous reputation

Van Mieris's paintings had a strong influence on younger artists, anticipating the late 17th-century development of a precious, more stylized form. It is remarkable how often during his lifetime and shortly afterwards his subjects were copied or slightly modified by others, including his sons Jan and Willem. Apart from his sons, the only other artist known to have been apprenticed to him is Karel de Moor, who, with Willem, probably contributed to some of his later works. The *Holy Family* (1681; priv. col., see Naumann, 1981, ii, pl. 121), signed and dated the year of Frans's death, is thought to be largely by Willem.

The extent to which van Mieris was highly respected during his life is also clear from the praise he received from contemporary writers, such as Cornelis de Bie, Joachim von Sandrart and Roger de Piles (the last two esteeming him more highly than Dou). All three emphasized the exorbitant prices paid for his paintings, which were much sought-after not only by wealthy citizens in Leiden, such as the famous physician François de la Boe Sylvius (1614–73), but also by foreign collectors. Archduke Leopold Wilhelm invited him to work at his court in Vienna on a substantial allowance, but van Mieris declined. In 1669 Cosimo III de' Medici, Grand Duke of Tuscany, visited his studio, after which two self-portraits and three genre paintings were acquired by the Florentine court. His *Family Concert* fetched the then unheard-of price of 2500 guilders. The correspondence of Giovacchino Guasconi, who was Cosimo's agent in the Netherlands, documents van Mieris's contact with the Florentine court and supports Houbraken's anecdotes about the artist's heavy drinking. The letters also reveal that van Mieris was inept with money, which would explain why, despite the prices paid for his

paintings, he never achieved great prosperity. Although van Mieris has always been recognized as one of the leading Dutch genre painters of the 17th century, the exceptional standing of his work during the late 17th century and the 18th fell off in the late 19th century. However, during the last decades of the 20th century there was an increased interest in his paintings; special attention has been paid to the iconological interpretation of his works, which often show amorous situations of a slightly erotic nature.

Bibliography

C. de Bie: *Het gulden cabinet* (1661), p. 404

J. von Sandrart: *Teutsche Academie* (1675–9); ed. A. R. Peltzer (1925), p. 196

R. de Piles: *Abrégé de la vie des peintres avec des reflections sur leurs ouvrages* (Paris, 1699), pp. 441–2

A. Houbraken: *De groote schouburgh* (1718–21), iii, pp. 1–12

O. Naumann: 'Frans van Mieris as a Draughtsman', *Master Drgs*, xvi (1978), pp. 3–34

Masters of Seventeenth-century Dutch Genre Painting (exh. cat., ed. P. Sutton; Philadelphia, PA, Mus. A.; Berlin, Gemäldegal.; London, RA; 1984), pp. xvi, xli–ii, 256–60; pls 57–9

See also family bibliography above.

<div align="right">ERIC J. SLUIJTER</div>

Mijtens [Meytens; Mytens]

Dutch family of painters of Flemish origin. The earliest known artist of this family was Aert Mijtens (*b* Brussels, 1541; *d* Rome, 1602), a history and portrait painter who worked in Naples and Rome. His brother Martin Mijtens, a saddle- and coach-maker, fled to the northern Netherlands and had two sons who also became painters: (1) Daniel Mijtens I, who was prominent in England for a period as a portrait painter in the Stuart court, and Isaac Mijtens (*b c.* 1602; *bur* The Hague, 22 Aug 1666), a portrait painter in The Hague. (2) Jan Mijtens was a nephew of these brothers and father of the portrait painter Daniel Mijtens II (*b* The Hague, 7 Aug 1644; *bur* The Hague, 23 Sept 1688). Martin Mijtens I, himself a son of Isaac, moved to Sweden where he worked as a portrait

painter in Stockholm, while his son Martin van Meytens II later became a portrait painter at the imperial court in Vienna. Several other minor members of the Mijtens family established reputations as painters.

(1) Daniel [Daniël] Mijtens I

(*b* Delft, *c.* 1590; *d* The Hague, *c.* 1647). He undertook his training either in The Hague, where he lived from an early age, with Jan Anthonisz. van Ravesteyn, or in his native town of Delft, with Michiel van Miereveld. In 1610 he joined the guild of painters in The Hague; two years later he married Gratia Cletcher, sister of the goldsmith Thomas Cletcher the elder. No work survives from this early period.

By August 1618 Daniel was working in London, where he painted the portraits of *Thomas Howard, 2nd Earl of Arundel* and his wife, *Aletheia Talbot, Countess of Arundel*. These paintings have been identified as the two unsigned full-scale portraits (London, N.P.G., on loan to Arundel Castle) showing in the background the sculpture gallery and the family portrait gallery of Arundel House in London. Mijtens can already be seen combining stylistic elements from his Delft–Hague background with certain formal aspects of the Elizabethan and Jacobean tradition of English court portraiture. His preference for full-length portraits, for instance, reflects this English tradition. In his later work Mijtens gradually arranged his compositions with more ease, a skill he first developed under the influence of Paul van Somer, who also worked at the English court from 1616 to 1621.

Within only a few years after his arrival in England, Mijtens had won the approval of both King James I and his son Charles, Prince of Wales. In 1624 James granted him an annuity, which was increased by Charles I in 1625. For most of the 1620s and in the early 1630s Mijtens was the leading court artist, as is evident from the numerous payments he received for portraits of the King or people connected with the court and for the many copies he made after the work of other artists. During these years Mijtens twice crossed to Holland, once in 1626 and once in 1630.

Mijtens's development as a painter can be traced in his series of portraits of *Charles I*, most of which survive in more than one version. The three earliest images, painted while he was still Prince of Wales (*c.* 1621, Parham House, W. Sussex, Mrs P. A. Tritton priv. col., see 1972 exh. cat., no. 18; 1623, British Royal Col.; and 1624, Ottawa, N.G.), are rather stiff in style, a quality completely resolved in the images painted between 1627 and 1633. In a number of cases replicas were made, suggesting the existence of a workshop and assistants. The portrait of *Charles I* of 1631 with the monogram *CJ* (Chatsworth, Derbys) shows that among the artists working in Mijtens's circle was Cornelis Jonson van Ceulen; it closely follows the original portrait painted and signed by Mijtens himself in 1629 (New York, Met.). The stylistic contrast between the early and late work painted in England is also evident in a comparison between the two portraits of *James Hamilton, 3rd Marquess and 1st Duke of Hamilton*: the rather stiff portrait from 1624 (London, Tate) shows the artist's skill in the detailed rendering of the sitter's face and costume, while the impressive portrait of 1629 (Edinburgh, N.P.G.), with its sophisticated silver-grey tonality and lucid arrangement of accessories, may be regarded as one of Mijtens's finest works.

Although there are a few smaller paintings from the English years, the bulk of the work from this period consists of life-size portraits showing the sitter at full length. These large paintings were the products of a new phase in the development of formal portraiture in England. Mijtens's achievements, however, seem to have had little lasting effect on other artists: in 1632 Anthony van Dyck arrived in London and soon became the city's most influential painter. Between 1632 and 1634 Mijtens executed a few more commissions, but by then his position was clearly overshadowed by the success of the Flemish master, who originally adopted some of the concepts developed by his Dutch colleague.

After the death of his first wife, Mijtens married the miniature painter Susanna Droeshout in 1628; in 1634 he returned to The Hague, where he became active not only as a painter but also as an art dealer, and his clients included the 2nd Earl of Arundel, whose portrait he had painted in England. Only four paintings survive from the artist's last 14 years, all bust-length portraits of excellent quality. They include the portraits of his first wife's nephew, the goldsmith *Thomas Cletcher the Younger* and his wife *Anna Hoeufft* (both 1643; The Hague, Gemeentemus.). These late paintings reveal clearly Mijtens's qualities as a portrait painter, despite being on a smaller scale and thus lacking the grandeur of his best English work. There is no documentary evidence of any pupils Mijtens may have had, but it seems that his nephew and later son-in-law Jan Mijtens may have been apprenticed to him for a while.

Bibliography

Thieme–Becker; Wurzbach

O. ter Kuile: 'Daniel Mijtens: "His Majesty's Picture-Drawer"', *Ned. Ksthist. Jb.*, xx (1969), pp. 1–106

The Age of Charles I: Painting in England, 1620–1649 (exh. cat. by O. Millar, London, Tate, 1972), pp. 12–13, 24–8

B. Haak: *The Golden Age: Dutch Painters of the Seventeenth Century* (New York, 1984), pp. 218–19

(2) Jan Mijtens

(*b* The Hague, *c.* 1614; *d* The Hague, *bur* 24 Dec 1670). Nephew of (1) Daniel Mijtens I. He was the son of Daniel's elder brother David, a saddle-maker in The Hague. Jan may have learnt to paint from his uncle Isaac Mijtens. After 1634 he may have trained with his uncle Daniel, who had by then returned to The Hague; Jan married Daniel's daughter Anna in 1642. In 1639 he had been admitted to The Hague's guild of painters, of which he became a governor in 1656. In the latter year he helped to found the painters' society De Pictura; from 1667–8 he was a governor of this society and from 1669–70 its dean.

Throughout his life Jan Mijtens worked as a portrait painter in The Hague. He received commissions from prominent citizens, members of the nobility and high-placed government officials as well as from the stadholder's circle, from families such as the Dohnas and the van Brederodes. He seems to have worked chiefly for those loyal to the Orange Nassau family and to have been

considerably less popular with the opposing political factions. Jan's oeuvre consists of an extensive series of portraits, the earliest from 1638, the year he entered the painters' guild, and the latest from 1668. His work divides into two main groups: life-size three-quarter-length and half-length portraits of individuals, and family groups painted on a smaller scale. Although his paintings are reminiscent of the later work of Anthony van Dyck, Jan Mijtens cannot be considered an immediate follower of the master, especially since technically he adhered to the Dutch tradition of portrait painting. The colourful and elegant manner in which he presented his sitters shows, however, that he worked in the same spirit as van Dyck. Typical is the *Lady Playing a Lute* (1648; Dublin, N.G.), painted in the elegant international style also used by Peter Lely and others.

The paintings surviving from Jan Mijtens's early years are mainly group portraits, which are always set in a landscape and usually show the figures at considerably less than life-size. Remarkably often they include deceased members of the sitter's family, who in some cases are given a space of their own, in others incorporated into the main group. The figures in the earliest group portraits, for instance the portrait of an *Unknown Family* (1638; Versailles, Château), are stiffly arranged, but Mijtens soon developed a talent for composing groups, as in *Pieter Stalpaert van der Wiele and his Family* (1645; The Hague, Gemeentemus.). One of his best-known compositions shows the *Marriage of Friedrich Wilhelm, Elector of Brandenburg, and Louise Henriette of Orange Nassau* (1647; Rennes, Mus. B.-A. & Archéol.), a work rather overcrowded with figures and not one of his most successful. It was followed by numerous commissions from the courts in The Hague and Berlin, resulting in, for example, the group portrait of *Elector Friedrich Wilhelm and his Family* (1667; Berlin, Jagdschloss Grunewald).

Among the surviving works of Jan Mijtens's later years are some individual portraits, good examples being the young *Wolphaert van Brederode* (c. 1663; The Hague, Mauritshuis) and *Admiral Cornelis Tromp* and his wife *Margaretha van Raephorst* (both 1668; Amsterdam, Rijksmus.).

Of greater importance are the few dozen group portraits, such as The Hague burgomaster *Willem van der Does and his Family* (1650; Antwerp, Mus. Mayer van den Bergh), the councillor *Willem van den Kerckhoven and his Family* (1652; The Hague, Gemeentemus.), the English court dignitary in exile *Sir Charles Cotterell and his Family* (1658; Fredericton, Beaverbrook A.G.) and the *Unknown Family* (1661; Dublin, N.G.). These later family portraits are, on the whole, larger than the early ones and show Mijtens's sense of arrangement, elegance and colour at its best. Besides his group portraits with pastoral elements, Mijtens painted a number of purely Arcadian scenes, which can be regarded as 'portraits historiés', for example the undated *Granida and Daiphilo* (Amsterdam, Rijksmus.).

Bibliography

Thieme–Becker; Wurzbach

W. Martin: *De Hollandsche schilderkunst in de zeventiende eeuw*, 2 vols (Amsterdam, 1935–6), ii, pp. 161–2

A. McNeil Kettering: *The Dutch Arcadia: Pastoral Art and its Audience in the Golden Age* (Montclair, 1983)

B. Haak: *The Golden Age: Dutch Painting in the Seventeenth Century* (New York, 1984), pp. 334–5

RUDOLF EKKART

Moeyaert, Claes [Nicolaes] (Cornelisz.)

(*b* Durgerdam, nr Amsterdam, 1591; *bur* Amsterdam, 26 Aug 1655). Dutch painter, etcher and draughtsman. He was the son of an aristocratic Catholic Amsterdam merchant and moved to the city with his family in 1605. He was the most prolific of the history painters now called the Pre-rembrandtists, whose representations of biblical and mythological narratives, as well as of more recent secular history, give particular emphasis to dramatic and psychological effects. After working initially as a draughtsman and etcher, Moeyaert soon made his name as a painter. Landscapes with animals feature prominently in both his etchings and his paintings. At first he followed the lead of Adam Elsheimer, then of fellow Pre-Rembrandtists Pieter Lastman and Jan and Jacob Pynas, eventually, in the mid-1630s, coming under the influence of Rembrandt himself.

1. Life and work

(i) Paintings. About 100 of Moeyaert's paintings are preserved, and there are documentary references to at least 200 more. What are considered his earliest surviving paintings are undated pictures of the *Dismissal of Hagar* (Düsseldorf, priv. col.; see Tümpel, fig. 96) and *Elisha and the Shunamite Woman* (Moscow, Pushkin Mus. F. A.), both of which date from before 1624. Small, decorative figures reminiscent of Elsheimer's move across a sketched-out landscape, and in places the painting is crude. There is already a marked emphasis on animated gestures, but the repertory of motifs is limited, and individual landscape elements have been borrowed directly from compositions by Jacob Pynas.

From 1624 onwards dated paintings occur at regular intervals, enabling a chronology to be established with some degree of certainty. The essentials of his style appear in the earliest dated examples: figures of powerful volume, using varied gestures, and clear, warm light, which suffuses the landscape and strongly models the figures, as in the *Allegory of Spring* (1624; Nuremberg, Ger. Nmus.). In some cases the horizon is so far distant that the figures are silhouetted against the sky, as in *Jacob Being Shown Joseph's Bloodstained Coat* (1624; Warsaw, N. Mus.).

Around 1629 Moeyaert's compositions and individual forms became calmer and simpler under the influence of Jan Pynas. This is evident in *Christ and the Captain from Capernaum* (1629; Herentals, St Waldetrudiskerk). Then, until *c.* 1636, he showed a preference for subjects with fewer figures (e.g. the *Good Samaritan Paying the Innkeeper*, *c.* 1635; ex-art market, Rome; see Tümpel, fig. 136); because of this, a compact, almost square format replaced the broad oblong. The change is evident in *Hippocrates and Democritus in Abdera* (*c.* 1636; Nijmegen, Radbout-Sticht.). However, the economy of movement and the unrelenting emphasis on the vertical often made the paintings appear monotonous, and up to *c.* 1633, the impression is one of outright rigidity. From this period dates the commission to portray one of the highest-ranking clerics in Amsterdam, *Sibrandus Sixtius* (1631; versions, Haarlem, Bisschopp. Mus.; Amsterdam, Begijnhof).

The new liveliness of style that is noticeable in the works of the mid-1630s can be directly attributed to the influence of Rembrandt. Moeyaert's colours became more intense and luminous, and he used them to greater narrative effect, while at the same time his repertory of motifs grew richer and his figures more animated. In 1638 he collaborated with the poets Samuel Coster and Jan Vechter on the triumphal arches erected in Amsterdam to receive Marie de' Medici; there are nine surviving preparatory drawings (all St Petersburg, Hermitage) for associated *tableaux vivants*. In the same year he painted a *Descent from the Cross* (Zwolle, Onze-Lieve-Vrouwekerk), and in 1640 he was commissioned to do a group portrait of the *Regents and Regentesses of the Old People's Home* (Amsterdam, Hist. Mus.). Between 1639 and 1641 he was also closely involved with the Amsterdam Theatre. In these and other paintings of the end of the decade he achieved a more complex and exciting structuring of space, as in the *Flight of Cloelia from Porsenna's Camp* (1640; St Petersburg, Hermitage).

In the 1640s Moeyaert returned to Lastman's example, adopting a number of his themes and quoting copiously from his basic compositions and individual motifs, as in *Joseph Selling Corn in Egypt* (1644; ex-art market, Stockholm; see Tümpel, fig. 154) and *Paul and Barnabas in Lystra* (1645; Imbshausen, Schloss). In 1643 he completed two monumental paintings commissioned four years earlier by Christian IV of Denmark: the *Burial of the Last Pagan King of Denmark* (Bålsta, Skoklosters Slott) and the *Baptism of the First Christian King of Denmark* (Hamburg, priv. col.; see Tümpel, fig. 23). In Moeyaert's latest work there was yet another change: space receded and the figures became larger but at the same time coarser (e.g. the *Finding of Moses*, 1649; St Petersburg, Hermitage). Between 1647 and 1652 he painted numerous portraits of Catholic dignitaries and, *c.* 1650, three altarpieces for the chapel of the Begijnenhof (two in Amsterdam, Johannes-en-Ursulakerk). His last two dated paintings, both

of 1653, are the *Stoning of Stephen* (ex-art market, Vienna, see Tümpel, fig. 169) and the *Raising of Lazarus* (Warsaw, N. Mus.).

(ii) **Drawings and etchings.** A large number of Moeyaert's drawings in pen and chalk have been preserved, as well as many copies; research has yet to identify the originals. Perhaps the earliest drawing, albeit one where the signature and date have been tampered with, is the *View of a Garden behind a House* (?1615; Berlin, Kupferstichkab.), which he used for the *Allegory of Spring*. His later drawings are more generous in scope, both in their details and in the composition as a whole. The strong chiaroscuro contrast that was present around 1624 later gave way to an airy brightness. Right up to his latest drawings (e.g. the preparatory study for the *Raising of Lazarus*, untraced; see Tümpel, fig. 66), he produced drawings that were fully worked out as finished pictures; these too used strong chiaroscuro effects. His draughtsmanship was generally skilful but not innovative.

About 20–30 etchings by Moeyaert are known, mostly from before 1624 and depicting history subjects in landscape settings, although some are pure landscapes, such as the *Shepherd with Cattle* (1638; see de Groot, no. 89). He may also have made the 18 etchings of sea battles and foreign lands that illustrate David Pietersz. de Vries's *Verscheyden voyagiens in de vier deelen des wereldsronde* ('Various voyages in the four parts of the globe'; Hoorn, 1655).

2. Posthumous reputation

Moeyaert, like the other Pre-Rembrandtists, always sought out challenging subjects, which he strove to represent in a lively and dramatic way. However, his narrative style was generally dry and occasionally obscure, as when his failure to distinguish compositionally between the principal and secondary characters makes interpretation of the event difficult. In other cases confusion is produced by a surfeit of figures. However, as his career progressed, his handling became freer and looser and his colouring softer and more unified. He was an influential figure for the next generation of landscape painters, and his pupils included the

leading Italianate landscape painters Nicolaes Berchem and Jan Baptist Weenix, as well as Jacob van der Does (1623–73), who painted landscapes with cattle, and Salomon Koninck, the history painter. As early as 1618 he was praised in Theodore Rodenburgh's poem 'Opsomming van de beroemdste Amsterdamse kunstenaars' ('Summary of the most famous Amsterdam artists').

Bibliography

Hollstein: *Dut. & Flem.*; Thieme–Becker

P. J. J. van Thiel: 'Moeyaert and Bredero: A Curious Case of Dutch Theatre, as Depicted in Art', *Simiolus*, vi (1972–3), pp. 29–49

A. Tümpel: 'Claes Cornelisz. Moeyaert', *Oud-Holland*, lxxxviii (1974), pp. 1–163, 245–90

The Pre-Rembrandtists (exh. cat., ed. A. Tümpel; Sacramento, CA, Crocker A. Mus., 1974), pp. 79–113

I. de Groot: *Landscape Etchings by the Dutch Masters of the Seventeenth Century* (London, 1979), no. 89

Dutch Landscape: The Early Years (exh. cat. by C. Brown, London, N.G., 1986), pp. 193–5

ASTRID TÜMPEL

Molenaer, Jan Miense

(*b* Haarlem, *c.* 1610; *d* Haarlem, *bur* 19 Sept 1668). Dutch painter and draughtsman. The surprisingly large oeuvre of this remarkably versatile genre painter displays an inventive symbolism, wit and humour, which identify him as the true forerunner of Jan Steen.

1. Life

He was the son of Jan Mienssen Molenaer and Grietgen Adriaens. The year of his birth is suggested by a notarized document of 21 November 1637 giving his age as about 27. His brother Bartholomeus Molenaer (*d* 1650) also painted, specializing in rustic peasant interiors in the manner of Adriaen van Ostade. Later in his career Jan Miense Molenaer occasionally collaborated with his nephew Klaes Molenaer (1630–76), a landscape painter and the son of another brother, Claes Jansz. Molenaer. On 1 June 1636 Molenaer married the genre painter JUDITH LEYSTER in Heemstede, near Haarlem; only two of their five children, Helena and Constantijn, survived childhood. Also

in 1636, following the court's confiscation of his property to pay debts, Molenaer and Leyster moved to Amsterdam, and a year later he was commissioned to paint an elaborate wedding portrait for the van Loon family, the *Wedding of Willem van Loon and Anna Ruychaver* (1637; Amsterdam, Mus. van Loon). His financial situation appears to have improved during his Amsterdam years, thanks in part to an inheritance received by Leyster in 1639. It was during this period that the painter Jan Lievens briefly lived with Molenaer (1644). After 12 years in Amsterdam, Molenaer purchased a house in Heemstede and moved there in October 1648. He acquired two more houses in 1655, one on the Voetboogstraat in Amsterdam (occupied for only six months), the other in Haarlem on the Lombardsteech; his remaining years were spent in the Haarlem/Heemstede area. Despite his house speculation, the painter regularly appeared in court for non-payment of debts; settlement often involved either full or partial payment in paintings. Molenaer was also arraigned on charges of fighting and using abusive language. A posthumous inventory of his possessions conducted on 10 October 1668 lists a large collection of 16th- and 17th-century paintings.

2. Works

Colourful genre paintings, genre-like group portraits and history paintings characterize the first half of Molenaer's career. The earliest works (c. 1628–30) reveal a strong affinity to paintings by Frans Hals from the 1620s. Examples such as *Children Playing with a Cat* (Dunkirk, Mus. B.-A.) and the *Breakfast Scene* (1629; Worms, Ksthaus Heylshof) suggest that Hals was Molenaer's teacher. As did Hals, he often depicted exuberant children and merrymakers in large half-length format. Paintings from this period have often been misattributed to Hals and Leyster, although Molenaer's brushwork tends to be more descriptive and his figures more substantial. An impulse to compress interior space often accompanies awkward neck and shoulder areas of his figures.

During the 1630s and into the 1640s Molenaer painted an enormous range of subjects, in which the boundaries between genre, portraiture and history are often unclear; examples include *Pastoral Scene* (1632; Paris, Louvre), the *Denial of St Peter* (1636; Budapest, Mus. F.A.), *Scene from Bredero's 'Lucelle'* (1639; Amsterdam, Ned. Theat. Inst.) and *The Duet* (c. 1630; Seattle, WA, A. Mus.). His imagery also reveals a unique combination of symbolism and allegory, description and humour, as in the *Artist in his Studio* (1631; Berlin, Bodemus.), the *Woman of the World* (1633; Toledo, OH, Mus. A.), *Boys with Dwarfs* (1646; Eindhoven, Stedel. van Abbemus.) and *The Dentist* (Brunswick, Herzog Anton Ulrich-Mus.). Molenaer's creative use of traditional themes, particularly the Virtues and Vices, has attracted the attention of iconographers and cultural historians. The riotous, often violent, actions of peasants often signal a warning to the upper classes found within the same compositions, as in the *Allegory of Marital Fidelity* (1633; Richmond, VA, Mus. F.A.). Molenaer's pictorial treatment varied greatly, depending on the subject represented: a coarse, painterly application and tonalist palette is usually reserved for peasant imagery (e.g. the *Five Senses*, 1637; The Hague, Mauritshuis); by contrast, representations of the upper classes involve a more controlled and polished treatment, with the use of brilliant local colours (e.g. *Family Making Music*, 1635–6; The Hague, Rijksdienst Beeld. Kst, on dep. Haarlem, Frans Halsmus.).

As Molenaer's debt to Frans Hals lessened, other stylistic influences ranging from Dirck Hals and Thomas de Keyser to the little-known Haarlem painter Isack Elyas (*fl* 1626) can be isolated. From the 1640s Molenaer specialized exclusively in low-life genre, his repeated variations of merry companies, peasant weddings, games and village scenes revealing the influence of Adriaen van Ostade. The compositions are crowded, the scale smaller and the colours muted; a script signature replaces the block lettering seen in earlier signatures and monograms; and the paintings are rarely dated. This dramatic change in Molenaer's art prompted many early commentators to conclude that his oeuvre was the work of two painters. The masterpiece of the second half of his career, the signed and dated *Peasants Carousing* (1662; Boston, MA, Mus. F.A.), displays the lively humour,

vivid description and ambitious composition that place it on a level with the best of his earlier works. Although Molenaer painted a number of exceptional works during the 1650s and 1660s, the overall quality of his paintings is poor. Scores of mediocre works have been misattributed to him, many of these by Jan Jansz. Molenaer (d 1685), whose figures are easily recognized by their heavy white highlights and pinched features.

Molenaer's graphic oeuvre consists of a handful of drawings of village scenes executed in the 1650s (e.g. *Peasants on their Way to a Fair*, Haarlem, Teylers Mus.). A few prints have also been attributed to him.

Bibliography

Hollstein: *Dut. & Flem.*; *NKL*; Thieme–Becker

T. Schrevelius: *Harlemias of de eerste stichting der stad Haarlem* [Harlemias, or the first founding of the city of Haarlem] (Haarlem, 1648), p. 384

W. Bode and A. Bredius: 'Der Haarlemer Maler Johannes Molenaer in Amsterdam', *Jb. Kön.-Preuss. Kstsamml.*, xi (1890), pp. 65–78

A. Bredius: 'Jan Miense Molenaer: Nieuwe gegevens omtrent zijn leven en zijn werk', *Oud-Holland*, xxvi (1908), pp. 41–2

P. J. J. van Thiel: 'Marriage Symbolism in a Musical Party by Jan Miense Molenaer', *Simiolus*, ii (1967–8), pp. 91–9

I. H. van Eeghen: 'De groepsportretten in de familie van Loon', *Amstelodamum*, lx (1973), pp. 121–7

Tot lering en vermaak [Towards learning and leisure] (exh. cat., ed. E. de Jongh; Amsterdam, Rijksmus., 1976), pp. 176–85

C. E. Bruyn-Berg: 'Bredero's *Lucelle*, Jan Miense Molenaer ca. 1610–1668', *Jversl. Ver. Rembrandt* (1978), pp. 25–8

Die Sprache der Bilder: Realität und Bedeutung in der niederländischen Malerei des 17. Jahrhunderts (exh. cat., ed. L. Dittrich; Brunswick, Herzog Anton Ulrich-Mus., 1978), pp. 106–15

C. Brown: *Scenes of Everday Life: Dutch Genre Painting of the Seventeenth Century* (London, 1984), p. 228

B. Haak: *The Golden Age: Dutch Painters of the Seventeenth Century* (London, 1984), pp. 72, 235–6

Masters of Seventeenth-century Dutch Genre Painting (exh. cat., ed. P. Sutton; Philadelphia, PA, Mus. A.; Berlin, Gemäldegal.; London, RA; 1984), xxxiv and pp. 260–65

P. Hecht: 'The Debate on Symbol and Meaning in Dutch Seventeenth-century Art: An Appeal to Common Sense', *Simiolus*, xvi (1986), pp. 173–87

N. Salomon: 'Political Iconography in a Painting by Jan Miense Molenaer', *Mercury*, iv (1986), pp. 23–38

Portretten van echt en trouw: Huwelijk en gezin in der Nederlandse kunst van de zeventiende eeuw [Portraits of spousage and loyalty: marriage and family in Dutch art of the seventeenth century] (exh. cat., ed. E. de Jongh; Haarlem, Frans Halsmus., 1986), pp. 689, 215–17, 280–84

DENNIS P. WELLER

Molyn [Molijn], Pieter (de)

(*b* London, *bapt* 6 April 1595; *d* Haarlem, *bur* 23 March 1661). Dutch painter, draughtsman and etcher of English birth and Flemish descent. His father, Pieter de Molijn, came from Ghent and his mother, Lynken van den Bossche, from Brussels. It is not known why they went to England, perhaps for employment rather than to avoid religious persecution. Pieter the younger apparently remained proud of his birthplace throughout his life, as can be inferred from his designation as 'The Londoner' in archival documents.

The earliest evidence of Molyn's presence in the Netherlands is his entry at the age of 21 into the Guild of St Luke in Haarlem in 1616, although no dated works by him before 1625 are known. Having apparently settled permanently in Haarlem, on 26 May 1624 he published his intention to marry Mayken Gerards, who also lived there. In the same year he became a member of the Dutch Reformed Church. Seven children were born to the couple between 1625 and 1639, not all of whom reached maturity. Molyn was also a member of the Haarlem Civic Guards in 1624, 1627 and 1630. Throughout the 1630s and 1640s he held the office of Dean and Commissioner in the Guild of St Luke. In 1637–8 he was the guild's alms collector. At his death he was buried in St Bavo's in Haarlem.

1. Paintings

Molyn's painted oeuvre can be divided into three distinct periods. During his early years, from 1625 to 1631, he employed an enormous variety of styles

and subject-matter, including dune landscapes, travelling people and wagons, cavalry battles, ambushes, winter scenes, cottages among trees and conversing and reposing peasants. His figures are typically shown with long noses and masklike faces (e.g. *Nocturnal Street Scene*, 1625; Brussels, Mus. A. Anc.). His compositions range from the multi-figured *Prince Maurice and Prince Frederick Henry Going to the Chase* ('*The Stadholder is Going to the Chase*') (1625; Dublin, N.G.) to the simplified arrangement found in his '*Sandy Road' (Dune Landscape with Trees and a Wagon)* (1626; Brunswick, Herzog Anton Ulrich-Mus.), in which Molyn employed the dynamic diagonal composition that was to become his hallmark. The small '*Sandy Road*' panel also represents an early stage of the style known by historians as the 'tonal phase' of 17th-century Dutch painting, in which simple vistas of the countryside are characterized by a broad painterly manner and a restricted palette of greys, greens, browns, dull yellows and blues. These early paintings are characterized by a dramatic play of light and dark, at times using a spotlight effect to establish the focus of the picture.

Molyn's paintings from 1632 to 1647 have simpler compositions, with fewer figures, firmly integrated within the landscape. His foliage becomes denser, but overall his compositions are more spacious and expansive. Solemnity of mood and strong atmospheric effects permeate some of these paintings, and the light is more evenly diffused on the picture surface, with strong patches of local colour. Although Molyn's dated paintings of the 1630s are scarce, his output from the 1640s is prodigious. The high point of his career is the *Peasants Returning Home* (1647; Haarlem, Frans Halsmus.), in which the monumentality of the composition may owe something to the influence of the young Jacob van Ruisdael. Yet the directness of expression, the forceful depiction of figures and the magnificent foliage are Molyn's own. In these years Molyn's compositional schemes also reflect the possible interchange of ideas with Salomon van Ruysdael and Jan van Goyen, although he did not prescribe to their full tonality.

During these middle years Molyn was busy as a teacher of Gerard ter Borch (ii) and may also

have had other students. He collaborated with ter Borch, Frans Hals and possibly with Pieter de Grebber, Jacob de Wet, Jacob Pynas and Nicolaes Berchem. Molyn painted landscape backgrounds for their figure compositions, while in some instances they added figures to his landscapes. In his late years, from 1648, Molyn produced numerous variations on previous compositions, refining their established stylistic and iconographic patterns. He shows more imagination in the elaboration and arrangement of his designs (e.g. *River Valley*, 1659; Berlin, Gemäldegal.), possibly under the influence of the work of Hercules Segers. The thick impasto of the foreground may have been inspired by Rembrandt's example (Stechow).

2. Prints and drawings

In 1625, the year of Molyn's first dated landscape painting, he also produced a series of four etchings depicting rustic and military figures set in landscapes with dilapidated huts in the manner of Abraham Bloemaert. These prints, Molyn's only firmly established work in the medium, are remarkable for his exploitation of the expressive possibilities of the blank sky, which is contrasted with the undulating patterns of the foreground. He also explores in them the same diagonal composition used a year later in the Brunswick painting. This format, with a high foreground on one side and a distinct panoramic view on the other, was taken over by generations of later Dutch landscape painters.

Molyn was a prolific landscape draughtsman, particularly in his later years. His earliest drawings, in pen and ink (e.g. two dated 1626; Brussels, Mus. A. Anc.), are similar to the graphic style of his etchings and have been compared to the landscape drawings of Jan II van de Velde (i), Hendrick Goltzius and Jacques II de Gheyn. Most of his drawings, however, are executed in black chalk with grey wash. They are almost invariably signed, and most are dated, the majority in the 1650s.

3. Critical reception and posthumous reputation

Molyn's work encompassed elements of both fantasy and reality. He was a transitional figure in the history of Dutch landscape painting whose

oeuvre formed a bridge between the manneristic devices of the previous century and the new naturalism of the 17th century. He integrated both extremes in his art in an imaginative and individualistic manner. One of his contributions is the sensitive and keenly observed way in which he depicted the contemporary rural life of the Netherlands and its inhabitants. Although his figures are rather weakly drawn throughout his career, they are an important and integral part of his compositions.

Molyn was appreciated as an outstanding artist in his own lifetime by Samuel Ampzing and Theodor Schrevelius. Although Houbraken later devoted only a short paragraph to Molyn, his name found its way into the influential 18th-century dictionaries. In the 19th century Adam Bartsch established the artist as a fine printmaker, while van der Willigen uncovered archival evidence of his life and art. Only since the mid-1960s, however, has Molyn come to be recognized as one of the leading figures of early 17th-century Dutch landscape art along with Esaias van de Velde (i) and Jan van Goyen.

Bibliography

Hollstein: *Dut. & Flem.*; Thieme–Becker

S. Ampzing: *Beschryvinge der stad Haarlem in Holland* [Description of the city of Haarlem in Holland] (Haarlem, 1628), p. 372

T. Schrevelius: *Harlemum* (Haarlem, 1647), p. 294

A. Houbraken: *De groote schouburgh* (1718–21), i, p. 25; ii, pp. 95, 343; iii, p. 183

A. von Bartsch: *Le Peintre-graveur* (1803–21), iv, pp. 7–12

A. van der Willigen: *Les Artistes de Haarlem* (Haarlem, 1870/R Nieuwkoop, 1970), pp. 18, 19, 21, 225–7

O. Granberg: 'Pieter de Molyn und seine Kunst', *Z. Bild. Kst*, xix (1884), pp. 369–77

R. Grosse: *Die holländische Landschaftskunst, 1600–1650* (Stuttgart, 1925), pp. 55–63

W. Stechow: *Dutch Landscape Painting of the Seventeenth Century* (London, 1966/R 1981), pp. 23–8

W. Strauss, ed.: *The Illustrated Bartsch*, v (New York, 1979), pp. 10–13

Dutch Landscape: The Early Years, Haarlem and Amsterdam, 1590–1650 (exh. cat. by C. Brown, London, N.G., 1986), pp. 151–4

E. J. Allen: *The Life and Art of Pieter Molyn* (diss., U. MD, 1987)

Masters of 17th-century Dutch Landscape Painting (exh. cat. by Peter C. Sutton, Amsterdam, Rijksmus.; Boston, MA, Mus. F.A.; Philadelphia, Mus. A.; 1987), pp. 374–6

A. M. Kettering: *Drawings from the Ter Borch Estate in the Rijksmuseum* (The Hague, 1988), V/i, pp. 86–91, 118–29; V/ii, pp. 772–3

H.-U. Beck: *Künstler um Jan van Goyen: Maler und Zeichner* (Doornspijk, 1991), pp. 273–91

EVA J. ALLEN

Moreelse, Paulus (Jansz.)

(*b* Utrecht, 1571; *d* Utrecht, 5 March 1638). Dutch painter, draughtsman, architect and urban planner. He was from a well-to-do family, which settled in Utrecht *c.* 1568. According to van Mander, Paulus studied with the Delft portrait painter Michiel van Mierevelt and was in Italy before 1596, the year he became an independent master in the saddlemakers' guild, to which Utrecht painters then belonged. On 8 June 1602 he married Antonia Wyntershoven, by whom he had at least ten children. The most famous of his many pupils was Dirck van Baburen, who studied with him in 1611, when the Utrecht artists set up their own Guild of St Luke. Moreelse was instrumental in this and became its first dean. In 1618, after a series of political disagreements, a number of citizens, including Moreelse and the painter Joachim Wtewael, petitioned the town council to resign. When that occurred, Moreelse became a member of the new council and continued to hold various public offices until his death. He was a strong supporter of plans to found a university in Utrecht and was closely involved in the preparations and in its opening in 1636, even designing the cap presented to graduating students.

Moreelse's most important architectural design (known from drawings and prints, Zeist, Rijksdienst Mnmtz.) was for the Catherijnepoort (1621–5; destr.), one of the town gates. With this impressive structure he introduced the Italianate style into Utrecht. In 1624 he presented plans for the town's expansion to the council, which rejected them. His son Hendrick Moreelse, law professor at Utrecht University and a burgomaster of the town, implemented them posthumously in 1663.

Moreelse's earliest dated portrait painting is a *Portrait of a Man* (1602; ex-E. Hahr priv. col., Stockholm; see de Jonge, fig. 18). In the following year he painted a *Militia Company* (1603; untraced) for the headquarters of the archers' company in Amsterdam and in 1616 another of the same title for the headquarters of the cross-bowmen's civic guard company (Amsterdam, Rijksmus.). As a consequence of his political activities, he received important commissions from the start of his career. Many eminent figures had their portraits painted by him or owned work of his. On 6 April 1627 the States of Utrecht resolved to present Prince Frederick Henry and his bride Amalia van Solms with one painting by Cornelis van Poelenburch, one by Roelandt Savery and two by Moreelse, these being *A Shepherd* (1627; Schwerin, Staatl. Mus.) and *A Shepherdess* (untraced). According to an inventory drawn up in 1632–4, five of Frederick Henry's *c.* 100 paintings were by Moreelse, whose many commissions from court circles included portraits of *Herzog Christian von Brunswick-Lüneburg* (1619; Brunswick, Herzog Anton Ulrich-Mus.) and *Sophia Hedwig, Countess of Nassau Dietz, as Caritas, with her Children* ('*Charity*', 1621; Apeldoorn, Pal. Het Loo). This striking painting, a good example of a *portrait historié* or combination of portrait and allegory, makes a remarkable contrast to the formal life-size portrait of the same woman, *Sophia Hedwig of Brunswick-Wolfenbüttel* (1611; London, Hampton Court, Royal Col.), that Moreelse had painted ten years previously. Apart from the court and nobility, he portrayed persons of his own circle, for example the Utrecht artist *Abraham Bloemaert* (1609) and the scholar and close friend *Arnhout van Buchell* (1610; both Utrecht, Cent. Mus.). Several of his surviving portraits are of fellow town councillors, such as *Philips Ram* (1625; Utrecht, Cent. Mus.) and *Anthonie van Mansfelt* (1636; Brussels, Mus. A. Anc.).

Moreelse's best paintings of mythological subjects include *Venus and Adonis* (1622; Stuttgart, Staatsgal.), *Venus and Cupid* (1630; St Petersburg, Hermitage), *Cimon and Pero* (1633; Edinburgh, N.G.) and *Paris Holding the Apple* (1638; Brussels, Mus. A. Anc.). Most notable among his religious paintings are the *Beheading of John the Baptist* (1618; Lisbon, Mus. N. A. Ant.) and *Allegorical Representation of Piety* (1619; ex-C. J. K. van Aalst priv. col., Hoevelaken; see de Jonge, fig. 157). He was one of the earliest painters of arcadian scenes, a genre that originated in Utrecht, producing his first shepherds and shepherdesses in 1622 and continuing to paint similar scenes throughout his career. Exceptionally attractive among the many that survive is the *Portrait of Two Children in Pastoral Dress* (1622; The Hague, Rijksdienst Beeld. Kst, on loan to Utrecht, Cent. Mus.).

Moreelse also made a number of drawings, which date primarily to his early period (e.g. *Judgement of Solomon*, before 1600; Amsterdam, Rijksmus.). Only a few engravings made after works or designs by him survive; two chiaroscuro prints of 1612 are attributed to him: *Cupid and Two Women* (Berlin, Kupferstichkab.) and the *Death of Lucretia* (Utrecht, Cent. Mus.).

Paulus's sister Maria married the sculptor Willem Colijn de Nole (*d* 1620), and three of his own children became artists—his sons Johannes (Pauwelsz.) Moreelse (after 1602–34) and Benjamin (Pauwelsz.) Moreelse (before 1629–49) and a daughter—as did his nephew Willem Moreelse (1618/23–66).

Bibliography

K. van Mander: *Schilder-boeck* ([1603]–04), fol. 280v
P. T. A. Swillens: 'Paulus Moreelse—"Const-schilder en raedt in de vroedtschap"', *Jb. Oud-Utrecht* (1926), pp. 114–35
C. H. de Jonge: *Paulus Moreelse: Portret- en genreschilder te Utrecht, 1571–1638* (Assen, 1938) [with many incorrect attrib.]
J. Rosenberg, S. Slive and E. H. ter Kuile, eds: *Dutch Art and Architecture, 1600–1800*, Pelican Hist. A. (Harmondsworth, 1966, rev. 2/1977), pp. 391–2
E. Taverne: *In 't land van belofte: In de nieuwe stadt* (Maarssen, 1978), pp. 242–78
M. J. Bok: 'Paulus Jansz. Moreelse', *Nieuw licht op de Gouden Eeuw* (exh. cat., ed. A. Blankert and L. J. Slatkes; Utrecht, Cent. Mus.; Brunswick, Herzog Anton Ulrich-Mus.; 1986–7), pp. 317–27

J. A. L. DE MEYERE

Moucheron, Frederik de

(*b* Emden, Germany, 1633; *bur* Amsterdam, 5 Jan 1686). Dutch painter of French descent. After training with Jan Asselijn in Amsterdam, he settled and worked in France for several years, where in 1656 he was recorded as staying in Paris and Lyon. He returned to Amsterdam after a brief period in Antwerp. In 1659 he married Marieke de Jouderville, daughter of the painter Isaac de Jouderville; they had 12 children. Frederik was strongly influenced by the work of the second generation of Dutch Italianates, particularly Asselijn and Jan Both. His landscapes also show similarities with the late work of Adam Pynacker. Dirck Helmbreker, Johannes Lingelbach, Adriaen van de Velde and Nicolaes Berchem all provided staffage for his paintings.

De Moucheron's work is appreciated primarily for its picturesque, decorative qualities, his paintings often rendered attractively atmospheric by use of silvery touches (e.g. *Italianate Landscape*, 1670s; Hannover, Niedersächs. Landesmus.). Towards the end of his life he painted landscapes for three *saletkamer* walls in a doll's house, which was made and furnished in Amsterdam for Adam Oortmans and Petronella de la Court between *c.* 1674 and 1690 (Utrecht, Cent. Mus.). These show how such landscape wall panels would have looked *in situ*, although to find an actual room so decorated as early as this would have been rare. In 1678 and 1679 he completed, with Berchem, several works by Willem Schellinks, who had died in 1678.

Bibliography

Thieme-Becker; Wurzbach

I. H. van Eeghen: 'Het poppenhuis van Petronella de la Court, huisvrouw van Adam Oortmans', *Jb. Amstelodamum*, xlvii (1960), pp. 159–67
Nederlandse 17e-eeuwse Italianiserende landschapschilders (exh. cat., ed. A. Blankert; Utrecht, Cent. Mus., 1965); rev. and trans. as *Dutch 17th-century Italianate Landscape Painters* (Soest, 1978)
L. Salerno: *Pittori di paesaggio del seicento a Roma*, 3 vols (Rome, 1977–80), ii, pp. 760–67; iii, p. 1060
Die Niederländer in Italien: Italienisante Niederländer des 17. Jahrhunderts aus Österreichischem Besitz (exh. cat. by R. Trnek, Salzburg, Residenzgal.; Vienna, Gemäldegal. Akad. Bild. Kst.; 1986), pp. 144–50
Masters of 17th-century Dutch Landscape Painting (exh. cat. by P. C. Sutton and others, Amsterdam, Rijksmus.; Boston, MA, Mus. F.A.; Philadelphia, PA, Mus. A.; 1987–8), pp. 378–80, pl. 121

TRUDY VAN ZADELHOFF

Muller, Jan (Harmensz.)

(*b* Amsterdam, 1 July 1571; *d* Amsterdam, 18 April 1628). Dutch engraver, draughtsman and painter. He was the eldest son of Harmen Jansz. Muller (1540–1617), the Amsterdam book printer, engraver and publisher. The family business, called De Vergulde Passer ('The gilded compasses'), was situated in Warmoesstraat, and Jan Muller worked there for many years. He may have been apprenticed to Hendrik Goltzius in Haarlem. Between 1594 and 1602 he is thought to have gone to Italy, where he stayed in Rome and Naples. He was related by marriage to the Dutch sculptor Adriaen de Vries, who was a pupil of Giambologna. He also maintained contacts with Bartholomeus Spranger and other artists in Prague, which under the rule of Emperor Rudolf II had become a flourishing centre of the arts. In 1602 he made an unsuccessful attempt to mediate on behalf of Rudolf II, who wanted to buy Lucas van Leyden's *Last Judgement* (Leiden, Stedel. Mus. Lakenhal). When Harmen Jansz. Muller died, he left the entire stock of his shop, including a number of copperplates, to his bachelor son Jan.

One hundred engravings by Muller are catalogued in Hollstein. Relatively few of the prints are based on the artist's own designs: the majority seem to have been after works by Haarlem Mannerists such as Goltzius and Cornelis van Haarlem, by Lucas van Leyden and Abraham Bloemaert, and by Rudolfine artists such as Adriaen de Vries, Spranger and Hans von Aachen. After *c.* 1590 Muller mastered and applied with great virtuosity Goltzius's volumetric engraving technique based on swelling and diminishing lines. This technique can be seen, for example, in a number of engravings after the early sculptural figure groups made by Adriaen de Vries in Prague. Muller's finest engraving is possibly *Belshazzar's Feast* (Hollstein, no. 11), a night scene

with beautiful light inspired by Tintoretto's *Last Supper* (Venice, S Giorgio Maggiore). Muller made the design (Amsterdam, Rijksmus.) for this print himself. Later he also made engravings after younger artists such as Michiel van Mierevelt, Thomas de Keyser and Peter Paul Rubens. In these he shows himself adept at reproductive techniques. The largest collection of engravings by Muller, including a number of early states and prints not yet described, is in the Albertina, Vienna.

There are 60 known drawings by the artist. Muller used a variety of drawing media, often in combination: pen and ink, wash and chalk. Apart from the series of four allegorical drawings he made as a youth in the manner of Maarten van Heemskerck (London, BM), his early development as a draughtsman was influenced by his contact with Goltzius and his knowledge of compositions by Spranger. Lagging behind the general trend away from Mannerism, he drew in an exaggerated style similar to that of Spranger and the young Cornelis van Haarlem. During his stay in Italy his style changed; after *c.* 1600 he moved away from the extreme, unnatural stylization and developed a kind of pseudo-realism. Around this time he achieved some remarkable results using chalk. Among his drawings there is a series of outstanding *vanitas* portraits in the manner of Goltzius's *Federkunststücke*, pen-and-ink drawings imitating the technique of engraving (e.g. Haarlem, Teylers Mus.). The artist's last drawings in pen and ink, for instance the *Magdalene* (Gorssel, J. U. de Kempenaar family priv. col., see Reznicek, 1956, fig. 26), are strongly influenced by Lucas van Leyden. There are also a number of studies and designs for engravings.

It is clear from the artist's will and various inventories of the period that Muller was also active as a painter. According to the inventory of his household effects in 1624, four years before his death, he left two large paintings from his Italian period to his sister. The first painting to be firmly attributed to him is the *Joseph and his Family before Pharaoh* (Dunkirk, Mus. B.-A.), which before 1975 was thought to be by Karel van Mander.

Bibliography

engravings

Hollstein: *Dut. & Flem.*

Zwischen Renaissance und Barock (exh. cat., ed. K. Oberhuber; Vienna, Albertina, 1976), pp. 227–31

W. L. Strauss: *Netherlandish Artists*, 4 [III/ii] of *The Illustrated Bartsch*, ed. W. L. Strauss (New York, 1980)

drawings

E. K. J. Reznicek: 'Jan Harmensz. Muller als tekenaar', *Ned. Ksthist. Jb.*, vii (1956), pp. 65–110

—: 'Jan Harmensz. Muller as Draughtsman: Addenda', *Master Drgs*, xviii/2 (1980), pp. 115–33; xix/4 (1981), pp. 460–61

E. K. J. REZNICEK

Naiveu [Neveu], Matthijs

(*b* Leiden, *bapt* 16 April 1647; *d* Amsterdam, 4 June 1726). Dutch painter. He was the son of a wine merchant from Rotterdam and began his training with Abraham Toorenvliet (*c.* 1620–92), a glass painter and drawing master in Leiden. From 1667 to 1669 Naiveu was apprenticed to the Leiden 'Fine' painter Gerrit Dou, who received 100 guilders a year (an exceptionally high sum) for instructing Naiveu. In 1671 Naiveu entered the Leiden Guild of St Luke, of which he became the head in 1677 and again in 1678, the year in which he moved to Amsterdam, where he was later appointed hop inspector. This work did not prevent him producing a considerable number of paintings; the earliest known work by Naiveu is dated 1668, the latest 1721. There are dated paintings for almost every year in between; his most productive periods were 1675–9 and 1705–12.

Naiveu's subject-matter and the fine and detailed manner of painting in his early work reveal the influence of Dou and, to a lesser degree, that of Dou's older pupils Frans van Mieris (i) and Pieter van Slingeland. Typical early subjects include a girl spinning, market vendors and women customers, children blowing bubbles and groups of elegant people in luxurious interiors (none of which is in public collections). In the 1670s, however, Naiveu—unlike most of

Dou's other pupils—began to distance himself increasingly from the example of his master. He continued to work in a fairly detailed manner, but his technique became noticeably less refined and polished, while his palette became brighter. Later on he occasionally returned to themes that were typical of Leiden 'Fine' painters: scenes of children, women or couples standing at a window (e.g. *Children Blowing Bubbles at a Window*, Boston, MA, Mus. F.A.). However, his windows were heavily decorated with pilasters, consoles, festoons and other carved work, giving these scenes an extravagance that is altogether uncharacteristic of the simple arched niches of Dou's pictures.

From the end of the 1670s Naiveu began to depict scenes rare in Dutch painting at the time, such as delivery rooms (e.g. *Visitors after the Birth*, 1675; New York, Met.), street parties with adults and children (e.g. *Street Festivities* and the *Morning after the Party*, both 1710; priv. col., see 1988 exh. cat., nos 60–61) and, above all, outdoor scenes of theatrical performances with harlequins and other comic figures from the *commedia dell'arte*, as in *Theatrical Performance outside the Town* (Amsterdam, Rijksmus., on loan to Amsterdam, Toneel Mus.) and *Theatrical Performance in a Dutch Town* (Geneva, Mus. A. & Hist.). Most of these theatrical scenes are set on an outdoor stage in a Dutch town or village; occasionally, however, the background is Italian—whether Naiveu actually visited Italy is unknown. These later paintings are strikingly original. From time to time there is a similarity to the work of Jan Steen; possibly Naiveu was also influenced by the *bamboccianti*, but it is very difficult to name any specific source of inspiration. Naiveu had no pupils of importance, but his street scenes and scenes with figures from the *commedia dell'arte* had a marked influence on Cornelis Troost. Naiveu's work also includes the occasional biblical, mythological and allegorical scene, a number of portraits and a few still-lifes; there are no known drawings by him.

Bibliography

A. Houbraken: *De groote schouburgh*, iii (Amsterdam, 1721), pp. 228–9

Leidse fijnschilders: Van Gerrit Dou tot Frans van Mieris de Jonge, 1630–1760 (exh. cat. by E. J. Sluijter, M. Enklaar and P. Nieuwenhuizen, Leiden, Stedel. Mus. Lakenhal, 1988), pp. 12–13, 42, 72–3, 186–95

ERIC J. SLUIJTER

Neer, van der

Dutch family of painters. The artists include (1) Aert van der Neer, a landscape painter, and his two eldest sons, (2) Eglon (Hendrick) van der Neer, known for his Dutch genres and Johannes [Jan] van der Neer (1637/8–65), a landscape painter who appears to have imitated his father's work. Johannes was also listed in Amsterdam, along with Aert van der Neer, as a *wyntapper* (tavernkeeper). None of his paintings is known for certain.

(1) Aert [Aernout] van der Neer

(*b* Amsterdam, ?1603–4; *d* Amsterdam, 9 Nov 1677). Although generally known by the name of Aert, he usually signed himself Aernout. According to Houbraken, van der Neer spent his youth in Arkel near Gorinchem (Gorkum), a town on the river Waal, east of Dordrecht, where he worked as a *majoor* (steward) for the lords of Arkel. He became an amateur painter, possibly as a result of his contact with the Camphuyzen brothers Rafael Govertsz. (1597/8–1657) and Jochem Govertsz. (1601/2–59). Aert married Lysbeth Govertsdr (Liedtke) who was almost certainly Rafael and Jochem's sister. Rafael acted as witness at the baptism of their daughter Cornelia in 1642. Around 1632 van der Neer and his wife moved to Amsterdam where, in about 1634, their eldest son, (2) Eglon, was born.

Aert's earliest-known painting is a genre scene dated 1632 (Prague, N.G. Šternberk Pal.) in the style of Pieter Quast. Dated the following year is a landscape (Amsterdam, P. de Boer; see Bachmann, 1982, fig. 2), signed jointly by van der Neer and Jochem Camphuyzen. Aert's earliest independent landscapes, exemplified by *River Landscape with Riders* (1635; Cologne, Gal. Edel), have a strong stylistic link with the Camphuyzens,

particularly Rafael, and also show the influence of Alexander Keirincx, Gillis d'Hondecoeter (for example the *Country Road*, Amsterdam, Rijksmus.) and Roelandt Savery, all artists from the Frankenthal school who took the idiom of Flemish landscape painting, particularly the tradition of Gillis van Coninxloo, to the Netherlands. This is evident in van der Neer's representation of trees with thick gnarled trunks and heavy foliation, particularly close to those in Hondecoeter's oeuvre. Even in some of his later paintings, such as *Winter Landscape* (1643; Great Britain, priv. col.; see 1986 exh. cat., no. 110) and *View of a River in Winter* (Amsterdam, Rijksmus.), van der Neer continued to use a number of Flemish devices, among them the placement of isolated figures on meandering paths or frozen rivers and the use of trees to close off one side of the composition. His views of skaters on frozen waterways are also Flemish in origin, reminiscent of Hendrick Avercamp's renderings of the same subject, painted some 50 years earlier in the tradition of Pieter Bruegel the elder. The restricted palette of earthy colours in some of van der Neer's paintings of the early 1640s suggests another source of inspiration: that of the Haarlem 'tonal' phase of landscape painting, developed during the 1620s and 1630s by Jan van Goyen, Salomon van Ruysdael and Pieter de Molijn (for example *Landscape with Duck Shooting*, 1642; Frankfurt am Main, Städel. Kstinst.).

By the mid-1640s Aert had established his own style and begun to specialize in a small number of subjects: winter scenes, exemplified by *Frozen Canal* (Worcester, MA, A. Mus.) and a *Frozen River by a Town at Evening* (London, N.G., 969); snow storms, typified by *Winter Scene* (London, Wallace); and nocturnes, especially moonlit river views, represented by *Fishing by Moonlight* (Vienna, Ksthist. Mus.; see fig. 39). He also produced many sunrises and sunsets, particularly the latter, including *Landscape with a River at Evening* (London, N.G., 2283). His landscapes have certain characteristic features: they are viewed from a slightly raised vantage-point and often incorporate a river or path that stretches (often to a small bank) right across the composition before

receding into the background. Frequently small figures animate the foreground and middle distance; the far bank of the river is often broken by the irregular silhouette of a townscape, and trees typically frame one side of the picture. Although most of van der Neer's landscapes are imaginary, a few contain recognizable buildings or topographical details, which suggest his familiarity with a particular location; for example, the ruins of Kostverloren, a castle on the bank of the Amstel, feature in *Moonlit Landscape with Castle* (1646; Jerusalem, Israel Mus.).

Perhaps van der Neer's greatest contribution to Dutch landscape painting was his ability to represent light, often subdued by heavy cloud formations or by the descending darkness of evening, through the use of subtle tonal changes, creating a sense of space and atmosphere. In his *Views of a River in Winter* (1655–60; Amsterdam, Rijksmus.), for example, he accurately captured the nature of northern light in winter. There is an emphasis on cool blue hues, alleviated in places by warmer touches of reds describing clothing and buildings. A bleaker winter atmosphere is conveyed in a *Frozen River by a Town at Evening* (London, N.G., 969), where grey and brown tones prevail. His nocturnes of the 1640s and 1650s provide further examples of this ability to capture the quality of light. In a *River near a Town by Moonlight* (London, N.G., 239) local colour is almost totally eliminated and replaced by a monochromatic build-up of browns, dull greens and pale greys, with touches of silver to represent the moonlight illuminating the clouds and reflecting on the water.

It is generally agreed that van der Neer's greatest work was produced from the mid-1640s until c. 1660. In 1659 and 1662 he is documented as having been the keeper of a tavern on the Kalverstraat (Bachmann, 1982, p. 10) with his son Johannes. On 12 December 1662 he was declared bankrupt; his property, including his paintings, was appraised and the latter considered to be of little value. Aert, however, continued to paint, residing in a state of extreme poverty on the Kerkstraat, near the Leidsegracht, until his death.

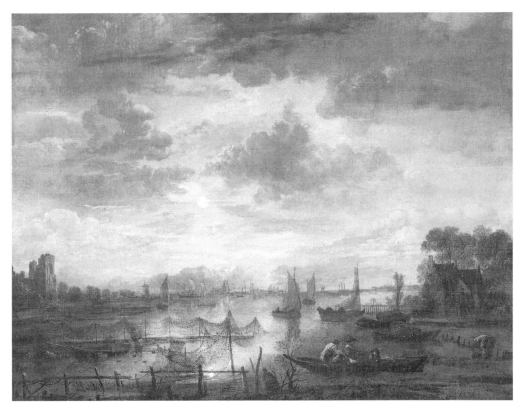

39. Aert van der Neer: *Fishing by Moonlight* (Vienna, Kunsthistorisches Museum)

Bibliography

A. Houbraken: *De groote schouburgh* (1718–21/R 1976), iii, p. 172

C. Hofstede de Groot: *Holländischen Maler* (1907–28), vii, pp. 283–8

A. Bredius: 'Waar is Aermont van de Neer begraven?', *Oud-Holland*, xxxix (1921), p. 114

N. Maclaren: *The Dutch School*, London, N.G. cat. (London, 1960), pp. 260–65

F. Bachmann: *Die Landschaften des Aert van der Neer* (Neustadt, 1966)

W. Stechow: *Dutch Landscape Painting of the Seventeenth Century* (London, 1966/R New York, 1980), pp. 96–8, 176–82

F. Bachmann: 'Die Brüder Rafael und Jochem Camphuysen und ihr Verhältnis zu Aert van der Neer', *Oud-Holland*, lxxxv (1970), pp. 243–50

——: *Art van der Neer als Zeichner* (Neustadt, 1972)

——: 'Die Herkunft der Frühwerke des Aert van der Neer', *Oud-Holland*, lxxxix (1975), pp. 213–22

F. Duparc: *Mauritshuis Hollandse schilderkunst: Landschappen in de 17de eeuw* (The Hague, 1980), pp. 60–64

G. Bachmann: *Aert van der Neer, 1603/4–1677* (Bremen, 1982)

M. Zeldenrust: 'Aert van der Neer's *Rivier landschap bij maanlicht opghelderd*', *Bull. Rijksmus.*, xxxi (1983), pp. 99–104

W. Liedtke: 'Aert van der Neer: *A Canal with a Footbridge by Moonlight*', *Liechtenstein: The Princely Collections* (exh. cat., ed. J. O'Neill; New York, Met., 1985), pp. 255–6

Dutch Landscape: The Early Years (exh. cat., ed. C. Brown; London, N.G., 1986), pp. 222–3

Masters of 17th-century Dutch Landscape Painting (exh. cat., ed. P. Sutton; Amsterdam, Rijksmus.; Boston, MA, Mus. F.A.; Philadelphia, PA, Mus. A.; 1987), pp. 39–41, 381–6

L. B. L. HARWOOD

(2) Eglon (Hendrick) van der Neer

(*b* Amsterdam, *c.* 1634; *d* Düsseldorf, 3 May 1703). Son of (1) Aert van der Neer. His birth date is based on Houbraken's statement that the artist was 70 years old when he died. He apparently studied first with his father and then with the genre and history painter Jacob van Loo. According to Houbraken, van der Neer was in France *c.* 1654, where he served as painter to the Counts of Dona, Dutch governors of the principality of Orange. He returned to Holland by 1659 and is recorded as a resident of Amsterdam at the time of his marriage to Maria van Wagensvelt in Rotterdam on 20 February 1659. The couple had 16 children.

By 1664 van der Neer had moved to Rotterdam, where he remained until 1679. During that time he made numerous trips to Amsterdam and to The Hague, where he joined the painters' confraternity Pictura in 1670. Adriaen van der Werff became his apprentice in Rotterdam *c.* 1671–6. Van der Neer's wife died in 1677, and two years later he moved to Brussels where he remained until 1689. In 1681 he married the miniature painter Marie du Chatel (*d* 1697), daughter of the Flemish genre painter François du Chatel (1625–94); this second marriage produced nine children.

After *c.* 1685 van der Neer's career was dominated by his service as painter to various noble courts. Possibly because of the esteem accorded an earlier portrait of *Marie Anne, Wife of Charles II of Spain* (Speyer, Hist. Mus. Pfalz), van der Neer was offered a position as court painter to Charles II in 1687. Apparently he never went to Spain (he is recorded in Amsterdam in 1689), but in 1696 and again in 1699 John William, the Elector Palatine, interceded on the artist's behalf in an attempt to obtain overdue payments from the Spanish court. In 1690 van der Neer accepted a position as court painter to John William and moved to the court at Düsseldorf in that year. After his second wife's death in 1697, he married Adriana Spilberg (*b* 1652), an accomplished portrait painter and daughter of Johann Spilberg II, his predecessor at the Düsseldorf court.

Van der Neer's mature works consistently display the smooth, seemingly brushless technique characteristic of the school of Leiden 'fine' painters. An early series of single three-quarter-length female figures, such as *Girl Holding a Letter* (*c.* 1650; Amsterdam, Rijksmus.), is thematically indebted to works by Gerard ter Borch (ii), but the precise, shimmering execution is derived from Gerrit Dou and more importantly Frans van Mieris (i), who painted a similar series of female figures in about 1663 (*Woman with a Parrot*; London, N.G.). Van der Neer's elegant ladies are shown reading (1665; New York, Met.), drawing (London, Wallace), proffering food (1665; Vaduz, Samml. Liechtenstein) or playing musical instruments (*Woman Playing the Mandolin*; Copenhagen, Stat. Mus. Kst.); all activities are performed with polite gentility. Van der Neer revived this compositional type in a series of lute players from the 1670s (e.g. *Woman Tuning a Lute*; 1678; Munich, Alte Pin.), though these later paintings place greater emphasis on the figure's sculptural qualities.

Van der Neer is one of the few artists of the late 17th century who continued to incorporate symbolic meaning into his genre paintings. They are, however, updated and given a sophisticated veneer with his introduction of stylish 'French' costume and architecture. For example, a moralizing message has been proposed for the *Lady Washing her Hands* (1675; The Hague, Mauritshuis), in which an elegant lady washes her hands in the basin held for her by a page. The ewer and basin, long interpreted as symbols of purity, signify the lady's virtuous detachment from the brothel scene in the background. The expression of a moralizing theme through the juxtaposition of virtue and vice is traditional, but the fashionable dress of the lady and her page, as well as the elegant classical architecture of the interior, clearly reflect the decorative and material preferences of the late 17th-century northern Netherlands.

Similarly, van der Neer's portraits correspond to the material aspirations of his sitters. The soberly dressed pair in *Couple in an Interior* (*c.* 1665–70; Boston, Mus. F.A.) smugly complement the understated elegance of the interior. An unusual feature of this portrait is the resplendent life-sized painting of a nude Venus over the chimneypiece.

Van der Neer began working on history paintings in the 1670s. *Judith* (London, N.G.) is related to his lute players, which also focus on a single figure set close to the picture plane; the resemblance is heightened by the fact that Judith is clothed in contemporary 'allegorical' dress. His depiction of the unusual biblical subject of *Gyges and the Wife of Candaules* (c. 1675–80; Düsseldorf, Kstmus.) is also set in an elegant contemporary interior.

The first of van der Neer's numerous representations of *Tobias and the Angel* (1685, Berlin, Gemäldegal.), which places large-scale figures in a landscape setting, marks the beginning of his gradual shift towards landscape painting. A later version of the same subject (1690; Amsterdam, Rijksmus.) shows the figures much reduced in scale, and the primary focus of the composition is transferred to the landscape itself. Curiously, van der Neer's landscapes show little evidence of his early training with his father and instead signal a nostalgic return to landscape styles of nearly a century earlier. With their densely wooded hills and lush, meticulously sculpted foliage, they are personal interpretations of the extraordinarily detailed and highly prized landscapes of Adam Elsheimer. Van der Neer's exacting and refined technique enabled him to re-create the exquisite enamel-like character of Elsheimer's landscapes, and these works only enhanced the reputation he had originally established as a figure painter. Cosimo III de' Medici, Grand Duke of Tuscany, commissioned a *Self-portrait* of van der Neer late in the artist's career (Florence, Uffizi), which was to show him working on or holding 'some small work with figures'. It is significant that van der Neer chose a landscape rather than a genre painting for this honoured setting.

Bibliography

A. Houbraken: *De groote schouburgh* (1718–21/R 1976), iii, pp. 172–5

C. Hofstede de Groot: *Holländischen Maler* (1907–28), v, pp. 505–62

H. Gerson: *Ausbreitung und Nachwirkung der holländischen Malerei des 17. Jahrhunderts* (Haarlem, 1942/R 1983)

Masters of Seventeenth-century Dutch Genre Painting (exh. cat., ed. P. Sutton; Philadelphia, Mus. A.; W. Berlin, Gemäldegal.; London, RA; 1984), pp. 269–71

De Hollandse fijnschilders: Van Gerard Don tot Adriaen van der Werff (exh. cat. by Peter Hecht, Amsterdam, Rijksmus., 1989), pp. 130–54

MARJORIE E. WIESEMAN

Netscher, Caspar

(b ?Heidelberg, 1639; d The Hague, 15 Jan 1684). Dutch painter of German origin. His father was the German sculptor Johann Netscher (d c. 1641) and his mother the daughter of Vetter, Mayor of Heidelberg. At an early age Caspar came to Arnhem, where he was apprenticed to Hendrik Coster, a little-known still-life and portrait painter (fl 1638–59). About 1654 Netscher moved to Deventer, where he completed his training in the workshop of Gerard ter Borch (ii). A number of signed and, occasionally, dated copies by Netscher after ter Borch survive from this period, such as the copy (1655; Gotha, Schloss Friedenstein) after ter Borch's *Parental Admonition* (c. 1654; Amsterdam, Rijksmus.) and a freely handled version (1659; untraced) of ter Borch's *Doctor's Visit* (1635; Berlin, Gemäldegal.). Netscher's first independent compositions, for example the small pendants *Portrait of a Man* and *Portrait of a Woman* (both 1656; Utrecht, Cent. Mus.), were strongly influenced by ter Borch. That these works are all fully signed suggests that Netscher held a special position in his master's workshop.

After completing his training c. 1658–9, he set off for Italy but got no further than Bordeaux, where on 25 November 1659 he married Margaretha Godijn, the daughter of a Walloon Protestant émigré. The young family moved to The Hague, where Netscher joined the painters' society Pictura on 25 October 1662. During his early years in The Hague he painted mostly small genre scenes, for example the *Chaff Cutter with a Woman Spinning and a Young Boy* (Philadelphia, PA, Mus. A.) and *The Kitchen* (Berlin, Gemäldegal.), which still show the dominant influence of ter Borch, noticeable in the use of rather dark colours and a preference for low-life subjects such as

stable and kitchen interiors. However, c. 1664–5 Netscher's manner of painting became looser, his palette brighter and his choice of subjects more pretentious. During this period he painted sumptuous interiors with elegantly dressed young men and women (e.g. *Gathering of Musicians*, 1666; Dresden, Gemäldegal. Alte Meister). Important elements in the paintings of this period are the fine rendering of silk and brocade and an arched format, which indicates that Netscher was also influenced by Leiden 'fine painters' such as Gerrit Dou and Frans van Mieris (i). In imitation of Dou, Netscher also began to paint genre scenes with half-length figures in a niche or window over a sculpted frieze (e.g. *Two Boys Blowing Bubbles*; London, N.G.). Another clearly recognizable source of inspiration for Netscher at this time was the masters of the Delft school. Netscher's masterpiece *The Lace-maker* (1664; London, Wallace) seems inconceivable without the examples of Pieter de Hooch and, above all, Johannes Vermeer.

After c. 1667 portraits gradually became Netscher's main interest, and the number of genre pieces decreased. In his portraits he followed the elegant, aristocratic court style of The Hague followers of Anthony van Dyck: Adriaen Hanneman, Jan Mijtens and Jan de Baen (see fig. 40). However, he hardly ever worked on the life-size scale so popular among these painters. Netscher's portraits tend to have the same small format as his genre pictures. In the background he often added luxurious elements such as parks, fountains and sculptures, motifs that are not always merely decorative but sometimes contain some symbolic reference to the sitter. From the 1670s until his death Netscher was the most sought-after portrait painter in The Hague and able to ask good prices for his work. In order to meet the enormous demand he resorted to workshop methods such as the in-filling of portrait heads, a method commonly used by popular portrait painters since the late 16th century. He also left a large part of the portrait production to his sons Theodorus (*b* Bordeaux, 1661; *d* Hontenisse, 1728) and Constantijn (*b* The Hague, *bapt* 16 Dec 1668; *d* The Hague, 27 March 1723), a process that did not always add to the quality of the work. A number

40. Caspar Netscher: *Portrait of William III of Orange Nassau, King of England* (London, Buckingham Palace, Royal Collection)

of portraits were engraved by Abraham Blooteling and Wallerant Vaillant almost immediately after their completion.

From 1667 Netscher also made history paintings, which, like his portraits and genre pieces, were of a small format (e.g. *Bathsheba*; Munich, Alte Pin.); most of the historical and religious works date from the 1670s. Some of these were also immediately published as prints, for example *Lucretia* by Cornelis van Meurs (*fl* ?Paris, 1676–8). In the 1680s Netscher also painted a number of pastoral landscape scenes (e.g. *Shepherd and Shepherdess*, 1683; Brunswick, Herzog Anton Ulrich-Mus.). Besides several hundred paintings, Netscher left a considerable number of excellent drawings, many of which can be directly related to his paintings. The drawings include intimate genre scenes (e.g. *Girl with a Top*; Amsterdam, Hist. Mus.) and individual studies of hands and arms in black or red chalk (Amsterdam, Rijksmus.). Netscher apparently kept his drawings as a record of his painted work. In a few cases he wrote on the *verso* when and for whom he had executed the

design in oil and how much money he had received for it. An example of such an inscription appears on the *verso* of the *Letter Writer* (1664; London, BM), which is a preparatory study for the painting of the same subject (1665; Dresden, Gemäldegal. Alte Meister). Similar notes can be found on the backs of some quickly sketched studies for portraits in pen or chalk, which he probably used to give prospective clients an idea of his range as an artist.

Bibliography

C. Hofstede de Groot: *Holländischen Maler* (1907–28), v, pp. 146–308

D. Angulo Iniguez: 'La Reina Dona Mariana recibe al embaja por holandés Beverninck, cuadro atribuido a G. Netscher', *Arch. Esp. A.*, xlvi (1974), pp. 351–2

P. H. J. Goldman: 'Two Rediscovered Portraits by Caspar Netscher', *Connoisseur*, clxxxix/761 (1975), pp. 264–5

J. G. van Gelder: 'Caspar Netscher's portret van Abraham van Lennep uit 1672', *Jb. Amstelodanum*, lxx (1978), pp. 227–38

E. Benkö: 'The Archetype of Netscher's *Portrait of Mary II Stuart* in Brussels and its Use', *Mus. Royaux B.-A. Belgique: Bull.*, xxx-xxxiii (1981–4), pp. 123–33

Masters of Seventeenth-century Dutch Genre Painting (exh. cat., ed. P. C. Sutton; Philadelphia, PA, Mus. A.; Berlin, Gemäldegal.; London, RA; 1984)

Portretten van echt en trouw [Portraits of matrimony and betrothal] (exh. cat., ed. E. de Jongh; Haarlem, Frans Halsmus., 1986)

De Hollandse fijnschilders van Gerard Dou tot Adriaen van der Werff (exh. cat. by P. Hecht, Amsterdam, Rijksmus., 1989–90), pp. 156–80

F. Simons: *Theodoor Netscher, 1661–1728: Ein vergeten schilder* (Voorburg, 1990)

G. JANSEN

Ochtervelt, Jacob

(*bapt* Rotterdam, 1 Feb 1634; *d* Amsterdam, 1682). Dutch painter. According to Houbraken, he and Pieter de Hooch were fellow students of the Dutch Italianate Nicolaes Berchem in Haarlem, probably between 1646, when Berchem returned from Italy, and 1655, when Ochtervelt married Dirkje Meesters in the Dutch Reformed Church in Rotterdam. Ochtervelt's earliest known works reveal the influences of a number of Dutch

Italianate painters. Landscapes with figures, such as *Hunters and Shepherds in a Landscape* (1652; Karl-Marx-Stadt, Städt. Kstsamml.), owe much to Berchem in subject and composition. They may also have been partly inspired by similar landscapes by Jan Baptist Weenix and Ludolf de Jongh. Towards the mid-1650s Ochtervelt began painting garden scenes (e.g. *Musical Trio in a Garden*, c. 1654–5; Brunswick, Herzog Anton Ulrich-Mus.) with classical architectural motifs and large, almost sculpturally modelled figures, which recall both the full-length Roman genre paintings of Karel Dujardin and the theatrically illuminated figure-pieces of the Utrecht Caravaggisti.

Shortly after 1660 Ochtervelt began to concentrate almost entirely on contemporary genre interiors with fully developed settings. He formulated his own distinctive style and became one of the leading genre painters in Rotterdam in the second half of the 17th century. The first of his elegant tavern scenes, the *Embracing Cavalier* and the *Sleeping Soldier* (c. 1660–63; both Manchester, Assheton Bennett priv. col., on loan to Manchester, C.A.G., see Kuretsky, 1979, figs 25–6), are similar to works by the Leiden artist Frans van Mieris the elder, whose interiors of the late 1650s (e.g. *Inn Scene with Officer and Maid*, 1658; The Hague, Mauritshuis) display the same figure types and costumes and the delicate, meticulously detailed brushwork associated with the Leiden 'fine' painters. Unlike van Mieris, however, Ochtervelt used deeper shadow with more selective light accents that emphasize his more angular compositional arrangements. The unusual oblique placement of figures and faces adds lightness and rhythm to scenes that are presented to the viewer as if they were staged, theatrical tableaux.

During the late 1660s Ochtervelt continued to paint scenes close to van Mieris's style, for instance the *Oyster Meal* (1667; Rotterdam, Mus. Boymans–van Beuningen). He also produced several paintings of figures in niches (e.g. *Man in a Niche*, 1668; Frankfurt am Main, Städel. Kstinst.), a compositional formula much favoured by the Leiden school artists. While Ochtervelt's genre paintings usually represent elegant lovers, musical ensembles or women in the boudoir,

during the 1660s he also began to paint scenes showing the foyer of a Dutch house with an open doorway at which street musicians or food vendors appear, for example *Street Musicians at the Door* (1665; St Louis, MO, A. Mus.) and the *Grape Seller* (1669; St Petersburg, Hermitage). These entrance hall paintings, which constitute Ochtervelt's most innovative contribution to Dutch genre painting, allowed him to explore both the contrast and the connection between people of different types and classes on the threshold of their different worlds.

By the end of the 1660s, in such works as *Violin Practice* (1668; Copenhagen, Stat. Mus. Kst) and *Singing Practice* (*c.* 1669; Kassel, Schloss Wilhelmshöhe), Ochtervelt had begun to respond to Gerard ter Borch (ii) in his emphasis on shimmering satins and his choice of figure types. The influence of Vermeer's lighting and diagonal figure arrangements can also be seen in such works as the *Dancing Dog* (1669; Hartford, CT, Wadsworth Atheneum) and the *Music Lesson* (1671; Chicago, IL, A. Inst). The same types of richly dressed figures, gracefully grouped in domestic interiors, are represented in Ochtervelt's family portraits of this period: *Family Portrait* (1670; Budapest, Mus. F.A.) and *Family Portrait* (*c.* 1670; Pasadena, CA, Norton Simon Mus. A.).

By 1674 Ochtervelt had moved to Amsterdam, where he was to remain until his death. His residence there is documented not only by archival references from 1674, but also in his group portrait the *Regents of the Amsterdam Leper House* (1674; Amsterdam, Rijksmus.). Paintings of the Amsterdam period reveal an increased diffusion of stylistic sources and, ultimately, considerable unevenness of quality. A number of works, for example *Concert in a Garden* (1674; St Petersburg, Hermitage), illustrate a return to Ochtervelt's own early Dutch Italianate style, perhaps as a response to Gerard de Lairesse's academic classicism, which came into fashion in Amsterdam during this period. Other paintings, such as the *Music Party* (*c.* 1676–80; London, N.G.), continue to display a more endemically Dutch style derived from ter Borch and Vermeer, but with less compositional coherence than works of the 1660s. Ochtervelt's late works offer a revealing insight into the complexities of late 17th-century Dutch art, a period often seen as a time of decline, in part because of the conflict between realism and classicism, two virtually opposing approaches to art. This uneasy combination can be seen clearly in Ochtervelt's the *Last Testament* (*c.* 1682; Berlin, Jagdschloss, Grunewald), in which a classical setting and frieze-like composition are used with unidealized figures in contemporary dress. The fact that Ochtervelt could never totally assimilate the elements of the classical style points up the quandary faced by many artists who develop successfully within an established tradition, only to be confronted by the beginnings of a new era.

Bibliography

A. Houbraken: *De groote schouburgh*, ii (1719), p. 35

F. D. O. Obreen: *Archief voor kunstgeschiedenis*, v (Rotterdam, 1883–4), pp. 316–22

W. R. Valentiner: 'Jacob Ochtervelt', *A. America*, xii (1924), pp. 269–84

E. Plietzsch: 'Jacob Ochtervelt', *Pantheon*, xx (1937), pp. 364–72

—: *Holländische und flämische Maler des 17. Jahrhunderts* (Leipzig, 1960), pp. 64–8

S. D. Kuretsky: 'The Ochtervelt Documents', *Oud-Holland*, lxxxvii (1973), pp. 124–41

—: *The Paintings of Jacob Ochtervelt (1634–1682)* (Oxford, 1979) [cat. rais.]

SUSAN DONAHUE KURETSKY

Ostade, van

Dutch family of artists. (1) Adriaen van Ostade and his brother (2) Isack van Ostade were among the eight children of Jan Hendricx van Eyndhoven, probably a linen-weaver, and Janneke Hendriksen, both of whom had moved to Haarlem from the Eindhoven area. In an active career that spanned more than 50 years, Adriaen became one of the most prolific Dutch artists of the 17th century. In his principal speciality, peasant and low-life genre painting, he enjoyed a leading position and considerable influence. The subjects of his single- and multi-figured compositions include, alongside the village fair (*kermis*) and other festivals, scenes of play and diversion both inside and outside the village inn, scenes of family life, domestic and

agricultural work, and schools and various trades (cobbling, weaving, baking, barbering, market trading, peddling, alchemy etc). He situated his own work as a painter within the same humble, artisanal context in his several versions of the *Painter's Workshop* (e.g. paintings of *c*. 1643, Amsterdam, Rijksmus.; and 1663, Dresden, Gemäldegal. Alte Meister, HdG 98; a drawing, Berlin, Kupferstichkab.; and an etching, B. 32). He also produced several single and group portraits, as well as a few sumptuous still-lifes. Isack, in the course of a brief but active career of only 11 years, produced an extraordinary volume of work, quite as original and varied as Adriaen's, including some outstanding winter landscapes. Once he had attained artistic maturity, he began to exert an influence of his own on his elder brother, who was apparently his first teacher. Both artists were prolific and accomplished draughtsmen.

Bibliography

Thieme–Becker

A. Houbraken: *De groote schouburgh*, i (1718), pp. 347–9

J. Smith: *A Catalogue Raisonné of the Works of the Most Eminent Dutch, Flemish and French Painters* (London, 1829–42), i, pp. 107–98; ix, pp. 79–136, 815

V. van der Willigen: *Les Artistes de Haarlem* (Haarlem and The Hague, 1870), pp. 233–41

C. Hofstede de Groot: *Holländischen Maler*, iii (1910), pp. 146–455, 459–583 [HdG]

A. Bredius: *Künstler-Inventare: Urkunden zur Geschichte der holländischen Kunst des XVI., XVII. und XVIII. Jahrhunderts* (The Hague, 1915–22), viii, pp. 99–100

E. Scheyer: 'Portraits of the Brothers van Ostade', *A.Q.* [Detroit], ii (1939), pp. 92–115

R. Klessmann: 'Die Anfänge des Bauerninteriurs bei den Brüdern Ostade', *Jb. Berlin. Mus.*, ii (1960), pp. 92–115

B. Schnackenburg: *Adriaen van Ostade, Isack van Ostade: Zeichnungen und Aquarelle*, 2 vols (Hamburg, 1981)

Masters of Seventeenth-century Dutch Genre Painting (exh. cat., ed. P. C. Sutton; Philadelphia, PA, Mus. A.; Berlin, Gemäldegal.; London, RA; 1984), pp. 281–91

P. Schatborn: 'Tekeningen van Adriaen en Isack van Ostade', *Bull. Rijksmus.*, xxxiv (1986), pp. 82–92

(1) Adriaen van Ostade

(*b* Haarlem, *bapt* 10 Dec 1610; *d* Haarlem, 27 April 1685). Painter, draughtsman and etcher. According to Houbraken's rather unreliable biography, he was a pupil concurrently with Adriaen Brouwer of Frans Hals in Haarlem. Hals influenced him very little, whereas Brouwer, who was described as 'known far and wide' as early as 1627, had a decisive influence on the evolution of Adriaen van Ostade's always idiosyncratic portrayal of peasant life. The first documentary mention of Adriaen van Ostade as a painter is in 1632 (Schnackenburg, 1970). Most of his paintings are signed and dated, the earliest firmly dated example being the *Peasants Playing Cards* (1633; St Petersburg, Hermitage). He was a member of the Haarlem Guild of St Luke by 1634 at the latest.

Adriaen van Ostade's pupils included his brother Isack and, probably at the same time, Thomas Wijck (Schnackenburg, 1981, pp. 65–6; close parallels between these two artists' drawings suggest that they were trained side by side). They were followed by Cornelis Bega, Jan Steen (probably), Michiel van Musscher, Jan de Groot (1650–1726) and finally Cornelis Dusart, who inherited a large part of the contents of Adriaen van Ostade's studio in 1685.

1. Paintings

The model of Adriaen Brouwer was the point of departure for Adriaen van Ostade's early animated fight scenes (e.g. the *Brawl with Knives out*, before 1633, Prague, N.G., Šternberk Pal., and the *Quarrel over Cards*, *c*. 1635, Antwerp, Kon. Mus. S. Kst., 959) and his parties of smoking, drinking, gambling, dancing and amorous peasants in colourful rags and in settings of chaotic squalor (e.g. *Country People in an Inn*, before 1633, Budapest, Mus. F.A., HdG 626; the *Dancing Couple*, *c*. 1635, Amsterdam, Rijksmus., HdG 16; and *Smell*, from a series of the *Five Senses*, 1635, St Petersburg, Hermitage). However, they lack Brouwer's individual characterization and acute observation of feeling. As subjects, the scenes still clearly stand within the tradition of peasant satire, aimed at the vices of mankind.

From the outset, Adriaen van Ostade also painted scenes of tranquil domestic comfort (e.g. *Peasant Interior*, before 1633, ex-P. de Boer priv. col., Amsterdam, see Schnackenburg, 1981, i, fig. 22; and *Village Alehouse with Four Figures*, 1635,

Salzburg, Residenzgal., HdG 584). In these, the action is less important than the depiction of a psychological state, and the setting gains in significance. The figures and the space blend in an atmospheric treatment of light. Similar concerns are found c. 1630 in the work of Frans Hals's brother Dirck, but Adriaen van Ostade employed stronger chiaroscuro light contrasts and stressed the element of spatial recession through the diagonal placing of his rafters.

From the early 1630s onwards he also painted single-figure compositions, both half-length and head-and-shoulders (e.g. *Old Man Reading by Candlelight*, 163 [?2 or 3], HdG 84, see Gerson, 1969, p. 335, fig. 10). In the *Old Woman with a Candle* (1636; see K. Bauch: *Der frühe Rembrandt und seine Zeit*, Berlin, 1960, fig. 198), Adriaen van Ostade used a concealed, artificial light source, a device favoured by the Utrecht Caravaggisti. A number of figure paintings by Adriaen from c. 1640 (e.g. *Laughing Peasant*, 1642; Rotterdam, Mus. Boymans–van Beuningen, 1635) display a broad, sketchy handling that has a certain affinity to that of Frans Hals. The *Merry Peasant with a Jug* (Amsterdam, Rijksmus., HdG 138) is a free variation on Hals's *Pickled Herring* (c. 1628–30; Kassel, Schloss Wilhelmshöhe).

From 1636, alongside compositions in which figures predominated, Adriaen began to paint spacious barn interiors, littered with straw, with diminutive figures of peasants at work (e.g. *Peasant Interior*, 1636, see Klessmann, 1960, fig. 10; and *The Washerwoman*, 1637, Hamburg, Ksthalle, HdG 456). In these works the tonality shifts from blue-grey to a warmer green-brown. The artist continued to paint barn interiors of this type well into the 1640s (e.g. *Peasant Family in a Large Hut*, 1642, Paris, Louvre, HdG 468; and *Peasants in a Barn*, 1647, Vienna, Ksthist. Mus., HdG 474). From 1637 onwards, he also started to paint open-air scenes, in an initially rudimentary landscape setting (e.g. *Slaughtering Pigs by Lanternlight*, 1637, Frankfurt am Main, Städel. Kstinst. & Städt. Gal., HdG 408). It was not until c. 1640—and probably under the influence of his younger brother Isack—that Adriaen began to concentrate more intensively on landscape. The

Landscape with Drovers (ex-Wetzlar priv. col., see Haak, 1964, fig. 3) is dated 1639, and the large *Peasant Dance Outside an Inn* (1640, ex-Wesendonck priv. col., HdG 794, see W. Drost: *Barockmalerei in den germanischen Ländern* (Wildpark-Potsdam, 1926), pl. xi) is the first work in which the painter combined a village landscape with genre figures. In the latter painting there is a conspicuous pair of onlookers, dressed as townsfolk, who may well be the painter himself and his first wife, Machtelgen Pietersen, of Haarlem, who died childless in 1642. The *Landscape with an Old Oak* (Amsterdam, Rijksmus.), a stylistically related work, also probably painted in 1640, is Adriaen van Ostade's only pure landscape painting.

The handling of the vegetation in the *Hermit Reading* (Vaduz, Samml. Liechtenstein, HdG 3), its tonality ranging from reddish-brown to yellow and the passages of vigorous, sketchy brushwork suggest that it was also painted in or soon after 1640, some years later than commonly supposed (see *Im Lichte Hollands*, exh. cat., Basle, Kstmus., 1987, no. 67). This painting is the only work by Adriaen van Ostade that shows any affinity, in form or in content, to the work of Rembrandt (at least since 1982, when the *Annunciation to the Shepherds* (Brunswick, Herzog Anton Ulrich-Mus., HdG 1) was reattributed to Benjamin Gerritsz. Cuyp; see *Die holländischen Gemälde* (Brunswick, 1982, p. 51)). This makes it necessary to make a much more cautious assessment of the supposed early influence of Rembrandt, on which the older authorities on Adriaen van Ostade laid such stress.

In the course of the 1640s, Adriaen van Ostade's characteristic form of interior changed: the rooms became larger and more imposing, flat-ceilinged and better furnished (as in *Peasant Revellers at the Alehouse*, 1642, St Petersburg, Hermitage, HdG 578; and *Peasants Dancing at the Inn*, 1645, HdG 553, S, i, fig. 30). The figures and their costumes, as well as the furnishings and utensils attendant on peasant life, are shown in more detail. This pictorial type found its definitive form c. 1647, for example in the *Merry Peasant Party* (Munich, Alte Pin., HdG 544) and the *Three Peasants at an Inn*, 1647 (London, Dulwich Pict. Gal., HdG 327). There is a greater sense of depth and atmosphere created

by means of clearly marked orthogonals and subtle gradations of chiaroscuro, and the figures are more individualized.

By the 1650s scenes of excessive drinking and gambling (e.g. *Peasants Brawling*, 1656; Munich, Alte Pin., HdG 609) became the exception rather than the rule. Adriaen van Ostade's peasants, and the petty burghers from whom they are almost indistinguishable, are mostly shown relishing the small pleasures permitted by their modest existence. This shift is accompanied by a change in the implicit meaning of the pictures, as recorded in the legends of related engravings. In place of, or alongside, the traditional satire on human frailty, the simplicity of peasant life is held up as a model (*Vivitur parvo bene*: 'One may live well on little') or even idealized, in the manner of bucolic poetry.

The peasant interiors of the 1650s show an increasing emphasis on detail. The strong local colouring of the figures stands out powerfully from the tonal twilight of the interior setting (e.g. in *Peasants with Skates by the Fireside*, 1650, Amsterdam, Rijksmus., HdG 621; and *Peasant Interior with a Hurdy-Gurdy Player*, 1653; London, N.G.). In the representation of landscape, too, Adriaen van Ostade shifted *c.* 1650 from broad, soft, tonal painting to a more detailed style with a stronger emphasis on local colour, as in the *Merry Countryfolk* (1648; Kassel, Schloss Wilhelmshöhe, HdG 425).

At the end of the decade the paint becomes smoother and more delicate, as in *Peasant Dance at an Inn* (1659; St Louis, MO, A. Mus., HdG 549), and the works of the early 1660s show a fully fledged 'Fine' painting technique as practised by Leiden artists. The colouring is marked by rich but subdued hues accompanied by a finely attuned cool tonality, as can be seen in *The Alchemist* (1661; London, N.G., HdG 397), the *Fireside Conversation* (1661: Amsterdam, Rijksmus., HdG 620) and the *Peasants at an Alehouse* (1662; The Hague, Mauritshuis, HdG 636). In 1667 Adriaen painted his only known biblical subject, the *Adoration of the Shepherds* (Russborough, Co. Wicklow, HdG 2).

In 1657, successful and prosperous, the painter took a second wife, Anna Ingels (*d* 1666), from a respected Amsterdam Catholic family. His previous contacts with the same milieu are documented by the group portrait of the *De Goyer Family* (after 1650, The Hague, Mus. Bredius, HdG 878), which incorporates a self-portrait; this is also the period of such single portraits as that of a lady (1651; HdG 896) and a boy (HdG 881; both St Petersburg, Hermitage) and of another group portrait (1654; Paris, Louvre, HdG 879). In 1662 Adriaen van Ostade became dean of the Haarlem Guild of St Luke, after holding the post of its *hoofdman* or leader in 1647 and 1661. Anna Ingels died after bearing her husband one daughter, Johanna Maria.

After 1670 Adriaen's paintings become brighter and more intense in their colouring. The local colour values are now tied together by a warm, mostly greenish tonality. There are relatively fewer interiors (exceptions being two works from 1674: the *Nine Peasants at an Inn*, Ascott, Bucks, NT, HdG 691; and the *Men and Women at a Peasant Inn*, Dresden, Gemäldegal. Alte Meister, HdG 629); instead there are many more open-air compositions (e.g. *Travellers Resting in an Inn Garden*, 1671, HdG 778, and *The Fishwife*, 1672, HdG 130, both Amsterdam, Rijksmus.; and *Peasants in a Summer Arbour*, 1676, Kassel, Schloss Wilhelmshöhe, HdG 277). In the last years of his life the artist confined himself to modest single-figure compositions, such as three small paintings from a series of the *Five Senses* (all 1681: St Petersburg, Hermitage, HdG 14–16).

Besides his own painted compositions, Adriaen van Ostade contributed staffage figures to paintings by Pieter Saenredam, Jacob van Ruisdael, Cornelis Decker (*fl* 1643–76), Jacob van Mosscher (*fl* 1635–55) and others.

2. Drawings

Alongside his brother Isack, Adriaen was the most important and the most prolific draughtsman in the whole field of Dutch genre. Schnackenburg's catalogue raisonné of 1981 lists 404 drawings by him. The earliest influence here may well have been that of Adriaen Brouwer; the style of the few sketches ascribed to Brouwer finds its clearest

reflection in the drawings done by Adriaen van Ostade c. 1637. Until the mid-1640s Adriaen concentrated on multi-figured compositions, drawn in pen and brown ink, with brown wash and sometimes watercolour; then he began to produce preparatory figure studies, both for paintings and etchings, in black and white chalk on tinted paper. These show the artist adopting the type of study 'from life' (*naer het leven*) that was pioneered by Roelandt Savery. There are a number of highly detailed studies of heads and shoulders, or heads alone, in red and black chalk.

About half of Adriaen van Ostade's drawings date from after 1670, by which time the dominant form was the finished watercolour, signed and usually dated, frequently sharing its composition with an oil painting or an etching, for instance the *Nine Peasants at an Inn* (1674; New York, Pierpont Morgan Lib.; see fig. 41), which relates to the painting of the same year (Ascott, Bucks, NT). In these high-priced and sought-after collector's pieces, Adriaen van Ostade set out to duplicate the effect of his oil paintings through a combination of pen, brush and transparent as well as opaque

watercolours (see col. pl. XXVII). In a number of these watercolours the preliminary underdrawing is in black and red chalk rather than pen, and the support is sometimes parchment. These miniature paintings, like the etchings, are mostly based on composition sketches traced through with a stylus. Alongside the multi-figured compositions, Adriaen produced numerous small single-figure drawings.

3. Etchings

After Rembrandt, Adriaen van Ostade was the major Dutch etcher of his day. Of the 50 known etchings, 11 bear dates between 1647 and 1679, and the remainder can be dated on stylistic grounds (Schnackenburg, 1981, pp. 45–7). The six earliest etchings (1647–52), with their fine gradations of chiaroscuro, have something of a painterly character. The contours are soft and tend to dissolve in the light. The graphic repertory consists of loose, sketchy, curving strokes, hooks and dots. The works of 1653–4, by contrast, show a graphic system of hatchings and crosshatchings, which becomes simpler and more rigid in the late etchings of 1671 and 1679. The artist worked towards the desired effect through a succession of states. Many of the etched compositions also exist in painted form (Trautscholdt, 1929).

In 1710 Adriaen van Ostade's copper-plates came into the hands of Bernard Picart, who reprinted them. The popularity of these works is further confirmed by two re-editions in the late 18th century (Basan, 1780); many of the plates had by this time been extensively reworked, and the impressions are consequently of little value.

Bibliography

Hollstein: *Dut. & Flem.*

C. de Bie: *Het gulden cabinet* (1661), p. 258

J. E. Wesseley: *Adriaen van Ostade: Verzeichnis seiner Originalradierungen und der graphischen Nachbildungen nach seinen Werken* (Hamburg, 1888)

W. von Bode: *Die Meister der höllandischen und vlamischen Malerschulen* (Leipzig, 1917; rev. 1919), pp. 128–37

E. Trautscholdt: 'Notes on Adriaen van Ostade', *Burl. Mag.*, liv (1929), pp. 74–80

41. Adriaen van Ostade: *Nine Peasants at an Inn*, 1674 (New York, Pierpont Morgan Library)

L. Godefroy: *L'Oeuvre gravé de Adriaen van Ostade* (Paris, 1930)

A. Bredius: 'Een en ander over Adriaen van Ostade' [Further notes on Adriaen van Ostade], *Oud-Holland*, lvi (1939), pp. 241–6

H. Gerson: *Ausbreitung und Nachwirkung der holländischen Malerei des 17. Jahrhunderts* (Haarlem, 1942); rev. by B. W. Meijer (Amsterdam, 1983)

J. W. von Moltke: '*Courtyard with Still-Life* by Adriaen van Ostade', *Oud-Holland*, lxxi (1956), pp. 244–5

J. N. Kusnetzow: *Adriaen van Ostade* (exh. cat., Leningrad, Hermitage, 1960) [Russ. text]

B. Haak: 'Adriaen van Ostade, *Landschap met de oude eik*' [Adriaen van Ostade, *Landscape with the Old Oak*], *Bull. Rijksmus.*, xii (1964), pp. 5–11

J. Rosenburg, S. Slive and E. H. ter Kuile: *Dutch Art and Architecture, 1600–1800*, Pelican Hist. A. (Harmondsworth, 1966, rev. 1977), pp. 184–6

H. Gerson: 'Rembrandt en de schilderkunst in Haarlem', *Miscellanea J. Q. van Regteren Altena* (Amsterdam, 1969), pp. 138–42

B. Schnackenburg: 'Die Anfänge des Bauerninterieurs bei Adriaen van Ostade', *Oud-Holland*, lxxxv (1970), pp. 158–69

Graphik in Holland (exh. cat. by K. Renger, Munich, Staatl. Graph. Samml., 1982), pp. 125–41

Dutch Prints of Daily Life: Mirrors of Life or Masks of Moral (exh. cat. by L. Stone-Ferrier, Lawrence, U. KS, Spencer Mus. A.; New Haven, CT, Yale U. A.G.; Austin, U. TX, Huntington A.G.; 1983–4)

B. Schnackenburg: 'Das Bild des bäuerlichen Lebens bei Adriaen van Ostade', *Wort und Bild in der niederländischen Kunst und Literatur des 15. und 16. Jahrhunderts* (Erftstadt, 1984), pp. 30–42

(2) Isack [Isaac; Isaak; Isak] van Ostade

(*b* Haarlem, *bapt* 2 June 1621; *d* Haarlem, *bur* after 16 Oct 1649). Painter and draughtsman, brother of (1) Adriaen van Ostade. Although Houbraken claimed he studied with his brother, Isack's early landscape studies suggest that he received additional instruction from a landscape painter, possibly Salomon van Ruysdael, who sued Adriaen van Ostade in 1640 for 'sums due for board and tuition'.

1. Paintings

Most of Isack's paintings are signed and dated. The relatively immature *Peasant Family by the Fireside* (1639; Boston, MA, Abrams priv. col.) was followed by a *Peasant Interior with a Slaughtered Pig* (1639; Munich, Alte Pin., HdG 144), which is close to the brownish-coloured interiors that Adriaen was painting from 1636. In the years that followed, Isack developed this formula further in a series of works culminating in the *Peasant Interior* (1645; Berlin, Gemäldegal.), with subtle reddish-brown tones. The horizontal oval format of the *Reception of the Bride* (Stockholm, Hallwylska Mus.) might have been derived from Salomon van Ruysdael, who often used the format. The *Landscape with Storm Clouds* (Rotterdam, Mus. Boymans–van Beuningen, bearing the forged signature *A. van Ostade*), with its contrast between a cool grey sky and reddish-brown earth tones and its use of minute brushstrokes for the foliage, recalls the works that van Ruysdael was painting in the 1630s. Only one other work of this type by Isack is known: the *Landscape at the Edge of the Dunes* (1641; Basle, Kunstmus.). In the ensuing period Isack came to specialize in a combination of genre and landscape; interiors are virtually unknown in his work after 1642.

The paintings of 1640–42 are notable for a minute painterly technique (e.g. the *Peasant Wedding*, 1640; The Hague, Rijksdienst Bild. Kst, HdG 198), which coexists with a broad, sketchy use of line (as in the *Peasant Interior*, 1640, Budapest, Mus. F.A., HdG 313; the *Bagpiper outside the Farmhouse*, 1640, exh. cat., Amsterdam, Gal. Goudstikker, May–July 1928, no. 28, repr.; and *The Cardplayers*, sold Amsterdam, Muller, 14 May 1912, lot 159, repr.). Isack derived this style from Adriaen but used it with more spirit and greater virtuosity. The *Country Dance outside an Inn* (1641; Hannover, Niedersächs. Landesmus.) is characteristic of many open-air scenes painted by Isack in 1641–2; its figures are marked by stylized, curving forms, their brightly coloured clothing has sparkling white highlights and the overall tone of the setting is a yellowish-brown. The frequent use of yellow and pink in the sky tones is also found in the work of Salomon van Ruysdael at the same period. In 1641 Isack undertook to supply a Rotterdam dealer with 13 paintings for only 27 guilders. In a subsequent court case, he pleaded

the increased value of his works; a judgement of 1643 reduced his commitment to 9 paintings and raised the price to 50 guilders. In this phase of growing success, Isack painted a number of striking works in larger format (e.g. *Round Dance outside an Inn*, 1.07×1.49 m; Raleigh, NC, Mus. A.).

Around 1640 Isack also painted a number of half-length figures inspired by Adriaen (e.g. *Peasant with a Pot and Pipe*, probably 1639, HdG 299; and *Peasant in a Slouch Hat*, c. 1641, both Berlin, Gemäldegal.). A related work is his only known *Self-portrait* (1641; Stockholm, Nmus., HdG 300), in which the youthful painter appears in a costume reminiscent of those in the work of the Dutch Italianates. The *Self-portrait* was something of an artistic manifesto. In 1643, the year of his entry into the Haarlem Guild, Isack committed himself to a new style of peasant genre painting inspired by Pieter van Laer, the leader of the Dutch Italianates, who had returned from Italy in 1638. Isack's style underwent a complete transformation, taking on an Italianate delicacy in the handling of figures, architecture and foliage. An important work in this style is the *Country Tavern with a Horse at the Trough* (1643; Amsterdam, Rijksmus., HdG 7). Older sources for the theme are to be found in the work of Pieter de Molijn and Salomon van Ruysdael, but the romanticized treatment is derived from van Laer. The theme of travellers resting outside an inn remained dominant in Isack's painting until 1649. The composition tends, as with Philips Wouwerman, to centre on a white horse. In the *Country Tavern with a Horse at the Trough* the horse forms a bright accent in a brownish context; later the lighting becomes more and more uniform and there is an increased emphasis on detail, as in the *Halt outside an Inn* (1645, Washington, DC, N.G.A., HdG 37). The outstanding works in this sequence are the two other versions of the theme, both dating from 1646 and both dominated by local colouring (The Hague, Mauritshuis, HdG 22; and Duisburg, Henle priv. col.).

Isack's second favourite subject was the winter landscape. The earliest example, *Ice Pastimes* (Schleissheim, Altes Schloss, HdG 257), which is derivative of Jan van Goyen and Pieter de Molijn,

was painted as early as 1641; in later versions of the subject the mêlée of skaters and horse-drawn sleighs found in this work tends to be resolved in a composition dominated by individual figures (e.g. *Winter Scene outside an Inn*, c. 1646, London, N.G., HdG 254; and *Sheet of Ice with Skaters*, Frankfurt am Main, Städel. Kstinst. & Städt. Gal., HdG 251). In a number of large paintings of the artist's late period (e.g. *Canal in Winter*, London, Kenwood House, HdG 275; *Frozen Lake*, 1648, St Petersburg, Hermitage, HdG 262), the initial animation has given way to stillness and tranquillity.

The characteristic works of the period after 1646 are paintings in an upright format with large, close-up figures (e.g. *Conversation outside the House*, 1649, Madrid, Mus. Thyssen-Bornemisza, HdG 107; *Peasants outside a Tavern*, Paris, Petit Pal., HdG 242). The handling in these works is broader, the contours softer. Bright local colours and white highlights join with a warm brown tone, and the composition is articulated by large-scale patterns of light and shade. The landscape element in Isack's paintings (e.g. *Halt outside a Tavern*, 1649, London, Earl of Crawford and Balcarres priv. col., HdG 24, Schnackenburg, 1981, i, fig. 61) has a monumental and atmospheric quality that recalls the work of Jacob van Ruisdael. A quiet corner of a courtyard, with a well and a stable, is treated like a still-life (London, N.G., HdG 306). Another work that probably belongs to the late period is the unusual *Cattle with a Milkmaid in a Meadow* (ex-Gal. Hoogsteder, The Hague, 1985), with its echoes of Paulus Potter and Philips Wouwerman. A new theme appears in the *Market in a Town* (London, Wallace Col., HdG 128), which incorporates some architectural motifs from the German city of Münster, possibly taken from Gerard ter Borch the younger.

Isack van Ostade also worked as a staffage painter, providing the figures, for example, in the *Landscape with Tall Trees* (St Gilgen, Butôt priv. col.) by Jacob van Mosscher (c. 1615–after 1655). A number of paintings left unfinished at Isack van Ostade's early death were completed by his brother Adriaen (e.g. *Peasants outside an Inn*, The Hague, Rijksdienst Beeld. Kst, NK 2496). Isack's influence as a painter was considerable; among its

recipients were Claes Molenaer (c. 1630–76), Cornelis Decker (before 1623–78), Roelof van Vries (c.1631–after 1681), Jan Wijnants and Johannes Oudenrogge (1622–53). Gerrit van Hees (fl 1640) closely imitated Isack's landscape and figure style, and three paintings hitherto attributed to Isack were probably painted by van Hees: *Outside the Tavern at the Edge of the Dunes* (Vienna, Ksthist. Mus., HdG 77; see fig. 42), the *Inn in the Dunes* (Rotterdam, Mus. Boymans–van Beuningen, HdG 38) and *Musicians and Peasants outside an Inn* (sold Berlin, H. W. Lange, 18 Oct 1940, lot 44, repr.).

2. Drawings

Isack's output of drawings is remarkable, both for its extent and for its variety. More than a third of all known Ostade drawings (226 out of the 500 catalogued by Schnackenburg, 1981) are by him, including many that were long ascribed to Adriaen. The matter of their correct attribution, however, is complicated by the fact that after Isack's death his drawings passed to Adriaen and after his death to CORNELIS DUSART, who reworked, cut up, copied and made commercial use of many of them, including a large number of sketches made in graphite. Few of the drawings can be directly linked to Isack's paintings; and, in contrast to the subjects of his paintings, interiors remained common among the drawings even after 1642. Like Adriaen, Isack used mostly pen and ink, with or without wash, over a preliminary sketch in graphite or black chalk; watercolour also occurs as a medium, particularly in the later work. Very few chalk studies or sketches by him are known.

In the 1640s Isack produced many individual figure sketches in the manner of Adriaen Brouwer (e.g. *Man Feeding a Child on his Knee*, c. 1643, Oxford, Ashmolean). The most important category of late drawings consists of studies of utensils (e.g. *Wheelbarrow with a Whetstone*, c. 1646–9, Paris, Fond. Custodia, Inst. Néer.) and of houses, some of them topographical. Alongside the sketches and

42. Isack Ostade or Gerrit van Hees: *Outside the Tavern at the Edge of the Dunes* (Vienna, Kunsthistorisches Museum)

studies, there are isolated examples of finished, pictorial presentation drawings from all periods of Isack's career. From the outset—and alongside the free, fluent, spirited shorthand line that was at its most characteristic *c.* 1640–43—Isack employed a delicate, precise style of penmanship with marked calligraphic features, loops, dots and hatchings, and the use of pressure for emphasis. Towards the end of his career, this manner increasingly came to predominate. Often, like Rembrandt, he used two different pens and inks in one drawing. There are also traces of the influence of Roelandt Savery and of Bartholomeus Breenbergh.

Bibliography

Wurzbach

A. van der Willigen: *Les Artistes de Haarlem* (Haarlem and The Hague, 1870), pp. 233–40

W. Stechow: *Dutch Landscape Painting of the Seventeenth Century* (London and New York, 1966, rev. London 1968), p. 493

K. Vermeeren: 'Isaac van Ostade tekende de Middeleeuwse St Catharinakerk van Eindhoven van twee Kanten', *Brabants Heem*, xxxviii (1986), pp. 228–36

B. SCHNACKENBURG

Ovens, Jürgen [Juriaen]

(*b* Tönning, Schleswig-Holstein, 1623; *d* Friedrichstadt, 9 Dec 1678). Danish painter and draughtsman, active in the Netherlands. According to Houbraken, he was a pupil of Rembrandt's, and to this (mistaken) report he owes a great deal of his renown. It is possible that Ovens was trained in Holland, but he must also have been in Flanders, possibly as a pupil of Jan Lievens, who had been residing in Antwerp since 1635. Ovens's earliest dated work is a *Portrait of a Man* (1642; Chicago, W. F. Petersen priv. col.; see Sumowski, 1983, p. 2275), which was inspired by van Dyck rather than Rembrandt. Flemish influences are unmistakably present throughout Ovens's entire oeuvre, from his official state portraits to his representations of the Virgin and his large altarpieces. Relatively few works are known from his first 'Dutch' period, but these confirm the fact that he must rapidly have made a name for himself in Holland as a portrait painter. In the *Portrait of a Woman in Blue* (1649; Schleswig, Schleswig-Holstein. Landesmus.) the wife of an Amsterdam merchant is portrayed with her child as a Flemish-style Virgin and Child. On 21 September 1652 the painter married Maria Martens in Tönning and shortly afterwards moved to Friedrichstadt, also in Schleswig-Holstein, as court painter to Duke Frederick III of Holstein-Gottorp (*reg* 1616–59), for whom he had painted family portraits (untraced) in 1651 while still in Amsterdam. In 1652 Ovens painted a group portrait measuring nearly 5 m in width, *Princess Hedwig Eleonore von Gottorp Taking Leave of her Family* (Mariefred, Gripsholm Slott). Ovens was present in Sweden at the wedding of the Princess to Karl X Gustav of Sweden on 24 October 1654, an occasion that he also recorded in three paintings (Stockholm, Nmus., and Drottningholm, Slott). In the *Self-portrait of the Artist Painting his Wife* (St Petersburg, Hermitage), which also dates from this period, the painter regards the viewer with a self-assured expression. Maria Ovens was also the model for the *Portrait of a Woman in Fancy Costume* (1655; Schleswig, Schleswig-Holstein. Landesmus.), after which Ovens made an etching in 1675.

In 1656 Ovens was temporarily in Amsterdam, where he executed the group portrait of *Six Regents and the Master of the Oudezijds Huiszittenhuis* (Amsterdam, Hist. Mus.). In 1657 he moved with his family to Amsterdam and became a citizen. Such works as the large *Portrait of an Unidentified Family* (1658; Haarlem, Frans Halsmus.) testify to his success as a society painter. In subsequent years he painted portraits of Amsterdam regents and wealthy merchants, such as *Cornelis Nuyts* (Amsterdam, Rijksmus.), *Dr Nicolaes Tulp* (1658; Amsterdam, Col. Six) and *Johan Bernard Schaep* (*c.* 1660; Amsterdam, Hist. Mus.). In 1661, two years after Christian Albert succeeded Frederick III as Duke of Schleswig-Holstein (*reg* 1659–95), Ovens painted a large allegorical scene representing him as protector of the Arts and Sciences (1661; Erholm Slot, nr Årup). In 1662 Ovens completed Govaert Flinck's *Conspiracy of the Batavians under Claudius Civilis* for the

then Amsterdam Stadhuis (*in situ*; Amsterdam, Sticht. Kon. Pal.), which served as a substitute for Rembrandt's rejected painting of the same subject (Stockholm, Nmus.). During the early 1660s Ovens visited England and also Antwerp, where he made a drawn copy (Hamburg, Ksthalle) of a painting by van Dyck that he admired.

Ovens returned to Friedrichstadt in 1663 and worked primarily at Gottorp Castle as court painter to Duke Christian Albert. During the 1660s Ovens painted a number of scenes from the history of the House of Gottorp and of Schleswig-Holstein (Hillerød, Frederiksborg Slot). He also executed altarpieces, for example that for Johann Adolf von Kielmannseck, the *Victory of Christianity over Sin* for Schleswig Cathedral (1664; *in situ*) and the *Resurrection* (1667; Eutin, Kreisheimatmus.), commissioned for St Michael's, Eutin. He also made drawings, often related to his official commissions. These were studies for biblical scenes and portraits in a more elaborate style (e.g. the *Presentation in the Temple*, c. 1651; Hamburg, Ksthalle).

Bibliography

A. Houbraken: *De groote schouburgh* (1718–21)

H. Schmidt: *Jürgen Ovens: Sein Leben und seine Werke* (Kiel, 1922)

G. Schlüter-Göttsche: *Jürgen Ovens: Ein Schleswig-Holsteiner Barockmaler* (Heide-in-Holstein, 1978)

W. Sumowski: *Gemälde der Rembrandt-Schüler* (Landau-Pfalz, 1983), iii, pp. 2218–2306; v, p. 3113

——: *Drawings of the Rembrandt School*, ix (New York, 1990), pp. 2028–126a

B. P. J. BROOS

Palamedesz., Anthonie [Stevers]

(*b* Delft, 1601; *d* Amsterdam, 27 Nov 1673). Dutch painter. He was the son of a gemcutter. Shortly after his birth, his father was recorded in the service of James I of England, and his brother, the battle painter Palamedes Palamedesz. I (1607–38), may have been born in London. Anthonie's teacher is unknown, but it has been speculated that he may have studied in Delft with the court painter Michiel van Mierevelt and/or Hendrik Pot, who was

in the city in 1620. Palamedesz. joined the Delft Guild of St Luke in 1621 and was head man in 1653 and 1673. He had three children by his first marriage in 1630 to Anna Joosten van Hoorendijk (*d* 1651) and a son by his second marriage in 1660 to Aagje Woedewart. In 1673 Anthonie was residing in Amsterdam, probably with his eldest son, the painter Palamedes Palamedesz. II (1633–1705). An inventory of Anthonie's estate is preserved.

Palamedesz. was a genre, portrait and still-life painter. He is best known for his paintings depicting musical or merry companies and soldiers on bivouac. He did not date paintings until 1632, the year he executed the *Merry Company* (The Hague, Mauritshuis), for example. These works attest to his acquaintance with the recent genre paintings by Haarlem and Amsterdam artists, such as Dirck Hals, Pieter Codde, Willem Duyster and Hendrik Pot. Since Palamedesz.'s earliest dated works are the accomplished efforts of a mature master, it may be assumed that he had begun his activity as a genre painter considerably earlier; indeed the painter's most successful paintings all date from 1632–4. Palamedesz.'s outdoor merry company scenes are rarer than his interiors and also acknowledge the precedents of genre painters such as Willem Buytewech, Esaias van de Velde and Dirck Hals. In the 1640s and 1650s Palamedesz. often painted guardroom scenes and soldiers with their camp followers in stables, adopting compositions recalling designs by Duyster and Jacob Duck but executed in a looser, less refined technique. A relatively long-lived painter, Palamedesz. produced elegant high-life genre scenes until his death (e.g. *Elegant Company in Interior with Gilt Leather* ('*A Wedding Party*'), 1673; Norfolk, VA, Chrysler Mus.). Palamedesz.'s oeuvre also includes at least one large-scale *Kitchen Still-life* (Philadelphia, PA, Mus. A.) in the tradition of 16th- and 17th-century Flemish artists and more recent Delft painters, such as Pieter Cornelisz. van Rijck (1568–?1628) and Cornelis Jacobsz. Delff (1571–1643). Palamedesz. also painted staffage in architectural paintings by Anthonie de Lorme (c. 1610–73) and Dirck van Delen.

In addition to his brother and son, Anthonie trained the Rotterdam portrait and genre painter

Ludolf de Jongh. The Delft genre painter Jacob van Velsen (d 1656) was his closest follower.

Bibliography

Thieme–Becker; Wurzbach

D. van Bleyswijck: *Beschryvinge der stadt Delft* (Delft, 1667), p. 847

A. Houbraken: *De groote schouburgh* (1718–21), i, p. 304; ii, p. 33

A. Bredius: 'Iets over de Palamedessen (Stevensz. of Stevaerts)', *Ned. Kstbode*, ii (1880), pp. 310–11

W. Bode: *Studien zur Geschichte der holländischen Malerei* (Brunswick, 1883), pp. 126–33

Masters of Seventeenth-century Dutch Genre Painting (exh. cat. by P. C. Sutton, Philadelphia, PA, Mus. A.; Berlin, Gemäldegal.; London, RA; 1984), pp. 292–3

PETER C. SUTTON

Pickenoy, Nicolaes Eliasz.

(*b* Amsterdam, *bapt* 10 Jan 1588; *d* Amsterdam, 1650–56). Dutch painter. He is frequently incorrectly referred to in the literature without his family name. He was a son of the monumental mason Elias Claesz. Pickenoy who had come to Amsterdam from Antwerp. Nicolaes may have studied painting with Cornelis van der Voort, one of the most important portrait painters in Amsterdam, who also originally came from Antwerp. The earliest work attributed to Pickenoy (see 1993–4 exh. cat.) is *Anatomy Lesson of Sebastiaen Egbertsz. de Vrij* (1619; Amsterdam, Hist. Mus.). Although Pickenoy's paintings included other subjects, he apparently earned his living primarily as a portrait painter. Soon after 1624 he succeeded to van der Voort's place as a portrait painter whose work was greatly in demand from the upper-class citizens of Amsterdam.

Pickenoy's painting style changed little if at all during the 25-year period in which almost all of his surviving works can be placed; it is characterized by fairly sharp contours and softer shadows, combined to give the impression of a somewhat flattering realism. The painter was particularly adroit in the depiction of textiles. No fewer than eight official portraits, three portraits of regents and five group portraits of civic guard companies, survive from the period 1625–45. Although he cannot be considered an innovating influence in group portraiture, he made exceptionally effective compositions, distributing the figures in a way that displays each one to best advantage. Among the finest examples are the civic guard paintings from 1632 and 1639 (Amsterdam, Hist. Mus.), where some of the figures are seated around a table, a composition reflecting the influence of Frans Hals. In 1642 Pickenoy painted a large militia company (Amsterdam, Rijksmus.) for the series of civic guard portraits in the Kloveniersdoelen (Arquebusiers' or Musketeers' Hall). Rembrandt's *'Night Watch'* was part of the same series. At the time that he painted these portraits Pickenoy was living in Amsterdam in a house in the Anthonisbreestraat, literally next door to Rembrandt.

Pickenoy was also a prolific painter of individual portraits, particularly pendant portraits of prominent Amsterdammers: those of *Maerten Rey* and *Maria Swartenhont* (1627; Amsterdam, Rijksmus.) are well known and fairly early examples of this type. Some years later, in the early 1630s, when the painter's abilities were at their peak, he produced such handsome works as the *Portrait of a 27-year-old Man* (England, priv. col.) and its pendant, the *Portrait of a 21-year-old Woman* (Malibu, CA, Getty Mus.), both from 1632. The life-size, full-length portraits of *Cornelis de Graeff* and *Catharina Hooft* (c. 1635; Berlin, Bodemus.) are among the most successful examples of this ambitious portrait type, which is not often found in Dutch painting. After 1640 Pickenoy's popularity apparently began to fade; the only surviving works from this period are two civic guard groups.

In addition to portraits Pickenoy also painted biblical scenes, only a few of which have survived, including the *Last Judgement* (Cádiz, Mus. Pint.) and the *Christ and the Woman Taken in Adultery* (ex-Suermondt-Ludwig-Mus., Aachen, destr. in World War II; a smaller variant is in Utrecht, Catharijneconvent). In these scenes, the painter followed the tradition of history painting in Antwerp in the latter part of the 16th century, himself showing no particular qualities of

imagination in the genre. No information survives regarding pupils of Pickenoy but it is probable, on stylistic grounds, that Bartholomeus van der Helst studied with him.

Bibliography

J. Six: 'Nicolaes Eliasz. Pickcnoy', *Oud-Holland*, iv (1886), pp. 81–108

P. Dirkse: 'Een Luthers bijbelstuk door Eliasz. Pickenoy' [A Lutheran biblical piece by Eliasz. Pickenoy], *Antiek*, xviii (1983/4), pp. 233–9

S. A. C. Dudok van Heel: 'De schilder Nicolaes Eliasz. Pickenoy (1588–1650/6) en zijn familie', *Liber amicorum Jhr. Mr. C. C. van Valkenburg* (The Hague, 1985), pp. 152–60

Dawn of the Golden Age: Northern Netherlandish Art, 1580–1620 (exh. cat., ed. G. Luijten and others; Amsterdam, Rijksmus., 1993–4), pp. 313, 595–6

RUDOLF E. O. EKKART

Poelenburch [Poelenburg; Poelenburgh], Cornelis van

(*b* ?Utrecht, between 21 Jan 1594 and 21 Jan 1595; *d* Utrecht, 12 Aug 1667). Dutch painter and draughtsman. He was the most important representative of the first generation of Dutch Italianates. His early work is so similar in style to that of BARTHOLOMEUS BREENBERGH that their paintings are sometimes difficult to tell apart. He was most famous for his small, charming paintings, on copper or panel, of Italianate landscapes with small figures, sometimes set in biblical or mythological scenes, sometimes in contemporary attire. Throughout his career he enjoyed the support of such noble and royal patrons as Cosimo II de' Medici, Grand Duke of Tuscany, Frederick V, Elector Palatine ('the Winter King' of Bohemia), Prince Frederick Henry of Orange Nassau, King Charles I of England and the Utrecht collector Willem Vincent, Baron van Wittenhorst (*d* 1674), who was his most important patron.

1. Life and work

(i) Training and early influences, before 1617. He was the son of Simon van Poelenburch (*d* 1596), Roman Catholic Canon of Utrecht Cathedral. According to early sources, he studied with Abraham Bloemaert

in Utrecht; he probably also had contacts with painters in Amsterdam, which was then dominated by the Pre-Rembrandtists, of whom Jan and Jacob Pynas had the greatest influence on him. The predominantly Mannerist style of the Utrecht and Amsterdam artists, inspired by the paintings of Adam Elsheimer and by contemporary Italian art, was a permanent influence on Poelenburch's work.

(ii) Early works: Italy, 1617–26. In 1617 Poelenburch was in Rome, where he contributed to the *album amicorum* of the Frisian painter Wybrandt de Geest (Leeuwarden, Prov. Bib. Friesland). Several signed and dated paintings or drawings inscribed *buijten roomen* (Dut.: 'around Rome') document Poelenburch's stay there until 1623; he probably remained until about 1625. In 1623 he was a founder-member of the Schildersbent, the fellowship of Dutch and Flemish artists in Rome whose members were known as *Bentvueghels* ('birds of a feather'). He was given the Bent-name 'Satiro' ('Satyr'). During the years 1620–21 he worked for a time in Florence at the court of Cosimo II, and many of his paintings are still in Florentine collections. In Rome Poelenburch became familiar with the work of the Flemish painter Paul Bril, whose later compositions, featuring gently sloping hills and Roman ruins, exerted an obvious influence on his early work.

The chronology of Poelenburch's early paintings has had to be established through stylistic analysis and by comparison with the few dated paintings. (Of the more than 60 paintings from 1625 or before, only 11 bear the artist's monogram and only 8 are dated.) The lack of signed and dated examples has long caused confusion between the early work of Poelenburch and that of Bartholomeus Breenbergh, although many of the difficulties have been resolved since the publication of monographs on both artists (Roethlisberger, 1981; Sluijter-Seijffert).

Only a few of Poelenburch's works can be dated before 1620, the year of his earliest dated piece, the *View of the Campo Vaccino at Rome* (Paris, Louvre). A fine example of his early style, it is painted on copper. The flat, open space with a

fountain at the centre flanked by ancient Roman ruins and populated by shepherds and cattle merchants indicates that, despite a few topographical inaccuracies, the scene is set in the Campo Vaccino (as the Roman forum has been called since the 15th century). Poelenburch seems to have specialized in views of Roman fora, a genre for which a large market apparently existed in Italy. Another example of his early style, with a similar subject, is *Roman Landscape* (*c*. 1620; Toledo, OH, Mus. A.). The relatively simple composition of this painting, with its slightly raised foreground and coulisses closing off both sides, has an impressive illusion of depth, achieved partly through subtle transitions between light and dark and between various grounds. Such adroit application of atmospheric perspective was to remain typical of Poelenburch's work, as was the hard and glossy paint surface. The painting's cool grey tones, which dominate the landscape and contrast with the brighter colours of the figures, are characteristic of his early style. The figures—lively, rather attenuated but anatomically correct—are depicted in restful, poised attitudes, in contrast to those in some other works, for example *Clorinda Saving Olindo and Sophronia from the Pyre* (Ottawa, N.G.), whose twisted and agitated poses suggest the Mannerist influence of Bloemaert. Several of the figures recall the style of Adam Elsheimer, who—according to early sources (e.g. Sandrart)—greatly influenced Poelenburch. While no direct influence can be proven, Elsheimer's small, detailed landscapes, so popular in Rome at that time, were certainly an indirect source of inspiration, most likely through the Pynas brothers or Bril. The Italian painter Filippo Napoletano also inspired Poelenburch, as can be seen most clearly in *Landscape with Ruins and Figures* (*c*. 1620; Florence, Pitti). The composition recedes diagonally from the picture plane, forming a sort of wide road that curves on one side and leads the viewer's eye into the distance. In the middle ground a range of hills covered with vegetation largely obscures the view to the hills on the horizon. The composition is animated by figures going about their daily activities and by animals. The lighting simultaneously highlights and

unifies the various elements of the composition; there are a few bright areas of local colour, but the entire work is permeated by a subtle shade of light grey. The figures are more solid and less exaggerated than those in *Clorinda Saving Olindo and Sophronia*. Both figural types, the more classical and the more Mannerist, are encountered in Poelenburch's paintings of the same period and even together within the same painting.

Among Poelenburch's early works are several history pieces of modest size, including religious representations, for example the *Stoning of St Stephen* (Paris, Louvre) and the *Martyrdom of St Lawrence* (Kassel, Schloss Wilhelmshöhe), subjects from Classical and contemporary literature, and from Classical mythology (e.g. *Mercury and Battus*, Florence, Uffizi (see col. pl. XXVIII); *Mercury and Herse*, The Hague, Mauritshuis; *Diana and Actaeon*, Nancy, Mus. B.-A.). These subjects were all popular with contemporary artists.

Poelenburch also produced some signed drawings during his stay in Italy. Two drawings of Tivoli (both priv. col., see Chong, pls 1–2) are inscribed and dated 1619; like his early paintings, these show the influence of Bril. Other early drawings, especially those with heavy washes and strong lighting effects (e.g. *Rocks and Foliage*; Paris, Louvre), have been attributed to Breenbergh in the past. Several sheets from *c*. 1622–4, such as the *Grotto* (Weimar, Goethe-Nmus. Frauenplan), were used for paintings of the same period.

(iii) Later works: Utrecht, 1627–67. In April 1627 Poelenburch was back in Utrecht, where he remained until his death, except for the years 1637 to 1641, when he worked at the English court of Charles I. In 1629 he married Jacomina van Steenre, who was the daughter of a notary and clerk of the Court of Utrecht and who, like himself, was a Roman Catholic. Notarized documents record the names of four children born to the couple. Once back in Utrecht, he also became a member of the Guild of St Luke and served several times as an officer of the guild.

There are only three dated paintings from the period after Poelenburch's return from Italy (1628, 1648 and 1659), and they exhibit so little affinity

with the rest of his oeuvre that they provide no clues as to the dating of any other of the paintings. Moreover, his style underwent few changes after c. 1625, making it impossible to establish a chronology of the later work. By this date Poelenburch had developed several landscape compositions and figural types, which he then continuously repeated in various combinations. In the course of time the figures became somewhat rounder with more stereotypical faces and rather heavy wrists and ankles. Their poses, however, still display great variety.

Poelenburch's subject-matter remained the same to a large extent: landscapes with biblical and mythological figures. Increasingly he represented fewer specific stories; instead of Diana and the Nymphs or Diana and Callisto he depicted more generalized scenes such as *Nymphs Bathing* (e.g. Amsterdam, Rijksmus.). The theme of the *Banquet of the Gods* is frequently portrayed (e.g. The Hague, Mauritshuis), and among religious subjects his favourite scene was the *Rest on the Flight into Egypt* (e.g. earlier version, Cambridge, MA, Fogg).

Poelenburch's later landscapes contain the same elements that characterize his early work: gently sloping hills, oddly shaped rock formations and detailed plant life in the foreground. Ruins of non-Classical buildings, higher and steeper hills, compositions that end in the middle ground and less sharp, somewhat 'woolly' contours are to be seen principally in the latest work, although not to such an extent or so pervasively that they form the basis for a more accurate chronology. The paint in which the landscapes are executed is often transparent, with the figures depicted in thicker, opaque paint, without any visible brushstrokes.

The measurements of Poelenburch's paintings remained small, and he continued to paint on panel or copper. He made only two paintings of larger format on canvas. One was *Mirtillo Crowned with a Wreath* (1635; Berlin, Bodemus.), which was part of a commission to four artists, including his teacher Bloemaert, to paint in the new royal palace at Honselaarsdijk a cycle based on Giovanni Battista Guarini's *Il pastor fido*. The other large-format painting (1.55×1.33 m) represents *Mercury and Herse* (New York, Colnaghi's) and also dates from the 1630s.

Among the drawings probably made after Poelenburch's return from Italy are several preparatory studies (e.g. Amsterdam, Rijksmus.; Hamburg, Ksthalle; Vienna, Albertina) for a series of nine landscape etchings by Jan Gerritsz. van Bronchorst (one dated 1636; Hollstein, nos 22–30). Another important group of drawings no doubt executed in Utrecht consists of landscapes, drawn with the brush and layers of silver-grey wash, more delicately applied than in the Italian-period drawings. Many of these wash landscapes can be connected with paintings: for example, the *Landscape with a House on a Hill* (Berlin, Kupferstichkab.) was used for the background of the painting *Landscape with Figures* (Mertoun, Borders). Another, more controversial, group of drawings, consisting of red-chalk studies of figures, has been assigned by Chong to Poelenburch's Utrecht period. It is more likely, however, that these drawings, which repeat the figural compositions of later paintings with only summary indications of background, are copies after paintings, perhaps intended for use in the artist's studio.

2. Studio and collaboration

Throughout his life Poelenburch occasionally collaborated with colleagues; he added figures to landscapes by Jan Both and Alexander Keirinckx and to church interiors by Bartholomeus van Bassen and Dirk van Delen. He also had a studio with numerous pupils, including Dirck van der Lisse (1607–69), Daniel Vertangen (c. 1598–1681/4) and Johan van Haensbergen (1642–1705). His pupils emulated his style and choice of subject-matter so closely that one can justifiably speak of a Poelenburch school. Although Poelenburch monogrammed his work more frequently after his return to the Netherlands, it remains difficult to distinguish his hand from those of his pupils. Some of their work is easily mistaken for that of their teacher, particularly when it includes the monogram *C.P.*, as is often the case. Correct attribution has been made harder because those paintings attributable to Poelenburch himself manifest

considerable variations in quality. The prices fetched by his paintings also fluctuate widely, a phenomenon that might be explained by the fact that he left the execution of less important pictures to his studio assistants. The quality of his work did not obviously diminish with age, as is evident from his last dated painting, *Diana and Actaeon* (1659; Copenhagen, Stat. Mus. Kst.).

3. Critical reception and posthumous reputation

Cornelis van Poelenburch was one of the most popular artists of his day, and, judging by his inclusion in the most important Dutch and French artists' biographies of the 17th and 18th centuries, his high standing continued throughout the century after his death. The biographers tended to praise his small, enchanting paintings more for his rendering of human figures, many of them nudes, than for the landscapes in which the figures were situated. During the 18th century and the early 19th many of his paintings were ascribed to Bartholomeus Breenbergh. From *c.* 1850 to 1950 the work of Poelenburch and the other Dutch Italianate painters was dismissed as being 'un-Dutch' and therefore unworthy of notice. Since the 1950s, however, there has been renewed appreciation of the quality of Poelenburch's work and of his importance as the leading light of the first generation of Dutch Italianate painters. His refined, highly polished style and the bright or silvery colour harmonies of his Italian landscapes are among the features most prized.

Bibliography

Hollstein: *Dut. & Flem.*

C. de Bie: *Het gulden cabinet* (1661), pp. 256–7

J. von Sandrart: *Teutsche Academie* (1675–9); ed. A. R. Peltzer (1925), ii, p. 305

A. Houbraken: *De groote schouburgh* (1718–21), i, pp. 128–30

E. Schaar: 'Poelenburgh und Breenbergh in Italien und ein Bild Elsheimers', *Mitt. Ksthist. Inst. Florenz*, ix (1959–60), pp. 25–54

Nederlandse 17e eeuwse Italianiserende landschap-schilders (exh. cat. by A. Blankert, Utrecht, Cent. Mus., 1965); rev. and trans. as *Dutch 17th-century Italianate Landscape Painters* (Soest, 1978)

W. Stechow: *Dutch Landscape Painting of the Seventeenth Century* (London, 1966)

M. Roethlisberger: *Bartholomeus Breenbergh: Handzeichnungen* (Berlin, 1969)

—: *Bartholomeus Breenbergh: The Paintings* (Berlin and New York, 1981)

N. C. Sluijter-Seijffert: *Cornelis van Poelenburch, c. 1593–1667* (Leiden, 1984) [with extensive bibliog.]

M. J. Bok: 'The Date of Cornelis van Poelenburch's Birth', *Hoogsteder-Naumann Mercury*, ii (1985), pp. 9–11

A. Chong: 'The Drawings of Cornelis van Poelenburch', *Master Drgs*, xxv/1 (1987), pp. 3–62

Masters of 17th-century Dutch Landscape Painting (exh. cat. by P. C. Sutton and others, Amsterdam, Rijksmus.; Boston, MA, Mus. F. A.; Philadelphia, PA, Mus. A.; 1987–8), pp. 402–10

Het gedroomde land: Pastorale schilderkunst in de Gouden Eeuw (exh. cat. by P. van den Brink and others; Utrecht, Cent. Mus., 1993), pp. 242–51

<div style="text-align: right">NICOLETTE C. SLUIJTER-SEIJFFERT</div>

Poorter, Willem de

(*b* Haarlem, 1608; *d* after 1648). Dutch painter. His father, Pieter, came from Flanders to Haarlem, where in 1631 works by Willem were recorded for the first time. In 1634 Willem was registered in Haarlem as a master painter, and in 1635 Pieter Casteleijn was named as his pupil. As late as 1643 Pieter Abrams Poorter and Claes Coenraets began their studies with him in Haarlem. Willem is mentioned for the last time in the archives of the Haarlem Guild of St Luke in 1645, the year he left for Wijk bij Heusden. He supposedly studied under Rembrandt, together with his fellow townsman Jacob de Wet. There is no documentation to support this assumption, but a number of de Poorter's small-scale biblical and history paintings bear such a striking likeness to Rembrandt's biblical compositions of *c.* 1630 that the two hands are often confused. Rembrandt's *Presentation in the Temple* (1631; The Hague, Mauritshuis) was copied (Dresden, Gemäldegal. Alte Meister) by de Poorter, who also painted his own version (Kassel, Schloss Wilhelmshöhe). The lighting in de Poorter's *Entombment* (Guernsey, D. Cevat priv. col.) was also apparently inspired by Rembrandt's example. Since de Poorter's paintings were first

reported in Haarlem in 1631, the year that Rembrandt moved from Leiden to Amsterdam, it seems likely that de Poorter received his training in the Leiden workshop, where Gerrit Dou had also been working since 1628. Dramatic Rembrandtesque lighting, 'Fine' painting in the manner of Dou and a preference for still-lifes (a Leiden specialism) remained characteristic of de Poorter's oeuvre.

A strong contrast of light and dark is evident in de Poorter's earliest dated work, *Penelope and her Servants* (1633; Toulouse, Mus. Augustins). Rembrandt, Dou and the Leiden environment also determined the conception of a *Vanitas Still-life* (1636; Rotterdam, Mus. Boymans–van Beuningen), in which the orange, white and blue royal flag in the display of armour may allude to current political affairs, namely the Eighty Years War, then at its height. De Poorter obviously enjoyed depicting shining armour and military implements, as is clear from another, similar *Vanitas Still-life* (Brunswick, Herzog Anton Ulrich-Mus.). An armour-clad figure features in an *Allegorical Subject (?The Just Ruler)* (London, N.G.), and there are representations of soldiers wearing armour with *vanitas* still-lifes in the foreground that were apparently also intended as portraits (e.g. *c.* 1645; Guernsey, D. Cevat priv. col., see Haak, fig. 542). A still-life with armour also fills the foreground of a history piece painted in horizontal format, the *Continence of Scipio* (Aachen, Suermondt-Ludwig Mus.), in which the strong lighting resembles that in the *Blessings of Peace* (1643) and in *Mercury and Proserpina* (both Copenhagen, Stat. Mus. Kst). The biblical scenes painted in Haarlem after 1631, such as *Paul and Barnabas at Lystra* (1635; The Hague, Schilderijenzaal Prins Willem V) and *Esther Appearing before Ahasuerus* (1645; Dresden, Gemäldegal. Alte Meister), show a rather more personal approach less dependent on Rembrandt than the work of his fellow student de Wet. History paintings of this period, undated but signed with the initials W. D. P., include the *Idolatry of Solomon* (Amsterdam, Rijksmus.), the *Imprisonment of Samson* (Berlin, Bodemus.), *Christ and the Woman Taken in Adultery* (Dresden, Gemäldegal. Alte Meister) and

Sophonisba Receiving the Cup of Poison (Providence, RI Sch. Des., Mus. A.). The spotlit illumination of these works was borrowed from Rembrandt, but its dramatic impact also suggests the influence of Leonard Bramer.

Bibliography

Thieme–Becker; Wurzbach

B. P. J. Broos: 'Vanitas-stilleven: Willem de Poorter (1608–na 1648)', *Openb. Kstbez.*, xv (1971), pp. 36a–b

W. Sumowski: *Gemälde der Rembrandt-Schüler* (London and Pfalz, 1983)

B. Haak: *The Golden Age: Dutch Painters of the Seventeenth Century* (New York, 1984), pp. 256–7

W. Sumowski: *Drawings of the Rembrandt School*, ix (New York, 1985)

B. P. J. BROOS

Porcellis, Jan

(*b* Ghent, before 1584; *d* Zouterwoude, 1632). Dutch painter, draughtsman and etcher of Flemish origin. His father, Captain Jan Pourchelles or Porcellis, was one of the many Flemish refugees from the renewed Spanish persecutions in 1585 who emigrated to the northern Netherlands. The family settled at Rotterdam, where Jan Porcellis is first recorded on the occasion of his marriage in 1605. He probably started his career as a graphic artist, not a painter, possibly working for the Rotterdam engraver and publisher Jan van Doetechum (*d* 1630), who published maps, book illustrations and engravings of ship portraits. Through his wife, van Doetechum was related to the English publisher of emblem books Geoffrey Whitney (1548–?1601), which may account for Porcellis's stay in London, where one of his daughters was born before 1615. Houbraken's suggestion that he was a pupil of Hendrick Vroom must be discounted. Research has established that two Vroom-like marine paintings (a battle scene and a *Storm at Night*), in the British Royal Collection since *c.* 1610 and formerly regarded as the earliest known paintings by Porcellis, are by Vroom. The earliest known secure paintings by Porcellis belong to the 1620s.

Porcellis is first mentioned as a painter in Antwerp, where he moved in 1615 following his bankruptcy in Rotterdam. He became a master of the Antwerp Guild of St Luke in 1617. Continued financial difficulties forced him to sign a contract for the delivery within 20 weeks of 40 marine paintings (untraced) to an Antwerp cooper. His fortunes changed after he settled in Haarlem in 1622. There he developed an original manner of Marine painting, pioneering the 'tonal' style that his contemporaries Pieter de Molijn, Salomon van Ruysdael and Jan van Goyen were exploring in landscape painting. The vivid local colours of Vroom and his followers gave way to a virtually monochrome palette of light grey and brown, enlivened with brilliant white highlights to mark the crests of the waves or to suggest sunlight filtering through hazy clouds. Porcellis moved the ships into the middle distance and veiled the scene in a translucent atmosphere, suggesting the moisture-laden skies of northern shores. Fleeting clouds over a very low horizon cast their shadows on the water, where they alternate with bright streaks of sunlight. This animated interplay of light and shade and the integration of the sky into the composition were innovations that changed the course of Dutch marine and landscape painting.

Early work as an illustrator, possibly of emblem books, may account for Porcellis's choice of subject-matter. Excepting an uncharacteristically large-scale *View of ?Santander Bay* (before 1622; Brit. Royal Col.), his paintings avoid any of the topographical references or detailed portraits of ships that had dominated the first phase of Dutch marine painting associated with Vroom. Although clouds, waves, wind and weather conditions are carefully observed from nature, the paintings offer a generalized vision of marine scenery and shipping, evocative of allegorical and emblematic interpretations, in which ships symbolize man's voyage through life. The tiny *Stormy Sea* (1629; Munich, Alte Pin.), with its *trompe l'oeil* frame and ambiguous space, clearly carries a symbolic, allegorical message. Porcellis also produced 15 drawings and a series of 20 etchings, featuring fishermen on the shore, published as *Verscheyden stranden en water gesichten* in Haarlem during the 1620s. The figures are derived from Hendrick Goltzius's drawings of Apostles, but some of the scenes are direct references to contemporary emblems based on fishermen's activities. However, a later series of 12 etchings after Porcellis's designs, published by Claes Jansz. Visscher I as *Icones variarum navium Hollandicarum* (Amsterdam, 1627), exceptionally illustrates various types of small Dutch working vessels, realistically observed in changing conditions of wind and weather.

Porcellis's continued commitment to graphic media may have influenced his choice of a monochrome palette for paintings. He was probably also familiar with the grisaille technique frequently used for the painting of emblems. The round format and small scale of a number of his paintings were popular with painters of allegorical and emblematic subjects, such as Adriaen van de Venne and Esaias van de Velde, and recall the example of Jan Breughel I, whose work Porcellis must have known in Flanders. The atmospheric treatment in his paintings points to Breughel's influence, while the dramatic rendering of storm-tossed waves under heavy clouds recalls the manner of Andries van Eertvelt, the leading Flemish marine painter of the early 17th century. Porcellis synthesized these impressions with the achievements of the Dutch marine painters in Haarlem. His stylistic innovations were hailed by contemporary Dutch connoisseurs as an achievement that, according to a remark in Constantijn Huygens's autobiography, left Vroom and other marine artists far behind. Samuel Ampzing, in his *Beschrijvinge ende lof der stad Haerlem . . .* (Haarlem, 1628, p. 372), hailed Porcellis as 'de grootste konstenaer in schepen' ('the greatest ship artist').

Porcellis's oeuvre is small: only c. 50 paintings have been identified, with varying degrees of certainty. Dated pictures, ranging from 1620 to 1631, are extremely rare. Porcellis left Haarlem for Amsterdam in 1624 and in 1626 lived in Voorburg near The Hague. His last few years, from c. 1628, were spent in Zouterwoude near Leiden, where he owned extensive properties.

Apart from pioneering 'tonal' painting in Haarlem in the 1630s, he inspired the leading Dutch marine painters of the mid-17th century, especially Simon de Vlieger, Jan van de Cappelle and their followers. Rembrandt as well as van de Cappelle collected paintings and drawings by Porcellis. A group of close followers continued to work in his manner, most notably his son Julius Porcellis (*b* Rotterdam, before 1610; *d* Leiden, 1645) and his pupil and brother-in-law, Hendrick van Anthonissen (*c.* 1606–between 1654 and 1660). Julius Porcellis's paintings, like many of his father's, are signed with the initials JP or IP, but none is dated—causing confusion regarding attributions, which have to be made on stylistic grounds. Though compositionally similar, Julius's paintings are weaker in execution; they lack the spatial depth and brilliant light effects of Jan's manner, and later works are painted in much brighter colours, as favoured by Dutch marine painters at the close of the 'tonal' phase, from *c.* 1640.

Prints

Verscheyden stranden en water gesichten [Various beaches and marine views] (Haarlem, 162[?])

Bibliography

A. Houbraken: *De groote schouburgh* (1718–21)

L. J. Bol: *Die holländische Marinemalerei des 17. Jahrhunderts* (Brunswick, 1973), pp. 91–104

J. Walsh: 'The Dutch Marine Painters Jan and Julius Porcellis', *Burl. Mag.*, cxvi (1974), pp. 653–62, 734–5

M. Russell: *Visions of the Sea: Hendrick C. Vroom and the Origins of Dutch Marine Painting* (Leiden, 1983), pp. 79–82, 163–92

MARGARITA RUSSELL

Post, Frans (Jansz.)

(*b* Haarlem *c.* 1612; *bur* Haarlem, 17 Feb 1680). Painter and draughtsman, brother of architect Pieter Post (1608–69). He was one of the first trained European landscape artists to paint in the New World. His paintings and drawings without exception depict Brazilian scenery with exotic buildings, plants, animals and natives. He probably received his early training from his father and was also influenced by his brother's early landscapes, although no works exist from this period. When Johan Maurits, Count of Nassau-Siegen went to Brazil as Governor General of the Dutch colony in the north-east in October 1636, Frans Post, together with ALBERT ECKHOUT, was among the artists and scientists on board to record various aspects of Brazilian life, landscape, fauna and flora. His earliest painting, of the *Island of Itamaracá* (Amsterdam, Rijksmus., on loan to The Hague, Mauritshuis), north-east of Recife in Brazil, bears the date '1637 1/3' and thus must have been executed shortly after his arrival in Brazil. It is one of a group of only six known paintings made in the New World by Post. All of them were painted between 1637 and 1640, and all are very closely related stylistically. They stand out by their directness and simplicity of vision. Though somewhat naive, they brilliantly capture the local atmosphere; moreover, they are of great topographical significance. Four other canvases of this group are in the Musée du Louvre, Paris, and probably formed part of a collection of more than 30 paintings by Post presented by Johan Maurits to Louis XIV of France in 1679. Remarkably, no paintings done during the last four years of his Brazilian sojourn seem to have been preserved. Post must also have made many drawings and sketches on the spot; however, surviving works on paper from his Brazilian period are even fewer in number than the paintings. They are characterized by the same originality and simplicity; a sketchbook containing 19 views made by Post on the voyage and during their arrival in Brazil in January 1637 is in the Nederlands Scheepvaartmuseum, Amsterdam.

Post returned to the Netherlands in 1644, probably shortly before the Count. He settled in Haarlem, where he is mentioned first in September 1644, and spent the rest of his career producing imaginary Brazilian landscapes. He entered the Guild of St Luke, Haarlem, in 1646, serving as an officer in 1656–7 and 1658. In 1650 he married the daughter of a schoolmaster, Jannetje Bogaert (*d* 1664) in Zandvoort. Using the drawings he had made in Brazil, Post produced a

large number of Brazilian landscape paintings. Those that date from the years immediately following his homecoming still exude some of the same originality and primitive atmosphere as the earlier works. His only known biblical scene, the *Sacrifice of Manoah* (1648; Rotterdam, Boymans–van Beuningen) also has a Brazilian setting (the figures are by another hand). One of his most successful compositions of that period is the *River Landscape* (1650; New York, Met.). Probably under the influence of the many Haarlem landscapists, Post's technique improved over the years; although the influence of his brother Pieter Post and of Cornelis Vroom can be detected in many of his paintings, Frans Post never abandoned his personal style.

Post's visual memory of the Brazilian countryside seems to have diminished towards the mid-1650s. In most of his paintings after that date an increasingly decorative tendency prevails. Often carefully rendered Brazilian plants and animals form part of a conspicuously heavy repoussoir. In addition, the subtle colours of his earlier work were gradually replaced by a more saturated and brighter palette, resulting in a less convincing rendering of the Brazilian scenery. Yet, in spite of being more conventional, several of his later landscapes are still admirable examples of his artistry. Particularly impressive is the *Ruins of Olinda Cathedral* (1662; Amsterdam, Rijksmus.). The impact of the large canvas is further enhanced by the 17th-century frame, richly carved with exotic plants and fruits, which may have been part of the original commission and was perhaps designed by Post himself.

Post produced few drawings after his return to the Netherlands, the majority being designs for C. Barlaeus's *Rerum per octennium in Brasília gestarum historia* (Amsterdam, 1647); this important book is an extremely informative document describing not only Johan Maurits's reign in Brazil but also the country and its inhabitants. Post apparently gave up painting and drawing after 1669 as no dated works of the 1670s are known. His portrait was painted by his fellow-artist Frans Hals (*see* HALS, (1)).

Bibliography

A. Bredius: *Künstler-Inventare*, 6 vols (The Hague, 1915–22) v, pp. 1691–1718

J. de Sousa-Leão: *Frans Post* (Rio de Janeiro, 1937)

R. Smith: 'The Brazilian Landscapes of Frans Post', *A. Q.* [Detroit], i (1938), pp. 238–67

J. G. van Gelder: 'Post en van den Eeckhout: Schilders in Brazilië', *Beeld. Kst*, xxvi (1940), pp. 65–72

Maurits de Braziliaan (exh. cat. by A. B. de Vries, J. de Sousa-Leão and W. Y. van Balen, The Hague, Mauritshuis, 1953), pp. 38–47, 58–9

A. Guimarães de Segadas Machado: 'Na Holanda, com Frans Post', *Rev. Inst. Hist. & Geog. Bras.*, ccxxxv (1957), pp. 85–295

E. Larsen: *Frans Post: Interprète du Brésil* (Amsterdam, 1962)

Os pintores de Mauricio de Nassau (exh. cat. by J. de Sousa-Leão, Rio de Janeiro, Mus. A. Mod., 1968), pp. 24–67

L. Reviglio: 'Frans Post, o primeiro paisagista do Brasil', *Rev. Inst. Estud. Bras.*, xiii (1972), pp. 7–33

J. de Sousa-Leão, *Frans Post, 1612–1680* (Amsterdam, 1973)

Zo wijd de wereld strekt (exh. cat., ed. E. van Boogaart and F. Y. Duparc; The Hague, Mauritshuis, 1979)

R. Joppien: 'The Dutch Vision of Brazil: Johan Maurits and his Artists', *Johan Maurits van Nassau-Siegen, 1604–1679: A Humanist Prince in Europe and Brazil: Essays on the Occasion of the Tercentenary of his Death*, ed. E. van den Boogaart (The Hague, 1979)

P. J. P. Whitehead and M. Boeseman: *A Portrait of Dutch 17th-century Brazil* (Amsterdam, Oxford and New York, 1989)

Frans Post, 1612–1680 (exh. cat. by T. Kellein and U.-B. Frei, Basle, Ksthalle; Tübingen, Ksthalle; 1990)

FREDERIK J. DUPARC

Pot, Hendrik (Gerritsz.)

(*b* ?Haarlem, *c.* 1585; *d* Amsterdam, shortly before 16 Oct 1657). Dutch painter. He has often been referred to, probably incorrectly, as a pupil of Karel van Mander I. In 1620 the city of Haarlem bought Pot's *Glorification of William I* (Haarlem, Frans Halsmus.), and his painting of the *Deathbed of William I* (1620; untraced) hung in the Delft Town Hall. In 1632 Pot was employed in England at the court of Charles I, whose portrait he painted (1632;

Paris, Louvre) and for whom he executed the group portrait *Charles I, Queen Henrietta Maria and Charles, Prince of Wales* (London, Buckingham Pal., Royal Col.). Pot was included by Frans Hals as a lieutenant in the *Officers and Sergeants of the St Hadrian Guard* (*c.* 1633) and the *Officers of the St George Civic Guard* (*c.* 1639; both Haarlem, Frans Halsmus.).

Pot's early small paintings of guardroom scenes and elegant companies recall the work of Willem Buytewech and Dirck Hals. They show figures in brightly coloured costumes, sitting around a table in a room that is otherwise somewhat empty, the whole rendered in muted, unobtrusive colours (e.g. *Merry Company at a Table*, 1630; London, N.G.). Pot's larger paintings, such as his masterpiece, the *Officers of the Militia of the Kloveniers of Haarlem* (*c.* 1630; Haarlem, Frans Halsmus.), his *Merry Company* (1633; Rotterdam, Boymans–van Beuningen) and his portrait of *Dirk Schatter* (1633; New York, Met.), recall the work of Frans Hals. Until the end of the 19th century portraits of *Emerentia van Beresteyn* (Waddesdon Manor, Bucks, NT) and *Paulus van Beresteyn and his Family* (Paris, Louvre) were attributed to Frans Hals, but it is now disputed whether they should be attributed to Pot or to PIETER CLAESZ. SOUTMAN. Other work now attributed to Pot was previously ascribed to Anthonie Palamedesz., Thomas de Keyser, Jacob Duck, Simon Kick (1603–52) and, owing to his identical monogram, to Horatius Paulyn (*c.* 1645–after 1674). Pot also produced a few history paintings and large-scale allegories, for example the *Coronation of Marie de' Medici* (The Hague, Rijksdienst Beeld. Kst, NK 2122), *Greed* (1622; Bonn, Rhein. Landesmus.), the *Quarrel over the Inheritance* (1625–30; Berlin, Gemäldegal.) and *Flora's Festival Chariot* (1637; Haarlem, Frans Halsmus.).

Pot's portraits, usually small-scale, vary in style and quality. His portrait of *Joost van den Vondel* (Amsterdam, Rijksmus.) is highly painterly, while other portraits are virtually miniatures (e.g. *Andries Hooftman*, Chantilly, Mus. Condé). In his later years Pot painted mostly small, sometimes formulaic portraits of single figures, either

seated at a table in an otherwise empty room or standing full length. Shortly after 1648 Pot moved to Amsterdam, where, according to Houbraken, Willem Kalf became his student. On 16 October 1657 an inventory was made of Pot's estate (see Bredius and Haverkorn van Rijsewijk).

Bibliography

Thieme–Becker

K. van Mander: *Het schilder-boeck* (Amsterdam, 1618) [incl. anon. biog. of van Mander]

T. Schreveli: *Harlemias: Ofte, om beter te seggen: De eerste stichtinghe der stadt Haerlem* [Harlemias: or, in other words: the foundation of the city of Haarlem] (Haarlem, 1648), p. 383

A. Houbraken: *De groote schouburgh* (1718–21), i, p. 252; ii, pp. 123, 218

A. Bredius and P. Haverkorn van Rijsewijk: 'Hendrick Gerritsz. Pot', *Oud-Holland*, v (1887), pp. 161–76

[A. Bredius and C. Hofstede de Groot]: *Catalogue raisonné des tableaux et des sculptures*, The Hague, Mauritshuis cat. (The Hague, 1895), p. 289

Catalogus der schilderijen en teekeningen in het Frans Halsmuseum der gemeente Haarlem, Haarlem, Frans Halsmus. cat. (Haarlem, 1929), pp. 98–9, inv. 238–42, 469

S. Slive: *Frans Hals*, 3 vols (London and New York, 1970–74), nos 79, 124, D70, D80

Frans Hals (exh. cat. by S. Slive, Washington, DC, N.G.A.; London, RA; Haarlem, Frans Halsmus.; 1989–90), pp. 22, 98–9, 151, 379, 397–8

J. E. P. LEISTRA

Potter

Dutch family of painters, draughtsmen and etchers. (1) Pieter Potter produced paintings in all the main genres; he was overshadowed by his son, (2) Paulus Potter, with whose works his have often been confused. Pieter signed his paintings *P. Potter*, whereas Paulus typically signed *Paulus Potter. F. 16* Paulus was one of the foremost 17th-century artists to depict animals. His detailed images of cattle, horses and other farm animals in landscape settings are presented in highly accomplished paintings, drawings and etchings and offer a striking, artfully naturalistic vision of the Dutch rural scene. His works were particularly

popular with French and British collectors in the late 18th century and the 19th.

(1) Pieter (Symonsz.) Potter

(*b* Enkhuizen, between 1597 and 1601; *d* Enkhuizen, 1653). He was the son of Dieuwe Simons and Simon Jacobsz., a glassmaker. He presumably trained with his father as a glass painter (*glasschrijver*) in Enkhuizen, where he worked until 1628, when he entered the Leiden glassmakers' guild as a master, becoming its headman in 1629. During the late 1620s, as his interests gradually shifted from glass painting to easel painting, his style became increasingly naturalistic. Whereas his first history scenes, such as *Joseph Accused by Potiphar's Wife* (1629; Rijswijk, Schulpen de Wit priv. col.), reflect the mannered style of elongated figures and tilted space found in the more conservative field of glass painting, the merry company and history scenes he produced after 1630, such as *A Conversation* (1631; Prague, N.G., Šternberk Pal.), represent more naturally proportioned figures and still-lifes carefully arranged within simple, box-like spaces. His clear definition of space in terms of three-dimensional volumes also characterizes his still-lifes. His monochromatic *Rustic Still-life* (1631; Warsaw, N. Mus.) of discarded utensils in the corner of a barn is stylistically and thematically close to works by Jan Davidsz. de Heem, while his more tightly and colourfully painted *Vanitas Still-life* (1636; Berlin, Gemäldegal.) recalls paintings by Harmen van Steenwyk (1612–after 1655) and Pieter van Steenwyk (1615–after 1659) and their uncle David Bailly. Pieter Potter served as a witness for the baptism of de Heem's son Cornelis in Leiden in 1631 and would also have known the van Steenwyks there. He probably produced his first landscapes in Leiden; a large landscape, which had been purchased directly from him, was the most highly valued painting listed in an inventory of the collection of the Leiden historian Jan Orlers (1570–1646) in 1640. His early monochromatic landscapes suggest the influence of Jan van Goyen, his neighbour in Leiden.

In 1631 Potter moved to Amsterdam, where in 1635 the Potter family lived on the St Antonisbreestraat. He entered into an ill-fated partnership in a gilded leather factory but continued primarily as a painter. His still-lifes, guardroom interiors, military skirmishes, portraits and landscapes associate him particularly with Pieter Codde and Jan Martszen the younger (*c.* 1607–after 1647). Potter also depicted scenes from the Old Testament, mythological and pastoral literature. Strongly influenced by the work of Claes Moeyaert, his compositions are distinguished by a concern for the definition of space through plastic forms and by the gentle, vulnerable character of his figures. His activity as a history painter is bracketed by the ceremonial entrances into Amsterdam of Marie de' Medici in 1638 and of the deposed English queen, Henrietta Maria, in 1641. He executed some of the prints for the commemorative book of the latter, published by Pieter Nolpe (Amsterdam, 1642), and may also have contributed with Moeyaert and others to the decorations for these major civic events. During the 1630s and 1640s he designed prints for various series published in Amsterdam by Nolpe, Salomon Savery and Gerrit de Heer (*fl* 1634–52), sharing commissions at times with Pieter Quast, Martszen, Bartholomeus Breenbergh and his eldest son, (2) Paulus Potter. Pieter continued to paint during his late career, joining the Guild of St Luke in The Hague in 1647, and he was increasingly influenced by the work of his more successful son.

(2) Paulus (Pietersz.) Potter

(*b* Enkhuizen, *bapt* 20 Nov 1625; *bur* Amsterdam, 17 Jan 1654). Son of (1) Pieter Potter. He was related through his mother, Aechtie Pouwels (*d* 1636), to the wealthy and powerful von Egmont and Semeyns families, who held important offices in Enkhuizen and at the court in The Hague. He worked in his father's studio in Amsterdam during the 1630s and, like him, painted history subjects that show the strong influence of Claes Moeyaert, with whom Paulus may also have studied. In the painting *Abraham Returning from Canaan* (1642; Boston, priv. col., see Romanov, 1934, fig. 1) he adapted the landscape setting from an etching by Moses van Uyttenbroeck (B. 56) and the figures from works by Moeyaert from over ten years

earlier. Significantly, however, he redistributed the numerous animals and figures that Moeyaert had aligned evenly across the frontal plane; Potter placed them to one side, permitting a view into the deep distance where other animals can be seen. Potter followed his father more than Moeyaert in searching for ways to integrate his figures with the landscape, suggesting space by carefully positioning the forms of the figures.

In May 1641 'P. Potter' is recorded as a student of painting in a notebook of Jacob de Wet, another history painter who had contributed to the decorations for the ceremonial entry of Henrietta Maria into Amsterdam in 1641. Paulus may have returned to Haarlem with de Wet, for in the following years his work shows the influence of de Wet's integrated compositions and of the monumental and realistic naturalism of the works of Gerrit Claesz. Bleker (fl 1625–56) and especially Pieter van Laer. Potter was probably attracted initially to Bleker's history paintings, with their ribbons of animals winding into the distance, but was more strongly influenced by his prints. The composition, characterization of the animals and the technique in Potter's related etchings, the *Cowherd* (1643; B. 14) and the *Shepherd* (1644; B. 15), reflect the direct influence of Bleker's own etchings of rustic shepherds and domestic animals (1638; B. 7–8). Potter's painting *The Milkmaid* (1643; Paris, Fond. Custodia, Inst. Néer.) expresses a similar concern for the realistic structure and texture of the animals, which help to define the compositional space. His detailed description of the flowers, butterflies and insects as well as of Dutch farming practices documents his careful observation of reality.

By the mid-1640s Potter had turned almost exclusively from historical narratives to depictions of animals in carefully arranged, flat landscapes and scenes of animals and farmers in the farmyard (see fig. 43). The paintings and popular etching series of domestic animals (1636; Hollstein, x, nos 1–14) by van Laer, who had recently returned from Italy, appealed to Potter for the way in which van Laer manipulated forms to define space. Under this influence Potter's animals increased in monumentality, and his

compositions increased in clarity. In his mature paintings, such as *Cattle Going out to the Fields in the Morning* (1647; Salzburg, Residenzgal.), he, like van Laer, arranged animals at strategic points in the composition to lead the viewer's eye through a doorway, into the distance or over a hill. This painting also demonstrates Potter's fascination and facility for rendering the different qualities of direct and reflected light. A similar concern is found in *Mercury and Argus* (1642; London, V&A), a small pencil drawing on parchment—one of c. ten known compositional drawings by Potter in this medium. Leaving the light edges of faces, legs and leaves undescribed or barely sketched in, he accented the dark shadows with crisp lines, often paralleled by a negative 'line' of light to suggest reflection and give the forms fuller three-dimensional definition. With a similar sensitivity, in the Salzburg painting, Potter recorded the way light reflects off the ground on to the underbelly of a cow, glows through its translucent ears and follows the brim of the farmer's hat, while a gentle morning light fills the air.

Potter's mature paintings from the late 1640s are also characterized by their rustic naturalism. By describing the farmers and animals in realistic detail, defining the manure caked on the sides of the cattle or the dirt under the farmer's nails and on his clothes, he emphasized the close connection of his subjects to the earth. As in contemporaneous literature, Potter portrayed the farmer and his animals in a positive light. His women are nursing mothers or milkmaids, his farmers caretakers of animals rather than tillers of the soil. On 6 August 1646 Potter joined the Guild of St Luke in Delft, but he may actually have been living in The Hague, where his parents were. His painting of 1647, the *Young Bull* (The Hague, Mauritshuis), has become famous for the extremely realistic rendering of the animals; the life-size painting includes a background view of Rijswijk, a village situated between Delft and The Hague. (The work created a sensation when it was exhibited at the Musée du Louvre in 1795, and for the next 100 years critics hotly debated the aesthetic merits and propriety of painting on such a

43. Paulus Potter: *Two Work Horses in front of a Farmhouse*, 1649 (Paris, Musée du Louvre)

large scale with such detail.) The *Bear Hunt* (The Hague, Schilderijenzaal Prins Willem V) is another example of Potter's monumental images. In 1649 he entered the Guild of St Luke at The Hague and the following year married Adriaena van Balckeneynde, the daughter of his neighbour, the court architect Claes Dircksz. van Balckeneynde (*d* 1664). From 1649 to 1652 Potter lived in the house of the painter Jan van Goyen.

Potter apparently enjoyed sophisticated patronage in The Hague, where, in the late 1640s, his paintings display a more elegant style and subject-matter. In a number of them, such as the *Great Farm* (1649; St Petersburg, Hermitage) and the *Reflected Cow* (1648; The Hague, Mauritshuis), he depicted elegant couples visiting the countryside within sight of the city and country houses to swim or simply to enjoy the sights and sounds of nature. Around 1650 he began to include horses in his paintings, such as the elegant *Hunting Party* (1653; Woburn Abbey, Beds). According to Houbraken, he painted the *Great Farm*, which he called *Het pissende koetje* ('the pissing cow'), for Amalia von Solms, who rejected it on account of the offending cow. Houbraken also noted that Potter was often visited by John Maurice of Nassau,

and that Dr Nicolaes Tulp (Rembrandt's former patron) persuaded Potter to leave The Hague for Amsterdam. Potter's personal and family connections in The Hague (a cousin, who was counsellor to Prince William II of Orange Nassau, and Willem Piso, a family friend who was personal physician to John Maurice) probably would have given him an entrée into this circle. This is supported, though somewhat confused, by the fact that the large equestrian portrait of *Dirk Tulp* (1653; Amsterdam, Col. Six), the son of Nicolaes Tulp, was originally a portrait of John Maurice, whose castle at Cleve is visible between the horse's legs; only after Potter's death was it changed to represent Tulp.

By May 1652 Potter had resettled in Amsterdam, where he died aged only 29; a portrait of him (1654; The Hague, Mauritshuis) painted shortly before his death by Bartholomeus van der Helst presents him as an elegant gentleman seated before his easel. The works of Karel Dujardin and Adriaen van de Velde, among others, reveal the influence of his small paintings of animals in landscapes or farmyards, while Albert Klomp (*c.* 1618–88) was a notable imitator of his style.

Potter's drawings include proficient studies of animals in black chalk (e.g. *Three Cows and a Donkey*, London, BM; *Standing Sow*, Paris, Louvre) and pen and ink (e.g. *Swineherd with Pigs*, Chantilly, Mus. Condé). There are *c.* 20 etchings of cattle (B. 1–8, 14, 16–17) and horses (B. 10–13), as well as prints after Potter by Marcus de Bije (1639–*c.* 1690), himself a prolific etcher of animal subjects.

Bibliography

Hollstein: *Dut. & Flem.*

A. Houbraken: *De groote schouburgh* (1718–21), ii, pp. 126–9

A. von Bartsch: *Le Peintre-graveur* (1803–21) [B.]

J. Smith: *Catalogue Raisonné of the Works of the Most Eminent Dutch, Flemish and French Painters*, 9 vols (London, 1829–42), v, pp. 113–65; ix, pp. 620–28

T. van Westrheene: *Paulus Potter: Sa vie et ses oeuvres* (The Hague, 1867)

A. Bredius: 'Pieter Symonsz. Potter: Glaseschrijver, ook schilder', *Oud-Holland*, xi (1893), pp. 34–46

E. Michel: *Paul Potter* (Paris, 1906)

C. Hofstede de Groot: *Holländische Maler* (1907–28), iv

R. von Arps-Aubert: *Die Entwicklung des reinen Tierbildes in der Kunst des Paulus Potter* (diss., Halle, Martin Luther U., 1932)

N. I. Romanov: 'An Unknown Painting by G. W. Horst and its Forerunners', *Oud-Holland*, li (1934), pp. 278–83

L. J. Slatkes: *Netherlandish Artists*, 1[I] of *The Illustrated Bartsch*, ed. W. Strauss (New York, 1978–) [B.]

A. L. Walsh: *Paulus Potter: His Works and their Meaning* (diss., New York, Columbia U., 1985)

—: 'Pieter Symonsz. Potter', *Oud-Holland* (in preparation)

<div align="right">AMY L. WALSH</div>

Pynacker [Pijnacker], Adam

(*b* Schiedam, nr Rotterdam, ?1620; *d* Amsterdam, *bur* 28 March 1673). Dutch painter and merchant. In both style and subject-matter, Pynacker belongs to the group of Netherlandish artists known as the Dutch Italianates. His earliest paintings, for example *Buildings from the Ripa Grande, Rome* (Cambridge, Fitzwilliam), show a first-hand knowledge of the Italian terrain, the subject of almost his entire output.

1. Schiedam, before 1656

Pynacker's mother, Maria, was from the prominent Graswinckel family of Delft; his father, Christiaen, an alderman and member of the Schiedam town council, was a prosperous wine merchant and owner of a fleet of ocean-going ships. It is likely that Adam worked for his father as a merchant, which may explain why he never registered as a member of the Guild of St Luke. According to Houbraken, he spent three years in Italy, probably in 1645–8. As he is not recorded as having associated with the other Netherlandish painters in Italy, most of whom belonged to the confraternity known as the Schildersbent, it is likely that he went there as a merchant on his father's behalf. During the late 1640s and early 1650s he is documented as being in Delft on a number of occasions, usually accompanying the innkeeper and wine merchant Adam Pick. As Pick was also a painter and art dealer, he may have helped Pynacker to launch his career as an artist.

Pynacker appears to have dated only six or seven of his paintings. The earliest surviving of these, an *Italian Seaport with Shipping and Figures* (priv. col., see Harwood, 1985, fig. 1), is dated 1650, but from both inventories and the style of such works as *Farmhouse at the Bend of a River* (c. 1648; Berlin, Gemäldegal.) it can be established that Pynacker produced over twenty works before this date. At the end of the 1640s he may also have spent some time in Utrecht, where several Dutch Italianates had gathered on returning from the south. Like many of them, Pynacker based some of his figures, such as those in *The Inn* (Paris, Louvre), on the staffage of the Haarlem-born painter Pieter van Laer. During his early career Pynacker also borrowed motifs from Rotterdam painters, particularly Ludolf de Jongh, for example the pairs of conversing couples in *Italian Seaport with Shipping and Figures* and *Harbour Scene* (Abergavenny, Gwent, Richard Hanbury Tenison priv. col., see Harwood, 1985, fig. 5).

Pynacker's earliest paintings, mostly on a small-scale, are characterized by three distinctive features: evocation of the strong sunlight and atmosphere of Italy; the reproduction of specific aspects of nature in minute detail; and a distinctive palette of sometimes cool, monochromatic tones enlivened by a touch of red or ultramarine. Although his travels to Italy were the main source of his subject-matter, his style and composition were often derived from fellow Italianates; the thin intertwining trees and diagonal lighting combined with *contre-jour* in Pynacker's second known dated painting, *Landscape with Waterfall and Shepherd* (1654; Berlin, Bodemus.), for instance, were taken from Jan Both, whose influence was particularly strong in the Netherlands immediately following his death in 1652. This painting is much larger than his other works of the late 1640s and early 1650s and was probably commissioned by the Brandenburg court in Berlin. However, Pynacker's paintings are clearly distinguishable from Both's: the strategic placement of the staffage in *Bridge in an Italian Landscape* (London, Dulwich Pict. Gal.) shows his more acute sense of design, as do his distinctive, slightly squat

figures, the latter described with a sharper line. In the representation of atmosphere and light, exemplified by the *River Landscape with Laden Barge* (c. 1655; St Petersburg, Hermitage), he surpassed the works of his Italianate contemporaries.

Some of Pynacker's harbour scenes and river views, among them *Riverscape with Laden Boats* (c. 1650–53;Vienna, Gemäldegal. Akad. Bild. Kst.), share features with paintings by Jan Baptist Weenix and Jan Asselijn, significantly such compositional devices as the use of a foreground wedge of land, on which most of the activity takes place, and the high vantage point. But again, the painting is invested with Pynacker's characteristic style; the nautical paraphernalia shows not only a first-hand knowledge of the transportation of goods by water, but also his tendency to portray foreground elements in minute detail. This is also evident in *Landscape with a Stone Bridge* (Balcarres, nr Colingsburgh, Fife, priv. col.), which, despite the prevailing atmosphere of calm, is animated in the lower left quadrant by haulers unloading cargo from three laden barges while peasants carry out domestic tasks. Yet although Pynacker depicted his foreground features in such accurate detail, his landscapes were never intended to be topographical. For example, it is arguable whether the bridge in *Landscape with a Stone Bridge* was based on that which crosses the Tyeron at Francheville or whether it represents a bridge over the Tiber.

In all but a few of his landscapes, Pynacker's subject-matter was limited to views of rivers, harbours and the countryside around Rome, often incorporating farmyard scenes with peasants performing everyday tasks. Similarly, he often used the same compositional format: one side built up with trees, hills and cliffs, often surmounted by a ruined fortress, balanced against a vista of slim trees or shipmasts and silhouetted against distant hills and alpine peaks. The light is almost always that of a rising or setting sun, its angle chosen to maximize the effect of contrasting light and shade (see col. pl. XXIX). Pynacker also delighted in using rays of light, not only to emphasize the edges of craggy branches, blades of grass and single wild carnations, but also to focus on small areas of

local colour—the patch of red from a travelling rug or the ultramarine of a goatkeeper's jacket.

2. Schiedam, 1656–61

Two dated paintings from the later 1650s, *Return from the Chase* (1657; priv. col., see Harwood 1989, no. 56) and *Landscape with a Collapsing Bridge* (1659; Schleissheim, Neues Schloss), represent a new departure in subject-matter and composition. In the first he introduced the theme of hunting, and there are signs of renewed links with Ludolf de Jongh and Jan Baptist Weenix. Among the features that characterized his paintings of the following seven or eight years are new forms of vegetation, particularly giant cabbage leaves and tangled vines placed in the immediate foreground, as if part of a still-life; gnarled and broken birch stumps covered with fungi; massive trees, often oaks, dominating the middle distance; and distant mountains which resemble those in his earlier landscapes. At the same time his paintings became much more fanciful, occasionally tending towards the turbulent.

In 1658 Pynacker married Eva Maria de Geest, a member of the influential Uylenburgh family and daughter of the Leeuwarden portrait painter Wybrand de Geest, and converted to Roman Catholicism, the faith of his wife. One of the final documents from Schiedam shows that he was acting as a merchant, possibly his chief occupation until 1661.

3. Amsterdam, 1661–73

Pynacker moved to Amsterdam soon after his father's death, probably in 1661, and lived there for the rest of his life. At this time Amsterdam was attracting a vast number of painters working in a wide range of fields. Although very few documents regarding Pynacker survive from this period, the larger size of his works suggests that they were commissioned to decorate the interiors of large city houses belonging to the newly established, wealthy middle classes. A poem written by his friend Pieter Verhoek, brother of Gysbert (1644–90), one of Pynacker's few known pupils, provides an insight into a contemporary viewer's opinion of Pynacker's work. Published by

Houbraken, the poem describes the painted walls of a hall or gallery at 548 Heerengracht, the home of Cornelis Backer, alderman and director of the East India Company. The paintings, possibly including Pynacker's *Landscape with Sportsmen and Game* (1665; London, Dulwich Pict. Gal.) and the pendants *Landscape with Waterfall* and *Hilly Landscape in Evening* (both Rotterdam, Mus. Boymans–van Beuningen), are described as an escape world beyond the Alps for Herr Backer's contemplation when 'worn out by the cares of state'.

Pynacker's paintings of the first half of the 1660s, such as *Landscape with Animals* (London, Wallace) and *Deerhunt in a Mountainous Landscape* (Luxembourg, Mus. Pescatore), are larger than any of the previous 12 years and are his best-known works. They are of an upright format in which light continues to be of great importance: sharp contrasts of light and shade pick out the foreground foliage, emphasizing irregularities on the surfaces of the leaves.

About 1665, Pynacker produced a group of even larger canvases, two almost 3 m in height and clearly intended for the home of a wealthy patron. One of them, *Landscape with Sportsmen and Game* (London, Dulwich Pict. Gal.), incorporates, in a horizontal frame, a group of silver birches, that are more delicate than the massive oaks of the previous five years, and an eloquent hunting scene that is reminiscent of his paintings of c. 1657.

During his last years, Pynacker reverted to small-scale works based on his own compositions of the mid-1650s, for example the pendants *Landscape with Waterfall* and *Landscape with Gateway* (Braunschweig, Herzog Anton Ulrich-Mus.), distinguishable from the earlier works by their greater stylization, which in some cases tends towards the hackneyed. Nevertheless they can be appreciated for the decorative effect of subtle tonal changes and an almost mystical quality of light.

There are a number of drawings associated with Pynacker. Among these are a *Deer Hunt on Hilly Terrain* (Amsterdam, Hist. Mus., of which there are a number of copies), *River Landscape*

(Berlin, Kupferstichkab.) and *The Torrent* (Haarlem, Teylers Mus.). However, it is possible that none of the drawings attributed to Pynacker are by him. At the time of his death Pynacker was living—as did Rembrandt—on the Rozengracht, then a poor area of Amsterdam. He was buried in the graveyard of the Roman Catholic Nieuwe Kerk. During the 18th and 19th centuries engravings were made after several of his paintings; about twenty are in the British Museum.

Bibliography

A. Houbraken: *De groote schouburgh* (1718–21), vol. ii, pp. 96–9

J. A. Smith: *A Catalogue Raisonné of the Works of the Most Eminent Dutch, Flemish and French Painters*, 9 vols and suppl. (London, 1829–42), vi, pp. 285–300, suppl. pp. 750–55

C. Hofstede de Groot: *Holländischen Maler* (1907–28), ix, pp. 521–68

J. Nieuwstraten: 'Netherlandish Italianising Landscape Painters at Utrecht', *Burl. Mag.*, cvii (1965), pp. 271–5

Nederlandse 17e eeuwse Italianiserende landschap-schilders (exh. cat., ed. A. Blankert; Utrecht, Cent. Mus., 1965; rev., enlarged, with Eng. trans. of intro., Soest, 1978), pp. 184–94

W. Stechow: *Dutch Landscape Painting of the Seventeenth Century* (London, 1966/R 1981), pp. 157, 160–61

A. Wassenbergh: 'Het huwlijk van Adam Pijnacker en Eva Maria de Geest', *Vrije Fries*, xlix (1969), pp. 93–5

K. J. Mullenmeister: *Meer und Land im Licht des 17. Jahrhunderts*, 3 vols (Bremen, 1973–80), iii, p. 30

L. Salerno: *Pittori di paesaggio del seicento a Roma* (Rome, 1977–80), ii, pp. 694–704 [in It. and Eng.]

Art in Seventeenth-century Holland (exh. cat., London, N.G., 1978), p. 68

F. J. Duparc: *Mauritshuis Hollandse schilderkunst landschappen 17de eeuw* (The Hague, 1980), pp. 68–9

L. B. L. Harwood: 'Les Pynacker du Louvre: A propos d'une récente acquisition', *Rev. Louvre*, ii (1983), pp. 110–16

——: 'Revelling in Contemplation: Adam Pynacker (c. 1620–73) and British Collectors', *Country Life*, clxxviii (22 Aug 1985), pp. 436–88

Masters of the 17th-century Dutch Landscape Painting (exh. cat., ed. P. C. Sutton; Amsterdam, Rijksmus.; Boston, MA. Mus. F.A.; Philadelphia, PA, Mus. A.; 1988), pp. 394–401

L. B. L. Harwood: *Adam Pynacker* (Doornspijk, 1989)

L. B. L. HARWOOD

Pynas

Family of Dutch painters and draughtsmen. The brothers (1) Jan Pynas and (2) Jacob Pynas came from an aristocratic Catholic family in Alkmaar; their father, Symon Jansz. Brouwer, became a citizen of Amsterdam in 1590. Their sister Meynsge married the artist Jan Tengnagel in 1611. By 1618, in a poem eulogizing the city of Amsterdam, Theodore Rodenburgh mentioned an artist by the name of Pynas as being celebrated in the city; however, it is not possible to be certain whether he was referring to Jan or Jacob. Until the 1930s the oeuvres of the two brothers were often confused and also generally subsumed in the category of works by followers of Adam Elsheimer.

Bibliography

Thieme–Becker

A. Bredius: 'Aanteekeningen omtrent de schilders Jan en Jacob Pynas' [Notes concerning the artists Jan and Jacob Pynas], *Oud-Holland*, iii (1935), pp. 252–7

A. Tümpel: 'Claes Cornelisz. Moeyaert', *Oud-Holland*, lxxxviii (1974), pp. 1–63

The Pre-Rembrandtists (exh. cat. by A. Tümpel, Sacramento, CA, Crocker A.G., 1974)

(1) Jan (Symonsz.) Pynas

(*b* ?Alkmaar, 1581–2; *d* Amsterdam, 1631). In 1605 he travelled to Italy, returning two years later to Amsterdam, where he made a reputation for himself with history paintings, particularly representations from biblical and ancient history. The painting of *Jacob Being Shown Joseph's Bloodstained Robe* (1618; St Petersburg, Hermitage) was the inspiration for the play *Joseph in Dothan* by the poet Joost van den Vondel. In Jan's early work (e.g. the *Raising of Lazarus*, 1605, Aschaffenburg, Schloss Johannisburg, Staatsgal.; and *Moses Turning Water into Blood*, 1610, Amsterdam, Rembrandthuis) there are signs of the influence of the artists with whose work he had obviously become familiar in Italy, especially Adam Elsheimer and Jacopo Tintoretto. Within a few years he came under the influence of Pieter Lastman and the group of Amsterdam artists known as the Pre-rembrandtists. In the *Dismissal of Hagar* (1613; Aachen, Suermondt-Ludwig-Mus.)

the size and the construction of Pynas's figures are reminiscent of Lastman's work. However, Pynas reduced the eloquent gesticulation used by Lastman to restrained gestures, which he then emphasized by depicting his protagonists in profile. In this he represented the opposite pole within the circle of Amsterdam Pre-Rembrandtists to his brother-in-law Tengnagel, who exaggerated the movement of his figures to such an extent that they seem to be dancing. Pynas's history pictures are generally simple and lacking in ornament, a tendency also cultivated at times by Claes Cornelisz. Moeyaert. A comparison between Pynas's painting of *Joseph Selling Corn in Egypt* (1618; ex-art market, London, see 1974 exh. cat. above, fig. 23) and Lastman's version of the same theme (1612; Dublin, N.G.) shows Pynas's inclination towards simplicity and the reduction of narrative devices.

From *c.* 1614 Jan Pynas's forms became strikingly heavy and harsh (e.g. the *Dismissal of Hagar*, 1614; Guernsey, D. Cevat priv. col., see 1974 exh. cat., fig. 76). There is an economy of movement and all violent, strident elements are eliminated; the figures are fixed in an upright position or bend forwards in an angular way. In his late work this typical view became more pronounced, principally by reducing the number of figures, as in the *Parable of the Vineyard Workers* (1622; Prague, N.G., Šternberk Pal.). At the same time the figures were enlarged to fill the canvas right up to the upper edge, in a manner not found in any other Pre-Rembrandtist painter except Tengnagel. However, Pynas, with his flat, almost transparent and, in the late work, even rough manner of painting, did not achieve the brilliance and expressivity of Tengnagel's work. The reduction of the space and strong emphasis on the figures are particularly well illustrated in Pynas's late painting of *Joseph and Potiphar's Wife* (1629; priv. col., see 1974 exh. cat., fig. 26).

Jan Pynas's drawings are few, but stylistically they are clearly distinguishable from those by Jacob. Jan's drawings, such as the double-sided sheet with a *Farmstead* (1608; Amsterdam, Rijksmus.) and *Figure Studies* on *verso*, are characterized by a fine, free-flowing line. The drawing

of *Rachel Concealing the Household Gods* (1613; Amsterdam, Rijksmus.) is similar, but the touch is surer. His later drawings show the same inclination towards simplified, compact forms found in his paintings. The line generally became more brittle and sometimes even dissolved into a series of dots, as in the preparatory drawing (Paris, Louvre) for the 1622 painting of the *Parable of the Vineyard Workers* and the drawing of *Diogenes* (1630; Brussels, Bib. Royale Albert 1er).

Bibliography

K. Bauch: 'Beiträge zum Werk der Vorläufer Rembrandts, I: Die Gemälde des Jan Pynas', *Oud-Holland*, lii (1935), pp. 145–58
——: 'Beiträge zum Werk der Vorläufer Rembrandts, II: Die Zeichnungen des Jan Pynas', *Oud-Holland*, lii (1935), pp. 252–7

(2) Jacob [Jakob] (Symonsz.) Pynas

(*b* Amsterdam, 1592–3; *d* ?Delft, ?after 1650). Brother of (1) Jan Pynas. The influence of Adam Elsheimer and Carlo Saraceni evident in his work suggests that he travelled to Italy. In 1631 Jacob was named as a citizen of Delft, and the following year he was a member of the Delft Guild of St Luke. In 1641 and 1643 he was back in Amsterdam. Jacob Pynas's oeuvre is not extensive, but his style is distinctive, with an idiosyncratic language of form, colour and figure type. He developed a warm, unified brown tone for his paintings, which was later adopted by Rembrandt in his early work in Amsterdam. (Earlier scholars had inferred from this that Rembrandt was apprenticed to Pynas, but there is no evidence for this.) In subject-matter Jacob Pynas followed the Amsterdam Pre-Rembrandtists in his choice of Old and New Testament stories and themes from mythology.

Jacob Pynas's earliest known painting is the *Adoration of the Magi* (1613 or 1617; Hartford, CT, Wadsworth Atheneum), of which the style is already so mature that it seems reasonable to suppose that there were earlier works. The figures stand out sharply against the landscape, emphasized by clear outlines and strongly marked drapery fold-lines; the dynamic sense of movement is suggestive of Mannerism, especially

compared to the quiet works of Moeyaert. Besides pictures with relatively large figures, there are landscapes by Jacob with figures so small they seem like mere staffage (e.g. *Mercury and Battus*, 1618; England, M. W. T. Leatham priv. col., see 1974 exh. cat. above, fig. 83). These narrative scenes with small figures are close enough to those of Elsheimer for them to have long been attributed to him; however, after the Elsheimer exhibition (Frankfurt, 1966–7) research enabled a clear distinction to be drawn between the two men's work. Jacob Pynas was the only artist in the Pre-Rembrandtist circle to work in two such different compositional styles.

Pynas's painting of *Nebuchadnezzar Restored to his Kingdom* (1616; Munich, Alte Pin.), with the figures fixed in twisting movements and overlapping one another in a richly animated landscape, makes a similar overall impression to the painting of *Paul and Barnabas in Lystra* (1628; Amsterdam, Rijksmus.). However, in the intervening dozen years there was a phase in which the artist's compositions were simpler and the general effect clearer, beginning with *Mercury and Battus* and in *Gideon's Sacrifice* (1620; ex-art market, Vienna, see 1974 exh. cat., fig. 36). In subsequent paintings the figures are deeply shaded and both landscape and figures were more strongly linked, unifying the picture as a whole. At the same time, the figures are more schematically constructed, as in the *Prophet Elisha Sending his Servant to the Shunnamite Woman* (?1621; Muiden, Rijksmus. Muiderslot). In Pynas's late work his subject-matter changed, and he favoured subjects from Ovid's *Metamorphoses* and scenes of saints, a typical example being *St Francis Receiving the Stigmata* (ex-art market, London, see 1974 exh. cat., fig. 38). This painting is unusual from the stylistic point of view as well: the usual solid forms and contours here merge into one another.

The development of Pynas's drawing runs parallel to that of his painting. The early drawings were carefully executed with a strong sense of volume (e.g. *Moses Turning Water into Blood*, Munich, Staatl. Graph. Samml.); then there was a lessening of detail and a broader stroke (e.g. the *Beheading of St Catherine*, 1640, Heidelberg, Goldschmidt priv. col., see 1974 exh. cat., fig. 41). In his late drawings the figures were again more strongly silhouetted, with almost no modelling inside the contours (e.g. the *Mocking of Ceres*, 1648; Rotterdam, Mus. Boymans–van Beuningen).

Bibliography

K. Bauch: 'Beiträge zum Werk der Vorläufer Rembrandts, III: Die Gemälde des Jakob Pynas', *Oud-Holland*, liii (1936), pp. 79–88
—: 'Beiträge zum Werk der Vorläufer Rembrandts, III: Die Handzeichnungen von Jakob Pynas', *Oud-Holland*, liv (1937), pp. 241–52

ASTRID TÜMPEL

Quast, Pieter (Jansz.)

(*b* ?Amsterdam, 1605–6; *d* Amsterdam, *bur* 29 May 1647). Dutch painter, draughtsman and engraver. He became a master of the Guild of St Luke in The Hague in 1634. His paintings of groups of elegant people, such as the *Merry Company* (Hamburg, Ksthalle) and *Noble Company* (Leipzig, Mus. Bild. Kst.), recall the work of Anthonie Palamedesz, while his scenes with soldiers, for example a *Stable Interior* (London, N.G.) and *Soldiers at an Inn* (1640; Karlsruhe, Staatl. Ksthalle), recall the work of Pieter Codde. Usually, however, Quast painted operations and tavern scenes with peasants and beggars, whose postures and faces approach caricature, as in the *Foot Operation* and *Card-players with a Woman Smoking a Pipe* (both Amsterdam, Rijksmus.). The scenes, usually on small panels, are heavily and powerfully rendered in warm shades of brown, set off by strong local colouring in the principal figures. His successful peasant scenes are characterized by the use of strong chiaroscuro and a gentle, harmonious palette. The caricatural quality of Quast's peasants recalls the work of his fellow-resident of The Hague, Adriaen van de Venne, but Quast's looser style and many of his individual types are closer to the paintings of Adriaen Brouwer, as well as of Adriaen van Ostade, to whom Quast's best work has sometimes been ascribed. Some of Quast's paintings take the form of political satire,

for example a small panel of a *Male and Female Beggar*, which symbolizes innocent poverty, and its pendant, a *Liquor Merchant and his Wife* (both Brunswick, Herzog Anton Ulrich-Mus.), which symbolizes self-induced poverty. Sources for such paintings included the *Balli de Sfessania* (1621) and *Gobbi* (1622) series of etchings by Jacques Callot. Contemporary theatre also provided inspiration for such paintings as the *Triumph of Folly* (1643; The Hague, Mauritshuis, on dep Amsterdam, Theatmus.). A *Crucifixion* (1633; ex-G. J. Nederpelt priv. col., Schiedam) is probably identical to a work described in the 1632 inventory of Quast's paintings as being incomplete.

In addition to paintings, Quast produced numerous finished drawings, usually signed and dated, and probably intended for sale. He was one of the few Dutch artists at this time who used graphite or chalk on parchment as a favoured technique. The collection of the Louvre, Paris, includes 56 such drawings of landscapes and townscapes. Six signed copies (St Petersburg, Hermitage) after Roelandt Savery's *Naer het leven* series of scenes from peasant life presumably date from the 1630s. In Quast's less coarsely rendered peasant figures, a stylistic or thematic similarity sometimes leads to confusion with the work of both H[endrik?] Potuyl (*fl c.* 1639), who also worked in graphite and chalk on parchment, and Andries Both, as can be seen in Quast's *Peasant Scene* (Munich, Staatl. Graph. Samml.) and his *Peasant Company* (Berlin, Kupferstichkab.). Other known drawings by Quast include an *Annunciation* (1638; Berlin, Kupferstichkab.) and *Death and the Rich Man* (1643; Dresden, Kupferstichkab.). Many prints appeared after work by Quast, for example the *Five Senses* (1638; Hollstein, nos 52–6) and *T is al verwart gaeren* ('It's all a riddle') (1638 and 1652; Hollstein, no. 7), but it is unclear whether Quast was responsible for the actual engraving. A unique item in Quast's oeuvre is a signed and dated terracotta relief of *Fighting Men* (1629; Amsterdam, Rijksmus.). Quast moved to Amsterdam before 1 June 1643, and he died in poverty there. His estate was inventoried on 6 June 1647.

Bibliography

Thieme–Becker; Hollstein: *Dut. & Flem.*

A. Bredius: 'Pieter Jansz. Quast', *Oud-Holland*, xx (1902), pp. 65–82

——: *Künstler-Inventare*, i (The Hague, 1915), pp. 273–4

J. Leeuwenberg: 'Beeldhouwwerk van de schilder Pieter Quast' [Sculpture by the painter Pieter Quast], *Bull. Rijksmus.*, xiv (1966), pp. 60–64

Y. I. Kuznetsov: 'Pieter Quast Copied Savery's *Naer het leven* Drawings', *Album Amicorum J. G. van Gelder* (The Hague, 1973), pp. 215–18

B. A. Stanton-Hirst: *The Influence of the Theatre on the Works of Pieter Jansz Quast* (diss., Madison, U. WI, 1978)

L. K. Reinold: 'The Beggar as Performer', *The Representation of the Beggar as a Rogue in Dutch Seventeenth-century Art* (diss., Berkeley, U. CA, 1981), chap. ii

B. A. Stanton-Hirst: 'Pieter Quast and the Theater', *Oud-Holland*, xcvi (1982), pp. 213–37

J. E. P. LEISTRA

Ravesteyn, Jan (Anthonisz.) van

(*b* The Hague *c.* 1572; *d* The Hague, *bur* 21 June 1657). Dutch painter. In 1598 he became a member of the Guild of St Luke in The Hague, and later he served as an officer in various capacities. The only known paintings by him are portraits. One of his few early works to have survived is the portrait of the future Remonstrant leader *Hugo de Groot Aged 16* (1599; Paris, Fond. Custodia, Inst. Néer.), which is unusual for its round format and striking close-up view of the sitter. The remainder of his extant oeuvre dates mainly from between 1610 and 1640, with portraits from nearly every year of this period.

In 1611 van Ravesteyn began to paint a series of portraits of high-ranking military officers from the stadholder's court in The Hague. Twenty-five of these works, executed by him and his associates during the period 1611–24, have been preserved (The Hague, Mauritshuis). Van Ravesteyn's patrons also included leading citizens of The Hague and government functionaries of other cities who were temporarily stationed in The Hague. In about 1612 he also painted the portrait of *Prince Frederick Henry of Orange Nassau* (Dutch Royal Col.). He also made several group portraits of militia companies

in The Hague, including the large painting *The Council Receiving Officers of the Civic Guard* (1618; The Hague, Gemeentemus., on dep. The Hague, Oude Stadhuis).

Van Ravesteyn's works after 1610 were influenced by Michiel van Mierevelt, who has been mentioned as his teacher, but his portraits can be distinguished from those of van Mierevelt by his more elegant manner of painting and by a slight inclination to flatter his sitters. During the course of his career van Ravesteyn must have painted hundreds of portraits, apart from the many smaller repetitions of those of well-known sitters, which were probably executed for the most part by other members of his workshop. A similar situation prevailed in the workshop of van Mierevelt.

There is some confusion between the oeuvre of Jan van Ravesteyn, that of his younger brother Anthonie van Ravesteyn (c. 1580/88–1669) and that of his brother's son Arnoldus van Ravesteyn (c. 1615–90), neither of whom are mentioned in archives as Jan's pupils. The painter Adriaen Hanneman, who married Jan's daughter Maria in 1640, received his training not from Jan but from Anthonie.

After 1641 van Ravesteyn apparently painted little or not at all, but in 1656 he was still mentioned as a doyen in the rolls of artists who were invited to become members of The Hague's newly founded artists' society, Pictura. Although van Ravesteyn was by no means the inferior of van Mierevelt artistically, he has never enjoyed the latter's international reputation. Van Ravesteyn received many commissions, but within the court and the most notable foreign and domestic circles his position was significantly weaker than that of van Mierevelt. Nonetheless, he can be counted among the Dutch portrait painters worthy of credit of the first half of the 17th century whose depiction of their contemporaries was perhaps limited in imagination but was rendered with meticulous care.

Bibliography

Thieme–Becker

A. Bredius and E. W. Moes: 'De schildersfamilie Ravesteyn', *Oud-Holland*, ix (1891), pp. 207–20; x (1892), pp. 41–52

W. Martin: 'Jan van Ravesteyn's *Magistraat en schutters*, 1618, en het ontwerp daarvoor' [Jan van Ravesteyn's *Town Council and Civic Guard*, 1618, and its design], *Oud-Holland*, xl (1923–4), pp. 193–8

R. E. O. Ekkart: 'The Portraits of "The Vrijdags van Vollenhoven Family" by Jan Anthonisz. van Ravesteyn', *Hoogsteder-Naumann Mercury*, xii (1991), pp. 3–16

Dawn of the Golden Age: Northern Netherlandish Art 1580–1620 (exh. cat., Amsterdam, Rijksmus., 1993–4), pp. 314, 596–8

RUDOLF E. O. EKKART

Rembrandt (Harmensz.) van Rijn [Rhyn]

(*b* Leiden, 15 July 1606; *d* Amsterdam, 4 Oct 1669; *bur* 8 Oct 1669). Dutch painter, draughtsman and etcher. From 1632 onwards he signed his works with only the forename *Rembrandt*; in documents, however, he continued to sign *Rembrandt van Rijn* (occasionally *van Rhyn*), initially with the addition of the patronymic 'Harmensz.'. This was no doubt in imitation of the great Italians such as Leonardo, Michelangelo, Raphael and Titian, on whom he modelled himself, sometimes literally. He certainly equalled them in fame, and not only in his own country. His name still symbolizes a whole period of art history rightfully known as 'Holland's Golden Age'. In 1970–71 a great exhibition in Paris was devoted to it under the eloquent title *Le Siècle de Rembrandt*. A century before, a popular work of cultural history by C. Busken Huet referred to the Netherlands as 'the land of Rembrandt'. His fame is partly due to his multi-faceted talent. Frans Hals was perhaps at times a greater virtuoso with the brush but remained 'only' a portrait painter. Vermeer may have excelled Rembrandt in the art of illusion but was less prolific. Rembrandt was not only a gifted painter but also an inspired graphic artist: he has probably never been surpassed as an etcher, and he often seems inimitable as a draughtsman. His subjects reflect his manifold talent and interests. He painted, drew and etched portraits, landscapes, figures and animals, but, above all, scenes of biblical and secular history and mythology. Contemporary critics ascribed the highest artistic value to his history paintings, as opposed to his portraits, which were regarded as a necessary evil. Rembrandt combined theory and practice,

inventing, for instance, a new kind of painting, the '*tronie*' or portrait head, a compromise between portraiture and history painting. His most famous portrait commission was that of the *Militia Company of Capt. Frans Banning Cocq and Lt Willem van Ruytenburch*, a picture known by its nickname, the '*Night Watch*' (1642; Amsterdam, Rijksmus.); it was praised in 1678 by Samuel van Hoogstraten on the grounds that the artist had made it into a 'history' instead of a mere group portrait. In 1641, the year before it was completed, J. J. Orlers, the artist's first biographer, described Rembrandt as 'one of the most famous painters of our age'.

Rembrandt executed about 400 paintings and over 1000 drawings (many attributions are still disputed; *see* §III below). The number of his etchings can be somewhat more accurately estimated at 290. In the present article the abbreviations 'B.', 'Ben.' and 'Br.' are used to denote the catalogues in which particular works can be identified: B.= A. Bartsch: *Catalogue raisonné de toutes les estampes qui forment l'oeuvre de Rembrandt* (Vienna, 1797); Ben.= O. Benesch: *The Drawings of Rembrandt* (London, 1973); Br.= A. Bredius: *Rembrandt: The Complete Edition of the Paintings* (London, 1969). For works for which these abbreviations do not occur, the numbers given are those of the collections in which they are located. The abbreviation RD refers to documentary references found in W. L. Strauss and M. van der Meulen: *The Rembrandt Documents* (New York, 1979).

I. LIFE AND WORK

1. Training and early work, to c. 1626

Rembrandt's father, Harmen Gerritsz. van Rijn (*c.* 1568–1630), came from an old family of millers in Leiden, where he was half-owner of the mill 'De Rijn' from 1589 onwards. In that year he married Cornelia (Neeltgen) Willemsdr. (van) Zuytbrouck (1568–1640), the daughter of a prosperous baker. They had ten children, three of whom died in infancy; Rembrandt, the second youngest, knew the others as adults. The chief source for the painter's life until 1625 is still Orlers's biography

of 1641, which states that Rembrandt attended the city's Latin school, where he would have studied Greek, Latin, Classical literature and history. While his brothers learnt a trade, Rembrandt was enrolled at Leiden University at age 14. Two years later he was still living with his parents, but, according to Orlers, instead of serving his native town as a scholar, he longed to be a painter and draughtsman. Accordingly, he became a pupil of the local figure painter Jacob van Swanenburgh, who had lived and worked for many years in Italy. For three years Rembrandt studied painting with van Swanenburgh, at which point the younger painter took a remarkable decision. Although he could have set up in a studio on his own, he entered into a six-month apprenticeship in Amsterdam 'with the celebrated painter P(ieter) Las(t)man' (Orlers). Asked in later years why he did not go to Italy like so many other ambitious young artists, Rembrandt replied that Italian art could just as easily be studied in Holland. It was probably Jan Lievens, a painter of his own age who at that time was creating a furore in Leiden as an infant prodigy, who persuaded Rembrandt that Lastman's Amsterdam studio was the most suitable place for further training. Lastman painted Raphaelesque history compositions in a small format similar to the cabinet pieces of Adam Elsheimer, and it seems clear that Rembrandt wished also to become a history painter and had no intention of specializing in still-lifes, landscapes or portraits. Orlers did not record exactly when Rembrandt went to Amsterdam to be taught by Lastman. Rembrandt's earliest documented works, which are signed and dated 1625 and 1626, are strongly influenced by Lastman and are generally thought to have been painted after his return to Leiden. However, it is just as likely that they were executed while in Lastman's studio, where Rembrandt enjoyed an independent position as an assistant. Based on the first hypothesis, his six months in Amsterdam would have occurred in or before 1625; on the second, 1625–6.

(i) Paintings. No works by Rembrandt from his period of study with van Swanenburgh are known, except possibly two unsigned painted allegories of the

senses, *The Singers (Hearing)* and the *Ear Operation (Feeling)* (both The Hague, Cramer Gal.; Br. 421–421A), which are somewhat doubtfully ascribed to him. The Italianate architecture in the background of the monogrammed *Stoning of St Stephen* (1625; Lyon, Mus. B.-A.; Br. 531A) is clearly borrowed from Lastman, as is the bright colouring. The same dependence can be seen in the early *History Scene* (1626; Leiden, Stedel. Mus. Lakenhal; Br. 460), the exact subject of which is not clear. It may have been a secular pendant to the *Stoning of St Stephen*, on the analogy of Lastman's painted pendants of 1614, *Paul and Barnabas at Lystra* (Warsaw, N. Mus.) and *Orestes and Pylades Disputing at the Altar* (Amsterdam, Rijksmus.). Rembrandt's history painting was an ambitious attempt to meet the theoretical requirements for the design and execution of such works, qualities that Rembrandt so admired in Lastman's *Coriolanus Receiving the Emissaries* (1622; Dublin, Trinity Coll.). This prototype of an 'Italianate' composition was etched on the painter's retina for the whole of his career. Also dated 1626 is *Balaam and the Ass* (Paris, Mus. Cognacq-Jay; Br. 487), in which the prophet and his beast are borrowed literally from a painting by Lastman (New York, Richard L. Feigen), but the composition of piled-up figures is Rembrandt's own. In his painting of the *Baptism of the Eunuch* (1626; Utrecht, Catharijneconvent, 380), which was identified as by Rembrandt only in 1976, he also took over figures and details from one or more versions by Lastman of the same subject.

Besides these multi-figured history pieces in Lastman's style, Rembrandt painted a scene of half-length figures in a piled-up composition: *Christ Driving the Money-changers from the Temple* (Moscow, Pushkin Mus. F.A.; Br. 532) and another biblical scene with only two figures that almost fill the picture plane: *Tobit and Anna with the Kid* (Amsterdam, Rijksmus.; Br. 486). In the latter he used, for the first time, a model other than Lastman, a print by Jan van de Velde after Willem Buytewech. This type of borrowing became a normal feature of his working method. Thus, even at the outset of his career, Rembrandt displayed tremendous zest for work and a profusion of new ideas.

2. Leiden years, 1626–31

The art dealer Hendrick van Uylenburgh, who later played such an important part in Rembrandt's life, came to live at the corner of Jodenbreestraat in Amsterdam in 1625 or a little later. He and Rembrandt may have been in touch from then onwards, if it was at that time (and not earlier) that Rembrandt worked in Lastman's studio in the nearby Anthoniesbreestraat. In any case, Rembrandt was back in Leiden in 1626, so as to 'practise the art of painting alone, on his own account' (Orlers). There, in the spring of 1628, he was noticed by the lawyer and connoisseur Arnout van Buchell, who was making notes for a book on painting: 'Also, the son of a miller in Leiden is esteemed highly, though prematurely' (RD 1628/1). Van Uylenburgh was also in Leiden in that year and may have bought *tronies* by Rembrandt for his Amsterdam customers. The Amsterdam hospital governor Joan Huydecoper possessed a small *tronie* in 1628 (Schwartz, 1984), and another, also by Rembrandt, was in the estate of the painter Barent Teunisz., who died at Amsterdam in 1629 (RD 1629/1).

In or about 1629 Constantijn Huygens the elder, secretary to the stadholder Frederick Henry, visited the studio Rembrandt was then sharing with Jan Lievens. The relationship between the two painters was apparently unusual: they did not work on pictures together but painted the same subjects and used the same models. In 1629 Lievens held a public sale of his own work and that of three other painters, of whom Rembrandt was probably one. This may be an indication of the rather poor state of the art market in Leiden; in any case, within two years its two most gifted artists had moved elsewhere for good. Rembrandt taught his first pupils in Leiden. Gerard Dou, aged 15, came to work with him on 14 February 1628, according to Orlers, who probably got the date from Dou himself. Isaac Jouderville, who joined the studio in 1629, paid Rembrandt 50 guilders per half year for tuition (RD 1630/2 and 1630/4). Fellow pupils were the Haarlem artists Willem de Poorter and Jacob de Wet, also perhaps Jacques des Rousseau (who worked more in the style of Lievens).

(i) **Paintings.** Another painting dated 1626, the *Musical Company* (since 1976 in Amsterdam, Rijksmus.; Br. 632), is a mysterious scene previously thought to represent a musical party in Rembrandt's house; it is more probably an allegory, though it has not been satisfactorily explained. The variegated colour scheme is still in Lastman's style, while the still-life of books in the foreground must have been inspired by the *vanitas* pieces that were so much in vogue in Leiden in the 1620s. A striking feature is the concentrated fall of light, which became characteristic of Rembrandt's work from then onwards. In his Leiden years he also painted a number of historical genre pieces or allegories. *The Money-changer* (Berlin, Gemäldegal.; Br. 420) represents the Parable of the Rich Man (Luke 12:21), while the *Sleeping Old Man* (1629; Turin, Gal. Sabauda; Br. 428) is probably an allegorical depiction of Sloth. The *Painter in his Studio* (Boston, Mus. F.A.; Br. 419) symbolizes the working of the mind (*ingenium*) before the artist executes his work: true art was considered to be the result of *ingenium*, *doctrina* (the rules of art) and *exercitatio* (correct execution). Striking chiaroscuro effects are used with excellent results in biblical scenes of 1627–9: *David with the Head of Goliath before Saul* (1627; Basle, Kstmus.; Br. 488), with a touch of Lastman's *Coriolanus*; the *Presentation in the Temple* (Hamburg, Ksthalle; Br. 535); and *Judas Returning the Pieces of Silver* (1629; Mulgrave Castle, N. Yorks; Br. 539A). Huygens saw this last painting when he visited Rembrandt's studio and praised it warmly, especially the pose of the repentant figure of Judas.

Huygens's autobiographical notes provide the first critical comment on the two Leiden artists. He praised Rembrandt's liveliness and taste and Lievens's bold approach, as reflected in the format of their works: Lievens painted on large canvases, while Rembrandt preferred small, concentrated scenes. This observation applies to their different personal interpretations of the same subject. Thus Rembrandt's *Samson and Delilah* (1628; Berlin, Gemäldegal.; Br. 489) looks insignificant beside Lievens's version with life-size figures (Amsterdam, Rembrandthuis). Similarly there are two versions of *St Paul at his Desk*, both from *c.* 1629–30, a small one by Rembrandt (Nuremberg, Ger. Nmus.; Br. 602) and a large one by Lievens (Bremen, Ksthalle). In the case of a third 'pair' of similar subjects, only Rembrandt's version has survived: the *Rape of Proserpine* (Berlin, Gemäldegal.; Br. 463), while that of Lievens is known only from a document of 1632 describing it as 'a large piece' in Frederick Henry's collection. This form of healthy competition between two artists was known as *aemulatio*.

Tronie was the name given to a new type of painting evolved by Rembrandt and Lievens in the Leiden studio. The models (who might be friends, relatives or the painters themselves) were dressed in exotic garments, with a turban or an ornamental cap and a golden necklace or the like. In inventories these paintings, a compromise between portraits and history pieces, were given such titles as 'A handsome young Turkish prince' or 'Head of a woman wearing an Oriental headdress' (RD 1637/4). The earliest example is the *Man Wearing a Plumed Beret and Armoured Neckpiece* (*c.* 1626–7; ex-Thyssen-Bornemisza Col., Lugano; Br. 132). Among the *tronies* in Amsterdam collections in 1628–9 may have been a *Self-portrait* (perhaps that now in Amsterdam, Rijksmus., A 4691). In such works Rembrandt experimented with different poses and expressions, as in the *Self-portrait with an Open Mouth* (1629; Munich, Alte Pin.; Br. 2), the *Self-portrait with a Feathered Cap* (Boston, MA, Isabella Stewart Gardner Mus.; Br. 8) or the *Self-portrait with Armoured Neckpiece* (The Hague, Mauritshuis; Br. 6). Rembrandt also apparently used his father and mother as models, for example in the *Old Man in a Fur Hat* (Innsbruck, Tirol. Landesmus.; Br. 76) and the *Old Woman Praying* (Salzburg, Residenzgal.; Br. 63). Many *tronies* attributed to Rembrandt over the years have proved after careful investigation not to be by his own hand; documents show that they were often copied by pupils in his studio. It is now even thought that Rembrandt may possibly have signed the pupils' versions merely as a kind of guarantee that they had come from his studio.

In his last years in Leiden (1629–31) Rembrandt painted biblical scenes or representations of single

figures in which dramatic lighting is the chief common element. *David Playing the Harp before Saul* (Frankfurt am Main, Städel. Kstinst.; Br. 490) is unfortunately heavily overpainted but may once have been as effective as the excellently preserved *Jeremiah Lamenting the Destruction of Jerusalem* (1630; Amsterdam, Rijksmus.; Br. 604). Another single figure is the *Prophetess Hannah Reading the Bible* (Amsterdam, Rijksmus.; Br. 69), where the model is again thought to have been Rembrandt's mother. In 1630 and 1631 Rembrandt was evidently carrying on a kind of visual dialogue with Lievens as to the best way of depicting the *Raising of Lazarus* (e.g. Rembrandt's version, Los Angeles, CA, Co. Mus. A.; Br. 538). The high-point of Rembrandt's Leiden period is the *Presentation in the Temple* (1631; The Hague, Mauritshuis; Br. 543). This multi-figured history piece in the style of Lastman combines the latter's attention to detail and thorough composition with Rembrandt's own powerful means of expression, the concentrated fall of light that dramatically illuminates the main figures.

(ii) Drawings. One function of the art of drawing that Rembrandt no doubt learnt from Lastman was that of making preliminary studies in red or black chalk for figures in paintings. These were drawn from the living model. The *Standing Archer* (Dresden, Kupferstichkab.; Ben. 3) is a fairly elaborate study for such a figure in the painting of *David with the Head of Goliath before Saul* (Br. 488) of 1627 and is thus Rembrandt's earliest datable drawing. A drawing in red and black chalk of a *Seated Old Man with a Book* (Berlin, Kupferstichkab.; Ben. 7) is a detailed study for *SS Peter and Paul (?) in Dispute* (c. 1628; Melbourne, N.G. Victoria; Br. 423), and another sheet (Amsterdam, Rijksmus.; Ben. 9) bears on one side a detailed study in red chalk of a woman's legs for the *Samson and Delilah* (Br. 489) and on the other a compositional sketch in pen and brush for *Judas Returning the Pieces of Silver* (Br. 539A). There is also a sketch for this work in black chalk (Rotterdam, Mus. Boymans–van Beuningen; Ben. 6) on the *verso* of a sheet with an elaborate study for a *Raising of the Cross* (which was never painted).

These sketches for *Judas Returning the Pieces of Silver* may have given Rembrandt the idea of making an independent pen-and-brush drawing (not a preliminary study) of a *Seated Old Man* (Paris, Louvre; Ben. 49). It is often difficult to be sure of the precise function of drawings by Rembrandt, owing to their great variety and the lack of further documentation.

Rembrandt also drew self-portraits around 1629 (e.g. Amsterdam, Rijksmus., Ben. 54; London, BM, Ben. 53); these anticipate the etchings depicting facial expressions (e.g. B. 13) and may have been drawn in connection with the painted *Self-portrait at The Hague* (Br. 6). Drawings from life also took the form of various studies of popular types, beggars and artisans, generally in black (sometimes red) chalk (e.g. Ben. 12, 22, 30, 31, 32, 45, 46 and 196); these can be dated c. 1629 on the basis of watermarks. Rembrandt's interest in these humble folk (not to be confused with social compassion) was one that he shared with Jacques Callot, and the style of drawing with long strokes of hatching is borrowed from the latter's popular print series *Les Gueux* (1622). Rembrandt used these studies of peasants in paintings as well as etchings, the earliest of which (B. 162) is really a sketch drawn with an etching needle on the copperplate. A drawn study of Rembrandt's father as a blind old man (Oxford, Ashmolean; Ben. 56) was turned into a posthumous portrait when the father died in 1630.

(iii) Etchings. Rembrandt made his first etching c. 1626, the *Rest on the Flight into Egypt* (B. 59). The composition of this early experiment was borrowed from an engraving of the subject by Lucas van Leyden (c. 1506; B. 38). It was, of course, no accident that Rembrandt sought inspiration from his 16th-century fellow townsman, who was renowned for his prints. Two small portraits of Rembrandt's mother, executed in 1628, show a development from a more linear style (B. 352) to one that is more tonal (B. 354), the latter being partly achieved by the careful use of drypoint. In 1630–31 Rembrandt made great progress with the etching needle and showed much enthusiasm for this medium; he never again produced so much in

such a short period. He achieved powerful chiaroscuro effects in two small biblical scenes (both 1630), *Christ among the the Doctors* (B. 66) and the *Presentation in the Temple* (B. 51), which evidently prompted his painted version of the latter theme dating from the following year (Br. 543). An undated etching of this period, the *Raising of Lazarus* (c. 1632; B. 73), is the impressive result of a search for the right composition and dramatic effect. It embodies figures from Rembrandt's painting (Br. 538) and from a drawn copy (London, BM; Ben. 17) after an etching by Jan Lievens (1630; B. 3), in which he transformed a scene of the Raising of Lazarus into an *Entombment of Christ.*

Etchings for which Rembrandt himself posed were intended not so much as self-portraits but as studies of expression. In the only etching dated 1629, a *Self-portrait* (B. 338) of which two impressions exist (Amsterdam, Rijksmus., and London, BM), he used a coarse needle that produced a double line, as if in imitation of a drawing in chalk. The infinite range of tones that could be rendered using a fine etching needle was successfully demonstrated in four self-portraits of 1630: one shown frowning, with a wrinkled brow (B. 10), one with his mouth open, as if shouting (B. 13), one laughing (B. 316) and one surprised, with wide-open eyes and pursed lips (B. 320). Only in 1631 did he attempt a more formal etched *Self-portrait* (B. 7), clearly imitating Rubens's painted *Self-portrait* (Windsor Castle, Berks, Royal Col.), which was engraved by Paulus Pontius in 1630. After many designs and proofs, Rembrandt's etching achieved its final form only in 1633 (*see* §3(ii) below). The only genuine portrait etchings of 1631 are those of his mother (B. 348 and 349), although these too could still be regarded as *tronies.* From 1630 onwards 'picturesque' old men posed for Rembrandt: a bald one (B. 292 and 294), a man with a broad white beard (B. 260, 309, 315 and 325), and a man thought to be the artist's father (B. 304 and 263). The last of these is dated 1631, which would make it a posthumous portrait. Rembrandt's interest in popular types, aroused by Callot's prints, was also expressed in a series of etchings of beggars (B. 162–6, 168, 171–4, 179, 182–4) and small genre scenes such as the *Man*

Making Water and *Woman Defecating* (B. 190–91), the *Blind Fiddler* (B. 138) and *Man with a Hurdy-gurdy* (B. 140), all bearing the date 1631 or executed in that year.

3. Early established career in Amsterdam, late 1631–c. 1640

At the end of 1631 Rembrandt left Leiden for Amsterdam, abandoning, once and for all, the staid university town for the bustling commercial centre. Earlier that year he had invested money in van Uylenburgh's art dealing business, and he now came to live in the latter's house, where in 1632 he was, in his own words, 'thank God, in good condition and in good health' (RD 1632/2). For at least two and a half years, and probably longer, Rembrandt, who was by then nearly 30, worked for the art dealer, who obtained portrait commissions for him and in whose 'academy' or studio he worked as a kind of tutor. There he must also have met van Uylenburgh's niece Saskia (1612–42), the daughter of Rombartus van Uylenburgh, a former mayor of Leeuwarden. An orphan from the age of 12, she lived alternately with her relations in Friesland and Amsterdam. Rembrandt made an appealing silverpoint portrait of her (Berlin, Kupferstichkab.; Ben. 427), which is inscribed (in Dutch): *This was made when my wife was 21 years old, the third day after our betrothal—the 8th of June 1633.* The wedding took place on 22 June 1634 in the parish church of St Anna in Friesland. Thereafter the young couple lived with Saskia's uncle Hendrick, until they sought their own home when their first child, Rumbartus, was expected. The infant was baptized on 15 December 1635 but lived only two months. In February 1636 the couple was living in the Nieuwe Doelenstraat (now Nos 16/18); in 1637 they moved to a nearby house on the Binnen Amstel (until recently No. 41, Zwanenburgerstraat), where a daughter, Cornelia, was born in 1638 but lived only two weeks. On 3 January 1639 Rembrandt bought the house next door to Hendrick van Uylenburgh. Their third child, also named Cornelia, was born in August 1640; she too lived only two weeks. Baptismal records suggest that it was mainly Saskia's family and their relations by marriage who played an

important part in the couple's social life. Rembrandt seems to have lost almost all contact with his family in Leiden. His mother did not attend his wedding, though he did make one more portrait of her (1639; Vienna, Ksthist. Mus.; Br. 71) before she was buried in Leiden on 14 September 1640. A year later, on 22 September 1641, Rembrandt's and Saskia's son Titus van Rijn was baptized in the Zuiderkerk, Amsterdam. By 1641 Rembrandt was one of the leading painters in Amsterdam, and his fame had spread abroad as well. The English traveller Peter Mundy described him as an outstanding painter (RD 1640/16), and in Garzoni's *Piazza universale* (Frankfurt am Main, 1641) he is mentioned as one of the principal etchers of the time (RD 1641/10).

(i) **Paintings.** The association with Hendrick van Uylenburgh brought about a radical change in Rembrandt's activity. Van Uylenburgh's customers could order portraits and buy paintings at all prices, both 'principals' and 'copies'. The studio assistants would copy Italian paintings or *tronies* by Rembrandt. Besides supervising this work, Rembrandt himself painted pictures on commission, chiefly portraits. The painting of history subjects, his real ambition, was temporarily pushed into the background, and he had scarcely any time for etching. During his period with van Uylenburgh he painted some 50 portraits—on the average, about one a month.

(a) Portraits. In 1631 Rembrandt painted a *Portrait of an Old Man with a Plumed Cap* (Chicago, IL, A. Inst.; Br. 81) in the style of the Leiden *tronies*; the sitter wears an ample cloak, a gold chain and an armoured neckpiece. It was only a short step in Rembrandt's development between this large half-length figure and his first real commissioned portrait, that of *Nicolaes Ruts* (New York, Frick; Br. 145). Ruts, a friend of van Uylenburgh, was a Baptist merchant, whom the artist decked out in a fur cloak and cap in allusion to his trade with Russia. It must also have been through van Uylenburgh that Rembrandt received the important commission for a group portrait of the Amsterdam surgeons' guild, known as the *Anatomy Lesson of Dr Nicolaes Tulp* (The Hague,

Mauritshuis; Br. 403; see col. pl. XXX). It is remarkable that a newcomer was selected for the work instead of experienced painters such as Thomas de Keyser and Nicolaes Eliasz. Pickenoy, who had already proved themselves in this genre. As a history painter, Rembrandt knew how to tell a story, and he justified the choice with a composition that broke with all existing traditions. Bright light falls on the demonstrating hands of Dr Tulp, who commands the complete attention of his audience; the painting, in fact, commemorates the first lessons in dissection by the guild's new Praelector, which were given in January 1632.

Rembrandt did not always strive to make innovations in portraiture: presumably his customers' wishes did not always permit this. When required, he painted in a traditional style, as in the portrait of *Marten Looten* (Los Angeles, CA, Co. Mus. A.; Br. 166), which was executed in January 1632, before the *Anatomy Lesson*. Sometimes only the details vary from picture to picture: a different collar, a hat or no hat, an attribute held in the hand. The portrait of *Joris de Caullery* (San Francisco, CA, de Young Mem. Mus.; Br. 170) shows a three-quarter-length figure whose pose is copied in another painting, the *Standing Man in Oriental Costume* (1632; New York, Met.; Br. 169), where it is unclear whether the main subject is the individual or his exotic clothing.

In 1632–3 Rembrandt painted a succession of smaller, hence cheaper, bust portraits of anonymous sitters, such as the *Portrait of a Young Man with Flushed Cheeks* (Sweden, priv. col.; Br. 155) and the *Portrait of an 83-year-old Woman* (London, N.G.; Br. 343), as well as some of Amsterdam sitters whose names are known. Production continued similarly in 1634–5 with, among others, the portrait of *Dirck Jansz. Pesser* (Los Angeles, CA., Co. Mus. A.; Br. 194) and that of his wife *Haesje Jacobsdr. van Cleyburg* (Br. 354), a run-of-the-mill portrait bought by the Rijksmuseum in 1985 for a sum that had previously been paid only for works of the first class. In 1632 Rembrandt also painted two companion portraits of his friends *Maurits Huygens* (Hamburg, Ksthalle; Br. 161) and the painter *Jacob de Gheyn III* (London, Dulwich Pict. Gal.; Br. 162), which moved Maurits's brother

Constantijn to write a satirical poem concerning their similarity. Perhaps indeed Rembrandt was less than inspired by this commission, the successor of so many others.

There were also, however, commissions that did give more scope to his talent. For instance, in 1633 an unidentified couple (probably newly married) was commemorated in two portraits: the *Portrait of a Man Rising from his Chair* (Cincinnati, OH, Taft Mus.; Br. 172) and the *Portrait of a Woman with a Fan* (New York, Met.; Br. 341); here the husband, as it were, presents his young wife to the spectator. Action in a portrait was unusual, but it is the most striking feature of the double portrait of *Jan Rijcksen and his Wife Griet Jans* (London, Buckingham Pal., Royal Col.; Br. 408), where the shipbuilder's wife seems to be rushing into the room to hand him a letter. Original as this may seem, there was a precedent in Thomas de Keyser's painting of *Constantijn Huygens and his Clerk* (1627; London, N.G.). Rembrandt's growing fame as a portraitist brought important commissions in 1634, the year he painted, among others, a full-length, life-size portrait of the preacher *Johannes Elison* and one of his wife *Maria Bockenolle* (both Boston, MA, Mus. F.A.; Br. 200 and 347), as well as pendants of the prosperous merchant *Maerten Soolmans* and his wife *Oopjen Coppit* (both Paris, heirs of Baron A. de Rothschild; Br. 199 and 342). These portraits, the largest he ever painted, must have brought him in a good deal of money.

In Rembrandt's self-portraits dating from 1630–35 (e.g. Br. 17–19) the successful painter gazes out in a serious, self-confident way. In the famous double portrait traditionally thought to represent *Rembrandt and Saskia* (Dresden, Gemäldegal. Alte Meister; Br. 30), he appears to be raising a glass to his own personal and material good fortune, but the scene is, of course, also an allusion to the story of the Prodigal Son; it is set in a tavern, and Saskia plays the role of a courtesan. In the early years of their marriage Rembrandt often painted his young wife in sumptuous garments hung with jewels (e.g. Kassel, Schloss Wilhelmshöhe; Br. 101, and as Flora, the goddess of spring and fertility (e.g., 1634, St Petersburg, Hermitage, Br. 102; and 1635, London,

N.G., Br. 103). During those years he also painted *tronies*, children and bearded men, and a young woman who was formerly identified as his sister (Stockholm, Nmus.; Br. 85). She may have been the wife of Hendrick van Uylenburgh, who had once posed for the 'head of a woman wearing an oriental headdress' (RD 1637/4).

(b) History subjects. Rembrandt was also able occasionally to pursue his favourite 'historical' subjects: episodes from Classical antiquity and the Bible. Moreover, during the 1630s he was occupied with an important commission from the Stadholder for a series of scenes of the *Life of Christ*. Evidently he secured this commission without difficulty. At the end of the 1620s the court had already acquired some of his pictures, and in 1632 he painted a portrait of Frederick Henry's wife, *Amalia von Solms* (Paris, Mus. Jacquemart-André; Br. 99). Following Rubens's *Crucifixion* (Antwerp, Kon. Mus. S. Kst.), of which Paulus Pontius made an engraving in 1631, Rembrandt painted in *aemulatio* a similar work in the same year (Le Mas d'Agenais, nr Bordeaux, parish church; Br. 543A), as did Jan Lievens (Nancy, Mus. B.-A.). In 1632 and 1633 Rembrandt executed two works in the same arched format, possibly intended as pendants, the *Raising of the Cross* and the *Descent from the Cross* (both Munich, Alte Pin.; Br. 548 and 550), both of which were purchased by Huygens for the Stadholder. To mark this honour, Rembrandt's assistant Jan Jorisz. van Vliet made an engraving (B. 81) after the *Descent from the Cross*. A privilege for the print, which measures over 500 mm, was obtained in 1633, and it was published by Hendrick van Uylenburgh. Rembrandt took a very personal view of the event in his painted composition: he gave his own features to one of the secondary figures and depicted Christ's body as a grey, limply falling mass. The Stadholder, in any case, was so pleased with his acquisitions that he commissioned three more scenes from the artist: an *Entombment*, a *Resurrection* and an *Ascension* (all Munich, Alte Pin.; Br. 560, 561 and 557). The negotiations led to a correspondence between Rembrandt and Huygens (Gerson, 1961), from which seven of the painter's letters have survived (Feb 1636–Feb 1639):

they show, among other things, how conscientiously he approached his task. He began on the *Resurrection* in the course of 1634 and wrote two years later that it was 'more than half finished' (RD 1636/1); the *Ascension* was then ready for delivery. On 12 January 1639 he reported that the *Resurrection* was at last completed 'with industrious care' and that the delay was because he had endeavoured to express in it 'the deepest and most lifelike emotion' (RD 1639/2). Another reason was evidently that he had hesitated between the biblical text (Matthew 28: 3–4) and pictorial tradition, the result being a compromise. In 1639 Rembrandt was paid 600 guilders for each painting; this was by no means prompt, but he later received further commissions from the Stadholder (*see* §4(i) below).

The 1630s are regarded as Rembrandt's most 'Baroque' period, with particular reference to his history paintings. Exceptional in both format and subject is the *Christ in a Storm on the Sea of Galilee* (1633; ex-Isabella Stewart Gardner Mus., Boston, stolen 1990; Br. 547). Rembrandt never painted the marine views that were so popular in the northern Netherlands, and it was presumably the customer who requested this unusual subject and also dictated its enormous size. Houbraken praised the work for its convincing representation of the frightened apostles. The boat, out of control amid the swirling waves, was probably borrowed from a print by Adriaen Collaert after Marten de Vos. Still greater in size is the *Holy Family* (163[?]4; Munich, Alte Pin.; Br. 544), which once belonged to Oopjen Coppit (RD 1660/8), the subject of Rembrandt's portrait of 1634 (Br. 342). Her first son was born in that year, and she may have commissioned this 'Flemish'-style Virgin and Child with St Joseph on that occasion. Rembrandt also painted a few large uncommissioned works, for instance the *Sacrifice of Isaac* (1635; St Petersburg, Hermitage; Br. 498), with its life-size figures. He was certainly acquainted with and may have possessed a similar work by Lievens. He borrowed the figure of the naked Isaac from Rubens, himself adding the dramatic touch of the knife flying through the air. However, he was not satisfied with the composition (in particular the position of the angel), so he reworked it in a drawing

(London, BM; Ben. 90). A pupil then executed this revised version of the composition in oils (Munich, Alte Pin., 438), and the master was so pleased with the result that he commended it with the inscription *Rembrandt. Altered and repainted. 1636*. Another dramatic moment is depicted in *Belshazzar's Feast* (London, N.G.; Br. 497), which shows Belshazzar turning around abruptly as the writing appears on the wall. Of the same period (c. 1635) is *Samson Threatening his Father-in-law* (Berlin, Gemäldegal.; Br. 499), where the action is concentrated in Samson's raised fist. In general, what Rembrandt owed to the Flemings and especially to Rubens was the animation and audacity of his compositions. The most striking example is probably the *Blinding of Samson* (Frankfurt am Main, Städel. Kstinst.; Br. 501; see fig. 44), which has been compared with the tortures and other bloody scenes of saints' lives in works by Rubens. The struggling, half-naked figure of Samson is thought to derive from Rubens's *Prometheus Bound* (c. 1611/12–18; Philadelphia, PA, Mus. A.), which between 1618 and 1625 (or later) could be seen in the collection of Sir Dudley Carleton, the English ambassador at The Hague. It was previously thought that the *Blinding of Samson* was the picture Rembrandt presented to Huygens in recognition of his taste for Rubens and in gratitude for his influence with the Stadholder, but this is by no means certain.

Rembrandt abandoned this 'dramatic' style after the *Blinding of Samson*. Painted on a large scale but much more intimate in character is the *Danaë* (1636; St Petersburg, Hermitage; Br. 474; see col. pl. XXXI), arguably the most impressive nude to be found in 17th-century history painting. With this work he continued a series of mythological scenes that initially were small in size and as a rule had many figures: the *Rape of Europa* (1632; New York, priv. col.; Br. 464) and *Diana and Actaeon and the Discovery of Callisto's Pregnancy* (1635; Anholt, Fürst Salm-Salm, Mus. Wasserburg Anholt; Br. 472). Although in preparation for this work Rembrandt studied Italian prints (by Antonio Tempesta and others), a Classical story has seldom been treated so unclassically as in the cluster of wrestling nymphs surrounding Callisto. The same

44. Rembrandt van Rijn: *Blinding of Samson*, 1636 (Frankfurt am Main, Städelsches Kunstinstitut)

can be said of the *Rape of Ganymede* (Dresden, Gemäldegal. Alte Meister; Br. 471), where Jupiter in the form of an eagle carries off the small boy, who weeps and screams and urinates out of fright. Rembrandt was no doubt inspired here by an actual occurrence; he had in the past seen and drawn a small boy struggling and screaming in this fashion (Berlin, Kupferstichkab.; Ben. 401).

Besides the enormous 'Flemish' canvases of biblical subjects from the 1630s, Rembrandt also painted smaller religious scenes of more conventional Dutch dimensions, for which Lastman's work, in particular, offered a renewed source of inspiration. These cabinet pictures seem to have been especially appreciated in Rembrandt's own day. Lastman died in 1633, and not long afterwards Rembrandt drew fluent copies of several of his

paintings (Ben. 446–9). In his drawing of *Susanna and the Elders* (Berlin, Kupferstichkab.; Ben. 448) after Lastman's original (Berlin, Gemäldegal.), Rembrandt altered the pose of the naked Susanna; he then made a painting of this revised version (1636; The Hague, Mauritshuis; Br. 505), in which Susanna's chaste attitude is that of the Classical statue of *Venus pudica*. The formula of a multi-figured history in the style of Lastman is fully exploited in *John the Baptist Preaching* (c. 1634; Berlin, Gemäldegal.; Br. 555), a grisaille that was probably a design for a print that was never executed. Another such design is the grisaille, or rather brunaille, of *Joseph Recounting his Dreams* (Amsterdam, Rijksmus.; Br. 504). It is executed in oil on paper—a fragile substance, indicating that the painting was not intended for sale. The figure

of Jacob in the brunaille is based on an earlier study in black and red chalk of a *Bearded Man in an Armchair* (1631; Paris, A. Delon priv. col.; Ben. 20) from Rembrandt's Leiden period. Another detail of the oil sketch appears in a preparatory drawing of a *Sleeping Dog* (Boston, MA, Mus. F.A.; Ben. 455), which was also used in an etching of *c*. 1640 (B. 158). However, the brunaille dates from towards the mid-1630s, as the composition and some of the figures were repeated in the etching of *Joseph Recounting his Dreams* of 1638 (B. 37). Another painting in oil on paper is the *Ecce homo* (London, N.G.; Br. 546), of which Rembrandt's assistant Jan Jorisz. van Vliet made a large reproductive print (B. 77). The inscription *Rembrandt f. 1636 cum privile[gio]* means only that Rembrandt designed the composition. Of the monochrome paintings of this period, one occupies a special place, the *'Concord of the State'* (Rotterdam, Mus. Boymans–van Beuningen; Br. 476). The title, which appears in the inventory of Rembrandt's possessions made in 1656 (*see* §5 below), has never been satisfactorily explained. Technical examination has shown that it is not a completed study for an etching, like the grisailles, but is a modello, a design for a presumably unexecuted painting. Moreover, it must date from before 1640 rather than after, as was always thought, since the panel is from the same tree as the so-called portrait of the *Polish Ambassador Andrzej Rej* (1637; Washington, DC, N.G.A.; Br. 211). The use of oil sketches as preparatory studies for paintings and etchings, the practice of employing numerous assistants (who, *inter alia*, made copies for sale) and the dissemination of the work by means of reproductive prints, which might be patented—all these conventions were introduced to the northern Netherlands by Rembrandt in conscious imitation of Flemish practice and that of Rubens in particular.

After 1636, as Rembrandt paid increasingly less attention to Flemish models and reverted to biblical cabinet pieces in the style of Lastman, he frequently drew inspiration from the apocryphal book of Tobit, with its moralizing tone and many human incidents, such as the *Angel Leaving Tobit and his Family* (1637; Paris, Louvre; Br. 503). For

this he borrowed the winged, departing angel from an engraving after Maarten van Heemskerck. This is one of the most often quoted indications of Rembrandt's thorough knowledge of early prints. Narrative material was supplied not only by the Bible but by pictorial tradition. Borrowings from old prints can also be seen in *The Visitation* (1640; Detroit, MI, Inst. A.; Br. 562). This is one of the high-points of the period, along with the *Noli me tangere* (1638; London, Buckingham Pal., Royal Col.; Br. 559), which prompted the poet Jeremias de Decker to exclaim: 'Your masterly strokes, friend Rembrandt, I first detected in this panel' (RD 1660/25). Also painted in the same year was the *Wedding of Samson* (1638; Dresden, Gemäldegal. Alte Meister; Br. 507). In 1641 Philips Angel, at a meeting of the Leiden painters' guild, praised this work as a model of history painting and the 'fruit of a most natural and well-trained understanding, thanks to careful study of the History and intelligent reflection on its meaning' (*Lof der schilderkonst*, 1642; RD 1641/5).

(c) *Landscapes*. A separate chapter in Rembrandt's painting is formed by a small group of landscapes from the second half of the 1630s, for example the *Landscape with the Good Samaritan* (1638; Kraków, Czartoryski Found.; Br. 442). In this work especially, the biblical theme is quite secondary and the emphasis is on the freakish scene and eerie atmosphere: this is most reminiscent of the work of Hercules Segers, whose landscapes Rembrandt admired and collected. Through Segers, the Flemish fantasy landscape of the early 17th century inspired Rembrandt's *Landscape in a Thunderstorm* (Brunswick, Herzog Anton Ulrich-Mus.; Br. 441), the romantic appearance of which recalls the history pieces of his 'Baroque' period. It is almost completely absent from his drawings and etchings, which after 1640 depict only realistic Dutch landscapes.

(ii) *Etchings*. Owing to the many portrait commissions during this period, Rembrandt's production of etchings fell off abruptly. There are only three prints dated 1632: *St Jerome Praying* (B. 101), the *Rat-poison Peddler* (B. 121) and *The Persian* (B. 152). In 1633 the (unusual) extended signature

Rembrandt inventor et fecit appeared on two etchings, the *Flight into Egypt* (B. 52) and the *Good Samaritan* (B. 90). At that time Rembrandt also completed, in a tenth state, the *Self-portrait* begun in 1631 (B. 7) and made a portrait of the preacher *Jan Cornelis Sylvius* (B. 266), Saskia's guardian and a family friend, of whom he also later etched a posthumous portrait in 1646 (B. 280). (A comparison of these two portrait etchings shows what enormous technical progress Rembrandt made within ten years or so.) In 1634, the year of his marriage, he etched a portrait of *Saskia with a Pearl Necklace in her Hair* (B. 347) and himself dressed up picturesquely with fantastic cloaks, a plumed cap and a sword (B. 18 and 23). The prints of that year were very elaborate, whether small, such as *Joseph and Potiphar's Wife* (B. 39), *Christ and the Woman of Samaria* (B. 71) and *St Jerome and the Lion* (B. 100), or much bigger, as in the *Annunciation to the Shepherds* (B. 44). In this latter masterpiece he achieved as early as 1634 the 'most lifelike emotion' which, as he said in 1639, he had striven after in the *Life of Christ* series. Other works full of movement are *Christ Driving the Money-changers from the Temple* (B. 69), in which the figure of Christ is taken from a woodcut by Dürer, and the *Stoning of St Stephen* (B. 97), both of 1635. In that year Rembrandt also etched the portrait of the Remonstrant preacher *Johannes Wttenbogaert* (B. 279) and the '*Great Jewish Bride*' (B. 340), a subject still unexplained (?portrait, allegory or biblical scene). The four 'oriental' heads (B. 286–9) are to be compared with the painted *tronies*: they were based on four etchings by Jan Lievens, which Rembrandt amended or 'retouched', as the inscription says, by way of *aemulatio*.

Between 1636 and 1640 the number of etchings gradually diminished, but not their quality. The series of self-portraits was continued with a print in 1636 that also included Saskia (B. 19) and one in 1638 in which Rembrandt wears a beard and a feathered cap; it culminated in 1639 with the famous *Self-portrait Leaning on a Stone Sill* (Haarlem, Teylers Mus.; B. 21). The direct model for this was Titian's *Portrait of a Man* ('*Ariosto*', c. 1510–15; London, N.G.), which Rembrandt had seen in an Amsterdam collection. In this way he compared himself with a famous painter and a Renaissance poet as well (*ut pictura poesis*). Portraits of others were rare in this period, except for the Portuguese–Jewish theologian *Samuel Menasseh Ben Israel* (B. 269), depicted with great clarity and accuracy. In the same 'sketchy' style, using the etching needle as if it were a pencil, he produced the *Studies of the Head of Saskia and Others* (1636; B. 365) and *Studies of the Heads of Three Women, One Asleep* (1637; B. 368). The clear linear approach also prevailed in biblical scenes, as in the *Return of the Prodigal Son* (1636; B. 91), the composition and details of which are borrowed from a print after Maarten van Heemskerck, and in *Jacob Caressing Benjamin* (c. 1637; B. 33). This is also the case with *Adam and Eve* (1638; B. 28), based on a model by Dürer, and *Joseph Recounting his Dreams* (B. 37). Also purely linear in conception is *Death Appearing to a Newly Wedded Couple* (B. 109), with reminiscences of the medieval Dance of Death. The high-point of this development was reached with the *Death of the Virgin* (1639; B. 99), a very large etching (409×315 mm) in which, along with bright areas, patches of contrasting shadow were introduced with drypoint in several later impressions.

In the 1640s Rembrandt concentrated increasingly on tonal effects, especially in landscapes. However, the earliest landscape etchings, of c. 1640, were still very pure of line and almost without shadows: for example the *View of a House and Trees beside a Pool* ('*Small Grey Landscape*'; B. 207) and the *View of Amsterdam from the North-west* (B. 210).

(iii) **Drawings.** In both style and technique, Rembrandt's drawings were always adapted to the function of the drawing. At the same time that he executed the refined silverpoint portrait of *Saskia* on the occasion of their engagement, he made a rapid sketch of *Saskia Looking out of a Window* (Rotterdam, Mus. Boymans–van Beuningen; Ben. 250) with the pen and brush. The first of these is a portrait, the other a fleeting impression or genre scene. Independent drawings are very rare: one exception is the portrait of *(?)Willem Jansz. van*

der Pluym (1634; New York, Mrs C. Payson priv. col.; Ben. 433), drawn in red and black chalk on parchment, with accents in pen and brush throughout. It is signed and dated in full, *Rembrandt. f. 1634*, but such signatures are infrequent, since the drawings were often made for Rembrandt's own use. In many cases it is difficult to attribute or date them. Comparison with dated works does not always provide the answer, as Rembrandt drew so much for his own pleasure, and using them as documents of his personal life is also often misleading. The many drawings of children that he made in the 1630s have frequently and incorrectly been identified as representing his own children. For example, a pen-and-brush drawing of a *Woman Carrying a Child Downstairs* (*c.* 1636; New York, Pierpont Morgan Lib.; Ben. 313) was previously entitled *Saskia with Rumbartus*, and the *Portait of a Boy* (Stockholm, Nmus.; Ben. 440) was also supposed to have represented the same first-born son (who lived only two months). In general, the children in Rembrandt's drawings are too old to be identified with those that died in infancy, as is the case, for instance, of those depicted in the *Studies of a Woman and Children* (Paris, Fond. Custodia, Inst. Néer.; Ben. 343), the *Woman with a Child and a Dog* (Budapest, Mus. F.A.; Ben. 411) and all other sheets with toddlers crawling, walking or playing.

On the other hand, some pen-and-wash drawings of a woman in bed probably do represent Saskia when pregnant in 1638 (e.g. Amsterdam, Rijksmus., Ben. 404; Dresden, Kupferstichkab., Ben. 255) and in 1640 or 1641 (Paris, Fond. Custodia, Inst. Néer.; Ben. 426). It sometimes seems that Rembrandt reserved a vigorous, sketchy style for drawings from life, but this is not always true either. He used this style for the sheet with *Two Women Teaching a Child to Walk* (Paris, Fond. Custodia, Inst. Néer.; Ben. 391) as well as for the *Study for an Adoration of the Magi* (Amsterdam, Rijksmus.; Ben. 115), both of *c.* 1635. The latter is partly borrowed from a print after Rubens, as was the *Standing Oriental* (London, BM; Ben. 207), though this also resembles a realistic portrait. Something similar is the case with his numerous drawings of actors in the 1630s: *Pantaloon* (Hamburg, Ksthalle; Ben. 296) seems to have been drawn from the wings of a stage, but there is also a version of the same actor (Groningen, Groninger Mus.; Ben. 295) that is clearly derived from a print by Jacques Callot. A few drawings, for instance *Willem Bartolsz. Ruyters as Bishop Goswin* (Chatsworth, Derbys; Ben. 120), are of known actors in Joost van den Vondel's play *Gijsbrecht van Amstel*, which was first performed at Amsterdam on 3 January 1638. Rembrandt's drawings are generally variations on a theme rather than actual preliminary studies: thus the drawing of *Joseph's Coat Shown to Jacob* (Berlin, Kupferstichkab.; Ben. 95) is a more detailed study of a scene that he had already depicted in an etching (B. 38). Such a direct preliminary study as that (Stockholm, Nmus.; Ben. 292) for the *'Great Jewish Bride'* is the exception rather than the rule.

Very rare, too, are fully worked-up drawings; it is not clear whether a sheet such as *Christ among his Disciples* (1634; Haarlem, Teylers Mus.; Ben. 89) was intended as a modello or for sale. Unelaborated drawings, some without wash, such as *Venus and Mars in Vulcan's Net* (Amsterdam, Hist. Mus.; Ben. 540), the *Prodigal Son in a Brothel* (Orléans, Mus. B.-A.; Ben. 528a) and *Samson and Delilah* (Groningen, Groninger Mus.; Ben. 530), all of *c.* 1635, were also intended as independent works, the almost stenographic style appearing to be an end in itself. But the pen could also be used for more detailed drawings, such as the sheet inscribed *Drommedaris. Rembrandt fecit. 1633. Amsterdam* (ex-Ksthalle, Bremen; ?destr. World War II; Ben. 453). At other times he used the brush and lavish washes to convey strong contrasts of light and dark in simple pen drawings, as in the *Farm in Sunlight* (Budapest, Mus. F.A.; Ben. 463).

Rembrandt continued to use red or black chalk for preparatory figure studies, as he had done in the 1620s, but he also adopted the medium for studies 'from life', for studies of animals and for copies. Examples in red chalk include *Saskia with a Child* (U. London, Courtauld Inst. Gals; Ben. 280a) and the studies of *Children Learning to Walk* (London, BM; Ben. 421 and 422); among the sheets in red and black chalk is *Two Horses at a Halting-place* (Amsterdam, Rijksmus.; Ben. 461). The black-chalk drawing of an *Elephant* (1637; Vienna,

Albertina; Ben. 457; see fig. 45) is exceptional in being signed and dated. Chalk was also used for the copies after paintings by Lastman (Ben. 446–9) and for two copies after Leonardo's famous *Last Supper* in S Maria delle Grazie in Milan, of which Rembrandt must have owned an engraving. The first copy (New York, Met.; Ben. 443) was set down carefully with a thin piece of red chalk, closely following the original composition; but Rembrandt was then dissatisfied with its stiff symmetry. So with another, broader piece of chalk he worked away the constructed perspective and rearranged certain figures in order to produce an effect of emotional movement among the apostles, with Christ as the dramatic centre. In the second copy, also in red chalk (London, BM; Ben. 444, preserved as a fragment), he sought new poses for the apostles. He concluded his analysis of Leonardo's composition in a drawing in pen and ink (1635; Berlin, Kupferstichkab.; Ben. 445), the most important effect of which is the deliberately asymmetrical arrangement of the figures. Rembrandt

subsequently presented his own vision in the painting of the *Wedding of Samson* (1638; Br. 507), which was praised in his own time as a product of 'careful study and intelligent reflection'.

4. Success and personal misfortunes, c. 1641–c. 1655

At the height of his fame, in 1640 or 1641, Rembrandt was honoured with the commission to paint one of the great group portraits for the new hall of the Kloveniersdoelen (the arquebusiers' headquarters). He delivered the work (commonly known as the *'Night Watch'*; Amsterdam, Rijksmus.; Br. 410) in 1642. On 14 June of that year Saskia died of tuberculosis, and Rembrandt was left alone with their small son Titus. His material prosperity at the time was reflected in extravagance at art sales: eye-witnesses in 1642 related how he paid hundreds of guilders for rare prints, including those of Lucas van Leyden (RD 1642/10), whose skills he greatly respected. About this time Geertge Dircx (1600/10–?1656), the widow of a ship's bugler from Hoorn, entered his household

45. Rembrandt van Rijn: *Elephant*, 1637 (Vienna, Graphische Sammlung Albertina)

as a nurse to Titus. The human drama that followed, and which lasted several years, is revealed in two important documents. On 24 January 1648 Geertge made a will leaving all her possessions to Titus, including Saskia's jewels, which Rembrandt had given her; she was evidently convinced that her link with the painter would be a permanent one (RD 1648/2). However, on 15 June 1649 Rembrandt seems to have made a separation agreement with her, according to a declaration by 'Hendrickje Stoffels, a spinster aged 23' (RD 1649/4). The widow from Hoorn had had to make way for Hendrickje (1626–63), who was some ten or twenty years her junior. Geertge was not satisfied with the maintenance allowance offered (60 guilders), and legal proceedings ensued. According to his own claim, Rembrandt had slept with her but apparently had not promised marriage; she was subsequently awarded an annuity of 200 guilders (RD 1649/9). Perhaps out of revenge, Rembrandt, with the help of Geertge's brother, then began a campaign of defamation that ultimately led to her being consigned to a reformatory in Gouda (RD 1650/3). She tried unsuccessfully to regain her liberty in 1652 (RD 1652/4) but was not finally released until 1655. Thereafter she sought rehabilitation (RD 1656/4, 5 and 17) but evidently died at the end of 1656. Meanwhile, on 30 October 1654, the young Hendrickje had borne Rembrandt's daughter Cornelia. Summoned before the church council, she admitted to having 'committed fornication with the painter Rembrandt' (RD 1654/15). At about this time Rembrandt ceased to be able to meet the mortgage payments on his house, and by borrowing money he replaced one debt with another.

(i) Paintings. In 1640 Rembrandt had used his etched *Self-portrait* of 1639 (B. 21) as the basis of a painted version (London, N.G.; Br. 34), in which he posed as 'the Titian of Amsterdam'. His former pupils Ferdinand Bol and Govaert Flinck then began to imitate this Italian pose in their own self-portraits, and it became popular among Rembrandt's clients; it was adopted, for instance, for the portrait of *Nicolaes van Bambeeck* (1641; Brussels, Mus. A. Anc.; Br. 218). It is interesting to compare this portrait and its companion, *Agatha Bas* (London, Buckingham Pal., Royal Col.; Br. 360), with those of *Herman Doomer* (1640; New York, Met.; Br. 217) and his wife *Baertje Martens* (1640; St Petersburg, Hermitage; Br. 357), painted the previous year. The first couple—a rich merchant and a mayor's daughter—exude social prestige, while the others—a picture frame maker and his wife—chose to be depicted much more simply. In 1641, also on a special request, Rembrandt made a double portrait of the pastor of the Mennonite community in Amsterdam and his wife: *Cornelis Claesz. Anslo and Aeltje Gerritsdr. Schouten* (Berlin, Gemäldegal.; Br. 409). The pastor is seen as an expounder of God's word, with his books to hand, emphasizing his argument with a gesture. Joost van den Vondel later wrote that Rembrandt had succeeded in 'painting Anslo's voice' (RD 1644/6). There are also two drawn versions of the portrait (London, BM, Ben. 758; and Paris, Louvre, Ben. 759), as well as an etching (B. 271), in which the rhetorical gesture is the essential feature. There is one last portrait of Saskia, who is depicted very informally, with a flower in her hand (1641; Dresden, Gemäldegal. Alte Meister; Br. 108).

Rembrandt must then have been busy with his most important commission to date, the '*Night Watch*', for he painted very little else in 1642, apart from this. In that year, the great group portrait was hung in the Kloveniersdoelen at Amsterdam, representing the officers and men of the civic militia under the command of Capt. Frans Banning Cocq and Lt Willem van Ruytenburch. Although the militia never paraded at night, the piece was later nicknamed the '*Night Watch*'; however, restoration carried out in 1975–6 revealed that the scene actually takes place in broad daylight. The painting remained in its original setting until the militia companies were disbanded in 1715, when it was transferred to the Stadhuis on the Dam, at which time the canvas was somewhat cut down. The fame of both the picture and the artist is indicated by the fact that when the new Rijksmuseum was opened in 1885, the '*Night Watch*' room was regarded as the centrepiece of the building and its collection. In 1985 the original arrangement of this room was partly

restored. In the 17th century the *'Night Watch'* was already famous abroad as well as at home: in 1685 the Italian biographer Baldinucci commented on its special light effects, and seven years earlier van Hoogstraeten had placed it on a par with all previous examples of militia pieces. Critics admired the treatment of form and the animated composition, which gives the effect of a narrative or subject picture as opposed to a static portrait. This was probably just what Rembrandt intended, while not departing from the terms of his commission (i.e. to produce a group portrait). At the same time as providing a number of excellent individual portraits, he cleverly used the group to demonstrate the operation of a militia company.

Rembrandt's zest for work was diminished by this *tour de force* and perhaps still more by Saskia's death. For the year 1643 there is only the unconvincingly attributed *Bathsheba at her Toilet* (New York, Met.; Br. 513) and for 1644 *Christ and the Woman Taken in Adultery* (London, N.G.; Br. 566). This latter work was much admired in its time: in 1657 it was sold for 1500 guilders, little less than the fee for the *'Night Watch'* (RD 1657/2). In the following years his output recovered slowly. It is perhaps not by chance that the widowed Rembrandt twice painted the *Holy Family* (1645, St Petersburg, Hermitage, Br. 570; and 1646, Kassel, Schloss Wilhelmshöhe, Br. 572); in the later version a fictitious painted frame and curtain are used as *trompe-l'oeil* devices. In 1645 he painted the *Young Girl Leaning on a Window Sill* (London, Dulwich Pict. Gal.; Br. 368) and the *Old Man with a Stick* (Lisbon, Mus. Gulbenkian; Br. 239). These are painted with a thickly loaded brush, in warm, often deep red tones, suggesting the increasing influence of 16th-century Italian masters. The same is true of *Young Woman in Bed* (Edinburgh, N.G.; Br. 110), thought by some to represent Geertge Dircx but perhaps intended as a biblical scene (e.g. Sarah waiting for Tobias). In 1646 the series of the *Life of Christ*, begun in the 1630s for the Stadholder, was completed by an *Adoration of the Shepherds* (Munich, Alte Pin.; Br. 574) and a *Circumcision* (known only from a copy). For these he received no less than 1200 guilders (RD 1646/6).

He also painted a second version of the *Adoration* (1646; London, N.G.; Br. 575). Without considering himself a court painter in the style of Rubens, Rembrandt had reason to be content with his connections at The Hague. However, when the time came in 1648 to decorate the Oranjezaal at the Huis ten Bosch, the commission was not given to Rembrandt but to more 'Flemish' painters. The reason is not known; given his flirtation with a 'Flemish' style in the 1630s, it could not have been that he was judged to be unacquainted with the Flemish vocabulary of forms or with their format and sense of drama.

In terms of subject-matter, the *Winter Landscape* (1646; Kassel, Schloss Wilhelmshöhe; Br. 452) is highly exceptional for Rembrandt, but it fits into the Dutch tradition of depicting winter amusements (e.g. those by Hendrick Avercamp) or pure winter landscapes (e.g. those by Jacob van Ruisdael). It is painted rapidly, with a broad brush: 'as if out of doors' was a much-heard comment. It seems likely, however, that it was based on Esaias van de Velde's *Winter Landscape* (1624; The Hague, Mauritshuis). Imaginary landscapes continued to be used as backgrounds to biblical scenes, such as the *Flight into Egypt* (Dublin, N.G.; Br. 576), a nocturn after a model by Adam Elsheimer. The most remarkable subject paintings of the late 1640s are *Susanna and the Elders* (1647 [or ?1644]; Berlin, Gemäldegal.; Br. 516) and two versions of the *Supper at Emmaus* (both 1648; Paris, Louvre, Br. 578; Copenhagen, Stat. Mus. Kst, Br. 579). Because of the repetition of certain motifs from other works (e.g. the attitude of Christ from the Paris version and the *trompe-l'oeil* curtain from the Kassel *Holy Family*), the authenticity of the Copenhagen version has been doubted, but it may be a question of a work produced in a hurry.

Personal problems were accumulating. After 1647 Rembrandt painted very little, except the two Emmaus pieces. In 1649 he produced no paintings at all, only etchings. Evidently he was fully occupied with his love for Hendrickje and his plans to get rid of Geertge. Once she was despatched to a reformatory, he returned to painting and produced a few simple pieces, such as the *Portrait of an Old Man* (1650; The Hague, Mauritshuis;

Br. 130), formerly thought to represent his eldest brother, Adriaen. Similar half-length figures followed in 1651: the *Old Man in Fanciful Costume* (Chatsworth, Derbys; Br. 266) and the *Bearded Man with a Hat and Head-band* (Vånas, Wachmeister Col.; Br. 263). In this period he also painted a series of the *Head of Christ* (Br. 620–24), all of which are undated and seem to have been produced routinely. His palette exhibits much brown and dark red, and the painting is broad and pastose, as it is in two other works of 1651: the *Girl with a Broom* (Washington, DC, N.G.A.; Br. 378) and the *Girl at a Window* (Stockholm, Nmus.; Br. 377).

By 1652 Rembrandt seems to have overcome his difficulties. A *Self-portrait* of that year (Vienna, Ksthist. Mus.; Br. 42) shows him with arms akimbo and a very self-assured look. Moreover, he was again receiving portrait commissions: for example the presumed portrait of the painter *Jan van de Cappelle* (Buscot Park, Oxon, NT; Br. 265) and the wealthy *Nicolaes Bruyningh* (Kassel, Schloss Wilhelmshöhe; Br. 268). At this important point in his life he suddenly received a flattering commission from abroad, to paint a historical half-length figure for the Sicilian nobleman Don Antonio Ruffo, with the possibility of more commissions to follow. Thus he painted *Aristotle Contemplating a Bust of Homer* (1653; New York, Met.; Br. 478), for which he no doubt consulted a Classical scholar, such as his friend Jan Six. Their close friendship can be seen from Rembrandt's drawing of *Homer Reciting Verses* in Six's *album amicorum* (Amsterdam, Col. Six; Ben. 913); he also painted Six's portrait (1654; Amsterdam, Col. Six; Br. 276). This is one of the most brilliant portraits ever made: the contrast between the subtle rendering of the facial expression and the very broadly painted hands displays a virtuosity with the brush that is equalled in the 17th century only by Frans Hals, if at all. Notable too is the suggestive treatment of the material of the cloak—no more than a red surface with dark furrows for the shadows, with the braid indicated by a single short brushstroke.

Also masterly in its brushwork is the *Woman Bathing in a Stream* (1654; London, N.G.; Br. 437), for which Hendrikje naturally posed. He also used her as a model for the *Bathsheba with King David's Letter* (1654; Paris, Louvre; Br. 521), his greatest history painting since his 'Flemish' period, and for *Flora* (1654; New York, Met.; Br. 114), the allegorical role for which his beloved Saskia had formerly posed; Hendrikje, in the year in which all three works were painted, gave birth to their daughter Cornelia. From 1655 onwards Rembrandt's 14-year-old son regularly served as his model (Br. 120–26). Although in the 1650s Dutch painting had evolved in favour of a refined, highly finished style and lighter tints, especially for portraits, Rembrandt emphasized his broad, loose touch and used increasingly sharp contrasts of light and dark. Despite his old-fashioned style, he received plenty of portrait commissions: for instance, that of a *Man in a Fur-lined Coat* (1654; Boston, MA, Mus. F.A.; Br. 278) and that of *Floris Soop as a Standard-bearer* (c. 1655; New York, Met.; Br. 275). The *Slaughtered Ox* (1655; Paris, Louvre; Br. 457), unique in terms of its subject, is a creation of pure colour and light, which has fascinated generations of artists; it inspired, for instance, Chaim Soutine to paint a series of Expressionist works (e.g. Grenoble, Mus. Grenoble).

(ii) Etchings. In 1641, the year before completing the 'Night Watch', Rembrandt found time to work on a long series of etchings: 13 dated prints emerged in a sudden rush of productivity that was never again equalled (B. 43, 61, 98, 114, 118, 128, 136, 225–6, 233, 261, 271 and 310). Typical of these is the sketchiness seen, for example, in the *Baptism of the Eunuch* (B. 98) and the 'Large Lion-hunt' (B. 114). Also purely linear are three Dutch landscapes, in which there is an element of topographical accuracy: *The Mill* (B. 233) shows part of the Amsterdam ramparts by the Lauriergracht. Rembrandt's landscape etchings were nearly all made in the 1640s. The latest are dated 1652, which appears on the *Landscape with a Haybarn* (B. 224), a site that was often represented by Rembrandt in his etchings and drawings (B. 213, Ben. 1226 and 1227) and by his pupils, who seem to have worked with him *sur place*. Over the years, the tonality of the landscapes became increasingly important. This was achieved by the use of drypoint, as is

evident, for instance, in the different states of the *Landscape with a Square Tower* (1650; B. 218) and the *Clump of Trees* (1652; B. 222), which was evidently drawn out of doors directly on to the plate. A more elaborate procedure was followed in the dramatic landscape known as the *Three Trees* (1643; B. 212), which combined the etching technique with drypoint and the use of an engraver's burin.

The same development can be followed in the biblical scenes of the period. The *Raising of Lazarus* (1642; B. 72) was drawn entirely with the etching needle, while *Abraham and Isaac* (1645; B. 34) and *St Jerome by a Pollard Willow* (1648; B. 103) were executed in drypoint alone, and the *Flight into Egypt* (B. 53), a successful experiment with nocturnal effects, was achieved by the extensive use of both drypoint and engraving. The *'Three Crosses'* (B. 78), dated 1653 in the third state, was also set down entirely with the drypoint and burin; in the fourth state the image was completely transformed, and, by inking the plate heavily, some prints were made to give the impression of a nightmare. (This presumably occurred much later, c. 1660.) Rembrandt also achieved fine nocturnal effects in the *Descent from the Cross* (1654; B. 83) and the *Entombment* (c. 1654; B. 86), which seem to form a series with the *Supper at Emmaus* (1654; B. 87). Another series consists of small scenes from the *Life of Christ* (B. 47, 55, 60, 63 and 64). Rembrandt's most powerful creation in the drypoint technique was the large (400×450 mm) *Ecce homo* (B. 76), drawn after a design by Lucas van Leyden. This print was dated 1655 from the fifth state onwards, but three more states followed in which the arrangement was drastically altered. The crowd before the podium was eliminated, so that the spectator himself became, as it were, part of the scene. In this period Rembrandt also produced some undated prints that have come to be known by their nicknames, such as the *'Hundred Guilder Print'* (c. 1643–9; B. 74) and *'La Petite Tombe'* (c. 1652; B. 67). Rembrandt himself is said to have paid 100 guilders for a copy of the former; its fame is further demonstrated by the fact that his last pupil, Aert de Gelder, depicted himself with an impression of it in his *Self-portrait* (St Petersburg, Hermitage). Both prints represent *Christ Preaching*, as described in Matthew 19. The composition of *'La Petite Tombe'* is reminiscent of Rembrandt's drawing (1652; Ben. 913) in Jan Six's *album amicorum*.

Almost a decade after his *Self-portrait* in the style of Titian (1639; B. 21), Rembrandt made an etched *Self-portrait* (1648; B. 22) showing himself at a window, at work with a pencil. In the case of the etched portrait of *Jan Six* (1647; B. 285), not only the copperplate but several preparatory drawings have survived (Ben. 749, 767, 768); together with the four states of the print, these provide a unique insight into the artist's creative process and the role played by the client's wishes. This was the case, too, with the etched portrait of the painter *Jan Asselijn* (c. 1647; B. 277), who, in the final version, had an easel with a painting removed from the background, preferring apparently not to be shown as a craftsman. Rembrandt made an especially lively portrait of the printseller *Clement de Jonghe* (1651; B. 272), who on his death in 1677 possessed many of Rembrandt's original etching plates. The so-called *Faust* (first half of the 1650s; B. 270), with its fascinating vision in front of a window, has not yet been satisfactorily interpreted—which indeed is its charm. Among Rembrandt's other unexpected (though not unprecedented) subjects are the mischievous *Flute-player* (*'L'espiègle'*, 1642; B. 188), *The Sow* (1653; B. 157), erotic scenes such as the *'Ledikant'* (*'Le Lit à la française'*; B. 186) and the *'Monk in a Cornfield'* (B. 187), both of 1646, and the studies of nude studio models from the same year (B. 193, 194 and 196). One version (B. 194) was elaborated in the background to represent a mother teaching her child to walk; it is seen as illustrating the proverb 'Practice makes perfect', appropriate to both the artist and the child.

(iii) Drawings. After 1642 Rembrandt did not paint much but was very productive as a draughtsman, especially of biblical subjects. In the 1640s he used mostly a quill pen, applying wash sparingly with the brush; by the first half of the 1650s the much stiffer reed pen had become his favourite instrument. Hence the flowing forms of the 1640s gave

way to a more angular play of lines, with an occasional brilliant example of drawing in brush alone, for example the *Woman Asleep* (London, BM; Ben. 1103), for which Hendrickje was perhaps the model (on the analogy of similar drawings of the pregnant Saskia in the 1630s). This sheet would therefore date from *c.* 1654; but this is purely guesswork, for the dating of Rembrandt's drawings is one of the greatest challenges they present. Thus the very typical sheet of *Two Women and a Child in front of a House* (Amsterdam, Rijksmus.; Ben. 407) is dated by some *c.* 1635, by others *c.* 1645. Two drawings of a *Woman on the Gallows* (both New York, Met.; Ben. 1105 and 1106) seem to represent Elsje Christiaens, who was condemned to death on 1 May 1664, so that they cannot date from the mid-1650s as was originally supposed. A date of *c.* 1645 has recently been suggested for the drawing of the *Noli me tangere* (Amsterdam, Rijksmus.; Ben. 538), whereas the painting of the same subject (Br. 559) is dated 1638. Exceptionally, the curious *Satire on Art Criticism* (New York, Met.; Ben. A35a) bears the date 1644, but even the presence of signatures and dates is not wholly reliable evidence: the inscription *Rembrandt f 1640* found on both the *View of St Albans Cathedral* (Haarlem, Teylers Mus.; Ben. 785) and the *View of Windsor Castle* (Vienna, Albertina; Ben. 786) is regarded by some as forged. In some cases there is a connection with a documented work that enables a drawing to be dated: the *Holy Family in the Carpenter's Shop* (Bayonne, Mus. Bonnat; Ben. 657) is a preparatory drawing for the picture of 1645 (St Petersburg, Hermitage; Br. 570), and the print of *Twelfth Night* (B. 113) of *c.* 1650 shows the same grouping of figures as the drawing of the same subject (London, BM; Ben. 736). Drawings of nude studio youths (Vienna, Albertina, Ben. 709; London, BM, Ben. 710 and 710a) were presumably made at the same time as three etchings of 1646 (B. 193, 194 and 196); some may be by Rembrandt, some by his pupils at the time.

Attributions between Rembrandt and his known and anonymous pupils pose many further problems. Another version of the *Noli me tangere* (Amsterdam, Rijksmus.; Ben. 537) was previously thought to be by Rembrandt but is now ascribed to Ferdinand Bol. Questions also surround the

drawing of *Eliezer and Rebecca at the Well* (Edinburgh, N.G.; Ben. 491), a variant of which was acquired in 1970 by the Fondation Custodia (Paris, Inst. Néer., 9629). Rembrandt did indeed sometimes make two almost identical versions of a particular subject, either in a search for the correct form or because one was meant for sale. (That drawings were made expressly for the latter purpose is known from a document from the mid-1640s, the first to mention a trade in the artist's drawings; RD 1645/1.) Examples of such repetitions include *Jacob and his Sons* (Amsterdam, Rijksmus., Ben. 541; Paris, Louvre, Ben. 542) and *Jacob's Dream* (Paris, Louvre, Ben. 557; Rotterdam, Mus. Boymans–van Beuningen, Ben. 558), all from the first half of the 1640s. But a duplicate version may also be the work of a contemporary or later imitator, as in the case of *Esau and Jacob* (Amsterdam, Hist. Mus.; Ben. 564), of which there is a copy (London, BM; Hofstede de Groot, no. 868). Rembrandt depicted the same biblical episode in another drawing (London, BM; Ben. 606) but in a drastically altered composition that was probably derived from a print (1609) by Willem Swanenburg (after Paulus Moreelse).

A remarkably forceful handling of line is evident in several drawings in reed pen made in preparation for portrait etchings, even though they are the earliest examples of Rembrandt's use of this stiff medium: these include the design (London, BM; Ben. 763) for the posthumous portrait of *J. C. Sylvius* (1646; B. 280) and a study (Amsterdam, Col. Six; Ben. 767) for the portrait of *Jan Six* (1647; B. 285). The original idea for the portrait of *Jan Six* can be found on the *verso* of a black chalk sketch of a *Beggar's Family* (Amsterdam, Hist. Mus.; Ben. 749), which itself seems to be a study for the etching of *Beggars at the Door* (1648; B. 176). A comparable drawing of *Doctors in Discussion* (Amsterdam, Hist. Mus.; Ben. 714) was used for the etching of *Christ among the Doctors* (1652; B. 65), and thus a whole group of similar studies in black chalk on thin paper can be dated to the years 1647–52 (including three not mentioned by Benesch: Amsterdam, Rijksmus., A 1930:55; and Berlin, Kupferstichkab., 1148 and 5790). These drawings may have belonged to a

sketchbook that was later broken up. This was what happened to a collection described in the inventory of 1656 as 'A small book containing views drawn by Rembrandt' (RD 1656/12-259). A reconstruction of this book, or a similar one, consists of an ensemble of 23 sketches in black chalk, all drawn from nature in and around Amsterdam. The style is summary, with the design confined to the main lines of the land- or townscape. Several sheets can be dated from topographical motifs (e.g. Ben. 810, before 1650; Ben. 1275, 1652; Ben. 804 and 806, before 1656; Ben. 819 and 820, after 1657). The rest of the 23 sketches are to be dated between 1640 and 1652, which is roughly when most of his other landscape drawings originated (as did the landscape etchings).

Rembrandt produced some masterly landscape drawings with the pen, which reflect the essence of the Dutch countryside: the *View of the Amstel* (Amsterdam, Rijksmus.; Ben. 844), the *View of Diemen* (Haarlem, Teylers Mus.; Ben. 1229) and the *View of the IJ* (Chatsworth, Derbys; Ben. 1239). Also once together at Chatsworth (all having come from the collection of Nicolaes Flinck, the son of Rembrandt's pupil Govaert Flinck) are sheets with a similar economy of line but somewhat more detail in the foliage and a greater use of wash: the *Landscape near Trompenburg* (Ben. 1218), the *Landscape near Kostverloren* (Ben. 1265) and *Farm Buildings among Trees* (Ben. 1232 and 1233; the latter sold, London, Christie's, 6 July 1987, lot 14). In the same style is the *Farm by a Dike* (Dresden, Kupferstichkab.; Ben. 1234): this scene was also depicted in an unwashed drawing (Oxford, Ashmolean; Ben. 1227) and in two etchings (both 1652; B. 213 and 223), so the whole group can be dated c. 1650-52. Probably somewhat later are landscapes drawn with short pen strokes, without any wash, the best example of which was also formerly at Chatsworth (Ben. 1314; sold London, Christie's, 6 July 1987, lot 15). This typical style is also found, for instance, in a sheet with a *View of the Kloveniersdoelen* (c. 1652; Amsterdam, Rijksmus.; Ben. 1334), where the *'Night Watch'* had been hanging since a decade earlier. Rembrandt drew purely topographical views not only in sketchbooks but also on larger sheets,

often animated with wash. An unwashed drawing of the *Velperpoort at Arnhem* (after 1649; Dresden, Kupferstichkab.; Ben. 1305) was probably made on the occasion of a visit to Hendrickje's family at Breevoort near Arnhem. Perhaps on a similar journey to Rhenen in the province of Utrecht he drew the *Oostpoort* (Bayonne, Mus. Bonnat; Ben. 827), the *Westpoort* (Haarlem, Teylers Mus.; Ben. 826) and the *Rijnpoort* (Paris, Louvre; Ben. 1304). The last two are copiously washed. One topographical drawing is given a historical reference by Rembrandt's inscription stating that it represented the old Stadhuis of Amsterdam 'after the fire of 9 July 1652' (Amsterdam, Rembrandthuis; Ben. 1278). For this rapid sketch, he used a soft quill pen and a stiff reed pen, a little red chalk and the brush. He was evidently standing on the steps of the Waag (Weigh-house), where he and several others, including Jan Abrahamsz. Beerstraten and Abraham Furnerius, were recording the dramatic sight. At the same period he used a reed pen to draw picturesque views in Amsterdam, such as the *Ruins of the Huis Kostverloren* (Chicago, IL, A. Inst.; Ben. 1270) and the *Montelbaan Tower* (Amsterdam, Rembrandthuis; Ben. 1309)—the latter intentionally depicted as a medieval structure, without the 17th-century spire.

Unique among Rembrandt's drawings are the copies after Indian miniatures of the Mughal school (Ben. 1187-1204), the originals of which were later incorporated in the decoration of the Millionenzimmer of the Schloss Schönbrunn, Vienna. The drawings must have been made before Rembrandt's collection was sold in 1655 and subsequent years. They are chiefly figure and costume studies; their most striking feature is the way in which Rembrandt livened up the stylized poses with his deft modifications.

As in his paintings and etchings, Rembrandt achieved outstanding results in the drawings of the 1650s, among them his masterly studies of recumbent lions (Paris, Louvre, Ben. 1214; Rotterdam, Mus. Boymans–van Beuningen, Ben. 1211). He captured lions in just a few strokes, as in *St Jerome in an Italian Landscape* (Hamburg, Ksthalle; Ben. 104), a sketch for the etching of

c. 1654 (B. 104). Another fascinating drawing of the period is that of *Homer Reciting Verses* (1652; Amsterdam, Col. Six; Ben. 913), a skilful analysis of a composition by Raphael. In the same pose as the painted *Self-portrait* of the same year (1652; Br. 42), Rembrandt drew himself in working clothes, in a challenging attitude with arms akimbo (Amsterdam, Rembrandthuis; Ben. 1171), as if facing his bankruptcy head-on.

5. Bankruptcy and final years, 1656–69

In 1656 Rembrandt was obliged to declare himself insolvent and to apply for a *cessio bonorum* (RD 1656/10). Besides his debts, his art dealings had apparently been unsuccessful, and he had speculated unwisely. On 25 and 26 July 1656 the secretary of the Chamber of Insolvent Estates went from room to room of the house in the Jodenbreestraat, while Rembrandt made an inventory (RD 1656/12) of the items to be sold at auction. In December 1655 he had already disposed of much of his collection, but what remained was of the greatest value. The collection has been described as an 'encyclopedic *Kunstkammer*', which conferred on him the status of a 'gentleman virtuoso' (Scheller, 1969). Its nucleus consisted of material accumulated for study purposes: Italian, Flemish, German and Dutch prints and drawings, and works by Rembrandt himself. The collection was sold off bit by bit over the next two years, ending with a sale of the graphic art on 20 December 1658 (RD 1658/29, 30). The proceeds for the latter amounted to only 470 guilders and 9 stivers, whereas Rembrandt had once paid hundreds of guilders for a single print by Lucas van Leyden. This was attributed to the recession from which the art of engraving was then suffering: a year later, the value of the collection was estimated at ten times as much (RD 1659/14). The house in the Jodenbreestraat was also sold, after which it was eventually possible to satisfy nearly all the creditors. In 1658 Rembrandt, Hendrickje, Titus and little Cornelia rented a more modest home in the Jordaan district (on the Rozengracht, now No. 184). In 1660 the art business was transferred into the name of Hendrickje and Titus, Rembrandt becoming their employee. He was allowed to go on painting, to act as their adviser and to 'live with them, receive free board, and be exempt from housekeeping expenses and rent' (RD 1660/20). His relief at this arrangement was expressed in a rapid succession of works of art. A series of portrait commissions bore witness to the fact that his social position was unimpaired. Hendrickje Stoffels, who in 1661 was described as 'wife of Sr. Rembrandt van Reyn' (RD 1661/12), was buried on 24 July 1663, after which Titus continued to manage his father's affairs. On 28 February 1668 Titus married Magdalena van Loo, the daughter of an old family friend, but six months later, on 7 September, he died of the plague, leaving a pregnant wife, whose daughter Titia was baptized on 22 March 1669. Rembrandt himself died that same year and was buried in the Westerkerk beside Titus and Hendrickje. An inventory of his possessions was drawn up for his heirs, but unfortunately the works of art were not described separately. Three rooms, behind locked doors, were filled with 'property, including paintings, drawings, curios, antiques and other objects' (RD 1669/5): Rembrandt had evidently again been collecting in his old style.

(i) **Paintings.** In 1656—the year when his financial distress was at its height—Rembrandt received his most important official commission since the '*Night Watch*': the *Anatomy Lesson of Dr Deyman* (1656; Amsterdam, Rijksmus., Br. 414, two thirds destr. by fire; the full composition is known from a preparatory drawing in reed pen, Amsterdam, Rijksmus., Ben. 1175). He also achieved an artistic zenith with the *Blessing of Jacob* (1656; Kassel, Schloss Wilhelmshöhe; Br. 525). The following year he painted another *Self-portrait* (1657; Edinburgh, N.G.; Br. 48). To this time also belong *Titus with a Gold Chain* (London, Wallace; Br. 123) and *Hendrickje at a Window* (Berlin, Gemäldegal.; Br. 116), the latter modelled on a Venetian painting, then in Amsterdam, in the style of Palma Vecchio. The brown and red tints and the broad style of these two works were certainly inspired by that and similar models. From them Rembrandt developed a new kind of history piece: biblical, mythological or historical scenes with one or two figures. His second commission for Don Antonio Ruffo,

Alexander the Great (*c.* 1657; Lisbon, Mus. Gulbenkian; Br. 479), features a half-length figure of this type. A series of life-size half-length figures of *Apostles* was painted between 1657 and 1661 (Br. 612–19), and in 1661 Rembrandt completed his series of the *Head of Christ* with the *Risen Christ* (Munich, Alte Pin.; Br. 630). *Jacob Wrestling with the Angel* (Br. 528) and *Moses with the Tablets* (Br. 527; both 1659; Berlin, Gemäldegal.) represent half-length figures in action rather than simply posed. The broad style of these works also charac terizes his most important biblical history piece of this period, the *Denial of St Peter* (1660; Amsterdam, Rijksmus.; Br. 594). The third commission for Ruffo was *Homer Dictating to Two Scribes* (1663; The Hague, Mauritshuis; Br. 483; preserved as a fragment). The series of historical half-length figures was completed with 'portraits' of famous women: two of *Lucretia* (1664; Washington, DC, N.G.A., Br. 484; and 1666, Minneapolis, MN, Inst. A., Br. 485) and one of *Juno* (1665; Los Angeles, CA, Armand Hammer Mus. A.; Br. 539).

A second type of history-piece dating from after 1656 was carried out in a small format, with many figures, yet was painted in the same very broad style: for example three versions of *Christ and the Woman of Samaria* (Br. 588, 589 and 592A); *Jupiter and Mercury Visiting Philemon and Baucis* (1658; Washington, DC, N.G.A.; Br. 481); *Tobit and Anna* (1659; Rotterdam, Mus. Boymans–van Beuningen; Br. 520); *Haman and Ahasuerus at the Banquet of Esther* (1660; Moscow, Pushkin Mus. F.A.; Br. 530); and the *Circumcision* (1661; Washington, DC, N.G.A.; Br. 596). The apotheosis of Rembrandt's career as a history painter was his contribution to the decoration of the new Stadhuis of Amsterdam, for which he painted the *Conspiracy of Claudius Civilis* (Stockholm, Nmus.; Br. 482); this was installed in 1662 but returned shortly afterwards. Perhaps his clients thought it insufficiently dignified: he had made it a night scene and shown Civilis as having only one eye. Rembrandt himself evidently cut it down to a marketable size: the original composition is preserved in a sketch (Munich, Staatl. Graph. Samml.; Ben. 1274). A more heroic scene by Juriaen Ovens took its place in the town hall.

Portrait commissions were not affected by Rembrandt's bankruptcy. He painted *Catrina Hoogsaet* (1657; Penrhyn Castle, Gwynedd, NT; Br. 391) and the arms manufacturer *Jacob Trip* and his wife *Marguerite de Geer* (both 1661; London, N.G.; Br. 314 and 394). A year after the latter pendants he received the important commission for a group portrait of the *Syndics of the Amsterdam Drapers' Guild* ('The Staalmeesters'; Amsterdam, Rijksmus.; Br. 415). The unusual commission for a life-size equestrian portrait of *Frederick Rihel* (1663; London, N.G.; Br. 255) was a task rather more suited to a specialist such as Paulus Potter, who had painted *Dirck Tulp on Horseback* (Amsterdam, Col. Six). Of the anonymous persons who sat for Rembrandt in the 1660s, the most striking are the *Portrait of a Man with a Magnifying Glass* and the pendant *Portrait of a Woman with a Carnation* (both New York, Met.; Br. 326 and 401). Also noteworthy are the portrait of fellow artist *Gérard de Lairesse* (1665; New York, Met.; Br. 321), whose features, disfigured by syphilis, are rendered without disguise, and the portrait of Rembrandt's old friend the poet *Jeremias de Decker* (1666; St Petersburg, Hermitage; Br. 320). The identity of the figures in the *'Jewish Bride'* (*c.* 1665; Amsterdam, Rijksmus.; Br. 416) has never been ascertained, nor is it known whether the painting is a history (Isaac and Rebecca or Jacob and Rachel?) or perhaps both a history and a portrait. In any case, the work has become world-famous thanks to the magical fall of light, the wonderful impasto and the tender gestures of the man and his bride. Also anonymous is the *Portrait of a Family* (Brunswick, Herzog Anton Ulrich-Mus.; Br. 417), which Rembrandt painted at the end of his life—or rather modelled on the canvas with a palette-knife.

In and after 1657 Rembrandt painted several more *Self-portraits* (Br. 48–62), some in an unusual setting. He depicted himself in an impressive pose in an armchair (1658; New York, Frick; Br. 50) and later as a painter with a palette and mahlstick (1660; Paris, Louvre; Br. 53; see col. pl. XXXII). These attributes also figure in his *Self-portrait* (*c.* 1665; London, Kenwood House; Br. 52) with a background of two circles symbolizing eternity

and perfection. Rembrandt concluded his career with three self-portraits (all 1669): one (London, N.G.; Br. 55) in which the pose is borrowed from Raphael's famous portrait of *Baldassare Castiglione* (c. 1516; Paris, Louvre); one (Cologne, Wallraf-Richartz-Mus.; Br. 61) in which he depicted himself as the Greek artist Zeuxis, who died of laughter painting a wrinkled old woman; and one (The Hague, Mauritshuis; Br. 62) in which there no longer seems to be a message—everything had been said. This grandiose finale is more suggestive of cynical vitality than weariness of life.

(ii) **Etchings and drawings.** After his bankruptcy, Rembrandt continued to receive commissions for etched portraits, just as he did for painted portraits. Some are informal, such as the etching of the apothecary *Abraham Francen* (c. 1657; B. 273), while others are more official in character, for instance that of the goldsmith *Jan Lutma* (1656; B. 276), who is shown formally seated in a chair, like the earlier etched portraits of *Pieter Haaringh* (1655; B. 275) and his distant relative *Thomas Haaringh* (c. 1655; B. 274), both of whom were involved in the sale of Rembrandt's goods after he was declared insolvent. The contrast of styles is best exemplified by the two different portraits of the writing master *Lieven Willemsz. van Coppenol* (both c. 1658; B. 282 and 283).

It has been speculatively suggested that Rembrandt's financial situation at the time may be reflected in his etching of *St Francis Praying beneath a Tree* (1657; B. 107), an unusual depiction (without the traditional stigmata) of the saint who preached voluntary poverty. It is, in fact, Rembrandt's last etched landscape, executed with a powerful use of the drypoint. The landscape contains Italian motifs that also occur in *Christ and the Woman of Samaria* (1658; B. 70). In this period Rembrandt showed great interest in the romantic landscape drawings of Venetian masters such as Titian. He himself 'improved' a drawing attributed to Domenico Campagnola (Budapest, Mus. F.A.; Ben. 1369) and also made a copy (Paris, Fond. Custodia, Inst. Néer., 375) of a *Landscape with a Campanile* by Titian (untraced). The bright, pastoral visions of Titian and his followers provided

the inspiration for the backgrounds to biblical scenes in both etchings (B. 70, 104, 107) and drawings: *Elijah at the Brook Cherith* (Berlin, Kupferstichkab.; Ben. 944) and *Elisha and the Widow with her Sons* (ex-F. Somary priv. col., Washington, DC; Ben. 1027). *Christ and the Woman of Samaria* (1658; B. 70), together with *SS Peter and John Healing a Cripple* (1659; B. 94), were Rembrandt's last etchings of a biblical scene. Apart from the print of *Phoenix or the Overthrown Statue* (1658; B. 110), the subject of which is still unexplained, he subsequently etched only female nudes (B. 197, 199, 200).

In these same years (1658–61) Rembrandt and his pupils drew from the nude according to the best academic traditions, as can be seen from a model observed from different viewpoints by the master himself (Chicago, IL, A. Inst.; Ben. 1122) and by a pupil (Rotterdam, Mus. Boymans–van Beuningen; Ben. 1121). The differences between the two versions are typical of a whole group of such sheets, several of which are still wrongly attributed to Rembrandt. The version (London, BM; Ben. 1143) of a *Seated Nude* (Amsterdam, Rijksmus.; Ben. 1142) seems to be the work of a pupil (?Johannes Raven). The somewhat indecorous etching of *Jupiter and Antiope* (1659; B. 203) is partly based on such a nude study (Amsterdam, Rijksmus.; Ben. 1137), but it also derives from a print by Annibale Carracci (B. 17). The drawing is executed in reed pen, Rembrandt's favourite drawing implement in the period 1650–60. He used it for landscapes (e.g. Berlin, Kupferstichkab., Ben. 1367; perhaps his last landscape drawing), for the study of a *Lion Resting* (Amsterdam, Rijksmus.; Ben. 1216) and for compositional studies, such as *Christ and the Woman Taken in Adultery* (Munich, Staatl. Graph. Samml.; Ben. 1047), *St Peter at the Death-bed of Tabitha* (Ben. 1068), *Diana and Actaeon* (Ben. 1210; both Dresden, Kupferstichkab.) and the *Continence of Scipio* (Rotterdam, Mus. Boymans–van Beuningen; Ben. 1034). All these sheets date from around the beginning of the 1660s. In 1662 Rembrandt made at least three studies for 'The Staalmeesters' (Br. 415): the *Study of Jacob van Loon* (Amsterdam, Rijksmus.; Ben. 1179), the *Study of Volkert Jansz* (Rotterdam, Mus.

Boymans–van Beuningen; Ben. 1180) and the *Study of Three Syndics* (Berlin, Kupferstichkab.; Ben. 1178). These are unique illustrations of the way in which Rembrandt prepared a group portrait.

Although Rembrandt continued to pull impressions from old plates until his death, his last new etchings were made in the early to mid-1660s. Among these is the image of a naked woman sitting on a bed, with a youth looking at her, which from an early date became known as the '*Woman with the Arrow*' (1661; B. 202). Titus van Rijn was speaking of this when he declared in 1664: 'Yes, my father engraves as curiously as anyone' (RD 1665/6).

B. P. J. BROOS

II. WORKING METHODS AND TECHNIQUE

Much information about Rembrandt's studio and working methods may be found in the writings of a number of authors who were trained by him or knew him—Samuel van Hoogstaten and Joachim von Sandrart in particular. In addition, many of Rembrandt's paintings have been the subject of detailed technical examinations, for instance all those in the National Gallery, London (see 1989 exh. cat.). The results of some of these investigations have been incorporated in the publications of the Rembrandt Research Project (*see* §III below).

1. Studio organization

In a well-known passage of the *Teutsche Academie* (written a decade after Rembrandt's death), Sandrart recorded how Rembrandt had 'countless distinguished children for instruction and learning, of whom every single one paid him 100 guilders annually'. The number of pupils allowed to be trained in a painter's studio was usually very strictly controlled by the Guild of St Luke, and while it is true that the Amsterdam guild was less effective in enforcing its regulations than those in other cities, it does seem that Rembrandt had many more pupils than the normal four to six. (Yet he clearly was not operating outside the guild since it was essential for him to have been a member.) The situation in his studio was far from the conventional arrangement of the master

instructing a limited number of pupils. Some members of the studio were long-term apprentices of the traditional kind: Samuel van Hoogstraten, for example, was with him for about seven years from the age of thirteen. Others, however, had probably already spent some years with another master, while still others may have been amateurs receiving instruction in what was essentially an 'academy' based on Italian prototypes; this system of training was fairly novel in Amsterdam in the 1630s and offered a freer, less rigidly administered regime of tuition than guild-regulated apprenticeships. The method of instruction in Rembrandt's studio may, at times, have resembled the informal cluster of chairs and young pupils sketching from a male model shown in Michiel Sweert's painting of *The Academy* (c. 1656; Haarlem, Frans Halsmus.). Surviving drawings of studio models by Rembrandt and his pupils would seem to confirm this. But according to Houbraken, Rembrandt's students worked in a warehouse that Rembrandt rented on the Bloemgracht in Amsterdam, where 'in order to be able to paint from life without disturbing each other, [they] made small cubicles, each one for himself, by setting up partitions of paper or oilcloth'.

Rembrandt's studio was an unashamedly commercial operation. As well as apprentices and paying pupils, a steady stream of young qualified painters passed through and painted under his guidance, sometimes in a style closely resembling the master's and sometimes with more individuality. It is clear that Rembrandt signed other painters' works as his own, and it is this fact, together with the inevitable similarity in materials and technique, that makes attribution of some works associated with him problematic. The names of perhaps 20 of his pupils and associate painters are recorded in Sandrart, van Hoogstraten, Houbraken and other sources, but the full list can never be known with certainty because the records of the Amsterdam Guild of St Luke have been almost wholly lost.

2. Paintings

Traditionally, painters seem to have preferred to live on east-west streets, so that rooms at either

the front or back faced north, the direction from which the most even source of light derived. The St Anthonisbreestraat in Amsterdam, on which Rembrandt's house stands, runs at an angle to the east-west direction; partial north light would therefore have been available, but it can only be speculated how concerned Rembrandt was with the constancy of a cool light source. Painters who were right-handed, as seems to have been the case with Rembrandt, would normally work with the window at their left, so that their arm did not cast a shadow as they worked, and it is noticeable in Rembrandt's paintings how often the light in portraits and other pictures falls from the left in accordance with this natural arrangement. In his small picture of the *Painter in his Studio* (*c.* 1629; Boston, MA, Mus. F.A.; Br. 419) a young painter (perhaps even himself at work in Leiden) steps back to consider his work. Unusually, the light source is somewhere high up and to the left (behind the painter and slightly to his right), although he is clearly right-handed. He is shown pausing in the act of painting standing up: this may well have been Rembrandt's normal practice, but many other painters of the period showed themselves seated at the easel. The easel shown is of a standard type, a simple hinged trestle with movable pegs to support the work at the right height. The panel on the easel is a large one and is strengthened at the top and bottom edges by grooved wooden battens.

Rembrandt appears to have been content to restrict himself to standard oak panel and canvas sizes—probably of necessity, since frames were produced to the same dimensions. Close similarities between some of Rembrandt's panels, as revealed by dendrochronological examination, suggest that he purchased them in batches from particular panelmakers. Larger panels were made by butt-jointing two or three planks together. The back edges were often bevelled in order to fit the finished painting into its frame, and this can be a useful indication of the original size and shape of a panel if it has later been cut down. The ground or preparation layers might be applied by the panelmaker or in the painter's studio. It is possible, for instance, that the panelmaker was responsible for the first layer of preparation and subsequent layers were the painter's responsibility. However, sometimes Rembrandt was dissatisfied with the way a panel was prepared: for *Christ and the Woman Taken in Adultery* (1644; London, N.G.; Br. 566) he clearly scraped down the ground in the centre of the panel before beginning to paint, presumably because it was too rough. Canvases too could be bought ready prepared but were also routinely stretched and prepared in the artist's studio. On occasion he cut up stretched and primed canvases and reused them, as, for example, he did for the *Lamentation* (*c.* 1635; London, N.G.).

The range of pigments that Rembrandt employed involves no arcane knowledge, no secret formulae, but falls firmly within the mainstream of Dutch painting practice in the 17th century. The palette is entirely made up of pigments that were commercially widely available and by that time well understood in their qualities and drawbacks. Some writers have been inclined to stress the restricted nature of Rembrandt's palette, implying in it a theoretical basis. It is true that Rembrandt's paintings are dominated by a limited selection of pigments—the artificial colours lead white (used especially for areas of high impasto, such as white ruffs) and bone black (used especially for the black clothes worn by his sitters), as well as a generous selection of natural earth pigments, such as the ochres, siennas and umbers. As a group, the earth pigments provide the greatest range of the more muted, warm colours of red, orange, yellow and brown. All the earth colours used by Rembrandt would have come from naturally occurring sources, abundant in many parts of Europe (particularly in Italy, France and England), and would have been an established part of the pigment trade. Sources farther afield in Cyprus and Turkey supplied specialized grades and colours, particularly of the umbers. The great advantages of earth colours are that they are entirely stable in all painting media and do not interact with more chemically sensitive pigments, making them suitable for any kind of pigment mixture, and that they dry perfectly well in oil. Some, like the umbers, are particularly effective driers. Their disadvantage, perhaps, is lack of intensity of colour,

but what they offer in range of colour and choice of translucency must have suited Rembrandt well.

Other pigments were regularly used by Rembrandt, but these were the staples. Yet this description of Rembrandt's palette, however accurate, obscures the point of his highly sophisticated painting method, in which colour and transparency are adjusted as continuously varied combinations of relatively few pigments and further modified and adjusted as one layer of paint is laid over another until the desired effect has been reached. In terms of painting technique, opacity and built-up texture are usually interrelated, with much of the thickest impasto formed from the most solid and opaque of pigments, frequently lead white and sometimes lead-tin yellow. But there are also passages to be found of very thickly laid, translucent, dark-coloured paint, and for these Rembrandt used novel methods involving unusual combinations of pigments chosen for their bulk and transparency as well as for their colour. It was these complex pigment mixtures and the elaborate paint layer structures that gave Rembrandt access to such an impressive range of effects in colour, translucency and texture. Moreover, his choice of mainly stable materials used in compatible combinations and his sound understanding of the ways in which those chosen materials behave singly and in combination account in large part for the good condition of many of his pictures.

In many cases, however, particularly with Rembrandt's late works, it remains a mystery how the elaborate surface structure was achieved; it is difficult to imagine what implement was used, for it is impossible to distinguish any clear brushstrokes, nor are there any obvious traces of the use of a palette knife. For example in the 'Jewish Bride' (c. 1665; Amsterdam, Rijksmus.), the woman's shoulder, which is covered with transparent fabrics and on which the man's hand emerges from the shadows, is amazing in its execution: lying on what appears to be a chaotically brushed-on and smudged underlayer are drippings of paint that, despite the seemingly haphazard way they were applied, enhance the effect of costly fabrics interwoven with metal thread. In the woman's red skirt a relief of light-coloured lumps of paint lying beneath the surface rises up out of a sea of pink and translucent veils of red paint. Rembrandt ended up painting in this 'rough manner' (as it was called in the 17th century), although he had begun his career with a 'fine' technique similar to that developed shortly thereafter by the Leiden 'Fine' painters. Until well into the 20th century this evolution was regarded as a spontaneous and highly personal development, culminating in an *ultima maniera*—that magical apotheosis that typifies some artists' biographies. However, as van de Wetering has shown (see 1991–2 exh. cat., *Paintings*, p. 16), there are also grounds for seeing this process as guided by conscious decisions based on current ideas on 'the smooth and rough manners', which were part of the 17th-century workshop culture.

CHRISTOPHER BROWN

3. Etchings

Although Rembrandt's early prints are executed in etching alone, in his later prints he usually combined etching with other techniques, especially drypoint. For example, in the second state of the etching of the *Supper at Emmaus* (1654; B. 87), rather than rebiting the plate, Rembrandt made additions with a drypoint needle, scratching directly into the copper. In this state of the print, the pungent drypoint lines overlie the airier etched lines of the basic design; they complete Jesus's face, increase the light emanating from him and add substance to the huge canopy that Rembrandt placed over the supper table to emphasize the importance of the event. Rembrandt was, in fact, the first printmaker to understand the full potentialities of drypoint. He sometimes used its fleeting, but powerful burr to give velvety shadows to an etching. In early impressions of the *Agony in the Garden* (c. 1657; B. 75) these strong black accents intimate the cloudy darkness surrounding the moonlit confrontation of Christ and the angel. Rembrandt also combined drypoint with the more incisive lines characteristic of engraving. These techniques were used together in the '*Three Crosses*' (1653; B. 78) to suggest the stark immediacy of the event and the terrible darkness. In many

prints all three techniques—etching, engraving and drypoint—were combined. In the *'Woman with the Arrow'* (1661; B. 202), for example, Rembrandt blended them with an extraordinary painterly intelligence to convey the soft roundness of the woman's flesh, the heavy material of the curtain behind her and the fine quality of the bed linen and clothing.

The successive states of Rembrandt's prints record very closely the ways in which he changed his mind about the composition or meaning of each print. This can be seen in the subtle though important changes he made in the composition of the portrait of the print-seller *Clement de Jonge* (1651; B. 272), which resulted in marked psychological alterations in the characterization of the sitter. The first state is for the most part lightly etched, so that the lines print on white paper as almost translucent greys: the expression of the print-seller, with his unevenly set eyes, seems reserved, indeed withdrawn. Rembrandt appears to have been satisfied with the etching at this stage, at least initially; it is the state most commonly found in public collections. The second state preserves much of the earlier luminosity, but the firmer outlining of de Jonge's cloak and chair, the darkening of his hat and the shadowing of his face all give the composition a strength it had previously lacked. In addition, there is now a powerful sense of the sitter's individuality, concentrated in rigid hands and shoulders and an intense burning face. In the third state Rembrandt added an arch, increasing the stability of the composition. He further shaded the right side of de Jonge's face, which softens the crooked effect of his right eye but also diminishes the individuality so evident in the preceding state. In the fourth state Rembrandt strengthened and darkened the arch and gave the print a new, quite different compositional balance by adding dark shadows to de Jonge's clothes and deepening the shadow cast on the wall to the left of his chair.

Both of the great drypoints, the *'Three Crosses'* and the *Ecce homo* (1655; B. 76), were radically altered, in the fourth and fifth states respectively. It has been suggested that Rembrandt made these changes because the fugitive drypoint lines had weakened, but although it is true that in some impressions the loss is appreciable, to attribute such a major reworking of the two plates to this single cause is to be unaware of the directions in which Rembrandt had been altering these masterpieces in their earlier states. In the first state of the *Ecce homo*, the artist was interested mainly in the response of individuals to the biblical event. Men, women and children stare at Jesus with curiosity, hatred or mockery; they stand beside him on the tribunal, peer down at him from the windows, crowd the stairway and spread out across the courtyard. In the following state Rembrandt changed the right side of the building, turning it into a complex barrier of light and shadow that directs the viewer's attention back to the figure of Christ. It is in the fifth and sixth states that Rembrandt made his major alterations to the plate. He strengthened the pattern of sunlight and shadow throughout the building, and he increased the size of the group at the left and eliminated all the figures standing in front of the tribunal, letting its blank front wall act as a pedestal for Christ. Finally, in the seventh state, he achieved what he seems to have been looking for earlier—a just and complex balance between the figure of Christ whom Pilate has placed on trial and the ordinary individuals condemning him to death.

In the *'Three Crosses'*, Rembrandt seems to have been attempting to resolve the same dichotomy: his perceptive interest in how the Crucifixion would affect human beings and his realization that this concern must not be allowed to diffuse the majesty of the event. In the first state, as Christ surrenders his spirit and the three-hour darkness begins to be lifted from the earth, a part of the mocking crowd turns to flee; mounted soldiers watch stolidly; the centurion, suddenly believing, kneels; the Marys and the Apostles grieve, each in his own fashion. In the first and second states, Rembrandt diminished the force of the crowd—not by adding further work to the plate, but by darkening these half-formed groups of people in various ways, and to varying degrees, with surface tone from ink left on the plate. In some impressions, in order to emphasize

the figure of Christ, he carefully wiped clean the strong verticals of the wooden cross and the body of Christ. In the signed and dated third state, Rembrandt modified the print, unifying the composition and changing its balance by adding considerable shading to the foreground and to figures throughout the crowd. The volume of light falling on the scene was reduced, and the group at the left now moves in a flickering light. In the radically altered fourth state (which may have been executed after an interval of several years), Rembrandt moved the event back in time so that Jesus is still alive and the profound darkness over the world, shot with light from heaven, falls principally on Christ. The attendant persons are now only half seen. What they feel must be grasped in part by an act of imagination. This fourth state is a profound and powerful work. But Rembrandt, still bent on exploring the possibilities of the plate, made even more beautiful and impressive prints by here too leaving carefully wiped surface tone on the plate. In a number of impressions, this produces a dramatic darkness that intensifies the harshness of the tragedy.

It is this masterly and imaginative use of tone that makes many of Rembrandt's prints unique and precious. In impressions of the *'Negress' Lying down* (1658; B. 205), for example, he carefully applied additional surface ink to the plate so that the subtleties of the contours of her body are delicately marked, and even the quality of her flesh is suggested. Probably no two early impressions of the ambitious *'Hundred Guilder Print'* (c. 1643–9; B. 74) were printed alike. Tone was used to give the rocky background different painterly aspects and to vary the relationship of Jesus to the crowd or to single out one or other of the groups who importune him. The portrait of the crippled artist *Jan Asselijn* (c. 1647; B. 277) was also inked in various ways, doubtless to lend grace to an ungainly body; in an impression of the second state (Boston, Mus. F.A.), surface tone has been left in the background and on the painter's clothing so that his stocky body acquires an unexpected monumentality and his spirit a sense of dignity.

The accidents that can occur in the process of etching a copperplate, customarily corrected by other printmakers, were often brilliantly exploited by Rembrandt. In both the portrait of *Clement de Jonge* and *St Jerome in an Italian Landscape* (c. 1654; B. 104), he preserved the abraded surface left by the polishing of the plate, which then printed as translucent areas of tone. Random lines caused by defects in the etching ground laid on the plate, which are visible through the open window in the second and third states of the *Self-portrait Drawing at a Window* (1648; B. 22), were incorporated into a landscape in the fourth state. Rembrandt was certainly capable of burnishing or scraping out rejected areas in a copperplate and hammering it back to its original level, thereby removing all traces of the former lines. But he did not always choose to do so. In the drastically reworked state of the *'Three Crosses'*, partly obliterated figures from the earlier states are retained, increasing the feeling of frightened confusion among the spectators. In the fifth state of the *Ecce homo*, when the crowd standing in front of the tribunal was scraped from the plate, a roughened area was left. This prints as an uneven tone by which Rembrandt suggested the mysterious character of the tribunal wall.

Rembrandt also experimented with his choice of papers. For example, he let handmade European paper, with its slight irregularities and faint hue, suggest the breadth of sky in the *Landscape with Three Gabled Cottages beside a Road* (1650; B. 217) or the quality of sunlight on stone in *'La Petite Tombe'* (c. 1652; B. 67). He printed some of the most beautiful impressions of *St Jerome in an Italian Landscape* on common, unbleached 'oatmeal' paper, the sober colour of which serves to bind together the light and dark components of the composition, including the lion with its rough, black mane and the figure of the saint reading in the sun. Occasionally Rembrandt used parchment, a material rarely employed by other contemporary Dutch printmakers. In impressions on parchment, the lines took on something of the breadth and strength of those made by the artist when he drew with a reed pen.

By 1647 Rembrandt had begun to use imported Japanese paper for his prints. He was not the only Dutch artist to do so, but he alone instinctively

understood how to exploit it. Japanese paper was available in several weights, textures and colours (from very nearly white to golden or almost tan). In an impression of the second state of the full-length portrait of *Jan Six* (1647; B. 285; New York, Pierpont Morgan Lib.), the warm colour of the Japanese paper on which it is printed gives the illusion of bright sunlight filtering through the open window against which the artist's friend is shown leaning and reading. Rembrandt sometimes used Japanese paper, as he did 'oatmeal' paper, to provide an intermediate tonality in a composition. In a very early impression of the *Goldweigher's Field* printed on white European paper (1651; B. 234; New York, Pierpont Morgan Lib.), the black touches of drypoint burr on the etched grove of trees are too pronounced, making the recession of the grove into the middle ground less convincing. By contrast, in an equally early impression printed on Japanese paper (Chicago, IL, A. Inst.), the light golden hue modifies the over-sharp contrasts. These are further diminished by the fact that Japanese paper catches and prints any residual tone of ink left on the plate, so that the colour of the paper appears darker than it is, and by the fact that its high degree of absorbency broadens and softens both etched and drypoint lines, bringing them into greater harmony with each other and with the paper.

FELICE STAMPFLE, ELEANOR A. SAYRE

4. Drawings

Rembrandt was probably not as prolific a draughtsman as has traditionally been assumed. For instance, he seldom made preparatory studies for paintings and etchings. In the case of his prints, there are only four preliminary drawings that he indented for transfer on to the copperplate, including one study (Amsterdam, Col. Six) of the two made for the etched portrait of *Jan Six* (1647; B. 285). In addition, there are a few unindented preliminary drawings related to etchings, as well as some other preparatory studies, mainly of figures, made for details of prints. These were done by Rembrandt either before he began the etching or while work was in progress. In the latter case he was searching for the appropriate

form of a particular detail that had been giving him some difficulty. For the same reason he also drew on early states of unfinished etchings in preparation for the completion of the print.

Preliminary compositional studies for paintings are even rarer than those made in connection with etchings. A few such drawings are based on compositions by other artists, such as the preliminary study for the *Rape of Ganymede* (c. 1635; Dresden, Kupferstichkab.) from a print by Nicolas Beatrizet after Michelangelo. A number of Rembrandt's individual figure studies, mainly from the Leiden period, were also used in paintings. Occasionally he made drawings after he had begun a painting, although the precise point in the process cannot always by determined with any certainty. These consist of both compositional drawings and figure studies. Presumably there were periods when Rembrandt drew either nothing at all or very little. That may have been the case at the beginning of the 1630s, when he worked in the Amsterdam studio of Hendrick van Uylenburgh and painted a large number of portraits. Only occasionally did he produce a portrait drawing.

Besides the drawings made in connection with works in other media, Rembrandt repeatedly produced groups of drawings on the same or related subjects. These are historical, especially biblical scenes, genre scenes, figure and animal studies and also model drawings, made especially for teaching purposes. Then there are landscapes and nude studies, both subjects that were drawn by Rembrandt as well as his pupils. Copies of other masters, including after Indian miniatures, form a separate category. Of course Rembrandt also drew for his own practice. His drawings, however, were mainly intended as a study collection, to serve as a source of inspiration for both himself and his pupils. They were kept in albums, along with works by other artists.

In a number of cases there is a clear connection between the choice of material used and the function or subject depicted in Rembrandt's drawings. For example, all indented designs for etchings were executed in red or black chalk; on the other hand, preliminary drawings for etchings

that were not transferred on to the copperplate were carried out in pen and ink. Nor does his choice of medium in the depiction of animals seem coincidental. Rembrandt naturally captured the elephant best in black chalk, while pen strokes were best suited to the representation of birds of paradise (e.g. Paris, Louvre). The supple coat of the lion was best conveyed by brush and wash (e.g. in *St Jerome in an Italian Landscape*; Hamburg, Ksthalle), and the flabby skins of pigs were rendered in pen and ink, the artist's preferred technique for most drawings.

Rembrandt's earliest drawings are figure studies in chalk, which are in some respects close to those of his second teacher, Pieter Lastman. In the late 1620s, however, Rembrandt developed a particularly evocative pen-and-ink technique, in which the effects of light and dark predominate. From the outset he used differences in the strength of his pen lines to convey such effects accurately. The shadow to the left of the head and in the eye socket in the study of a *Seated Man with a Tall Hat* (Rotterdam, Mus. Boymans–van Beuningen), for instance, as well as the powerful outline and shadow of the shoulder and arm, make it clear from which direction the light is coming. Forms are seldom defined by a single line, but each figure is made up largely of a combination of parallel and intersecting lines. Some of these lines are very characteristic of the artist, such as the lively and twisting contour near the bottom of the seated man's leg. It is not only the effects of light and dark over which Rembrandt took great care; he was also careful in the accurate rendering of details. The seated figure's eye in shadow is subtly but clearly delineated, and the row of shirt buttons riding up a little over his stomach conveys the shape of the figure underneath. Besides a powerful feeling for the effects of light, it is precisely this combination of carefully evoked details with boldly and schematically drawn shapes that is typical of almost all of Rembrandt's drawings. Generally it is the faces that are carefully drawn, while the rest of the figures are more schematic, depending on how far Rembrandt had worked out the composition.

As with many artists, it was Rembrandt's normal practice to draw in fine lines first and then to elaborate this light sketch with heavier lines. The thicker strokes were therefore usually applied last to the composition and also serve to correct the preceding fine lines. Rembrandt even followed this method when he drew landscapes, proceeding from the fine lines of the background to the darker lines of the foreground. The countryside and the buildings in the *View of the IJ* (before 1651; Chatsworth, Derbys) show how subtly and delicately he used his pen to create the background, while the proximity of the foreground motifs is emphasized by the addition of dark washes. The artist's method of beginning a drawing can be seen from the sketch on the *verso* of the *Entombment* (Amsterdam, Rijksmus.), a sketch made in connection with the etching of the *Beheading of John the Baptist* (1640; B. 92). The figure of John the Baptist is depicted kneeling with his hands folded: he is drawn with faint but precise lines, though not fully worked up. The executioner is sketched with equally fine lines, but the figure was subsequently redrawn with slightly darker lines, which improve on the first version in several places. The shift in the position of the head, from upright to inclining forward, is the most obvious change. This study also shows that Rembrandt's line was more assured when drawn over a preliminary sketch, which served as a starting-point and guide for the second version. In numerous other drawings the first, lightly sketched version can be detected beneath and alongside the subsequent development. Rembrandt seems to have deviated from this practice only when following the model of another artist. His red chalk copy (Berlin, Kupferstichkab.) of a painting of *Susanna and the Elders* by Lastman (Berlin, Gemäldegal.), for example, was largely set down directly in fairly bold strokes. The position of Christ's knee in Rembrandt's drawing of *Christ Washing the Feet of the Apostles* (Amsterdam, Rijksmus.) is another example of a correction made in darker lines over a preliminary sketch. These extra lines would not have had the required effect alone, but added to the existing lines they convincingly suggest the position of the

leg, without outlining it precisely. This convention of using lines that, when combined, accurately convey a sense of form (although they are not precisely defining in themselves) is particularly characteristic of Rembrandt's drawings.

Various examples show that Rembrandt rarely abandoned a drawing once he had started it, not even when he had made an ink blot or become dissatisfied with one part that had not worked. If he used too much ink or made a mistake with the pen or brush, he tended to use white paint to cover the offending lines or spots. This masking layer is found in countless drawings, although with the passage of time it is often not immediately detectable, since the lead in the white paint often causes it to oxidize to a darker colour, the opposite of what Rembrandt intended. Sometimes Rembrandt simply whited out a number of misplaced lines, such as on the back of the black chalk drawing of a *Man Standing with a Stick* (Amsterdam, Rijksmus.); sometimes a whole area is covered in white to soften the tone. White could also be used to throw certain sections into relief, or highlight them, as can be seen in the study of a *Seated Female Nude as Susanna* (Berlin, Kupferstichkab.), also in black chalk.

When Rembrandt made alterations to his drawings, he often did not bother to hide or remove the earlier version, although at times his corrections almost completely obscure the earlier version, which is visible only on closer inspection. This applies, for example, to the *Three Studies of an Elephant with an Attendant* (Vienna, Albertina), in which an elephant is seen walking forward with a raised trunk, while the earlier, lower position of the trunk is integrated into the advancing leg of the animal's attendant. Another self-corrected drawing, in which the changes are more immediately obvious, is that of *Saskia in Bed* (Groningen, Groninger Mus.): her right arm was drawn first resting on the bed covers and subsequently supporting her chin. In this case Rembrandt did not bother to paint out the first lines, though he did use a heavier line for the final position of the arm.

When a section of a drawing was clearly beyond redemption, Rembrandt took a knife and cut the passage out from the sheet of paper. Sometimes he stuck a new piece of paper over the hole from behind and completed the drawing on it; sometimes he covered it with a patch and redrew the figure. Such procedures show that the artist was determined to preserve the successful parts of the drawing. At other times he realized after starting a drawing that the piece of paper chosen was not large enough, as in the *Landscape near Kostverloren* (Chatsworth, Derbys), where the right-hand edge of the sheet is an addition.

In the mid-1630s Rembrandt produced a group of figure drawings characterized by a very free handling of line. It is again the faces, in particular, that are more carefully executed and elaborated. The remaining lines indicate the form in a seemingly disconnected rhythm. However, the direction of the pen hatching used to represent shadows, like the cursory outlining of the shapes, is in no way arbitrary but contributes greatly to the plasticity of the figures and the effect of depth in the compositions. If it were possible to examine the pattern and direction of the hatching separately from the rest of the drawing, it would be clear that the hatching forms a balanced pattern that focuses attention on the most important part of the drawing, for example the actor's head in the *Seated Actor in the Role of Capitano* (mid-1630s; Amsterdam, Rijksmus.). Another characteristic example of Rembrandt's pen-and-ink drawing style of the 1630s is *Christ Carrying the Cross*, one of a small group of biblical scenes. The longer the viewer looks at this image, the more sharply it comes into focus, the more clearly the figures stand out and the more emphatic a part the individual lines and shading play in the whole composition. In this case Rembrandt also used a brush and brown wash, not only to add a figure in the left foreground but also to create a darker area above the fallen figure of Mary. This patch suggests shadow and depth but optically has another effect: placed centrally between the figures, this area emphasizes the oval shape of the composition. Rembrandt often used such optical effects, which especially enhance the composition as a whole without necessarily representing anything definite. As the drawing progressed, the composition

that emerged under Rembrandt's hand naturally began to assume a proportionally greater significance for what he had yet to draw. The elaboration consisted of corrections and changes of emphasis, including such optical effects.

Rembrandt employed similar optical devices when he considered there to be too much empty white surface left on the sheet of paper. In such cases he simply drew a short line or a series of scribbles, which in themselves do not stand out in the overall composition but which counteract the flat impression made by the blank paper. This can be seen in a black chalk landscape (Wrocław, Ossolineum), where he placed some zigzag shading at the top of the sheet, which, rather than representing a canopy of leaves, helps to fill the empty space. In the *Seated Female Nude* (c. 1660; Chicago, IL, A. Inst.) such 'auxiliary lines' are again found; they do not appear to represent any actual form in themselves (e.g. the short line on the woman's breast) but certainly have a definite effect (e.g. the line through her calf).

What is perhaps most remarkable was Rembrandt's ability to impart expression to the faces of his figures with just a few lines, a skill that was probably unprecedented in the history of drawing. This is particularly well demonstrated in a sheet with three studies of the *Prodigal Son and a Harlot* (1630s; Berlin, Kupferstichkab.). In the first scene at top centre the young man's hands begin to wander; in the scene on the left his behaviour is punished with a furious reproach from the woman; and on the right the woman is seen finally to have relented and the young man to have got his way. His triumphant pleasure and the acquiescent pleasure of the woman he is petting are perfect examples of Rembrandt's capacity to represent human feelings in the most succinct form.

In a group of drawings from the late 1630s, carried out in iron-gall ink, often on light ochre prepared paper, there is the same astonishing sense of characterization, whether of figures and their facial expressions or even of animals. It is as though Rembrandt's plastic language had become more resonant than ever, he himself more confident. The way in which he depicted his wife *Saskia Looking out of a Window* (Rotterdam, Mus.

Boymans–van Beuningen) is extraordinarily direct. Producing a likeness with so few lines—compared with the silverpoint portrait of 1633—requires extreme sureness of touch. An important aspect of the pen-and-ink portrait is the use of carefully applied washes, which give relief to the subject: the fine, almost transparent brushstroke on Saskia's collar, for example, follows the line of her right arm to bring her shoulder a little forward, and the slightly curved brushstrokes above her right hand exactly indicate the curve of her breast beneath the collar. The brushstrokes in the background are also translucent and use different tones to suggest the darkness of the room. This transparency of the wash is characteristic of Rembrandt's use of the brush. Much later, when he drew a portrait of *Hendrickje at a Window* (Stockholm, Nmus.), he added an equally transparent wash in the background of a much bolder drawing in reed pen.

Occasionally Rembrandt drew with the brush alone, as he did for one of his most famous drawings, the *Woman Asleep* (London, BM), thought to depict his second wife, Hendrickje. The secret of this drawing's unequalled expressiveness lies in the well-considered pattern of lines produced with transparent brushstrokes. By imposing this limitation of means on himself and particularly by carefully separating light and dark, Rembrandt produced an evocative portrait. The artist's brush was just as effective in depicting light and dark in an interior, whether he was drawing from life, as in the case of the study of the *Artist's Studio with a Model* (c. 1652; Oxford, Ashmolean), or from his imagination, as in *Minerva in her Study* from the *album amicorum* of Jan Six (Amsterdam, Col. Six). Every stroke counts, though in a completely different way from those in the study of the sleeping Hendrickje. Not only does the brush convey a sense of space, but the atmosphere is made tangible. Finally, Rembrandt occasionally used the brush to create a background in which shapes are scarcely distinguishable but where an abstract pattern of lines evokes the space surrounding the figure, a device he employed in the late *Seated Female Nude* (c. 1660; Chicago, IL, A. Inst.).

PETER SCHATBORN

III. Critical reception and post-humous reputation

In his own lifetime Rembrandt strove not only for success in his artistic career but also for social status and recognition. This, to a large extent, he achieved: he received commissions from the court, painted prominent citizens of Amsterdam and also depicted antique heroes for the Sicilian noble-man Antonio Ruffo, to whom, in the last year of his life, he also supplied 189 etchings. In his sumptuous house on the Jodenbreestraat in Amsterdam (now the Rembrandthuis Museum) he accumulated a large collection that both provided artistic inspiration and reflected his social prestige; it was evidently intended as an investment and for the purposes of trading. In these circumstances, many pupils came his way, and he consorted with Amsterdam patricians and scholars, writers and preachers, merchants and artists. In particular, he moved in Baptist (Mennonite) circles and profited by their wealth and influence. His bankruptcy in 1656 did not, as is often thought, reduce him to penury, nor did it deprive him of his customers.

The supposed decline of Rembrandt's posthumous reputation was subsequently ascribed to his stubborn character and deliberate violation of the 'rules of art' (Emmens, 1968). Some late 17th-century writers (e.g. Joachim van Sandrart, 1675; Andries Pels, *Gebruik en misbruik des tooneels* ['Use and abuse of the stage'], 1681; Roger de Piles, 1699) criticized him severely on the grounds that he had ignored Italian theories of art and academic traditions, preferring the pure imitation of nature. Indeed, Rembrandt did not conform to Italian models after the style of these classicists, but their views were not formulated until after his death. There was probably no other artist in the Netherlands in the 17th century who had such a large collection of Italian art in the form of prints, which he studied with profit, though also with a critical eye. In accordance with the ideal of the '*génie méconnu*', Pels's picture of Rembrandt, in the Romantic period, as the 'first heretic of art' was seen to his credit rather than the reverse. Théophile Thoré in 1860 regarded Rembrandt as the complete antithesis of, for example, Raphael.

Only later did Rembrandt's links with tradition gradually become visible. His interpretation of earlier art came to be appreciated as highly personal, arbitrary as well as orthodox. Karel van Mander, whose *Schilder-boeck* ([1603]–1604) was a 'bible' for 17th-century artists, referred more than once in his theoretical and practical treatise to the concept of 'individual insight'. Despite all criticism, Rembrandt achieved what van Mander regarded as an artist's chief aim, namely 'honour and profit'. Some days before his marriage in 1634 Rembrandt wrote a variant of this as his personal motto: 'Een vroom gemoet—Acht eer voor goet' ('A pious mind places honour above wealth'; RD 1634/6). This pious aspiration was, in any case, fulfilled.

Contrary to what is sometimes asserted by modern scholars, by no means everything has been said or written about Rembrandt. This will continue to be the case until the scope and character of his work is firmly established. For the time being, many attributions are still fiercely debated, especially among the paintings and drawings. The problems are less severe for the etchings, which were well catalogued in the 18th century by, among others, Adam von Bartsch (1797), whose numbering is rightly still used. Detailed descriptions of the different states were compiled by White and Boon (Hollstein: *Dut. & Flem.*, 1969), and actual-size reproductions of the originals (not from photographs) were published by Schwartz (1977). The actual differences between states can be studied only first hand, in large printroom collections (e.g. Amsterdam, Rijksmus. and Rembrandthuis; Haarlem, Teylers Mus.; London, BM; New York, Pierpont Morgan Lib.; Paris, Petit Pal.).

Rembrandt's drawings were first thoroughly described and reproduced in the six-volume catalogue by O. Benesch (1954–7); a new edition, by his widow, appeared in 1973 but took little account of criticism, new discoveries and divergent opinions published in the meantime. Following the 'Rembrandt year' of 1956, Sumowski, in particular, considered the question of the attribution of drawings; this resulted in the publication of his multi-volume *Drawings of the Rembrandt School* (New York, 1979), in which many sheets regarded

by Benesch as originals by Rembrandt are ascribed to his pupils. The limitations of the connoisseurship methods used by Benesch and Sumowski have been pointed out in subsequent publications, in which much attention is devoted to inscriptions, signatures, collectors' marks, kinds of paper, watermarks, old descriptions and provenances (see especially publications by Schatborn). The largest collections of Rembrandt drawings are in Berlin (Kupferstichkab.) and London (BM), and there are interesting groups in Amsterdam (Rijksmus.), Dresden (Kupferstichkab.) and Paris (Louvre); the finest private collection is at Chatsworth (Derbys), though several sheets were sold in 1984 and 1987.

Beginning in 1968 a group of five Dutch scholars—J. Bruyn, B. Haak, S. H. Levie, P. J. J. van Thiel and E. van de Wetering—formed the Rembrandt Research Project (RRP) with the aim of studying, above all from a technical point of view, and recataloguing all paintings by the artist. (Until then, Bredius's 1935 catalogue raisonné (revised by Gerson in 1969) was the standard source.) In 1993, after three catalogues of the *Corpus of Rembrandt Paintings* had been published, the group disbanded, with the promise that the work would be carried on by van de Wetering and a younger team of scholars. In the first three volumes of the RRP *Corpus*, all paintings that had ever been attributed to Rembrandt were arranged in three categories: authentic works (A), those whose genuineness could neither be accepted nor rejected (B) and those certainly not by Rembrandt (C). This classification is useful, but it provides insufficient insight into the nature of the rejected works and does not answer, among other questions, whether studio paintings were also signed by Rembrandt. It was decided to abolish these much-debated categories for the two final volumes.

The subject of Rembrandt's iconography has been dealt with in numerous scattered studies and some general surveys (Clark, 1966). These initially concentrated on pure comparisons of form but later considered Rembrandt's position with reference to literary as well as pictorial tradition. A survey of the motifs he borrowed in his works is provided by the *Index to the Formal Sources of Rembrandt's Art* (Broos, 1977). There is still no analysis of the content of Rembrandt's work, which could usefully replace the older stylistic studies. A valuable insight into the sometimes fatal influence of ill-informed biographers and critics limited by the taste of their time is provided by S. Slive: *Rembrandt and his Critics* (1953). J. A. Emmens's *Rembrandt en de regels van de kunst* ('Rembrandt and the rules of art'; 1968) set the tone for a critically minded generation of art historians who sought to strip the Rembrandt phenomenon of romantic and 'aesthetic' accretions: among the typical works that resulted was B. Haak: *Rembrandt: Zijn leven, zijn werk, zijn tijd* (1969). The out-of-date archival study *Die Urkunden über Rembrandt* (1906) by C. Hofstede de Groot was replaced in 1979 by *The Rembrandt Documents* (ed. W. Strauss and M. van der Meulen); although the recent edition of the documents is marred by negligence and inaccuracies, it formed the basis of G. Schwartz's biography (1984), in which he succeeded in disentangling the web of social relations between Rembrandt and his clients. Schwartz did not discuss the etchings or drawings, and his choice of paintings was based on Gerson's revised, but still unreliable edition of Bredius. Hence a definitive biography remains to be written.

Bibliography

EWA; Thieme–Becker

early sources and documents

C. Huygens: *De jeugd van Constantijn Huygens door hem zelf beschreven* (MS., 1629–31); ed. A. H. Kan (Rotterdam and Antwerp, 1946) [the Lat. text of the MS. with the passage concerning Rembrandt trans. and commented on in RRP, *Corpus*, i, pp. 193–4]

J. J. Orlers: *Beschrijvinge der stadt Leyden* [Description of the city of Leiden] (Leiden, 1641) [incl. first biog. of Rembrandt]

J. von Sandrart: *Teutsche Academie* (1675–9); ed. A. R. Pelzer (1925), ii, bk 3, chap. 23, p. 326 [first non-Dutch biog.]

S. van Hoogstraten: *Inleyding tot de hooge schoole der schilder-konst* (Rotterdam, 1678)

F. Baldinucci: *Cominciamento e progresso dell'arte dell'intagliare in rame* (Florence, 1686), pp. 78–80 [biog. info. from Rembrandt's pupils]

A. de Piles: *Abrégé de la vie des peintres, avec des réflexions sur leurs ouvrages* (Paris, 1699), pp. 421–7 [first Fr. critique]

A. Houbraken: *De groote schouburgh* (1718–21), i [first extended biog.]

C. Hofstede de Groot: *Die Urkunden über Rembrandt, 1575–1721*, Quellenstud. Holl. Kstgesch., iii (The Hague, 1906) [sources up to Houbraken]

H. Gerson: *Seven Letters by Rembrandt* (The Hague, 1961)

W. Strauss and M. van der Meulen: *The Rembrandt Documents* (New York, 1979) [sources up to 8 Oct 1669] [RD]; review in *Simiolus*, xii (1981–2), pp. 245–62

Amstelodamum [numerous articles by I. H. van Elghen and S. A. C. Dudok van Heel, indispensable for the interpretation of early sources; summary as far as 1979 in RD, pp. 637–8]

Oud-Holland [numerous articles by A. Bredius; summary in RD, pp. 634–5]

monographs

E. Kollof: *Rembrandts Leben und Werke*, Raumers Taschenbuch, iii/5 (Leipzig, 1854/R Hamburg, 1971)

C. Vosmaer: *Rembrandt: Sa vie et ses oeuvres* (The Hague, 1877) [first gen. cat.]

E. Michel: *Rembrandt: Sa vie, son oeuvre et son temps* (Paris, 1893)

O. Benesch: *Rembrandt: Werk und Forschung* (Vienna, 1935/R Lucerne, 1970) [expanded version of entry in Thieme–Becker]

J. Rosenberg: *Rembrandt*, 2 vols (Cambridge, MA, 1948)

C. White and H. F. Wijnman: *Rembrandt* (The Hague, 1964)

B. Haak: *Rembrandt: Zijn leven, zijn werk, zijn tijd* (Amsterdam, 1969)

C. Tümpel: *Rembrandt in Selbstzeugnissen und Bilddokumenten* (Reinbek bei Hamburg, 1977)

G. Schwartz: *Rembrandt: Zijn leven, zijn schilderijen* (Maarssen, 1984)

paintings

J. Smith: *A Catalogue Raisonné of the Works of the Most Eminent Dutch, Flemish and French Painters*, vii (London, 1836)

W. R. Valentiner: *Rembrandts Gemälde*, Klass. Kst Gesamtausgaben (Stuttgart and Berlin, 1909) [3rd edn with 643 illus.]

C. Hofstede de Groot: *Holländischen Maler*, vi (1915)

A. Bredius: *Rembrandt: Schilderijen* (Vienna, 1935) [630 illus.]

K. Bauch: *Rembrandt: Gemälde* (Berlin, 1966)

H. Gerson: *De schilderijen van Rembrandt* (Amsterdam, 1968)

——: *Rembrandt: The Complete Edition of the Paintings by A. Bredius* (London, 1969) [630 illus, 56 of which are rejected] [Br.]

J. Bruyn, B. Haak, S. H. Levie, P. J. J. van Thiel and E. van de Wetering: *A Corpus of Rembrandt Paintings*, Rembrandt Research Project (The Hague, Boston and London, 1982–) [RRP, *Corpus*]

etchings

Hollstein: *Dut. & Flem.* [2 vols by C. White and K. G. Boon, with states and their locations]

E. F. Gersaint: *Catalogue raisonné de toutes les pièces qui forment l'oeuvre de Rembrandt* (Paris, 1751)

A. von Bartsch: *Catalogue raisonné de toutes les estampes qui forment l'oeuvre de Rembrandt et ceux de ses principaux imitateurs* (Vienna, 1797) [B.]

D. Rovinski: *L'Oeuvre gravé de Rembrandt*, 4 vols (St Petersburg, 1890; suppl., 1914) [first complete edn of all states then known, with illus.]

A. M. Hind: *Rembrandt's Etchings* (London, 1912); rev. as *A Catalogue of Rembrandt's Etchings* (London, 1923) [poor repros, but cat. nos often used]

L. Münz: *A Critical Catalogue of Rembrandt's Etchings*, 2 vols (London, 1952) [fullest descrip. of the etchings, incl. those by pupils that were previously attrib. to Rembrandt; concordances, sources and crit. bibliog.]

C. White: *Rembrandt as an Etcher: A Study of the Artist at Work*, 2 vols (London, 1969)

J. P. Filedt Kok: *Rembrandt Etchings and Drawings in the Rembrandt House*, Amsterdam, Rembrandthuis cat. (Amsterdam, 1972)

G. Schwartz: *Rembrandt: All the Etchings Reproduced in True Size* (Maarssen and London, 1977)

drawings

C. Hofstede de Groot: *Die Handzeichnungen Rembrandts: Versuch eines beschreibenden und kritischen Katalogs* (Haarlem, 1906)

A. M. Hind: *Drawings by Rembrandt and his School* (1915), i of *Catalogue of Drawings by Dutch and Flemish Artists*, London, BM cat. (London, 1915–)

W. R. Valentiner: *Rembrandt: Des Meisters Handzeichnungen*, Klass. Kst Gesamtausgaben, xxxi–xxxii (Stuttgart and Berlin, 1924–35) [excl. landscapes]

F. Lugt: *Rembrandt, ses élèves, ses imitateurs, ses copistes* (1933), iii of *Inventaire général des dessins des écoles du nord: Ecole hollandaise*, Paris, Louvre cat. (Paris, 1929–33)

M. D. Henkel: *Tekeningen van Rembrandt en zijn school* (1942), i of *Catalogus van de Nederlandsche tekeningen in het Rijksprentenkabinet*, Amsterdam, Rijksmus. cat. (The Hague, 1942–)

O. Benesch: *The Drawings of Rembrandt*, 6 vols (London, 1954–7); 2nd edn rev. and enlarged by E. Benesch (London and New York, 1973) [Ben.]; reviews of 1st edn by E. Haverkamp-Begemann in *Kunstchronik*, xiv (1961), pp. 10–14, 19–28, 50–57, 85–91; and J. Rosenberg in *A. Bull.*, xxxviii (1956), pp. 63–70, and xli (1959), pp. 108–19

W. Sumowski: *Bemerkungen zu Otto Beneschs Corpus der Rembrandtzeichnungen II* (Bad Pyrmont, 1961)

S. Slive: *Drawings of Rembrandt: With a Selection of Drawings by his Pupils and Followers*, 2 vols (New York, 1965) [based on a facsimile edn by C. Hofstede de Groot and others, 1906]

B. Broos: *Rembrandt en tekenaars uit zijn omgeving* (1981), iii of *Oude tekeningen in het bezit van de Gemeentemusea van Amsterdam waaronder de collectie Fodor*, Amsterdam, Hist. Mus. cat. (Amsterdam, 1976–)

P. Schatborn: *Tekeningen van Rembrandt, zijn onbekende leerlingen en navolgers/Drawings by Rembrandt, his Anonymous Pupils and Followers* (1985), iv of *Catalogus van de Nederlandsche tekeningen in het Rijksprentenkabinet*, Amsterdam, Rijksmus. cat. (The Hague, 1942–)

J. Giltaij: *The Drawings by Rembrandt and his School*, Rotterdam, Mus. Boymans-van Beuningen cat. (Rotterdam, 1988)

exhibition catalogues

Rembrandt after Three Hundred Years (exh. cat. by E. Haverkamp-Begemann, A. M. Logan and others, Chicago, IL, A. Inst., 1969)

Rembrandt, 1669–1969 (exh. cat., Amsterdam, Rijksmus., 1969)

Rembrandt: Experimental Etcher (exh. cat., Boston, Mus. F.A.; New York, Pierpont Morgan Lib.; 1969–70)

Rembrandt legt die Bibel aus (exh. cat. by C. and A. Tümpel, W. Berlin, Kupferstichkab., 1970)

Le Siècle de Rembrandt (exh. cat., Paris, Petit Pal., 1970–71)

The Impact of a Genius: Rembrandt, his Pupils and Followers in the Seventeenth Century (exh. cat. by A. Blankert, B. Broos, G. Jansen and others, Amsterdam, Waterman Gal.; Groningen, Groninger Mus.; 1983)

Bij Rembrandt in de leer/Rembrandt as Teacher (exh. cat. by E. Ornstein-van Slooten and P. Schatborn, Amsterdam, Rembrandthuis, 1984–5)

Rembrandt en zijn voorbeelden/Rembrandt and his Sources (exh. cat. by B. Broos, Amsterdam, Rembrandthuis, 1985–6)

Art in the Making: Rembrandt (exh. cat. by D. Bomford, C. Brown and A. Roy, London, N.G., 1988)

Rembrandt et son école: Dessins du Musée du Louvre (exh. cat. by M. de Bazelaire and E. Starcky, Paris, Louvre, 1988–9)

Rembrandt's Landscapes: Drawings and Prints (exh. cat. by C. P. Schneider, Washington, DC, N.G.A., 1990)

The Master and his Workshop: Paintings (exh. cat. by C. Brown, J. Kelch and P. van Thiel, Berlin, Gemäldegal.; Amsterdam, Rijksmus.; London, N.G.; 1991–2)

The Master and his Workshop: Drawings and Etchings (exh. cat. by H. Bevers, P. Schatborn and B. Welzel, Berlin Kupferstichkab.; Amsterdam, Rijksmus.; London, N.G.; 1991–2)

Rembrandt/Not Rembrandt in the Metropolitan Museum of Art, 2 vols (exh. cat., ed. H. von Sonnenburg and W. Liedtke; New York, Met.; 1995–6)

bibliographical overviews

H. van Hall: *Repertorium voor de geschiedenis der Nederlandsche schilder- en graveerkunst* (The Hague, 1936–49), i, pp. 528–91, nos 13971–15628; ii, pp. 310–31, nos 7329–7900 [bibliog. to 1946]

H. Roosen-Runge: 'Zur Rembrandt-Forschung: Literaturbericht und Bibliographie', *Z. Kstl*, xiii (1950), pp. 140–51 [pubns outside Ger., 1940–50; within Ger., 1945–50]

E. Haverkamp-Begemann: 'The Present State of Rembrandt Studies', *A. Bull.*, liii (1971), pp. 88–104 [bibliog. to 1 June 1970]

B. P. J. Broos: *Index to the Formal Sources of Rembrandt's Art* (Maarssen, 1977) [bibliog. on sources, 1751–1977]

S. Nijstad: *An Index* (The Hague, 1978) [pubns before 1700]

specialist studies

books

W. R. Valentiner: *Rembrandt und seine Umgebung* (Strasbourg, 1905)

F. Lugt: *Wandelingen met Rembrandt in en om Amsterdam* [Walks with Rembrandt in and around Amsterdam] (Amsterdam, 1915; Ger. trans., 1920)

J. L. A. A. M. van Rijckevorsel: *Rembrandt en de traditie* (Rotterdam, 1932)

S. Slive: *Rembrandt and his Critics*, Utrechtse bijdragen tot de kunstgeschiedenis, ii (The Hague, 1953)

W. S. Heckscher: *Rembrandt's 'Anatomy of Dr. Nicolaas Tulp': An Iconographical Study* (New York, 1958)

J. Bruyn: *Rembrandt's keuze van bijbelse onderwerpen* (Utrecht, 1959)

K. Bauch: *Der frühe Rembrandt und seine Zeit* (Berlin, 1960)

K. Clark: *Rembrandt and the Italian Renaissance* (London, 1966)

J. A. Emmens: *Rembrandt en de regels van de kunst* (Utrecht, 1968)

M. W. Ainsworth and others: *Art and Autoradiography: Insights into Paintings by Rembrandt, van Dyck and Vermeer* (New York, 1982)

E. Haverkamp-Begemann: *Rembrandt: The Nightwatch* (Princeton, 1982)

S. Alpers: *Rembrandt's Enterprise: The Studio and the Market* (Chicago, 1988)

H. P. Chapman: *Rembrandt's Self-portraits: A Study in Seventeenth-century Identity* (Princeton, 1990)

articles

C. Tümpel: 'Ikonographische Beiträge zu Rembrandt: Zur Deutung und Interpretation seiner Historien', *Jb. Hamburg. Kstsamml.*, xiii (1968), pp. 95–126

J. S. Held: *Rembrandt's 'Aristotle' and other Rembrandt Studies* (Princeton, 1969)

E. de Jongh: 'The Spur of Wit: Rembrandt's Response to an Italian Challenge', *Delta*, xii (Summer 1969), pp. 49–67

R. Scheller: 'Rembrandt en de encyclopedische kunstkamer', *Oud-Holland*, lxxxiv (1969), pp. 81–147

C. Tümpel: 'Studien zur Ikonographie der Historien Rembrandts: Deutung und Interpretation der Bildinhalte', *Ned. Ksthist. Jb.*, xx (1969), pp. 107–98

Oud-Holland, lxxxiv (1969) [issue devoted to Rembrandt with articles by, among others, J. Bialostocki, H. Gerson, H. Miedema and W. Stechow]

B. P. J. Broos: 'The "O" of Rembrandt', *Simiolus*, iv (1971), pp. 150–84

C. Tümpel: 'Ikonographische Beiträge zu Rembrandt: Zur Deutung und Interpretation einzelner Werke: II', *Jb. Hamburg. Kstsamml.*, xvi (1971), pp. 20–38

M. Kahr: 'Rembrandt and Delilah', *A. Bull.*, lv (1973), pp. 240–59

O. von Simson and J. Kelch, eds: *Neue Beiträge zur Rembrandt-Forschung: Rembrandt-Kongress: Berlin, 1969* (Berlin, 1973)

Rembrandt after Three Hundred Years: A Symposium— Rembrandt and his Followers: Chicago, 1969 (Chicago, 1973)

B. P. J. Broos: 'Rembrandt's *Portrait of a Pole and his Horse*', *Simiolus*, vii (1974), pp. 192–218

S. Donahue Kuretsky: 'Rembrandt's Tree Stump: An Iconographic Attribute of St Jerome', *A. Bull.*, lvi (1974), pp. 571–80

H. van de Waal: *Steps towards Rembrandt: Collected Articles, 1937–1972* (Amsterdam and London, 1974)

B. P. J. Broos: 'Rembrandt and Lastman's *Coriolanus*: The History Piece in 17th-century Theory and Practice', *Simiolus*, viii (1975–6), pp. 199–228

A. McNeil Kettering: 'Rembrandt's *Flute Player*: A Unique Treatment of Pastoral', *Simiolus*, ix (1977), pp. 19–44

M. Russel: 'The Iconography of Rembrandt's *Rape of Ganymede*', *Simiolus*, ix (1977), pp. 5–18

S. A. Sullivan: 'Rembrandt's *Self-portrait with a Dead Bittern*', *A. Bull.*, lxii (1980), pp. 236–43

J. A. Emmens: *Kunsthistorische opstellen*, 2 vols (Amsterdam, 1981)

K. Jones Hellerstedt: 'A Traditional Motif in Rembrandt's Etchings: The Hurdy-gurdy Player', *Oud-Holland*, xcv (1981), pp. 16–30

P. Schatborn: 'Van Rembrandt tot Crozat: Vroege verzamelingen met tekeningen van Rembrandt', *Ned. Ksthist. Jb.*, xxxii (1982), pp. 1–53

D. R. Smith: 'Rembrandt's Early Double Portraits and the Dutch Conversation Piece', *A. Bull.*, lxiv (1982), pp. 259–88

B. Broos: 'Fame Shared is Fame Doubled', *The Impact of a Genius* (exh. cat., Amsterdam, Waterman Gal.; Groningen, Groninger Mus.; 1983), pp. 35–58

P. Schatborn: 'Tekeningen van Rembrandt in verband met zijn etsen', *Kron. Rembrandthuis*, xxxviii (1986), pp. 1–38

—: 'Rembrandt's Late Drawings of Female Nudes', *Drawings Defined*, ed. W. Strauss and T. Felker (New York, 1987), pp. 307–20

Master Drgs, xxvii/2 (1989) [issue devoted to Rembrandt drawings with articles by E. Haverkamp-Begemann, J. Giltaij, P. Schatborn and M. Royalton-Kisch]

B. Bakker: 'Het onderwerp van Rembrandts ets *De drie boerenheuzen*', *Kron. Rembrandthuis*, xlii (1990), pp. 21–9

B. P. J. BROOS

Renesse, Constantijn (Daniel) van [à]

(*b* Maarssen, 10 Sept 1626; *d* Eindhoven, 12 Dec 1680). Dutch draughtsman, etcher and painter. He was the son of Lodewijk van Renesse, a theologian and minister of Maarssen who from 1634 was attached to Frederik Hendrik of Orange Nassau as Military Chaplain. In the course of this service Lodewijk and his family moved to Breda in 1638. On 18 July 1639 Constantijn went to university at Leiden to read literature; while there he produced

his earliest known work of art, a drawing *Skull with Books* (1640), known only from a document. In 1642 he turned to reading mathematics and in the same year produced *The Execution* (Vienna, Albertina), a drawing inspired by a print by Jacques Callot and drawn in the minutely worked and somewhat caricature-like style of Pieter Quast. He also borrowed from Quast the subject and the use of parchment as a support for his signed drawing *The Quack* (1645; Stockholm, Nmus.). He occasionally repeated this detailed style, for example in his *Historical Scene* (1663; Vienna, Albertina) and *Young Man Seated on a Chair in a Landscape* (1672; Paris, Louvre). Meanwhile he had received some instruction from Rembrandt, who had tried to teach him a different style of drawing, evident in the *Annunciation* (Berlin, Kupferstichkab.), which shows corrections made by Rembrandt to the figures and the definition of space with a broad-nibbed reed pen. Further evidence of Rembrandt's tutelage is provided in van Renesse's drawing *Daniel in the Lions' Den* (Rotterdam, Mus. Boymans-van Beuningen), which is signed and dated 1652 on the recto and inscribed on the verso: *de eerste tijckening getoont Bij Rem Bramt in jaer 1649 den 1 october* ('the first drawing shown to Rembrandt in the year 1649 on 1 October'). This implies that he had shown the first design to Rembrandt in 1649 and had completed the page three years later. Numerous drawings, mostly biblical scenes, with corrections by Rembrandt have been ascribed to van Renesse, including the *Prophet Gad Offers David his Choice of Punishment* (Amsterdam, Rembrandthuis), a *Crucifixion* (Rotterdam, Boymans-van Beuningen) and *Job with his Wife and Friends* (Stockholm, Nmus.).

Despite his university education, van Renesse had originally intended to be a painter. In 1651 he produced his most famous painting, the *Family Concert Party* (Salzburg, Residenzgal.), which depicts his father (then a professor), his brothers Frederik and Carel, his sister Margarita and Constantijn himself holding his pencil and sketchbook. Other known paintings are the *Satyr with Peasant* (1653), a *Dismissal of Hagar*, which is attributed to him (both Warsaw, N. Mus.), and the

undated *Kermis* (Washington, DC, Corcoran Gal. A.). Otherwise his paintings are known only from written accounts.

Van Renesse was also active as an etcher. His earliest dated etching is *Young Man Seated* (1650; see L. Münz: *A Critical Catalogue of Rembrandt's Etchings*, London, 1952, ii, p. 185); he etched similar figure studies in 1651, including a self-portrait. In 1653 he was unexpectedly appointed Town Clerk of Eindhoven to take the place, as a good Reformed churchman, of a Roman Catholic predecessor. He kept the office until his death. After his appointment, he practised his art infrequently, and then only as a draughtsman, producing drawings such as the *Trial of Susanna* (1662; Konstanz, Städt. Wessenberg-Gemäldegal.) and a fine signed portrait of his eldest son, *Lodewijk van Renesse* (1669; ex-C. R. Rudolf priv. col., London).

Bibliography

K. Vermeeren: 'Constantijn Daniel van Renesse, zijn leven en zijn werken', *Kron. Rembrandthuis*, xxx (1978), pp. 3–23; xxxi (1979), pp. 27–32

W. Sumowski: *Drawings of the Rembrandt School*, ix (New York, 1985), nos 2143–2206

B. P. J. BROOS

Roghman

Dutch family of artists. They were active in Amsterdam in the 17th century. Hendrick Lambertsz. Roghman (*d* after 1647) was an engraver who married Maria Savery, daughter of the well-known painter and draughtsman Jacob Savery. The Roghmans ran a workshop with their six children, three of whom became established artists: (1) Geertruydt Roghman was an engraver and etcher of genre scenes; (2) Roelant Roghman was a painter, etcher and draughtsman, mainly of forest scenes and mountain landscapes; and Magdalena Roghman (*b* Amsterdam, *bapt* 30 Jan 1632; *d* after 1669) was an engraver.

(1) Geertruydt Roghman

(*bapt* Amsterdam, 19 Oct 1625; *d* ?Amsterdam, before Dec 1657). Engraver and etcher. Her earliest-known work is an engraving after Paulus Moreelse

of her great-uncle *Roelandt Savery* (1647; Hollstein, p. 60). However, she is best known for a series of five engravings (Hollstein, nos 1–5), published between 1645 and 1648 in Amsterdam by Claes Jansz. Visscher I, in which women are depicted sewing, spinning, cooking, cleaning the house or either pleating fabric or examining it (e.g. *Pancake-baker*). Geertruydt depicted these domestic tasks from a woman's perspective and experience rather than within the traditional framework of eroticism, symbolism or moralizing allegory, as employed by her male contemporaries. Each engraving emphasizes the woman, her engagement with her particular task and the implements she uses for each. The figures are portrayed unself-consciously engrossed in their work. Roghman's personal variation of these themes, common in Dutch art, is thought to be indicative, in a larger sense, of the way that women felt about themselves and their domestic environment at that time. The last archival evidence of her was in March 1651.

Bibliography

Hollstein: *Dut. & Flem.*

W. Chadwick: *Women, Art and Society* (London and New York, 1990)

M. M. Peacock: 'Geertruydt Roghman and the Female Perspective in 17th-century Dutch Genre Imagery', *Woman's A. J.*, xiv/2 (1993–4), pp. 3–10

☐

(2) Roelant [Roeland] Roghman

(*b* Amsterdam, *bapt* 14 March 1627; *d* Amsterdam, *bur* 3 Jan 1692). Painter, etcher and draughtsman, brother of (1) Geertruydt Roghman. Arnold Houbraken said: 'He was in his day, with Gerbrand van den Eeckhout, a great friend of Rembrandt van Rijn'. Roghman is usually considered a pupil of Rembrandt in Amsterdam, but there is no documentary evidence, and his style gives little support for this. Houbraken also mentioned that Roghman was blind in one eye. What is certain is that Roghman was familiar with the work of his great-uncle Roelandt Savery and that he travelled a great deal in the Netherlands and probably also through the Alps. A series of

etchings of eight *Mountainous Tyrolean Land-scapes* was published in Augsburg (Hollstein, nos 25–32); given their realistic character, it is likely that they were executed after his travels. It is possible but unconfirmable that Roghman also visited Italy, but he is documented in Amsterdam again in 1658.

Roghman's oeuvre includes many drawings, paintings and etchings, principally forest views and mountainous landscapes, many of which are not taken from nature but seem to be a product of the artist's imagination. However, he also executed a series of topographically accurate drawings of castles and etched village views, and these are among his earliest works. To this group belongs one of his two earliest dated drawings, *Treehouses along the IJ near Amsterdam* (black chalk and grey wash, 1645; Amsterdam, Gemeente Archf), and a group of 241 drawings in black and white chalk, many with wash, of castles and country villas in the provinces of Holland, Utrecht and Gelderland, made in 1646 and 1647. As Roghman rarely dated his works, it is difficult to place them in chronological order, although it is possible to group related works. For instance, he also made a number of drawings and etchings of landscapes and views of villages in and around Amsterdam, several of which display his typical zigzag pen technique. This same technique is employed in a small sheet (in pen and black ink and grey wash) of a tollgate near a ferry and a distant view of Amsterdam with a tower, probably the Westertoren (Heino, Hannema–De Stuers Fund.).

Some of Roghman's works show a decorative manner related to the Dutch Italianates; for example the dated drawing *Landscape with Muleteers near a High Stone Bridge* (1655; Leipzig, Mus. Bild. Kst.) includes certain elements, such as the mule rider with the parasol, that would have appealed to the 17th-century taste for the pastoral. Many of the drawings may have been made in preparation for paintings and etchings, but there are so few connections between the various compositions that they equally well could have been intended to stand in their own right as independent works.

The *c.* 35 known paintings by Roghman are all undated and therefore can be grouped only on stylistic grounds. Most of the paintings are characterized by a bold, broad touch. His early paintings show a simple, diagonal composition, while the more mature landscapes feature a rich assembly of rocks, trees and streams (e.g. the *Mountainous Landscape with a Fisherman*, Amsterdam, Rijksmus.). His use of colour is conspicuously exuberant with frequent use of blue and orange–red tones. Roghman's loose touch and striking sense of colour show some connection with the scarce landscapes of his colleague Gerbrand van den Eeckhout, who was mainly concerned with history pieces, in which the landscape, however, often plays an important place. The strong, bristly technique possibly derives from the school of Rembrandt, particularly Jan Lievens. Roghman's compositions also suggest associations with the work of painters with a more refined manner, such as Jacob van Ruisdael and Allart van Everdingen. This varied combination of elements and influences contributes to the difficulty of defining Roghman's place within 17th-century Dutch landscape painting.

Bibliography

Hollstein: *Dut. & Flem.*; Thieme–Becker

A. Houbraken: *De groote schouburgh* (1718–21), i, p. 174

P. Beelaerts van Blokland: *Roeland Roghman: Dessinateur de châteaux en Hollande* (The Hague, 1940)

W. Stechow: *Dutch Landscape Painting of the Seventeenth Century* (London, 1966)

W. Sumowski: *Gemälde der Rembrandt-Schüler*, iv (London and Pfalz, 1983), pp. 2479–500

Masters of 17th-century Dutch Landscape Painting (exh. cat. by P. C. Sutton and others, Amsterdam, Rijksmus.; Boston, MA, Mus. F.A.; Philadelphia, PA, Mus. A.; 1987–8), pp. 435–7

F. J. Duparc: 'Roelant Roghman', *Landscape in Perspective* (exh. cat., Cambridge, MA, 1988), pp. 184–6

De kasteeltekeningen van Roelant Roghman (exh. cat. by H. M. W. van Wyck and J. W. Niemeijer, Amsterdam, Rijksmus., 1989)

W. Sumowski: *Drawings of the Rembrandt School*, x (New York, 1992), pp. 4989–5174

NETTY VAN DE KAMP

Ruisdael, Jacob van

(*b* Haarlem, 1628–9; *d* Amsterdam, *c.* 10 March 1682; *bur* Haarlem, 14 March 1682). Dutch painter, draughtsman and etcher. He is regarded as the principal figure among Dutch landscape painters of the second half of the 17th century. His naturalistic compositions and style of representing massive forms and his colour range constituted a new direction away from the 'tonal phase' (*c.* 1620–*c.* 1650) associated with the previous generation of landscape painters and exemplified by the work of his uncle Salomon van Ruysdael, Jan van Goyen, Cornelis Vroom, Pieter Molijn and others. Ruisdael showed unusual versatility: he produced several distinct landscape types—mountainous, woodland (see fig. 46) and river settings, waterfalls, beach and dune scenes, seascapes, panoramas (see fig. 47) and winter scenes—and created images that were both innovative and among the best in their category. He was not apparently interested in the fashion for Italianate landscapes but stands out as a unique talent in the context of such notable contemporaries as Aelbert Cuyp and Philips Koninck. His oeuvre comprises *c.* 700 paintings and *c.* 100 drawings, the majority undated.

1. Life and work

(i) Early works: Haarlem, c. 1646–c. 1650. Ruisdael's birth date is based on a document of 1662 in which he gave his age as 32. He was probably a child of the second marriage of his father, Isaack van Ruisdael (1599–1677), who is mentioned in the records of the Haarlem Guild of St Luke as a frame maker and picture dealer. Old inventories refer to paintings by the father, none however known. Jacob was probably taught by him or by Salomon van Ruysdael, with whose work he would also have been well acquainted. Houbraken stated that Ruisdael studied Latin and medicine in his youth, and some later biographers have inconclusively identified the painter with the Jacobus Ruijsdael recorded in an Amsterdam register of doctors, who completed his medical studies at Caen on 15 October 1676 (although this entry has inexplicably been crossed out in the register). At the age of 17 or 18, after visits to Egmond and Naarden, Jacob

46. Jacob van Ruisdael: *The Pond* (St Petersburg, Hermitage Museum)

produced paintings of high quality, such as *View of Egmond aan Zee* (1646; Eindhoven, Philips-de Jongh priv. col., see 1981–2 exh. cat., no. 2). In 1648 he entered the Guild of St Luke in Haarlem, whose members between 1645 and 1655 included several of the best Dutch landscape painters, among them his uncle, Pieter Molijn, Cornelis Vroom and, after his return *c.* 1645 from Sweden, Allaert van Everdingen.

Ruisdael's versatility is already evident from the seascapes, panoramas, river and wooded landscapes and dune views he made before 1650. In *Dune Landscape* (1646; St Petersburg, Hermitage) he used a compositional type favoured by the older generation: houses surrounded by trees on rising ground in the centre, backed by a distant view. The ambitious size of this canvas (1.05×1.63 m), however, distinguishes it from examples by his predecessors. His early works, especially the

wooded landscapes, are clearly influenced by Vroom, whose fine differentiation of forms, compositional harmony, ochre and green tints and romantic mood were a powerful source of inspiration to Ruisdael, notably in 1648–9. In the impressive *River Landscape* (1649; U. Edinburgh, on loan to Edinburgh, N.G.), Vroom's influence is evident in the rendering of the trees' foliage, the lighter and more refined palette and the poetic atmosphere. Some years later the roles were reversed, Ruisdael's style influencing the older master. There are differences, though: in *Landscape with a Hut* (Hamburg, Ksthalle) Ruisdael used a naturalistic rather than a tonal or atmospheric treatment, despite restricting his palette to the same olive-green and brown colours characteristic of 'tonal phase' paintings.

Dated drawings by Ruisdael are known only from the period 1646–9, for example *Huntsman*

47. Jacob van Ruisdael: *A Landscape with Ruined Castle and a Church* (London, National Gallery)

with Dogs beside a Forest (1646; Berlin, Kupferstichkab.). He began this drawing in black chalk, then partly erased it and finished it with pen and grey ink wash. In the first 10 years of his career he also made etchings, 13 of which are known. In view of their high quality he cannot have been purely self-taught, but his teacher is unidentified: neither Vroom nor Salomon van Ruysdael are known to have made etchings. In *Cottage and a Clump of Trees near a Small River* (1646; Hollstein, no. 7) the effect of sparkling sunlight is conveyed through scattered dots and short irregular lines, a technique frequently found in his drawings of this period.

(ii) The 'Wanderjahre', c. 1650–c. 1656. Around 1650 Ruisdael visited the Dutch–German border region, probably with his friend Nicolaes Berchem, and depicted a number of new subjects, such as half-timbered houses and water-mills, for example *Two Water-mills and an Open Sluice* (1653; Malibu, CA, Getty Mus.). Paintings from the early 1650s show that his style changed, becoming more powerful, with livelier forms, fresher colours and a more 'heroic' mood. In constructing his landscapes he relied less on such traditional aids as the use of diagonals to suggest depth, displaying instead a bold emphasis on mass and contrast. Perhaps the best-known example is *Bentheim Castle* (1653; Dublin, N. G.), a canvas that demonstrates Ruisdael's tendency to introduce a monumental character into nature through the seemingly realistic, though intentionally modified, presentation of observed sites. Van Goyen or van Ruysdael would have adopted a more everyday, less decorative vision, whereas Ruisdael maximized the grandeur by placing the castle on a hill of much exaggerated height. The imposing subject of the

background is further contrasted with the detailing of the coulisse-like foreground, thereby giving the landscape a strong feeling of space and depth.

Pictures of large trees constituted another new development for Ruisdael. The *Great Oak* (1652; Los Angeles, CA, priv. col., see 1981–2 exh. cat., no. 16) shows how he made a wooded landscape monumental through focusing on a single mighty tree. The forest is pushed to the background, and sharp areas of light, as on the patch of sand in front of the oak and on the path leading into the middle distance, give the landscape a more spacious structure and enhance the contrast between light and shade. The earlier *Dune Landscape* (St Petersburg), by comparison, looks rather opaque, and its undergrowth comes close to the picture's edge. Several etchings of this period, such as the *Great Beech* (c. 1652; Hollstein, no. 2), similarly depict single large trees, possibly inspired by the work of Roelandt Savery.

(iii) Amsterdam, c. 1656–c. 1669. Around 1656 Ruisdael moved to Amsterdam. The first document concerning his stay there is a request, dated 14 June 1657, to be baptized into the Reformed church (he was a Mennonite). Though he may have moved in order to benefit from Amsterdam's larger art market, the only known commissioned work is *Cornelis de Graeff and Members of his Family Arriving at his Country House of Soestdijk* (c. 1660; Dublin, N.G.), a collaborative work with Thomas de Keyser, who painted the portraits. Immediately after the move Ruisdael accepted into his household Meindert Hobbema, who became his best-known and most talented pupil.

In Amsterdam, Ruisdael considerably extended his range of subjects; he painted waterfalls, winter scenes, fantastic landscapes, beach views and seascapes. Around 1656 his style underwent a further change: dramatic mood gave way to a more relaxed serenity and more open treatment of space. The atmosphere is defined by light alone, rather than by his former, theatrical contrast between light and shade. He also paid greater attention to specifically Dutch motifs, as in the *Windmill* (c. 1657; Detroit, MI, Inst. A.). These stylistic features are evident in the wooded landscapes. In *Cornfield*

at the Edge of a Wood (c. 1655; Oxford, Worcester Coll.) the dense forest mass offsets the distant open view on the right and the narrow panoramic view through the trees. The cool, clear atmosphere both enhances the impression of spaciousness and heightens individual colours. The brown and olive-green tints are lightened with bluish-green, and a delicate grey enlivens the highlights on the tree trunks. The precise representations of the different kinds of tree bear witness to Ruisdael's remarkable powers of observation, though no preliminary studies are known.

Similarly, only one chalk drawing (c. 1655; New York, Pierpont Morgan Lib.) has been identified for the c. 130 paintings of waterfalls. The artist's interest in the subject may have been stimulated partly by his earlier tour of the Dutch–German border region c. 1650, after which he painted many watermills with foaming water, and partly by Allaert van Everdingen's work, which, as a result of his stay in Sweden, often featured waterfalls. Ruisdael considerably surpassed van Everdingen, for example in the *Waterfall with Castle and Cottage* (c. 1665; Cambridge, MA, Fogg). The waterfalls he painted in the early 1660s often have a vertical format, in which downward-cascading water makes a powerful impression of force and movement. Later in the decade and in the 1670s he switched to a horizontal format, and these landscapes take on a calmer and more static character.

Depictions of cornfields (e.g. c. 1665; New York, Met.) were another innovation of these years, as were winter landscapes, which he probably began to paint in the late 1650s (of c. 25 examples, none is dated), usually in small, vertical format. He revitalized the latter subject by departing from cheerful scenes of sport and recreation on the ice typical of earlier artists and instead concentrated on the sombre atmosphere of a bleak winter's day, as in *Village in Winter* (c. 1665; Munich, Alte Pin.), with its beautiful combination of blue, grey, white and brown tints.

In the late 1660s Ruisdael combined two of his earlier stylistic traits: he placed large sculptural forms viewed from close-up, which were reminiscent of works of the early 1650s, in open

pastoral landscapes typical of his initial Amsterdam years. A good example is the *Mill at Wijk* (c. 1670; Amsterdam, Rijksmus.), where the windmill, made to look much larger than its actual size, is set in flat, open terrain beside a seemingly unlimited expanse of water. The deliberately low viewpoint and detailed treatment of the foreground make the mill loom monumentally against the clouded sky and in strong contrast to the distant view. The grandeur and balance are achieved by bringing into equilibrium directional elements, such as the vanes and the clouds. In the *Pool in a Forest* (c. 1665; St Petersburg, Hermitage) Ruisdael again combined an open landscape with close-up forms, grouping massive trees around a forest pool. This composition was influenced by Savery's *Stag Hunt in a Marsh*, known through an engraving by Aegidius Sadeler (Hollstein, xxi–xxii, no. 233), but Ruisdael transformed Savery's fantastic Mannerist trees into a naturalistic representation of the depths of an imposing forest. The painting is remarkable for its open character, through which the denser part of the forest is viewed.

One of Ruisdael's most unusual and celebrated landscapes is the *Jewish Cemetery*, of which he made two versions (Detroit, MI, Inst. A.; Dresden, Gemäldegal. Alte Meister; see col. pl. XXXIII). The versions have been ascribed very different dates: Rosenberg and Slive place both in the 1650s, Sutton dates the Detroit version c. 1668–72 and the Dresden version c. 1665–8, and the matter continues to arouse debate. The *Jewish Cemetery* is exceptional in Ruisdael's oeuvre on account of its unequivocally allegorical character. The graves, broken-off tree, brook and ruin can all be interpreted as allusions to the transience of life (*vanitas*), though opinions differ about the meanings of details (*see* §3 below). The picture could also be said to contain the promise of new life and hope, expressed in the rainbow and the sunlight breaking through the clouds. Goethe was among the first to discuss the underlying content of the painting, and subsequent critics have continued to enthuse about it and to examine the possibilities and significance of its symbolism (see 1987–8 exh. cat., pp. 452–6).

(iv) **The 1670s and final years.** In his forties, Ruisdael produced a series of panoramic views of Haarlem, known as the *Haarlempjes*, which represent a high achievement in that genre and draw on conventions used in distant views of towns, topographical prints and works by older painters such as van Goyen and van Ruysdael. Unusually Ruisdael generally used a vertical format for such views. One of the series, a *View of Haarlem* (c. 1675; The Hague, Mauritshuis), has such a high viewpoint that the woods and distant houses hardly overlap. The vast sky with its accumulation of high cloud defines the pattern of light and dark on the ground and also reflects the receding countryside, thus emphasizing the skyline with St Bavo's church projecting above it. The *Haarlempjes* are full of detail and painted with a delicate touch, their atmosphere created by bright colours: light blue, grass-green and brick-red. Some preliminary sketches are known, such as *View of Haarlem* (Amsterdam, Rijksmus.), and a comparison between them and the paintings shows how Ruisdael improved the coherence and accentuated the effects of distance in the finished paintings.

In the late 1660s and early 1670s Ruisdael painted beach landscapes, seven of which survive, and all follow a simple plan, as in *Coast of the Zuider Zee near Muiden* (1670s; Polesden Lacey, Surrey, NT). With a low horizon beneath heavy clouds, the dunes run at an angle into the distance on one side and on the other is a stretch of sand and the sea. This compositional type was also used by van Goyen, Simon de Vlieger and Adriaen van de Velde. From about 1668 Ruisdael also began to paint townscapes, such as the *Dam with the Weigh-house of Amsterdam* (c. 1678; Berlin, Bodemus.).

In the last years of his life Ruisdael's subjects became more idealized, and the quality fell off somewhat, as seen in a rather less sensitive use of colour, more decorative forms and looser composition. In *Country House with Park* (c. 1678; Washington, DC, N.G.A.) the structure is weak, and the trees, meagre spruces, are quite unlike the massive, leafy trees of his earlier works. He painted imaginary landscapes in this period too,

such as *Mountainous Wooded Landscape with a River* (*c.* 1680; St Petersburg, Hermitage).

Ruisdael made his will twice in 1667, indicating that his health must have deteriorated, but whatever the illness it did not seriously affect his output. It was long supposed that Ruisdael died in the almshouse in Haarlem, but this was a confusion with his cousin, also a landscape painter, Jacob (Salomonsz.) van Ruysdael (*c.* 1629/30–81), who was one of his pupils.

2. Working methods and technique

(i) **Paintings.** At first, Ruisdael preferred to paint on panel, especially for his smaller works. He used canvas more often after *c.* 1650. In the 1640s and 1650s he used a grainy paint and a bristly brush; the brushwork is particularly visible in the skies. Later he applied paint in a smoother, more flowing manner. The white lead with chalk and reddish-brown or yellow ochre he used for priming, as was then common among Dutch painters, sometimes shows through in lighter areas, such as the sky. He worked from the background forwards, 'wet on wet' using a dark ground, to mark out the broad divisions between sky, grassland and water. These areas were then worked up with successive applications of paint from dark to light, leaving the highlights and staffage until last. The layers of browns and greens, for example, are clearly visible in the vegetation and demonstrate the subtle colour nuances he sought to achieve, a technique at which he was particularly skilled and which he successfully employed to balance colour contrasts. Ruisdael's early landscapes give the impression of direct borrowings from nature. In the crowded vegetation so typical of his later woodland subjects, he distinguished with great accuracy between the various species of tree and bush. Comparisons between versions of the same subject demonstrate how he constantly improved on his thoughtfully constructed compositions.

Ruisdael occasionally called on others to supply the staffage in his pictures, including Wouwerman, Johannes Lingelbach and Adriaen van de Velde. He signed his works with his name always spelt 'Ruisdael', or with the monogram JvR. His pupils, apart from his cousin and Hobbema,

included Cornelis Decker (before 1623–1678), Claes Molenaer (*c.* 1630–76), Claes Hals (1628–86), Jan van Kessel (ii), Adriaen Verboom (*c.* 1628–*c.* 1670), Jan Vermeer van Haarlem II and Roelof van Vries (*c.* 1631–after 1681).

(ii) **Drawings and etchings.** Ruisdael's drawings are broadly of two types: the more elaborate, such as *Huntsman with Dogs beside a Forest*, and the sketchy, such as *Trees at the Edge of a River* (*c.* 1655; Washington, DC, N.G.A). Few can be tied to specific paintings. Since the total number of his drawings is relatively small, either many of them have been lost or he was content to paint mainly without reference to preliminary sketches.

He apparently did not find etching, which he did only until the mid-1650s, a satisfactory medium for achieving the effects he sought. He was unable to obtain a smooth transition between the dense and heavily worked foreground and the open and airy background. He would have achieved a wider tonal range had he resorted to successive bitings of the plate, but, since he did not adopt this technique, the contrasts in his prints, such as the *Great Beech*, are somewhat abrupt.

3. Critical reception and posthumous reputation

During his career Ruisdael seems to have obtained reasonable prices for his paintings: between 1651 and 1675 their average value was about 42 guilders (Chong), high compared to van Goyen (17 guilders), though there were other landscape painters, particularly those who chose Italianate subjects, who received more. Apart from Hobbema, most of his pupils were not notably original artists; their paintings are chiefly based on Ruisdael's themes and compositions, though Jan Vermeer van Haarlem and Jan van Kessel produced some outstanding panoramas. Moreover, the best works by Rusidael's pupils and followers have probably been long since ascribed to him and reckoned as part of his oeuvre. He also influenced the work of certain contemporaries, Guillam Dubois (*c.* 1610–80), Jan Looten (1618–80) and Jan Wijnants among them.

Interpretation of the iconography of Dutch 17th-century landscape paintings in general, and

Ruisdael's in particular, has become increasingly problematic. Critics such as Eugène Fromentin, writing in the 19th century, insisted these works were faithful 'portraits' of observable actuality and asserted that they were a self-evident celebration of the Dutch countryside. Scholars in the 20th century, however, have examined the possibility that underlying moralizing and pietistic meanings of the types recognized to have been employed in contemporary portraiture, still-lifes and genre works may also be present in the painted landscapes. Their characteristic and highly prized 'realism', it has been suggested, was a skilful means of creating apparently uncomplicated aesthetic vehicles for conveying deeper and perhaps ambivalent meanings. Wiegand, for example, connected Ruisdael's use of the waterfall motif with references in contemporary literature to the 'cascade' as a familiar topos for the transience of human life. Taking this in conjunction with the trees with broken branches that Ruisdael often included, he interpreted the landscapes in terms of *vanitas* symbolism. Kauffmann read the *Mill at Wijk* as a moralizing metaphor in which the wind driving the vanes round represents the divine spirit that gives life to man. Slive and others have, however, rejected such proposals as 'far fetched'; they have argued that any moralizing symbolism that may have been apparent to 17th-century viewers was too unspecific to be subject to programmatic 'decoding' by later critics.

Bibliography

Hollstein: *Dut. & Flem.*

J. Rosenberg: *Jacob van Ruisdael* (Berlin, 1928) [biog., cat. and chronology of Ruisdael's work still largely satisfactory]

W. Stechow: *Dutch Landscape Painting of the Seventeenth Century* (London, 1966)

W. Wiegand: *Ruisdael-Studien: Ein Versuch zur Ikonologie der Landschaftsmalerei* (diss., U. Hamburg, 1971)

R. H. Fuchs: 'Over het landschap: Een verslag naar aanleiding van Jacob van Ruisdael, "Het Korenveld"', *Tijdschr. Gesch. & Flklore*, lxxxvi (1973), pp. 281–92

H. Kauffmann: 'Die Mühle von Wijk bei Duurstede', *Festschrift für Otto von Simson zum 65. Geburtstag* (Frankfurt am Main, 1977), pp. 379–97

D. Freedberg: *Dutch Landscape Prints of the Seventeenth Century* (London, 1980)

J. Giltay: 'De tekeningen van Jacob van Ruisdael', *Oud-Holland*, xciv (1980), pp. 141–208 [cat. of drawings with many illus.]

H. J. Raupp: 'Zur Bedeutung von Thema und Symbol für die holländische Landschaftsmalerei des 17. Jahrhunderts', *Jb. Staatl. Kstsamml. Baden-Württemberg*, xvii (1980), pp. 85–110

W. Schmidt: *Studien zur Landschaftskunst Jacob van Ruisdaels: Frühwerke und Wanderjahre* (Hildesheim and New York, 1981)

Jacob van Ruisdael (exh. cat. by S. Slive and H. R. Hoetink, The Hague, Mauritshuis; Cambridge, MA, Fogg; 1981–2) [good survey with many illus.]

Dutch Landscape: The Early Years, Haarlem and Amsterdam, 1590–1650 (exh. cat. by C. Brown, London, N.G., 1986)

A. Chong: 'The Market for Landscape Painting in Seventeenth-century Holland', *Masters of 17th-century Dutch Landscape Painting* (exh. cat. by P. C. Sutton and others, Amsterdam, Rijksmus.; Boston, Mus. F.A.; Philadelphia, Mus. A.; 1987–8), pp. 104–20, nos 80–89

E. J. Walford: *Jacob van Ruisdael and the Perception of Landscape* (New Haven and London, 1991)

LUUK BOS

Ruysdael [de Gooyer; de Goyer; Ruijsdael; Ruyesdael], Salomon [Jacobsz.] van

(*b* Naarden, nr Amsterdam, ?1600–03; *d* Haarlem, *bur* 3 Nov 1670). Dutch painter. He is best known for his atmospheric, almost monochromatic, river scenes, painted in the 1630s during the 'tonal phase' of Dutch art. His work in this genre is very close in style to that of Jan van Goyen, and their paintings have often been confused. Towards the end of his career, van Ruysdael's work took on a more classicizing style—perhaps influenced by that of his famous nephew JACOB VAN RUISDAEL. Salomon's son Jacob Salomonsz. Ruysdael (*c.* 1629–81) was also a landscape artist and much influenced by his cousin, as can be seen from the *Waterfall by a Cottage in a Hilly Landscape* (London, N.G.). Jacob Salomonsz. was working in Amsterdam by 1666, but died insane in the Haarlem workhouse.

1. Life and work

(i) Background and early career, to c. 1631. His father was Jacob Jansz. de Goyer (*c.* 1560–1616), a moderately wealthy cabinetmaker. Although Salomon initially used the name 'de Go(o)yer' [of Gooiland], he soon followed the example of his eldest brother and adopted 'Ruysdael' from the castle of Ruijschdaal in Gooiland, which may once have been a family possession. Shortly after his father's death, Salomon and another brother, Isaack van Ruysdael (1599–1677), a painter, framemaker and dealer, moved to Haarlem, where Salomon entered the Guild of St Luke in 1623 (as 'Salomon de Gooyer').

Among Salomon's earliest paintings are three winter scenes dated 1627 (e.g. *Frozen Landscape with Skaters*, Vienna, Ksthist. Mus.; see fig. 48). The composition of each, with its low horizon and narrow strip of land in the foreground punctuated by small playful figures, recalls the work of Hendrick Avercamp and, particularly, Esaias van de Velde. Other paintings from these years represent the sandy and hilly terrain bordering Haarlem. Many are clearly dependent on Pieter Molyn, a key figure in the rise of realistic Dutch landscape painting who also lived in the town. Van Ruysdael's *Landscape with a Peasant Farmhouse* (1631; Berlin, Gemäldegal.) conforms to a pattern for depicting dunes that Molyn had evolved: a rugged country road stretches obliquely from the right foreground to the left middle distance, while a second diagonal formed by the trees moves in a contrapuntal direction from the upper right of the painting. The illusion of space is further heightened by a darkened area in the left foreground, which contrasts with the intensely lit road. Van Ruysdael's palette of greens and browns also suggests the influence of Molyn. Van Ruysdael quickly gained a reputation among his contemporaries in Haarlem for his direct unembellished interpretations of the surrounding countryside, and in 1628 Samuel van Ampzing included van Ruysdael in his town history (*Beschryvinge ende lof der stad Haerlem in Holland* ['Description and praise of the town of Haarlem in Holland']), in a section dealing with famous Haarlem painters; he referred to him and Gerrit Claesz. Bleker (*fl* 1625–56) as 'good at landscapes with small figures in them'.

48. Salomon van Ruysdael: *Frozen Landscape with Skaters*, 1627 (Vienna, Kunsthistorisches Museum)

(ii) Tonal phase, c. 1632–1640. During the early 1630s van Ruysdael began to paint river scenes, probably in emulation of Esaias van de Velde, but also in close parallel with van Goyen, who simultaneously began to develop the same theme in a similar way. The painters must have been in close personal contact, and in 1634 van Goyen was fined three guilders by the Haarlem guild for painting without permission in the house of Salomon's brother Isaack. Painting during this decade in Haarlem is known as the 'tonal phase' since it is generally characterized by an extreme restraint, with colour restricted to striations of greys, greens, yellows, browns and blues. An early example of van Ruysdael's work in this rather severe style is his *River Bank with Old Trees* (1633; The Hague, Mauritshuis), in which he confined himself to a near monochromatic palette of blue-grey tones. Also typical is the composition: instead of arranging the elements parallel to the picture plane, a space-creating diagonal consisting of the bank and distant sailing vessels and trees was employed. The draining of colour has a unifying effect, as does the mirroring of the trees and boats on the ruffled surface of the water. However, this economy of pictorial means could not last indefinitely, and by the late 1630s he had begun to use purer and more varied hues.

(iii) Later career, after 1640. These changes in van Ruysdael's art became more absolute after 1640, and he moved further away from the example of van Goyen. He reduced the number of trees in his compositions to one central cluster; his colours became more varied and bright; a new emphasis was given to the clouds, and in place of the familiar wedge-shaped river views, broader expanses of water began to appear. He also began to depict other types of landscapes, for example halts before inns. This transformation in his art can be seen as part of a wider movement in landscape painting from tonality towards a 'classicizing' of the subject. The impulse to paint the more mundane features of the Dutch environment in a relatively uncomplicated manner was supplanted by a desire to imbue the landscape with a new sense of grandeur and refinement, perhaps under the influence of such early Dutch Italianates as Cornelis van Poelenburgh and Bartholomeus Breenbergh.

This tendency towards a greater stateliness can be observed in *River Bank near Liesvelt* (1642; Munich, Alte Pin.). While the painting still features a diagonally projecting mass of land to the right, its severity is offset by a group of tall slender trees and strong horizontals and verticals created through the boats and fishing nets on the left. The same is true of the use of colour. An overall yellow-brown tonality is enlivened with more intense values and splashes of local colour. A painting from the end of this decade, *River Landscape with Ferry* (1649; London, N.G.), shows van Ruysdael's progression from his earlier style at a more advanced stage. Here he adopted the river views with ferries by Jan Breughel the elder and Esaias van de Velde but brought greater dramatic interest to the subject with his highly animated figural groups that crowd the small vessels. Van Ruysdael was also concerned with the introduction of compositional variation and achieved it by the zigzag rhythms of the river banks that gently recede towards the church and village, and, to the left, in the diagonal of the three sketchily indicated sailing boats. The work also features a greater definition of form and an even stronger colouristic sense, especially evident in the warm glowing reds of the mounted figures in the ferry.

After 1640 van Ruysdael also began to paint what are often categorized as 'marines'; however, in van Ruysdael's case, this term is inappropriate as he preferred calm inland stretches of water to stormy seas. Works from the 1640s that feature large expanses of river and lake (e.g. *Laying the Net*, Frankfurt am Main, Städel. Kstinst. & Städt. Gal.) are indebted to van Goyen, but van Ruysdael introduced subtle variations of colour into the predominant grey tonality. Paint is applied quite thickly and with great haste in some passages, especially in the sky. A successful recurrent motif is the graceful line of sailing boats, which almost imperceptibly diminish in size towards the horizon. Ruysdael also painted related scenes of water and shipping in an upright format, thus giving them greater structure and presence.

Sailing Boats on an Inland Sea (*c*. 1650; Rotterdam, Mus. Boymans–van Beuningen) is a particularly striking example; a broad sweep of water extends perpendicularly from the picture plane, creating the illusion that the viewer is actually on the water, observing the scene from a nearby craft.

In 1647 and again in 1669 van Ruysdael was named an officer of the Guild of St Luke and in 1648 a deacon. Like many of his contemporaries, he did not earn his living exclusively from painting, and in 1651 he was recorded as a merchant dealing in blue dye for Haarlem's famous bleacheries. Around 1650 van Ruysdael returned to the subject of the winter landscape. His *View of Dordrecht* (1653; Zurich, Ksthaus) recalls the winter scenes painted in the 1640s by van Goyen and Isaack van Ostade. Across the wide frozen Maas, peopled by tiny skating figures, horsedrawn sledges and a tent in the left foreground, the prominent tower of the Groote Kerk looms large. Through his concentration on the sky with its large cumulus clouds reflected on to the ice below, he powerfully evoked the crisp atmospheric conditions of a fine winter's day.

Ruysdael also painted a limited number of still-lifes. Seven such signed and dated works were executed between 1659 and 1662; these invariably show hunting equipment together with game (e.g. *Hunter's Bag with Dead Birds*, 1662; The Hague, Mus. Bredius), and the elements are usually arranged on a stone plinth against a muted grey background and are clearly inspired by similar compositions executed by Willem van Aelst and the Hague painter Cornelis Lelienbergh (*c*. 1626–after 1676). Another popular motif of van Ruysdael's was that of horsemen and carriages congregating before an inn. (It appears with slight variations in over 30 works from the mid-1630s to the last decade of his life.) One of the largest and finest examples is *The Halt* (1661; Dublin, N.G.), in which three clusters of trees and a towering tavern are silhouetted against a bright windswept sky which fills almost two-thirds of the canvas. Although the composition is still controlled by a gently sloping diagonal that moves from the tree-tops in the right foreground to the low horizon on the left, the use of brilliant colour and the

stressing of such details as the trees are characteristic of van Ruysdael's later phase. Some of van Ruysdael's last works, for example *Landscape with the Journey to Emmaus* (1668; Rotterdam, Mus. Boymans–van Beuningen), clearly reveal the impact of his nephew Jacob van Ruisdael: a gnarled leafless tree and rocky area in the foreground, divided by a running brook from a lush green panorama with a castle beyond, are all elements that appear in the work of van Ruisdael.

Throughout his career, Ruysdael restricted himself to a narrow range of subject-matter and, particularly after 1640, an easily identifiable style. In part, this was determined by the art market; once an artist had found a successful and popular style, he could repeat compositions and motifs endlessly. Nevertheless, despite the dangers of predictability, van Ruysdael's art never has a tired appearance and always retains a sense of vitality and freshness.

2. Working methods and technique

Infrared reflectography carried out on a number of works by Salomon van Ruysdael has revealed extensive charcoal underdrawings in works from the 1630s. The sketch beneath *River Landscape with Footbridge* (1631; London, N.G.) establishes how van Ruysdael first rapidly mapped out the main components of the scene. It was only when he began to apply paint to the panel that smaller elements such as figures were added and other details undertaken. As no independent drawings by van Ruysdael are known, it is probable, at least in his early period, that he drew directly on to the support in his studio without first making preliminary studies.

Infrared photographs of later paintings (e.g. *River Landscape with Fishermen*, 1645; Madrid, Mus. Thyssen-Bornemisza) show no evidence of underdrawing and indicate that he composed his landscape views directly on the canvas or panel, making changes and additions as he worked. Presumably as he became more accomplished and reworked familiar themes, there was no longer a need to outline his compositions. Despite spending his entire career at Haarlem, van Ruysdael probably made extensive trips throughout the

Netherlands since there are views by him of Leiden, Utrecht, Amersfoort, Arnhem, Alkmaar and Rhenen. Works such as *View of Rhenen* (1648; London, N.G.), which has no underdrawing, suggest that it and similar paintings were the products of memory, something borne out by topographical inaccuracies. Alternatively, he may have used topographical prints, at least as an *aide-mémoire* when he composed the scene in his studio.

In general, van Ruysdael painted thinly on a light-coloured ground and during his tonal period often allowed the grain of the panel to become visible in places. This practice not only binds the entire composition together but also gives the paint layers an added depth.

Bibliography

W. Stechow: *Salomon van Ruysdael: Eine Einführung in seine Kunst mit kritischem Katalog der Gemälde* (Berlin, 1938, rev. and enlarged 1975)

——: *Dutch Landscape Painting of the Seventeenth Century* (London, 1966)

J. Foucart: 'Une Nature morte de Salomon van Ruysdael au Louvre', *Rev. Louvre*, xvii (1967), pp. 157–64

L. J. Bol: *Die holländsche Marinemalerei des 17. Jahrhunderts* (Brunswick, 1973), pp. 148–56

Dutch Landscape, the Early Years: Haarlem and Amsterdam, 1590–1650 (exh. cat., ed. C. Brown; London, N.G., 1986)

Masters of Seventeenth-century Dutch Landscape Painting (exh. cat., ed. P. C. Sutton; Amsterdam, Rijksmus.; Boston, MA, Mus. F.A.; Philadelphia, PA, Mus. A.; 1987–8), pp. 466–75

JOHN LOUGHMAN

Saenredam [Sanredam; Zaenredam]

Dutch family of artists. (1) Jan Saenredam is best known as a gifted engraver and draughtsman in the circle of Hendrick Goltzius. Besides his artistic activities, a document shows that he invested wisely in the Dutch East India Company and made sufficient profits to ensure that his only son, (2) Pieter Saenredam, need not ever depend on painting for his living. Pieter was nevertheless enormously successful as a painter; he is generally appreciated as the artist whose depictions of actual church interiors established a new genre in Dutch painting. While important precedents occur in the work of other artists (mainly Flemings, such as Hendrik van Steenwyck (i)), no painter or draughtsman before Saenredam had the interest, tenacity or the art market to support a career largely devoted to this speciality.

(1) Jan (Pietersz.) Saenredam

(*b* Zaandam, *c.* 1565; *d* Assendelft, 1607). Engraver, draughtsman and mapmaker. Orphaned in childhood, he was raised by an uncle, Pieter de Jongh, a bailiff in Assendelft. Though brought up for a life of farm labour and handiwork, he turned to drawing and in time attained some success as a mapmaker. With the help of a local lawyer, he entered the circle of Hendrick Goltzius relatively late in life, in 1589, and worked for short periods with both Goltzius and Jacques de Gheyn II. According to both de Bie and Schrevelius, there was some rivalry between each of these masters and Saenredam, who quickly absorbed what they had to offer him. About 1595 Saenredam returned to Assendelft, where he married and where his son (2) Pieter was born.

Four drawings by Jan Saenredam of scenes from the *Story of Lot* (three in London, BM, and one in Vienna, Albertina) show the influence of de Gheyn in the swirling rhythms of figures and landscape elements and in the nervous lines of hair and drapery folds. Saenredam's early engravings, however, reflect his contact with Goltzius, whose drawings were models for many of Saenredam's prints. In 1593–4 Saenredam engraved some of the more important drawings brought back by Goltzius from Italy. These include the *Frieze of Niobe* (B. 33, based on Goltzius's drawings after Polidoro da Caravaggio), which exploits Goltzius's broadest manner of swelling burin line to mimic the plasticity and uniform texture and colour of a stone frieze. It recalls Goltzius's *Pygmalion and Galatea* (1593; B. 138), in which this technique is used for its sculptural effect. Saenredam's prints of a few years later, the *Seven Planetary Gods* (1596; B. 73–9), the *Homage to Venus, Ceres and Bacchus* (1596; B. 70–72) and the *Temptation of Christ* (1597; B. 40), all after Goltzius, display the

characteristic burin manner and value range of the latter's prints of the 1580s and 1590s.

Jan Saenredam's most individual prints date from 1600 onwards, when he engraved many of his own compositions. His *Allegory of the Flourishing United Provinces* (1602; B. 10) and series of the *Wise and Foolish Virgins* (1605; B. 2–6), compositions of figures outdoors, show a refined sense of spatial relationships and an attention to individualized, naturalistic detail quite different from the more reductive approach of Goltzius and his other pupils. Adept rendering of the effects of sunlight, shade and evening torch-light is complemented by skill at achieving soft, lustrous surfaces, particularly on faces and flesh, by the use of the finest burin lines.

Jan Saenredam's wit for improvisation is well displayed in the multitudinous composition of the *Beached Whale at Beverwijck* (1602; B. 11), in such details as the long queue of spectators along the curving shoreline, the placement of Prince Ernst of Nassau at centre foreground as the first onlooker and the figures of Saenredam and an assistant wrapped in one cloak as they sketch in the blustery weather. This ambitious work was clearly meant to surpass Jacob Matham's *Beached Whale at Katwijk* (1598; B. 61). A more subtle display of skill is found in Saenredam's engraving after Cornelis Cornelisz. van Haarlem's mystical re-creation of *Plato's Cave* (1604; B. 39). Here, compositional interest is created from the patterns of light and dark, themselves the basis of the symbolism of the scene.

Bibliography

Thieme–Becker

T. Schrevelius: *Harlemias* (Haarlem, 1648), p. 318

C. de Bie: *Het gulden cabinet* (1661), pp. 498–9

A. von Bartsch: *Le Peintre-graveur* (1803–21), iii/2 [B.]

Graphik der Niederlande, 1508–1617 (exh. cat. by K. Renger, Munich, Staatl. Graph. Samml., 1979), p. 63

W. L. Strauss: *Netherlandish Artists* (1980), 4 [III/ii] of *The Illustrated Bartsch*, ed. W. Strauss (New York, 1978–)

I. Q. van Regteren Altena: *Jacques de Gheyn: Three Generations*, i (The Hague, 1983), pp. 31–3, 50, 123

 DOROTHY LIMOUZE

(2) Pieter (Jansz.) Saenredam

(*b* Assendelft, 9 June 1597; *d* Haarlem, *bur* 31 May 1665). Painter and draughtsman, son of (1) Jan Saenredam. His paintings of churches and the old town halls in Haarlem, Utrecht and Amsterdam must have been appreciated by contemporary viewers principally as faithful representations of familiar and meaningful monuments. Yet they also reveal his exceptional sensitivity to aesthetic values; his paintings embody the most discriminating considerations of composition, colouring and craftsmanship. His oeuvre is comparatively small, the paintings numbering no more than 60, and each is obviously the product of careful calculation and many weeks of work. Their most striking features, unusual in the genre, are their light, closely valued tonalities and their restrained, restful and delicately balanced compositions. These pictures, always executed on smooth panels, are remarkable for their sense of harmony and, in some instances, serenity. Here, perhaps, lies a trace of filial fidelity to the Mannerist tradition of refinement and elegance, of lines never lacking in precision and grace. But Mannerist figures and the more comparable components of strap- and scrollwork embellishment lack the tension and clarity of Saenredam's designs, which also have a completeness reminiscent of the fugues of Gerrit Sweelinck (1566–?1628).

1. Life and work

Pieter Saenredam's widowed mother moved to Haarlem in 1609, two years after her husband's death, and in May 1612 assigned her son, then 15, to the workshop of Frans de Grebber (1573–1649), one of a circle of Haarlem painters whose styles adhered to the 'classical reform' of the early Baroque period. Until he joined the Haarlem Guild of St Luke on 24 April 1623, Saenredam stayed in de Grebber's studio. Eleven years was an exceptionally long time to serve as an apprentice and, presumably, assistant. This may perhaps be explained in part by the artist's physical condition: as seen in a portrait drawing (1628; London, BM) by his friend and fellow pupil the architect Jacob van Campen, Saenredam was stunted in

stature and apparently hunchbacked, which might have made him somewhat reclusive.

Saenredam's activity until 1628, the date of his first painting, the *Interior View of St Bavo's, Haarlem* (Malibu, CA, Getty Mus.), can barely be accounted for by the drawings he made *c.* 1627 to be engraved (by Willem Ackersloot) for Samuel Ampzing's *Beschryvinge ende lof der stad Haerlem* (Haarlem, 1628) and those designs for independent prints, such as the *Siege of Haarlem* (1626) by Cornelis van Kittenstein (*c.* 1600–after 1638). In view of Saenredam's evident command of linear perspective by 1628 and the professionally produced ground-plans and elevations dating from a few years later (e.g. two copies of Salomon de Bray's *Design for Warmond Castle*, 1632; Haarlem, Gemeentearchf), it is possible that he had already worked as an architect's draughtsman, perhaps with de Bray or van Campen. Saenredam's use of perspective, in any case, was consistently more sophisticated than the procedures, usually little more than patterns, that contemporary painters such as Pieter Neeffs adopted from perspective treatises. This expertise was instrumental in Saenredam's subsequent depictions of actual architecture. His early experience in oil painting must also have been more extensive than previously recognized, for his pictures of 1628 and the next few years are not in any way naive. The most plausible candidates for early pictures are small-scale portraits, like those recorded in Saenredam's early drawings and prints. These painted portraits would have been of the type that Frans Hals occasionally and later Gerard ter Borch (ii)—and coincidentally the church painter Emanuel de Witte—executed on the scale of engravings. What is consistently evident in all of Saenredam's early known work—the drawings of people and plants, the maps, the landscape drawings with ruined castles, and the interior and exterior views of St Bavo's made for Ampzing's book—as well as in his subsequent drawings of architectural views, is the artist's high regard for exact appearances. For Saenredam, the function of drawing was to record, not to invent. Such a documentary approach was not unknown in the Goltzius circle (to which Pieter's father Jan belonged), but it finds closer

parallels in the work of younger artists such as Esaias and Jan van de Velde, Hendrick Vroom and Jacques de Gheyn II.

For the first eight years of his career as an architectural painter (1628–36), Saenredam devoted most of his attention to the interior of St Bavo's in Haarlem. Three paintings depict extensive views of the building, that dated 1628 (Malibu, CA, Getty Mus.), representing nearly all of the transept and the open spaces around the crossing, the others surveying the length of the church to the east (?1628; Philadelphia, PA, Mus. A.; corresponding to the plate in Ampzing, 1628) and to the west (1635; Edinburgh, N.G.), the latter being perhaps his most ambitious work. Other panels depict a view from the choir to the Brewers' Chapel (1630; Paris, Louvre); the southern aisle (1633; Glasgow, A.G. & Mus.); the southern ambulatory (1635; Berlin, Gemäldegal.); and five views across the choir (1635, Warsaw, N. Mus.; 1636, Amsterdam, Rijksmus.; Paris, Fond. Custodia, Inst. Néer.; Zurich, Stift. Samml. Bührle; and 1637, London, N.G.). A view of the Brewers' Chapel was also the setting for religious figures (as in the *Presentation in the Temple*, 1635; Berlin, Gemäldegal.), serving as what would too dismissively be described as staffage. This first and, remarkably, only series of paintings depicting St Bavo's (the subject, so closely associated with Saenredam's name, was not treated again for another 25 years) exhibits a characteristic attempt to record each interesting view in the church (see col. pl. XXXIV), without repetition, and a similarly comprehensive plan to explore the potential of various compositional ideas (e.g. long recessions along elevations; views across elevations with framing motifs in the foreground; elevations with no repoussoirs). Curiously, the only later painting of the *Interior of St Bavo's* (1660; Worcester, MA, A. Mus.) is a wide-angle view of the choir, which seems to complete Saenredam's survey of the site.

Saenredam also recorded sites outside Haarlem, for instance the St Pieterskerk in the newly captured town of 's Hertogenbosch (1632; London, priv. col., see Schwartz and Bok, fig. 98), where his uncle (and presumed host), the Revd Johannes Junius, who had moved there from Assendelft in

February 1631, was minister. On the same trip in July 1632, Saenredam made a sketch (London, B.M.) of the choir of the great Gothic cathedral of St Jan and the monumental rood-screen (1611–13; London, V&A). In the later painted view (1646; Washington, DC, N.G.A.), Saenredam inserted the altarpiece by Abraham Bloemaert (Paris, Louvre) that had already been removed or covered by the Dutch when he drew the site. Here and in the careful drawings of the rood-screen and the tomb of *Bishop Gisbert Masius* ('s Hertogenbosch, Noordbrabants Mus.), Saenredam seems to have been consciously recording for posterity, and in many cases architectural historians are indeed indebted to him: the St Pieterskerk at 's Hertogenbosch, for example, was destroyed in 1646.

The most productive of Saenredam's sojourns away from Haarlem was spent in Utrecht from June to October 1636. Bloemaert's busy studio was probably open to the Haarlem artist, since his father had been one of the celebrated Utrecht master's leading engravers. The first and most extensive series of sketches made in Utrecht are of the St Mariakerk (destr.); after a month of regular work on sketches of both the interior and exterior of that imposing Romanesque monument (e.g. Utrecht, Gemeentearchf; Haarlem, Teylers Mus.; Rotterdam, Mus. Boymans–van Beuningen), Saenredam turned to the other churches of Utrecht, the Buurkerk the St Jacobskerk in August, the St Janskerk (see fig. 49) and the cathedral in September and October and finally the St Catharinakerk. In each case, the fully dated drawings reveal that Saenredam proceeded from principal to subordinate views. The first paintings derived from the Utrecht portfolio

49. Pieter Saenredam: *St Janskerk, Utrecht*, 1636 (Rotterdam, Museum Boymans van Beuningen)

represent the St Mariakerk and form a consistent group: two paintings dated 1637 (Amsterdam, Rijksmus., and Kassel, Schloss Wilhelmshöhe), two of 1638 (Brunswick, Herzog Anton Ulrich-Mus., and Hamburg, Ksthalle), two minor works of c. 1638–40 (Amsterdam, Rijksmus., and Utrecht, Cent. Mus.) and the large panel dated 1641 (Amsterdam, Rijksmus.), Saenredam's second most ambitious work. The chronology and the number of sketches and finished paintings support the hypothesis (see Schwartz, 1966–7) that Saenredam's trip to Utrecht depended on Constantijn Huygens the elder's interest in the St Mariakerk and other examples of Romanesque architecture. Huygens, artistic impresario and private secretary to the Dutch Stadholder, was known to Saenredam through his staffage painter Pieter Post, who was also Huygens's architectural protégé. Two of the Mariakerk paintings, those of 1637 and 1641 (both Amsterdam), the latter with figures by Post, once hung in Huygens's house in The Hague.

Saenredam married in December 1638 and thereafter stayed mostly in Haarlem; in 1640 he was named steward and in 1642 dean of the painters' guild there. Apart from the meticulous drawing, dated 15–20 July 1641, of the Old Stadhuis, Amsterdam (Amsterdam,Gemeentearchf; painted version, 1657; Amsterdam, Rijksmus.), the next evidence of Saenredam's activity outside Haarlem is found in drawings (e.g. Haarlem, Teylers Mus., and Amsterdam, Rijksmus.) from July 1644 of the Koningshuis, the palace (built 1630–31) of the 'Winter King' Frederick V of Bohemia, and the St Cunerakerk at Rhenen. Huygens and the designer of the Koningshuis, Bartholomeus van Bassen (who was court architect in and around The Hague), were probably responsible for Saenredam's interest in the subject. Similarly, the new subjects of Saenredam's later years— the Nieuwe Kerk in Haarlem (drawings, 1650 and 1651; Haarlem, Gemeentearchf) and the Grote Kerk at Alkmaar (drawings, May 1661; Vienna, Albertina, and Berlin, Kupferstichkab.)— involve a building and church furniture designed by his associate Jacob van Campen. It would be mistaken, however, to imagine Saenredam's

subjects were assigned to him by others. His like-minded colleagues provided him with opportunities to pursue his profound interest in architecture and its representation: thus the St Mariakerk in Utrecht, for example, led the artist to depict every other church in town and to produce independent pictures from 1637 to nearly the end of his life (e.g. the Mariaplaats and the St Mariakerk from the West, 1663; Rotterdam, Mus. Boymans–van Beuningen).

2. Working methods and technique

Most of Saenredam's oeuvre can be divided into one of three categories: on-site sketches (i.e. 'from life'), construction drawings and finished paintings. These present few problems of chronology, for the artist was devoted to documentation, inscribing almost all of his material with dates (to the day) and keeping it on file. A good example of this methodical approach is the series of views of the Interior of the St Odulphuskerk, Assendelft. The on-site sketch (Amsterdam, Hist. Mus.) is dated 31 July 1634, and the corresponding construction drawing (The Hague, Rijksdienst Mnmtzorg) bears two sentences in Saenredam's handwriting describing the subject (including the remark 'Assendelft, a village in [the province of] Holland') and giving the date as the '9th day of December in the year 1643'. There then follows in different ink and larger letters: 'This was painted on the same scale as this drawing, on a panel of one piece, and the painting was finished on the 2nd day of the month October in the year 1649, by me Pieter Saenredam.' Finally, the painted panel (Amsterdam, Rijksmus.) is inscribed 'this is the church at Assendelft, a village in Holland by Pieter Saenredam, this painted in the year 1649, the 2nd October'. In the foreground of the picture is a tombstone inscribed, in Latin, 'Jan Saenredam famous engraver'.

Such a systematic approach differed greatly from the working methods of most contemporary architectural painters. The majority of those active c. 1550–c. 1650 evidently composed their underdrawings on the panel itself, whereas Saenredam used construction drawings, which were drawn

on cream-coloured paper, blackened on the *verso* and then traced on to the prepared panels. Saenredam's construction drawings are further distinguished by the fact that they incorporate and modify all the information found in the on-site sketches. These sketches confronted problems of design that were rarely, if ever, addressed by other architectural painters, either those active before Saenredam or those, such as Gerard Houckgeest, Hendrick van Vliet and Emanuel de Witte, who were active in Delft from 1650 onwards.

Saenredam, unlike others, accepted the terms dictated by the actual viewing situations: a close vantage point, consequently wide-angle views and fragmentary arrangements of architecture. Parallel developments are evident in Haarlem in other genres; Jan van Goyen's landscapes and Pieter Claesz.'s still-lifes, for example, move in much closer to their subjects than would comparable works by an older artist. The subject of the church interior brought with it unique dilemmas of design, but extensive evidence suggests that Saenredam fully understood the practice of artificial perspective and was well aware of the differences between looking at architecture in the round and transcribing it on to a flat surface. His on-site sketches of church interiors usually bear a circled dot and even a measurement indicating the vanishing-point, which in the underdrawing of a corresponding painting occurs in the same place. However, the sketches were made without the help of a straightedge or a system of orthogonals, and Saenredam paid only scant attention to his vanishing-point as he looked in many directions, which together considerably exceeded the angles of view recommended in perspective treatises of the period. Only a camera with a wide-angle or 'fish-eye' lens could record the subjects found in most of Saenredam's paintings, but the distortions he allowed (being free of unwonted curves) are comparable to the contemporary Mercator projection, a system of representation used in mapmaking. While the marginal distortions and overall fanning effects of a typical Mercator projection were potentially very troublesome to Saenredam (whose subject was structured by regular solids such as columns spaced at constant rather than increasing intervals), he turned this inherent perspective problem into a principle of design. His paintings are not at all illusionistic, nor are they realistic in the same way as his drawings made 'from life'. The degree of stylization or abstraction in many of his finished pictures is more akin to that of the mapmaker, the architect or the marquetry designer.

3. Critical reception.

The sophisticated and abstract character of Saenredam's paintings is a feature that appeals more to the modern mind than it would have to all but a few of the painter's contemporaries. What is now regarded as exquisite subtlety in Saenredam's work might have been appreciated, if at all, as an appropriate sobriety by viewers of the time, some of whom had seen St Bavo's walls and columns stripped of their 'Popish' appointments and whitewashed. Only in hindsight is it clear that Saenredam's sense of refinement and his spirit of reform (he tended to temper Gothic arches and to omit decorations that the Calvinists had left behind) are contradictions characteristic of this conflict-ridden period, like those of the black Dutch dress, derived from Spanish court costume, which was (when well tailored) at once elegant and reserved.

Saenredam's eccentric, if orthodox, use of perspective to stylize the image was not a programme that other artists could easily adopt, especially if, as in Delft, the illusion of three-dimensional space was a primary goal. Thus he had no real followers, though his compositions occasionally influenced other artists, especially the Haarlem painters Gerrit Berckheyde and Isaac van Nickele (*fl* 1659–1703). The significance of Saenredam's achievement exceeds his importance for a single genre of painting: he demonstrated, like Vermeer and other Dutch painters of exceptional ability, that perception is always subjective, that art is more than a mirror of reality. Architecture, in Saenredam's selective view, is not a subject found in nature, but an expression of the human spirit, another art form.

Bibliography

P. T. A. Swillens: *Pieter Janszoon Saenredam: Schilder van Haarlem, 1597–1665* (Amsterdam, 1935)

Catalogue raisonné van de werken van Pieter Jansz. Saenredam (exh. cat., essays by P. T. A. Swillens and J. Q. van Regteren Altena; Utrecht, Cent. Mus., 1961)

G. Schwartz: 'Saenredam, Huygens and the Utrecht Bull', *Simiolus*, i (1966–7), pp. 69–93

W. A. Liedtke: 'Saenredam's Space', *Oud-Holland*, lxxxvi (1971), pp. 116–41

—: 'The New Church in Haarlem Series: Saenredam's Sketching Style in Relation to Perspective', *Simiolus*, viii (1975–6), pp. 145–66

M. Kemp: 'Simon Stevin and Pieter Saenredam: A Study of Mathematics and Vision in Dutch Science and Art', *A. Bull.*, lxviii (1986), pp. 237–51

R. Ruurs: *Saenredam: The Art of Perspective*, Oculi: Studies in the Arts of the Lowlands, i (Amsterdam, 1987); review by W. Liedtke in *Burl. Mag.*, cxxx (1988), p. 39

G. Schwartz and M. J. Bok: *Pieter Saenredam: De schilder in zijn tijd* (Maarssen and The Hague, 1989; Eng. trans., 1990)

WALTER LIEDTKE

Saftleven [Zachtleven]

Dutch family of artists. Few works survive by Herman Saftleven I [not II, as in Thieme–Becker and elsewhere] (*b c.* 1580; *d* Rotterdam, 1627), a history painter and draughtsman active in Rotterdam from *c.* 1609. He married Lijntge Cornelisdochter Moelants (*d* Rotterdam, 2 Feb 1625), and three of their sons became artists: (1) Cornelis Saftleven, (2) Herman Saftleven II [not III, as in Thieme–Becker and elsewhere] and Abraham Saftleven (*b* Rotterdam, 1613). Cornelis and Herman the younger both grew up in Rotterdam, where they trained as painters, possibly with their father. Abraham was also a painter and the pupil of Abraham van der Linden, by whom no works are known. One of Herman II's daughters, Sara Saftleven (*b* Utrecht, after 1633), also became a painter, specializing in watercolours of flowers in the manner of her father.

(1) Cornelis Saftleven

(*b* Gorinchem, 1607; *bur* Rotterdam, 5 June 1681). Painter and draughtsman. After training as a painter in Rotterdam, he may have visited Antwerp *c.* 1632–4. From *c.* 1634 he was in Utrecht, where his brother (2) Herman the younger had settled, and they collaborated on a portrait of *Godard van Reede and his Family* (1634–5; Maarssen, Slot Zuylen). In 1637 Cornelis was back in Rotterdam, where in 1648 he married Catharina van der Heyden (*d* Rotterdam, 1654). The year after her death, he married Elisabeth van der Avondt. He became dean of the Guild of St Luke in Rotterdam in 1667.

According to Houbraken, Cornelis Saftleven painted peasant scenes, soldiers' guard-rooms and rural interiors; and even modern art historians still tend to regard him as specializing in rural genre subjects. But he was, in fact, much more versatile: his subjects include portraits, farmhouse interiors, other rural and beach scenes, landscapes with cattle, cattle markets, biblical and mythological themes, images of Hell, allegories, satires and illustrations of proverbs. There is documentary evidence for *c.* 200 oil paintings, 70 of which are dated between 1629 and 1678, and *c.* 500 drawings (probably less than half his total output), 170 of which are dated between 1625 and 1677.

1. Paintings

Some of Cornelis's earliest paintings are portraits, including the *Self-portrait as a Painter* (1629; Paris, Louvre) and the *Self-portrait Holding a Drawing of an Animal* (*c.* 1629; Paris, Fond. Custodia, Inst. Néer.). Cornelis's early interiors with peasants of *c.* 1633–5 (e.g. Prague, N.G., Šternberk Pal.; Berlin, Bodemus.) were influenced by the work of Adriaen Brouwer. About this same time (*c.* 1633–7) he also produced a number of paintings in collaboration—or in competition—with his brother Herman II, for instance the *Two Musicians* (*c.* 1633; Vienna, Akad. Bild. Kst.; see fig. 50), a double portrait of himself and his brother, as well as rustic interiors (e.g. Brussels, Mus. A. Anc.; Vienna, Ksthist. Mus.); these works established their dominance in this genre over the young David Teniers II. Other characteristic genre scenes by Cornelis from the 1630s include the *Interior with a Shoulder Operation* (1636; Karlsruhe, Staatl. Ksthalle) and the *Egg Dance*

50. Cornelis Saftleven: *Two Musicians*, c. 1633 (Vienna, Akademie der Bildenden Künste)

(1637; Warsaw, N. Mus.). One of his best rural interiors is the later *Stable Interior* (Hanover, NH, Dartmouth Coll., Hood Mus. A.). Saftleven also depicted rural life in outdoor settings, as in the *Peasant Company* (1642; Amsterdam, Rijksmus.), the *Peasant Company outside an Inn* (1642; Stockholm, Nmus.) and the *Beach Scene* (1658; untraced; see Schulz, no. 582).

Cornelis's paintings of cattle, for example *Landscape with Cattle and Herder* (1651; Amsterdam, Rijksmus.) and *Landscape with Cattle and Herder on a Bridge* (1652; Brunswick, Herzog Anton Ulrich-Mus.), compare well with those by masters well known for their depiction of cattle, such as Adriaen van de Velde, Paulus Potter and Nicolaes Berchem. Between 1659 and 1666 Cornelis produced several paintings of cattle markets (e.g. 1660, Valenciennes, Mus. B.-A.; 1663, Budapest, Mus. F.A.; Nîmes, Mus. B.-A.; and Vaduz, Samml. Liechtenstein). He also created lively pictures of ducks, goats and oxen in their natural habitat, using warm green and brown tones to convey a strong sense of atmosphere. His superb rendering of individual animals is also evident in his oil studies.

Landscapes with cattle also provide the setting for some of the artist's paintings of Old Testament and mythological subjects, as in *Jacob Dividing the Caravan* (1650; Stockholm, Nmus.), the *Reconciliation of Jacob and Esau* (untraced; see Schulz, no. 540), *Jacob's Departure from Canaan* (1655; priv. col., see Schulz, no. 541), the *Angel Departing from Tobias and his Family* (Munich, Alte Pin.) and the apparent pendants *Io and Argus* (1650) and *Mercury and Argus* (both St Petersburg, Hermitage). Some religious themes were repeated in several versions, for instance the *Annunciation to the Shepherds* (e.g. 1642, Munich, Alte Pin.; 1663, Amsterdam, Rijkmus.; and 16[??], Moscow, Pushkin Mus. F.A.) and the *Adoration of the Shepherds* (e.g. Munich, Alte Pin.). There are also two painted versions of *Christ Driving out the Devils* (1653 and 1660; both St Petersburg, Hermitage), for which preparatory drawings

survive in Darmstadt (Hess. Landesmus.), Oxford (Ashmolean) and Edinburgh (N.G.).

Cornelis Saftleven's most individual contribution to Dutch painting is his representation of Hell and supernatural figures. Examples include the *Witches' Sabbath* (Chicago, IL, A. Inst.), the *Landscape with the Entrance to Hell* (1652; untraced, see Schulz, no. 519), *Tymon the Magician* (1660; Copenhagen, Stat. Mus. Kst) and *Orpheus and Eurydice at the Entrance to Hell* (1662; Dijon, Mus. Magnin). Related to these in motif are the numerous versions of the *Temptation of St Anthony* (e.g. 1629, Recklinghausen, K. Herweg priv. col., see Schulz, no. 508; and Barnard Castle, Bowes Mus.) and such works as *Job* (1631; Karlsruhe, Staatl. Ksthalle) and the *Rich Man in Hell* (1631; Warsaw, N. Mus.).

Equally innovative are Cornelis's satires and allegories, a category that includes some of his earliest works (e.g. 1629; Rotterdam, Boymans–van Beuningen). In several of these pictures Saftleven made animals the active characters, occasionally with a hidden allegorical role (e.g. representing the Duke of Alba or Prince Maurice of Orange). Saftleven's masterpiece in this genre is the *Allegory of the Trial of Johan van Oldenbarnevelt* (1663; Amsterdam, Rijksmus.). His sense of satire is also revealed in paintings depicting the folly of the world through proverbs and sayings: these include *Greed for Gold* (1630; Dijon, Mus. Magnin), *Death the Reaper* (1649; Richmond, VA Mus. F.A.) and two versions of *Stultitia mundi* (1657, Allschwil, Gemeindesamml.; 1664, Riom, Mus. Mandet).

2. Drawings

Cornelis Saftleven generally drew in black chalk, occasionally using a brush and grey wash. Sometimes he worked on paper prepared with a coloured wash. Most of the drawings are signed with his characteristic monogram—composed of the letters C, S and L. The shape of the letter S changed over the years, and this helps in dating some of the undated sheets. He is also known to have made repetitions of some of his own drawings and to have supplied others with designs for etchings; however, there is no documentary evidence (*pace* Hollstein) that he himself produced any original prints.

As with his paintings, Cornelis was more versatile in terms of subject-matter than most 17th-century Dutch draughtsmen, producing drawings ranging from allegorical subjects and multi-figured rural scenes to landscapes. However, he is best known for his studies from life of individual figures (e.g. *Study of a Standing Man*, 1641; Darmstadt, Hess. Landesmus.), animals and birds (e.g. *Head of an Owl*, 1669; Berlin, Kupferstichkab.). He was influenced in his landscape drawings by those of Roelant Roghman, in his animal drawings by Roelandt Savery, Frans Snyders and Aelbert Cuyp, and in his figure studies by Cornelis Dusart and Gabriel Metsu. Extensive collections of his drawings can be found in Berlin (Kupferstichkab.), Rotterdam (Boymans–van Beuningen), Amsterdam (Rijksmus.), Brussels (Mus. A. Anc.), Paris (Ecole N. Sup. B.-A. and Fond. Custodia, Inst. Néer.), Besançon (Mus. B.-A.), London (BM) and Copenhagen (Stat. Mus. Kst).

Bibliography

A. Houbraken: *De groote schouburgh* (1718), i, pp. 340–43
W. Schulz: *Cornelis Saftleven (1607–1681): Leben und Werke* (Berlin, 1978)

(2) Herman Saftleven

(*b* Rotterdam, 1609; *d* Utrecht, 5 Jan 1685). Painter, draughtsman and engraver, brother of (1) Cornelis Saftleven. He settled in Utrecht *c.* 1632 and in 1633 married Anna van Vliet. They had two sons, Dirck Saftleven (*d* 1679) and Herman Saftleven III (*d* before 1685), and two daughters, Sara (who married Jacob Adriaensz. Broers in 1671) and Levina (who married Paul Dalbach). From 1639 onwards Herman Saftleven II lived at Achter St Pieter 7, Utrecht, and in 1659 he became a citizen of the city. He recorded views of his adopted city in several drawings and etchings, for instance the *Panoramic View of Utrecht* (1648, B. 35; and 1669, B. 36). He several times served as head man (*overman*) and dean of the Guild of St Luke there. In 1662 he arranged the sale of part of the Earl of Arundel's collection in Utrecht. A hurricane destroyed the city in 1674, and Saftleven drew

many devastated houses and streets. Some eight years later, c. 1682, he sold the city a series of 22 drawings he had made of Utrecht churches before they were destroyed. About this same time (1680 and 1682–4) he was commissioned by the amateur botanist and horticulturalist Agnes Block (1629–1704) to draw flowers and plants at Vijverhof, her country estate situated on the River Vecht, near Utrecht.

1. Paintings

There are over 300 paintings by Herman Saftleven II, produced between 1630 and 1684, all of them probably originally bearing monograms or signatures. His early work is indebted to Pieter de Molijn and Jan van Goyen; he subsequently fell briefly under the influence of Abraham Bloemaert and that of Jan Both. His subjects include farmhouse interiors, imaginary riverscapes and Italianate landscapes.

At the time of his brief collaboration with his brother Cornelis, from c. 1633, he produced a number of rustic barn interiors. These he continued to paint until 1637, and they were superior to similar subjects by his brother. Herman's genre paintings have been mistaken for works by Pieter de Bloot (b Rotterdam, 1601; d Rotterdam, 1658), Frans Rijckhals (b Middelburg, c. 1600; d Rotterdam, 1647) and Hendrick Sorgh. In 1635 Herman collaborated on the painted decoration of Prince Frederick Henry's palace of Honselaersdijck, south of The Hague. From about that time Herman began painting Italianate landscapes in the style of Cornelis van Poelenburch, with whom he occasionally collaborated, for example in Christ Predicting the Destruction of Jerusalem (1641; Bonn, Rhein. Landesmus.). Other biblical subjects include works dated 1642, 1648 and 1667 (Jesus Preaching at Lake Gennesaret; London, N.G.). He also painted mountainscapes in the style of Roelandt Savery and wooded landscapes in the style of Alexander Keirinckx and Jan Both. By about 1645, however, Saftleven abandoned Italianate subjects in favour of native 'Dutch' landscapes, a change probably stimulated by a visit in 1644 to the eastern Dutch province of Gelderland. From 1650 onwards he concentrated on imaginary Rhineland views and on topographically accurate hilly and rocky landscapes, peopled with tiny figures.

2. Drawings and prints

More than 1200 topographical and imaginary landscape drawings have survived, most of them bearing monograms and about 200 of them dates. The drawings are not rough sketches, but for the most part finished, often large-scale, drawings made for collectors, such as 37 sheets made for the Atlas van der Hem (Vienna, Österreich. Nbib.) assembled c. 1663–6 by the Amsterdam lawyer Laurens van der Hem. As well as the drawings of Utrecht, there are another 60 of other views in the Netherlands and around 50 from the Lower and Middle Rhine regions of Germany (e.g. of castles). In 1651 Herman made a second visit to the eastern Netherlands, to Arnhem and Cleve (now Kleve, Germany), whence he proceeded up the Rhine to Bingen. In 1677 he produced an integrated series of imaginary Rhineland views. His imaginary landscapes and drawings of animals reflect the influence of Roelandt Savery. His drawings and watercolours of plants made for Agnes Block are among the most impressive botanical studies in 17th-century Dutch art. There are large collections of his drawings in Brussels (Mus. A. Anc.), Berlin (Kupferstichkab.), Amsterdam (Rijksmus.), Utrecht (Gemeente Archf), Vienna (Albertina), Haarlem (Teyler Mus.), London (BM) and Weimar (Ksthalle).

Herman II was also very active as a printmaker and produced an extensive oeuvre of etchings and engravings. The earliest etchings date from 1627 and show the influence of Willem Buytewech. Saftleven completed a series of landscape etchings c. 1640, and by c. 1644 he was making Italianate etchings in the style of Jan Both. Jan van Almeloveen and Jan van Aken, who may have worked directly for Saftleven at times, emulated his landscape prints. Besides landscapes, Saftleven's prints include a portrait engraving of Coenrad Waumans, which was published in Images de divers hommes d'esprit sublime (Antwerp, 1649) and in Cornelis de Bie's Het gulden cabinet (Antwerp, 1661). He also etched a portrait of Jan Gerritsz. van Bronchorst (Hollstein,

no. 17) and an etching of an unidentified subject after a painting by Dirck Saftleven, dating from 1660.

3. Critical reception and posthumous reputation

During his lifetime, Saftleven's paintings of imaginary river views and drawings of realistic landscapes made him one of the best-known Dutch artists. In 1660 Joost van den Vondel published panegyrics on him in *Hollantsche parans*, as well as others in 1661 and 1669. Saftleven's pupils included from *c.* 1645 the landscape painter Jan Gerritsz. van Bemmel (*b* Utrecht, 1628; *d* Utrecht, 1673) and his brother Willem van Bemmel (*b* Utrecht, 1630; *d* Wöhrd/Nuremberg, 1708) and from 1668 to 1671 Jan van Bunnick (*b* Utrecht, 1654; *d* Utrecht, 1727). Within a few years of his death, and especially in the 18th and 19th centuries, his paintings were much sought after and also frequently copied, for example by Jan Griffier I, whose copies were often mistaken for originals, and by Griffier's sons Robert (*b* London, 1688) and Jan II (*b* London, *c.* 1700). Saftleven also influenced several 18th-century German painters, including Johann Christian Vollerdt (*b* Leipzig, 1708; *d* Dresden, 1769), Christian Hilfgott Brand, Johann Christian Brand, Christian Georg Schütz (*b* Flörsheim, 1718; *d* Frankfurt am Main, 1791) and the latter's nephew, Christian Georg Schütz II (*b* Flörsheim, 1758; *d* Frankfurt am Main, 1823).

Bibliography

Hollstein: *Dut. & Flem.*

A. von Bartsch: *Le Peintre-graveur* (1803–21) [B.]

J. Nieuwstraten: 'De ontwikkeling van Herman Saftlevens kunst tot 1650', *Ned. Kst. Jb.*, xvi (1965), pp. 81–117

W. Schulz: 'Blumenzeichnungen von Herman Saftleven d. J.', *Z. Kstgesch.*, xl (1977), pp. 135–53

D. Freedberg: *Dutch Landscape Prints of the Seventeenth Century* (London, 1980), pp. 63–7

W. Schulz: *Herman Saftleven (1609–1685): Leben und Werke* (Berlin, 1982)

J. Salomonson: 'Op de wal, agter St Marije' [On the bank, behind St Marije], *Meded. Kon. Ned. Acad. Wet.* (Amsterdam, 1983)

Masters of 17th-century Dutch Landscape Painting (exh. cat., ed. P. C. Sutton; Amsterdam, Rijksmus.; Boston, MA, Mus. F.A.; Philadelphia, PA, Mus. A.; 1988), pp. 475–80

WOLFGANG SCHULZ

Santvoort [Zantvoort], Dirck (Dircksz.)

(*b* Amsterdam, *c.* 1610; *d* Amsterdam, *bur* 9 March 1680). Dutch painter. He was a son of the painter Dirck Pietersz. Bontepaert and, on his mother's side, a grandson of Pieter Pietersz. and a great-grandson of Pieter Aertsen. His elder brother was the landscape painter Pieter Dircksz. Santvoort (1603–35). Dirck probably received part of his training from his father, whose work no longer survives. The assertion that he also studied with Rembrandt has no factual basis, though he was undeniably influenced by the older artist.

Signed and dated works by Santvoort survive from 1633 onwards. Santvoort's *Christ's Supper at Emmaus* (1633; Paris, Louvre) betrays Rembrandt's strong influence. A number of other biblical scenes in this style are also attributed to Santvoort. In the mid-1630s Santvoort started the series of portraits that form the most important part of his oeuvre, conventional and straightforward in style, sometimes even seeming a little old-fashioned. One of the earliest examples is the group portrait of the *Family of Dirck Jacobsz. Bas, Burgomaster of Amsterdam* (1634/5; Amsterdam, Rijksmus., on dep. Amsterdam, Hist. Mus.). Also in this style, Santvoort painted a number of portraits of individual sitters over the following years, including the portrait of *Agatha Geelvinck* (*c.* 1637–8) and her husband *Frederik Alewijn* (1640; both Amsterdam, Rijksmus.). These paintings are subdued in colour and style, distinguished by their sharply perceptive character and the care with which this perception is committed to canvas. Santvoort also undertook two official group portraits: in 1638 the *Regentesses and Housemistresses of the Spinning House* (a house of correction for women; Amsterdam, Hist. Mus.) and in 1643 the *Directors of the Serge Cloth Industry* (Amsterdam, Rijksmus.). Both are tranquil compositions, the first more successful in its depiction of the individual figures than the second.

Santvoort's most striking gift was his ability to portray children, where his gifts of precise observation and his uncluttered style produced some delightful results. The earliest individual portrait of a child is that of *Willem van Loon* (1636;

Amsterdam, Mus. van Loon), in which, unusually for children's portraits at that time, Santvoort adopted an oval format. A series of similar paintings, in rectangular format, date from the following years. Worthy of note are the portraits of *Elisabeth Spiegel* (*c.* 1639; Cleveland, OH, Mus. A.) and *Simon van Alteren* (*c.* 1642; priv. col., see 1952 exh. cat., no. 152). The painting of a mischievous *Boy with a Stick* (1644; Darmstadt, Hess. Landesmus.) represents a high point of extremely natural child portraits. In the portraits of *Martinus Alewijn* and *Clara Alewijn* (1644; Amsterdam, Rijksmus.) Santvoort depicted the children as pastoral figures.

Dirck Santvoort married Baertgen Pont in 1641, by which time he was already a rich man. After her death he married, in 1657, Trijntje Rieuwertsdr. By then Santvoort had probably not painted for many years, since no works survive dating from after 1645. However, he was still active as head of the painters' guild in 1658 and regularly appraised paintings (as late as 1673). He had no known students.

Bibliography

Thieme–Becker

N. de Roever: 'Pieter Aertsz., gezegd Lange Pier, vermaard schilder' [Pieter Aertsz., known as Lange Pier, the famous painter], *Oud-Holland*, vii (1889), pp. 1–38

W. Martin: *De Hollandsche schilderkunst in de zeventiende eeuw* [Dutch painting in the seventeenth century], 2 vols (Amsterdam, 1935–6)

Drie eeuwen portret in Nederland, 1500–1800 [Three centuries of portraiture in the Netherlands, 1500–1800] (exh. cat., Amsterdam, Rijksmus., 1952)

R. E. O. Ekkart: 'Vyf kinderportretten door Dirck Santvoort' [Five children's portraits by Dirck Sandvoort], *Oud-Holland*, civ (1990), pp. 249–55

RUDOLF E. O. EKKART

Savery, Roelandt [Roelant]

(*b* Kortrijk, 1576; *d* Utrecht, 1639). Dutch painter, draughtsman and etcher, brother of painter Jacob Savery I (*c.* 1565–1603). The subject and miniaturist precision of his earliest dated work, *Birds by a Pond* (1600; St Petersburg, Hermitage), reflect the influence of Jacob, his presumed teacher. The strong Flemish current in Amsterdam *c.* 1600 is apparent in the *Village Edge* (Pommersfelden, Schloss Wissenstein), with its mixture of decorative and realistic—the gracefully swaying trees reminiscent of Hans Bol and the robust peasant figures based on Jacob's studies from life. Also from the same year are two identical *Flowers in a Niche* (Utrecht, Cent. Mus., and New York, priv. col., see Müllenmeister, 1988, no. 270). As earlier flower-pieces known from contemporary sources are lost, these are the earliest dated, independent flower paintings in the Netherlands.

Roelandt may have been invited to the court of Rudolf II as a promising artistic descendant of Pieter Bruegel I, many of whose best paintings Rudolf owned. This would explain why Roelandt abandoned his borrowing of Jacob's figure drawings and developed his own repertory of peasant studies, made largely in the Prague markets. He inscribed them with colour notations and usually the phrase *naer het leven* ('after the life'), confirming the source of the unfamiliar costumes. Indeed, the drawings were thought to be by Bruegel until 1970, when Roelandt's authorship was demonstrated (Spicer, 1970a, and van Leeuwen). The related paintings of peasant life range from 1604 to 1611 (e.g. *Peasants Carousing*, 1608; Brussels, Mus. A. Anc.). Roelandt's studies also encompassed more exotic subjects: Hungarian cavalrymen (e.g. London, BM) and unprecedented studies of Jews (e.g. Frankfurt am Main, Städel. Kstinst.).

Artistic life at Rudolf's court was marked by the personal quality of his patronage and by the mutual influence of a small but diverse circle of protégés, including such painters as Bartholomeus Spranger and Hans von Aachen, the silversmith Paulus van Vianen, the sculptor Adriaen de Vries and several important composers and scientists. This stimulating environment was further enriched by access to the greatest *Kunst- und Wunderkammer* of the day. Rudolf's interest in the *Kunst- und Wunderkammer* doubtless accounts for his sending Roelandt into the Tyrol *c.* 1606–7 to draw 'wonders'. The resultant drawings, depicting awesome mountain peaks and, especially, waterfalls, are among the earliest

interpretations of these thrilling natural phenomena. Like his woodland compositions and drawings of Prague and its environs, these alpine views, done from nature but enhanced in the studio, served as reference material for later paintings, such as the *Cascade* (*c.* 1608; Ghent, Mus. S. Kst.). Composed views on a more intimate scale were drawn for prints published by Aegidius Sadeler, many of which were engraved by his assistant Isaac Major, who also made etchings after Roelandt's drawings. Roelandt's only autograph etching, *Gnarled Tree* (Hollstein: *Dut. & Flem.*, no. 2), dates from *c.* 1608–9. Other etchings have been attributed to him. While his delicately washed pen drawings owe much to Jacob and to van Vianen, his expressive use of black and coloured chalks for dramatic landscapes and studies is his own.

Rudolf's menageries and hunting-grounds provided the background for Roelandt's scenes of the hunt, such as the *Boar Hunt* (1609; Munich, Alte Pin.) and for encyclopedic depictions of the animal kingdom. Thus, his careful observations of individual animals (e.g. chalk studies of lions in Dresden, Kupferstichkab.) could later be used in such animal paintings as *Orpheus Charming the Animals* (1610; Frankfurt am Main, Städel. Kstinst. & Städt. Gal.).

Roelandt's flower paintings, like those of his contemporaries, are open to Christian interpretation as *vanitas* images. That he intended them as such is suggested by the common associations attached to the specific, and sometimes unusual, species (Segal), the inclusion of fading flowers and the impossible floral combinations. A good example is the *Flowers on a Ledge* (1612; Vaduz, Samml. Liechtenstein). No flower drawings have been attributed to Roelandt. In some cases he may have painted blossoms directly from life, in others indirectly: the flowers and insects in *Flowers in a Niche* (1611; England, priv. col., see Müllenmeister, 1988, no. 272) are borrowed from watercolour and gouache drawings in Joris Hoefnagel's emblematic natural history compendium, the *Four Elements* (ex-Rosenwald priv. col.; Washington, DC, N.G.A.), which Rudolf II possessed. This is the only flower painting for which an emblematic 'key' is known to have been available.

Roelandt returned to Amsterdam in 1613, remaining there until 1619, when he moved to Utrecht with his nephew Hans Savery II (1589–1654). The landscapes Roelandt produced in Amsterdam typically offer to the lowlander the vicarious thrill of the mountain wilderness by combining plunging views and breathtaking waterfalls into a composite view, as, for example, in the *Wilderness with the Temptation of St Anthony* (1617; Brian and Esther Pilkington priv. col., on loan to London, N.G.). His characteristic brilliant detail of woodland flowers and water spray is set against the broad colouristic sweep of the rocks. Only a few drawings, of ruins or imaginary mountain landscapes (and a few animal studies), were done in Amsterdam and possibly none in Utrecht. Of his Dutch surroundings he depicted only cattle, whose worthiness as subject-matter he seems to have been the first to celebrate in paint (e.g. *Bulls Fighting*, 1616; Geneva, Mus. A. & Hist.). Perhaps in response to popular demand for accessible exotica, he began producing animal and bird fantasies with nominal biblical or mythological themes, such as *Exotic Birds with the Abduction of Ganymede* (*c.* 1618; Vienna, Akad. Bild. Kst.). The artist's last paintings of peasants, such as the sympathetic 'portrait' of a *Peasant Resting* (Karlsruhe, Staatl. Ksthalle), date from *c.* 1617.

Roelandt Savery never married, and died in poverty and mental confusion, hardly working in his last years. Inconsistencies and harshness in paintings from the later 1620s onwards suggest that parts were done by Hans II or another assistant. Even before the master's death Hans II and other imitators began producing a few hundred such pastiches. However, Roelandt continued to paint flower-pieces until near the end of his life, culminating in the extravagance of the *Bouquet in a Niche* (1624; Utrecht, Cent. Mus.), a disquieting picture, 1.3 m high, in which the brevity, even nastiness, of life is reflected in the cockatoo killing a frog beneath cascading blossoms.

Many Dutch artists active in the first half of the 17th century felt Roelandt's influence, but only his nephew Hans Savery II can have been a pupil. In Utrecht, Roelandt's flower-pieces provided models for Jacob Marrel, while his

landscapes and animal paintings were the inspiration for Gillis d'Hondecoeter. Allaert van Everdingen's scenes of Scandinavian wilderness recall Roelandt's alpine drawings, some of which he reworked. Antoni Waterlo, the Willaerts family and Herman Saftleven II copied and adapted his drawings. Beyond Utrecht, Jacob van Ruisdael took his gnarled trees as a point of departure, while Rembrandt owned an album of Tyrolean views, many of which were later bought and copied by Lambert Doomer.

Bibliography

J. Spicer: 'The naer het leven Peasant Studies, by Pieter Bruegel or Roelandt Savery?', Master Drgs (1970), pp. 3–30

——: 'Roelandt Savery's Studies in Bohemia', Uměni, xviii (1970), pp. 270–75

F. van Leeuwen: 'Iets over het handschrift van de "naer het leven"-tekenaar' [Some notes on the handwriting of the 'naer het leven' drawings], Oud-Holland, lxxxv (1970), pp. 25–32

J. G. C. A. Briels: De Zuidnederlandse immigratie in Amsterdam en Haarlem omstreeks 1572–1630 (diss., U. Utrecht, 1976), p. 282–3

J. Spicer: The Drawings of Roelandt Savery (diss., Yale U., 1979)

S. Segal: 'The Flower Pieces of Roelandt Savery', Leids Ksthist. Jb., i (1982), pp. 309–37

J. Spicer: 'De Koe voor d'aerde [statt]: The Origins of the Dutch Cattle Piece', Essays in Northern European Art Presented to Egbert Haverkamp-Begemann (Amsterdam, 1983), pp. 251–6

T. DaCosta Kaufmann: L'Ecole de Prague (Paris, 1985)

Roelandt Savery in seiner Zeit (1576–1639) (exh. cat. by E. Mai, K. J. Müllenmeister and others, Cologne, Wallraf-Richartz-Mus., 1985) [essays by S. Segal and H.-J. Raupp]

K. Müllenmeister: Roelant Savery: Die Gemälde (Frerens, 1988)

J. Spicer: Roelandt Savery: Drawings and Paintings (London, in preparation)

JOANEATH A. SPICER

Schalcken, Godfried

(b Made, nr Breda, 1643; d The Hague, 13 Nov 1706). Dutch painter and etcher, active also in England. He was the second son of Cornelis Schalcken from Heusden, a clergyman in Made, and Aletta Lydius, who came from a famous clerical family in Dordrecht. In 1654 the family moved to Dordrecht, where Cornelis was appointed headmaster of the Latin school. There Godfried was apprenticed to Samuel van Hoogstraten. He completed his training in Leiden with Gerrit Dou and by 1665 had returned to Dordrecht. Schalcken's earliest known works, for example the Doctor's Visit (1669; Germany, priv. col., on loan to Cologne, Wallraf-Richartz-Mus.), are dominated by the influence of Dou and the Leiden 'fine painters'. Like Dou, Schalcken painted small genre pieces with a wealth of painstakingly rendered detail, and his themes and frequent use of artificial lighting are strongly reminiscent of the Leiden master. The six prints known by him, including a portrait of Gerrit Dou and a few portraits after van Hoogstraten, must also originate from this period. Possibly under the influence of Caspar Netscher and Frans van Mieris, Schalcken soon afterwards adopted a freer touch with gentler transitions and a lighter palette and applied himself to painting genre pieces with elegant figures. One of his best works in this style is Vrouwken komt ten hoof (the 'Game of "Lady come to court"', c. 1673–5; Brit. Royal Col.).

After Nicolaes Maes's departure for Amsterdam in 1673, Schalcken became Dordrecht's most popular portrait painter. Wealthy citizens living or born in this town formed an appreciative public for his elegant style, and many of his half-length portraits of them have survived. One splendid example is the portrait of Pieter de la Court the Younger (1679; Leiden, Stedel. Mus. Lakenhal). The elaborate preparatory study for this, in charcoal and black chalk, has also been preserved (Hamburg, Ksthalle). The fact that there are several studies of this type known by Schalcken—including even one that can be dated after 1700 (Dordrecht, Dordrechts Mus.)—suggests that he usually prepared his portraits in this way. On 31 October 1679 the artist married Françoisia van Diemen, daughter of a wealthy officer from Breda, who bore him seven children. The only one to reach adulthood was their daughter Françoisia (bapt 28 June 1690); she later married the architect Pieter Roman from The Hague.

Between 1680 and 1690 Schalcken won international fame, based, above all, on his subtle rendering of various kinds of natural and artificial light. Schalcken not only showed technical virtuosity in this respect but also managed to exploit this speciality in his choice of suitable subjects or elegant contrasts, as can be seen in the *Toilet of Venus, Daylight* and *Venus and Cupid, Artificial Light* (both 1690; Kassel, Schloss Wilhelmshöhe). In Paris his work was sold successfully by Jan van der Bruggen, and in Germany also it was much sought-after. In the Netherlands the rich court circle from The Hague formed an increasingly important group of his clients. On 28 February 1691 Schalcken was admitted to The Hague painters' society, Pictura, although officially he continued to live in Dordrecht.

In May 1692 he and his family moved to London, where they stayed until 1697. In England he painted mainly portraits, some of them signed *Londini* (e.g. *Portrait of a Boy in Festive Costume*, 1693; Stockholm U., Kstsaml.), but also genre pieces with artificial lighting (e.g. *Boy Blowing Charcoal*, ex-Althorp House, Northants; art market, NY, 1988). In addition, he painted a portrait of *King William III by Candlelight* (Amsterdam, Rijksmus.) and various self-portraits, which demonstrate once again his special qualities as a painter of nocturnal light (Florence, Uffizi; Hagerstown, MD, Washington Co. Hist. Soc. Mus.).

In June 1698 Schalcken was back in The Hague, where he acquired citizenship in 1699 and remained until his death. He worked during this time for John William, the Elector Palatine. The Elector bought almost exclusively works with a religious theme, including the *Wise and Foolish Virgins* (1700; Munich, Alte Pin.). In its harsh and dry style, dominated by an unnatural orangey-red, this history painting is characteristic of the master's later work.

Bibliography

B. Roland: 'Das letzte Selbstbildnis von Godfried Schalcken', *Die Weltkunst*, xxxiii (1963), pp. 10–11

E. Larsen: 'A Self-portrait by Godfried Schalcken', *Oud-Holland*, lxxix (1964), pp. 78–9

Tot Lering en Vermaak: Betekenissen van Hollandse genrevorstellingen uit de zeventiende eeuw [To instruct and delight: meanings of Dutch genre painting in the 17th century] (exh. cat., ed. E. de Jongh; Amsterdam, Rijksmus., 1976)

P. Hecht: 'Candlelight and Dirty Fingers, or Royal Virtue in Disguise: Some Thoughts on Weyerman and Godfried Schalcken', *Simiolus*, xi (1980), pp. 23–38

Masters of 17th-century Dutch Genre Painting (exh. cat., ed. P. C. Sutton; Philadelphia, PA, Mus. A.; Berlin, Gemäldegal.; London, RA; 1984), pp. 299–302

H. T. van Veen: 'A Schalcken for Prince Ferdinando de' Medici', *Hoogsteder-Naumann Mercury*, v (1987), pp. 49–52

T. Beherman: *Godfried Schalcken* (Paris, 1988)

E. Epe: 'A Clio by Godfried Schalcken for Ferdinando de' Medici, Prince of Tuscany', *Hoogsteder-Naumann Mercury*, viii (1989), pp. 27–33

De Hollandse fijnschilders van Gerard Dou tot Adriaen van der Werff [Dutch fine painters from Gerard Dou to Adriaen van der Werff] [exh. cat. by P. Hecht, Amsterdam, Rijksmus., 1989–90)

G. JANSEN

Schellinks [Schellincks; Schellings], Willem

(*b* Amsterdam, 2 Feb 1623; *d* Amsterdam, 11 Oct 1678). Dutch draughtsman, painter, etcher and poet. He was the oldest surviving son of Laurens Schellinks, tailor and freeman of Amsterdam, and Catalijntje Kousenaer. Laurens originally came from Maasbree (Limburg) but established himself in Amsterdam in 1609. There were seven other children, of whom Daniel Schellinks (1627–1701) also became a painter.

Although Willem Schellinks is said to have been apprenticed to Karel Dujardin, there is no factual or stylistic evidence to support this assumption. His earliest known works, a group of drawings of Amsterdam houses and details from them, show his interest in topographical subjects. They are drawn from life and can be associated stylistically with a sheet dated 1642 of the *Steps of the St Elisabeth Hospital in Amsterdam* (Leiden, Rijksuniv., Prentenkab.). These early drawings are executed mainly in black chalk and grey wash.

In 1646 Schellinks travelled through France with Lambert Doomer. Their journey is recorded

in a diary kept by Schellinks (Copenhagen, Kon. Bib., MS. Ny.Kgl.S.370; later copy, Oxford, Bodleian Lib., MS. 17436/8) and in a large number of topographical drawings by both artists (e.g. *View of the Château de Blois on the Loire*, Vienna, Nbib., Atlas van der Hem). By this time Schellinks preferred pen and ink to chalk, and, no doubt influenced by the work of his more talented travelling companion, he used wash to create more atmospheric effects. Schellinks occasionally used sketches from this journey for his subsequent paintings.

Soon after his trip to France Schellinks began to depict Italianate subject-matter in both drawings and paintings. Even though he had not yet visited Italy, he sought inspiration in the work of other Dutch Italianates. He was influenced principally by the work of Jan Asselijn in such paintings as *City Wall in Winter* (Amsterdam, Rijksmus.) and, to a lesser extent, by the work of Jan Both (e.g. Schellinks's drawing *View of the Ripa Grande*, Leiden, Rijksuniv., Prentenkab., with Both's version of the same subject, Frankfurt am Main, Städel, Kstinst.). In these years Schellinks published a number of poems in a series of anthologies, *De Olipodrigo* (Amsterdam, 1654–5), which were accompanied by four of his own etchings.

From 1661 to 1665 Schellinks undertook another journey, this time as tutor to the 13-year-old son of the Amsterdam merchant Jacob Thierry. This tour through France, England, Italy, Malta and Germany was also recorded in the artist's diary and in a series of topographical sketches and landscape drawings (facsimile published as *Viaggio al sud*, Rome, 1983). The trip was financed in part by the rich Amsterdam merchant and art collector Laurens van der Hem, who had a particular interest in topography. On his return Schellinks expanded dozens of the sketches he had made on the journey into large, panoramic drawings, often on several sheets of paper and measuring as large as 468×1045 mm. These constitute the high point of his oeuvre and were included along with earlier drawings in the *Atlas maior* assembled by Johannes Blaeu and later in the possession of van der Hem. The drawings by Schellinks make up about 120 pages of the atlas,

which is preserved intact (Vienna, Nbib., Atlas of Prince Eugene or Atlas van der Hem). Schellinks's panoramic drawings are executed mainly in pen and ink with brown and grey wash and are richly detailed, painstaking in their rendering of topography and splendid in their use of atmospheric perspective. Compositionally, they are related to the graphic work of Israël Silvestre, examples of which are also in the Atlas van der Hem.

During his stay in Italy Schellinks was admitted to the group of Dutch artists in Rome known as the Schildersbent, whose members were called 'Bentvueghels'; they gave him the nickname 'Spits' (Dut.: 'Point' or 'Peak', metaphorically applied to someone of quick wit and initiative). In 1667 he married Maria Neus (d 1678), the widow of the Amsterdam engraver and bookseller Dancker Danckerts (1634–66); they had seven children. During these years he painted several versions of the Medway disaster, a maritime battle of 1667 led by the Dutch seafaring hero Michiel de Ruyter. These marine works (e.g. the *Burning of the English Fleet near Chatham*, Amsterdam, Kon. Coll. Zeemanschap, on loan to Amsterdam, Rijksmus.) are characterized by the same panoramic composition as his drawings in the Atlas van der Hem. After Schellinks's death, his colleagues Frederik de Moucheron and Nicolaes Berchem completed a number of his paintings. Schellinks left a considerable estate of 20,000 guilders.

Bibliography

A. D. de Vries Azn: 'Willem Schellinks: Schilder, teekenaar, etser, dichter', *Oud-Holland*, i (1883), pp. 150–63

H. van den Berg: 'Willem Schellinks en Lambert Doomer in Frankrijk', *Oudhdknd. Jb.*, xi (1942), pp. 1–31

G. J. Hoogewerff: *The Bentvueghels* (The Hague, 1952)

P. H. Hulton: 'Drawings of England in the Seventeenth Century by Willem Schellinks, Jacob Esselens and Lambert Doomer, from the van der Hem Atlas of the National Library, Vienna', *Walpole Soc.*, xxxv (1954–6), pp. 11–24 [intro. and cat.]

A. C. Steland-Stief: 'Jan Asselyn und Willem Schellinks', *Oud-Holland*, lxxix (1964), pp. 99–109

P. F. M. Mens: *Catalogue of the Drawings of Willem Schellinks* (in preparation)

PIERRE F. M. MENS

Segers [Seghers], Hercules (Pietersz.)

(*b* Haarlem, 1589–90; *d* ?The Hague, 1633–8). Dutch painter, etcher, draughtsman and dealer. As early as 1678 Samuel van Hoogstraten, in *Inleyding tot de hooge schoole der schilderkonst* ('Introduction to the academy of painting'), discussed Segers's career, presenting him as the prototype of a mis-understood genius. His fanciful account was based entirely on his knowledge of Segers's unusual etchings, for he had at best only a vague knowl-edge of his paintings. Since then, the lack of biographical data on the artist, his striking subject-matter and his inimitable manipulation of etching techniques have led to exaggeration and mystification. The legend of 'Segers's secret' has fascinated etchers, especially since the 19th century. Yet he made no great technical innova-tions; instead he combined all the known tricks of his time in a revolutionary way. He invented only one new technique, that of Lift-ground Etching (also called sugar-bite aquatint), which was rediscovered in the 18th century by Alexander Cozens and Gainsborough. Segers's painted and etched compositions are haunting and melan-cholic in mood, but neither his subjects nor his concept of nature were new; they had their origins in the work of his predecessors, from Albrecht Altdorfer to Adam Elsheimer and from Pieter Bruegel I to Hendrick Goltzius. His treatment of old themes was original, however, as was the novel combination of flat Dutch panoramas with fan-tastic mountain landscapes.

1. Life

Although the artist's name has been commonly spelt 'Seghers' since the 19th century, it does not appear in this form either in early biographies or in 17th-century documents. From 1620 he signed himself *Hercules Segers*, but he had earlier called himself Hercules Pietersz., the patronym deriving from his father Pieter Segers, a Flemish textile merchant who also occasionally dealt in paintings. As a Mennonite, his father had fled to Haarlem to escape persecution, settling in Amsterdam about 1595. A document of 1607 states that Pieter Segers owed the estate of the Amsterdam painter Gillis van Coninxloo 16

guilders and 9 stuivers for his son's tuition, an amount that suggests that Hercules had been a pupil of van Coninxloo for at least six months in 1606. In March 1607 Hercules bought from his teacher's estate a number of drawings, some unspecified works (?paintings) and one painting described as 'a rocky landscape'. These purchases attest to the regard Hercules had for van Coninxloo, who, like Hercules's father, had fled Flanders for religious reasons, also arriving in Amsterdam in 1595. Van Coninxloo's inventory lists works by other Netherlandish and Flemish artists, including Paul Bril, Pieter Bruegel the elder and the younger, Gillis Mostaert, Adriaen van Nieulandt, Joachim Patinir and, in particular, fantastic landscapes by Josse de Momper II, which must have made an impression on the 17- or 18-year-old Hercules.

Segers is presumed to have gone to Haarlem in 1611, since he was registered in the Guild of St Luke there in 1612, about the same time as Willem Buytewech and Esaias van de Velde, the latter also from Amsterdam and a former pupil of van Coninxloo. Segers is recorded as being back in Amsterdam in two documents of 1614, in one of which he declared his intention to care for his ille-gitimate daughter Nelletje, a statement prompted by his planned marriage to a woman other than Nelletje's mother. On 27 December 1614 Segers became engaged to Anneken van der Brugghen of Antwerp, who was 16 years his elder, and they were married on 10 January 1615 in Sloterdijk near Amsterdam. Anneken and Segers had no children together, and their testament of 1618 reveals that they accepted Nelletje as Segers's natural child. Probably his wife had money of her own, for in 1619 they bought a large house on the Lindengracht in Amsterdam, which was called 'the Duke of Gelder' but was rechristened by Segers 'the Falling Water' (reflecting, perhaps, his pen-chant for untamed landscapes with waterfalls). In the 1620s he was regularly named in documents as a painter in Amsterdam, and after 1625 there is reference to his debts. These had apparently risen so high that he was forced to sell his house in 1631. He then settled in Utrecht, where he dealt in paintings. One document of 1633 refers to

'Hercules de Haerlem' as a resident of The Hague, and another describes him as a picture seller there. In 1638 a certain 'Cornelia de Witte' is named as the widow of 'Hercules Pietersz.', who can probably be identified with Segers. If so, Segers must have remarried, possibly in The Hague, after the death of his first wife.

2. Paintings

Hercules Segers was active as a painter for at most ten years, and much of his painted oeuvre may have been lost. The total number of surviving authenticated works is only eleven. Of these only four are signed and none is dated, making it difficult to establish a definite chronology. In general the 'visionary' mountainous landscapes are considered earlier than those with Dutch or topographical elements.

(i) Early works, before c. 1625. The *River Scene in a Hilly Landscape* (Herdringen Castle) is an example of dating problems. Its provenance can be traced directly to the collection of Willem Vincent, Baron van Wyttenhorst of Utrecht, who in 1649 received it as a gift from the painter Herman Saftleven the younger. It is assumed to be identical with 'A Landscape by Hercules', mentioned in 1627 in the estate of Herman Saftleven the elder (c. 1580–1627). The painting must therefore have been made before 1627, probably in 1625 or 1626 and

possibly even earlier. However, confusingly, the composition in Wyttenhorst's collection was described as 'A waterfall by Hercules Zeegers'; the surviving work does depict rapidly running water, but not a waterfall. The identification is nonetheless probably correct, especially as the manner of painting is analogous to that of two early signed works, the *River Valley in a Hilly Landscape* (The Hague, Mauritshuis; see fig. 51) and the *River Valley* (Amsterdam, Rijksmus.). The thin application of paint and the palette of these three works reveal similarities that became particularly apparent after the cleaning of the Amsterdam painting (1982). Instead of the brown tonalities that were due to impurities in the old coats of varnish, the dominant tones in this and both associated works are bright green and grey tints, enlivened by light blue (in the water and the sky), white heightening (in the mountain tops) and colourful accents, such as red (in the roofs of the houses). The two signed landscapes are also similar in composition, with splendid views into the distance enframed between soaring, formless mountains, while the foregrounds are taken up by rough hilly slopes with tree stumps and figures of travellers struggling onward. These paintings are certainly datable before 1620, and the noticeable influence of Flemish landscapes (by Joos de Momper for example) suggests an even earlier date in the 1610s. A lost hilly landscape of the same style is preserved

51. Hercules Segers: *River Valley in a Hilly Landscape* (The Hague, Mauritshuis)

in a drawing made after it in a sketchbook by Leonard Bramer (Amsterdam, Rijksmus.).

Segers's most famous painting is another early work, the *Mountain Landscape* (*c.* 1620–25; Florence, Uffizi; see col. pl. XXXV), which is imposing in its measurements and striking sense of atmosphere. In 1656 the work was in Rembrandt's collection, where it was described as 'a great Landscape by Hercules Segers'. Rembrandt is thought to have touched up this canvas with the vigorous brushstrokes visible especially in the sky and the mountain tops. During the repainting he may also have added the figures with horse and wagon at the lower left; such lively figures are rare in Segers's work. These corrections were not by way of criticism, but rather well-meaning embellishment of the original. Rembrandt greatly admired Segers, as is evident from his own *River Landscape* (*c.* 1645; Kassel, Schloss Wilhelmshöhe), which took its inspiration from landscapes painted some 20 years earlier by Segers.

(ii) Later works, c. 1625–31. Two works apparently painted not long after the Uffizi *Mountain Landscape* are the signed *Landscape with a Valley* and the *River Valley with a Group of Houses* (both Rotterdam, Mus. Boymans–van Beuningen). The first work is painted on a canvas, which the painter glued on to a panel, an unusual practice in the 17th century (one used also for the Uffizi picture). Its composition closely resembles the slightly earlier *Mountain Landscape*: a distant view in the centre, receding hills to the left, tall mountains to the right and a raised foreground. A deliberately 'strange' element is the round, Italianate building with campanile in the middle. The *River Valley with a Group of Houses* must also have been painted soon after 1625. A topographical element appears here for the first time: the same view from a window of his house on the Lindengracht that he also rendered in an etching (*see* §3 below). The group of houses with stepped gables was not actually situated in this rugged mountain landscape (which used to be thought to represent the Maas Valley), but rather at the foot of the Noorderkerk, in the Jordaan area of Amsterdam. (The church is depicted in the etching, as is a fence that

presumably existed but was replaced in the painting by a dark foreground consisting of the crest of a hill.) Segers also represented the Noorderkerk in a lost painting, which *c.* 1709 was in the possession of the estate of the painter Allaert van Everdingen. These paintings and the etching can thus be dated between 1623, when the Noorderkerk was completed, and 1631, when Segers was forced to leave his home in Amsterdam. Fewer contrasts between fantasy and reality were employed in the *Hilly and Wooded Landscape* (London, Edward Speelman), in which a village church and some houses are placed in the fields at the foot of a wooded hill near a river valley, a situation reminiscent of some areas of the lower Rhine. During the cleaning of this painting (after 1975) the figures of riders and armed soldiers were revealed at the lower right, a surprising element in a painting by Segers.

During the second half of the 1620s Segers made several topographical views in which he avoided imaginary elements as much as possible. In the *View of Brussels from the North-east* (Cologne, Wallraf-Richartz-Mus.) the church of St Goedele, the town hall and the city walls are rendered so convincingly that the artist must have made use of topographical sketches, perhaps his own. Anticipating a genre for which, above all, Philips Koning was to become famous are two typically Dutch panoramic landscapes, each of them with a bird's-eye view and a low horizon: *Village by a River* (Berlin, Gemäldegal.) and *Landscape with Two Windmills* (Fareham, Hants, Mrs E. S. Borthwick-Norton priv. col., see Rowlands, fig. 38), which may represent Wageningen and its environs. These were presumably painted before 1630 and before the last known painting by Segers, the signed *View of Rhenen* (Berlin, Gemäldegal.), which previously bore a false signature of Jan van Goyen. Together with the *View of Brussels*, this is the most realistic landscape executed by the painter. In the 17th century an attempt was made to 'modernize' this work: the panel was considerably enlarged at the upper edge, nearly doubling its height and thereby creating a lower horizon line. Panels were also added *c.* 1640 to the tops of the two unidentified panoramic landscapes

(Berlin and Fareham), presumably at the instigation of art dealer Johannes de Renialme, in order to give these works the allure of genuine paintings by van Goyen. Ironically, it must have been just this type of painting that inspired van Goyen himself to work in the genre for which he became so popular, namely the Dutch panoramic landscape. If the *View of Rhenen* was indeed painted in or before 1631, the year Segers left for Utrecht, as seems probable given certain details of the city, then his panoramas preceded those of van Goyen.

3. Prints and drawings

The chronology of Segers's etchings is even more difficult to unravel than that of his paintings, for there is no thematic development within his graphic oeuvre. Neither can a stylistic development, for example from linear to more tonal effects, be discerned. Moreover, Segers was apparently in the habit of pulling prints from old plates and working these up at different times. Parallels with the paintings provide at best only a starting-point for determining a chronology.

The two paintings of a river valley (Amsterdam, Rijksmus., and The Hague, Mauritshuis), datable to around 1620, show compositional similarities to the print *Winding River in a Valley* (Amsterdam, Rijksmus.; *see* Haverkamp-Begemann, no. 14), one of the rare etchings that was not touched up later. Segers must have been inspired by the engraved series of *Large Landscapes* after Pieter Bruegel the elder published in the 1550s by Hieronymus Cock. In visionary landscapes such as *Mountain Gorge Bordered by a Road* (Amsterdam, Rijksmus.; HB 17{???}) Segers created 'immeasurable spaces' (van Hoogstraten's description) with menacing groups of mountains and stark rocky plateaux. For this print Segers cut up a larger etching plate with the representation of a fully rigged sailing vessel on it and reused the fragment without completely grinding away the previous image, thus enhancing the mysterious aura of the composition.

Conceived almost as paintings are three etchings executed in an unusually large format (almost 300×500 mm): the *River Valley with Four Trees* (London, BM; HB 4{???}), apparently the etched version of the painting in the Mauritshuis (and

thus datable c. 1620); the *Rocky Mountain Valley with Waterfalls* (HB 5), of which only one impression exists (London, BM); and the *Mountain Valley with Fenced Fields* (HB 6), similar in composition and motifs to the landscape in the Uffizi. The same atmosphere—a peaceful distant view framed by awesome mountains—is conveyed in the etching *Distant View with Branch of a Pine Tree* (Amsterdam, Rijksmus.; HB 27). A small round building present in the etching of the *Large Tree* (HB 34) is like that in the painted *Landscape with a Valley* in Rotterdam. The manner of drawing leaves is identical in both works, suggesting a date of c. 1625. This is also true for the etching *Old Oak Tree and Distant View* (HB 28), which repeats the composition and motifs of the *Landscape with a Valley*. The curious etched *View through a Window of Segers's House* probably dates from the second half of the 1620s (Amsterdam, Rijkmus.; HB 41). Only one state and one impression of this print exists. Among his most striking impressions, or visions, of nature are the *Two Trees* (Amsterdam, Rijksmus.; HB 33) and the *Mossy Tree* (Amsterdam, Rijksmus.; HB 32), both of which are printed in brown and green ink on pink and light blue hand-tinted paper. The refined draughtsmanship evokes something of the spirit of Chinese painting, while the almost gruesome forms are reminiscent of early 16th-century Danube school prints. Segers returned to reality with several topographical prints, such as the *Ruins of the Abbey of Rijnsburg*, executed in a large and a small version (HB 46 and 47), and two different representations of the *Ruins of 'Castle Brederode'* (HB 39 and 40), as well as producing several panoramic views, such as a *View of Amersfoort* (HB 30) and a *View of Wageningen* (HB 31). Although the technical execution of these panoramas can be compared with that of the earliest prints (e.g. HB 14), they are probably relatively late, a theory strengthened by the connection between the *View of Wageningen* and the painted *Landscape with Two Windmills*, in which the same town is depicted from the opposite side.

As well as subjects from nature, Segers made prints representing ships (HB 50 and 51), storms at sea (HB 48 and 49) and still-lifes (e.g. *The Skull*, HB

53; and *Books*, HB 54). In a few cases he borrowed motifs from other prints. *Rearing Horse* (HB 52) is inspired by a print by or after Antonio Tempesta. The *Lamentation of Christ* (HB 2) is a personal translation of a woodcut by Hans Baldung, while the figures in *Tobias and the Angel* (HB 1) are borrowed from a print by Hendrick Goudt after Adam Elsheimer. The latter work is particularly famous because, after Segers's death, the etched plate came into the possession of Rembrandt, who reworked it *c.* 1653, changing the subject to the *Flight into Egypt* (B. 56).

Only two drawings can be ascribed to Segers with certainty. The *Steep Cliffs Bordering a River Valley*, drawn with brush and gouache, is a repetition of an etching (HB 23) and the *Farm Building in a Country Lane* is a study for an etching (HB 36). The drawing of leaves with small brushstrokes and dots is similar to that for the etching of the *Large Tree* (HB 34) of *c.* 1625.

4. Printmaking technique

The unique character of Segers's etchings, which was recognized by van Hoogstraten, lies in the fact that every print was treated separately, making each an individual work of art. From the approximately 54 different plates some 183 impressions have been preserved, averaging about 3 per plate, of which no 2 are the same; 22 of the 54 prints exist in only one state and one impression.

The extraordinary variety of tone and polychrome effects was achieved by printing with coloured inks on different types of supports and by hand-colouring sheets. Segers printed on both white and tinted papers, and on cotton cloth, which led van Hoogstraten to the sad conclusion that he had been forced 'out of poverty' to resort to cutting up his own shirts and bed linens. He used black, dark green, dark brown and blue ink on white, grey, light green or pink prepared grounds, and he hand-coloured the resulting works with white, purple, green, brown, yellow, grey or black watercolour or with yellow, pink or grey oil paint. Afterwards he sometimes applied varnish. Some of these works were thus painted prints rather than 'printed paintings', as van Hoogstraten called them. Technically they are monochrome prints and not colour or chiaroscuro prints because Segers used only one plate per impression. In the large etching *Ruins of the Abbey of Rijnsburg* (HB 46) he created an ominous nocturnal effect by printing the plate in yellow ink on paper with a black ground and by hand-colouring the bricks red and the sky greenish-blue (Amsterdam, Rijksmus.; HB 46{???}). The individual treatment of each impression also entailed drastically cutting the sheets, like a photographer cropping an image, so that the resulting fragment revealed an entirely new composition. In this way the *River Valley with Four Trees* (London, BM; HB 4{???}) became a *River Valley with Three Trees* (Dresden, Kupferstichkab.; HB 4{???}).

In addition to a variety of surfaces and coloured pigments, Segers also experimented with counterproofs, which he worked up in much the same way as some of his normal impressions. He often combined etching with drypoint and did not always wipe the plate clean before printing, thus obtaining further interesting tonal effects. He also sometimes used varnish to stop out certain areas from printing. Some of his most unusual surface effects were the result of his invention of lift-ground etching. When printed these etchings have a grainy textured appearance, best seen in the *Winding River in a Valley* (HB 14{???}).

5. Critical reception and posthumous reputation

Although in the 18th and 19th centuries Hercules Segers was virtually forgotten as a painter, during his own lifetime he achieved a certain measure of success, and even after his death he was admired within a limited circle. As early as 1621 a work by 'Hercules Pietersen' was purchased by King Christian IV of Denmark, and in 1632 two of his landscapes were at the court of the Princes of Orange in The Hague. In 1627 three works by Segers were mentioned in the estate of the Amsterdam painter Johannes Rocourt: 'two small ruins' and 'a water-well'. The mid-17th-century dealer Johannes de Renialme had access to a regular supply of paintings by Segers (33 works in 1640; 7 works in 1657), from which it can be assumed that an unusually large portion of his painted oeuvre has been lost. Jan van de Cappelle,

whose estate included five landscapes by Segers in 1680, among them the *View of Brussels*, must have been one of his admirers.

Segers had no pupils, but Johannes Ruisscher later became famous as one of his followers and was given the nickname 'the young Hercules'; yet while Ruisscher studied and imitated the panoramas and Dutch landscapes in Segers's prints and drawings, he never made use of Segers's technical experiments. The bird's-eye view often exploited by Segers was a particular source of inspiration for the panoramic landscape drawings and paintings of Philips Koninck. Other anonymous followers imitated his subjects and style in paintings that were or still are ascribed to Segers. The *Mountain Landscape with a Waterfall* (The Hague, Mus. Bredius) and the *Mountain Landscape with Fallen Trees* (London, N.G.) were probably painted by the same hand. The first panel has an illegible signature, not that of Segers. Another group of paintings, known as the 'Ten Cate Segers', include the *Hilly River Landscape* (The Hague, Cramer Gal.) and the *Valley Surrounded by Mountains* (Vienna, Ksthist. Mus.). Both are painted variations of etchings by Segers (HB 29 and 13 respectively).

Rembrandt, above all, was deeply impressed by Segers's visionary landscapes, the atmosphere of which he imitated more than once. In 1656 he owned no fewer than eight of Segers's paintings, including the large *Mountain Landscape* (Florence, Uffizi) and several small, apparently lost works described as 'A wood', 'Some little houses' and 'A landscape in grisaille'. When the *Mountain Landscape* was presented to the Uffizi in 1838, it was, in fact, attributed to its previous owner, and it was only in 1871, when Wilhelm von Bode and Karl Eduard von Liphart independently recognized the similarities between the painting and Segers's etchings, that Segers was rediscovered as a painter.

Rembrandt was also greatly influenced by Segers's prints, which can now best be studied in the Rijksprentenkabinet in Amsterdam. It owns 75 prints, which have an impressive provenance: 48 of these works come from the collection of the Amsterdam regent Michiel Hinloopen, who probably bought his prints *en bloc* from a collector who quite possibly purchased them directly from Segers (this would explain the presence of the unique impressions). Another source is the collection of Pieter Cornelis, Baron van Leyden (1717–88), for whom Jacob Houbraken bought prints, possibly from the former collection of Samuel van Hoogstraten, who was the teacher of his father, Arnold Houbraken. (Van Hoogstraten was himself an eager collector of Segers's etchings, which he claimed were rare after the artist's death because they had been discarded or used as wrapping paper.) Jacob Houbraken also collected prints by Segers for the King of Saxony. These sheets are now in the Staatliche Kunstsammlungen, Dresden. A fourth early collection was assembled by John Sheepshanks and bequeathed to the British Museum, London, in the 19th century. The basis for all further research on Segers's prints is Haverkamp Begemann's complete catalogue of the etchings and their various impressions (1973).

Bibliography

Hollstein: *Dut. & Flem.*; Thieme–Becker
S. van Hoogstraten: *Inleyding tot de hooge schoole der schilderkonst* (Rotterdam, 1678), p. 312
N. de Roever: 'De Coninxloo's', *Oud-Holland*, iii (1885), pp. 33–52
A. Bredius: 'Hercules Seghers', *Oud-Holland*, xvi (1898), pp. 1–11
W. Bode: 'Der Maler Hercules Segers', *Jb. Kön.-Preuss. Kstsamml.*, xxxiv (1903), pp. 179–96
J. Springer: *Die Radierungen des Hercules Seghers* (Berlin, 1910–12)
J. G. van Gelder: 'Hercules Seghers erbij en eraf', *Oud-Holland*, lxv (1950), pp. 216–26
—: 'Hercules Seghers, Addenda', *Oud-Holland*, lxviii (1953), pp. 149–57
Hercules Seghers (exh. cat. by E. Haverkamp-Begemann, Rotterdam, Mus. Boymans–van Beuningen, 1954)
E. Trautschold: 'Neues Bemühen um Hercules Seghers', *Imprimatur*, xii (1954–5), pp.78–85
W. van Leusden: *The Etchings of Hercules Seghers and the Problems of his Graphic Technique* (Utrecht, 1961)
Hercules Seghers (exh. cat. by K. G. Boon and J. Verbeek, Amsterdam, Rijksmus., 1967)
E. Trautschold: 'Der "Seghers ten Cate"', *Pantheon*, xxx (1972), pp. 144–50
E. Haverkamp-Begemann: *Hercules Seghers: The Complete Etchings*, 2 vols (Amsterdam, 1973) [HB]
J. Rowlands: *Hercules Segers* (New York, 1979)

D. Freedberg: *Dutch Landscape Prints of the 17th Century* (London, 1980), pp. 44–50

T. Gerszi: 'Landschaftsdarstellungen von Pieter Bruegel und Hercules Seghers', *Pantheon*, xxxxi (1981), pp. 133–9

J. P. Filedt Kok: '*Rivierdal* van Hercules Segers schoongemaakt', *Bull. Rijksmus.*, xxx (1982), pp. 169–76

Masters of 17th-century Dutch Landscape Painting (exh. cat. by P. Sutton and others, Amsterdam, Rijksmus.; Boston, MA, Mus. F.A.; Philadelphia, PA, Mus. A.; 1987–8), pp. 484–9

B. P. J. BROOS

Steen, Jan (Havicksz.)

(*b* Leiden, 1626; *d* Leiden, early 1679). Dutch painter. He is best known for his genre scenes depicting busy interiors, often with a strongly moralizing theme and frequently illustrating Dutch sayings. These cheerful and disorderly scenes themselves gave rise to the Dutch expression 'a Jan Steen household'. His work, in which his goal seems to have been to combine narrative, instruction and entertainment, revives the moralizing tradition of earlier Dutch genre painters. Yet his inquisitive mind provoked him continuously to explore new styles and themes, an attitude probably stimulated by his frequent moves between Dutch cities. Steen was a prolific artist (although the quality of his work varies greatly), and, as well as his many genre pieces, he executed biblical and mythological subjects and a few portraits; he particularly excelled in the depiction of children. At the end of his life he produced paintings that foreshadow the Rococo idylls of 18th-century artists.

1. Life

Steen was the son of a brewer. In 1646 he enrolled, aged 20, as a student of Leiden University, where, like Rembrandt, he studied for only one year. He must have begun his professional training in 1647. Three painters are mentioned in early sources as his teacher, of whom the Haarlem genre painter Adriaen van Ostade seems the most probable. In 1648 Steen joined the newly established painters' guild in Leiden. His amazingly short period of training may have been compensated for by drawing lessons in his youth. In 1649 he married Grietje, a daughter of the landscape painter Jan van Goyen (another of his proposed teachers), indicating that he was considered capable of supporting a family through his work. However, he may never have planned to be a full-time painter. In 1654 Steen's father rented a brewery in Delft for his son, a project that was shortlived and unsuccessful. With the whole of the brewing industry, the fortunes of the Steen family plummeted. Jan Steen lived in a number of different places but always kept contact with the guild of his native Leiden. Surprisingly, he seems to have left no traces as a painter in the Delft archives. From 1661 until 1670 he lived in Haarlem, where he created his most important works. From 1670 until his death he lived in the Leiden house he had inherited from his father, and from 1672 onwards, the year of the disastrous French–German invasion, he kept a tavern in this house. Financial difficulties and low prices for his art marked most of his career.

2. Work

Unlike most 17th-century Dutch painters who sought a successful combination of theme, style and compositional methods, to which they then adhered throughout their career, Steen never found such repose, either in terms of style or range of subjects. He was constantly studying and trying to emulate the work of numerous colleagues. The fact that he was never very successful during his lifetime may also have motivated him to keep looking for new possibilities in different directions. This has earned him the ill-deserved reputation of being fickle and too easily influenced.

(i) **Stylistic development.** It is not easy to reconstruct Steen's development, since he dated only a few of his works. Despite his lack of success during his lifetime, however, he must have been immensely popular in Holland in the early 18th century, when his signature was added to many works more or less closely connected with his style and subject-matter. Numerous copies and imitations

originated in that period. These are not always easily distinguishable from genuine works; moreover, a certain form of crude humour in a painting seems to have been enough for some dealers and collectors to consider an attribution to Jan Steen. *(a) 1650s.* That Adriaen van Ostade was presumably Steen's teacher, as is now generally accepted, is supported by early works, such as *The Dentist* (1651; The Hague, Mauritshuis), that reflect the Haarlem tradition of low-life genre but are still somewhat uncertain in style and execution. Probably earlier still are two peasant scenes (both The Hague, Mauritshuis) and *The Fortune-teller* (Philadelphia, PA, Mus. A.). It was not until 1653 that the artist evolved his own recognizable artistic personality, as in his *Village Wedding* (1653; Rotterdam, Mus. Boymans–van Beuningen). The long-held belief that Steen's father-in-law, Jan van Goyen, was his teacher led to the attribution to Steen of a number of landscapes with genre-like figures, although most of these seem not to be by Steen's hand, but some are signed.

Steen's contact with the art of Delft, Rotterdam and Dordrecht had a lasting effect on his oeuvre, which makes it all the more amazing that he did not live longer in Delft. He studied the work of Pieter de Hooch, Nicolaes Maes, Samuel van Hoogstraten and Hendrick Sorgh in great detail. Since low-life genre in the days of van Ostade had lost almost all of its former predilection for dramatic action, Steen turned to other genre painters for their use of light, space and perspective as narrative elements. He was fascinated by open doors and windows that enabled contact between figures in different rooms, as in the *Priest Admonishing a Woman through an Open Window* (priv. col.). The result was a fusion of styles and motifs from low-life genre scenes with other genre themes. Though undated, the *Cutting of the Stone* (Rotterdam, Mus. Boymans–van Beuningen) can be placed in the 1650s. The exceptional portrait of a man and a girl in front of a house in Delft is dated (1655; Penrhyn Castle, Gwynedd, NT) and is roughly contemporary with the *Supper at Emmaus* (Amsterdam, Rijksmus.) and *Christ in the House of Martha and Mary* (priv. col.), the latter a rather unsophisticated variation of Vermeer's

composition of the same subject (*c.* 1655; Edinburgh, N.G.).

In the late 1650s Steen lived in the village of Warmond, near Leiden. There he moved away even more from the tradition of low-life genre in which he had been trained, and he became more interested in the work of Gerard ter Borch (ii), whose works he had studied earlier. Steen's contact with Gabriel Metsu seems to date from this period. He also met Frans van Mieris (i), who was still in the earliest phase of his career; described as close friends by Houbraken, the two painters must have engaged in an intensive exchange of ideas. The highly finished, minutely detailed paintings of the Leiden school of 'Fine Painters' (e.g. Dou, van Mieris) fascinated Steen, but in trying to imitate their effects, he never adopted their elaborate technique. At first sight Steen's *Woman Eating Oysters* (The Hague, Mauritshuis) looks like a Leiden school painting, but the unusual perspective and the abbreviated rendering of background details are completely different. Also painted in Warmond were the *Acta virum probant* (or *Young Woman Playing a Harpsichord*, 1659; London, N.G.), the *Itinerant Musicians* (1659; Ascott, Bucks, NT) and the portrait of *Bernardina van Raesfelt* (1660; The Hague, Mauritshuis).

(b) 1660s. Around 1660 there was a rather superficial connection between Steen's work and that of the Utrecht artist Nicolaes Knüpfer (*c.* 1603–55), the third of Steen's supposed masters; the contact between the two artists may have come about through Metsu, who was a pupil of Knüpfer and whose work strongly influenced Steen in the 1660s. In Haarlem, where Steen became a guild member in 1661, he tried to achieve a scale and monumentality, combined with a freedom of brushwork, that were never before seen in Dutch genre painting. The great days of Haarlem genre art were over, but Jan Steen may have been stimulated by Frans Hals's early genre works, as well as the large peasant scenes of Jacob Jordaens, who in the 1660s was working in Amsterdam for the new Stadhuis. This tendency reached its culmination in the *As the Old Sing, So the Young Twitter* (The Hague, Mauritshuis), a subject often painted by Jordaens. The works of Metsu, de Hooch and other painters

active in nearby Amsterdam stimulated Steen in his Haarlem years to study the relation between figure groups and interior spaces, as can be seen in *Easy Come, Easy Go* (1661; Rotterdam, Mus. Boymans–van Beuningen), *Twelfth Night* (1662; Boston, MA, Mus. F.A.; see also fig. 52) and *Take Heed in Times of Abundance* (formerly dated 1663; Vienna, Ksthist. Mus.). As a rule, the smaller works of this period are undated, but the artist's creativity and productivity must have been almost unlimited. He touched a wide range of subjects, treated them in highly original ways and never repeated himself. Most of his famous doctor's scenes are from his Haarlem period, although he probably took up the subject much earlier. New in the iconography of his medical scenes is the fact that patients do not visit their physician, but he pays them a house call. The traditional 'Dottore' of the popular theatre is transformed into a family doctor, who most often does not recognize the true cause of the patient's illness— invariably a young lady suffering from love sickness. Some of these works are inscribed *Daar baat geen Medesyn Want het is minepyn* ('Here a physician is of no avail, since it is love sickness'; e.g. Munich, Alte Pin.).

It is difficult to form a coherent image of Steen's production in the late 1660s. For whatever reasons, he began to experiment in widely differing directions. Some works hark back to the subjects and the style of Adriaen van Ostade, for example *The School* (Edinburgh, N.G.). The elegant companies in well-furnished interiors show the increased influence of Amsterdam, as in *Backgammon-players* (Amsterdam, Rijksmus.). In these works the light is softer and the colours are more subdued than in comparable paintings from previous decades. At the same time the

52. Jan Steen: *Feast of the Twelfth-night Cake*, 1660 (Kassel, Staatliche Kunstsammlung)

number of biblical and mythological paintings began to increase, of which the absolute masterpiece is the *Marriage of Tobias and Sarah* (Brunswick, Herzog Anton Ulrich-Mus.). It is in the history paintings that Steen's personal style and skill can best be seen, for instance his *Samson and Delilah* (1668; Los Angeles, CA, Co. Mus. A.), *Iphigenia* (1671; Amsterdam, Rijksmus.) and *David with the Head of Goliath* (1671; Copenhagen, Stat. Mus. Kst).

(c) c. 1670 and after. With the exception of a few history paintings, there seems to have been a severe loss of quality around 1670, especially in the genre pieces. While Steen surely did not produce masterworks throughout his whole career, the existence of a number of weak paintings cannot be satisfactorily explained; for the moment these works of disappointing quality are dated *c.* 1670, when Steen returned to Leiden.

A surprising new development in the genre paintings—one that in many ways anticipated the Rococo—occurred with the *Festive Company* (1674; Paris, Louvre; see fig. 53). The colours are bright and soft and the paint thinly applied in a very

53. Jan Steen: *Festive Company*, 1674 (Paris, Musée du Louvre)

free, almost nervous movement of the brush. The scale of the figures is reduced and the interiors far more spacious. Good examples of this new trend are the *Wedding Feast at Cana* (1676; Pasadena, CA, Norton Simon Mus.) and the *Feast in the Garden of the Paets Mansion* (1677; ex-art market).

(ii) **Subject-matter and sources.** Steen's richly varied subject-matter centres around a few topics: family life and the education of children and adolescents; the follies of love; and varying forms of intemperance—drinking, squandering money, giving way to anger or lust. The painter often included inscriptions on his works (e.g. *In Weelde Siet Toe*: 'Take heed in times of abundance'; *De Wyn is een Spotter*: 'The wine is a mocker'; and *Soo voor gesongen, soo na gepepen*: 'As the old sing, so the young twitter' etc), but even where he did not, the moralizing intention is clear from the way he mocked the misbehaviour of his characters. Steen has rightly been praised for the characterization of the protagonists in his works and for the staging of his scenes. Both are aspects of his gift for storytelling. In his multi-figured compositions, gestures and glances link the individuals in an intricate network. These connections are so important that anatomical proportions or spatial relations are, when necessary, somewhat violated. In most cases, consequently, his figure groups are conceived as intricate configurations on the flat surface of the canvas or panel, much more than a number of spatial forms located in an imagined pictorial space. The spectator is compelled to see the attitude, gestures and facial expression of one of Steen's figures together with the reactions they cause in face, limbs and body of one or more other figures. This effect reinforces or varies the characterization of standard types. It is never simply the character of 'Dottore' or 'Capitano'—but 'Dottore' in the course of being deceived, 'Capitano' hesitating between the safety of fleeing and the danger of bluffing his adversaries into retreat. Most contemporary genre painters had a tendency to limit the figures in their works to no more than three, which severely restricted their dramatic possibilities.

Steen often found his inspiration in 16th-century prints, and deservedly he is often compared with Pieter Bruegel I. A popular, sometimes vulgar tone, complemented by an intentionally primitive style can be detected in aspects of the oeuvre of both masters. Steen's figures are generally flat and strongly silhouetted in a way not unrelated to Bruegel's *Children's Games* (1560; Vienna, Ksthist. Mus.). Steen's humour functions on two levels simultaneously. At first sight the comical effect seems to rely solely on overstatement: strong and schematic characterization, expressive and often grimacing faces and rhetorical gestures. At the same time, however, there are subtle innuendos and ambiguous hints in the narrative that create an amazingly wide margin for the spectator's own interpretation. Thoré (see Bürger) was the first of many writers to compare the painter with Molière. Gudlaugsson pointed out how strong the affinity was between the popular theatre of the 17th century and Steen's genre. Both art forms relied on psychological and social stereotypes cast in standard situations; this material was used in both media as an inexhaustible source for variation and improvisation.

Steen's few biblical and mythological subjects were sometimes treated as if they were genre subjects. He transplanted them to his own time and place so as to make the stories more accessible to his audience. In this respect he is the most direct 17th-century descendant of Lucas van Leyden and Pieter Bruegel. This intentional trespassing on the borderline between two pictorial traditions, genre and history painting, was often frowned on or misunderstood. Many considered it to show a lack of decorum aggravated by the mixture of theatrical and contemporary costume. Steen's use of costume is not at all unusual when compared with the works of figure painters from the early 17th century. However, by the later years of the century history painters took more trouble to reconstruct period costume, whereas genre painters followed the latest fashions. The subjects and compositions of Steen's biblical scenes were often inspired by prints from Pieter Lastman's circle or by Rembrandt's etchings. The *Adoration of the Golden Calf* (Raleigh, NC Mus. A.) is strongly reminiscent of Lucas van Leyden's treatment of the same subject.

Steen made a very limited number of portraits, and these are remarkable because they do not follow any tradition. They seem to be *ad hoc* solutions, unrelated among themselves, created in the pictorial language of genre. The circle of his sitters may have been limited to his nearest relatives and friends.

(iii) Technique. Steen has been seen by such authors as Thoré as a 'literary' painter, who was motivated by his desire to narrate and who adapted his style to the content of his stories. Thoré considered the style as well as the technique of Steen's work to be the result of the fact that he painted rapidly, urged on by the multitude of ideas and images in his head. Certainly the literary element in Steen's oeuvre is very strong; he was the only one in his generation to integrate explanatory texts into his paintings.

Steen's use of colour is sometimes daring and often very subtle. His 'strong and manly' handling of the brush, admired by Reynolds, is not very elaborate but is very effective, creating the maximum of expressiveness with a minimum of labour. In the last phase of his development this 'shorthand' technique evolved into a virtuoso style of brushwork, which was quite unique in its period. Steen's rendering of surface texture can be very convincing, but the treatment of details is restricted to passages where composition and narrative require objects to be brought to the viewer's attention. The difference in execution between two separate works, and even within one single work, can be substantial. Steen's contemporaries (e.g. ter Borch, van Mieris or Metsu) had a tendency to enhance the elegance and luxury of their subjects, by concentrating on the surface beauty of their works and a technical perfection of execution. This often involved a loss in the narrative and moralizing content of their paintings. Steen was their opposite in all respects. His rapid execution seems to have been rather careless in some cases, and many of his works have since suffered from overcleaning. His subjects, even his most well-bred companies, are always tinged with elements of low-life

or petty bourgeoisie. Aesthetic concerns were never uppermost in his mind, and creating forms never became an end in itself. Steen did not master even the most basic rules of linear perspective, was careless about human anatomy and seems to have trusted to improvisation rather than careful planning in his compositions. The almost complete absence of drawings from Steen's hand reinforces the impression that most of his paintings must have been executed directly on to the support.

3. Critical reception and posthumous reputation
The first biography of Steen was written by Houbraken in 1718. The numerous anecdotes Houbraken told to demonstrate parallels between Steen's life and his work have long determined the painter's reputation and the interpretation of his work. He was believed to have been a drunkard, whose household was as dissolute as the ones he depicted and whose life style was reflected in his own low-life tavern scenes. Houbraken described the *Marriage of Tobias and Sarah* as if it were an ordinary genre scene; the author knew the painting well, because he had owned it himself, but the description of a biblical scene would have conflicted with his image of Steen as a painter who mirrored his own day-to-day surroundings in his art. Even more influential was the work of Houbraken's imitator J. C. Weyerman, who paraphrased and embellished Houbraken's biography of Steen. Weyerman added some spicy anecdotes and some reliable facts to Houbraken's material, mentioned more paintings and described them correctly, but left out all discussion of art theory. The tenacious tradition initiated by Houbraken and Weyerman culminated in Heinrich Heine's *Aus den Memoiren des Herrn von Schnabelewopski*, a book that is as valuable from a literary point of view as it is misleading art historically. It mistakenly contends, for instance, that Steen's self-portrait, as well as the portraits of his first and second wife and of his children can be identified in most of his works. Bredius subsequently even tried to date Steen's paintings by the age of the children depicted in them.

Sir Joshua Reynolds showed a strikingly independent judgement, admiring Steen's artistic qualities (i.e. his technique, compositional skill and use of light and shade), although he thought his genre subjects were unworthy and his history pieces lacking in decorum. Steen and 'others of the same school have shewn great power in expressing the character and passions of those vulgar people, which were the subjects of their study and attention. I can easily imagine, that ... this extra-ordinary man ... [could] ... have ranged with the great pillars and supporters of our Art.'

Still valuable are the insights provided by Thoré, who stressed the literary content as well as the moral value of Steen's works: 'Mais ce terrible homme s'est souvent montré sous des aspects très-divers. Ses variations de manière tiennent à la variété des sujets. Son style et sa pratique se conforment toujours à la nature qu'il veut traduire.' Parts of Steen's work are completely realistic, and in other cases the painter 's'abandonne à une fantaisie de pratique aussi originale que la conception même des caractères, des physionomies, des attitudes'. Thoré considered Steen as a 'mélange inexplicable de science et de licence, de profondeur et de frivolité; grand praticien, qui a ses défaillances; grand philosophe, et triple fou!'

Working in precisely the same years as Thoré but completely independently was the Dutch author van Westrheene. His goal was to restore the art of his own time by stimulating the study of well-chosen examples from the past. Dutch mid-19th-century artists should take the great masters of the 17th century as their guiding stars, and Steen had been one of the most important among them. This painter, however, could not serve van Westreheene's didactic purposes, as long as he held such a controversial reputation. Therefore the author tried to prove, with the help of archival studies, that Steen had been misrepresented in earlier texts. Van Westrheene's book on Jan Steen was one of the earliest monographic studies of a Dutch artist to include a catalogue raisonné of the oeuvre. Later attempts to improve Steen's reputation, for instance by Bredius and Martin, were motivated even more by Dutch patriotism. Both made a great issue of whether Steen had been forced to marry Grietje van Goyen. In his

numerous publications on Steen, Martin contributed to the painter's popularity in the 20th century, abandoning the Steen created by Houbraken, Weyerman and Heine, although this was not replaced by a convincing new conception about the artist and his work). Much more influential has been later iconographical research on Dutch art, which has revived interest in moralizing messages. Since these publications often originated in the discipline of literary studies, they did not always pay enough attention to the specific way in which Jan Steen fused the artistic form and the literary content of his works. Sometimes he is represented as a stern moralizer, but this does no justice to his humour and wit, his exceptional place among his contemporaries and the pictorial qualities of his works. Others still hold the opinion that moralistic messages were a mere pretext for Steen to ridicule his philistine patrons, to follow his painterly instincts and to give way to his undisciplined humour. It is a tenacious misunderstanding that moral admonition and humour are mutually exclusive. Both are represented in Steen's oeuvre on a high level and in a very personal, inextricable combination.

Bibliography

Thieme–Becker

A. Houbraken: *De groote schouburgh* (1718–21), i, p. 374; ii, p. 245; iii, pp. 7, 12–30

J. C. Weyerman: *De levens-beschryvingen der Nederlandsche kunst-schilderen*, ii (The Hague, 1729), pp. 347–66

H. Heine: 'Aus den Memoiren des Herrn von Schnabelewopski', *Sämtliche Werke*, vi (Amsterdam, 1855), pp. 190–96

T. van Westrheene Wz.: *Jan Steen: Etude sur l'art en Hollande* (The Hague, 1856)

W. Bürger [T. Thoré]: *Musées de la Hollande, Amsterdam et La Haye* (Paris, 1858), pp. 104–18, 252–8

—: *Musées de la Hollande: Musée Van der Hoope à Amsterdam et Musée de Rotterdam* (Brussels, Ostend and Paris, 1860), pp. 107–20, 262–7

H. W. Beechy, ed.: 'A Journey to Flanders and Holland in the Year 1781', *The Literary Works of Sir Joshua Reynolds*, ii (London, 1890)

C. Hofstede de Groot: *Holländischen Maler* (1907–28), iv, pp. 1–252

A. Bredius: *Jan Steen* (Amsterdam, 1927)

F. Schmidt Degener and H. E. van Gelder: *Veertig meesterwerken van Jan Steen* (Amsterdam, 1927)

W. Martin: 'Jan Steen as a Landscape Painter', *Burl. Mag.*, lxvii (1935), pp. 211–12

—: *De Hollandsche schilderkunst in de zeventiende eeuw*, ii (Amsterdam, 1936), pp. 246–68

S. J. Gudlaugsson: *Ikonographische Studien über die holländische Malerei und das Theater des 17. Jahrhunderts* (Würzburg, 1938)

—: *De komedianten bij Jan Steen en zijn tijdgenooten* (The Hague, 1945; Eng. trans., Soest, 1975)

H. Gerson: 'Landschappen van Jan Steen', *Ksthist. Meded Rijksbureau Ksthist. Doc.*, 's Gravenhage, iii (1948), pp. 550–56

C. H. de Jonge: *Jan Steen* (Amsterdam, 1954)

W. Martin: *Jan Steen* (Amsterdam, 1954)

R. R. Wark, ed.: *Sir Joshua Reynolds: Discourses on Art* (San Marino, 1959/R New Haven, 1975) [6th and 13th Discourses]

L. de Vries: *Jan Steen: De schilderende uilenspiegel* [Jan Steen: the comedian in paint] (Amsterdam and Weert, 1976)

B. D. Kirschenbaum: *The Religious and Historical Paintings of Jan Steen* (New York and London, 1977)

L. de Vries: *Jan Steen: De kluchtschilder* [Jan Steen: the painter of comedies] (diss., U. Groningen, 1977)

K. Braun: *Alle tot nu toe bekende schilderijen van Jan Steen* [All the known paintings of Jan Steen] (Rotterdam, 1980)

Dutch Figure Drawings from the Seventeenth Century (exh. cat. by P. Schatborn, Amsterdam, Rijksmus.; Washington, DC, N.G.A.; 1981–2), pp. 79, 143

P. C. Sutton and M. H. Butler: 'Jan Steen, Comedy and Admonition', *Bull. Philadelphia Mus. A.*, lxxviii (1982–3), pp. 2–64

L. de Vries: 'Jan Steen zwischen Genre- und Historienmalerei', *Niederdt. Beitr. Kstgesch.*, xxii (1983), pp. 113–28

Masters of Seventeenth-century Dutch Genre Painting (exh. cat. by P. C. Sutton and others, Philadelphia, Mus. A.; W. Berlin, Gemäldegal.; London, RA; 1984), pp. 307–25

LYCKLE DE VRIES

Stom [Stomer], Matthias

(*b* Amersfoort, nr Utrecht, *c.* 1600; *d* ?Sicily or northern Italy, after ?1652). Dutch painter, active in Italy. According to Pauwels (1953), Hoogewerf discovered a document that firmly located Stom's birth in Amersfoort, but his family could have

come from the southern Netherlands where the name Stom is fairly common. Although he is referred to as Stomer in art-historical literature, his few signed pictures bear some form of the name Stom, which form also appears in the few documents concerning the artist. It is often stated that he was a student of Gerrit van Honthorst in Utrecht, but this is unlikely since Stom must have started his training before 1620, the year in which van Honthorst returned from Italy.

However, Stom must have had some contact with van Honthorst's academy during the mid-1620s, for a number of his early works, for example the *Calling of St Matthew* (c. 1629; San Francisco, CA, de Young Mem. Mus.), show the strong influence of the Utrecht Caravaggisti. The broad, painterly approach that characterizes this painting and all of Stom's work has led to the suggestion that he was trained in the southern Netherlands, although similar stylistic tendencies are present in the work of Dirck van Baburen in Utrecht and Jacob van Campen in Amersfoort and Haarlem.

The earliest documented reference to Stom is in a census of 1630 made in the Roman parish of S Nicolà in Arcione in which his age is given as 30. The house that Stom occupied on the Strada dell'Olmo was the one that the Amersfoort painter Paulus Bor had shared with other painters some years earlier. Stom and Bor could well have met in Amersfoort before Stom left for Italy, for Bor was back in Amersfoort by 1626, four years before Stom is first recorded in Rome. In 1631 Stom, along with the French artist Nicolas Provost, is listed as living in the same house on the Strada dell'Olmo. Works probably executed in Rome, while under the strong influence of Caravaggio and such Utrecht artists as Dirck van Baburen, include *Christ and the Woman Taken in Adultery* (Montreal, Mus. F.A.), with its spirited brushwork, tight composition and rough peasant types. It is one of at least three versions of the theme by the artist.

Stom probably went to Naples shortly after 1633 and remained in that city until c. 1640, when he travelled to Sicily. He is documented in Naples by late 17th-century and early 18th-century Italian sources, which mention pictures (untraced)

painted for the church of S Efemo Nuovo; other paintings are known to have come from various palaces in that city. During his stay in Naples Stom was influenced by Ribera's style, as is evident in such works as *St Onofrius* (Naples, Pin. Girolamini) and *Christ among the Doctors* (sold London, Sotheby's, 5 July 1989, lot 7; see 1986–7 exh. cat., no. 77). In this his Utrecht-based palette is momentarily tempered by the earthier tones of contemporary Neapolitan painting. Stom in turn inspired some Neapolitan artists, for instance Domenico Viola, a pupil of Andrea Vaccaro, whose own work, indeed, also reveals some of Stom's influence. Viola is said to have imitated Stom's nocturnal effects in some of his pictures. A number of pictures by Stom with a Maltese provenance suggest that while in Naples he might have had some contact with Valetta.

Stom's activity in Sicily is documented by pictures in churches in Caccamo, Messina and Monreale. Stom's only signed and dated work, the *Miracle of St Isidorus Agricola*, was painted for the high altar of the church of the Agostiniani, Caccamo, Sicily (1641; *in situ*). Its typically Italian composition shows the scene of the miracle in the lower register, with the Virgin and Child with cherubs in clouds above. A *Martyrdom of St Cecilia*, painted for the Capuchin church in Messina (destr. 1908), is said to have been signed *Flandriae Stomus coloribus expressit*. Another altarpiece still *in situ* is the *S Dominico di Silos* in St Salvatore, Monreale.

Between 1646 and 1649 the important Italian collector Antonio Ruffo, Duke of Messina, best known as a patron of Rembrandt, purchased three pictures from Stom. Recorded payments for a large altarpiece depicting the *Assumption of the Virgin with Three Saints* (1652; S Maria Assunta, Chiuduno, Bergamo) suggest that Stom may have left Sicily and settled in northern Italy. It may be significant that a member of a late 17th-century family of battle-scene painters, active in Venice and northern Italy, was called Mathäus Stom.

Bibliography

H. Voss: 'Charakterköpfe des Seicento, 3: Der Meister des sterbenden Cato', *Mhft. Kstwiss.*, ii (1909), pp. 108–15

A. von Schneider: *Caravaggio und die Niederländer*
 (Marburg, 1933)

C. H. Pauwels: 'De schilder Matthias Stomer', *Gent. Bijdr.
 Kstgesch.*, xiv (1953), pp. 139–92

——: 'Nieuwe toeschrijvingen aan M. Stomer', *Gent. Bijdr.
 Kstgesch.*, xv (1954), pp. 233–40

J. Walsh jr: 'Stomer's Evangelists', *Burl. Mag.*, cxviii (1976),
 pp. 504, 507–8

B. Nicolson: 'Stomer Brought Up-to-date', *Burl. Mag.*, cxix
 (1977), pp. 230 45

——: *The International Caravaggesque Movement* (Oxford,
 1979); review by L. J. Slatkes in *Simiolus*, xii (1981–2),
 pp. 167–83

*Painting in Naples, 1606–1705: From Caravaggio to
 Giordano* (exh. cat., ed. C. Whitfield and J. Martineau;
 London, RA; Washington, DC, N.G.A.; Paris, Grand Pal.;
 Turin, Fond. Agnelli; 1982–4), p. 277

Caravaggio in Sicilia: Il suo tempo, il suo influsso (exh.
 cat., Syracuse, Pal. Bellomo, 1984–5)

Civiltà del seicento a Napoli (exh. cat., Naples,
 Capodimonte, 1984–5)

*Holländische Malerei in neuem Licht: Hendrick ter
 Bruggen und seine Zeitgenossen* (exh. cat., ed. A.
 Blankert and L. J. Slatkes; Utrecht, Cent. Mus.;
 Brunswick, Herzog Anton Ulrich-Mus.; 1986–7), nos
 75–8

Il seicento a Bergamo (exh. cat., Bergamo, Pal. Ragione,
 1987)

F. Fischbacher: *Matthias Stomer: Die sizilianischen
 Nachtstücke* (Frankfurt am Main and Berlin,
 1993)

LEONARD J. SLATKES

Storck [Sturck; Sturckenburch]

Dutch family of painters. No paintings are known by the Amsterdam painter Jan Jansz. Sturck, who later changed his name to Sturckenburch, but he had three sons, all painters, who used the name Sturckenburch until *c.* 1688, later calling themselves Storck or Sturck. There are no surviving works by the eldest son, Johannes (*b* Amsterdam, *c.* 1630; *bur* Amsterdam, 5 Aug 1673). (2) Abraham Storck, the youngest, was the best known of the three artists. He was a versatile artist, renowned for his marine paintings, topographical views and Italianate harbour scenes. His brother (1) Jacobus Storck painted similar subjects, but his works are fewer and less accomplished. Both brothers' pictures are mainly of a modest size and painted on canvas more often than on panel.

(1) Jacobus Storck

(*bapt* Amsterdam, 8 Sept 1641; *d* Amsterdam, *c.* 1688). Jacobus, whose slighter talent was already noticed by Houbraken, may have worked in the studio of his younger brother (2) Abraham Storck. Only a few paintings can be attributed to him with certainty (e.g. the *Castle on a River*, London, Wallace; *Southern Port*, The Hague, Ksthand. Nijstad, see Bol, fig. 318; *View of Overtoom*, Enschede, Rijksmus. Twenthe). They are competently painted in bright and sparkling colours, and his work, though undistinguished, has a quiet charm.

(2) Abraham Storck

(*bapt* Amsterdam, 17 April 1644; *bur* Amsterdam, 8 April 1708). Brother of (1) Jacobus Storck. He trained and worked with his father and became a member of the Guild of St Luke in Amsterdam. In 1694 he married Neeltje Pieters van Meyservelt, a surgeon's widow. His river and coastal scenes were greatly influenced by Ludolf Bakhuizen in the pictorial treatment of sky and water, as, for example, in the *Shipping Scene* (Dublin, N.G.) and the *Roads of Enkhuizen* (Amsterdam, Rijksmus., A 1521). Abraham also absorbed influences from other well-known Amsterdam marine painters, notably Willem van de Velde the younger and Jan Abrahamsz. Beerstraten. The Beerstraten and Storck families were close friends and distantly related by marriage. In his paintings of sea battles Abraham emulated Jan Beerstraten's somewhat crowded and agitated compositions. His stylistic dependence on the older artist is demonstrated by a comparison of Beerstraten's *Battle of Terheide, 10 August 1653* (Amsterdam, Rijksmus.) with Storck's *Four-day Battle between the Dutch and English Fleets, 12–14 June 1666* (London, N. Mar. Mus.).

Storck's occasional winter scenes (e.g. Haarlem, Frans Halsmus.; Rotterdam, Mus. Boymans–van Beuningen) also follow the example of Jan Beerstraten and his brother Anthonie, who

specialized in the genre. The van de Veldes, father and son, may have inspired Storck's accuracy in the rendering of ships' rigging and technical details, which is admired by ship historians. A few paintings are devoted to the activities of the Dutch whaling fleets in northern waters (e.g. Rotterdam, Mar. Mus.; Amsterdam, Rijksmus., A 4102; for an engraving of this subject, see fig. 54), but his most attractive and popular paintings are the views of harbour cities and river scenes. Most of these topographical views are of Dutch subjects, but some feature German cities and scenery along the Rhine, suggesting that the artist must have travelled to Germany. The Dutch harbour and river views often depict the recreational and ceremonial aspects of shipping, with an emphasis on colourful pleasure yachts occupied by passengers in festive dress (e.g. *Shipping on the IJ at Amsterdam*, London, N. Mar. Mus.). The most famous of the marine festivities depicted by Storck is the *Mock Battle Staged for Peter the Great on the River IJ* (Amsterdam, Ned. Hist. Scheepvaartsmus.), which commemorates the

54. Abraham Storck: *Whale Fishing, Dutch Ships*, detail (Rotterdam, Maritime Museum Prins Hendrik)

spectacle arranged in honour of the visit of the Tsar to Holland in 1697. Like other popular works by Storck, such pictures of ceremonial gatherings of ships, known as marine 'parades', were repeated in several versions.

The emphasis on spectators and passengers in the marine 'parades' and in scenes of commercial and pleasure shipping gave Storck an opportunity to exercise his considerable skill in rendering the human figure, a skill that many other marine painters lacked. Like Johannes Lingelbach he seems to have sometimes painted the staffage in other painters' scenic views (e.g. *The Dam at Amsterdam* (Dublin, N.G.) by Jan van Kessel). The careful characterization of figures and attention to details of costume are also noticeable in Storck's Italianate architectural views with staffage. Storck shared his interest in this genre with Jan Beerstraten and Jan Baptist Weenix, among others. Storck's views of Italian and Mediterranean ports are sometimes 'realistic' (e.g. *View of Venice*, Schwerin, Staatl. Mus.; Schleissheim, Neues Schloss), and he has been described as one of the precursors of the *veduta*. He must have travelled to Italy, but this has never been proved. Most of the artist's southern views are architectural fantasies, the decorative artificiality of which is emphasized by the postcard-blue Mediterranean skies and water rendered as strips of tiny, silvery waves. These scenes also anticipate the popular 18th-century Italian *capriccio*.

Storck's reputation has suffered from the very popularity of his paintings during his lifetime and beyond. His large workshop turned out many replicas of popular compositions, and copyists and imitators abounded. This accounts for the uneven quality of paintings attributed to Storck, which, though frequently bearing his signature, are not painted by him. Storck's best work is comparable with that of Bakhuizen and Willem van de Velde the younger.

Storck was an excellent draughtsman, and drawings are preserved in several museums, for example in Amsterdam, Haarlem, Vienna, Edinburgh, Cambridge and London. He also produced at least six etchings of various subjects.

Bibliography

Hollstein: *Dut. & Flem.*

A. Houbraken: *De groote schouburgh* (1718–21), iii, p. 255

F. C. Willis: *Die niederländische Marinemalerei* (Leipzig, 1910), pp. 94–5

L. Preston: *The Seventeenth Century Marine Painters of the Netherlands* (London, 1937), pp. 46–9

I. H. Van Eeghen: 'De schildersfamilie Sturck, Storck of Sturckenburch', *Oud-Holland*, lxviii (1953), pp. 216–23

L. J. Bol: *Die holländische Marinemalerei des 17. Jahrhunderts* (Brunswick, 1973), pp. 315–23

S. A. C. Dudok van Heel: 'Het sterfjaar van de schilder Abraham Storck (1644– . . .)', *Amstelodamum*, lxix (1982), pp. 76–7

B. Haak: *The Golden Age: Dutch Painters of the Seventeenth Century* (New York, 1984), pp. 480–82

MARGARITA RUSSELL

Swanevelt, Herman van [Herman d'Italie; Monsieur Herman]

(*b* ?Woerden, *c.* 1600; *d* Paris, 1655). Dutch painter, draughtsman and etcher, active in France and Italy. His first signed and dated works are two views of Paris dated 1623 (Brunswick, Herzog Anton Ulrich-Mus.). He was in Rome from 1629 to 1641. His earliest dated painting there is an *Old Testament Scene* (1630; The Hague, Mus. Bredius), a compositional formula that he often used, with some variations, in Rome. A flat, low foreground is closed on the left by a house and a tree; on the right is a distant hilly scene; and groups of figures are disposed horizontally. This design, derived from Cornelis van Poelenburch, is well suited to van Swanevelt's many landscapes with biblical and mythological subjects. The large tree extending beyond the frame gives a monumental touch to the composition. The distant view bathed in hazy sunshine is also typical.

In the 1630s, with such landscapes, van Swanevelt was an important link between the Dutch Italianates of the first generation, such as van Poelenburch and Bartholomeus Breenbergh, and those of the second generation, such as Jan Both, Jan Baptist Weenix and Nicolaes Berchem, who imitated his monumental compositions and his treatment of southern sunlight. The same elements are seen in the contemporary work of Claude Lorrain. Their styles probably developed in parallel, rather than Claude's influence being dominant, as was previously thought. Van Swanevelt was popular in Rome and undertook several commissions for, among others, the Barberini family and the Vatican. Together with Claude, Both and others, he painted a number of landscapes for the Buen Retiro in Madrid.

After Rome, van Swanevelt lived in Paris except for occasional visits to Woerden. He became a member of the Académie Royale de Peinture et de Sculpture in 1651 and assisted in the decoration of the Cabinet de l'Amour of Hôtel Lambert (e.g. *Italian Landscape, c.* 1646–7; Paris, Louvre). In this painting and other late works, such as *Mountain Landscape with a View of Tivoli* (*c.* 1648; Vienna, Gemäldegal. Akad. Bild. Kst.) and *Landscape with Goatherds* (1654; Paris, Louvre), recurring features are a loose style of painting rich in contrasts, the yellowish-green foliage and the crisp, stipple-like treatment of vegetation and staffage.

Many drawings and 116 etchings by van Swanevelt are known. Some of the drawings were studies for etchings and paintings, such as *Joseph Recounting his Dreams to his Brothers* (New York, Pierpont Morgan Lib.; painting, Cambridge, Fitzwilliam). In such drawings as *Porta Pinciana* (Amsterdam, Rijksmus.), for the etching of the subject (Hollstein, no. 96), van Swanevelt applied bold washes to give a convincing impression of southern sunlight, a technique also used by Breenbergh. In Paris van Swanevelt published series of etchings in collaboration with Israël Silvestre (Hollstein, nos 32–5) and views of Rome. He used both etching and drypoint, as can be seen in *Rest on the Flight into Egypt* (Hollstein, no. 9). His pupils included Francesco Catalano (*c.* 1610–after 1681) in Rome and Jacques Rousseau in Paris.

Bibliography

Hollstein: *Dut. & Flem.*

M. Waddingham: 'Herman van Swanevelt in Rome', *Paragone*, xi (1960), pp. 37–50

Nederlandse 17e eeuwse Italianiserende landschapschilders (exh. cat., ed. A. Blankert; Utrecht, Cent. Mus., 1965); rev. and trans. as *Dutch 17th-century Italianate Painters* (Soest, 1978), pp. 98–105

L. Salerno: *Pittori di paesaggio del seicento a Roma*, 3 vols
(Rome, 1977–80), ii, pp. 410–23
Masters of 17th-century Dutch Landscape Painting (exh.
cat. by P. C. Sutton and others, Amsterdam, Rijksmus.;
Boston, MA, Mus. F.A.; Philadelphia, PA, Mus. A.;
1987–8)

LUUK BOS

Terwesten, Augustinus [Augustin]

(*b* ?The Hague, 4 May 1649; *d* Berlin, 21 Jan 1711).
Dutch painter, draughtsman and etcher. His first
teacher was Nicolaas Wieling (before 1640–1678),
according to Houbraken. After Wieling was
appointed court painter to Frederick William,
Elector of Brandenburg, Terwesten became a
pupil of Willem Doudijns (1630–97). Subsequently
Terwesten travelled through Germany and Italy.
Houbraken's claim that Terwesten spent three
years in Rome is confirmed by signed drawings
of Roman subjects dated 1675, 1676 and 1677
(Amsterdam, Rijksmus., and Leiden, Rijksuniv.,
Prentenkab.). In Rome he joined the Schildersbent,
the northern painters' confraternity, who gave
him the bent-name 'Patrijs'. After a stay in Venice,
Terwesten returned to The Hague via France
and England. In 1682, together with Doudijns,
Theodorus van der Schuer (1628–1707), Daniel
Mijtens and Robert Duval, he was a co-founder of
the Hague Academie, which offered artists the
opportunity to draw from live models on some
evenings each week.

Among his contemporaries Terwesten enjoyed
a prominent reputation as a painter of ceiling
and wall pieces. In 1687 he painted a ceiling in
the Schepenkamer (Council Chamber) of the
Leiden Stadhuis (burnt down, 1929; drawing
in Leiden, Gemeentearchf), a ceiling piece at the
palace of Soestdijk and various commissions in
Rotterdam, Dordrecht and The Hague, none of
which is known to have survived. An impression
of the completed decorations is gained from a
series of red chalk copies (Amsterdam, Rijksmus.)
by Augustinus's younger brother Mattheus
Terwesten (*b* The Hague, 1670; *d* 1757). In 1692
Augustinus Terwesten became court painter

to Frederick III, Elector of Brandenburg (later
Frederick I, King of Prussia). None of Terwesten's
numerous decorations survives from the country
houses or the palaces in Berlin (Stadtschloss
Berlin, Schloss Köpenick and Charlottenburg).
Only at Schloss Oranienburg is any of his work
to be seen. Terwesten was closely involved with
preparations for setting up the Akademie in
Berlin, of which he served as director several
times.

Terwesten's history pieces, allegorical subjects
and mythological scenes were painted in an ornate
Baroque manner. Despite the influence of Italian
and French examples, his work was always ridden
with a provincial stiffness. His drawings comprise
copies after the Antique and later works in Rome,
designs for ceiling and wall decorations and a
number of figure studies. He also left some etch-
ings, after Veronese among others. His brother
Mattheus faithfully followed his style.

Bibliography

Hollstein: *Dut. & Flem.*; Thieme-Becker; Wurzbach
A. Houbraken: *De grote schouburgh* (1718–21), iii,
pp. 268–71
J. C. Weyerman: *De levensbeschrijvingen der
Nederlandsche kunstschilders*, iii (The Hague, 1729),
pp. 120–24
J. B. Descamps: *La Vie des peintres flamands,
allemands et hollandais*, iii (Paris, 1760),
pp. 245–50
J. Gram: *De schildersconfrerie Pictura en hare Academie
van Beeldende kunsten te 's-Gravenhage, 1682–1882*
(Rotterdam, 1882), pp. 30–31, 34
J. H. Plantenga: *De Academie van 's-Gravenhage*
(The Hague, 1938), pp. 18, 20, 23–24; figs 7, 18,
19–21
G. J. Hoogewerff: *De Bentvueghels* (The Hague, 1947),
p. 144
E. Berckenhagen: 'Zeichnungen von Augustin Terwesten,
Johann Friedrich Wentzel und Johann Georg
Wolffgang in der Kunstbibliothek', *Berlin Mus.:
Ber. Staatl. Mus. Preuss. Kultbes.*, n.s. xii (1962),
pp. 14–18
——: *Die Malerei in Berlin vom 13. bis zum ausgehenden
18. Jahrhundert* (Berlin, 1964), figs 125–6, 156–7,
163

MARIJN SCHAPELHOUMAN

Uyttenbroeck [Wtenbrouck], Moses [Moyses] (Matheusz.) van

(b The Hague, c. 1600; d The Hague, after 1646). Dutch painter and etcher. He was the younger brother of the painter Jan (Matheusz.) van Uyttenbroeck (c. 1581–1651), who was accepted into the Guild of St Luke in The Hague in 1614. Moses van Uyttenbroeck was a contemporary of the group of history painters now known as the Pre-rembrandtists, who were active in Amsterdam. However, compared with the varied repertory of subjects depicted by the Pre-Rembrandtists, his range was limited, being mainly centred on themes from the Old Testament and Classical mythology, the latter usually based on Ovid's *Metamorphoses*. He also painted pastoral scenes, which are often difficult to distinguish clearly from the mythological works. Representations of bacchanalia with music, dancing and erotic scenes are particularly prevalent. A few portraits by him have also survived, including a picture thought to be a self-portrait (Doorn, priv. col., see Weisner, pl. 1).

Moses van Uyttenbroeck's earliest known work is the dated etching of *Peter Healing the Lame Man at the Door of the Temple* (1615); although it is still very awkward in the way it is executed, it shows the influence of the Amsterdam painter Pieter Lastman. In 1620, six years after his brother, Moses himself entered the Guild of St Luke, The Hague, of which he was dean in 1627 and possibly again in 1633. He married Cornelia van Wyck by 1624. Probably dating from about the time he joined the guild is what is considered to be his earliest painting (Rennes, Mus. B.-A. & Archéol.), which depicts a spacious, very dramatic landscape with a riverbank in the foreground, a large, tree-covered range of hills and small figures. Van Uyttenbroeck then developed his compositional approach, building up his pictures from landscape elements placed close to one another rather in the manner of a stage set, often using boulders, running or still water and tall plants. Hills or trees delimit the pictures on either side, and the backgrounds consist of gentler, less precipitous wooded countryside, as in the *Mythological Scene* (1623; on dep. Basle, Kstmus.). The paintings from the mid-1620s are more peaceful and balanced; the scenery is flatter and therefore clearer, no longer distracting attention as much from the figures (e.g. *Old Testament or Mythological Scene*, 1625; The Hague, Gemeentemus.). For his figures, he preferred the calm profile or frontal view, and the individual forms became larger, heavier and sturdier, as can be seen in the *Judgement of Paris* (1626; Kassel, Schloss Wilhelmshöhe) and the *Triumph of Bacchus* (1627; Brunswick, Herzog Anton Ulrich-Mus.).

No reliable chronology can be established for paintings dating from the 1630s and 1640s. Paintings apparently belonging to this period include the *Shepherds and Nymphs* (1631 or 1633; Algiers, Mus. N. B.-A.); the *Landscape with a Shepherd and his Flock* (?1633; London, priv. col., see Weisner, pl. 18); a *Mythological Scene* (1642; Berlin, Jagdschloss Grunewald), the only known commissioned work to have survived; and the *Two Nymphs* (1644; ex-art market, Düsseldorf, see Weisner, pl. 32). The oddly contrived branches on the trees conceal the landscape and provide a lively background for the figures, which, as in the paintings of the early 1620s, were again reduced to the size of staffage. There is little or no coherence in this group, either in terms of individual motif or in general subject-matter.

During his lifetime van Uyttenbroeck was highly regarded: Constantijn Huygens mentioned him with approval in his autobiography, and Prince Frederick Henry bought his paintings and involved him in the decoration of Honselaarsdijk. The merit of his oeuvre as a whole lies in the contribution it made to the depiction of Classical mythology. However, van Uyttenbroeck often repeated himself and did not achieve the same density or pithiness in his subject-matter as the Pre-Rembrandtist painters from Amsterdam. Dirk Dalens (d 1676) was his pupil, as probably was his son Matheus van Uyttenbroeck, also an artist.

Bibliography

Thieme–Becker

U. Weisner: 'Die Gemälde des Moyses van Uyttenbroeck', *Oud-Holland*, lxxix (1964), pp. 189–228

The Pre-Rembrandtists (exh. cat., ed. A. Tümpel;
 Sacramento, CA, Crocker A. Mus., 1974), pp. 41–3,
 115–25
Masters of 17th-century Dutch Landscape Painting (exh.
 cat. by P. C. Sutton and others, Amsterdam, Rijksmus.;
 Boston, MA, Mus. F.A.; Philadelphia, PA, Mus. A.;
 1987–8), pp. 535–7

<div align="right">ASTRID TÜMPEL</div>

Velde, van de [den] (i)

Dutch family of artists. (1) Esaias van de Velde was
the second son of Cathalyne van Schorle and the
painter and art dealer Hans van den Velde
(1552–1609), a Protestant who fled religious per-
secution in Antwerp and settled in Amsterdam in
1585. On his father's death, Esaias, a painter,
draughtsman and etcher, moved to Haarlem with
his mother, and the same year he married
Katelyna Maertens, with whom he had four chil-
dren: Jan (*b* 1614), Esaias the younger (*b* 1615),
Anthonie the younger (1617–72) and a daughter,
Jacquemijntgen (*b* 1621). Both Esaias the younger
and Anthonie the younger became artists, the
latter a still-life painter named after his uncle, the
Antwerp painter Anthonie van den Velde the elder
(*b c.* 1557). Esaias's older brother, Jan van de Velde
I (1568–1623), was a famous calligrapher, who
moved from Antwerp to Rotterdam after his mar-
riage in 1592. His eldest son, (2) Jan van de Velde
II, was a painter, draughtsman and printmaker,
like his uncle. He had a son, Jan van de Velde III
(1619/20–62), who became a still-life painter. Both
(1) Esaias and (2) Jan played an important role in
the development of naturalistic Dutch landscapes
in the 17th century.

(1) Esaias [Esias] van de Velde

(*b* Amsterdam, *bapt* 17 May 1587; *d* The Hague, *bur*
18 Nov 1630). Painter, draughtsman and etcher. He
probably received his earliest training from his
father. It is also possible that he studied with the
Antwerp painter Gillis van Coninxloo, who moved
to Amsterdam in 1595 (ten years after Esaias's
father). He may also have trained with David
Vinckboons, whose work shows similarities with
that of Esaias. Esaias became a member of the

Haarlem Guild of St Luke in 1612, the same year
as Willem Buytewech and the landscape painter
Hercules Segers. During this Haarlem period
Esaias had two pupils, Jan van Goyen and Pieter
de Neijn (1597–1639), but by 1618 he had moved
with his family to The Hague, where he joined the
Guild of St Luke in October of that year.

1. Paintings

Esaias left an extensive painted oeuvre of over 180
pictures, 117 of which are landscapes. He signed
his paintings in two different ways: in the early
period (*c.* 1614–16) *E Van Den Velde*; in the later
period simply *E. V. Velde*. However, a clear chrono-
logical dividing line between the use of the two
signatures cannot be drawn.

(i) **Landscapes.** The work of Esaias's predecessors
Coninxloo, Vinckboons and Roelandt Savery rep-
resents the last of the Mannerist tradition, in
which landscapes were constructed in a fantastic
and unrealistic manner, showing turbulent and
hilly scenes from a low point of view so that the
sky or the horizonline almost disappears. The
German painter Adam Elsheimer, whose work
became known in Holland through reproductive
prints, offered a new alternative: simple composi-
tions—often with a strong diagonal—and a tighter
conception of the individual forms achieved by
means of clear outlines and the use of chiaroscuro.
Such a concept of landscape was truer to nature
and became the point of departure for Esaias's own
landscapes. The earliest known examples, *Winter
Landscape* (1614; Cambridge, Fitzwilliam) and
Riders in a Landscape, were executed in Haarlem
and already show his characteristic low horizon, a
landscape articulated by a diagonal river course,
vertical framing groups of trees and horizontal
elements. The colouration is tonal, uniform and
undramatic; Esaias's striving after a realistic recre-
ation of the Dutch landscape in all its monotony
can already be clearly sensed in this early picture
(see also fig. 55).

 The incidental character of that early land-
scape is even more evident in the *View of Zierikzee*
(1618; Berlin, Gemäldegal.), in which the silhou-
ette of the city of Zierikzee is captured as a play

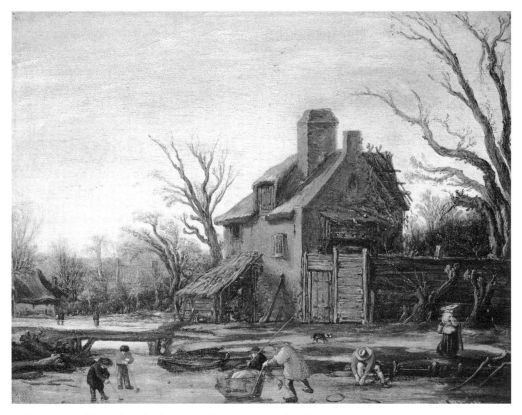

55. Esaias van de Velde: *Winter Landscape*, 1614 (The Hague, Mauritshuis)

of masses and outlines under an open sky, without framing devices on either side. The bold realism of this little picture from the beginning of Esaias's Hague period is unmatched in his oeuvre. The colouring, with a series of fine greenish, blueish and brownish tones, composed from myriad tiny flecks of paint, foreshadows the dissolution of form that was to be the most important innovation of Dutch landscape painting later in the 17th century: the effect of the ambient air on the appearance of objects.

In the 1620s Esaias occupied himself primarily with three types of landscape: the dune and coastal landscape, the river landscape and the hilly or fantasy landscape. Only the coastal landscapes build on the accomplishments of the earlier Haarlem pictures, for example *Dune Panorama*. His river landscapes show the most compositional experimentation: the idyllic central composition of *The Ferry* (1622; Amsterdam, Rijksmus.) depicts a gently bending river framed in the foreground by trees. The drawing *Boat Moored before a Walled Farm* (1623; Brighton, A.G. & Mus.) shows a variation of this theme, in which the river course is pushed to one side of the picture. The extensive use of chiaroscuro to define the composition is a new development in the art of the Dutch landscape. Jan van Goyen took up this compositional principle and made it the foundation of his own work. Esaias's third type of landscape picture, the so-called 'hilly landscape', represents the most traditional and academic aspects of his work.

The imaginary landscape is fundamentally un-Dutch in character and originates in part from the

works of Coninxloo and the Frankenthal school artists. The contemporary academic definition of landscape derived from van Mander's *Schilderboek* (1604), where landscape was defined as an autonomous pictorial genre for the first time (Bengtsson). The work of Savery and the Dutch Italianates must also be considered when assessing Esaias's fantasy landscapes. These are best represented as three types: a cliff landscape untouched by civilization (e.g. *Path to the Left of Cascade Falls*, 1625; Riga, Mus. Foreign A.); a mountain landscape with distant fortifications or circular Roman temples (e.g. *Hilly Landscape*, 1624; Prague, N.G., Šternberk Pal.); and the panoramic landscape, which is in part developed out of the second type (e.g. *Hilly Country*, 1627; Copenhagen, Stat. Mus. Kst).

(ii) **Subject pictures.** Esaias also painted genre and sacred scenes, most of which are set within a landscape. Genre paintings, such as the outdoor parties (*buitenpartijen*), date from the years 1614–24 and reflect the influence of Mannerism (e.g. *Garden Party before a Palace*, 1614; The Hague, Mauritshuis). Many of these banquet pictures are also intended to be read as moralizing representations of the Prodigal Son, or the theme of love for sale may be intended. The iconography of the Five Senses also plays a role in the composition. Often the landscape in these works dwarfs the foreground figures, even those with religious content; the figures become purely staffage before a landscape that is sometimes fantastic, sometimes purely Dutch (e.g. *Christ and the Canaanite Woman*, 1617; New York, S. P. Steinberg priv. col., see Keyes, pl. 76). These pictures also frequently have the character of an interior scene, with the narrative action pushed sharply into the foreground of an enveloping coulisse of trees, recalling the work of Elsheimer (cf. the *Preaching of John the Baptist*, 1618; Karlsruhe, Staatl. Ksthalle; and the version of *c.* 1622; Vienna, Ksthist. Mus.).

In the 1620s Esaias is documented as collaborating with the architectural painter BARTHOLOMEUS VAN BASSEN, for whose interior scenes Esaias painted the figures and also the representations of 'pictures within the picture'. Together they worked on licentious genre subjects but also on ostentatious interiors with religious themes or ecclesiastical interiors. A rich interior that is typical of van Bassen's collaboration with Esaias is found in the painting *Sumptuous Interior with Banqueters* (Amsterdam, Rijksmus.), which shows a room with exceptionally rich furnishings including a coffered ceiling, marble-tiled floor and leather wall-hangings. Esaias's figures enliven these grandiose interiors and present a parallel to the garden parties and banqueting scenes in their selection of *dramatis personae*. The moral content of the interior scenes is underlined through the choice of the pictures within the picture, which are to be understood as providing a contrast to the loose conduct of the characters. Esaias also peopled van Bassen's magnificent church interiors, and here as well the actions of the figures are not casual, but carefully composed and subordinated to a higher didactic content (e.g. *Interior of a Renaissance Church*, 1626; The Hague, Mauritshuis).

The pictures produced by van de Velde and van Bassen were highly prized in their time: the collector Cornelis Cornelisz. van Leuwen of Delft, for whom an entire series of such pictures was painted, paid between 100 and 160 guilders per work. About 30 or so paintings survive from this collaboration. Esaias also provided the staffage for landscape paintings by other artists.

2. Drawings and prints

Esaias's graphic work is as extensive as his paintings, with over 200 secure attributions recognized today; its development mirrors that found in his paintings. Drawings from his Haarlem years, such as the *View of Spaarnewoude* (Amsterdam, Rijksmus.), have a rigid construction with sharply outlined forms, whereas landscape drawings produced after his move to The Hague, for instance *River Landscape with a Ferry* (*c.* 1625; Chantilly, Mus. Condé), are experimental in nature, with the river no longer the centre of the composition, but to one side.

Esaias was also active as an engraver and etcher, and *c.* 120 prints by him are known (e.g. *Farmhouse in the Vicinity of Haarlem*, *c.*1614). In

these works the strokes are short and straight, and changes in direction are conveyed in short breaks and intervals rather than curves; often a few strokes firmly laid down suffice to achieve the desired painterly effect. In the place of the older, more volumetric mode of representation, Esaias employed a planar, painterly mode as the decisive means of expression.

Bibliography

A. Houbraken: *De groote schouburgh* (1718–21), i, p. 275

K. Zoege von Manteuffel: *Die Künstlerfamilie van de Velde* (Bielefeld and Leipzig, 1927)

W. Stechow: 'Esaias van de Velde and the Beginning of Dutch Landscape Painting', *Ned. Ksthist. Jb.* (1947), pp. 83–94

A. Bengtsson: *Studies on the Rise of Realistic Landscape Painting in Holland, 1610–1625*, Figura, iii (Stockholm, 1952)

W. Stechow: *Dutch Landscape Painting of the 17th Century* (London, 1966), pp. 19–23, 51–6, 84–8

L. J. Bol: *Holländische Maler des 17. Jahrhunderts neben den grossen Meistern* (Brunswick, 1967), pp. 135–6

T. Gerszi: 'Zur Zeichenkunst Esaias van de Veldes', *Acta Hist. A. Acad. Sci. Hung.*, xxiv (1978), pp. 273–7

E. Spickernagel: 'Holländische Dorflandschaften im frühen 17. Jahrhundert, *Städel-Jb.*, n. s. vii (1979), pp. 133–48

Esaias van de Velde, schilder, 1590/91–1630: Jan van Goyen, tekenaaer, 1596–1656 (exh. cat., Amsterdam, Ksthandel Gebr. Douwes; 1981)

Dutch Figure Drawing from the Seventeenth Century (exh. cat. by P. Schatborn, Amsterdam, Rijksmus.; Washington, DC, N.G.A.; 1981), pp. 24, 43, 62, 74, 144

G. S. Keyes: *Esaias van de Velde (1587–1630)* (Doornspijk, 1984)

Masters of 17th-century Dutch Landscape Painting (exh. cat., ed. P. C. Sutton; Amsterdam, Rijksmus.; Boston, MA, Mus. F.A.; Philadelphia, PA, Mus. A.; 1987–8), pp. 497–502

<div align="right">IRENE HABERLAND</div>

(2) Jan van de Velde II

(*b* Rotterdam or Delft, *c.* 1593; *d* Enkhuizen, Nov 1641). Draughtsman, printmaker, painter and print publisher, nephew of (1) Esaias van de Velde. In 1613 he was apprenticed to the draughtsman–engraver Jacob Matham in Haarlem and was registered there as a master in 1614. In the years following he made several series of landscape prints, some of which he published himself, others with the addresses of Claes Jansz. Visscher, Robert de Baudous (1574–after 1656) and Hendrick Hondius the elder. Although a number of views of Rome and a large *Panorama of Naples* have been attributed to Jan II, it seems unlikely that he actually went to Italy but rather based his southern landscapes on the drawings and prints of colleagues who had been there. Together with Willem Buytewech and Claes Jansz Visscher, Jan van de Velde made important innovations in Dutch landscape art. His landscape drawings and prints are characterized by simple compositions and fluent hatching and had an enormous influence on the work of other artists, including Rembrandt.

In 1618 van de Velde married Stintje Fredericksdr. Non in Enkhuizen and then went to live in Haarlem, where in 1635 he became commissioner for the Guild of St Luke. There he produced *c.* 480 prints, not only landscapes but also portraits and genre scenes, as well as illustrations for Bredero's *Groot liedboek* ('Large book of songs'; 1622), Samuel Ampzing's *Beschrijvinge ende lof der stad Haerlem* ('Description and praise of the city of Haarlem'; 1628) and other works.

Initially van de Velde worked after his own designs, but later he mostly based his etchings and engravings on drawings by other artists, including Buytewech, Pieter Saenredam, Moses van Uyttenbroeck, Pieter de Molijn, (1) Esaias van de Velde and Jan Martsen the younger. Jan's night scenes in the manner of Adam Elsheimer and Hendrick Goudt are famous. Some of his portrait prints were inspired by paintings of Frans Hals, for example his engraving after Hals's *Jacobus Zaffius* (Haarlem, Frans Halsmus.), which shows that the painting was later considerably reduced in size.

A small oval panel, *Winter Landscape*, with the monogram I.V.V. (Amsterdam, Rijksmus.), confirms that van de Velde was also a painter. On the basis of this work, a group of six paintings has been ascribed to him, including a *Winter Landscape* (Paris, Fond. Custodia, Inst. Neer.). His drawn oeuvre comprises *c.* 100 sheets, mostly executed in

pen and brown ink in a distinctive linear style. Occasionally a drawing is finished with water-colour or gouache or given broad washes with a brush (e.g. *Landscape with Trees and Farms*; Rotterdam, Mus. Boymans–van Beuningen).

This technique can also be seen in a number of market scenes, which were very much influenced by drawings by Buytewech. Jan van de Velde's pupils are thought to have included Willem Outgersz. Ackersloot, Cornelis van Kittenstein (1598–1652), Claes Pouwelsz. and Simon Poelenburch (1591–after 1625). By 5 July 1641 he and his wife were again living in Enkhuizen.

Bibliography

Hollstein, *Dut. & Flem.*; Thieme–Becker

D. Franken and J. P. van der Kellen: *L'Oeuvre de Jan van de Velde, graveur hollandais, 1593–1641* (Amsterdam, 1883, rev. 1968)

J. G. van Gelder: *Jan van de Velde, 1593–1641: Teekenaar-schilder* [Jan van de Velde, 1593–1641: draughtsman-painter] (The Hague, 1933)

——: 'Jan van de Velde, 1593–1641: Teekenaar-schilder, Addenda 1, *Oud-Holland*, lxx (1955), pp. 21–40

——: 'Drawings by Jan van de Velde', *Master Drgs*, v (1967), pp. 39–42

Dawn of the Golden Age: Northern Netherlandish Art, 1580–1620 (exh. cat., Amsterdam, Rijksmus., 1993–4), pp. 320–21, 658–62

GER LUIJTEN

Velde, van de (ii)

Dutch family of painters and draughtsmen of Flemish origin.

I. INTRODUCTION

The family came from Oostwinkel, near Ghent in East Flanders, the birthplace of the seaman Willem van de Velde, who was for a time master of a transport vessel. By 1631 his son, the marine painter (1) Willem van de Velde I, had moved to Leiden, where he married Judith van Leeuwen, whom he divorced in 1662. Two of their sons became painters: (2) Willem van de Velde II, born in Leiden, and ADRIAEN VAN DE VELDE, born after the family moved to Amsterdam *c.* 1633–6. Willem II was a marine artist like his father; the two worked closely together and moved to England in the winter of 1672–3. By contrast, Adriaen was primarily a landscape painter, influenced by Jan Wijnants and Philips Wouwerman; he died shortly before his father and brother emigrated to England.

The reasons for Willem the elder and Willem the younger's move are not fully documented, but no doubt the principal cause was the politically unsettled and dangerous state of the northern Netherlands following the French invasion in May 1672. A letter from Pieter Blauw to Cardinal Leopoldo de' Medici of June 1674 clearly states that Willem I had departed for England more than 18 months before, 'seeing that he, as a result of the bad condition here during these wars, cannot do his work'. Many other Dutch artists, engravers and craftsmen had likewise fled to England from Holland, encouraged to do so by Charles II's declaration of 1 June 1672. The move proved particularly beneficial for the van de Veldes because both Charles and his brother James, Duke of York (later James II), were yachtsmen and took a keen interest in maritime affairs. Charles provided them with a house in East Lane, Greenwich, allowed them the use of the Queen's House as a studio and on 12 January 1674 issued a royal warrant which ordered: the Salary of One hundred pounds p. Annm unto William Van de Velde the Elder for taking and making Draughts of sea fights, and the like Salary of One Hundred pounds p. Annm unto William Van de Velde the Younger for putting the said Draughts into Colours for our particular use.

In 1691 the van de Velde family moved from Greenwich to Westminster, London, where both Willem I and Willem II died. They are buried alongside each other in the church of St James, Piccadilly, London. Willem II's sons, Willem van de Velde III (*b* Amsterdam, *bapt* 4 Sept 1667; *d* ?London, after 1708) and Cornelis van de Velde (*fl* 1699–1729), about whom little is known, were both marine painters in London. Certain paintings, once thought to be inferior works by the hand of Willem II, are often assigned to Willem III.

II. Marine artists

(1) Willem [William] **van de Velde I** [de oude; the elder]

(*b* Leiden, 1611; *d* London, Dec 1693). His training and early activity in Leiden and Amsterdam is not well documented, but he spent his entire working life drawing ships and small craft. His drawings provided him with the raw material for his grisailles (*penschilderingen* or 'pen paintings' drawn in ink on a prepared white canvas or oak panel). He was constantly at sea with the Dutch fleet, sometimes as an independent observer, sometimes in an official capacity. He was present at the Battle of Scheveningen in 1653 and made drawings from the deck of his galliot (a small Dutch sailing vessel). He witnessed the Battle of the Sound in 1658, which is recorded in a grisaille (London, N. Mar. Mus.), and the defeat of the Dutch fleet at the Battle of Lowestoft in 1665. In 1666 he made a sequence of drawings recording every stage of the epic Four Days' Battle off Dunkirk, with the approval and protection of Admiral de Ruyter. For the next six years he was at home in Amsterdam working on his grisailles. On the outbreak of the Third Anglo-Dutch War in 1672 he rejoined the Dutch fleet and made on-the-spot drawings of the Battle of Sole Bay.

One of Willem I's first commissions in England was the design of a series of tapestries commemorating the Battle of Sole Bay (five tapestries in London, Hampton Court, Royal Col.; one in London, Queen's House). In 1673 he was at sea again, in a vessel provided for him by the Duke of York, making drawings of the first and second battles of Schooneveld. The King would not allow him to risk his life again, however, and so he missed the second battle of the Texel. During the ensuing years of peace, he recorded royal embarkations and arrivals in the Thames estuary. He was still drawing ships and painting grisailles in his seventies.

Willem I's drawings, mostly carried out in pen and grey wash, provide an extraordinarily complete record of the ships and small craft of Holland and England in the late 17th century. The complex forms of men-of-war are drawn from all angles with a thorough understanding of ship construction. Particular attention is always paid to such details as figureheads, stern carvings and gunports, which differentiate one ship from another. Some of the drawings are tightly controlled and carefully worked, whereas others, such as his portrait of *The Ship 'Mordaunt'* (*c.* 1681; London, N. Mar. Mus.), are executed with a dashing freedom of touch. The fluidity of his best drawings contrasts markedly with his grisaille paintings, which have a curiously static appearance. The waves are stylized and follow the conventions of earlier engravers. The elegantly drawn groups of figures often introduced in the foreground are humorously observed, but curiously frozen in appearance. Only the ships seem to come to life. In the large grisaille painting of *The Dutch Ship 'Oosterwijk' under Sail near the Shore* (London, N. Mar. Mus.) he showed an absolute mastery of form and detail in his drawing of the elaborately decorated hull, the sails, rigging and flags of the principal ship. His battle scenes combine acute observation of ships in action with a regard for the decorative appearance of the picture as a whole. The *Battle of the Sound* (London, N. Mar. Mus.) and the *Battle of Scheveningen* (Amsterdam, Rijksmus.) are good examples. Although his fame rests on his grisailles and his drawings, van de Velde the elder occasionally produced oil paintings in his later years. Most of these are ship portraits, and though useful as historical documents, they lack the vigour and assurance of his son (2) Willem van de Velde II's work in this medium.

(2) Willem [William] **van de Velde II** [de jonge; the younger]

(*b* Leiden, 1633; *d* London, 6 April 1707). Son of (1) Willem van de Velde I. Around 1648 Willem II moved to Weesp to study under Simon de Vlieger, whose sombre and atmospheric seascapes were a foil to the more prosaic realism of his father's work. In 1652 he was back in Amsterdam, where he married Petronella le Maine. The marriage was dissolved a year later. He took up work in his father's studio, and his earliest paintings were signed by van de Velde the elder as head of the studio. In 1666 Willem II married Magdalena Walraven in Amsterdam. His domestic life and his character remain a mystery.

Willem II had precocious gifts as an artist, and many of his celebrated calm scenes with shipping were painted while he was still in his twenties. The *States Yacht in a Fresh Breeze Running down towards a Group of Dutch Ships* (1673; London, N. Mar. Mus.) shows many of the qualities that brought him fame: exquisitely drawn ships, a careful regard for the placing of each vessel to create a satisfying composition and an atmosphere of serene tranquillity. During the next ten years he painted a succession of calms. These usually depict Dutch fishing boats at low tide among the mud banks of Holland's northern coast. One of the finest examples of these, *Calm: A Wijdschip and a Kaag in an Inlet close to a Sea Wall* (or *Dutch Vessels close Inshore at Low Tide*; London, N.G.), has a sky of breathtaking beauty comparable with those of Jacob van Ruisdael and John Constable. Willem the younger was still only 32 when he painted *Calm: Dutch Ships Coming to Anchor* (London, Wallace), regarded by many as his masterpiece. In this picture he demonstrated that he was as capable of working on a large scale as he was on the much smaller scale of the cabinet picture. The picture was commissioned by Admiral Cornelis Tromp and shows the *Liefde*, Tromp's flagship, at the Battle of Lowestoft in 1665.

The subject-matter of van de Velde's paintings underwent a marked change during the 1670s, after his removal to England. Instead of groups of anonymous fishing boats, he tended to paint portraits of particular ships, such as royal yachts and men-of-war, while storm and shipwreck subjects replace the calms of the 1660s. One reason for this change in mood may have been the influence of Ludolf Bakhuizen, who specialized in dramatic storm scenes. He had settled in Amsterdam in 1649 and soon became a serious rival to the van de Veldes. However the talents of van de Velde the younger were more than equal to the challenge, and in his celebrated *The English Ship 'Resolution' in a Gale* (London, N. Mar. Mus.) and *Vessels Close Hauled* (London, N.G.; see col. pl. XXXVI) he showed that he could paint storms with the same mastery he had brought to calms.

Apart from several paintings depicting the Four Days' Battle of 1666, Willem II painted few

sea battles before coming to England. From 1672 they became a major preoccupation (see fig. 56), as both the Duke of York and the King commissioned depictions of English naval actions. After the end of the Anglo-Dutch wars in 1674, he also painted sea battles for Dutch patrons. The greatest of his battle pieces, *The 'Gouden Leeuw' at the Battle of the Texel* (1686; London, N. Mar. Mus.), was commissioned by Admiral Tromp (1629–91), almost certainly for display in Trompenburg, his recently built château near Hilversum.

Unlike his father, Willem II did not make a regular practice of sailing with the Dutch or the English fleets, and the only action of the Anglo-Dutch wars that he is likely to have witnessed was the Four Days' Battle. All his other battle pictures were painted from sketches made by his father. His working method seems to be illustrated in Michiel van Musscher's amusing portrait of *Willem van de Velde the Younger in his Studio* (c. 1665–7; England, Lord Northbrook priv. col., see *The Treasure Houses of Britain* (exh. cat., ed. G. Jackson-Stops; Washington, DC, N.G.A., 1985), no. 305), in which the artist is shown seated at his easel with drawings of ships scattered on the floor for reference. After the death of his father in 1693, however, it became necessary for van de Velde the younger to be present himself at important maritime events, and an order from the English Admiralty dated 18 May 1694 indicates his official role. Soon afterwards he joined the fleet commanded by Admiral Russell and spent a year in the Mediterranean.

No longer subject to his father's obsession with accuracy, Willem II adopted a freer approach in his later work. His brushwork became fluid and open, and some of his smaller pictures have something of the immediacy of oil sketches, in contrast to the highly finished state of his earlier works. His last major work was the *Calm: The 'Royal Sovereign' at Anchor* (1703; London, N. Mar. Mus.). Less dramatic than the similar, though more celebrated *Cannon Shot* (c. 1660; Amsterdam, Rijksmus.), it shows no weakening of the artist's power. The drawing of the principal ship is as masterful as ever, the smaller vessels are grouped with his usual skill, and the great

56. Willem van der Velde II: *Naval Battle* (Rouen, Musée des Beaux-Arts)

expanse of cloudy sky is painted with the utmost subtlety.

III. COLLECTIONS

The major collections of paintings by the two marine artists are divided between England and the Netherlands. Some of the finest oil paintings by van de Velde the younger are in the British Royal Collection, the Wallace Collection and the National Gallery in London. The National Maritime Museum, Greenwich, London, has the largest collection of van de Velde drawings, numbering over 1400 sheets, together with an impressive selection of paintings and grisailles by both the elder and the younger.

In the Netherlands the major collection of drawings is in the Boymans–van Beuningen Museum, Rotterdam, while the Rijksmuseum,

Amsterdam, has a comprehensive collection of grisailles and paintings. The Mauritshuis in The Hague has several fine works, and the Amsterdam Historisch Museum has one of van de Velde the younger's masterpieces, *The 'Gouden Leeuw' off Amsterdam*, a sweeping view of shipping on the River IJ painted for the City of Amsterdam in 1686.

IV. STUDIO ORGANIZATION

The huge quantity of paintings and drawings that the van de Veldes produced has caused considerable problems of attribution. Apart from the fact that Willem I assisted his son by supplying him with detailed drawings, evidence suggests that the van de Veldes employed a number of studio assistants who collaborated with van de Velde the younger on many of his pictures. These included Joris van der Haagen and Willem II's son Cornelis,

who married van der Haagen's daughter. Willem II's other son, also called Willem, also worked in the studio for a time. The fame of the van de Veldes also attracted a number of Dutch and English followers, many of whom produced versions and imitations of van de Velde compositions. Peter Monamy and Robert Woodcock (c. 1691–1728) in England and Jacob Knyff (1639–81) and Isaac Sailmaker (c. 1633–1721) in the Netherlands were among the most talented of these.

V. POSTHUMOUS REPUTATION

Willem II's work continued to influence several generations of English marine artists throughout the 18th century and into the 19th. Samuel Scott, who owned some van de Velde pictures, was heavily influenced by him in his early years. Charles Gore (1729–1807) painted charming watercolours in the van de Velde manner. Charles Brooking, Dominic Serres and Nicholas Pocock are all known to have copied van de Velde compositions. J. M. W. Turner regarded van de Velde as one of the great masters, and his famous Bridgewater sea-piece, *Dutch Boats in a Gale: Fishermen Endeavouring to Put their Fish on Board* (exh. RA 1801; Duke of Sutherland priv. col., see *Turner, 1775–1851* (exh. cat. by M. Butlin and A. Wilton, London, Tate; London, RA; 1984–5), no. 71), was a deliberate challenge to van de Velde's *Kaag Closehauled in a Fresh Breeze* (Toledo, OH, Mus. A.). Constable admired van de Velde and copied his work, and so did the two most gifted English marine artists of the Victorian period, Clarkson Stanfield and E. W. Cooke.

Bibliography

E. Michel: *Les van de Velde* (Paris, 1892)
C. Hofstede de Groot: *Holländischen Maler* (1907–28), vii, pp. 1–171
K. Zoege von Manteuffel: *Die Künstlerfamilie van de Velde* (Bielefeld, 1927)
H. P. Baard: *Willem van de Velde de oude, Willem van de Velde de jonge* (Amsterdam, 1942)
M. S. Robinson: *Van de Velde Drawings in the National Maritime Museum*, 2 vols (Cambridge, 1958–74)
R. E. J. Weber: 'Willem van de Velde de oude als topograaf van onze zeegaten' [Willem van de Velde the elder as topographer of Dutch seaways], *Oud-Holland*, xc/2 (1976), pp. 115–31
P. D. Fraser: 'Charles Gore and the Willem van de Veldes', *Master Drgs*, xv/4 (1977), pp. 375–87
M. S. Robinson and R. E. J. Weber: *The Willem van de Velde Drawings in the Boymans–van Beuningen Museum, Rotterdam*, 3 vols (Rotterdam, 1979)
R. E. J. Weber: 'The Artistic Relationship between the Ship Draughtsman Willem van de Velde the Elder and his Son the Marine Painter in the Year 1664', *Master Drgs*, xvii/2 (1979), pp. 152–61
Willem van de Velde de oude, 1611–1693: Scheepstekenaar [Willem van de Velde the elder: ship draughtsman] (exh. cat. by A. W. F. M. Meij, Rotterdam, Boymans–van Beuningen, 1980)
Zeichner der Admiralität: Marine-Zeichnungen und -Gemälde von Willem van de Velde dem Älteren und dem Jüngeren (exh. cat., ed. G. Kauffman; Hamburg, Altonaer Mus.; London, N. Mar. Mus.; 1981–2)
E. H. H. Archibald: 'The Willem van de Veldes: Their Background and Influence on Maritime Painting in England', *J. Royal Soc. A.*, cxxx/5310 (1982), pp. 347–60
The Art of the van de Veldes (exh. cat. by D. Cordingly and W. Percival-Prescott, London, N. Mar. Mus., 1982)
M. S. Robinson: *The Paintings of the Willem van de Veldes* [cat. rais.], 2 vols (London, 1990)

DAVID CORDINGLY

Velde, Adriaen van de

(*bapt* Amsterdam, 30 Nov 1636; *bur* Amsterdam, 21 Jan 1672). Dutch painter, draughtsman and etcher, son of Willem van de Velde I (*see* VELDE (ii), VAN DE, (1)). According to Houbraken, he first studied in Amsterdam with his father; however, unlike his father and his brother, Willem van de Velde II, Adriaen did not incline towards marine painting, so he was sent to Haarlem to complete his training with the landscape painter Jan Wijnants. By 1657 Adriaen had settled in Amsterdam, where various documents regularly record his presence until his death. During a career of less than two decades, van de Velde produced an extensive and varied body of paintings, drawings and prints. Meadows and Italianate views with herdsmen and their cattle make up the bulk of his oeuvre, although—as far as is known—he never travelled to Italy. He also painted beaches, dunes, forests, winter scenes, portraits in

landscape settings, at least one genre piece (*Woman Drinking*, 1662; ex-Gemäldegal. Alte Meister, Dresden, see Zoege van Manteuffel, pl. 58) and a few historical pictures. His earliest known works are six etchings of 1653, and dated paintings survive for every year from 1654 to 1671. Pastures with cattle and herders predominate in his work of 1653–8. The paintings and prints of these years reveal no trace of Wijnants's influence. Instead, the young van de Velde emulated the art of Paulus Potter and, to a lesser extent, that of Karel Dujardin.

1. Paintings

Potter's example informs not only Adriaen's choice of the cattle-piece as his preferred subject, but also his depiction of the meadow landscape, the tight, precise technique he employed to paint grass, foliage and fur, and the hard, cool sunlight that pervades pictures of the mid-1650s, such as *Two Cows* (1656; Wanas, Sweden, Wachtmeister priv. col., see Hofstede de Groot, no. 234). Warmer hues and a softer, yellower sunlight—a response to the works of the Italianate painters Dujardin, Nicolaes Berchem and Jan Asselijn—entered van de Velde's pictures about 1658, and, at the same time, he began to engage a broader range of landscape subjects. A farmyard (London, N.G.) and two forest scenes (London, N.G., and Frankfurt am Main, Städel. Kstinst. & Städt. Gal.), all conspicuously indebted to Potter, date from this year, as does the *Riding School* (Raleigh, NC Mus. A.), based on similar depictions of equestrian subjects by Dujardin.

Also from 1658 is the brilliant *Beach at Scheveningen* (Kassel, Schloss Wilhelmshöhe), the most original and harmonious of van de Velde's rare beach scenes. Unlike the monochromatic atmosphere of most contemporary views of the Dutch coast, van de Velde suffused the entire scene with a warm sunlight that deepens the shadows and catches the figures' vivid colours against the rich browns of the sand and greys of the sea. This luminosity and pronounced local colour, adapted from the Italianate painters' evocation of Mediterranean light, eventually extended to Adriaen's pictures of Dutch pastures, woods and dunes, as well as to his own Italianate views.

In 1659 van de Velde painted *The Ferry* (Schwerin, Staatl. Mus.), the first of his landscapes in which the large scale and the individuality of the figures transcend the function of mere staffage. The prominence of the meticulously drawn figures and animals in his landscapes constitutes another essential ingredient in van de Velde's mature style of the late 1650s. A life study in red chalk (Leiden, Rijksuniv., Prentenkab.) for one of the boatmen in *The Ferry* affirms that this crucial element in van de Velde's work depended on his practice of drawing from the model in the studio and from cattle in the fields (*see* §2 below). The stylistic innovations of 1658–9 laid the foundation for van de Velde's remarkable development during the 1660s, which culminated in such works as the *Migration of Jacob* (1663; London, Wallace), with its numerous large-scale and painstakingly individualized figures. This is also apparent in pastoral and Italianate scenes dominated by relaxing shepherds and grazing cattle, for instance the *Landscape with Cattle and Figures*, which epitomizes the type of pastoral scene that constituted van de Velde's favourite subject during the last decade of his short life. Its idyllic Italianate setting, congenial herders surrounded by various farm animals, warm light, intensely green, feathery foliage (turned blue in places due to pigment changes), majestic fair-weather sky and immense foreground tree with a truncated crown are recurring elements in his mature works.

Due to his skill in painting figures and animals, van de Velde was frequently employed to add staffage to pictures by fellow landscape artists, including Jacob van Ruisdael, Meindert Hobbema, Jan Wijnants, Jan van der Heyden and Frederik de Moucheron. As early as 1664 an inventory lists paintings by Wijnants and Moucheron 'gestofferd door Adriaen van de Velde', and Adriaen's contribution to these collaborative efforts demonstrably increased their market value.

Besides the *Migration of Jacob*, van de Velde's rare history paintings include a group of biblical and allegorical works set in interiors. Among the latter are a Passion series executed for the Augustinian *schuilkerk* (clandestine church) 'De Ster' in Amsterdam (1664; Nijmegen, Augustinian

Friars; see Hofstede de Groot, nos 11, 14–16 and 18), an *Allegory* (1663; Moscow, Pushkin Mus. F.A.) and an *Annunciation* (1667; Amsterdam, Rijksmus.). The style he adapted for these large-scale figural paintings derives from the classicizing manner practised in Amsterdam and Haarlem during the 1650s and 1660s by such artists as Dujardin and Jan de Bray.

2. Drawings

One of the most gifted and versatile 17th-century Dutch draughtsmen, van de Velde is also one of the few landscape painters of the period whose method of design can to some degree be reconstructed. His numerous surviving drawings include landscapes sketched from nature, compositional ideas for paintings and prints, cattle drawn from life and nudes and other figures executed from studio models. Van de Velde used three types of preparatory study for his paintings. He began with a preliminary compositional sketch, in which he summarily jotted down the broad outlines of the design. From this first idea he produced a second, fully resolved and detailed drawing of the whole composition. Although not transferred directly to the canvas or panel, this second design served as the model for the finished work. In addition, he made chalk studies from life for the principal figures and animals in his pictures.

3. Etchings

Van de Velde's activity as a printmaker was concentrated in the years 1653, 1657–9 and 1670. Most of his 28 etchings depict farm animals. The finest are distinguished by their forceful draughtsmanship and the masterful evocation of strong light and deep shadows on the solid flanks of grazing and resting cows. While the subject-matter and design of his prints was suggested by the work of other etchers of animal subjects (e.g. Potter, Dujardin and Berchem), van de Velde's brilliant use of the etching needle at once emulates and surpasses Dujardin's technique.

Bibliography

Hollstein: *Dut. & Flem.*; Thieme–Becker

A. Houbraken: *De groote schouburgh* (1718–21), iii, pp. 90–91

A. D. de Vries: 'Biografische aanteekeningen betreffende voornamelijk Amsterdamsche schilders, plaatsnijders, enz.', *Oud-Holland*, iv (1886), pp. 143–4

C. Hofstede de Groot: *Holländischen Maler*, iv (1911), pp. 475–608

K. Zoege van Manteuffel: *Die Künstlerfamilie van de Velde* (Bielefeld and Leipzig, 1927), pp. 55–83

W. Stechow: *Dutch Landscape Painting of the Seventeenth Century* (London, 1966), pp. 31–2, 60–61, 80, 98–9, 107–9, 160–62

W. Robinson: 'Preparatory Drawings by Adriaen van de Velde', *Master Drgs*, xvii (1979), pp. 3–23

——: 'Some Studies of Nude Models by Adriaen van de Velde', *Donum Amicorum: Essays in Honour of Per Bjurström* (Stockholm, 1993), pp. 53–66

WILLIAM W. ROBINSON

Venne, Adriaen (Pietersz.) van de

(*b* Delft, 1589; *d* The Hague, 12 Nov 1662). Dutch painter, draughtsman and poet.

1. Early training and Middelburg years, 1589–1624

De Bie's account (1661) is the only known source on van de Venne's youth and training. He was born of 'worthy' parents who had fled to Delft from the southern Netherlands to escape war and religious strife. Inspired by his early study of Latin to become an illustrator, he was partly self-taught but also received instruction in painting and illumination from the otherwise unrecorded Leiden goldsmith and painter Simon de Valck. His second teacher, Hieronymus van Diest (not the later marine artist), is equally obscure, but according to de Bie he painted grisailles, a technique that van de Venne later employed extensively.

Van de Venne's father, Pieter, and his elder brother, Jan (*bur* Middelburg, 3 May 1625), are recorded in Middelburg, Zeeland, in 1605 and 1608 respectively, and Adriaen is documented there from 1614 to 1624. His earliest dated paintings, *Summer* and *Winter* (both Berlin, Gemäldegal.) and *Fishing for Souls* (Amsterdam, Rijksmus.), all from 1614, reveal a mature artist with a knowledge of landscapes done by local Middelburg painters and the Fleming Jan Breughel the elder; *Fishing for Souls* also displays the iconographic individuality that characterizes most of his work.

An extensive, yet minutely detailed, panel, it is an allegory of the religious divisions in Europe set in the context of the Dutch war of independence from Roman Catholic Spain. Boats on a wide river are occupied by either Protestant or Catholic churchmen. Each faction attracts converts, the Protestants through the scriptures, the Catholics through music and other methods considered to be underhand. The two camps are also presented on each riverbank in a multitude of small portraits. The informal, vernacular language dispenses with the personifications and trumpeting angels that were standard in such allegorical works. This formula is repeated in van de Venne's three other major paintings, all completed during his Middelburg years. The *Celebration in Honour of the Truce of 1609* (1616; Paris, Louvre; see col. pl. XXXVII) again makes extensive use of portraits, this time to illustrate the benefits of peace that resulted from the ceasefire agreed in 1609 between the Dutch (under their Stadholder, Prince Maurice of Orange Nassau) and the Spanish-dominated southern Netherlands (under their regents, Albert and Isabella). *Prince Maurice and Frederick Henry Visiting the Horsefair at Valkenburg* (1618; Amsterdam, Rijksmus.) contains innumerable vignettes of the peasantry in the tradition of Pieter Bruegel I and the *View of the Harbour at Middelburg* (Amsterdam, Rijksmus.), said by Franken (1878) to have been dated 1625 but more probably painted *c.* 1616, apparently commemorates the visit of Elizabeth Stuart (the future 'Winter Queen') to the town in 1613.

Van de Venne produced other, more minor paintings in Middelburg but also embarked on his varied activities as a book illustrator, print designer, political propagandist and poet; in these he worked closely with his brother Jan, by then a well-known publisher and art dealer. Van de Venne's book illustrations usually concentrate on the human figure and are among his most successful works, combining a gift for narrative clarity with an informal compositional charm. They contributed greatly towards the popularity of Dutch emblem books in the 17th century, and his talents were employed by the leading writers of his day. His earliest illustrations were published

in 1618 in the first works of the poet Jacob Cats (i): *Silenus Alcibiadis* or *Proteus*, later republished as *Sinne- en minnebeelden* ('Emblems of the mind and of love'), and *Maechden-plicht* ('Maids' duty'). Jan van de Venne was Cats's publisher until Jan's death in 1625, but Adriaen remained the poet's chief illustrator until at least 1656, when *Dootkiste* ('Coffins') and *Aspasia* were published. In 1623 Jan published Constantijn Huygens's first two literary works: *Costelyck mal* ('Costly folly') and *Batava Tempe ... Haagse Voorhout*, with plates designed by Adriaen. The illustrations had originally been intended for inclusion in the *Zeeusche nachtegael* ('Zeeland nightingale'), also published by Jan in 1623, a collection of writings in praise of Zeeland for which Adriaen again supplied the illustrations as well as much of the text. It was his first publication as a writer and is a landmark in the history of book design. He also produced the illustrations for Johannes de Brune's *Emblemata of zinnewerk* (Amsterdam, 1624), which are among his finest compositions.

From 1618 van de Venne designed several prints on a larger scale, most of them propagandist in intent. His portraits of the Stadholder *Prince Maurice* and of his successor *Frederick Henry* were engraved in 1618 by Willem Jacobsz. Delff (with a portrait of *William the Silent* added en suite in 1623 from a painting of 1621) and impressions were purchased by the States General, the ruling executive of the United Dutch Provinces. They and the municipality of Middelburg also acquired impressions of Delff's *Cavalcade of Nassau Princes*, made to van de Venne's design in 1621. A large engraving on four plates of the *Arrival of Frederick V, Elector Palatine, and his Bride, Elizabeth Stuart, in Flushing in 1613* appeared in 1618, the year in which his first political broadsheets were published. The engraving *The Righteous Sieve*, for which van de Venne's preparatory drawing survives (Rotterdam, Hist. Mus., 1388), defends Prince Maurice's overthrow of Johan van Oldenbarnevelt (the powerful Advocate of the States of Holland) and of the Remonstrant faction in the Dutch Calvinist church (see Royalton-Kisch, 1988, pp. 59–61). Other political prints appeared in the 1620s (and to a lesser extent

later), always supporting the house of Orange Nassau or the cause of the 'Winter King and Queen', who from 1621 lived in exile in The Hague.

2. The Hague, 1625–62

Evidence that van de Venne was ever directly employed by either the house of Orange Nassau or the court of the 'Winter King and Queen' is only circumstantial, but the nature of the first works he produced in The Hague strongly supports the suggestion. Van de Venne is first documented there on 22 March 1625, the date of the copyright granted him for Cats's *Houwelyck* ('Marriage'), which he had also illustrated. This was the last book to be published by Jan van de Venne. Prince Maurice died on 23 April 1625, an event commemorated by Adriaen in several paintings (e.g. Amsterdam, Rijksmus.) and a propagandist print of his deathbed. Impressions of the latter were purchased by the States General on 21 July 1625. Four small, precisely detailed panels of the *Four Seasons* (Amsterdam, Rijksmus.) also date from 1625. The same year he must have begun work on the exquisite album of 105 miniatures (completed 1626; London, BM), of which three are now missing. Internal evidence suggests that the album may have been commissioned by the 'Winter King' as a personal gift to the new Stadholder, Frederick Henry, celebrating the latter's assumption of power and his marriage in 1625 to Amalia von Solms, a maid of honour to the 'Winter Queen' and the daughter of the King's late chief steward. Entitled *tLants sterckte* ('Fortress and strength of the land'), the album eulogizes the Stadholder's rule, country and people at all levels of society. The nation's military prowess, its court, professions and major industries are illustrated, together with a section devoted to peasant 'drollery'. The drawings also depict a variety of topics emblematically, from the Stadholder's political aspirations to coarse sexual jokes. In its breadth of scope, purpose and technique, it is a unique production in Dutch art, distantly related to the German tradition of the *album amicorum*. It draws on every facet of van de Venne's wide artistic experience, and the small scale as well as the medium of brightly coloured

bodycolour, often heightened in gold, provided him with a perfect vehicle for expression.

The album's dependence on an emblematic language and on peasant genre is repeated in most of van de Venne's numerous grisaille paintings. The earliest dated examples (Plokker, nos 1, 56 and 57) are from 1621, when he was still in Middelburg, but the overwhelming majority were executed in The Hague. In style and iconography these broadly executed works contrast sharply with the polychrome paintings of the Middelburg period. They concentrate on human (usually peasant) folly, the moral often being conveyed by an inscribed motto, such as *Armoe soeckt list* ('Poverty seeks cunning') or *Let op U selven* ('Observe yourself'). This combination of word and image allies them to the tradition of emblematic literature, but the motifs are usually unique to van de Venne. Also in grisaille are his large portrait of the *'Winter King and Queen' with Frederick Henry and Amalia von Solms* (1626; Amsterdam, Rijksmus.), based on a composition in the British Museum album of miniatures, the portrait of *Christian IV of Denmark as Pacifier* (1643; Helsingør, Kronborg Slot) and several religious paintings. Polychrome works executed in The Hague are not common, although in 1647–8 he designed a tapestry almost 8 m long depicting the *Battle of Nieuwpoort* (Brussels, Pal. B.-A.). The later works never repeat the precise touch of the Middelburg paintings, which is echoed only in his preparatory drawings for book illustrations, a large collection of which is in the Museum Catsianum (now in Leiden, Bib. Rijksuniv.). He also designed plates for Adrianum Valerium, Jacobus van Heemskerck, Philips van Lansbergen, Lieuwe van Aitzema, Jacob van Oudenhoven and others. Van de Venne seems never to have practised engraving, but employed numerous reproductive printmakers.

Van de Venne published his main literary works with his own illustrations during his years in The Hague, chief among them *Sinne-vonck op den Hollantschen turf* ('Spark of sense on Dutch peat') and *Wys-mal* ('Wise folly'), both from 1634, and *Tafereel van de belacchende werelt* ('Picture of the ridiculous world') of 1635. Highly imaginative

books, they draw their inspiration from contemporary colloquial language and shun the imitation of antique models preferred by writers such as P. C. Hooft, Huygens and Joost van den Vondel. This attempt to formulate a new vernacular style in Holland is the one factor that unifies most of van de Venne's art, whatever the medium. His intensely felt and vivid response to contemporary life distinguishes him from other artists working in a similar vein, such as David Vinckboons, Hendrick Avercamp and Esaias van de Velde. Yet despite his apparent rejection of an international grand style, he did associate himself with the court on both a political and personal level. He also worked to improve the status of the artist in society, playing an active role in the Guild of St Luke in The Hague (member 1625; deacon 1631–2 and 1636–8; dean 1640). He was also a founder-member of Pictura, the artists' confraternity established in The Hague in 1656. At his death he was in debt. He married in 1614 and had two sons who were painters, Pieter van de Venne (1624–57), a still-life specialist, and Huybrecht van de Venne (1635–76 or later), who is said by de Bie to have followed his father's style, but none of whose works is known.

Unpublished Sources

Amsterdam, Rijksmus., MS. Rijksprentenkab. [D. Franken and F. G. Waller: *L'Oeuvre de Adriaen van de Venne, c.* 1910]

Bibliography

Hollstein: *Dut. & Flem.*

C. de Bie: *Het gulden cabinet* (1661), pp. 234–6

D. Franken: *Adriaen van de Venne* (Amsterdam, 1878)

G. van Rijn, ed.: *Katalogus der historie . . . prenten . . . verzameld door A. van Stolk* (Amsterdam, 1895–7); *Index* (The Hague, 1933)

L. J. Bol: 'Adriaen Pietersz. van de Venne, schilder en teyckenaer', *Tableau*, v (1982–3), nos 2–6; vi (1983–4), nos 1–5 [with further bibliog.]

A. Plokker: *Adriaen Pietersz. van de Venne (1589–1662): De grisailles met spreukbanden* (Leuven, 1984)

M. Royalton-Kisch: 'The Tapestry of the *Battle of Nieuwpoort*', *Bull. Mus. Royaux A. & Hist.*, lviii (1987), pp. 63–78

——: *Adriaen van de Venne's Album in the British Museum* (London, 1988)

L. J. Bol: *Adriaen Pietersz. van de Venne: Painter and Draughtsman* (Doornspijk, 1989)

MARTIN ROYALTON-KISCH

Vermeer, Johannes [Jan]

(*b* Delft, *bapt* 31 Oct 1632; *d* Delft, *bur* 16 Dec 1675). Dutch painter. He is considered one of the principal Dutch genre painters of the 17th century. His work displays an unprecedented level of artistic mastery in its consummate illusion of reality. Vermeer's figures are often reticent and inactive, which imparts an evocative air of solemnity and mystery to his paintings.

I. LIFE AND WORK

Johannes Vermeer was the second and youngest child of Digna Baltens and Reynier Jansz. Vermeer (alias Vos), both Reformed Protestants. Vermeer's father was trained in Amsterdam to weave caffa (a fine, patterned fabric of satin, silk or velvet) and eventually became an innkeeper and picture dealer (a capacity in which he registered with the Delft Guild of St Luke in 1631). Reynier Jansz.'s activities as a picture dealer with contacts among local painters and collectors undoubtedly influenced the career choice of the young Vermeer, who presumably began his artistic training sometime in the mid-1640s.

In December 1653 Vermeer was admitted as a master to the Delft Guild of St Luke, an act that granted him the right to sell his work in Delft, take on pupils and even to sell paintings by other artists as his father had done before him, an occupation in which he would later engage. According to guild regulations, any painter who enrolled as a master had to serve at least six years as an apprentice with a recognized artist (or artists), either in Delft or elsewhere. The identity of Vermeer's teacher or teachers has long been debated. In one version of the frequently quoted poem by Arnold Bon published in Dirck van Bleyswijck's *Beschryvinge der stadt Delft* (1667), Vermeer is described as the artist who trod masterfully in the path of 'the Phoenix', Carel Fabritius. The poem alludes to the explosion

of the Delft municipal arsenal in 1654, a catastrophe that levelled a large portion of the city, tragically claiming many victims, including Fabritius, an artist who had arrived in the city around 1650 and become its leading master. The poem has led to the misleading theory that Fabritius was Vermeer's teacher, even though Bon merely implied that Vermeer succeeded Fabritius as the foremost painter in Delft. Although the two artists' similar subjects and style, along with their common interest in perspective and optics, are adduced to support the theory, it is unlikely, since Fabritius enrolled in the Guild of St Luke only in October 1652 (one year before Vermeer).

Leonard Bramer also could have been Vermeer's teacher. When he returned to his native Delft after a long stay in Italy in 1628, he quickly established himself as one of the principal painters in the city. Given Bramer's prominence it is possible that he taught Vermeer, even if his surviving work consists largely of easel paintings depicting luminous, energetic figures sometimes posed within dark, cavernous settings, a style that has little in common with Vermeer's art. Whether or not Bramer was Vermeer's teacher, there is evidence that he was a friend of the artist's family. A document dated 5 April 1653 indicates that Bramer attempted to intervene on Vermeer's behalf in an effort to convince the latter's future mother-in-law to consent to his marriage to her daughter.

Montias (1989) hypothesized that Vermeer, after spending the first four years of his apprenticeship in Delft, concluded his training in Amsterdam or Utrecht, or possibly both cities in succession. The influence of painters from Amsterdam and Utrecht on Vermeer's early work and the fact that the Utrecht artist Abraham Bloemaert was a distant relative of his future wife's family support this theory.

On 20 April 1653, several months before enrolling in the guild, Vermeer married Catharina Bolnes (*b* 1631; *bur* 2 Jan 1688). Catharina's mother, Maria Thins (*b c.* 1593; *bur* 27 Dec 1680), initially objected to the marriage, possibly on social and financial grounds—Maria was descended from a distinguished family from Gouda—and also because she and her daughter were practising

Roman Catholics. However, Vermeer must have converted to Catholicism sometime between the couple's betrothal and the wedding ceremony, since the latter occurred in a small, predominantly Catholic village outside Delft. Vermeer and his wife eventually had eleven children; this large family undoubtedly placed a tremendous economic strain on the artist.

The only undisputed, dated works by the artist are *The Procuress* (Dresden, Gemäldegal. Alte Meister) of 1656 and two others, *The Astronomer* (Paris, Louvre) of 1668 and *The Geographer* (Frankfurt am Main, Städel. Kstinst.) of 1669. (In the latter two cases the dates may be later additions based on the original ones.) Nevertheless, scholars agree on a general outline of the chronology of Vermeer's paintings, with only slight variations. Thirty-five paintings are considered genuine, although the authorship of three is debated: *St Praxedis* (priv. col.; see Wheelock, 1986), the *Woman with a Lute* (New York, Met.) and the *Girl with a Red Hat* (Washington, DC, N.G.A.). Vermeer's artistic career can be conveniently divided into three periods.

1. Early period, c. 1655–7

The early period of Vermeer's artistic career was devoted to experimentation in techniques and subject-matter. His earliest works are history paintings. Such paintings, illustrating episodes from the Bible, mythology or Classical and modern history, were most highly esteemed by contemporary art theorists. Clearly at this stage in his career, Vermeer aspired to be a history painter. *Christ in the House of Mary and Martha* (Edinburgh, N.G.) is perhaps his earliest surviving work, painted *c.* 1655. Like all of those produced during Vermeer's early period, it is much larger than most of his later paintings and includes large-scale figures placed in the foreground. It is a broadly painted work and reveals the artist's knowledge of contemporary developments in history painting in Amsterdam, for it is clearly dependent on a painting of the same subject (Valenciennes, Mus. B.-A.) by the Fleming Erasmus Quellinus (i), an artist active in the decoration of the new town hall in Amsterdam. Quellinus's work resembles Vermeer's

in motifs such as the open door in the background, and in the pose of Christ with Mary at his feet. The figure of Christ is also dependent on prototypes from Italian art. The sensitivity to light in this painting—its cool effects reminiscent of pictures by the Utrecht Caravaggisti—together with its colour scheme and such motifs as the Oriental rug on the table anticipate later developments in Vermeer's art. Vermeer's knowledge of contemporary trends in history painting in Amsterdam is also demonstrated in his only surviving mythological painting, *Diana and her Companions* (The Hague, Mauritshuis). It was completed around the same time as *Christ in the House of Mary and Martha*. The figures were influenced by those in the background of a painting of the same subject (Berlin, Bodemus.) by the Amsterdam artist Jacob van Loo.

Despite Vermeer's early dependence on artistic developments in Amsterdam and to a lesser extent Utrecht, his work is somewhat distinctive: the rich palette and facture of *Diana and her Companions*—which differs markedly from *Christ in the House of Mary and Martha*—has long been compared to that of 16th-century Venetian paintings, particularly those by Titian; moreover, its composition derives from representations of *Diana and Acteon* by Titian and Rubens (see Blankert in 1980–81 exh. cat., no. 54).

Vermeer's ambitions to become a history painter may also explain his interest in Italian art. Since he presumably did not travel to Italy, his knowledge of Italian art was possibly acquired in Amsterdam, which had more important collections of Italian painting than did his native Delft. Johannes de Renialme, the owner of the *Visit to the Tomb* (untraced), was an important dealer–collector of Italian art who was primarily based in Amsterdam (but also active in Delft; Montias, 1980). Vermeer himself was eventually recognized as an expert in Italian art, for in May 1672 he was summoned to The Hague (along with several other painters) to appraise a collection of 12 Italian paintings that were at the source of a dispute between the art dealer Gerrit Uylenburgh and their prospective buyer, Frederick William, the Grand Elector of Brandenburg.

The controversial *St Praxedis* (priv. col.) also testifies to Vermeer's exposure to Italian art during the early stages of his career. This work, a copy of a painting by the contemporary Florentine master Felice Ficherelli (1605–?1669), is signed and dated 1655 in the lower left and also has an additional signature in the lower right: *Meer N[aar] R[ip]o[s]o*, 'Vermeer after Riposo', the latter being Ficherelli's nickname.

The last painting ascribed to Vermeer's early period is the signed and dated *Procuress* (1656; Dresden, Gemäldegal. Alte Meister; see fig. 57), which shows continued links with the Amsterdam and Utrecht schools. The warm colours and chiaroscuro effects recall the paintings of Rembrandt and his pupils of the late 1640s and 1650s, for example Nicolaes Maes. The subject was probably inspired by pictures by the Utrecht Caravaggisti; Vermeer's mother-in-law owned a work of the same subject (Boston, MA, Mus. F.A.) by Dirck van Baburen, which later appeared in the background of two paintings by Vermeer. At first glance, *The Procuress* could be categorized as a genre painting. However, the anachronistic Burgundian costume of the smiling man on the

57. Johannes Vermeer: *The Procuress*, 1656 (Dresden, Gemäldegalerie Alte Meister)

left—a possible self-portrait of the artist—indicates that Vermeer intended it to be a history painting. It probably represents an episode from the New Testament parable of the prodigal son, in which the unruly youth dissipates his inheritance, an episode often rendered in contemporary guise by Dutch artists.

2. Middle period, c. 1657–67

The Procuress can be considered a crucial transitional work as its subject shares many features with genre paintings, the type of work that is most frequently associated with Vermeer. Most of the paintings of the middle period (along with those of the late period) are genre paintings, that is, scenes of everyday life.

Vermeer's first genre pur is his Girl Asleep at a Table (New York, Met.). Its comparatively large scale, spatial ambiguities and palette recall The Procuress, suggesting that it should be dated c. 1657. This and related works reflect Vermeer's response to the revolutionary formal and iconographic developments in Dutch genre painting around 1650. The raucous scenes painted in earlier decades (often of peasants and soldiers) declined in popularity in favour of subjects such as elegantly attired figures engaged in a wide variety of leisure activities. Accompanying this shift in subject-matter were stylistic changes as well: individual paintings exhibit reduced numbers of figures whose dimensions are enlarged in relation to overall space. The newer generation of artists, such as Gerard ter Borch (ii) and Pieter de Hooch, remained sensitive to the renderings of textures and stuffs but also focused on the subtle, natural evocations of light and shadow on figures and objects firmly planted within the confines of carefully constructed spaces. Their superbly balanced, dramatic works contrast strongly with the evenly lit, monochromatic interiors of their predecessors. Vermeer was certainly familiar with ter Borch's work and probably with the artist himself, even though the latter lived in Deventer: they both signed a notary document in Delft on 22 April 1653 (Montias, 1980).

The stimulus of de Hooch, who lived in Delft between c. 1652 and c. 1661, must explain Vermeer's growing interest in the placement of figures within solidly constructed, light-filled spaces. Vermeer's next four paintings, a closely related group, all differ considerably from the artist's previous work and reflect in varying degrees the influence of de Hooch. Soldier with a Laughing Girl (New York, Frick), Girl Reading a Letter at an Open Window (Dresden, Gemäldegal. Alte Meister; see fig. 58), The Milkmaid (Amsterdam, Rijksmus.) and the Glass of Wine (Berlin, Gemäldegal.) were probably painted between 1658 and 1661. In contrast to the paintings of his early period, Vermeer reduced the size of the figures in relation to the overall space, and his application of paint became thicker as he modelled the figures and objects to display a tremendous tactility. He also paid scrupulous attention to the naturalistic effects of light within the interiors of these works.

58. Johannes Vermeer: Girl Reading a Letter at an Open Window, c. 1658–61 (Dresden, Gemäldegalerie Alte Meister)

The *Soldier with a Laughing Girl* is considerably accomplished in this respect: the superb rendition of the myriad effects of light and shadow within this brightly illuminated interior reveals Vermeer's great technical mastery and introduces a heretofore unseen level of realism in Dutch art. The distortions in size and scale between the soldier (silhouetted in stark *contre-jour* in the foreground) and the woman (seated in the middleground), along with the unfocused look of such motifs as the lion-headed finial on her chair, her hands and the wine glass she is holding, provide the earliest evidence of Vermeer's interest in optical devices (*see* §II below). Vermeer replicated the unfocused appearance of the motifs that he would have seen through an optical device by applying his famous *pointillés* (small dots of paint employed to yield the effect of broken contours and dissolved forms in light).

Pointillés are used in *The Milkmaid* to impart an extraordinary tactile reality to such objects as the chunks of bread. The chunks are encrusted with so many *pointillés* that these dots of paint seem to exist independently of the forms they describe. This tactility is also detected in other works of this phase: the carpets on the table of the *Girl Reading a Letter at an Open Window* and the *Glass of Wine* have a palpable knubby quality that is completely different from the broad, general planes of the carpet in the early *Christ in the House of Mary and Martha*.

Vermeer's rapid mastery of the depiction of forms in space probably stimulated his interest in townscape painting, a genre in which he produced at least three pictures, as is known from the catalogue of the auction in 1696 of Jacob Dissius's collection (*see* §IV below), which includes 'A view of a house standing in Delft', 'A view of some houses . . .' and 'The town of Delft in perspective, to be seen from the south . . .'. Two of them survive, the *Little Street* (*c.* 1658–60; Amsterdam, Rijksmus.) and the famous *View of Delft* (*c.* 1661; The Hague, Mauritshuis; see col. pl. XXXVIII). The titles in the old sale catalogue suggest that Vermeer might have done the three paintings in sequence, working from the simplest composition of a house in Delft to the most complicated one,

a view of the city itself. Vermeer took liberties with the dimensions of buildings for aesthetic effect in his *View of Delft*, but it is nonetheless an extraordinary document of the 17th-century appearance of the city and a *tour de force* in the rendition of light and shadow.

Despite his comparative youth, Vermeer had reached great artistic heights by the early 1660s. His colleagues elected him headman of the Guild of St Luke in the autumn of 1662 (a two-year position to which he was re-elected in 1670). He was the youngest artist to be chosen for the post since the guild had been reorganized in 1611, a reflection certainly of the esteem of his fellow artists but also of the fact that by 1662 many other possible candidates had either died or left the city (Montias, 1989).

Vermeer continued to modify his style throughout the 1660s. A level of refinement that had hitherto been lacking was introduced in such works as *Woman with Two Men* (Brunswick, Herzog Anton Ulrich-Mus.), as well as the 'pearl pictures' (a group of paintings of women, usually dated between 1662 and 1665, that share a common motif of pearls and a luminous, silvery tonality), among which are the *Woman with a Water Jug* (New York, Met.), *Woman Reading a Letter* (Amsterdam, Rijksmus.), *Woman with a Pearl Necklace* (Berlin, Gemäldegal.) and the *Woman Holding a Balance* (Washington, DC, N.G.A.). Vermeer no longer relied on pasty modelling with thick impasto, and his use of *pointillés* became less obtrusive. The paint surfaces are smoother, with less tactile detail, and the lighting effects, though at times retaining their brilliance, are generally less bold. Many of these works exude an air of reticence and introspection that has been so highly esteemed in Vermeer's art in the 20th century.

Vermeer's stylistic shift towards greater refinement is best explained as a response to contemporary developments by the Leiden 'fine' painters, particularly the precision and sophistication characteristic of the work of Frans van Mieris (i). Vermeer's famous *Head of a Girl with a Pearl Earring* (*c.* 1665; The Hague, Mauritshuis; see col. pl. XXXIX) also belongs to this period. All the

contours of this small canvas are created with delicately modulated tones of paint in place of outlines. Even the bridge of the young woman's nose is delineated not by line but by a subtle, barely perceptible application of impasto. The edge of the nose is not even distinguishable from the right cheek; the two features simply blend together. The resultant optical effects are stunning, as the girl's features are refined and purified (in a manner far removed from the highly detailed figures painted by van Mieris) to the extent that it is difficult to identify this work as a portrait of a specific person.

During his middle period Vermeer also produced two paintings with deep spatial recessions: the *Music Lesson* (London, Buckingham Pal., Royal Col.) and *The Concert* (ex-Isabella Stewart Gardner Mus., Boston, MA; 1990), which were probably painted slightly later than the 'pearl paintings'—perhaps 1665 or 1666. Although these pictures evolved from the earlier *Glass of Wine* and *Woman with Two Men*, they represent Vermeer's most spatially complex works to date. In both, the figures are placed in the background in an effort to exploit the volumetric qualities of the scene as a whole. The *Music Lesson*, possibly the later of the two, displays a rigorous spatial construction with carefully orchestrated arrangements of light, colours and forms (for instance, the parallel beams of the ceiling and the white, grey and black pattern of the lozenge-shaped floor tiles).

The crowning achievement of Vermeer's middle period is the equally ambitious *Allegory of Painting* (c. 1666–7; Vienna, Ksthist. Mus.; see fig. 59), a work still in the artist's possession at his death. In it, Vermeer harmoniously integrated a variety of exquisitely painted figures and objects within a carefully constructed, light-suffused room. The result is an unsurpassed masterpiece of luminosity and spatial illusion, one that is also characterized by the quintessential detachment and reticence so often associated with Vermeer's art.

3. Late period, c. 1667–75

Various details in the *Allegory of Painting* anticipate the style that characterizes Vermeer's late period. The material lying on the table beside the mask is so unfocused and abstract that it resem-

59. Johannes Vermeer: *Allegory of Painting*, c. 1666–7 (Vienna, Kunsthistorisches Museum)

bles melted wax. The chandelier exhibits similar abstract qualities, its diffuseness enhanced by *pointillés* that, when compared to those in earlier pictures, have been reduced to small, flat rectangular planes. The abstraction evident in these motifs became a dominant feature in Vermeer's late paintings as he tended to focus on patterns of colours on objects at the expense of describing their textures. The increased stylization was not unique to him: such tendencies are seen in the art of many Dutch painters active in the 1670s and after. The long-desired goal of mastering the illusion of reality, which was finally achieved by painters, including Vermeer, who were active between 1650 and 1670, left many artists (particularly those of a younger generation) with few aesthetic alternatives save the introduction of mannered elegance and refinement into their work (Blankert, 1978).

The *Love Letter* (c. 1667; Amsterdam, Rijksmus.) is Vermeer's first painting to display on a wide scale those stylistic features associated with his late style. The mistress and maid are viewed through a

vestibule, an unusual device that was perhaps influenced by the work of the Dordrecht painter Samuel van Hoogstraten (Slatkes, 1981). The architectonic features of the vestibule and back room are sharply linear. Such details as the right door jamb in the vestibule are delineated by single, vertical strokes of light. This geometric purity extends to the figures themselves. Vermeer's earlier interest in the depiction of subtle nuances of light has disappeared in favour of crisp, clear divisions of light and shadow. These cold, refined features are especially strong in paintings executed around 1670-71. The same linear precision is displayed in works such as the *Lady Writing a Letter with her Maid* (Dublin, N.G.). The refinement and abstraction of forms towards geometric ends is complete. The garments of the maid looking out of the window are so sharply defined in terms of light and shadow that they actually resemble the fluting on Classical columns. Even the carpet on the table on which the mistress is writing shares these abstract features: unlike the carpet in the early *Christ in the House of Mary and Martha*, with its broad general planes, and the carpets in such middle period works as the *Glass of Wine*, with their knubby quality, it hangs in a most unnatural, boxlike manner.

The impression of abstraction and purity conveyed in the works produced c. 1670-71 increased in those painted during the artist's last years (1672-5), as in the *Allegory of Faith* (New York, Met.) and the *Guitar Player* (London, Kenwood House). The composition of the *Guitar Player* is unusual, as the artist has placed the girl so far to the left that her arm is partly cut off. The forms are again crisply defined, and the girl's fingers, the head of the guitar and the frame of the picture on the wall in the background are highlighted with the *pointillés* of Vermeer's late period: extremely flat, geometric touches of impasto.

Perhaps there are links between Vermeer's style in these paintings and his circumstances at this time. His last three years were filled with great financial hardship, much of which was caused by the economic crisis that engulfed the Netherlands in the wake of the French invasion of 1672. In 1677 Vermeer's widow—still saddled with formidable debts—testified that during the ruinous war with France the artist could sell none of his paintings nor those by other masters in whose work he dealt. This turmoil undoubtedly affected the production and sale of art everywhere, but in Vermeer's case the problems were clearly exacerbated by his laborious approach to his craft.

II. Working methods and technique

It has been observed that since the Renaissance no artist's fame has rested on so few pictures as has Vermeer's (Slatkes, 1981). He probably did not paint many more works than the 35 that survive; his total output has been estimated at between 43 and 60 paintings (Montias, 1989). Vermeer thus most likely produced on average about two to three paintings per year. The reasons for this are undoubtedly linked to his meticulous working methods. Laboratory analysis has revealed that the artist continually reworked his paintings to clarify compositional, spatial and iconographic relationships, as he did, for example, in the *Girl Asleep at a Table*. At various stages in its genesis, it included a dog in the doorway, a man entering the room, an additional chair or table at the middle right edge and grapes and grape leaves in a bowl on the table in the foreground (Ainsworth and others, 1982). Vermeer also adjusted the shapes of objects within the composition. For instance, in the *Music Lesson* he made the lid of the clavecin wider on the girl's right than on the left in order to reduce the viewer's visual propensity to connect the two halves of the lid through the girl, which, in effect, would have lessened the painting's convincing illusion of reality (Wheelock, 1981). Occasionally changes in Vermeer's paintings can be observed by the naked eye. The faint shadow of one of his lion-headed chair finials can be seen directly to the right of the lower edge of the window in the *Woman with a Water Jug*. As laboratory examination has confirmed, this is a vestige of a chair that Vermeer painted out of the composition (Wheelock, 1984). Similarly, a close inspection of the jug and hands of the servant in *The Milkmaid* reveals a number of pentiments, created as the artist struggled to depict them convincingly.

Vermeer was a fastidious artist who diligently strove to achieve the masterful harmony that is now associated with his paintings. That he achieved such extraordinary states of compositional equilibrium is all the more remarkable given that no preparatory drawings by him survive. In the *Allegory of Painting* the canvas on which the artist is working includes a white chalk outline of the figure of History; perhaps Vermeer worked in the same manner (though no evidence of this has been found).

Vermeer's application of paint was equally painstaking and complex. This is particularly true of the pictures produced during his middle period, in which he gradually abandoned the use of thick impasto in favour of an intricate application of opaque and semi-transparent paints and thin glazes. In the *Woman with a Water Jug* Vermeer applied a light ochre ground to provide a warm base for the overlying colours and to delineate shadows such as those on the right side of the girl's jacket. In the lower right a second ground layer (the imprimatura) of reddish-brown covers the first one; it enhances the reddish glow of the reflections on the brass basin and also serves as the base colour for the tablecloth. The rich pattern of the tablecloth is simply composed of freely but carefully brushed strokes of primary colours and oranges (Wheelock, 1981).

Vermeer's complex technique also accounts for the scumbled appearance of his paintings. For example, in the *Head of a Girl with a Pearl Earring* the contour of the young woman's face is blurred by a fine line of flesh-coloured glaze extended over the dark background (Wheelock, 1981). Vermeer achieved equally impressive visual effects by subtly changing the hues that define objects in relation to the amount of light that strikes them. In the *Music Lesson*, for instance, the inscribed letters on the cover of the clavecin are painted in ochre to the left of its player and in lilac to her right, where there is more shadow. Similar colour changes are seen in the windows at the left as Vermeer captured the play of sunlight and shadow on the glass (Wheelock, 1981).

The scumbled contours and subtle colour modulations of Vermeer's paintings demonstrate his unrivalled expertise in rendering optical effects, as do the objects that appear distorted and out of focus. He could not have seen these distortions with the naked eye, and it is now generally accepted that he observed them through a camera obscura, a device consisting of a darkened chamber with a small opening that receives an image and projects it with a lens, while retaining its natural appearance, on to a facing surface. Renaissance artists had used the camera obscura as an aid in rendering perspective, which probably explains Vermeer's initial interest in it as well. However, the general enthusiasm among Delft artists such as Bramer and Fabritius for optical phenomena may have prompted Vermeer to begin experimenting with the device. The camera obscura has a limited depth of field, and spatial and focal distortions are therefore intrinsic to the image it projects. Moreover, the device reduces the scale of objects but not the amount of colour or light that reflects off them, so colour accents and light contrasts gain in intensity. The difference between Vermeer's use of the camera obscura and that by earlier artists—as well as later ones, among them Canaletto—was that the others always corrected its inherent distortions. Vermeer, by contrast, seemed to revel in them, as he attempted to replicate the optical distortions seen through the apparatus. For instance, in the *Soldier with a Laughing Girl* (c. 1658)—probably Vermeer's first work created with the assistance of the camera obscura—there are discrepancies in scale between the two figures, along with diffuse highlights, particularly around the lion-headed chair finials and the girl's hands. Vermeer also applied *pointillés* to these motifs in order to duplicate the halations that were viewed through the device.

Vermeer frequently employed the camera obscura thereafter, which accounts for such unusual optical phenomena as the collapsed perspective in such paintings as the *View of Delft* or the sensuous halations and focal distortions of the *Girl with a Red Hat*. However, Vermeer's use of the device should not be overemphasized. There is no evidence, for example, that Vermeer either traced or copied his compositions directly from the projected image of the camera obscura. The

enchanting optical effects produced by the apparatus no doubt stimulated his aesthetic interest to such an extent that he often imitated them in his art. Yet simultaneously Vermeer modified these effects to suit his artistic vision, often, surprisingly, exaggerating them. This is especially true of his *pointillés*. Although Vermeer first used *pointillés* to reproduce halations that are commonly seen through the camera obscura, he soon realized their independent aesthetic potential. It is unlikely, for instance, that he observed them on the bread depicted in *The Milkmaid* since the camera obscura will only cause halations on projected objects that reflect light (such as metal or polished wood). In the *View of Delft* Vermeer applied *pointillés* to the shadowy hulls of the boats moored along the Schie in an effort to suggest flickering reflections from the water. Had these boats been viewed through a camera obscura, reflections would not have been detected because they would be visible only in direct sunlight (Wheelock, 1981). It would thus be reductive to consider the *View of Delft*—or, for that matter, any painting by Vermeer—as a simple transcription of the image that the artist had seen through the camera obscura.

Vermeer's laborious working method apparently precluded his training students within a traditional studio setting, although it is possible that he trained one or more of his many children. The *Girl with a Flute* (Washington, DC, N.G.A.), once thought to be by Vermeer, is now ascribed to the artist's immediate circle; it may have been completed by one of his children, since there is no record of any students.

III. Iconography

Like genre paintings by other Dutch artists, those by Vermeer do not reproduce value-free slices of daily life in Delft, for it is now known that Dutch 17th-century art was laden with meaning. Vermeer's art may be stunningly naturalistic and mysteriously solemn, but it is nevertheless symbolic. In other ways, however, he parted company with many of his colleagues' more traditional approaches to symbolism. Attempts to decipher the iconographic complexities of Vermeer's art have often proved elusive. Fortunately, our frustrations are more than adequately compensated for by the solemn beauty and mystery of his creations.

In many instances the rooms in Vermeer's paintings closely resemble one another (cf. the *Glass of Wine* and the *Woman with Two Men*; the *Girl Reading a Letter at an Open Window* and the *Soldier with a Laughing Girl*). This has led to unsuccessful attempts to identify the spaces depicted in the paintings with those that actually existed in his mother-in-law's house (into which Vermeer and his family had probably moved c. 1660; Swillens, 1950). Vermeer also resorted to an impressive array of 'studio props' ranging from paintings (which he reproduced so faithfully that their authorship can often be determined) to costumes, musical instruments, furniture and wall coverings, including maps, which are generally rendered with great fidelity (Welu, 1975). While many of these objects are identifiable (thanks to the artist's death inventory of 1676; van Peer, 1957), he continually varied their appearance along with that of the rooms in which they are depicted. The variations from painting to painting are seemingly inexhaustible: the famous chairs with lion-headed finials are often shown with different upholstery, the patterns of tiles on the floors change, the pictures on the walls vary in scale and have different frames, the placement of windows is altered with respect to the back walls etc. Vermeer's endless adjustments to existing objects and spaces in his work suggest that his paintings, like those of his contemporaries, are best understood as carefully orchestrated constructs of reality, created in the interests of meaning.

Scholars have addressed the question of meaning in Vermeer's art with only limited success, a reflection no doubt of the evocative yet enigmatic nature of his imagery. Vermeer's works are arresting for their general lack of narrative, for their eternalization of seemingly inconsequential moments. On those occasions when there is a motif with an ostensibly unequivocal meaning, the ambiguity of the overall context in which it appears invariably gives rise to

contradictory interpretations. On the wall in the background of *The Concert* is a copy of Dirck van Baburen's *Procuress*, which is generally acknowledged to symbolize venal love. However, while some scholars have concluded that Vermeer represented an elegant brothel in this work (Gowing, 1952; Mirimonde, 1961), others, noting the subtle, understated character of the musical trio in combination with the landscapes elsewhere on the wall and on the lid of the harpsichord, have interpreted it in a more positive light, as a contrast to the group in Baburen's *Procuress* (Moreno, 1982; Goodman-Soellner, 1989).

In some cases, motifs that would have clarified the meaning seem to have been deliberately omitted or painted out. For example, in the *Girl Reading a Letter at an Open Window* Vermeer originally included a large roemer and, more significantly, a picture of Cupid holding up a card on the wall behind the woman (Mayer-Meintschel, 1978–9). If these motifs had remained, the significance of the woman's activity of reading a letter—often associated with love in 17th-century Dutch art—would have been apparent. In its final state, with Vermeer's deliberate removal of these motifs, the painting is mysteriously ambiguous, which undeniably contributes to its appeal.

The imagery of other paintings by Vermeer is far less allusive. The presence of a stained-glass medallion of Temperance within the mullioned window in the *Woman with Two Men* was clearly meant to be interpreted in relation to the potentially intemperate actions of the couple in the room (Klessman in 1978 exh. cat.). Similarly, the pose of the woman in the *Girl Asleep at a Table*, with her hand supporting her head, must be linked with traditional images of sloth (Kahr, 1972). The *Allegory of Painting* was once thought to be a self-portrait of Vermeer, but owing to the archaic costume of the artist, the presence of Clio (the muse of history) and such motifs as the masks on the table, it is now universally understood as an allegory of painting. In creating this picture, Vermeer, an artist with a respectable library, probably had recourse to the most famous iconographic handbook of the day, Cesare Ripa's *Iconologia*, available in a Dutch translation of 1644. This same book

informs the ambitious *Allegory of Faith*, a painting probably commissioned by a wealthy Catholic patron (de Jongh, 1975–6). Its complex symbolism, explicating the mysteries of the Roman Catholic faith, was already recognized when it was auctioned at the end of the 17th century. The *Woman Holding a Balance* is ostensibly a genre scene, but it has also been convincingly interpreted as an allegory of truth (Gaskell, 1984).

IV. CRITICAL RECEPTION AND POSTHUMOUS REPUTATION

Despite the mastery of Vermeer's art, it did not exert a lasting impact on other artists. Vermeer had no recorded pupils, and there are only isolated examples of his influence on other artists, such as Emanuel de Witte (Slatkes, 1981), Jan Steen, Pieter de Hooch and Gabriel Metsu. Yet he was a well-respected member of the Delft artistic community and enjoyed the patronage of contemporary collectors, particularly those in his native town. This must have assured him, at least to some extent, of a regular income. Vermeer's principal patron, a man who possibly had first right of refusal over his paintings, was a wealthy Delft citizen, Pieter Claesz. van Ruijven (*bapt* 10 Dec 1624; *bur* 7 Aug 1674). Van Ruijven loaned Vermeer and his wife 200 guilders in 1657. According to Montias (1987), who has written extensively on Vermeer's possible patrons, this loan may have been an advance towards the purchase of one or more paintings. Vermeer possibly had more than a professional association with van Ruijven and his wife, Maria de Knuijt (*bur* 26 Feb 1681). In her section of the couple's last will and testament (1665), Maria de Knuijt instructed that 500 guilders be left to the painter, the only non-family member to be singled out for a special bequest. This is apparently a rare, if not unique, example of a 17th-century Dutch patron bequeathing money to an artist (Montias, 1987). The bulk of the van Ruijven estate—including the couple's collection of paintings—was inherited by their only surviving child, Magdelena (*bapt* 12 Oct 1655; *bur* 16 June 1682). Several months before the death of her mother,

Magdelena had married Jacob Abrahamsz. Dissius (*bapt* 23 Nov 1653; *bur* 14 Oct 1695), who became the heir of the estate when Magdelena died childless in June 1682 (Montias 1987). In May 1696, seven months after Dissius's own death, his art collection, including 21 paintings by Vermeer, was auctioned. This sale is well documented, which led to the earlier, erroneous assumption that Dissius had been a patron of Vermeer. Despite the reasonably steady income that Vermeer could depend on from van Ruijven, this arrangement was also injurious. The fact that a significant proportion of Vermeer's works remained in the family collection until 22 years after van Ruijven's death probably limited the spread of the artist's reputation beyond his native city.

Hendrick van Buyten (*b* 1632; *d* July 1701) was another Delft citizen who owned a number of paintings by Vermeer. He was a baker by trade, though he accrued substantial wealth through a large inheritance (Montias, 1987). An inventory of his possessions, drawn up on the occasion of his second marriage in 1683, includes three paintings by Vermeer. Two of these paintings were acquired after Vermeer's death from his widow as collateral for a huge debt owed for bread. The other painting was already in van Buyten's possession by 1663, as is known from remarks made by the Frenchman Balthazar de Monconys in his diary (published in 1666). De Monconys visited Delft on 11 August 1663 in the company of a Catholic priest and a layman. The three men visited Vermeer's studio, but since there were no paintings to be seen—the artist was probably working on commission by this time—they were sent to the shop of a baker who owned one. This baker, undoubtedly Hendrick van Buyten, showed them his painting of a single figure by Vermeer, boasting that 600 livres (probably 600 guilders) had been paid for it. Van Buyten's quotation of such an exorbitant price might be construed as a feeble attempt to impress a well-to-do foreigner; de Monconys himself commented that he considered the painting overpaid for if it had been bought for 'six pistoles' (60 guilders).

Paintings by the artist also appear in collections in other Dutch cities. A 'face by Vermeer' was listed in the death inventory (4 Aug 1664) of the sculptor Jean Larson (*d* 1664), who lived in The Hague. A wealthy Amsterdam banking official named Hendrick van Swoll (1632–98) also owned a painting by Vermeer, which was auctioned in April 1699, along with other works in his collection. In the auction catalogue it is described as 'a seated woman with several meanings, representing the New Testament'. This painting, which fetched the high price of 400 guilders, can be identified as the *Allegory of Faith*. Outside the Dutch Republic, the Antwerp jeweller and banker Diego Duarte owned a large collection of paintings that included a work by Vermeer. In an inventory of July 1682, the picture was valued at 150 guilders and described as 'a piece with a lady playing the clavecin with accessories . . .'.

Despite Vermeer's connections with van Ruijven and the fact that his paintings appear in the inventories of collectors in Amsterdam, Antwerp and The Hague, references to Vermeer in the art literature of his day are scarce. He is mentioned twice in Dirck van Bleyswijck's *Beschryvinge der stadt Delft* (1667), once in van Bleyswijck's list of painters still working in Delft and then briefly in the poem by Arnold Bon (*see* §I above). That these references are cursory should not be construed negatively, since authors of Dutch city descriptions were traditionally most verbose about deceased artists or ones who no longer resided in the city in question. Van Bleyswijck's succinct reference to Vermeer is quoted verbatim in the first volume of Arnold Houbraken's *Groote schouburgh der Nederlantsche konstschilders en schilderessen* (1718). This extremely short entry might seem surprising, but Houbraken was only well informed about artists who had been active in his native Dordrecht or in his adopted city, Amsterdam. His dependence on van Bleyswijck as a source for information about Vermeer and other Delft artists merely testifies to his unfamiliarity with the artistic scene in that city.

Vermeer's works were not entirely forgotten in the 18th century, even if his name sometimes was. The major reason for the artist's partial fall into obscurity was the rather limited size of his oeuvre.

Before the invention of photography, the degree of recognition of works by a particular artist often hinged on the quantity produced. Large numbers of paintings guaranteed familiarity, since these would appear with some frequency in private collections and at auctions. Thus such artists as Nicolaes Berchem and Philips Wouwerman enjoyed great prestige among 18th-century and early 19th-century connoisseurs, while the names of Vermeer and others with comparatively small outputs were often forgotten. It is not surprising, then, that paintings now known to be by Vermeer were earlier occasionally attributed to other, more widely known artists such as Rembrandt and Pieter de Hooch. Yet Vermeer's name did not entirely sink into oblivion: there is a reference to him in the *Mercure de France* of June 1727 by the connoisseur Dezallier d'Argenville, who advised aspiring collectors to include paintings by 'Vanderméer' in their collections (Wheelock, 1977). Further evidence of the high esteem in which the artist's paintings were held is provided by enthusiastic descriptions found in certain 18th-century auction catalogues (Blankert, 1978). Moreover, confusion over attributions worked both ways: paintings by Vermeer were misattributed, but his name was sometimes erroneously attached to the works of other artists.

The first engravings after paintings by Vermeer were produced towards the end of the 18th century. With the onset of the 19th century his reputation gradually rose. In van der Eynden and van der Willigen's *Geschiedenis der vaderlandsche schilderkunst* (1816) he is called 'the Titian of the modern painters of the Dutch school, for his strong colours and fluent brush technique' (Blankert, 1978). National admiration for Vermeer's art in the Netherlands in the early years of the 19th century culminated in 1822 with the purchase of the *View of Delft* by the Mauritshuis, the newly opened State Museum in The Hague, for the then exorbitant sum of 2900 guilders.

The revolutionary social and political developments that took place in Europe during the 1830s and 1840s led to renewed appreciation of many Dutch artists. The rise of the Realist school of painting in France coincided in particular with a growing interest in the works of 17th-century Dutch painters, whose views of daily life were mistakenly considered precedents for the socially and politically informed paintings of such realists as Gustave Courbet. Vermeer himself was rediscovered during the formative stages of the Impressionist movement, when followers of Courbet began to depict scenes of contemporary life with great sensational immediacy (Meltzoff, 1942). Naturally, Vermeer's art—with its bold display of tactile reality, its extraordinary optical fidelity and its eternalization of seemingly inconsequential moments—appealed greatly to these artists. Perhaps equally significant, Vermeer's art gained recognition at approximately the same time that photography was invented.

The first scientific analyses of Vermeer's art were published by Théophile Thoré (under the pseudonym Willem Bürger) in a number of books and journals in the late 1850s and 1860s, culminating with his lengthy study in 1866. Thoré's appreciation of Vermeer's art was indelibly linked to his political views; a radical republican, he had been exiled after the failed coup of May 1848. During his 13-year exile he travelled extensively in Switzerland, England, Belgium and the Netherlands, studying collections first-hand and refining his skills as an art critic and connoisseur. To Thoré, Vermeer's work embodied the purest expression of what he believed to be art's supreme purpose: to portray and ennoble the daily life of common man. Thoré's socio-political view of Vermeer and Dutch art in general is now seen as anachronistic. Yet despite this and many other shortcomings in his studies—most notably his erroneous attribution of some 40 paintings to Vermeer (*see* Vrel, Jacobus)—its impact was enormous. Studies by Henry Havard (1888), Cornelis Hofstede de Groot (1907) and Eduard Plietzsch (1911) followed in the wake of Thoré's as Vermeer rapidly acquired a reputation as one of the greatest Dutch artists of the 17th century. During the years in which these publications appeared, several wealthy American businessmen and socialites acquired the few remaining paintings by Vermeer available on the art market; their munificence accounts for the impressive number of

works by the artist now in public collections in Boston, New York and Washington, DC.

Perhaps the most fantastic ramification of the veritable explosion of interest in Vermeer's art was the case of the forger Han van Meegeren. Van Meegeren produced a number of forgeries of paintings by Vermeer and other 17th-century Dutch artists. One of these, the *Supper at Emmaus*, was purchased in 1937 by the Boymans Museum in Rotterdam for the enormous sum of 550,000 guilders. The attribution to Vermeer of this and other paintings produced by van Meegeren was not seriously doubted until 1945, when the forger, in order to exonerate himself from charges that he sold Dutch national treasures to the Nazis, claimed that he had painted the *Supper at Emmaus*. Subsequent scientific examination of the canvas, together with van Meegeren's demonstration to the court of his complicated method of creating convincing forgeries, proved that his claims were truthful. The *Supper at Emmaus*, with its distinct resemblance to the art of Caravaggio, was cleverly calculated to appeal to scholars who were desperately searching for early works by Vermeer. Clearly, the overwhelming enthusiasm for Vermeer's art at that time, which had completely outpaced cautious scholarship, had prejudiced the otherwise sound critical faculties of many noteworthy art historians. This is the only way to explain how forgeries that to the modern eye have such glaring weaknesses could have ever been considered authentic.

Scholarly interest in the art of Vermeer continued in the post-World War II era. Studies such as those by Gowing (1952), Blankert (1978, rev. in Blankert, Montias and Aillaud, 1986), Wheelock (1981), Slatkes (1981) and Montias (1989) have been characterized by an increasingly refined critical approach to his oeuvre.

Bibliography

general

EWA

H. Havard: *L'Art et les artistes hollandais*, 4 vols (Paris, 1879–81)

——: *Van der Meer de Delft* (Paris, 1888)

C. Hofstede de Groot: *Holländischen Maler*, i (1907)

A. K. Wheelock: *Perspective, Optics and Delft Artists around 1650* (New York, 1977)

Die Sprache der Bilder: Realität und Bedeutung in der niederländischen Malerei des 17. Jahrhunderts (exh. cat., ed. R. Klessman; Brunswick, Herzog Anton Ulrich-Mus., 1978)

Gods, Saints and Heroes: Dutch Painting in the Age of Rembrandt (exh. cat. by Albert Blankert and others, Washington, DC, N.G.A.; Detroit, MI, Inst. A.; Amsterdam, Rijksmus.; 1980–81)

M. W. Ainsworth and others: *Art and Autoradiography: Insights into the Genesis of Paintings by Rembrandt, Van Dyck and Vermeer* (New York, 1982)

J. M. Montias: *Artists and Artisans in Delft: A Socio-economic Study of the Seventeenth Century* (Princeton, 1982)

monographs

W. Bürger [E. J. T. Thoré]: *Van der Meer de Delft* (Paris, 1866)

E. Plietzsch: *Vermeer van Delft* (Leipzig, 1911)

P. T. A. Swillens: *Johannes Vermeer: Painter of Delft, 1632–1675* (Utrecht, 1950)

L. Gowing: *Vermeer* (London, 1952; New York, 1970)

A. Blankert: *Vermeer of Delft* (Oxford, 1978)

L. J. Slatkes: *Vermeer and his Contemporaries* (New York, 1981)

A. K. Wheelock: *Jan Vermeer* (New York, 1981)

A. Blankert, J. M. Montias and G. Aillaud: *Vermeer* (Paris, 1986; Eng. trans., 1988)

J. M. Montias: *Vermeer and his Milieu: A Web of Social History* (Princeton, 1989)

D. Arasse: *Vermeer: Faith in Painting* (Princeton, 1994)

specialist studies

S. Meltzoff: 'The Rediscovery of Vermeer', *Marsyas*, ii (1942), pp. 145–66

A. J. J. M. van Peer: 'Drie collecties schilderijen van Vermeer', *Oud-Holland*, lxxii (1957), pp. 92–103

A. P. de Mirimonde: 'Les Sujets musicaux chez Vermeer de Delft', *Gaz. B.-A.*, n. s. 6, lvii (1961), pp. 29–50

C. Seymour: 'Dark Chamber and Light-filled Room: Vermeer and the Camera Obscura', *A. Bull.*, xlvi (1964), pp. 323–31

A. J. J. M. van Peer: 'Jan Vermeer van Delft: Drie archiefvonsten', *Oud-Holland*, lxxxiii (1968), pp. 220–24

D. A. Fink: 'Vermeer's Use of the Camera Obscura: A Comparative Study', *A. Bull.*, liii (1971), pp. 493–505

M. Kahr: 'Vermeer's *Girl Asleep*: A Moral Emblem', *Met. Mus. J.*, vi (1972), pp. 115–32

J. Welu: 'Vermeer: His Cartographic Sources', *A. Bull.*, lvii (1975), pp. 529–47

E. de Jongh: 'Pearls of Virtue and Pearls of Vice', *Simiolus*, viii (1975–6), pp. 69–97

J. M. Montias: 'New Documents on Vermeer and his Family', *Oud-Holland*, xci (1977), pp. 267–87

A. Mayer-Meintschel: 'Die *Briefleserin* von Jan Vermeer van Delft: Zum Inhalt und zur Geschichte des Bildes', *Jb. Staatl. Kstsamml. Dresden*, xi (1978–9), pp. 91–9

J. M. Montias: 'Vermeer and his Milieu: Conclusion of an Archival Study', *Oud-Holland*, xciv (1980), pp. 44–62

I. L. Moreno: 'Vermeer's *The Concert*: A Study in Harmony and Contrasts', *Rutgers A. Rev.*, iii (1982), pp. 51–7

A. K. Wheelock and C. J. Kaldenbach: 'Vermeer's *View of Delft* and his Vision of Reality', *Artibus & Hist.*, iii (1982), pp. 9–35

I. Gaskell: 'Vermeer, Judgement and Truth', *Burl. Mag.*, cxxvi (1984), pp. 557–61

A. K. Wheelock: 'Pentimenti in Vermeer's Paintings: Changes in Style and Meaning', *Holländische Genremalerei im 17. Jahrhundert: Symposium, Berlin, 1984*, pp. 385–412

——: '*St Praxedis*: New Light on the Early Career of Vermeer', *Artibus & Hist.*, vii (1986), pp. 71–89

J. M. Montias: 'Vermeer's Clients and Patrons', *A. Bull.*, lxix (1987), pp. 68–76

E. Goodman-Soellner: 'The Landscape on the Wall in Vermeer', *Ksthist. Tidskr.*, lviii (1989), pp. 76–88

P. O. Elousson: 'The Geographer's Heart: A Study of Vermeer's Scientists', *Ksthist. Tidskr.*, lx (1991), pp. 17–25

G. J. M. Webber: 'Johannes Vermeer, Pieter Jansz. van Asch und das Problem der Abbildungstreue', *Oud-Holland*, cviii (1994), pp. 98–106

Johannes Vermeer (exh. cat by A. K. Wheelock and B.J.B. Broos, Washington, DC, N.G.A.; The Hague, Mauritshuis; 1995–6)

WAYNE FRANITS

Verspronck, Jan [Johannes] (Cornelisz.)

(*b* Haarlem, ?1606–9; *d* Haarlem, *bur* 30 June 1662). Dutch painter. He was the son of the Haarlem painter Cornelis Engelsz. (*c.* 1575–1650) and was born not in 1597, as was formerly believed, but about ten years later. He was probably apprenticed to his father and possibly also for a period to Frans Hals. In 1632 he joined the Guild of St Luke in Haarlem, where he continued to paint until his death.

Of the approximately 100 works by him to have survived, most are portraits, with the exception of a few genre paintings, such as *Guardroom with Officer and Soldiers* (*c.* 1640; Jerusalem, Israel Mus.), and a *Still-life with Loaf, Fish and Onions* (*c.* 1640; the Netherlands, priv. col., see Ekkart, 1979, no. 27), his only known still-life. His earliest known portraits date from 1634 and are closely related in composition and in the poses of his subjects to works by Hals, but the brushwork is less free and the portrayal of the sitters more static. Verspronck's style developed only slightly over a period of about 25 years. At the beginning of his career he evolved for his portraits a number of standard compositional forms, which he continued to use for many years with only slight variations. The only development in the early works is in the background of his portraits, which became an important element for displaying the effects of light and dark; there is usually a light area close to the right side of the figure, which gradually darkens across the picture. Among the best examples from his early work are the pendant portraits of *Anthonie Charles de Liedekerke* and *Willemina van Braekel* (both 1637; Haarlem, Frans Halsmus.).

The most productive period for Verspronck was between 1640 and 1643, when he painted the group portraits of the *Governesses of the St Elisabeth Hospital* (1641; Haarlem, Frans Halsmus.) and of the *Governesses of the Orphanage* (1642; Haarlem, Frans Halsmus.) and more than 20 individual portraits, including his best-known painting, *Girl in Blue* (1641; Amsterdam, Rijksmus.). Most of these are either head-and-shoulder or half-length portraits, but there are also some impressive three-quarter-length pieces, such as *Portrait of a Man* (1641; Louisville, KY, Speed A. Mus.) and its pendant *Portrait of a Woman* (1642; priv. col., see Ekkart, 1979, nos 38 and 41).

The portraits painted between 1644 and 1650, of which several examples can usually be dated in each year, do not differ greatly in composition from the early ones. From *c.* 1650, however, Verspronck usually portrayed his models seated. Among the best examples from this later period are the portraits of *Eduard Wallis* and his wife *Maria van Strijp* (both 1652; priv. col., on loan to

Amsterdam, Rijksmus.). In some other works after 1650 he used a broader style of painting. In his final years he appears to have painted very little.

Verspronck was an isolated figure in the art circles of 17th-century Haarlem and must have led a withdrawn existence. He was a bachelor and initially lived with his parents, later moving into a residence of his own, with one brother and an unmarried sister. Through his painting he attained some affluence. His patrons, as far as can be identified from his portraits, were Haarlem citizens or people closely connected with the town, suggesting that he worked exclusively in that area. Among his models are representatives of the ruling Calvinist patriarchy but also members of the many well-to-do Catholic families of Haarlem. Verspronck himself was probably a Catholic. His significance lies in the original way in which he took the compositions of Hals as a starting-point and developed a personal, sober and quiet style of portrait painting, combining a fairly meticulous technique with a subdued range of colours, mainly white, black, grey and brown. No pupils are known.

Bibliography

R. E. O. Ekkart: *Johannes Cornelisz. Verspronck: Leven en werken van een Haarlems portretschilder uit de 17-de eeuw* (Haarlem, 1979) [incl. cat. rais. and illus. of all works; with Eng. summary]

——: 'Johannes Verspronck: Een Haarlemse portretschilder uit de zeventiende eeuw', *Antiek*, xiv (1979–80), pp. 105–16

RUDOLF E. O. EKKART

Victors [Victoors], Jan

(*b* Amsterdam, *bapt* 13 June 1619; *d* East Indies [now Indonesia], after Jan 1676). Dutch painter. He was half-brother to the bird painter Jacobus Victors (?1640–1705) and the noted Delft potter Victor Victors (*b* 1638). About 150 oil paintings by Jan Victors, comprising portraits, genre scenes and historical subjects on both canvas and panel, have been catalogued. No signed or securely attributable drawing by him is known. Although his training is undocumented, Victors has long been

considered a member of the school of Rembrandt in Amsterdam. His paintings of 1640–70 show many formal and thematic interrelationships with Rembrandt and his documented pupils of the 1630s: Govaert Flinck, Ferdinand Bol and Gerbrandt van den Eeckhout. Certain archaisms of Victors's style—his peculiarly ponderous figure types, marked linearity, emphatic gestures and generally cluttered compositions—show the direct influence of Pieter Lastman and Claes Moeyaert. His interest in the art of manual rhetoric and the theatre is shown by the arrested histrionics of his figures and their exotic costumes and accessories.

During his early years (1640–45) Victors established a firmly controlled manner of figure painting in his portraits and historical scenes. Such works as the *Young Woman at an Open Window* (1640; Paris, Louvre) and the *Capture of Samson* (Brunswick, Herzog Anton Ulrich-Mus.) show a linear definition of form, sturdy three-dimensional figures and strong Baroque lighting. However, Victors's middle years were his most productive, and from 1646 to 1655 he produced his most accomplished works. His light-filled compositions became increasingly vibrant and frequently included more subsidiary figures, animated gestures, agitated drapery and atmospheric effects, for example in the monumental *Jacob Seeking the Forgiveness of Esau* (1652; Indianapolis, IN, Mus. A.). From 1646 Victors expanded his thematic repertory to include genre subjects depicting a variety of rustic types and provincial activities. Affinities with the genre production of Jan Miense Molenaer, Govaert Camphuyzen and Hendrick Sorgh are apparent in such works as *The Dentist* (1654; Amsterdam, Hist. Mus.), *Scene outside a Dutch Farm* (1650; Copenhagen, Stat. Mus. Kst) and the *Greengrocer at the Sign of 'de Buyskool'* (1654; Amsterdam, Rijksmus.).

After the mid-1650s Victors became less prolific, eventually abandoning painting to become a *ziekentrooster* ('comforter of the sick') in the service of the Dutch East India Company. His late work is generally less polished. The *Portrait of a Family in Oriental Dress* (1670; sold London, Sotheby's, 14 Dec 1977, lot 111), Victors's last dated

work, shows a marked tendency towards stylization and harshness. Figure proportions are more elongated (though not more attenuated), modelling is darker and more opaque, colours more garish and the definition of space less logical, in keeping with the contemporary Dutch vogue for mannered aesthetics and schematization.

Victors is last documented in Amsterdam in January 1676. Shortly thereafter he departed for the East Indies and is reported to have died there of unspecified causes. A son, Victor Victors (*b* 16 Sept 1653), had travelled to the East and was recorded in Australia in 1696–7 as a *zieken-trooster*, draughtsman and cartographer with the Dutch East India Company.

Bibliography

Bénézit; Thieme–Becker; Wurzbach

F. D. O. Obreen: *Archief voor Nederlandsche kunst-geschiedenis*, 7 vols (Rotterdam, 1877–90/ *R* Utrecht, 1971), ii, pp. 282–3

A. D. de Vries: 'Biografische aanteekeningen', *Oud-Holland*, iv (1886), pp. 217–24

A. Bredius: *Künstler-inventare*, VI/ii (The Hague, 1916), pp. 596–600; XIII/vii (The Hague, 1921), pp. 255–6

H. Gerson: 'Jan Victors', *Ksthist. Meded.*, iii (1948), pp. 19–22

M. Haraszti-Takács: 'Les Tableaux de Jan Victors dans les collections de Budapest', *Bull. Mus. Hong. B.-A.*, xx (1962), pp. 61–70

E. Zafran: 'Jan Victors and the Bible', *Israel Mus. News*, xii (1977), pp. 92–118

D. Miller: 'Jan Victors: An Old Testament Subject in the Indianapolis Museum of Art', *Perceptions*, ii (1982), pp. 23–9

—: *Jan Victors (1619–76)* (diss., Newark, U. DE, 1985)

—: '*Ruth and Naomi* of 1653: An Unpublished Painting by Jan Victors', *Mercury*, ii (1985), pp. 19–28

V. Manuth: *Ikonografische Studien zu den Historien des Alten Testaments drei Rembrandt und seiner frühen Amsterdamer Schule* (diss., Berlin, Freie U., 1987)

W. Sumowski: *Gemälde der Rembrandt-Schüler*, iv (Landau, 1989), pp. 2589–2722

—: *Drawings of the Rembrandt School*, x (New York, 1990)

D. Miller: 'The World of Calvin in the Art of Jan Victors', *Ksthist. Tidskr.*, lxi/3 (1992), pp. 99–105

DEBRA MILLER

Vinckboons [Vingboons].

Dutch family of artists of Flemish origin. Philip Vinckboons (*d* 1601) painted watercolours on canvas (*waterschilderijen*)—an art form practised mainly in Mechelen, which he taught to his son David Vinckboons, later active as a painter, draughtsman and printmaker. The Vinckboons household moved to Antwerp *c.* 1580. The religious wars in the southern Netherlands probably occasioned their subsequent move to Middelburg *c.* 1586 and finally to Amsterdam, where Philip was registered as a citizen in 1591. Five of David's sons were artists, the most important being Philips Vingboons, an architect renowned for his work in and around Amsterdam, where he built houses for affluent merchants and members of the patrician class. Johannes Vingboons (1616/17–1670) was a mapmaker and engraver who worked with his brother Philips on the two volumes illustrating Philips's architectural designs. Justus Vingboons (1620/21–1698) was also an architect, whose outstanding work was the monumental double house (1660–62) in Amsterdam for the brothers Louys and Hendrick Trip, a magnificent example of Dutch Classicism in the style of Jacob van Campen.

(1) David Vinckboons

(*b* Mechelen, 1576; *d* Amsterdam, before 12 Jan 1633). Painter, draughtsman and printmaker. He does not appear to have had any teacher other than his father. Although the influence of Gillis van Coninxloo III (who lived in Amsterdam from 1595) is unmistakable in his work, van Mander mentioned nothing about a definite period as a pupil. In 1602 David Vinckboons married Agneta van Loon, daughter of a notary from Leeuwarden; they had ten children. In 1611 David bought a house on the Antoniebreestraat in Amsterdam. His widow, who appeared before the Amsterdam orphanage committee on 12 January 1633, and some of his children continued to live there after his death.

1. Paintings

David Vinckboons's paintings comprise landscapes, often with many small figures, peasant

scenes, courtly companies, biblical scenes with numerous small figures and a few history pieces with large figures. The earliest dated work is from 1602, the latest from 1629. In his early wooded landscapes (e.g. *Wood with Hunting Scene*, 1602; ex-E. Perman priv. col., Stockholm, see Gossens, 1954, p. 21), Vinckboons was completely inspired by van Coninxloo's example. In a large panel such as the *Flemish Kermis* (1610; Brussels, Mus. A. Anc.) the high horizon and accumulation of architectural elements also recall the work of Pieter Bruegel the elder and Hans Bol. Similarly unimaginable without Bruegel's example are Vinckboons's fantastic landscapes with meadows, peopled by innumerable tiny figures and representing a biblical episode (e.g. the *Large Crucifixion*, 1611; Munich, Alte. Pin.). He also continued Bruegel's tradition of peasant scenes (e.g. the *Jew's Harp Seller*, 1614; Brussels, Mus. A. Anc.). Such paintings form an important link between the work of Bruegel and that of such Dutch artists as Adriaen and Isaack van Ostade. Vinckboons made an entirely personal contribution to the peasant genre with his series entitled *Peasant Sorrows* (various series are known, not only as paintings and drawings but also as prints). These portray the tense relationship between the local people and the Spanish soldiers during the Revolt of the Netherlands, particularly in the period preceding the Twelve-Year Truce (1609–21). Such scenes were probably regarded as counterparts to the many pamphlets that appeared concerning the forthcoming Truce. Of greater significance for the development of Dutch painting in the first decades of the 17th century, however, are Vinckboons's paintings of fashionably attired groups entertaining themselves with food, drink and flirtation in country-house landscapes (e.g. *The Party in the Country*; Vienna, Akad. Bild. Kst.; see fig. 60). Country-house parties by Willem Buytewech, Esaias van de Velde and Dirck Hals were directly influenced by Vinckboons's models. Some large figural history-pieces occupy a separate place in Vinckboons's oeuvre that is difficult to define (e.g. *Hercules, Nessus and Deianeira*, 1612; Vienna, Ksthist. Mus.).

60. David Vinckboons: *The Party in the Country* (Vienna, Akademie der Bildenden Künste)

2. Drawings and prints

Vinckboons's drawings are more numerous than his paintings. Wegner and Pée catalogued 83 autograph drawings, and the total number is now estimated at *c.* 90. There must originally have been many more, given the many engravings after lost designs by Vinckboons. Nearly all the drawings are executed in pen and brown ink with a wash of grey, brown and sometimes yellow, green and blue. An exception is the *Jew's Harp Seller* (*c.* 1608; Amsterdam, Rijksmus.), an earlier version of the painted composition; it is drawn in pen and ink only, in a style that imitates an engraving. Vinckboons's earliest dated drawing is a large *Landscape with the Healing of the Blind* (1601; Amsterdam, Rijksmus.), which belongs to a group of six landscapes with biblical subjects, all engraved by Johannes van Londerseel. The *Large Kermis* (1602; Copenhagen, Stat. Mus. Kst, engraved by Nicolaes de Bruyn and later by Boetius Bolswert) and the *Party in a Park* (*c.* 1602–4; USA, priv. col.; engraved by de Bruyn) are among the most spectacular of the young Vinckboons's drawings. One subject to which he repeatedly turned in his drawings is that of the *Birdsnester* (e.g. *c.* 1604–6, Amsterdam, Rijksmus.; *c.* 1606–7, Brussels, Bib. Royale Albert 1er; *c.* 1607–8, Stuttgart, Staatsgal.), derived from Pieter Bruegel's model. Vinckboons also supplied drawings for print series, such as the four drawings of the *Story of the Prodigal Son* (London, BM; engraved by Claes Jansz. Visscher I, 1608) and the twelve *Hunting Scenes* (Berlin, Kupferstichkab.; engraved by Pieter Serwouters (1586–1657) and Visscher in 1612). Vinckboons also executed designs for decorations on a number of maps, including those for world maps by Willem Jansz. Blaeu (1605), Petrus Planicus (1607) and Jodocus Hondius I (*c.* 1611). Vinckboons designed many book illustrations although none of the drawings survives; there are prints after his drawings in such works as Daniel Hensius's *Nederduytsche poemata* (1616), J. van Heemskerck's *Ovidius' minne-kunst, gepast op d' Amsterdamsc[h]e vrijagien met noch andere minne-dichten ende mengel-dichten* (1622) and G. A. Bredero's *Boertigh, Amoreus, en aendachtig*

grood lied-boeck ('Amorous, humorous and religious songbook'; 1622).

Vinckboons also designed one of the stained-glass windows in Amsterdam's Zuiderkerk (removed before 1658), for which the drawing of *Moses and the Burning Bush*, possibly dating from *c.* 1609, survives (Amsterdam, Rijksmus.). Two drawings assumed to be designs for wall hangings are the *Continence of Scipio* (Windsor Castle, Berks, Royal Lib.) and *Quintus Fabius Cunctator Meeting his Son on Foot* (*c.* 1609–10; left half, New York, Pierpont Morgan Lib., right half, Amsterdam, Rijksmus.). After *c.* 1610 Vinckboons's drawing style became looser, the design less rigid and the characterization more spirited. Far fewer works are preserved from the years after 1610; the *Triumph of Frederick Henry* (*c.* 1629; New York, Met.; print by an unknown engraver) is typical of his later style. No Dutch artist of the early 17th century had as many drawings made into prints as David Vinckboons. Apart from the artists already named, Simon Frisius, Hessel Gerritsz. (1581–1632), Jacob Matham, Salomon Savery (1594–1665) and Jan van de Velde II engraved after his designs. Vinckboons executed a few prints himself, only three of which are known: the *Annunciation to the Shepherds* (drawing, 1604; Amsterdam, Rijksmus.), a *Beggar Woman with Two Children* (1604) and the *Bagpipe-player with a Child under a Tree* (1606).

Bibliography

Hollstein: *Dut. & Flem.*; Thieme–Becker
K. van Mander: *Schilder-boeck* ([1603]–1604), fols 299r–v
I. H. van Eeghen: 'De familie Vinckboons–Vingboons', *Oud-Holland*, lxvii (1952), pp. 217–32
K. Gossens: *David Vinckboons* (Antwerp and The Hague, 1954/R Soest, 1977)
——: 'Nog meer over David Vinckboons', *Jb.: Kon. Mus. S. Kst.* (1966), pp. 59–106
W. Wegner and H. Pée: 'Die Zeichnungen des David Vinckboons', *Münch. Jb. Bild. Kst.*, n. s. 2, xxxi (1980), pp. 35–128
Printmaking in the Age of Rembrandt (exh. cat. by C. S. Ackley, Boston, MA, Mus. F.A.; St Louis, MO, A. Mus.; 1980–81), pp. 39–41
The Age of Bruegel: Netherlandish Drawings in the Sixteenth Century (exh. cat. by J. O. Hand and others,

Washington, DC, N.G.A.; New York, Pierpont Morgan Lib.; 1986-7), pp. 298-302

M. Schapelhouman: *Netherlandish Drawings circa 1600 in the Rijksmuseum* (The Hague, 1987), pp. 152-71

S. K. Bennett: 'Drawings by David Vinckboons as Models for Ornamenting Bible Maps', *Hoogsteder-Naumann Mercury*, x (1989), pp. 15-25

J. F. Heijbroek and M. Schapelhouman, eds: *Kunst in kaart: Decoratieve aspecten van de cartografie* (Utrecht, 1989), pp. 65 70

J. E. Huisken and F. Lammertse, eds: *Het kunstbedrijf van de familie Vingboons* (Maarssen, 1989)

S. K. Bennett: *Art on Netherlandish Maps, 1585-1685: Themes and Sources* (diss., Baltimore, MD, Johns Hopkins U., 1990), pp. 192-211

<div align="right">MARIJN SCHAPELHOUMAN</div>

Visscher, Claes Jansz.

(*b* Amsterdam, 1587; *d* Amsterdam, 19 June 1652). Dutch draughtsman, printmaker and publisher. His father was a ship's carpenter. Visscher's master is unknown, although Constantijn Huygens the elder suggested that Jacques de Gheyn the younger taught him to etch. Visscher is recorded as an engraver in Amsterdam in 1608, and his early engravings, from 1605 onwards, consist entirely of reproductive prints after the designs of Flemish artists, in particular David Vinckboons, who settled in Amsterdam in 1602. In the second decade of the 17th century Visscher etched and published landscapes of a strong local character, of both real and imaginary views, to the designs of young Dutch draughtsmen such as Jan and Esaias van de Velde (i) and Willem Buytewech. These proved extremely popular and formed the basis of Visscher's early success as a publisher. He became the most important Amsterdam print publisher, specializing in portraits, landscapes and maps, the elaborate borders of which were often to his own designs. He himself etched more than 200 plates.

Visscher's unquestioned importance as a publisher of prints and maps has tended to overshadow his contribution as a draughtsman to the early development of landscape in the Netherlands. Few of his drawings are dated, but etchings after some of them made by Visscher and published by him *c.* 1611-12 in a series known as *Pleasant Places around Haarlem* show how advanced a draughtsman he was by this date. A number of these sheets, almost certainly drawn from life, are on similar paper, are of similar size and may have come from a single sketchbook. Several are dated 1607 or 1608, some years before the earliest works of the van de Veldes or Willem Buytewech, thus putting Visscher at the forefront of the development of Dutch landscape art.

Visscher's earliest drawings, such as the *View of the Bergevaerderscamer* (1608; Amsterdam, Gemeente Archf) and the *View of Houtewael* (*c.* 1608; Newton, MA, Maida and George Abrams priv. col., see 1991-2 exh. cat., no. 22), are simply executed in pen and brown ink over black chalk. Slightly later sheets, such as the *Study of a Farm* and the *View of a Village*, both of similar dimensions (both *c.* 1610; Paris, Fond. Custodia, Inst. Néer), incorporate brown wash. In handling, they are clearly influenced by David Vinckboons, particularly in the use of wash, by Jacques de Gheyn and by the landscape drawings of the Haarlem Mannerist artists Hendrick Goltzius and Jacob Matham. In composition, however, they are much more advanced than the work of these artists, and a likely source of inspiration is the set of 14 prints called *Multifarium casularum . . .* , showing views in a village engraved after drawings by the Master of the Small Landscapes and published by Hieronymus Cock in 1559. Their realistic treatment of the subject-matter and the approach to the composition, with a low horizon and limited reliance on framing elements, prefigure Visscher's early drawings. Visscher was undoubtedly well aware of these prints (which he took to be after designs by Pieter Bruegel the elder), since he engraved and published an extensively revised edition of them in 1612. Visscher's later drawings, none of which is dated, do not differ much in style from his early work, although he appears to have used a greater variety of washes, perhaps initially under the influence of Jan van de Velde. Ater the second decade of the 17th century, he seems to have made few if any drawings, perhaps as a result of the demands that his increasingly successful business was making on his time. After his death,

the firm continued to flourish under his son, Nicolaes Visscher (1618–1709).

Bibliography

Hollstein: *Dut. & Flem.*: 'Cock, Hieronymous'

J. G. van Gelder: *Jan van de Velde* (The Hague, 1933), pp. 25–30

M. Simon: *Claes Jansz. Visscher* (diss., U. Fribourg, 1958)

Landscape in Perspective: Drawings by Rembrandt and his Contemporaries (exh. cat. by F. J. Duparc, Cambridge, MA, Sackler Mus.; Montreal, Mus. F.A.; 1988), pp. 221–3

Seventeenth-century Dutch Drawings: A Selection from the Maida and George Abrams Collection (exh. cat. by W. W. Robinson, Amsterdam, Rijksmus.; Vienna, Albertina; New York, Pierpont Morgan Lib.; Cambridge, MA, Fogg; 1991–2), pp. 62–3

GEORGE GORDON

Vlieger, Simon (Jacobsz.) de

(*b* Rotterdam, *c.* 1600–01; *d* Weesp, March 1653). Dutch painter, draughtsman, etcher and stained-glass designer. He was one of the leading marine and landscape artists of the Dutch school and decisively influenced the direction of Dutch marine art during the 1630s and 1640s. His late works anticipated the shift from the monochrome or tonal phase of Dutch marine art to the more classical style of Jan van de Cappelle and Willem van de Velde the younger. Although de Vlieger's reputation rests chiefly on his marine paintings, he was also a notable draughtsman and etcher.

De Vlieger moved from his native Rotterdam, where he married Anna Gerridts van Willige on 10 January 1627, to Delft in early 1634 and became a member of the Guild of St Luke there on 18 October that same year. In December 1637 he bought a house in Rotterdam from the painter Cryn Hendricksz. Volmaryn (1604–45) for 900 guilders; as part of this transaction, de Vlieger agreed to deliver each month for a stipulated period paintings with a total value of 31 guilders. He was still living in Delft on 12 March 1638, but by 19 July he was resident in Amsterdam where he became a citizen on 5 January 1643. He may have been attracted to Amsterdam by the commission to provide two designs for the festivities associated with Marie de' Medici's entry into Amsterdam

on 31 August 1638; etchings by Salomon Savery (1594–1665) after de Vlieger's designs appear in C. Barlaeus: *Medicea hospes* (Amsterdam, 1638; Hollstein: *Dut. & Flem.*, xxiv, no. 144e–g). De Vlieger fulfilled commissions for tapestry designs from the city magistrates of Delft (1640 and 1641) and in 1642 received the commission to paint the organ shutters (destr. 1788) for the St-Laurenskerk, Rotterdam, for which he received the substantial payment of 2000 guilders on 7 January 1645. Presumably he resided in Rotterdam at least sporadically during these years, but in September 1644 he sold his house there. Early in 1648 he received the prestigious commission to design some stained-glass windows for the Nieuwe Kerk in Amsterdam, for which he was paid 6000 guilders by the city. On 16 May 1648 he appeared as a witness in Amsterdam on behalf of Willem van de Velde the elder, giving his age as about 47. On 13 January 1649 de Vlieger bought a house in Weesp, a small town near Amsterdam.

Although de Vlieger's early training is undocumented, his paintings of the 1620s and 1630s show the strong influence of the marine painter Jan Porcellis. By the 1640s, for his mature marine pictures, he had transformed Porcellis's monochrome palette into a transparent silvery tonality. De Vlieger also appears to have been familiar with Adam Willaerts's rugged coastal scenes from the 1620s, and he developed this motif in his depictions of such subjects in calm and stormy weather. De Vlieger's versatility as an artist is evident from the wide variety of his marine subjects, which constitute the vast majority of his paintings. He depicted the open ocean and the estuaries of the Dutch Republic in calm and breezy weather (characteristic examples in Copenhagen, Stat. Mus. Kst; London, N.G.; Paris, Fond. Custodia, Inst. Néer.; Rotterdam, Mus. Boymans–van Beuningen; and Vienna, Akad. Bild. Kst). The imaginary coastal scenes inspired by Willaerts represent Dutch fleets approaching a rugged coast in calm weather (four such pictures in London, N. Mar. Mus., and another in Montreal, priv. col., see 1987–8 exh. cat., no. 113) or use such rocky terrain as an awesome setting for shipwrecks in stormy weather. Late in his career de Vlieger represented

parades in which many different vessels are crowded together as part of official ceremonial arrivals of important dignitaries (e.g. 1649; Vienna, Ksthist. Mus.; see fig. 61). Among de Vlieger's most ambitious paintings are those depicting shipping scenes before distant cities in cloudy weather (e.g. 1651; Cambridge, Fitzwilliam; and Schwerin, Staatl. Mus.). As early as 1633 de Vlieger produced beach scenes (e.g. London, N. Mar. Mus.) in which he refined the monochrome palette of Jan Porcellis. Late in his career, possibly in response to Jan van de Cappelle, de Vlieger's colours became brighter and more blond. An outstanding example of his late manner is the large panel painting of a *Dutch Herring Fleet* (Budapest, Mus. F.A.). De Vlieger only rarely represented naval battles or religious subjects (e.g. *Christ in the Storm on the Sea of Galilee*, c. 1638; Oakly Park, Ludlow, Salop; see 1980–81 exh. cat., no. 74). Like

Jan van Goyen, de Vlieger occasionally depicted sail-boats and larger ships in thunderstorms.

De Vlieger was also a landscape artist of note. His few surviving forest subjects (e.g. *Landscape with Hunters*, Budapest, Mus. F.A.) are a significant contribution to the genre and anticipate the work of Jacob van Ruisdael and Meindert Hobbema. Paralleling these rare landscape paintings are de Vlieger's numerous large chalk representations of wooded landscapes, often on blue paper (e.g. Berlin, Kupferstichkab., Groningen, Groninger Mus.; Paris, Fond. Custodia, Inst. Néer.; and Rotterdam, Mus. Boymans–van Beuningen). He also produced splendid marine drawings of two types: ships along rocky coasts in calm weather (e.g. Cambridge, Fitzwilliam; Vienna, Albertina) or ships in Dutch estuaries (e.g. Amsterdam, Rijksmus.). In addition, he drew townscapes and large-scale topographical subjects, which rank

61. Simon de Vlieger: *Naval Visit of Frederick Henry of Orange*, 1649 (Vienna, Kunsthistorisches Museum)

among the finest examples in this specialized category (e.g. Boston, Abrams priv. col., see 1991–2 exh. cat., nos. 36–7; and Leiden, Rijksuniv. Prentenkab.). His sympathetic depiction of animals is manifest in his large signed drawing of *Goats before a Shed* (Berlin, Kupferstichkab.). De Vlieger also produced 20 etchings, ranging from landscapes and beach scenes to a series of 10 prints representing various types of domesticated animals.

A number of younger marine painters were influenced by de Vlieger, the most prominent of whom were Jan van de Cappelle, Hendrik Dubbels and Willem van de Velde the younger. Arnold Houbraken asserted that Willem van de Velde the younger was de Vlieger's pupil *c.* 1648. This list has been enlarged (Bol) to include Hendrick van Anthonissen (1606–after 1660), Arnoldus van Anthonissen (*fl* 1662–9), Willem van Diest (1610–after 1663), Claes Claesz. Wou (*c.* 1592–1665), Henrick Staets (*c.* 1558–1631), Pieter Mulier the elder (*c.* 1615–1670), Abraham van Beyeren and two marine painters active in Rotterdam, Hendrick Martensz. Sorgh (1611–70) and Jacob Adriensz. Bellevois (*c.* 1621–after 1672). Although de Vlieger's exact relationship to Jan van de Cappelle remains unclear, the fact that van de Cappelle possessed so many paintings and more than 1300 drawings by him suggests that he was able to secure much of this material *en bloc* from de Vlieger's estate. De Vlieger's daughter Cornelia married the painter Paulus van Hillegaert II (1631–58).

Bibliography

Hollstein: *Dut. & Flem.*

A. Houbraken: *De groote schouburgh* (1718–21), ii, p. 325

P. Haverkorn van Rijsewijk: 'Simon Jacobsz. de Vlieger', *Oud-Holland*, ix (1891), pp. 221–4; ix (1893), pp. 229–35

F. C. Willis: *Die niederländische Marinemalerei* (Leipzig, 1911), pp. 44–50

A. Bredius: *Künstler-Inventare*, i (The Hague, 1915), pp. 356–8; iv (The Hague, 1916), p. 1643

Catalogue of Old Foreign Paintings, Copenhagen, Stat. Mus. Kst cat. (Copenhagen, 1951), pp. 346–8

H. Gerson and W. Godison: *Catalogue of Paintings, I: Dutch and Flemish*, Cambridge, Fitzwilliam cat. (Cambridge, 1960), pp. 136–8

J. Kelch: *Studien zu Simon de Vlieger als Marinemaler* (diss., U. Berlin, 1971)

L. J. Bol: *Die holländische Marinemalerei des 17. Jahrhunderts* (Brunswick, 1973), pp. 176–90

Gods, Saints and Heroes: Dutch Painting in the Age of Rembrandt (exh. cat., ed. A. Blankert; Washington, DC, N.G.A.; Detroit, MI, Inst. A.; Amsterdam, Rijksmus.; 1980–81), pp. 260–61

R. Ruurs: '"Even If It Is Not Architecture": Perspective Drawings by Simon de Vlieger and Willem van de Velde the Younger', *Simiolus*, xiii (1983), pp. 189–200

Masters of Seventeenth-century Dutch Landscape Painting (exh. cat. by P. Sutton, Amsterdam, Rijksmus.; Boston, MA, Mus. F.A.; Philadelphia, PA, Mus. A.; 1987–8), pp. 511–15

Mirror of Empire: Dutch Marine Art of the Seventeenth Century (exh. cat. by G. Keyes, Minneapolis, MN, Inst. A.; Toledo, OH, Mus. A.; Los Angeles, CA, Co. Mus. A.; 1990–91), pp. 184–91, 263–4

Seventeenth-century Dutch Drawings: A Selection from the Maida and George Abrams Collection (exh. cat. by W. W. Robinson, Amsterdam, Rijksmus.; Vienna, Albertina; New York, Pierpont Morgan Lib.; Cambridge, MA, Fogg; 1991–2), pp. 90–93

GEORGE S. KEYES

Vrel, Jacobus

(*fl* 1654–?1670). Dutch painter. Some 38 paintings, depicting domestic interiors, street scenes and a church interior, have been attributed to this enigmatic artist. Four copies after his works are possibly autograph; one drawing has also been ascribed to him. Over half of Vrel's paintings are signed or bear traces of signatures that were altered to read *Johannes Vermeer* or *Pieter de Hooch*, with whose paintings Vrel's work was often confused. Indeed, Theophile Thoré discussed Vermeer as a townscape painter largely on the basis of works that were actually by Vrel.

Vrel has been associated on stylistic grounds with the Delft school of painters in the circle of de Hooch and Vermeer, but this has been questioned since his *Woman at a Window* (1654; Vienna, Ksthist. Mus.) predates comparable works by these two artists. There is also no firm basis for believing he worked in Delft. His name does not

appear in the Delft archives and his seemingly naive style would be unusual in an artist working in a major Dutch city. Certain architectural elements in his street scenes may indicate that he worked in an outlying area such as Friesland, Flanders or the lower Rhineland. However, there is reason to believe that Vrel had ties with a major art centre. The *Woman at a Window* and two other paintings by Vrel are listed in Archduke Leopold Wilhelm's inventory (1659), which suggests that they were available in one of the cities visited by the Archduke's agent and curator David Teniers (ii). It also indicates that Vrel's paintings were highly regarded during his lifetime.

Vrel's interiors show an affinity to the schools of Amsterdam and Delft, but his narrow, cramped street scenes in vertical format, probably painted later in his career, are paralleled in works by Haarlem artists. The townscape painter Gerrit Berckheyde occasionally used a similar vertical format for his street views. A painting by Nicolaes Hals (1628–86), *Grote Houtstraat* (Haarlem, Frans Halsmus.), is even closer to Vrel's work in composition, tonality and the type of figures depicted.

Vrel's style is remarkable for its clear and controlled simplicity. He rejected the traditional Dutch detailed description of surfaces in favour of the depiction of lofty spaces, which often convey an eerie feeling of emptiness. Typical of his quiet domestic scenes is an *Interior* (Detroit, MI, Inst. A.), set in a high, bare room where a mother is absorbed in combing the hair of a child whose face is hidden in her lap; another child looks through a doorway, out of the painting, to the world beyond. Equally unusual is the total anonymity of Vrel's street scenes, which depict unremarkable back streets and their ordinary inhabitants. In the *Street Scene* (date barely legible, ?1670; Hartford, CT, Wadsworth Atheneum) both social and commercial exchange are absent. The bakery, which appears repeatedly in Vrel's works, attracts no customers; the baker watches from a window high above the shop and a sign announces that the house is to let. A pair of Capuchin monks disappearing into a chapel adds to the sense of mystery and silence.

Bibliography

T. Thoré: 'Van der Meer de Delft', *Gaz. B.-A.*, xxi (1866), pp. 458–70

C. Brière-Misme: 'Un "Intimiste" hollandais: Jacob Vrel', *Rev. A. Anc. & Mod.*, lxviii (1935), pp. 97–114, 157–72

G. Regnier: 'Jacob Vrel, un Vermeer du pauvre', *Gaz. B.-A.*, n.s. 6, lxxi (1968), pp. 269–82

Masters of Seventeenth-century Dutch Genre Painting (exh. cat., ed. P. C. Sutton; Philadelphia, Mus. A.; W. Berlin, Gemäldegal.; London, RA; 1984), pp. 352–4

E. A. Honig: 'Looking in(to) Jacob Vrel', *Yale J. Crit.*, iii/1 (1989)

ELIZABETH ALICE HONIG

Vroom

Dutch family of artists. Cornelis Hendricksz. Vroom the elder was a sculptor and ceramic artist, and his brother Frederick Vroom I (*d* 1593) was city architect in Danzig (now Gdańsk). Cornelis's son (1) Hendrick Vroom initiated the Dutch 17th-century tradition of Marine painting. His three sons—(2) Cornelis Vroom the younger, (3) Frederick Vroom II and Jacob Vroom I—all became painters, as did his grandson Jacob Vroom II (*d* 1700), the son of (2) Cornelis Vroom.

(1) Hendrick (Cornelisz.) Vroom

(*b* Haarlem, *c.* 1563; *bur* Haarlem, 2 Feb 1640). Painter and draughtsman. By his own account, he received his early training in Delft, home of his mother's family. Van Mander reports that Hendrick's stepfather, like his father a ceramic artist, forced him to work as a decorator of ceramic vessels, which caused the young artist to leave home and embark on extensive travels in Spain and Italy. After working for ecclesiastical patrons in Florence and Rome, he was employed for at least two years (*c.* 1585–7) by Cardinal Ferdinando de' Medici, who in October 1587 succeeded Francesco I as Grand Duke of Tuscany. Ferdinando's keen interest in ships and the navy seems to have been a determining factor in Vroom's choice of subject-matter. According to Lanzi, he was known in Rome as 'Lo Spagnolo' (since he had arrived there from Spain). Among

his earliest works may be a group of marine paintings attributed to him (Rome, Villa Colonna). His friendship in Rome with Paul Bril, mentioned by van Mander, had no effect on Hendrick's painting style, but Bril's influence is discernible in a group of landscape drawings (Russell, figs 105–11), apparently produced in the Rhône region of France, where the artist stopped on his return journey from Italy.

Vroom was back in Haarlem by 1590, when he purchased a house on 28 April, shortly before marrying Joosje Cornelisse. After their marriage the young couple went to stay in Danzig with Hendrick's uncle Frederick Vroom, who was the town architect. There Hendrick made paintings (untraced) for the Danzig Jesuits. After returning to Haarlem in 1591, around which time his first son, (2) Cornelis, was born, Hendrick sailed to Portugal, where he survived a shipwreck. He sold pictures of the event and of other marine subjects in Lisbon and Setubal. Two paintings of sea battles (Lisbon, Mus. N.A. Ant.; Portugal, priv. col.) probably belong to that period (Santos).

When Vroom subsequently settled in Haarlem, his reputation as an expert painter of ships was well established. His first commission of international importance was to design a series of tapestries, illustrating the crucial English victory in 1588 over the Spanish Armada, for the English Lord High Admiral, Charles, 2nd Baron Howard of Effingham (1536–1624). The magnificent set of ten huge tapestries, woven by Frans Spiering (c. 1550–1630) in Delft from 1592 to 1595, hung in the House of Lords from 1650 until 1834, when it was destroyed along with the Parliament buildings by fire. (It is known from an 18th-century engraved series by John Pine (1690–1756).) A similar set of six tapestries, commemorating the victories at sea of the Dutch over the Spanish (1572–4), was commissioned from Vroom by the States of Zeeland. It is known as the 'Middelburg Tapestries' and, except for the first hanging, which was woven by Spierings, was made by Hendrick de Maecht between 1595 and 1603 and hung on the walls of the great chamber of the abbey of Middelburg (now Zeeuws Mus.; in situ).

Vroom's return to Haarlem coincided with an unprecedented increase in shipping in the Netherlands, for both military and commercial purposes: the northern provinces achieved political independence through superior seamanship, while simultaneously undertaking voyages of discovery that brought them great commercial gain. Vroom, the only expert marine painter available, was called on to paint mementos of Dutch ships before they sailed to faraway lands, or after they had returned home laden with treasures from the Indies or Brazil. His first known painting of a festive gathering in honour of Dutch ships is *Ships in Dordrecht Harbour* (1594; destr. 1945; see Russell, fig. 122). Such paintings secured Vroom's exemption from military duty by a decree of the burgomasters of Haarlem dated 7 February 1594. On 28 January 1597 he was also exempted for life from any administrative duties in the Guild of St Luke. The *Return to Amsterdam of the Second Expedition to the East Indies, 19 July 1599* (Amsterdam, Rijksmus.) was painted to commemorate the spectacular success of the new Compagnie van Verre, predecessor to the Dutch East India Company (founded 1602). Other paintings celebrated Dutch and English victories at sea, for example the *Seventh Day of the Battle of the Armada* (1600–01; Innsbruck, Tirol. Landesmus.; see fig. 62), which Vroom produced on his return from a visit to Lord Howard in London.

From the 1590s Vroom produced paintings and drawings illustrating the most important events in Dutch naval history, including such masterpieces as the *Battle of Cadiz, 1596* and its pendant, the *Great Sea Storm* (both English priv. col., see Russell, figs 136 and 135), known from many reproductions. The battle scene, with accurate details of ships, flags and manoeuvres, is juxtaposed with a dramatic rendering of the ocean in a storm, with monster fish and a whale threatening a Dutch ship that is skilfully steering through all these dangers. This painting probably symbolizes the 'Ship of State' and in a wider sense Dutch statesmanship prevailing over the stormy seas of warfare with Spain. Excursions into this 16th-century type of symbolism are rare in Vroom's work and usually confined to his drawings.

62. Hendrick Vroom: *Seventh Day of the Battle of the Armada*, 1600–1 (Innsbruck, Tiroler Landesmuseum Ferdinandeum)

Supported throughout his long career by the municipalities and the Admiralty, the Dutch East India Company and individuals concerned with shipping, Vroom portrayed almost every coastal city in the northern Netherlands and many minor and major engagements at sea. Outstanding in the first category, which often included ceremonial gatherings of ships, is the *Arrival of Frederick V, Elector Palatine, with his Wife, Elizabeth Stuart, at Flushing, May 1613* (1623; Haarlem, Frans Halsmus.). This, one of Vroom's best works, is one of a group of retrospective historical paintings. In 1629, reviving the theme of the 'Middelburg Tapestries', he painted the *Battle between Dutch and Spanish Ships on the Haarlemmermeer, 26 May 1571* (Amsterdam, Rijksmus.). Apart from these officially commissioned works, he painted 'portraits' of individual ships, such as *Dutch Ship off a Rock with Castle* (1626; London, N. Mar. Mus.), and many beach scenes, often featuring the coast at Scheveningen.

Vroom was a pioneer in marine painting and, as such, had to find his own stylistic means of representing ships in harbour or on the open sea. His characteristic approach was already apparent in the early *Ships in Dordrecht Harbour* (1594), which incorporates many features that were adopted and refined by later generations of Dutch marine painters, notably Jan Porcellis. A diagonal strip of foreshore with figure groups sets off alternating zones of brightly lit and shaded water, animated by a breeze that fills the ships' sails and makes the flags flutter. Tiny coastal profiles mark the far horizon; light vibrates from the ships' hulls and sails. Ship outlines are crisp while the atmosphere softens the background, merging water and sky in the distance. Having found this way of representing ships in their natural setting, he introduced few stylistic changes. Occasionally he varied the height of the horizon: raising it in the *Seventh Day of the Battle of the Armada* to allow a panoramic view of ships engaged in battle, lowering it to give an almost eye-level view and to emphasize the sky in *The Mauritius and Other East Indiamen Sailing out of the Marsdiep* (Amsterdam, Rijksmus.). He used this lower horizon, which was a new compositional feature in Dutch painting, most frequently in beach scenes and views of

harbour cities seen across water with relatively little shipping, such as *View of Hoorn* (c. 1622; Hoorn, Westfries. Mus.) and *View of Haarlem* (c. 1625; Haarlem, Frans Halsmus.). Occasionally it occurs in 'portraits' of single ships. He was also a pioneer in presenting meticulous observations of water, clouds and weather conditions, for which van Mander praised him. Dutch 17th-century landscape painting has its roots in his realistic depiction of ships, convincingly moving in the wind with clouds drifting in the same direction.

Vroom was also a skilful and individualistic draughtsman. While his views along the Rhône, which are landscapes rather than seascapes, recall the manner of Bril, his studies of beaches with fisherfolk and small craft are entirely original. He appears to have been the first artist to sketch such motifs from life. In his drawings he also experimented more boldly than in his paintings with a low horizon, having huge clouded skies over a narrow strip of water or coastline (e.g. two *Marine Studies*, *verso* and *recto*, c. 1600; Amsterdam, Rijksmus.; and *Beach Scene*, London, V&A). Etchings made from his drawings by other artists anticipated and clearly stimulated the pronounced emphasis on skies found in Dutch landscape and marine painting later in the 17th century. His most famous drawing is the large *Landing at Philippine, 1600* (Rotterdam, Boymans–van Beuningen), which realistically portrays the countless vessels assembled by Prince Maurice near the Flemish border. For this he chose a long, horizontal format and a very high skyline, reminiscent of the tapestry designs, to accommodate the ships against the panoramic views of the territory in the background. Prints after this drawing were presented to the Dutch towns and the States General, which rewarded the painter handsomely.

Vroom's paintings and drawings were always in great demand and were highly priced. He had a large studio and many followers, among them Aert Anthonisz. (*b* 1579), Cornelis Verbeeck (1590–1631/5), Cornelis Claesz. van Wieringen and Abraham de Verwer (*d* 1650). Houbraken's remark that Jan Porcellis was a student is, however, unfounded.

(2) Cornelis (Hendricksz.) Vroom the younger

(*b* Haarlem, c. 1591; *bur* Haarlem, 16 Sept 1661). Painter and draughtsman, son of (1) Hendrick Vroom. He studied with his father and collaborated with him on the painting *Dutch Ships Ramming Spanish Galleys off the Flemish Coast* (1617; Amsterdam, Rijksmus.); Cornelis provided the figures and the background. Only one signed marine painting by Cornelis is known, the *Spanish Men-of-War Engaging Barbary Corsairs* (1615; London, N. Mar. Mus.). The *Battle of Lepanto* (Ham House, Surrey, NT) is unsigned but plausibly attributed to him. By c. 1620 he seems to have abandoned marine painting and joined the group of young Haarlem artists whose drawings pioneered a new realistic landscape style. Jan and Esaias van de Velde and Willem Buytewech strongly influenced Cornelis's drawings and early landscape paintings, which are also reminiscent of Adam Elsheimer's arcadian scenes, known in the Netherlands through Hendrick Goudt's popular engravings. The first known dated landscape painting, *River View with Boating* (1622; London, F. Paynhurst priv. col., see Keyes, fig. 23), anticipates the river-shore landscapes of Salomon van Ruysdael. Other paintings and drawings feature wooded scenes and panoramic views of dunes and countryside. The panoramas, with their simple horizontal division of sky and ground, recall the compositional structure of many of Hendrick Vroom's marines, including the diagonal foreground repoussoir, which now sets off a brightly lit expanse of fields in place of the water surface, as in the drawing *Country House before an Inland Sea* (New Haven, CT, Yale U. A.G.). Cornelis's late paintings, such as *Edge of a Forest* (1651; Copenhagen, Stat. Mus. Kst) and *Forest View with Cattle* (late 1650s; Rotterdam, Mus. Boymans–van Beuningen), show a great affinity with Jacob van Ruisdael's wooded scenes. The contact between the two artists was mutually beneficial: Vroom's early work, particularly the drawings, played an important part in van Ruisdael's development.

Cornelis Vroom emerged from the stimulating milieu of early marine painting to become one of the most influential artists of the first phase of Dutch 17th century landscape painting. His

training and early work no doubt account for his masterly treatment of light: even in his dense forest scenes he achieved an all-pervading luminosity that distinguishes them from the prototypes by Gillis van Coninxloo and other earlier painters of wooded landscapes.

(3) Frederick (Hendricksz.) Vroom II

(b Haarlem, c. 1600; d Haarlem, 16 Sept 1667). Painter and draughtsman, son of (1) Hendrick Vroom. He seems to have worked with his father longer than did Cornelis. However, no marine painting or drawing signed by him has ever been found. The only extant signed painting is his *Self-portrait* (Darmstadt, Hess. Landesmus.). Inventories made after his death list marine paintings by him and also still-lifes, landscapes and portraits. The large painting of the *Return of Prince Charles and the Duke of Buckingham from Spain, 5 October 1623* (London, N. Mar. Mus.; smaller version, Hampton Court, Royal. Col.) and a group of drawings (e.g. *Two Marine Studies*, Paris, Fond. Custodia, Inst. Néer.) are tentatively attributed to Frederick.

Bibliography

K. van Mander: *Schilder-boeck* ([1603]–1604)
A. Bredius: 'Bijdragen tot de levensgeschiedenis van
 Hendrick Goltzius', *Oud-Holland*, xxxii (1914),
 pp. 137–8
—: *Künstler Inventare, Urkunden zur Geschichte der
 holländischen Künstler des 16., 17. und 18.
 Jahrhunderts* (The Hague, 1915–22), v–vii, x–xiv
L. R. Santos: 'Hendrick Vroom en Portugal', *Bol. Mus. N.A.
 Ant.*, i/4 (1949), pp. 207–8
L. J. Bol: *Die holländische Marinemalerei des 17.
 Jahrhunderts* (Brunswick, 1973)
G. Keyes: *Cornelis Vroom* (Alphen aan den Rijn, 1975);
 review by P. Biesboer in *Simiolus*, x/3–4 (1978–9) [the
 review points out that several attributions, particu-
 larly of drawings, have not been accepted by other
 scholars]
M. Russell: *Visions of the Sea: Hendrick C. Vroom and
 the Origins of Dutch Marine Painting* (Leiden,
 1983)
—: 'Seascape into Landscape', *Dutch Landscape: The Early
 Years* (exh. cat., London, N.G., 1986)

MARGARITA RUSSELL

Waterlo [Waterloo], Antoni [Anthonie]

(b Lille, bapt 6 May 1609; d Utrecht, 23 Oct 1690). Dutch painter, draughtsman and etcher. He was the son of a Flemish cloth-shearer who had fled to Amsterdam for religious reasons. In 1640 Antoni married Cathalyna van der Dorp in Amsterdam, and between 1641 and 1651 they had six children. Although he is recorded as a 'painter' in the baptismal registers of his children, his work predominantly consists of landscape drawings and etchings. His earliest known dated work is a sheet depicting a *View of the Blaauwbrug in Amsterdam* (1649; Amsterdam, Gemeente Archf).

Woodland scenery compositionally inspired by Jacob van Ruisdael and technically executed in the vein of Jan Vermeer van Haarlem II features prominently in his few paintings. There are two works signed *A. waterlo f* in public collections: *Forest Scene with a Wooden Bridge* (Gotha, Schloss Friedenstein) and *Ambush in a Wood* (Munich, Alte Pin.). Works bearing the monogram AW may be found in private collections or on the art market. Several unsigned works have been ascribed to him, including *Landscape with Trees* (Amsterdam, Rijksmus.), *Winter Scene with Houses* (Bordeaux, Mus. B.-A.) and *Landscape with Farmhouses* (Innsbruck, Tirol. Landesmus.). Paintings ascribed to Waterlo have sometimes turned out to be copies after his etchings (e.g. *Landscape*, Liverpool, Walker A.G.).

Waterlo was a renowned etcher in his time and there are almost 140 prints to his name, mostly forest and woodland scenes with both Dutch and Italianate motifs and usually published in series. A number of etchings of panoramic views from the Cunera Tower in Rhenen are not by Waterlo, as was originally thought, but are by Johannes Ruisscher. The inscriptions *AW ex.* indicate only that these works were published by Waterlo, though he did rework the original copperplates. In 1653 a painter of this name was given freedom of the city of Leeuwarden, but it is unclear whether this refers to the same artist.

Between 1650 and 1653 Waterlo made many topographical views of Amsterdam. These were large detailed drawings of folio size, which were not conceived as studies, but were intended for

sale. During this period, Waterlo, with Jan Beerstraten and Roelant Roghman, popularized this genre. Among the best examples are views of the Binnen Amstel River (Paris, Fond. Custodia, Inst. Néer.), the Rijzenhoofd ramparts (Amsterdam, Hist. Mus.) and the Haarlem, Heiligeweg and Zaagmolen city gates (all three Amsterdam, Fodor Mus., Rijksmus. and Gemeente Archf respectively). Waterlo travelled a great deal after 1655, the year he probably made the traditional Rhine voyage. While travelling along the lower Rhine he drew large-scale landscapes of Utrecht, near Rhenen, Arnhem, Nijmegen and Cleves (e.g. Amsterdam, Rijksmus.; Edinburgh, N.G.; London, BM). His drawing of a *View of Augsburg* (Vienna, Albertina) indicates that afterwards he went south and possibly visited Italy. Some time between this trip and 1660 he toured northern Germany and Poland, recording his impressions in a sketchbook. He presumably sold the sheets of this book himself, after inscribing them with his monogram, AW. He also made large, detailed drawings of views in and around Hamburg, along the Elbe (Altona, Blankenese) in the province of Holstein, near Bergedorf and from Lüneburg east to Danzig (now Gdańsk), where he depicted, among other things, the Oliva monastery (e.g. Hamburg, Ksthalle).

In 1674 his wife died and he settled in Maarssen, a country seat near Utrecht. From about 1675 he was in regular contact with Jan Weenix, who painted the staffage in his landscapes. In 1677 he lived in Paarlenburg, a small country house outside Maarssen, where he drew a series of country houses and views of the nearby seigniory of Maarsseveen (Amsterdam, Hist. Mus. and Rijksmus.; Brussels, Mus. A. Anc.; Haarlem, Teylers Mus.; Leiden, Rijksuniv., Prentenkab.; Ottawa, N.G.; Paris, Fond. Custodia, Inst. Néer.). Waterlo is presumed to have left before 1688 for Utrecht, where he died in Job's Hospital.

Bibliography

L. Stubbe and W. Stubbe: *Um 1660 auf Reisen gezeichnet: Anthonie Waterloo, 1610–1690. Ansichten aus Hamburg, Altona, Blankenese, Holstein, Bergedorf, Lüneburg und Danzig-Oliva* (Hamburg, 1983)

B. P. J. Broos: ' "Anthonie Waterlo f(ecit)" in Maarsseveen', *Jb. 'Niftarlake'* (1984), pp. 18–48

B. P. J. BROOS

Weenix [Weenincks; Weenincx; Weeninx]

Dutch family of artists. The architect Johannes Weenix had four children: a son (1) Jan Baptist Weenix, who became a painter, and three daughters, the youngest of whom, Lijsbeth, married the painter Barent Micker (1615–87), whose brother Jan Christiaensz. Micker (c. 1598–1664) was probably Jan Baptist's first teacher in Amsterdam. In 1639 Jan Baptist, who specialized in painting Dutch Italianate landscapes and harbour views, married Justina d'Hondecoeter, daughter of the landscape painter Gillis d'Hondecoeter, sister of Gysbert (1604–53) and Niclaes (1607/8–42), both also landscape painters, and aunt of Melchior d'Hondecoeter. They had two children: (2) Jan Weenix, who became a still-life, landscape and portrait painter, and Gillis Weenix, about whom little is known.

(1) Jan Baptist [Giovanni Battista] Weenix

(*b* Amsterdam, 1621; *d* Huis ter Mey, nr Utrecht, ?1660–61). Painter, draughtsman and etcher. After possibly training with Micker, Weenix is said by Houbraken to have studied with Abraham Bloemaert in Utrecht and then with Claes Cornelisz. Moeyaert for about two years in Amsterdam. Weenix's earliest known work is a signed and dated drawing of an Italianate landscape with goats and sheep, a shepherd resting near a Classical pillar and a large group of trees (1644; Vienna, Albertina). His early painting *Sleeping Tobias* (1642; Rotterdam, Boymans–van Beuningen) is related thematically to works by Moeyaert and Rembrandt. Weenix's supple contours, liquid brushwork and rich colour, however, already reveal the qualities that were prized by later artists and collectors.

In 1642, shortly after the birth of his son (2) Jan, Jan Baptist made his will in Amsterdam before setting out for Italy. He arrived late in 1642 or in 1643 and stayed in Rome for four years. There he

became a member of the Schildersbent, the Netherlandish artists' society founded in 1623, and was given the nickname 'Ratel' (Dut.: rattle) on account of a speech defect. By 1645 the artist was in the service of a 'Kardinaal Pamfilio', often assumed to be Cardinal Giovanni Battista Pamphili, who, however, had already become Pope Innocent X in 1644. By 1647 Weenix had adopted what became his standard signature: Gio[vanni] Batt[ist]a Weenix, presumably in the Pope's honour. Schloss (*Essays in Northern European Art*, 1983) suggested that the cardinal referred to in 1645 may have been Innocent X's nephew, the art-loving Prince Camillo Pamphili, and Houbraken's assertion that Weenix was introduced into the Pope's service by Camillo seems to be confirmed by records of payment to the artist (in 1645 and 1646) found among Camillo's papers in the Pamphili archives.

By June 1647 Weenix was once again in Amsterdam, at which time his portrait was painted by Bartholomeus van der Helst (untraced, engraved by Jacobus Houbraken). Weenix's *Landscape with Ford and Rider* (1647; St Petersburg, Hermitage) shows all the characteristics of his mature, painterly and fluid style. The subject of sunlit ruins may have been inspired by similar works of Viviano Codazzi.

Weenix often employed architectural motifs, thus inspiring many other artists, notably Nicolaes Berchem. Sometimes the ruins are identifiable, such as the temple of Jupiter Tonans in *A Hunting Party near Ruins* (1648; Cleveland, OH, S. A. Millikin priv. col., see 1965 exh. cat., no. 97). He also inserted depictions of sculpture, such as the Medici vase and Giambologna's *Rape of the Sabine Women*, into his fantasy landscapes. The *Dioscuri* from the Capitol in Rome found their way into the background of Weenix's *Port Scene* (1649; Utrecht, Cent. Mus.). The scene is painted in warm colours: yellow, green and blue for the foreground, where the figure of the horseman is painted in shades of orange, red and grey, while his female companion's clothing is in a sumptuous blue-grey. The brushwork is refined and supple. From this date Weenix began to produce the Italian harbour views for which he is best known, combining

fanciful or real Classical ruins, colonnades, tombs, pyramids or obelisks with picturesque figures in a conscious fusion of past and present (e.g. *Landscape with Orientals*; Paris, Louvre; see fig. 63).

Weenix also painted a few still-lifes and some portraits, including one possibly of the French philosopher *René Descartes* (Utrecht, Cent. Mus.), which is signed and can be dated c. 1647–9, between the philosopher's arrival in Holland and his death in 1650. He also painted an impressive family portrait, *Aernhout van Wyckersloot and Christina Wessels with their Children Angelina, Petronella and Jan Aernout* (Utrecht, Cent. Mus.), in which he depicted himself at the left holding a palette and mahlstick.

The artist had moved to Utrecht by the time he was elected an officer of the painters' college there in 1649, along with the Dutch Italianate landscape painters Cornelis van Poelenburch and Jan Both. By 1653 Weenix was acting as painter and agent for the wealthy art collector from Utrecht Willem Vincent, Baron van Wittenhorst (d 1674). Weenix's figures are increasingly monumental from this time; the architectural elements are more forcefully expressed, and he paints in the slightly nervous, agitated style practised by such contemporaries as Adam Pynacker, Nicolaes Berchem and Jan Asselijn (e.g. *Sleeping Woman*, 165?; Munich, Alte Pin.).

By 1657 he was living in the Huis ter May, a mansion (destr.) near de Haar, not far from Utrecht. His last known painting, which enjoyed a great reputation in the 18th century, *Italian Peasants in Front of an Inn* (1658; The Hague, Mauritshuis), is related in theme to earlier works. At the left a seated woman holds a child in her lap; nearby two dogs play, while a small herd of sheep and a goat rest at the right. The fleeces of the sheep are meticulously rendered, and the contrast of light and shade is stronger than in his previous work.

Some confusion as to when and where the artist died has arisen, due to the suggestion that he may have been a certain Jan Weninx who died at Doetinchem, Gelderland, sometime before 1663. However, since it cannot be proved that this

63. Jan Baptist Weenix: *Landscape with Orientals* (Paris, Musée du Louvre)

Jan Wenincx was a painter, there seems little reason to dispute Houbraken's statement that Weenix moved to the Huis ter May three years before his premature death in 1660 or 1661. In his sister's will of November 1663 Weenix was mentioned as deceased.

According to Houbraken, Weenix's pupils included his son (2) Jan, his nephew Melchior d'Hondecoeter and his cousin Nicolaes Berchem. The family link with Berchem has yet to be verified, and Houbraken's statement that Berchem studied with Weenix is also problematic. The two artists are said to have travelled together to Italy; however, no firm evidence exists to substantiate a trip by Berchem, who was two years older than Weenix and already had pupils of his own by 1642. Nevertheless significant stylistic affinities exist between the two artists, perhaps because they were both apprenticed to Claes Cornelisz. Moeyaert at approximately the same time. Berchem's fantasy Italian harbour scenes painted after 1654 reveal his debt to Weenix. The two artists collaborated on the *Calling of St Matthew* (*c.* 1665; The Hague, Mauritshuis), which is signed by both. The various parts of the painting have yet to be attributed to separate hands. The sheep and other animals in the foreground, as well as some of the figures, were probably painted by Weenix, while the woman riding a donkey is probably by Berchem. Jan Baptist also collaborated with other artists: he signed a *Landscape with Figures and Animals* (untraced, see *Gaz. B.-A.*, ix (1861), p. 305) with Bartholomeus van der Helst, and a *Seaport* (*c.* 1648–9; Vienna, Gemäldegal. Akad. Bild. Kst.) with Jan Asselijn.

Drawings by Weenix range from topographical studies of both Italian and Dutch subjects, such as the red chalk drawing of the *Colosseum* in Rome (Leiden, Rijksuniv., Prentenkab.) and the signed view of *Nijenrode*, a castle in Breukeleen (Amsterdam, Rijksmus.), to landscapes and scenes of rustic farm buildings. He also made a number

of sensitive figure studies, some of them on blue paper, for example the *Man Playing 'Koten'* (Amsterdam, Rijksmus.). His drawings are sometimes confused with those of his son as well as those of Maerten Stoop (1620–47) and Emanuel Murant (1622–1700). Only a few etchings can be securely attributed to Jan Baptist Weenix. They show bulls and cows and are reminiscent of similar subjects by Berchem.

(2) Jan Weenix

(*b* Amsterdam, ?June 1642; *bur* Amsterdam, 19 Sept 1719). Painter and draughtsman, son of (1) Jan Baptist Weenix. Jan probably received his first instruction as a painter from his father, and it is possible that he helped finish certain of his father's works. He probably remained in Utrecht after his father's death. By 1664 he had become a member of the Guild of St Luke in Utrecht without, however, having submitted the required entrance painting, which he provided by 1668. There are several documented references to Jan in the late 1660s. He inherited a legacy along with his uncle, the painter Barent Micker, and other family members in 1667, at which time Gillis, his younger brother, apparently still required a guardian. He received another legacy in 1668, the year of his marriage, and in 1669 served as a witness for the inventory of the painter Jacob de Hennin (1629–*c*. 1688) in The Hague. In 1675 he and his wife were living in Amsterdam, of which Jan became a citizen.

He most likely began to paint in his own right after his father's death; at the age of 18 he signed and dated *Shepherds in an Italian Landscape* (1660; untraced, see Schloss, *Oud-Holland*, 1983, fig. 1). His first works are Italianate genre scenes set in landscapes or exotic ports modelled on his father's successful compositions, with which they are sometimes confused. However, Jan's execution is more precise than his father's and his colouring subtler, while his contrasts of light and dark are stronger. The two artists also used different figure types. Typically Jan Baptist Weenix's figures are hearty and round-faced while Jan's are more elegant and refined. This difference also corresponds to a general shift in taste after

mid-century, when many artists adopted a more slender, attenuated figure type accompanied by a corresponding interest in elegant, aristocratic clothing. Jan generally signed his paintings: *J. Weenix*, most often including a date. Jan's mature genre style is evident in a *Landscape with Figures* (1664; London, Dulwich Pict. Gal.) representing a shepherd with his herd and his dogs resting in an Italianate landscape. Like his father, Jan often included architectural ruins and antique statues in his paintings, including a sculpture of a man about to strike another, identified as either *Cain and Abel* or *Samson Killing a Philistine*, which was also used in paintings by other 17th-century Dutch artists such as Gerrit Dou, Pieter Codde and Jan van der Heyden.

In the course of the 1670s Jan adapted the harbour compositions of his father, introducing explicitly amorous figures in contrast to his father's more generally demure figure groups. In the same period other artists began to modify the cast of characters to include scenes of debauchery and merrymaking in an exotic setting. Whereas the earlier Italianate harbour scenes by Nicolaes Berchem were dependent on works by the elder Weenix, the later ones reveal his interest in depicting amorous couples, to the extent that some are called the *Prodigal Son*. This kind of imagery has rightly been interpreted within a moralizing context; however, the mood of enjoyment and gaiety somewhat undermines the admonitory intent.

After 1680 Jan abandoned harbour scenes in favour of the numerous still-lifes of dead game and birds, flower pieces and statuary for which he is best known, such as *Still-life with Dead Hare* (1682; Karlsruhe, Staatl. Ksthalle; see col. pl. XL), which shows a meticulously rendered hare with small birds and hunting gear. Exquisitely painted and observed, this scene and others like it are set against an elegant, park-like background with sculpture, urns, putti and palatial houses, flooded with warm, romantic lighting. These hunting or trophy still-lifes, while not always appreciated in the 20th century, were highly valued in the 17th century. Hunting was a royal sport and a favourite aristocratic activity; it was strictly regulated and illegal for even the rising bourgeoisie. It has been

suggested, therefore, that these still-lifes were purchased by wealthy burghers in order to lend themselves a degree of social prestige (Sullivan, 1984). Although they could not hunt, they could buy art. Jan and his cousin Melchior d'Hondecoeter, who painted similar hunting still-lifes, emphasized the textural and colouristic beauty of their subjects. Among the artist's few floral still-lifes are the lovely bouquets with exotic flowers such as a passion flower (1692; Lyon, Mus. B.-A.) and another stunning signed and dated example (1696; London, Wallace).

At the beginning of the 18th century the hunting still-life became increasingly popular for stately wall decorations. From *c.* 1702 to 1714 Jan served as court painter to the Elector Palatine John William of Düsseldorf, for whom he painted 12 large hunting scenes designed as wall panels (*c.* 1710–14) for the Elector's lodge, Schloss Bensberg, near Cologne, fragments of which survive (Munich, Alte Pin.). These paintings have been interpreted as an allegory of abundance placed before the feet of the Elector. Goethe saw these impressive works *in situ* in 1774 and claimed that Weenix had surpassed nature in visually rendering every tactile value of his subject.

Jan also painted portraits set in classicizing surroundings, for example *Abraham van Bronckhorst* (1688; Amsterdam, Rijksmus.), which shows the sitter full-length and wearing an elegant robe over his everyday clothing, accompanied by a slender dog. Among his distinguished sitters were Sybrand de Flines and his wife Agnes Block, who was a well-known horticulturist and patron of the arts in Amsterdam.

Jan's drawings include a series of birds drawn in oiled black chalk with coloured wash (e.g. Amsterdam, Rijksmus.) and several botanical studies. Among his figure drawings is a compositional study in brush and grey wash (Amsterdam, Rijksmus.) for an unidentified painting showing either the finding of Moses or the recognition of Achilles.

Jan's only known pupil, Dirk Valkenburg (1675–1721), imitated his master so closely that it is sometimes difficult to tell works by the two artists apart.

Bibliography

A. Houbraken: *De groote schouburgh* (1718–21)

G. J. Hoogewerff: 'Het spokend ruiterstandbeeld' [The haunting equestrian statue], *Mdbl. Beeld. Kst.*, xviii (1941), pp. 257–66

W. Stechow: 'Jan Baptist Weenix', *A. Q.* [Detroit], xi (1948), pp. 181–98

Nederlandse 17e-eeuwse Italianiserende landschapschilders (exh. cat., ed. A. Blankert, Utrecht, Cent. Mus., 1965; rev. and trans. as *Dutch 17th-century Italianate Landscape Painters*, Soest, 1978), pp. 174–84

A. Chudzikowski: 'Jan-Baptist Weenix, peintre d'histoire', *Bull. Mus. N. Varsovie/Biul. Muz. N. Warsaw.*, vii/1 (1966), pp. 1–10

W. Stechow: 'A Wall Paneling by Jan Weenix', *Allen Mem. A. Mus. Bull.*, 27 (Fall 1969), pp. 13–25

R. Ginnings: *The Art of Jan Baptist Weenix and Jan Weenix* (diss., Wilmington, U. DE, 1970)

P. Eikemeier: 'Der Jagdzyklus des Jan Weenix aus Schloss Bensberg', *Die Weltkunst*, xlviii (1978), pp. 296–8

S. A. Sullivan: 'Jan Baptist Weenix: *Still-life with a Dead Swan*', *Bull. Detroit Inst. A.*, lvii (1979), pp. 64–71

C. Schloss: *Travel, Trade and Temptation: The Dutch Italianate Harbor Scene, 1640–1680* (Ann Arbor, MI, 1982)

—: 'The Early Italianate Genre Paintings by Jan Weenix (ca. 1642–1719)', *Oud-Holland*, xcvii (1983), pp. 69–97

—: 'A Note on Jan Baptist Weenix's Patronage in Rome', *Essays in Northern European Art Presented to Egbert Haverkamp Begemann on his Sixtieth Birthday* (Doornspijk, 1983), pp. 237–8

S. A. Sullivan: *The Dutch Gamepiece* (Totowa, NJ, 1984)

J. M. Kilian: 'Jan Baptist Weenix—1643 bis 1647: Zur Datierung des zeichnerischen Frühwerks anhand von Signaturänderungen', *Niederdt. Beitr. Kstgesch.*, xxxiii (1994)

JENNIFER M. KILIAN

Wieringen, Cornelis Claesz. van

(*b* Haarlem, *c.* 1580; *d* Haarlem, 29 Dec 1633). Dutch draughtsman, painter, etcher and navigator. His name first appears in the Haarlem records in 1597. It is generally assumed that he was a pupil of Hendrick Vroom, whose work strongly influenced his own. Documentary sources confirm that he maintained close friendships with both Hendrick Goltzius, who made woodcuts after his drawings, and Cornelis Cornelisz. van Haarlem. Van Wieringen was more than once governor of

the Haarlem Guild of St Luke, a position in which he was responsible for updating the guild's outmoded organization. He specialized in seascapes and received commissions from the city of Haarlem, the Dutch Admiralty in Amsterdam and others. His interest lies primarily in his influence on Dutch marine painters of the 17th century. His son Claes Cornelisz. van Wieringen (*fl* 1636), also a painter, died young.

1. Drawings

The preliminary catalogue by Keyes contains sixty-five examples of drawings by Cornelis van Wieringen, only one of which has a reliable signature (Paris, Fond. Custodia, Inst. Néer.). Accurate attributions are often difficult since van Wieringen followed closely not only drawings with sea subjects by Vroom but also landscapes by Goltzius and Jacques de Gheyn II. In 1613 the Amsterdam publisher Jan Claesz. Visscher published 14 landscape etchings after van Wieringen. These etchings—made by Visscher himself—are partly in the tradition of Pieter Bruegel the elder and were important for the development of realistic Dutch landscape painting. Furthermore, they form a starting-point for the attribution of van Wieringen's drawings. Van Wieringen also executed tapestry designs, including, in 1629, that for the *Capture of Damiatta* for the city of Haarlem; the huge tapestry, woven by Joseph Thienpont, can still be seen in its original place in the town hall in Haarlem. The tapestry's patriotic theme—a heroic moment in the history of Haarlem's fleet at the time of the Crusades—recurs in drawings and paintings by the artist.

2. Paintings

In his paintings, too, van Wieringen shows himself strongly dependent on the example of Vroom, using even the same deep greenish-blue tones. The paintings are easier to identify than the drawings, since quite a few are either signed and dated or documented. What is considered his most important work is the large, fully documented *Battle of Gibraltar* (1.8×4.9 m, 1622; Amsterdam, Ned. Hist. Scheepvaartsmus.). Interestingly, the ships in this picture also appear in engravings after Pieter

Bruegel. The subject is again patriotic and has political implications: the triumph of the Dutch navy, led by Admiral Jacob van Heemskerck, over the Spanish fleet at Gibraltar in 1607. The *Battle of Gibraltar* was commissioned by the Amsterdam Admiralty as a gift to Prince Maurice, Commander-in-Chief over the united forces of the Dutch Republic. Van Wieringen also made a number of smaller scenes with ships at sea; these are mostly on wood and have no political bearing. The colours are reminiscent of Flemish painting.

Bibliography

H. van de Waal: *Drie eeuwen vaderlandsche geschieduitbeelding* [Three centuries of national history in images], 2 vols (Amsterdam, 1952), pp. 200, 247, 251–2

L. J. Bol: *Die holländische Marinemalerei des 17. Jahrhunderts* (Brunswick, 1969, rev. 1973), pp. 29–35

G. S. Keyes: 'Cornelis Claesz. van Wieringen', *Oud-Holland*, xciii (1979), pp. 1–46

E. K. J. REZNICEK

Wijck [Wyck]

Dutch family of painters and draughtsmen. Thomas Wijck was active for a short time in Italy and is best known for his scenes of popular life set in Roman squares and courtyards, themes he continued to paint even after his return to the northern Netherlands. He travelled to England shortly after the Restoration and was followed there by his son and pupil Jan Wyck, who remained in Britain for the rest of his career and played an important role in the development of English sporting painting.

(1) Thomas Wijck

(*b* Beverwijck, nr Haarlem, ?1616; *bur* Haarlem, 19 Aug 1677). His date of birth, reported by Houbraken, cannot be confirmed in documents. His training probably took place in Haarlem. He journeyed to Italy, presumably by 1640, the year in which a 'Tommaso fiammingo, pittore' (Thomas the Fleming, painter) is documented as residing in Rome in the Via della Fontanella. In 1642 Wijck was once again in the northern Netherlands, enrolled in Haarlem's Guild of St Luke. It is

unlikely that the artist was again in Rome in the spring of 1644 (as Busiri Vici maintained), given the fact that on 22 May of that year he was married in Haarlem. His presence in his native city is further documented in 1658, 1659, 1669 and 1676.

Given the lack of dated works by Wijck, it is difficult to establish which paintings he executed in Rome, since even after his return to the Netherlands he painted Dutch Italianate themes, using black chalk and wash drawings done from life in Rome, a large number of which have survived. It is likely that the paintings most directly reflecting the work of northern artists active in Rome c. 1640 and those depicting the city's landscape with the greatest sense of immediacy and realism date from his Roman period and the years shortly thereafter. Works that can be dated to the 1640s include the *View of the Aracoeli* (Munich, Alte Pin.), the *Market Place at the Portico d'Octavia* (priv. col., see Trezzani, fig. 7.8), the *Roman Courtyard with a Blacksmith* (priv. col., see Trezzani, fig. 7.4) and the *Washerwomen in a Courtyard* (Warsaw, N. Mus.), for which there is a preparatory drawing of a deserted courtyard (Amsterdam, Rijksmus.). Whatever Wijck's training, these paintings show that during his stay in Rome, Wijck was aware of the late works of Andries Both, such as Both's *Musicians in a Courtyard* (Munich, Alte Pin.). Wijck also harked back to the works of Pieter van Laer (Il Bamboccio), whose paintings were despatched regularly to Haarlem from Rome, so Wijck may have seen examples even before travelling to Italy. Through examples of van Laer's work, such as *Travellers in a Courtyard* (Florence, Uffizi) and *Flagellants* (Munich, Alte Pin.), Wijck learnt to structure his characteristic views of courtyards and small squares framed, in the foreground, by archways and enclosed, in the background, by rooftops and loggias.

Wijck presented a 'backstreet' view of Rome, bereft of the great Classical and Renaissance monuments that were the main focus of attention for other Dutch Italianates and, more especially, for their northern clientele. It is rarely possible to identify specific locations in his works, but despite or perhaps because of this, Wijck's views of the

city, undoubtedly composed in the studio according to specific structural principles, seem more convincing and more realistic than those created by the Italianate artists of the second half of the 17th century. Scenes of Roman popular life crowded with small figures, so typical of the Bamboccianti (followers of van Laer), are of relatively little importance when compared with Wijck's overwhelming interest in the urban setting. Yet some of Wijck's paintings, for example the *Morra Players* (Vienna, Gemäldegal. Akad. Bild. Kst.) and the *Peasants in a Courtyard* (Philadelphia, PA, Mus. A.), show strong connections with the *bambocciata* paintings (low-life scenes) of the early 1640s and in particular with the work of the so-called Master of the Small Trades, who may perhaps be identifiable with the young Jan Lingelbach.

There is a much greater concentration on landscape elements in paintings such as *Washerwomen* (Hannover, Niedersächs. Landesmus.) and *View of the Ponte Molle* (Brunswick, Herzog Anton Ulrich-Mus.), which is partly based on an engraving of the same subject by Jan Both. A vital part of Thomas Wijck's development as a landscape artist was undoubtedly the example set by Jan Asselijn, who was probably active in Rome between 1639 and 1643, and perhaps also that set by the much older artist Filippo Napoletano who, in works such as the *Mill* (Florence, Pitti), had earlier displayed the same propensity for realism and the same method of structuring his compositions.

In the course of his travels in Italy Wijck probably also visited Naples. Though unconfirmed by documents, there are a number of views by his hand relating to the Gulf of Naples, for example the small and highly realistic *View of the Bay of Naples* (Naples, Causa priv. col., see Trezzani, fig. 7.15) and the imaginary views of harbours showing Mt Vesuvius and the Torre di S Vicenzo in the background with figures of travellers and exotic Orientals in the foreground (e.g. *Imaginary View of a Port*, Munich, Alte Pin.). These imaginary harbour and shore scenes enriched with picturesque figures were highly prized by 18th-century collectors and connoisseurs. Wijck's

example may have inspired other northern Italianates to enrich their thematic repertory with Neapolitan subjects.

In his last years Wijck produced works closely linked in style and subject-matter to Dutch genre painting. They are completely independent of his Italianate works, while still preserving some of the artist's earlier compositional devices. For instance, an arch frames the scene of a mother and child in the Dutch Interior (Copenhagen, Stat. Mus. Kst). Interior scenes with alchemists (e.g. Brunswick, Herzog Anton Ulrich-Mus.; Munich, Alte Pin., 856) were typical of the artist according to Horace Walpole. Walpole also recalled the artist's visit to London, during which he is said to have painted views of the city before the Great Fire of 1666 (e.g. Badminton House, Glos) and also depicted the fire itself (e.g. Chatsworth, Derbys). This journey probably took place between 1660 and 1668, a period during which Wijck is not recorded in his homeland. Walpole's statement that the artist died in London in 1682 is incorrect.

Bibliography

Thieme–Becker

A. Houbraken: De groote schouburgh (1718–21), ii, pp. 16–17

H. Walpole: Anecdotes of Painting in England, 1762–80, ii (London, 1869, rev. 2/1876), p. 234

Nederlandse 17e-eeuwse Italianiserende landschap-schilders (exh. cat. by A. Blankert, Utrecht, Centraal Mus., 1965; rev. and trans. as Dutch 17th-century Italianate Landscape Painters (Soest, 1978), pp. 144–6

M. Roethlisberger: 'Around Filippo Napoletano', Master Drgs, xiii/1 (1975), pp. 23–6

L. Salerno: Pittori di paesaggio del seicento a Roma, i (Rome, 1977), pp. 342–7

A. Busiri Vici: 'Porti, piazzette, casolari di Roma e dintorni di Tomaso Fiammingo', L'Urbe, xli/4 (1978), pp. 9–14

C. S. Schloss: Travel, Trade, and Temptation: The Dutch Italianate Harbour Scene, 1640–1680 (Ann Arbor, 1982)

L. Trezzani: 'Thomas Wijk', The Bamboccianti: Painters of Everyday Life in 17th-century Rome, ed. G. Briganti, L. Trezzani and L. Laureati (Rome, 1983), pp. 223–37, figs 7.1–7.16

Die Niederländer in Italien (exh. cat. by R. Trnek, Vienna, Bib. Akad. Bild. Kst., 1986), pp. 212–22

A. C. Steland: 'Thomas Wijck als italienisierender Zeichner: Beobachtungen zu Herkunft, Stil und Arbeitsweise', Wallraf-Richartz-Jb., xlviii–xlix (1988), pp. 215–47, figs. 1–35

<div style="text-align:right">LUDOVICA TREZZANI</div>

Wijnants [Wynants], Jan [Johannes]

(b ?Haarlem, c. 1635; d Amsterdam, bur 23 Jan 1684). Dutch painter. Suggested dates for his birth range from 1605 (Bode) to 1635 (Brown); Bredius's proposed birthdate of c. 1630–35 (rejected by Hofstede de Groot and MacLaren) is almost certainly correct, with the later part of this period being the most acceptable. Wijnants's father was probably the art dealer Jan Wijnants, who was recorded as a member of the Haarlem Guild of St Luke in 1642. Jan the younger is documented in Haarlem several times until his departure for Amsterdam around 1660. A document pertaining to his father (see Bredius, p. 180) implies, however, that in 1653 Wijnants the younger was in Rotterdam, where the painters Ludolf de Jongh and Adam Pynacker were active. Perhaps the most important early influence on Wijnants was de Jongh's brother-in-law, Dirck Wijntrack (before 1625–78), noted for his paintings of wildfowl. There is much evidence to suggest that the two artists often worked together during the 1650s.

Although Hofstede de Groot dated 12 of Wijnant's pictures to an early period from 1643 to 1652, most of these can be assigned to a later period either on stylistic grounds or by a correct reading of the dates, or else reattributed to other artists (Stechow, 1965). Wijnants probably began to paint shortly after 1650. Among his earliest certain dated works is the Cottage (1654; untraced; see Stechow, 1965, fig. 6). The painting is signed by both Wijnants and Wijntrack, and the chickens, ducks and other birds in the foreground are clearly by Wijntrack's hand. Wijntrack may also have been responsible for the wildfowl in the slightly later Peasant Cottage (Amsterdam, Rijksmus.). In both of these characteristic early paintings brick farm buildings and cottages occupy a major portion of the composition.

In 1659 Wijnants is again documented in Haarlem, and in the paintings of this period, such as *Landscape with a Dead Tree and a Peasant Driving a Sheep along a Road* (1659; London, N.G.), the buildings, considerably smaller, have been relegated to the middle distance. The stark tree-trunk, a motif derived from Jacob van Ruisdael, was to re-emerge as a kind of leitmotif in Wijnant's paintings of the second half of his career. By December 1660 Wijnants had moved to Amsterdam, where he married Catharina van der Veer. He remained there for the rest of his life, keeping an inn to supplement his income (he was constantly falling into debt). He was buried in the graveyard of the Leidsekerk.

Almost all of Wijnants's later paintings, such as *Landscape with a Sandy Slope* (St Petersburg, Hermitage), are landscapes, particularly dunescapes based on the broad ridge of sand dunes near Haarlem. Wijnants followed in the tradition of dune painting established by Pieter de Molijn, Philips Wouwerman, van Ruisdael and others. Typical of his early work of the 1660s is *Landscape with Cattle* (1661; London, Wallace). A sense of space is created in the left half of the picture by the pattern of the trees and meandering, ribbon-like paths that diminish as they recede into the distance. Sunlight appears to fall naturally on fields and dunes, highlighting at strategic points the blond tones of the sand. By contrast, the right half of the picture builds up to a dense clump of trees reminiscent of those in van Ruisdael's forest pictures of the mid-1650s. The staffage, almost certainly not by Wijnants, has been attributed to Adriaen van de Velde, who according to Houbraken was Wijnants's pupil. This remains conjectural given Wijnants's presumed birthdate, but there is no doubt that the two artists occasionally worked together. Johannes Lingelbach also added figures to some of Wijnants's paintings, including *Landscape with a Sandy Slope* and *Landscape with Huntsmen* (1661; Bonn, Rhein. Landesmus.).

There is no reason to doubt Wijnants's authorship of *View of the Herengracht, Amsterdam* (Cleveland, OH, Mus. A.), although as a topographical urban scene it is apparently unique in

terms of subject-matter. It must have been painted between 1660 and 1662 since the trees are reminiscent of those in Wijnants's dated works of 1661 (Stechow, 1965); the figures in the painting are in the style of Lingelbach, although not by him. During the mid-1660s Wijnants also painted the best of his Italianate landscapes, for example the *Angler* (1665; untraced; see Stechow, 1966, fig. 331), which find their closest parallel in the work of Jan Hackaert from the 1660s. Wijnants never travelled to Italy, however, and it is difficult to judge the date of his first and last Italianate works.

Wijnants's later paintings are characterized by the frequent inclusion of a blasted elm or oak tree dominating the foreground. Two examples are the *Hawking Party with a Falconer* (1666; Buckingham, priv. col., see *Apollo*, viii/45 (1928), p. 118), of which there is a signed replica (London, Kenwood House), and the somewhat later *Landscape with Two Dead Trees* (London, N.G.). Highly stylized foliage and fallen tree-trunks are also common motifs in these later works, which suggest, in addition to the influence of van Ruisdael, that of such artists as Pynacker and Otto Marseus van Schrieck, both of whom were working in Amsterdam from around 1660.

Wijnants's pictures appealed strongly to the 18th-century English collectors' enthusiasm for Dutch landscapes. His paintings also influenced 18th- and 19th-century artists, including François Boucher, Thomas Gainsborough and John Crome; the latter is said to have had a painting by Wijnants in his collection. Perhaps it was the decorative, blue tonality of Wijnants's works of the 1660s and 1670s that was preferred by artists and collectors alike to the restricted palette of earth tones used by landscape artists in the 1620s and 1630s during the so-called 'tonal phase' of 17th-century Dutch painting.

Bibliography

A. Houbraken: *De groote schouburgh* (1718–21), iii, p. 90
J. Smith: *A Catalogue Raisonné of Works of the Most Eminent Dutch, Flemish and French Painters*, vi (London, 1835), pp. 225–82
——: *Supplement to the Catalogue Raisonné of Works of the Most Eminent Dutch, Flemish and French Painters* (London, 1842)

W. Bode: *Great Masters of Dutch and Flemish Painting* (London, 1909), p. 211

A. Bredius: 'Een en ander over Jan Wijnants' [A few things about Jan Wijnants], *Oud-Holland*, xxix (1911), pp. 179–84

C. Hofstede de Groot: *Verzeichnis*, viii (1923), pp. 463–639

N. Maclaren: *The Dutch School*, London, N.G. cat. (London, 1960)

W. Stechow: 'Jan Wijnants: *View of the Heerengracht, Amsterdam*', *Bull. Cleveland Mus. A.*, lii/10 (Dec 1965), pp. 164–73

—: *Dutch Landscape Painting of the Seventeenth Century* (London, 1966/R 1981)

Dutch Landscape: The Early Years (exh. cat., ed. C. Brown; London, N.G., 1986)

L. B. L. HARWOOD

Willaerts

Dutch family of painters. The marine painter (1) Adam Willaerts was one of the many Protestants who emigrated from Flanders to the northern Netherlands at the end of the 16th century. He had three sons who became painters, at least two of whom, (2) Abraham Willaerts and (3) Isaac Willaerts, studied with him and painted marine subjects as well as portraits. Unlike his father and younger brothers, the eldest son Cornelis Willaerts (1600–66) was a history painter who also painted portraits and landscapes, including Arcadian scenes in the manner of Cornelis van Poelenburch. He remains a shadowy figure, by whom only one signed work is known, *Husband and Wife with Little Daughter before a Landscape* (Mersham, Kent, Mrs Irby priv. col.).

(1) Adam Willaerts

(*b* Antwerp, 1577; *d* Utrecht, 4 April 1664). During his early years in Antwerp he was impressed with the colourful paintings of the Fleming Jan Breughel the elder, but the subject and style of his earliest known picture, *Dutch East Indiamen off the West African Coast* (1608; Amsterdam, Hist. Mus.), presumably painted after the artist's arrival in Holland, shows the influence of the Dutch marine painter Hendrick Cornelisz. Vroom. In this painting Willaerts adopted Vroom's austere compositional scheme of an uninterrupted horizontal expanse of water with no framing devices, but he lacked Vroom's skill in depicting ships.

In 1611 Willaerts became one of the founder-members of the Utrecht Guild of St Luke, serving as Dean during the periods 1620–22, 1624–31 and 1636–7. Utrecht had a strong religious life, in which a tradition of Catholicism survived, and this affected Willaerts's subject-matter. He painted several seascapes with biblical themes, such as *Christ Preaching from a Boat* (1621; sold London, Sotheby's, 10 Dec 1975), which recalls Breughel's *Sea Harbour with Christ Preaching* (Munich, Alte Pin.) with its assembly of figures in colourful costumes. In this painting, however, Willaerts devoted more space to water and placed Christ in a Vroom-like Dutch ship, thus associating the Christian scene unhesitatingly with Dutch shipping. In Willaerts's *Miraculous Draught of Fishes* (Ripon, Earl of Swinton priv. col.) the Disciples have disembarked from a Dutch flagship. Most of Willaerts's marine paintings are beach scenes with many figures in the foreground and decorative lateral framing devices, such as trees, rocks and castles. Pure seascapes without such additional motifs are rare and mainly confined to the early period. In later works, such as the *Dutch Beach Scene* (1613; Amsterdam, P. de Boer priv. col.) and the dramatic *Storm at Sea* (1614; Amsterdam, Rijksmus.), he tried to emulate Vroom's compositional formulae, but in the *Sea Battle off Gibraltar* (1617; Amsterdam, Rijksmus.) he introduced decorative parallel bands of tiny wave crests and used a three-zone colour scheme (brown foreground, green middle distance, pale blue sky) derived from Breughel and Mannerist painting. Willaerts retained these attractive but artificial colours long after they had become outdated by the naturalistic palette of Dutch 17th-century marine painting.

In 1619 the landscape painter Roelandt Savery, another native of Flanders, settled in Utrecht. His wild rocky and wooded scenes, which often included animals, inspired Willaerts, who began to incorporate animals as coastal motifs in his marine paintings, as in the *Chamois Hunt on the Coast* (1620; Hamburg, Ksthalle), in which a chamois hunt set in alpine rocks is featured next

to an expanse of sea with Dutch ships in full sail. In 1623 Willaerts painted the *Arrival of Frederick V, Elector Palatine, with his Wife Elizabeth Stuart, at Flushing, 1613* (sold London, Sotheby's, 27 Nov 1968, lot 128) to coincide with Vroom's painting of the same subject (Haarlem, Frans Halsmus.). In an earlier painting by Willaerts the splendid ship the *Prince Royal*, which carried Frederick and Elizabeth on their festive voyage, appears surrounded by other shipping (1619; Amsterdam, Ned. Hist. Scheepvaartsmus.). High on the rocky coast on the right is the castle of Prague, where Frederick became the 'Winter King'. Willaerts used the motif of this castle in other related marine paintings, forsaking geographic accuracy for the sake of symbolic allusion to Frederick's kingdom (Luttervelt). Later paintings, for instance *Mouth of the Maas at Den Briel* (1633; Rotterdam, Mus. Boymans–van Beuningen), combine a view of a harbour with, in the foreground, a portrait group, which has been attributed to Adam's son (2) Abraham Willaerts.

Like Vroom, Adam Willaerts painted harbour views of Dutch cities. The huge decorative *View of Dordrecht* (1629; Dordrecht, Dordrechts Mus.), in a long horizontal format typical of Vroom, is one of Willaerts's masterpieces. The artist painted his self-portrait in a boat prominently placed in the centre foreground.

After 1650 Willaerts sometimes collaborated with Willem Ormea (d 1673), a painter of still-lifes of fish, adding the background of sea, coast and shipping to Ormea's catch of fish displayed on a beach. Some of these scenes are biblical, featuring the *Miraculous Draught of Fishes* (Bruges, Comm. Openb. Onderstand).

(2) Abraham Willaerts

(b Utrecht, c. 1603; d Utrecht, 18 Oct 1669). Son of (1) Adam Willaerts. After training with his father he later studied with Jan van Bijlert in Utrecht and with Simon Vouet in Paris. In 1624 he became a master of the Utrecht Guild of St Luke; from 1637 to 1644 he was in Brazil in the entourage of Count John Maurice of Nassau-Siegen, and in 1659 he visited Naples and Rome. His marine paintings closely follow those of his father, for example

Coast Scene (1647; Haarlem, Frans Halsmus.), but often have an atmospheric softness, as in *Beach Scene with Ruin* (1662; Brunswick, Herzog Anton Ulrich-Mus.). Abraham's foreign travels had little effect on his style but resulted in Mediterranean harbour views (real and imaginary), such as *Harbour of Naples* (London, N. Mar. Mus.). He painted a series of portraits, both single figures (several were admirals) and family groups (e.g. Cambridge, Fitzwilliam; Schleissheim, Neues Schloss). He also contributed portraits in the foreground of some of his father's harbour scenes.

(3) Isaac Willaerts

(b Utrecht, c. 1620; d Utrecht, 24 June 1693). Son of (1) Adam Willaerts. In 1637 he was a master, and in 1666 the dean, of the Utrecht Guild. His mediocre coastal scenes are derived from his father's but are more loosely painted (e.g. *Marine Scene with Rocky Coast and Ruin*, Utrecht, Cent. Mus.). He also followed his father in contributing marine backgrounds to Ormea's still-lifes of fish. His paintings of southern ports resemble those of his brother (2) Abraham Willaerts.

Bibliography

R. van Luttervelt: 'Een zeegezicht met een historische voorstelling van Adam Willaerts', *Historia*, xii (1947), pp. 225–8

L. J. Bol: *Die holländische Marinemalerei des 17. Jahrhunderts* (Bunswick, 1973), pp. 63–80

M. Russell: *Visions of the Sea: Hendrick C. Vroom and the Origins of Dutch Marine Painting* (Leiden, 1983), pp. 179, 182

MARGARITA RUSSELL

Witte, Emanuel de

(b Alkmaar, c. 1617; d Amsterdam, 1691–2). Dutch painter. He was one of the last and, with Pieter Saenredam, one of the most accomplished 17th-century artists who specialized in representing church interiors. He trained with Evert van Aelst (1602–57) in Delft and in 1636 joined the Guild of St Luke at Alkmaar, but he was recorded in Rotterdam in the summers of 1639 and 1640. In

October 1641 his daughter was baptized in Delft, where he entered the Guild of St Luke in June 1642 and lived for a decade, moving to Amsterdam *c.* 1652. He began his long career as an unpromising figure painter, as can be seen in the *Vertumnus and Pomona* (1644) and two small pendant portraits (1648; all Rotterdam, Mus. Boymans–van Beuningen). *Jupiter and Mercury in the House of Philemon and Baucis* (1647) and a Rembrandtesque *Holy Family* (1650; both Delft, Stedel. Mus. Prinsenhof) presage de Witte's interpretation of architectural interiors predominantly in terms of light and shade, and—in their casual drawing, comparatively broad brushwork and uncertain articulation of space—are stylistically consistent with the unsigned *Nieuwe Kerk, Delft* (*c.* 1651; Winterthur, Stift. Briner), showing the tomb of William the Silent. The latter picture is based directly on Gerrit Houckgeest's church interiors of the same years, as is de Witte's version of the *Nieuwe Kerk, Delft* (1650–51; Hamburg, Ksthalle), with the tomb seen from the rear. Like Hendrick van Vliet, de Witte turned from figure painting to a subject that had always been a perspectivist's speciality. It can be assumed, and there is evidence in inventories, that a mostly local demand in traditionally royalist Delft encouraged de Witte and Hendrick van Vliet to concentrate on national monuments and the churches that enshrined them.

However, de Witte was less interested than van Vliet in fidelity to the actual site or in the architecture itself than his initial debt to Houckgeest might indicate. From the beginning, de Witte's imagination seems to have responded more to the great spaces than to the forms of Dutch Gothic churches, to the evocative contrasts of sunlight and shadow and to the people who visited and worshipped in these communal and spiritual environments. The *Oude Kerk in Delft with Pulpit* (1651; London, Wallace), de Witte's first dated church interior, suggests in its descending daylight some communication between the heavens and the quiet congregation; the preacher in the pulpit, unlike van Vliet's gravediggers and some of Houckgeest's tourists, plays a comparatively inconspicuous part.

In style and technique, too, de Witte soon became independent of Houckgeest's influence, producing unprecedented examples of the genre. He adopted Houckgeest's 'two-point' perspective scheme and placement of columns in the immediate foreground, but in de Witte's approach, archways and windows are as assertively shapes in the compositional pattern as a solid architectural element or a piece of furniture. In the *Oude Kerk, Delft* (Ottawa, N.G.) and other views with pulpits (e.g. *Sermon in the Oude Kerk, Delft, c.* 1653–5; Brussels, Mus. A. Anc.; the *Oude Kerk in Amsterdam during a Service,* 1654; The Hague, Mauritshuis; see fig. 64), de Witte de-emphasized diagonal and direct recessions into depth in favour of forms spaced at rhythmic intervals from side to side. Zones of space are thus layered and interrelated by a continuous interplay of solid and void, as well as by rich harmonies of light and shade. Although this effect, seen close up, appears more painterly and less illusionistic than the more conventional cues to depth used by Houckgeest

64. Emanuel de Witte: *Oude Kerk in Amsterdam during a Service,* 1654 (The Hague, Mauritshuis)

and van Vliet, at a normal distance de Witte's paintings are persuasive representations of actual views. A somewhat similar quality is found in contemporary works by Vermeer.

De Witte's use of linear perspective was creative both because he felt free to ignore its stringent requirements and because he was able to make pictorial assets out of perspective difficulties, a practice probably learnt in part from paintings by Pieter Saenredam, whose design ideas and even subject-matter he borrowed in a number of church interiors dating from the mid-1650s to c. 1670, such as the *St Janskerk, Utrecht* (1654; Paris, Fond. Custodia, Inst. Néer.) and the *Protestant Gothic Church* (1668; Rotterdam, Mus. Boymans–van Beuningen). But de Witte's preference for orthogonal recessions along or perpendicularly through elevations probably derived from other architectural painters, such as Anthonie de Lorme (d 1673) and even Houckgeest, who had used these arrangements both before and after the early 1650s. In any event, Saenredam's paintings provided only broad ideas and compositional patterns; his more exploratory on-site drawings may have greater relevance to de Witte's paintings in that they appear to describe space as an infinite continuum made comprehensible but not measurable by architecture.

As might be expected of an artist with such an intuitive grasp of the subject, who would confidently dismiss an intrusive elevation or render capital carvings with a twist of the brush, de Witte passed without hesitation from 'portraits' of actual churches to paintings of imaginary buildings, many of which incorporate elements of Amsterdam's main churches and Stadhuis (now Royal Palace). These structures, which can be only loosely categorized, as, for example, a *Protestant Gothic Church* (1669; Amsterdam, Rijksmus.), are the ultimate examples of the 'realistic imaginary church', a theme merely intimated by such earlier architectural painters as Houckgeest and Bartholomeus van Bassen. In subject and style, then, de Witte worked rather like a landscape painter, employing plausible and sometimes actual elements to create largely invented views.

No essential change of technique was necessary when de Witte painted outdoor market scenes, such as the *Fish Stall* (1672; Rotterdam, Mus. Boymans–van Beuningen) with three figures, the more extensive townscape in the *Small Fish Market, Amsterdam* (1678; Hartford, CT, Wadsworth Atheneum) or even the *Harbour at Sunset* (Amsterdam, Rijksmus.). A few landscapes and a still-life are also recorded: a *Kitchen Interior* (Boston, MA, Mus. F.A.) and an impressive *Interior with a Woman at a Clavichord* (c. 1665; The Hague, Dienst Verspr. Rijkscol., on dep. Rotterdam, Mus. Boymans–van Beuningen; autograph version, c. 1667; Montreal, Mus. F.A.) are original contributions to Dutch genre painting. The quality of de Witte's work varied considerably, due partly to his unstable temperament, which provoked domestic and financial difficulties to which Houbraken referred. But most of his surviving works are exceptionally good and even the minor ones are distinguishable from closely related Delft views by van Vliet or views of Amsterdam churches by de Witte's only pupil, Hendrick van Streek (1659–after 1719).

Bibliography

A. Houbraken: *De groote schouburgh* (1718–21), i, pp. 223, 282–7; ii, p. 292

I. Manke: *Emanuel de Witte, 1617–1692* (Amsterdam, 1963)

W. A. Liedtke: *Architectural Painting in Delft: Gerard Houckgeest, Hendrick van Vliet, Emanuel de Witte* (Doornspijk, 1982)

WALTER LIEDTKE

Wittel, Gaspar [Caspar] (Adriaansz.) van [Vanvitelli, Gaspare or Gasparo]

(*b* Amersfoort, 1652–3; *d* Rome, 13 Sept 1736). Dutch painter and draughtsman, active in Italy. After early training in Amersfoort in the workshop of Matthias Withoos, he went to Rome, where he is first recorded in 1675; known as Vanvitelli, he spent the rest of his life there apart from a few trips to northern Italy during the early 1690s, a stay in Naples from 1700 to 1701 and possibly other, undocumented, trips before c. 1730. He became one of the principal painters of

topographical views known in Italy as *vedute*. His first recorded work in Rome comprises 50 drawings executed in 1675–6 (Rome, Bib. Accad. N. Lincei & Corsiniana, Cod. Corsiniana 1227), illustrating the plans by the hydraulic engineer Cornelis Meyer (1629–1701) to restore navigability to the River Tiber between Rome and Perugia. (Though generally accepted, the attribution of these drawings has been disputed by Zwollo.) Van Wittel's first *vedute* were also collaborations with Meyer, who illustrated one of his tracts with a series of engraved Roman views (pubd 1683 and 1685), of which those depicting the Piazza del Popolo, the Piazza S Giovanni in Laterano and the Piazza S Pietro are taken from designs by van Wittel, probably executed in 1678 and repeatedly used by the artist from the early 1680s in tempera and oil paintings. Van Wittel's first painted *vedute* date from 1680, and his style was established by the beginning of the 1690s. Even before 1690, in fact, he had elaborated his chosen compositional and perspectival principles: subsequently only the subject-matter changed.

The type of *veduta* van Wittel created has certain precedents in the work of Viviano Codazzi and Johann Wilhelm Baur, who was active in Rome during the 1640s. Anticipating the 18th-century style, van Wittel's *vedute* are, both in aim and method, realistic views structured according to rational principles of vision: they combine careful description of the subject with strict adherence to its panoramic perspective, while their point of view, which often coincides with ground-level in the view itself, corresponds exactly to that of the spectator. His choice of subject was also innovative when compared with that of his 17th-century predecessors, as can be seen particularly in his views of Rome. Since the 16th century painters had concentrated on scenes of ruined architecture overrun by vegetation, giving expression to poetic and literary themes associated with the past and with the contrast between ancient splendour and modern decay. The output of northern landscape artists active in Rome during the late 17th century tended to convey a generic Italianate atmosphere rather than showing the city and its surrounding countryside as it then appeared. Van

Wittel, on the other hand, documented the most up-to-date and least familiar aspects of the modern city, remaining immune to the conventional lure of the ruins. With the exception of the Colosseum, portrayed from various points of view (e.g. 1703; Paris, priv. col., see Briganti, no. 30, 38–9), he rarely depicted the ancient monuments and religious sites of Rome. When he did, his treatment was novel, as can be seen in the *View of the Arch of Titus from the Colosseum* (e.g. 1685; Rome, priv. col.), which for the first time shows the arch from its most complete side. His *vedute* depict places not yet hallowed by tradition or different angles on well-known ones, as in the paired views of *Trinità dei Monti* and the *Villa Medici* (earliest examples 1681; Rome, Gal. Colonna) and his *View of the Campo Vaccino from the Side Stairway of Aracoeli* (1683; Rome, Gal. Colonna). There were no precedents for his *View of Campo Marzio from the Prati* (e.g. c. 1682; Rome, Pin. Capitolina) or the fine series of *Views of the Tiber* between the Porto della Legna and the Ripa Grande (begun 1683), employing 15 different vantage points (e.g. 1683, Rome, Gal. Colonna; 1685, Florence, Pitti).

Van Wittel's drawings made in Lombardy resulted in the signed and dated *View of the Borromeo Islands on Lake Maggiore* (1690; Rome, Gal. Colonna) and views of the town of Vaprio d'Adda (e.g. 1719; Rome, priv. col., see Briganti, no. 187). A trip to Venice is documented by a series of *vedute*, the earliest dated 1697 (Madrid, Prado). Some of these, most notably the *View of the Piazzetta from St Mark's Basin* (Rome, Gal. Doria-Pamphili), the *St Mark's Basin towards the Grand Canal* (priv. col., see Briganti, no. 173) and the *Punta della Dogana with S Maria della Salute* (Rome, Gal. Colonna), anticipate Canaletto in their perspective layout and in the angle of the views (see also fig. 65).

Beginning in 1700 van Wittel painted views of Naples, where he went at the invitation of the Viceroy, Luis de la Cerda, Duque de Medinaceli. The most notable are his versions of the *View of Darsena* (e.g. 1702, Naples, Mus. N. S Martino; 1703, London, N. Mar. Mus.) and his *View of the Largo di Palazzo*, which was also replicated (e.g. 1701;

65. Gaspar van Wittel: *Church of the Salute and the Giudecca* (Rome, Galleria Doria Pamphili)

Rome, priv. col., see Briganti, no. 199; 1700–02, Rome, Banca Commerc. It.).

Throughout his career van Wittel used drawings, made in Rome during the early 1680s and during his various travels, to create several painted versions of a single view. Many of these sheets, which were drawn from life and completed in the studio, have survived: the most interesting are in Naples (Mus. N. S Martino) and Rome (Bib. N. Cent.). The format of these studio drawings matches that of the paintings, and many of them, divided into squares, served as the artist's aide-mémoire when creating a painting, at which point they were probably used together with more rapid sketches that had been made on the spot.

Van Wittel was nicknamed 'Gasparo dagli Occhiali' (Gaspare with the spectacles) and his Bent-name (given him by colleagues in the Schildersbent, the association of Dutch and Flemish artists in Rome) was 'Piktoorts' (or Pitch-torch). His son, Luigi Vanvitelli, became a leading architect in Naples.

Bibliography

C. Lorenzetti: *Gaspare Vanvitelli* (Milan, 1934)

G. Doria: *Il 'Largo di Palazzo' a Napoli e Gaspare dagli Occhiali* (Milan, 1964)

G. Briganti: *Gaspar van Wittel e l'origine della veduta settecentesca* (Rome, 1966) [rev. edn, ed. L. Louresti and L. Trezzani, in preparation]

H. Wagner: 'Ein unbekanntes Frühwerk Gaspar van Wittels', *Berlin. Mus.: Ber. Staatl. Mus. Preuss. Kultbes.*, xviii (1968), pp. 24–9

G. Morelli: 'Appunti bio-bibliografici su Gaspar e Luigi Vanvitelli', *Archv Soc. Romana Stor. Patria*, xcii (1969–70), pp. 117–36

J. Michalkowa: 'Ancora un Vanvitelli', *Bull. Mus. N. Varsovie/Biul. Muz. N. Warszaw.*, xii/3 (1971), pp. 59–65

W. Vitzthum: 'Gaspar van Wittel e Filippo Juvarra', *A. Illus.*, iv/41–2 (1971), pp. 5–9

A. Zwollo: *Hollandse en Vlaamse veduteschilders te Rome (1675–1725)* (Assen, 1973)

Drawings by Gaspar van Wittel from Neapolitan Collections (exh. cat. by W. Vitzthum, intro. by G. Briganti, Ottawa, N.G., 1977)

Gaspare Vanvitelli (1652/53–1736): Zeichnungen und Acquarelle (exh. cat. by R. Harprath, Munich, Staatl. Graph. Samml., 1983)

All'ombra del Vesuvio: Napoli nelle veduta europea dal quattrocento all'ottocento (exh. cat., Naples, Castel S Elmo, 1990)

LUDOVICA TREZZANI

Wouwerman [Wouwermans], Philips [Philippus]

(*b* Haarlem, *bapt* 24 May 1619; *d* Haarlem, 19 May 1668). Dutch painter and draughtsman. He was the eldest son of the painter Paulus [Pauwels] Joostens Wouwerman of Alkmaar (*d* 28 Sept 1642), whose two other sons, Pieter Wouwerman (1623–82) and Johannes Wouwerman (1629–66), also became painters. Philips probably received his first painting lessons from his father, none of whose work has been identified. According to Cornelis de Bie, Wouwerman was next apprenticed to Frans Hals, although no trace of Hals's influence is discernible in Wouwerman's work. Wouwerman is also reputed to have spent several weeks in 1638 or 1639 working in Hamburg in the studio of the German history painter Evert Decker (*d* 1647). While in Hamburg, he married Annetje Pietersz. van Broeckhof. On 4 September 1640 Wouwerman joined the Guild of St Luke in Haarlem, in which in 1646 he held the office of *vinder* (agent or 'finder'). Given the many southern elements in his landscapes, it has repeatedly been suggested that Wouwerman must have travelled to France or Italy, but there is no documentary evidence that he left his native Haarlem for more than short periods. During his lifetime he must have attained a certain degree of prosperity, as demonstrated by the relatively large sums inherited by each of his seven children after his wife's death in 1670. However, there is no confirmation for Houbraken's statement that Wouwerman's daughter Ludovica took with her a dowry of 20,000 guilders when she married the painter Hendrik de Fromantiou (1633/4–after 1694) in 1672.

Wouwerman was undoubtedly the most accomplished and successful 17th-century Dutch painter of horses, which were included in his many small cabinet pictures depicting battle scenes, hunting scenes, army camps, smithies and stables (e.g. *Interior of a Stable*, Paris, Louvre; see fig. 66). That he was a more versatile painter, however, is shown by his sensitively executed silvery-grey landscapes, his genre scenes and his few, original religious and mythological pictures. He was also exceptionally productive: although he lived to be only 48 years old, more than 1000 paintings bear his name, but some of these should be attributed to his brothers Pieter and Johannes. Only a small number of drawings by Philips are known.

In spite of Wouwerman's extensive oeuvre, it is difficult to establish a chronology, since only a comparatively small number of his paintings are dated. The style of his signature enables pictures to be dated only within wide limits: a monogram composed of P, H and W was used only before 1646, after which he used a monogram composed of PHILS and W. His earliest dated work, depicting a *Military Encampment* (1639; sold London, Christie's, 10 Oct 1972, lot 13), is of minor quality, but his talents developed rapidly in the 1640s. During that period the artist was strongly influenced, both in style and subject-matter, by Pieter van Laer, who had returned to Haarlem from Italy in 1638. Houbraken claimed that Wouwerman obtained sketches and studies by van Laer after the latter's death, and van Laer's influence is clearly demonstrated in *Attack on a Coach* (1644; Vaduz, Samml. Liechtenstein), in which several figures and details are quotations from the older artist's work. During the mid-1640s most of Wouwerman's compositions are dominated by a diagonal hill or dune, with a tree as repoussoir and a few rather large figures, usually with horses. Three works dated 1646, a *Landscape with Peasants Merrymaking in front of a Cottage* (Manchester, C.A.G.), a *Battle Scene* (London, N.G.) and a *Landscape with a Resting Horseman* (Leipzig, Mus. Bild. Kst.), show that Wouwerman gradually developed his own style, while continuing to be inspired by the work of van Laer.

By 1649 Wouwerman's sombre palette had become more colourful and his compositions increasingly horizontal. At about the same time his pictures began to reflect a growing interest in

66. Philips Wouwerman: *Interior of a Stable* (Paris, Musée du Louvre)

landscape, and during the first half of the 1650s the artist produced a number of paintings that demonstrate his mastery of the subject. In a *Landscape with Horsemen* (1652; GB, priv. col., see Stechow, fig. 41), painted in silvery tones, the figures and horses have been reduced to rather insignificant staffage. Genre elements continued to play an important role in most of his paintings, however, as can be seen in one of his most successful works of that period, *Festive Peasants before a Panorama* (1653; Minneapolis, MN, Inst. A.). Perhaps nowhere else in his oeuvre did the artist succeed in producing such a happy synthesis of genre and landscape elements. During the second half of the 1650s Wouwerman produced many fanciful hunting scenes, often with a vaguely Italian setting and brighter local colours; these were particularly sought after in the 18th century and the early 19th, especially in France.

Although only a few dated works from the last decade of his life survive, these reveal a tendency towards a more sombre palette and show a slight decline in artistic skill. Van Laer's influence on Wouwerman's style had almost disappeared, but his work continued to influence Wouwerman's choice of subject-matter.

Wouwerman had several pupils, including Nicolaes Ficke (*b c.* 1620), Jacob Warnars and the Swedish artist Koort Witholt in 1642; Antony de Haen (1640–before 1675) studied with him in 1656. Emanuel Murant (1622–*c.* 1700), Hendrick Berckman (1629–79), Barend Gael (*c.* 1630/40–after 1681) and his own two brothers were also pupils. Wouwerman also had many followers. All the important collections created during the 18th and the early 19th century, including those that form the nucleus of the museums in St Petersburg, Dresden and The Hague, contain a large number

of his works. Between 1737 and 1759 Jean Moyreau (1690–1762) published 89 engravings after paintings by Wouwerman. From the mid-19th century Wouwerman's popularity declined, but in the late 20th century there was a revival of interest in his work.

Bibliography

Thieme–Becker

C. de Bie: *Het gulden cabinet* (1661), p. 281

A. Houbraken: *De groote schouburgh* (1718 21), ii, p. 71

J. Moyreau: *Oeuvres de Philippe Wouvermens gravées d'après ses meilleurs tableaux* (Paris, 1737–59)

J. Smith: *A Catalogue Raisonné of the Works of the Most Eminent Dutch, Flemish and French Painters*, i (London, 1829), pp. 199–358; ix (London, 1842), pp. 137–233

C. Hofstede de Groot: *Holländischen Maler* ii (1908), pp. 274–659

S. Kalff: 'De gebroeders Wouwerman', *Elsevier's Geïllus. Mdschr.*, xxx (1920), pp. 96–103

W. Stechow: *Dutch Landscape Painting* (London and New York, 1966), pp. 29–31

Masters of 17th-century Dutch Landscape Painting (exh. cat., ed. P. C. Sutton; Amsterdam, Rijksmus.; Boston, MA, Mus. F.A.; Philadelphia, PA, Mus. A.; 1987–8), pp. 527–34

F. J. Duparc: 'Philips Wouwerman's *Festive Peasants before a Panorama*', *Bull. Minneapolis Inst. A.* (1991)

—: 'Philips Wouwerman, 1619–1668', *Oud Holland* cvii (1993), pp. 257–86

FREDERIK J. DUPARC

Wtewael [Utenwael; Uytewael; Wttewael], Joachim (Anthonisz.)

(*b* Utrecht, 1566; *d* Utrecht, 1 Aug 1638). Dutch painter and draughtsman. He was one of the last exponents of Mannerism. From *c.* 1590 until 1628, the year of his latest known dated paintings, he employed such typical Mannerist formal devices as brilliant decorative colour, contrived spatial design and contorted poses (see fig. 67). He sometimes combined such artifice with naturalism, and this amalgam represents the two approaches Dutch 16th- and 17th-century theorists discussed as *uyt den geest* ('from the imagination') and

67. Joachim Wtewael: *Perseus Saving Andromeda*, 1611 (Paris, Musée du Louvre)

naer 't leven ('after life'). Wtewael's activity reflects the transition from Mannerism to a more naturalistic style in Dutch art. Slightly over 100 of his paintings and about 80 drawings are known. Subjects from the Bible and mythology predominate; he also painted several portraits, including a *Self-portrait* (1601; Utrecht, Cent. Mus.).

According to his contemporary van Mander, the artist was trained in his father's glassworks in Utrecht. He spent four years (*c.* 1588–92) in Italy and France with his patron Charles de Bourgneuf de Cucé, Bishop of St Malo. Wtewael's large canvas of the *Apotheosis of Venus and Diana* (1590–92; priv. col., see Lowenthal, 1986, pl. 2) displays familiarity with the styles of Parmigianino and the Fontainebleau school, exalting the goddesses of love and hunting in a suave, elegant manner, in which pink, flesh and yellow tones predominate. Wtewael had returned to Utrecht by 1592, when he was admitted to the saddlers' guild, to which painters then belonged. His earliest Utrecht works reflect an enthusiastic response to Haarlem developments of the late 1580s. Hendrick Goltzius,

Cornelis Cornelisz. van Haarlem, and their mentor van Mander had formed a trio that exercised powerful influence throughout the northern Netherlands. The Haarlem late Mannerist style was indebted to the exaggerated Italianate manner of the Fleming Bartholomaeus Spranger, a friend and colleague of van Mander. In *The Deluge* (1592–5; Nuremberg, Ger. Nmus.), Wtewael based the convoluted, muscular figures on Goltzius's engravings the *Disgracers* (1588; Hollstein, viii, nos 306–9) after designs by Cornelis van Haarlem. Other typical features are the contrasting pale and ruddy flesh tones of the figures, their upturned faces, prominent noses and splayed fingers and toes. The landscape style reflects that of Abraham Bloemaert, a fellow Utrecht artist, who had also been influenced by Haarlem Mannerism. Wtewael's earliest known signed and dated work, *Parnassus* (1594; Dresden, Gemäldegal., destr.; see Lowenthal, 1986, pl. 4), was a small painting on copper that used as a model Goltzius's drawing of the *Judgement of Midas* (1590; New York, Pierpont Morgan Lib.), which had departed from Spranger's style in its restrained, orderly grace. The classicizing style of such works initiated an important trend in Dutch art. Wtewael's *Apotheosis*, *Deluge* and *Parnassus*, with their contrasting sizes, supports and artistic styles, typify his protean abilities. Throughout his career he varied these factors, producing quite different treatments of a given subject. For example, he depicted the *Adoration of the Shepherds*, one of his favourite themes, on small coppers (e.g. 1601; Stuttgart, Staatsgal.), canvases and panels of medium size (e.g. 1598; Utrecht, Cent. Mus.; *c.* 1606; Oxford, Ashmolean) and a monumental canvas (1618; Pommersfelden, Schloss Weissenstein). His relatively meticulous painting technique is consistent for both large and small works.

Around 1600 Wtewael and the artists of the Haarlem circle began to temper the extravagance of their designs. In his *Kitchen Scene with the Parable of the Great Supper* (1605; Berlin, Bodemus.) Wtewael based the composition on gently receding diagonals, while retaining the Mannerist formula of two openings into depth.

Figural poses are only moderately contorted. He treated the subject traditionally, filling the foreground with foodstuffs and figures that signify earthly temptations, which distract the viewer from the scene of salvation in the background. He used familiar Netherlandish motifs, such as a kitchen maid putting chickens on a spit, which alludes to the colloquialism *vogelen* (to bird, meaning to fornicate). Such word-plays, together with the modern Dutch costumes and furnishings, made the picture's didacticism readily accessible to his contemporaries. Many motifs in the painting have both positive and negative connotations, with the ambiguity left to the viewer to contemplate, thereby confronting him with the moral choices of everyday life. Wtewael often constructed his works on this principle, in keeping with current Dutch practice.

In his later works Wtewael developed an especially sophisticated use of Mannerist contrivance. For example in *Moses Striking the Rock* (1624; Washington, DC, N.G.A.) the procession of Israelites winds with choreographic grace into the distance, the hues of their garments ranging from dusky pink to silvery green. Yet here too he introduced realistic elements, such as the vividly depicted animals and kitchen utensils in the foreground. The influence of Venetians such as Jacopo Bassano, evident in these genre motifs, remained important to Wtewael.

Wtewael's drawings are as varied in style as his paintings. Typically he worked in ink with wash and white heightening on white or buff-coloured paper. He sometimes used chalk, as in *Christ Blessing the Children* (Detroit, MI, Inst. A.). In style, the drawings, too, developed from a boldly expressive manner, as in the *Wedding of Peleus and Thetis* from the 1590s (Berlin, Kupferstichkab.), to the refined treatment of the same subject from 1622 (Haarlem, Teylers Mus.). Sometimes the function of a drawing is difficult to determine; highly finished sheets, such as the last named, may be records that he used as models for painted replicas, which are numerous. In 1596 he made designs for two glass windows in the St Janskerk, Gouda. Several of his designs were engraved, most notably the *Thronus justitiae*

(1606; Amsterdam, Rijksmus., see Lowenthal, 1986, figs 58–71), 13 scenes of justice plus title-page by Willem Swanenburgh.

Wtewael was a flax merchant and politician as well as an artist. A Calvinist sympathizer and supporter of Prince Maurice of Orange Nassau, he was elected to the Utrecht town council several times. He was among the founder-members of the painters' own St Luke's Guild in 1611. One of his sons, Peter Wtewael (1596–1660), was also a painter, whose works until recently were confused with his father's. Peter Wtewael's oeuvre comprises five signed paintings (e.g. *Adoration of the Shepherds*, 1624; Cologne, Wallraf-Richartz-Mus.; *Way to Calvary*, 1627; priv. col.) and about twenty attributed ones.

Bibliography

C. M. A. A. Lindeman: *Joachim Anthonisz. Wtewael* (Utrecht, 1929)

A. W. Lowenthal: 'Some Paintings by Peter Wtewael (1596–1660)', *Burl. Mag.*, cxvi (1974), pp. 458–67

E. McGrath: 'A Netherlandish History by Joachim Wtewael', *J. Warb. & Court. Inst.*, xxxviii (1975), pp. 182–217

S. Helliesen 'Thronus justitiae: A Series of Pictures of Justice by Joachim Wtewael', *Oud-Holland*, xci (1977), pp. 232–66

A. W. Lowenthal: *Joachim Wtewael and Dutch Mannerism* (Doornspijk, 1986)

—: 'Wtewael's Netherlandish History Reconsidered', *Ned. Ksthist. Jb.*, xxxviii (1987), pp. 215–25

—: *Joachim Wtewael: Mars and Venus Surprised by Vulcan* (Malibu, 1995)

ANNE W. LOWENTHAL

Black and White Illustration
Acknowledgements

We are grateful to those listed below for permission to reproduce copyright illustrative material. Every effort has been made to contact copyright holders and to credit them appropriately; we apologize to anyone who may have been omitted from the acknowledgements or cited incorrectly. Any error brought to our attention will be corrected in subsequent editions.

Alinari/Art Resource, NY Figs 47, 65

Erich Lessing/Art Resource, NY Figs 5, 6, 9, 10, 16, 21, 25, 27, 28, 29, 32, 33, 34, 37, 39, 42, 43, 45, 48, 50, 53, 57, 58, 59, 60, 61, 62, 66

Foto Marburg/Art Resource, NY Figs 12, 35, 44

Giraudon/Art Resource, NY Figs 7, 8, 13, 14, 23, 40, 52, 56, 67

Kavaler/Art Resource, NY Figs 11, 17, 22, 49, 51

National Gallery, London/Art Resource, NY Fig 2

The Pierpont Morgan Library/Art Resource, NY Fig 41

Scala/Art Resource, NY Figs 1, 3, 4, 15, 19, 20, 24, 26, 30, 31, 36, 38, 46, 55, 63, 64

SEF/Art Resource, NY Fig 54

Victoria & Albert Museum, London/Art Resource, NY Fig. 18

Colour Illustration
Acknowledgements

Alinari/Art Resource, NY Plate III

Erich Lessing/Art Resource, NY Plates I, II, VII, IX, XI, XV, XVI, XVII, XVIII, XXI, XXIV, XXV, XXIX, XXX, XXXII, XXXIII, XXXIV, XXXVIII, XL

Foto Marburg/Art Resource, NY Plates VI, XXVI

Giraudon/Art Resource, NY Plates XXII, XXXVII

National Gallery, London Plate V

National Gallery, London/Art Resource, NY Plate XXXVI

The Pierpont Morgan Library/Art Resource, NY Plate XIV, XXVII

Scala/Art Resource, NY Plate IV, VIII, X, XII, XIII, XIX, XX, XXIII, XXVIII, XXXI, XXXV, XXXIX

Appendix A
LIST OF LOCATIONS

Every attempt has been made to supply the correct current location of each work of art mentioned, and in general this information appears in abbreviated form in parentheses after the first mention of the work. The following list contains the abbreviations and full forms of the museums, galleries and other institutions that own or display art works or archival material cited in this book; the same abbreviations have been used in bibliographies to refer to the venues of exhibitions.

Institutions are listed under their town or city names, which are given in alphabetical order. Under each place name, the abbreviated names of institutions are also listed alphabetically, ignoring spaces, punctuation and accents. Square brackets following an entry contain additional information about that institution, for example its previous name or the fact that it was subsequently closed.

Aachen, Suermondt-Ludwig-Mus.
 Aachen, Suermondt-Ludwig-
 Museum
Adelaide, A.G. S. Australia
 Adelaide, Art Gallery of South
 Australia
Algiers, Mus. N. B.-A.
 Algiers, Musée National des
 Beaux-Arts
Alkmaar, Stedel. Mus.
 Alkmaar, Stedelijk Museum
Allschwil, Gemeindesamml.
 Allschwil, Gemeindesammlung
Amersfoort, Mus. Flehite
 Amersfoort, Museum Flehite
Amiens, Mus. Picardie
 Amiens, Musée de Picardie
Amsterdam, Hist. Mus.
 Amsterdam, Historisch Museum
Amsterdam, Kon. Coll. Zeemanschoop
 Amsterdam, Koninklijk College
 Zeemanschoop
Amsterdam, Ksthand. Gebr. Douwes
 Amsterdam, Kunsthandel
 Gebroeders Douwes
Amsterdam, Mus. Fodor
 Amsterdam, Museum Fodor
Amsterdam, Mus. van Loon
 Amsterdam, Museum van Loon
Amsterdam, Ned. Hervormde
Gemeente
 Amsterdam, Nederlands
 Hervormde Gemeente

Amsterdam, Ned. Hist.
 Scheepvaartsmus.
 Amsterdam, Nederlands Historisch
 Scheepvaartsmuseum
Amsterdam, Ned. Theat. Inst.
 Amsterdam, Nederlands Theater
 Instituut [houses Theatermus.]
Amsterdam, P. de Boer
Amsterdam, Rembrandthuis
Amsterdam, Rijksmus.
 Amsterdam, Rijksmuseum
 [includes Afdeeling Aziatische
 Kunst; Afdeeling Beeldhouwkunst;
 Afdeeling Nederlandse
 Geschiedenis; Afdeeling
 Schilderijen; Museum von
 Asiatische Kunst; Rijksmuseum
 Bibliotheek; Rijksprentenkabinet]
Amsterdam, Sticht. Kon. Pal.
 Amsterdam, Stichting Koninklijk
 Paleis te Amsterdam
Amsterdam, Waterman Gal.
 Amsterdam, K. en V. Waterman
 Galerij
Anholt, Fürst Salm-Salm, Mus.
 Wasserburg-Anholt
 Anholt, Fürst zu Salm-Salm,
 Museum Wasserburg-Anholt
Ansbach, Residenz & Staatsgal.
 Ansbach, Residenz und
 Staatsgalerie
Antwerp, Kon. Acad. S. Kst.
 Antwerp, Nationaal Hoger

 Instituut en Koninklijke Academie
 voor Schone Kunsten
Antwerp, Kon. Mus. S. Kst.
 Antwerp, Koninklijk Museum voor
 Schone Kunsten
Antwerp, Mus. Mayer van den Bergh
 Antwerp, Museum Mayer van den
 Bergh
Antwerp, Mus. Smidt van Gelder
 Antwerp, Museum Smidt van
 Gelder
Apeldoorn, Pal. Het Loo
 Apeldoorn, Rijksmuseum Paleis
 Het Loo
Arles, Mus. Réattu
 Arles, Musée Réattu
Atlanta, GA, High Mus. A.
 Atlanta, GA, High Museum
 of Art
Auckland, C.A.G.
 Auckland, City Art Gallery
Baden-Baden, Staatl. Ksthalle
 Baden-Baden, Staatliche
 Kunsthalle Baden-Baden
Baltimore, MD, Mus. A.
 Baltimore, MD, Baltimore Museum
 of Art
Bamberg, Neue Residenz, Staatsgal.
 Bamberg, Staatsgalerie in der
 Neuen Residenz
Barnard Castle, Bowes Mus.
 Barnard Castle, Bowes
 Museum

Dijon, Mus. Magnin
 Dijon, Musée Magnin
Dordrecht, Dordrechts Mus.
 Dordrecht, Dordrechts Museum
Dordrecht, Mus. van Gijn
 Dordrecht, Museum Mr Simon van
 Gijn
Douai, Mus. Mun.
 Douai, Musée Municipal [La
 Chartreuse]
Dresden, Gemäldegal. Alte Meister
 Dresden, Gemäldegalerie Alte
 Meister [in Zwinger]
Dresden, Kupferstichkab.
 Dresden, Kupferstichkabinett
Dublin, N.G.
 Dublin, National Gallery of
 Ireland
Dublin, Trinity Coll.
 Dublin, University of Dublin,
 Trinity College
Dunkirk, Mus. B.-A.
 Dunkirk, Musée des Beaux-Arts
Düsseldorf, Kstmus.
 Düsseldorf, Kunstmuseum im
 Ehrenhof
Düsseldorf, Kstsamml. Nordrhein-
Westfalen
 Düsseldorf, Kunstsammlung
 Nordrhein-Westfalen
 [Landesgalerie]
Edinburgh, N.G.
 Edinburgh, National Gallery of
 Scotland
Edinburgh, N.P.G.
 Edinburgh, National Portrait
 Gallery
Eindhoven, Stedel. Van Abbemus.
 Eindhoven, Stedelijk Van
 Abbemuseum
Emden, Ostfries. Landesmus. & Städt.
Mus.
 Emden, Ostfriesisches
 Landesmuseum und Städtisches
 Museum
Enschede, Rijksmus. Twenthe
 Enschede, Rijksmuseum
 Twenthe [houses
 Oudheidkamer]
Eutin, Kreisheimatmus.
 Eutin, Kreisheimatmuseum

Evanston, IL, Northwestern U.
 Evanston, IL, Northwestern
 University
Feltre, Mus. Civ.
 Feltre, Museo Civico
Florence, Uffizi
 Florence, Galleria degli Uffizi
 [incl. Gabinetto dei Disegni]
Framingham, MA, Danforth
Mus. A.
 Framingham, MA, Danforth
 Museum of
 Art
Frankfurt am Main, Städel. Kstinst. &
Städt. Gal.
 Frankfurt am Main, Städelsches
 Kunstinstitut und Städtische
 Galerie
Geneva, Mus. A. & Hist.
 Geneva, Musée d'Art et
 d'Histoire
Ghent, Mus. S. Kst.
 Ghent, Museum voor Schone
 Kunsten
Glasgow, A.G. & Mus.
 Glasgow, Art Gallery and Museum
 [Kelvingrove]
Gouda, Archf Ned. Hervormde
Gemeente
 Gouda, Archief Nederlandse
 Hervormde Gemeente
Gouda, Stedel. Mus. Catharina
Gasthuis
 Gouda, Stedelijk Museum Het
 Catharina Gasthuis
Greenville, SC, Bob Jones U. Gal.
Sacred A.
 Greenville, SC, Bob Jones
 University Gallery of Sacred Art
 and Bible Lands Museum
Grenoble, Mus. B.-A.
 Grenoble, Musée des Beaux-
 Arts
Grenoble, Mus. Grenoble
 Grenoble, Musée de Grenoble
 [formerly Mus. Peint. & Sculp.]
Groningen, Groninger Mus.
 Groningen, Groninger Museum
Haarlem, Bisschopp. Mus.
 Haarlem, Bisschoppelijk
 Museum

Haarlem, Frans Halsmus.
 Haarlem, Frans Halsmuseum
Haarlem, Teylers Mus.
 Haarlem, Teylers Museum
Hagerstown, MD, Washington Co. Hist.
Soc. Mus.
 Hagerstown, MD, Washington
 County Historical Society Museum
The Hague, Binnenhof
The Hague, Cramer Gal.
 The Hague, H. M. Cramer Gallery
The Hague, Dienst Verspr. Rijkscol.
 The Hague, Dienst Verspreide
 Rijkscollectie
The Hague, Gemeentemus.
 The Hague, Haags
 Gemeentemuseum [houses Oude
 en Moderne Kunstnijverheid;
 Haagse Stadgeschiedenis; Moderne
 Kunst; Museon;
 Muziekinstrumenten; Nederlands
 Kostuummuseum]
The Hague, Kon. Bib.
 The Hague, Koninklijke
 Bibliotheek [Nationale
 Bibliotheek]
The Hague, Ksthand. Nijstad
 The Hague, Kunsthandel Nijstad
The Hague, Mauritshuis [incl.
Koninklijk Kabinet van Schilderijen]
The Hague, Mus. Bredius
 The Hague, Museum Bredius
The Hague, Oude Stadhuis
The Hague, Rijksdienst Beeld. Kst
 The Hague, Rijksdienst Beeldende
 Kunst
The Hague, S. Nystad Gal.
 The Hague, S. Nystad Gallery
Hamburg, Altonaer Mus.
 Hamburg, Altonaer Museum
 [Norddeutsches Landesmuseum]
Hamburg, Ksthalle
 Hamburg, Hamburger Kunsthalle
 [incl. Kupferstichkabinett]
Hannover, Niedersächs. Landesmus.
 Hannover, Niedersächsisches
 Landesmuseum [Niedersächsische
 Landesgalerie; formerly called
 Provmus.]
Hanover, NH, Dartmouth Coll., Hood
Mus. A.

Utrecht, Cent. Mus.
 Utrecht, Centraal Museum
Vaduz, Samml. Liechtenstein
 Vaduz, Sammlungen der Fürsten
 von Liechtenstein
Valletta, Pal. Grand Masters
 Valletta, Palace of the Grand
 Masters [houses Palace
 Armoury]
Versailles, Château [Musée National
du Château de Versailles et du
Trianon]
Vienna, Akad. Bild. Kst.
 Vienna, Akademie der Bildenden
 Künste
Vienna, Albertina
 Vienna, Graphische Sammlung
 Albertina
Vienna, Bib. Akad. Bild. Kst.
 Vienna, Bibliothek der Akademie
 der Bildenden Künste
Vienna, Gal. Friederike Pallamar
 Vienna, Galerie Friederike
 Pallamar

Vienna, Gemäldegal. Akad. Bild. Kst.
 Vienna, Gemäldegalerie der
 Akademie der Bildenden Künste
Vienna, Ksthist. Mus.
 Vienna, Kunsthistorisches
 Museum [admins Ephesos Mus.;
 Ksthist. Mus.; Mus. Vlkerknd.;
 Nbib.; Neue Gal. Stallburg; Samml.
 Musikinstr.; Schatzkam.; houses
 Gemäldegalerie; Neue Hofburg;
 Kunstkammer; Sammlung für
 Plastik und Kunstgewerbe]
Vienna, Österreich. Nbib.
 Vienna, Österreichische
 Nationalbibliothek [Hofbibliothek]
Warsaw, N. Mus.
 Warsaw, National Museum
 (Muzeum Narodowe)
Washington, DC, Corcoran Gal. A.
 Washington, DC, Corcoran Gallery
 of Art
Washington, DC, N.G.A.
 Washington, DC, National Gallery
 of Art

Weimar, Schlossmus.
 Weimar, Schlossmuseum
Winterthur, Stift. Briner
 Winterthur, Stiftung Jacob Briner
Worcester, MA, A. Mus.
 Worcester, MA, Worcester Art
 Museum
Worms, Ksthaus Heylshof
 Worms, Kunsthaus Heylshof
 [Heylshof Kunstsammlungen]
Wrocław, Ossolineum [Ossolinski N.
 Establishment]
York, C.A.G.
 York, City Art Gallery [until
 1892 called F.A. & Ind. Exh.
 Bldgs]
Zeist, Rijksdnst Mnmtz.
 Zeist, Rijksdienst voor de
 Monumentenzorg
Zurich, Ksthaus
 Zurich, Kunsthaus Zürich
Zwolle, Prov. Overijssels Mus.
 Zwolle, Provinciaal Overijssels
 Museum

Appendix B
LIST OF PERIODICAL TITLES

This list contains all of the periodical titles that have been cited in an abbreviated form in italics in the bibliographies of this book. For the sake of comprehensiveness, it also includes entries of periodicals that have not been abbreviated, for example where the title consists of only one word or where the title has been transliterated. Abbreviated titles are alphabetized letter by letter, including definite and indefinite articles but ignoring punctuation, bracketed information and the use of ampersands. Roman and arabic numerals are alphabetized as if spelt out (in the appropriate language), as are symbols. Additional information is given in square brackets to distinguish two or more identical titles or to cite a periodical's previous name.

A. America
 Art in America [cont. as *A. America & Elsewhere*; *A. America*]
A. Ant. & Mod.
 Arte antica e moderna
A. Bull.
 Art Bulletin
Acta Hist. A. Acad. Sci. Hung.
 Acta historiae artium Academiae scientiarum Hungaricae
A. Hist.
 Art History
A. Illus.
 Arte illustrata: Rivista d'arte antica e moderna
Allen Mem. A. Mus. Bull.
 Allen Memorial Art Museum Bulletin
Amstelodamum
An. & Bol. Mus. A. Barcelona
 Anales y boletín de los Museos de arte de Barcelona
Antiek
Apollo
A. Q. [Detroit]
 Art Quarterly [Detroit]
Archv Soc. Romana Stor. Patria
 Archivio della Società romana di storia patria
Artis
ARTnews
Ber. Hist. Gez. Utrecht
 Berigten van het Historisch gezelschap te Utrecht
Berlin. Mus.: Ber. Staatl. Mus. Preuss. Kultbes.

Berliner Museen: Berichte aus den Staatlichen Museen preussischer Kulturbesitz [prev. pubd as *Amtl. Ber. Kön. Kstsamml.*; cont. as *Berlin. Mus.: Ber. Ehem. Preuss. Kstsamml.*]
Bol. Mus. N. A. Ant.
 Boletim do Museu nacional de arte antiga
Brabants Heem
 Brabants heem
Bull. Cleveland Mus. A.
 Bulletin of the Cleveland Museum of Art
Bull. Detroit Inst. A.
 Bulletin of the Detroit Institute of Arts
Bull. Minneapolis Inst. A.
 Bulletin of the Minneapolis Institute of Arts
Bull. Mus. Ermitage
 Bulletin du Musée de l'Ermitage
Bull. Mus. Hong. B.-A.
 Bulletin du Musée hongrois des beaux-arts [A Szépművészeti múzeum közleményei [cont. as *Bull. Mus. N. Hong. B.-A.*]
Bull. Mus. N. Varsovie/Biul. Muz. N. Warszaw.
 Bulletin du Musée national de Varsovic/Biuletyn Muzeum narodowego w Warszawie
Bull.: Philadelphia Mus. A.
 Bulletin: Philadelphia Museum of Art [prev. pubd as *Philadelphia Mus. A.: Bull.*; *PA Mus. Bull.*]

Bull. Rijksmus.
 Bulletin van het Rijksmuseum
Burl. Mag.
 Burlington Magazine
Connoisseur
Country Life
Delineavit & Sculp.
 Delineavit et sculpsit
Delta
Die Weltkunst
Dordrechts Mus. Bull.
 Dordrechts Museum Bulletin
Dresdn. Kstbl.
 Dresdner Kunstblätter
Eigen Haard
 Eigen haard
Fem. A. J.
 Feminist Art Journal
Forsch. & Ber.: Staatl. Mus. Berlin
 Forschungen und Berichte: Staatliche Museen zu Berlin
Gaz. B.-A.
 Gazette des beaux-arts [suppl. is *Chron. A.*]
Gent. Bijdr. Kstgesch.
 Gentsche bijdragen tot de kunstgeschiedenis [Ghent contributions to art history; cont. as *Gent. Bijdr. Kstgesch. & Oudhdknd.*; *Gent. Bijdr. Kstgesch.*]
Getty Mus. J.
 J. Paul Getty Museum Journal
Giessen. Beitr. Kstgesch.
 Giessener Beiträge zur Kunstgeschichte
Historia [Utrecht]

Pantheon
 Pantheon: Internationale
 Zeitschrift für Kunst [cont. as
 Bruckmanns Pantheon]
Paragone
Perceptions
Prt Q.
 Print Quarterly
Raggi
Rec. A. Mus., Princeton U.
 Record of the Art Museum,
 Princeton University
Rev. A. Anc. & Mod.
 Revue de l'art ancien et moderne
Rev. Belge Archéol. & Hist. A.
 Revue belge d'archéologie et
 d'histoire de l'art [prev. pubd as
 Rev. Belge Archéol. & Hist.
 A./Belge Tijdschr. Oudhdknde &
 Kstgesch.]
Rev. Louvre
 Revue du Louvre et des musées de
 France
RI Des. Bull.
 Rhode Island Design Bulletin
Rotterdam. Jb.
 Rotterdamsche jaarboekje

Simiolus
Städel-Jb.
 Städel-Jahrbuch
Stor. A.
 Storia dell'arte
Tableau
Tijdschr. Gesch. & Flklore
 Tijdschrift voor geschiedenis en
 folklore [Journal of history and
 folklore]
TLS
 The Times Literary Supplement
Uměni [Arts]
Versl. & Meded. Ver. Beoef.
Overijsselsch Regt & Gesch.
 Verslagen en mededelingen der
 Vereeniging tot beoefening van
 Overijsselsch regt en geschiedenis
 [Reports and communications of
 the Association for the Study and
 History of the Overijssel Area]
Vita Artistica
Wallraf-Richartz-Jb.
 Wallraf-Richartz-Jahrbuch
Westfalen: Hft. Gesch., Kst & Vlksknd.
 Westfalen: Hefte für Geschichte,
 Kunst und Volkskunde

Woman's A. J.
 Woman's Art Journal
Worcester A. Mus. Bull.
 Worcester Art Museum
 Bulletin
Yale J. Crit.
 Yale Journal of
 Criticism
Z. Kstgesch.
 Zeitschrift für Kunstgeschichte
 [merger of Z. Bild. Kst with
 Repert. Kstwiss. & with Jb.
 Kstwiss.]
Z. Schweiz. Archäol. & Kstgesch.
 Zeitschrift für schweizerische
 Archäologie und
 Kunstgeschichte
Ned. Ksthist. Jb.
 Nederlands(ch) kunsthistorisch
 jaarboek
Z. Bild. Kst
 Zeitschrift für bildende Kunst
 [incorp. suppl. Kstchron. &
 Kstlit.; merged with Jb. Kstwiss.
 & with Repert. Kstwiss. to form Z.
 Kstgesch.]

Appendix C

LISTS OF STANDARD REFERENCE BOOKS AND SERIES

This Appendix contains, in alphabetical order, the abbreviations used in bibliographies for alphabetically arranged dictionaries and encyclopedias. Some dictionaries and general works, especially dictionaries of national biography, are reduced to the initial letters of the italicized title (e.g. *DNB*) and others to the author/editor's name (e.g. Colvin) or an abbreviated form of the title (e.g. *Contemp. Artists*). Abbreviations from Appendix C are cited at the beginning of bibliographies or bibliographical subsections, in alphabetical order, separated by semi-colons; the title of the article in such reference books is cited only if the spelling or form of the name differs from that used in this dictionary or if the reader is being referred to a different subject.

Bénézit
 E. Bénézit, ed.: *Dictionnaire critique et documentaire des peintres, sculpteurs, dessinateurs et graveurs*, 10 vols (Paris, 1913-22, rev. 3/1976)

BNB
 Biographie nationale [belge] (Brussels, 1866-)

Foskett
 D. Foskett: *A Dictionary of British Miniature Painters*, 2 vols (London, 1972)

Hollstein: *Dut. & Flem.*
 F. W. H. Hollstein: *Dutch and Flemish Etchings, Engravings and Woodcuts, c. 1450-1700* (Amsterdam, 1949-)

Hollstein: *Ger.*
 F. W. H. Hollstein: *German Engravings, Etchings and Woodcuts, c. 1400-1700* (Amsterdam, 1954-)

NKL
 Norsk kunstnerleksikon, 4 vols (Oslo, 1982)

NNBW
 Nieuw Nederlandsch biografisch woordenboek, 10 vols (Leiden, 1911-37)

Thieme-Becker
 U. Thieme and F. Becker, eds: *Allgemeines Lexikon der bildenden Künstler von der Antike bis zur Gegenwart*, 37 vols (Leipzig, 1907-50) [see also Meissner above]

Waterhouse: *16th & 17th C.*
 E. Waterhouse: *The Dictionary of 16th and 17th Century British Painters* (Woodbridge, 1988)

Wurzbach
 A. von Wurzbach: *Niederländisches Künstler-Lexikon auf Grund archivalischen Forschungen bearbeitet*, 3 vols (Vienna and Leipzig, 1906-11/R Amsterdam, 1974)